GIOTTO TO DÜRER

Early Renaissance Painting in The National Gallery

GIOTTO TO DÜRER

Early Renaissance Painting in The National Gallery

JILL DUNKERTON, SUSAN FOISTER, DILLIAN GORDON AND NICHOLAS PENNY

YALE UNIVERSITY PRESS, NEW HAVEN AND LONDON

IN ASSOCIATION WITH

NATIONAL GALLERY PUBLICATIONS LIMITED, LONDON

For

Sophie

Felix Isabella

Alice Olivia

Caroline Elizabeth

Library of Congress Catalog Card Number 91-65547

British Library Cataloguing in Publication Data

Giotto to Dürer
 I. Dunkerton, Jill
 II. National Gallery (Great Britain)
759.94074

ISBN 0-300-05070-4
ISBN 0-300-05082-8 pbk

Designed by Harry Green

Edited by Diana Davies

Maps by Antony White Publications Limited, 1991

Set in Linotron Bembo by SX Composing Ltd, Rayleigh, Essex
Printed in Italy by Amilcare Pizzi s.p.a., Milan

FRONTISPIECE: Detail from the Wilton Diptych (No. 10).

CONTENTS

❧

ACKNOWLEDGEMENTS

The authors wrote much of the book together and owe much to each other in those parts where they were working independently. They are particularly indebted to Erika Langmuir for her help with the initial planning and final polishing of the book, and for compiling the Glossary. Parts of the text were read at an early stage and commented on by Lorne Campbell and Caroline Elam – their contributions and those of Ashok Roy and Raymond White of the National Gallery Scientific Department and of Martin Wyld and David Bomford of the National Gallery Conservation Department were vital. The authors are also especially grateful to Jo Kirby for the Note on Measurement and Coinage, and to Tom Henry and Ailsa Turner for their helpful suggestions. They would like to record their appreciation of the painstaking preparation of the typescript by Louise Woodroff, Sarah Perry and Beverly Nicholson. The patience and care of Sara Hattrick and the National Gallery Photographic Department in taking many of the photographs for this book have been exceptional, as have been the diligence and dispatch displayed by Diana Davies, Felicity Luard, Emma Shackleton and Patricia Williams of the National Gallery and John Nicoll of Yale University Press in preparing the book for publication.

FOREWORD

The history of art can be told in many ways – as the history of great artists, as the development of local schools of painting, or as the evolution of modes of feeling and seeing. This book, the first of four such National Gallery volumes, is above all a history of pictures.

All the paintings discussed in detail hang in the National Gallery. Acquired over many decades, all were added to the Collection with one steady and clearly defined purpose: to show, through the best possible examples, how painting in Western Europe changed (the nineteenth century would have said improved) between the mid-thirteenth century and the years around 1500.

The visitor to the National Gallery can follow those changes in the major centres of the Netherlands, Germany and Italy in a way hardly possible in any other collection. And at the National Gallery these pictures have in the last fifty years been closely examined by curators, conservators, scientists and photographers, initially to help preserve them from the polluted London atmosphere, more recently to unravel the complexities of construction, pigment and medium. We can now plot the changes in how pictures were made almost as closely as we can follow the changes in how they reflect the visible world.

The opening of the Sainsbury Wing extension in 1991 made necessary the re-ordering of the entire National Gallery Collection. Reasons of conservation suggested giving the earliest, most fragile pictures the protection of the new building's controlled climate. It also provided the opportunity to present the Collection in a new way: pictures of the same date from Northern and Southern Europe now hang together on the walls of the National Gallery, and thus tell a more truly European story of painting, the story told in this book.

NEIL MacGREGOR
Director

PREFACE

This book is about painting in Europe of the period 1260 to 1510. Its international emphasis reflects the nature of our subject. We are used to thinking of paintings as belonging to separate 'national schools' – Italian, Netherlandish, or German. But those categories meant little at the time, and not only because neither Italy nor Germany existed. Paintings moved easily across Europe. Art, like other luxuries, often served for diplomatic gifts, and was transported to foreign courts. Thus the Duc de Berry in the early years of the fifteenth century owned hangings sewn with jewels – *opus florentinum* (after Florence, the city where it was made) – and caskets of parquetry inlaid with bone from Venice. The Italian courts at the same date had tapestries made in the Netherlands – or by Netherlandish craftsmen – for artists of all kinds, as well as art, moved from court to court. The courts were not only in communication with each other but often had interests in more than one part of Europe. The Church as an international organisation, and the great councils and pilgrimages, encouraged traffic in art and, as we shall see, the scanty evidence that survives of the market for ready-made devotional images suggests that it was international in scope.

However, our chief concern in this book is not to trace the movement of art or of artists. We are concerned with what was constant. The essential needs which art served – and the uses to which it was put – were the same all over Christian Europe and that alone would justify the treatment which we have attempted here. The altarpiece, for instance, in the late thirteenth century served the same purpose in Siena, Westminster and Cologne, and this purpose had changed very little two centuries later.

We do of course discuss the transmission of style, the spread of new ideas in both subject matter and above all technique, often across frontiers, tracing, in particular, in the fifteenth century some of the influences which spread from the Netherlands to the rest of Europe and transformed the very nature of painting. The National Gallery's collection of paintings is sufficiently rich for it to be used to illustrate this.

The reader should, however, be warned that the history which we have attempted here does have certain limitations. Although there are several detached fresco paintings in the Collection, mural paintings can only be studied in the churches and palaces for which they were made. Consequently many of the most ambitious paintings, and in particular some of the most interesting narrative paintings, are excluded

from our discussion. Less surprisingly, manuscript illuminations cannot play an important part in this book. For the most part the manuscripts are of course in libraries. Such paintings were sometimes made by the artists who worked on a larger scale, and there was always a vital relationship between the different types of painting.

Other limitations arise from the Collection. It includes nothing from Bohemia and only a couple of works from the Iberian peninsula, while among the great German towns only Cologne is well represented. There are pictures of extraordinary importance by some Netherlandish painters in the Collection, but the number of Netherlandish works is small when compared with the number of paintings from Italy – or indeed merely from Florence.

It is, of course, Florence that is chiefly conjured up by the words Early Renaissance – the very idea of the Renaissance implies a priority for Italian art and it was in Tuscany that the most important early theories of art and the earliest histories of art were written. The term Early Renaissance is used here only as a vague chronological indicator, and our emphasis is different from that which is familiar from books on Renaissance art, not least because it conceives of this period as one in which the great developments in art were found both north and south of the Alps.

A NOTE ON THE ORGANISATION OF THIS BOOK
Most of the major paintings of this period in the National Gallery are illustrated and given separate commentaries in Part Three. Reference is often made to them in the first two parts of the book by their number.

Figure numbers refer to illustrations in Parts One and Two. Comparative illustrations in Part Three have been given letters. Thus No. 32a refers to the first comparative illustration used for No. 32, *The Entombment* by Dieric Bouts, in Part Three.

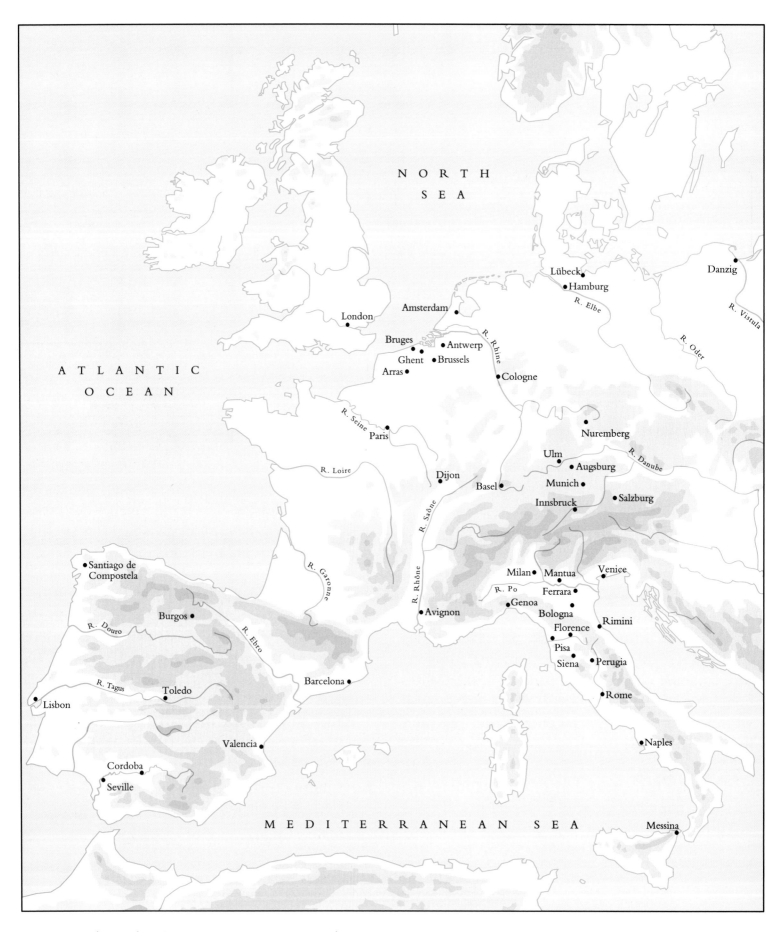

NORTH SEA

ATLANTIC OCEAN

MEDITERRANEAN SEA

Lübeck
Hamburg
Danzig
R. Elbe
R. Vistula
R. Oder
London
Amsterdam
Bruges
Antwerp
Ghent
Brussels
R. Rhine
Arras
Cologne
R. Seine
Paris
Nuremberg
Ulm
R. Danube
Dijon
Augsburg
R. Loire
Basel
Munich
Innsbruck
Salzburg
R. Saône
Santiago de Compostela
R. Rhône
Milan
Mantua
Venice
R. Po
Ferrara
R. Garonne
Avignon
Genoa
Burgos
Bologna
Rimini
R. Douro
Florence
R. Ebro
Pisa
Siena
Perugia
R. Tagus
Toledo
Barcelona
Rome
Lisbon
Valencia
Naples
Cordoba
Seville
Messina

Europe 1260-1510 showing the main towns in Western Europe mentioned.

WESTERN EUROPE

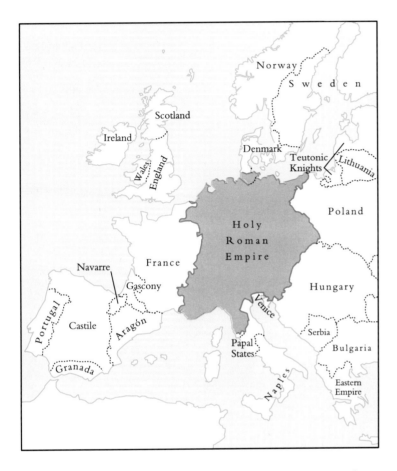

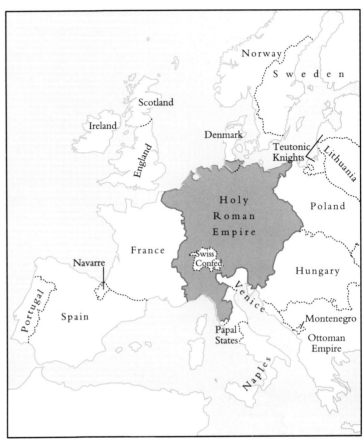

Major political boundaries in 1260. The largest political entity in Europe was the Holy Roman Empire, but at this date it was only a loose confederation. The towns and larger territories of which it was composed paid homage to the Emperor, but were not in practice always obedient to him. Most of Europe was ruled by Christian princes who acknowledged the authority of the Pope in Rome. The Eastern Empire, however, although Christian, did not do so. Lithuania had not yet been claimed for Christianity. Granada in Spain was Moslem in 1260 and was ruled from North Africa; after 1269 it was an independent emirate. The kingdom of Navarre was under French rule.

Major political boundaries in 1500 (before the French conquests in Italy recognised at the Peace of Granada and the Peace of Trent). The extent of the Holy Roman Empire remained largely unchanged. The kingdoms of Aragón and Castile in Spain had been united in 1479 and the Moslem emirate of Granada had been conquered in 1492. Meanwhile the Ottoman Turks had not only conquered the vestiges of the Byzantine Empire but much of Eastern Europe, including Serbia and Southern Greece.

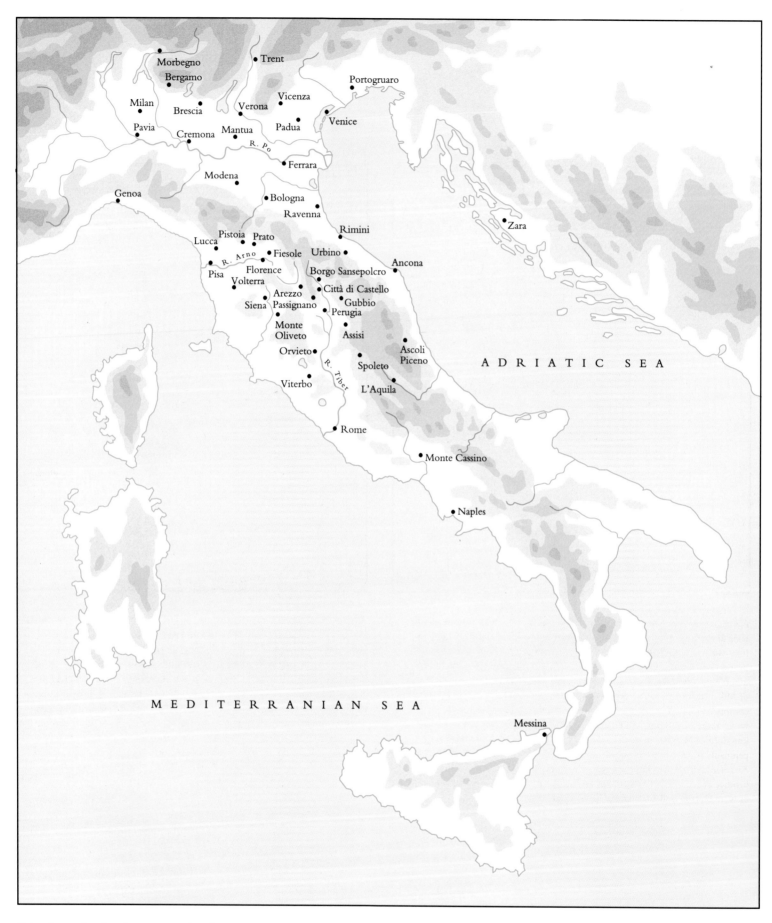

Italy 1260-1510 showing the towns mentioned.

ITALY

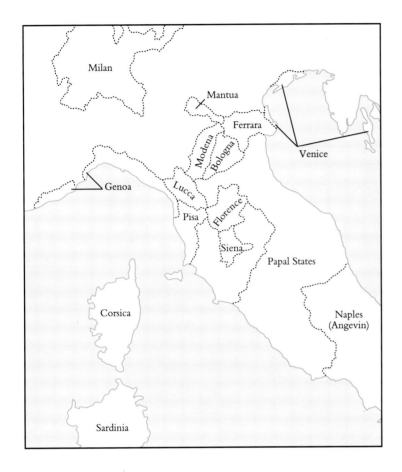

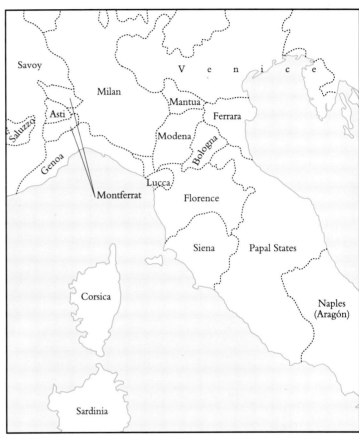

Northern and Central Italy in the first half of the fourteenth century showing *some* of the major political boundaries. Such boundaries changed frequently. Italy was not a unified nation state. Some parts of it were governed by a more or less democratic commune (e.g. Siena) or by an oligarchy (e.g. Venice), others by a ruling family (e.g. Milan). Some Italian states, notably the Duchy of Milan, formed a part of the Holy Roman Empire. The Papal States comprised numerous territories and towns (here indicated as a single unit) which were often rivals and enjoyed varying degrees of independence. The kingdom of Naples extended into the whole southern part of the Italian peninsula and included Sicily. In this period it was mostly ruled by the Angevin dynasty, having been conquered in 1266 by Charles of Anjou, brother of the King of France, but the island of Sicily was soon lost to them, as were Corsica and Sardinia (taken by Genoa and Aragón respectively).

Northern and Central Italy showing the political boundaries in 1454, the date of the Peace of Lodi between Venice and Milan. This Peace was endorsed by the other great powers in Italy and established a new equilibrium in Italian politics. Venice greatly increased its mainland territories. Her rule extended down the coast of the Adriatic and included the island of Crete. As will be seen by comparing this map with the one above left, Pisa had been eliminated as a power. Genoa, Florence, Siena, Milan and Venice had greatly expanded. The Spanish kingdom of Aragón now also ruled Majorca, Sardinia and the kingdom of Naples, although in 1458 this latter was made a separate kingdom ruled by an illegitimate son of the Spanish king.

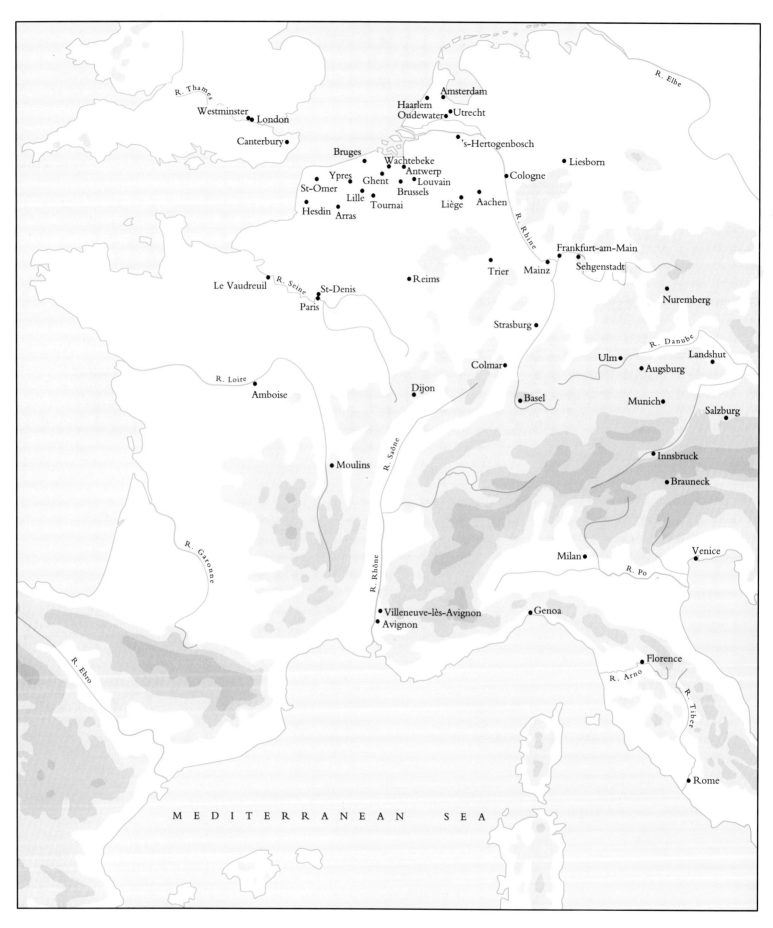

R. Thames

Westminster London

Canterbury

Amsterdam

Haarlem
Oudewater Utrecht

's-Hertogenbosch

Liesborn

Bruges

Wachtebeke

Antwerp

Ypres Ghent Louvain

St-Omer Brussels

Cologne

Lille Liège Aachen

Hesdin Arras Tournai

R. Elbe

R. Rhine

Le Vaudreuil R. Seine

St-Denis

Paris

Reims

Trier Mainz

Frankfurt-am-Main

Sehgenstadt

Nuremberg

Strasburg

R. Danube

Ulm Landshut

R. Loire

Colmar

Augsburg

Amboise

Dijon

Basel

Munich

Salzburg

R. Saône

Moulins

Innsbruck

Brauneck

R. Garonne

R. Rhône

Milan

Venice

R. Po

Villeneuve-lès-Avignon

Avignon

Genoa

R. Ebro

Florence

R. Arno

R. Tiber

Rome

M E D I T E R R A N E A N S E A

France, Burgundy and the Empire 1260-1510 showing the towns mentioned (for towns in Italy see p.12).

FRANCE, BURGUNDY
AND THE EMPIRE

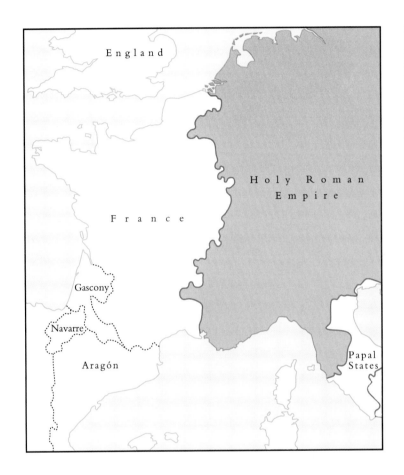

North-Western Europe in 1260 showing the kingdom of France, the Holy Roman Empire, the kingdom of England (which then included Gascony) and the kingdom of Navarre (which was then ruled by France). Among the rulers who owed allegiance to the kingdom of France were the Dukes of Brittany and Burgundy. Whereas Brittany was to be absorbed, Burgundy became a great independent power as can be seen from the map above right.

North-Western Europe in 1475 showing the possessions of the Dukes of Burgundy, the major divisions of which included Brabant and Lorraine. At this date, under Charles the Bold, the Burgundian territories were at their greatest extent, but Lorraine, which linked the northern and southern possessions, was only briefly under Charles's control. With the death of Charles in 1477 the Duchy of Burgundy itself passed to France and the remaining territories to the Empire. Gascony was retrieved from the English in 1451, but Calais remained under English control until 1558.

CHRONOLOGY

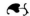

Painting	Cultural and Spiritual Life	Political Events
1260		
1260s? Decoration of the Church of San Francesco, Assisi (consecrated 1253), begun; continues into 14th century	1260 Constitution of Saint Bonaventura (Reform of Franciscan Order)	1261 Constantinople reconquered from Turks for Byzantine Empire
c.1262 Margarito of Arezzo active	Nicola Pisano completes pulpit in Baptistery, Pisa	1264 Venetian fleet defeats Genoese off Trapani
1266-7 (?) Birth of Giotto	Flagellant movement begins in Perugia	1265-8 Conquest of Kingdom of Naples (including Sicily) by Charles of Anjou
	before 1264 *The Golden Legend* by Jacobus de Voragine	
	1264 Merton College, Oxford, founded	
	1265 Birth of Dante Alighieri in Florence	
	1268-76 Papermill established at Fabriano	
1270		
c.1270-80 Westminster Retable, Westminster Abbey	c.1270 Pseudo Bonaventura's *Meditations on the Life of Christ*	1270 Death of Louis IX, King of France, while heading the seventh (and last) crusade
1272 Master of Saint Francis active in Perugia	1274 Death of Saint Thomas Aquinas (canonised 1323)	1272 Death of Henry III of England
	1279 Santa Maria Novella, Florence, nave begun	1274 Coronation of Edward I of England
		1275 Marco Polo enters service of Emperor Kublai Khan in China
1280		
1280s Cimabue's Santa Trinità Madonna	1280 Invention of mirror glass	1283 Prussia and Estonia conquered by Military Order of Teutonic Knights
1285 Duccio contracted to paint *Rucellai Madonna*, Santa Maria Novella, Florence	1284 College of Peterhouse, Cambridge, founded	
1290		
1290s In Rome, Pietro Cavallini working on frescoes in Santa Cecilia in Trastevere and mosaics in Santa Maria in Trastevere, Jacopo Torriti working on apse mosaics of Santa Maria Maggiore	1291 Nave of York Minster begun (completed 1324)	1290 Jews expelled from England
	1294/5 Santa Croce, Florence, begun by Arnolfo di Cambio	1291 Fall of Acre to Turks and loss of control of Jerusalem, leading to end of Christian rule in Eastern Mediterranean
	1298 Palazzo Pubblico, Siena, begun	1295 Matteo Visconti becomes Tyrant of Milan
	1299 Palazzo della Signoria, Florence, begun	1298 Bankruptcy of Buonsignori, leading bankers of Siena
1300		
?1302 Death of Cimabue	1302 Dante expelled from Florence	1306 Jews expelled from France
c.1305 Giotto painting Arena Chapel, Padua	1308 Dante begins *The Divine Comedy* in exile	1307 Death of Edward I of England: succeeded by Edward II
		1309 Papal court moved from Rome to Avignon (until 1376)
1310		
c.1310 Giotto's *Ognissanti Madonna*	1310 Synod of Trier decrees all altars should bear indication of their dedication	1310 Knights of Saint John move from Venice to Rhodes
1311 Duccio completes *Maestà* for high altar of Duomo, Siena	1313 Berthold Schwarz develops gunpowder	
1312 Bernardo Daddi active in Florence	1315 Brethren of the Free Spirit emerge in the Upper Rhineland	
1318/19 Death of Duccio in Siena		
1319 Simone Martini's polyptych for Santa Caterina, Pisa		
1320		
c.1324-5 Ugolino di Nerio painting in Florence	1321 Death of Dante in Ravenna	1323-8 Revolt of cloth weavers in Flanders
1327 Ambrogio Lorenzetti in Florence	1321 Lady Chapel, Ely, founded (completed 1353)	1327 Rise of Swiss Federation
	1322 Choir of Cologne Cathedral completed	Edward II of England resigns throne to Edward III
1330		
1332 Taddeo Gaddi active in Florence	1334 Florence, Campanile of the Duomo begun	1337 Start of 100 Years War between England and France
1333 Simone Martini's *Annunciation*, Duomo, Siena	1335 Decoration of second Papal Palace at Avignon begun	
1337 Death of Giotto	1336 Reform of Benedictine Order	
1338 Ambrogio Lorenzetti's *Good Government* frescoes, Palazzo Pubblico, Siena	1337 Florence, Orsanmichele begun	
1340		
1340s Maso di Banco active in Florence	1341 Petrarch crowned Poet Laureate on Capitol, Rome	1340 Alfonso XI of Castile defeats Moors
1342 Ambrogio Lorenzetti's *Purification of the Virgin*, Duomo, Siena	1348 Prague University founded by Charles IV (1304-74)	1345 Bankruptcy of Bardi and Peruzzi banks in Florence
1342 Pietro Lorenzetti's *Birth of the Virgin*, Duomo, Siena	1349 Flagellant movement suppressed by Pope Clement VI	1346 Battle of Crécy, French army defeated
1344 Death of Simone Martini in Avignon		1346 Charles IV elected King of the Germans
1348 Deaths of Ambrogio and Pietro Lorenzetti		1347 English capture Calais
Probable death of Bernardo Daddi		1347-51 Black Death
1350		
1357 Andrea di Cione (Orcagna) completes Strozzi Altarpiece, Santa Maria Novella, Florence	1353 Giovanni Boccaccio completes *Decameron*	1354 Turks seize Gallipoli from the Byzantine Empire
		1355 Charles IV crowned Holy Roman Emperor
		1358 Jacquerie (Peasants' revolt) in France
		Genoese defeat Venetians: Dalmatia ceded to Hungary
1360		
c.1360 Lorenzo Veneziano active in Venice	1360 Major alterations of Alcazar fortress commenced by Moors at Seville (completed c.1400)	1363 Grant of Duchy of Burgundy to Philip the Bold by his brother King John II of France
1365-7 Andrea di Bonaiuto da Firenze paints frescoes of Spanish Chapel, Santa Maria Novella, Florence	1365 Vienna University founded by Rudolf IV of Austria	
by 1366 Death of Taddeo Gaddi		
1368 Death of Andrea di Cione (Orcagna)		
1368 Niccolò di Pietro Gerini active in Florence		
1370		
1370-1 Jacopo di Cione's *Coronation of the Virgin*	1373 Death of Saint Bridget of Sweden (canonised 1391)	1376 Return of Papacy to Rome
	1374 Deaths of Petrarch and William of Ockham	Foundation of Swabian League
	1375 Death of Boccaccio	1377 Death of Edward III of England, accession of Richard II
	1376 Bruges Town Hall begun (completed 1401)	1378-1417 Great Schism – Two Popes
		1378 Ciompi (clothworkers) revolt in Florence; death of Emperor Charles IV
		1379-82 Industrial Revolt in Flanders, Italy and England (1381 Peasants' Revolt in England)
1380		
1383(?) Birth of Masolino in Panicale	1380 Death of Saint Catherine of Siena (canonised 1461)	1384 Philip the Bold, Duke of Burgundy, becomes Count of Flanders
1385-95 Agnolo Gaddi frescoes of the *True Cross*, choir of Santa Croce, Florence	1384 Death of Gerard Groote, founder of *Devotio Moderna* religious movement (Brethren of Common Life)	1386 Conversion of Lithuania to Christianity and unity with Poland
1387(?) Birth of Fra Angelico	Death of John Wycliff	
	1385 Chaucer's *Troilus and Criseyde* completed	
	c.1387-1400 Chaucer's *Canterbury Tales*	
	1387 Milan Cathedral begun	
	1389 Claus Sluter in charge for sculpture of Philip the Bold, Duke of Burgundy, at Carthusian monastery, Champmol	

1390

1399 Melchior Broederlam and Jacques de Baerze complete altarpiece for Carthusian Monastery at Champmol 1399 Lorenzo Monaco first recorded as painter	1390 San Petronio, Dominican church in Bologna, begun 1390s(?) Cennino's *Libro dell'Arte* 1396 Certosa (Charterhouse) at Pavia founded by Gian Galeazzo Visconti, Duke of Milan	1390 Byzantines driven out of Asia Minor by Turks 1395 Milan becomes Duchy under Gian Galeazzo Visconti 1397 Union of Kalmar unites Norway, Sweden and Denmark 1399 Deposition of Richard II of England and accession of Henry IV

1400

1401 Birth of Masaccio 1406 Robert Campin active at Tournai Birth of Filippo Lippi	1400 Death of Chaucer 1401 Baptistery doors competition, Florence, won by Ghiberti against Brunelleschi 1406 Death of Claus Sluter	1401 Gian Galeazzo Visconti controls Lombardy 1404 Death of Philip the Bold, Duke of Burgundy; succeeded by John the Fearless 1406 Venetians acquire Padua; Florentines subdue Siena 1409 Council of Pisa deposes two Popes and elects Alexander V

1410

by 1411 Limbourg brothers established in service of Duc de Berry for whom they illustrate the *Très Riches Heures* 1414 Lorenzo Monaco's *Coronation of the Virgin* for Santa Maria degli Angeli, Florence 1415 Death of Niccolò di Pietro Gerini	1413 John Hus preaches in Southern Bohemia 1415 Thomas à Kempis' *The Imitation of Christ* written John Hus burnt as heretic 1419 Death of Saint Vincent Ferrer (canonised 1455)	1410 Battle of Tannenburg, Poland and Lithuania defeat Teutonic Knights 1413 Death of Henry IV of England; succeeded by Henry V 1414 Sigismund (elected King of Germans in 1411) crowned Emperor (rules until 1448) 1414-18 Council of Constance 1415 Battle of Agincourt: Henry V of England defeats French 1417 Council of Constance deposes two Popes and elects Martin V 1419-36 Hussite wars in Bohemia 1419 Death of John the Fearless, Duke of Burgundy; succeeded by Philip the Good

1420

Masaccio and Masolino at work on Brancacci Chapel, Florence 1422-4 Jan van Eyck working for John of Bavaria 1423 Gentile da Fabriano's *Adoration of the Magi* for Palla Strozzi 1425-7 Masolino in Hungary 1425 Van Eyck working for Philip the Good 1426 Masaccio's Pisa Altarpiece 1427 Rogier van der Weyden apprenticed to Robert Campin 1428 Death of Masaccio in Rome	1420-34 Cupola of Duomo, Florence (Brunelleschi architect) 1421 Brunelleschi begins Ospedale degli Innocenti, Florence (completed 1445) 1425 Ghiberti's 'Paradise' doors for Baptistery, Florence, commissioned (completed 1452) 1427 Donatello's and Ghiberti's reliefs for Siena Baptistery completed	1420 Pope Martin V returns to Rome Treaty of Troyes between England and France 1422 Death of Henry V, King of England; succeeded by Henry VI 1427 Siege of Orléans raised by Joan of Arc Order of Golden Fleece created by the Duke of Burgundy 1428-30 Netherlands united under the Duke of Burgundy 1429 Albizzi family dominant in Florence

1430

1432 Jan van Eyck completes altarpiece at Ghent 1435 Rogier van der Weyden town painter at Brussels 1437 Contract for Sassetta altarpiece for San Francesco, Borgo Sansepolcro 1438 Pisanello in Ferrara	1433-9 Donatello's *Cantoria*, Florence, Duomo 1435-6 Alberti's Latin and Italian treatise, *On Painting* 1439 Lorenzo Valla exposes forgery of Donation of Constantine from which Pope's temporal authority was in part derived 1439 Church of St Lawrence, Nuremberg, begun	1431 Joan of Arc burnt at Rouen 1432 Battle of San Romano, Florentine victory over Sienese 1433 Sigismund crowned Holy Roman Emperor 1434-64 Cosimo de' Medici establishes family rule in Florence 1439 Council of Basel deposes Eugene IV and elects Felix V Pope

1440

1441 Death of van Eyck 1442 Stephan Lochner in Cologne 1444 Death of Robert Campin at Tournai Petrus Christus active in Bruges Birth of Botticelli 1446 Death of Brunelleschi ?1447 Death of Masolino in Hungary 1449 Paintings by van der Weyden seen at Ferrara	c.1440 Johan Gutenberg invents art of printing with movable type in Germany 1441 King's College, Cambridge, and Eton College founded by Henry VI 1443-5 Donatello working in Padua 1444 Death of Saint Bernardino of Siena (canonised 1450) Palazzo Medici begun by Michelozzo 1445 Ghiberti's *Commentarii* probably begun 1446 King's College Chapel, Cambridge, begun (completed 1515) 1446-50 Palazzo Rucellai, Florence, begun by Alberti	1442 Conquest of Naples (Kingdom) by Alfonso of Aragon and end of Angevin rule 1443 Naples reunited with Sicily; Burgundy acquires Luxemburg 1449 Last Antipope Felix V resigns

1450

1450 Death of Sassetta 1451 Death of Stephan Lochner 1454 Mantegna completes Saint Luke Polyptych c.1455 Death of Pisanello 1455 Death of Fra Angelico c.1457 Dieric Bouts active at Louvain ?1457 Birth of Filippino Lippi	1450 Alberti commissioned to design exterior of Tempio Malatestiano (San Francesco, Rimini) c.1450 Printing perfected in Germany	1452 Borso d'Este made Duke of Milan and Reggio 1453 Turks recapture Constantinople End of 100 Years War 1455 Wars of the Roses (Civil War) begins in England 1456 Turks conquer Athens (except Acropolis, taken 1458) 1458 Matthias Corvinus elected King of Hungary Aeneas Silvius Piccolomini elected Pope Pius II

1460

1464 Death of Rogier van der Weyden 1465 Memlinc active at Bruges Mantegna commences work in Camera degli Sposi, Mantua 1469 Death of Filippo Lippi in Spoleto	1461 Saint Catherine of Siena canonised 1462 Pius II forbids communion in the form of wine to laity 1463 Sultan Mehmet II's mosque begun in Constantinople (completed 1470) 1465 Printing press established at Subiaco, Italy 1467 Birth of Erasmus	1461-83 Louis XI King of France 1461 Edward IV King of England 1467 Death of Philip the Good and accession of Charles the Bold 1468 Marriage of Charles the Bold to Margaret of York in Bruges 1469-92 Lorenzo de' Medici 'the Magnificent' rules Florence 1469 Ferdinand of Aragon marries Isabella of Castile

1470

1474 Bosch active at 's Hertogenbosch 1475-6 Antonello da Messina in Venice 1475 Death of Uccello; Birth of Michelangelo ?1475 Giovanni Bellini's Pesaro Altarpiece 1478 Birth of Giorgione 1479 Gentile Bellini working in Constantinople for Sultan Mehmet II (until 1481)	1470 Sant' Andrea, Mantua, by Alberti begun 1471 Death of Thomas à Kempis, author of *The Imitation of Christ* 1475 St George's Chapel, Windsor, begun	1471 Edward IV finally victorious over Lancastrians; Henry VI murdered Francesco della Rovere elected Pope Sixtus IV 1477 Death of Charles the Bold in Battle of Nancy against Swiss Maximilian Regent of Low Countries 1478 Pazzi conspiracy against the Medici

1480

1481-3 Botticelli, Ghirlandaio, Perugino, Pintoricchio and Signorelli painting in Sistine Chapel, Rome 1482 Death of Giovanni di Paolo; Death of Hugo van der Goes 1483 Birth of Raphael Leonardo court artist to Lodovico Sforza 'il Moro' in Milan Contract for Leonardo's *Virgin of the Rocks* Costa working in Bologna 1484 Gerard David active at Bruges	1480 Giulio da Sangallo commissioned to build Medici Villa at Poggio a Caiano 1483 Birth of Martin Luther 1487 Diaz rounds the Cape of Good Hope *Miscellanea* of Poliziano published 1488 Duke Humphrey's library (now part of the Bodleian Library), Oxford, in use	1483 Death of Edward IV of England and accession of Richard III 1485 Death of Richard III of England and accession of Henry VII 1486 Accession of Emperor Maximilian

1490

1490 Crivelli knighted by Ferdinand II of Naples Giovanni Bellini working for Isabella d'Este 1491 Massys active in Antwerp 1494 Death of Memlinc and Domenico Ghirlandaio 1495 Death of Cosimo Tura ?1495-6 Probable first visit of Dürer to Venice 1498 Dürer publishes his *Apocalypse* woodcuts	1494 First book published by Aldine Press in Venice 1497 Vasco da Gama rounds the Cape of Good Hope	1490 Death of Matthias Corvinus, King of Hungary 1491-2 Fall of Granada; Christian reconquest of Spain 1492 Columbus in America Death of Lorenzo the Magnificent 1494 Charles VIII of France invades Italy Medici expelled from Florence 1498 Savonarola burnt at stake in Florence 1499 Swiss Wars; Plague in Rhineland and Austria 1499 French expel Lodovico Sforza from Milan Cesare Borgia conquers Romagna

1500

1504 Raphael intends to visit Florence 'for study' Death of Filippino Lippi 1505-7 Dürer in Venice 1506 Death of Mantegna 1508 Raphael probably leaves Florence for Rome	1503 Erasmus's *Handbook of a Christian Knight* published 1503 Henry VII's Chapel in Westminster Abbey begun 1506 Bramante commences rebuilding of St Peter's 1509 *In Praise of Folly* by Erasmus published	1501 Leonardo Loredan elected Doge of Venice Giuliano della Rovere elected Pope Julius II 1502 Spain conquers kingdom of Naples 1503 Spaniards expel French from Naples 1509 Accession of Henry VIII of England

WESTERN EUROPE

1260-1510

Europe between 1260 and 1510 saw and described itself as Christendom, the kingdom of Christ. The Christian Church was divided along the lines of the late Roman Empire, between the East – the Greek or Byzantine Church with its Patriarch in Constantinople (present-day Istanbul) – and the West – the Roman Catholic Church ruled by the Pope, the successor of Saint Peter, in Rome. The Roman Empire in the East survived until the mid-fifteenth century but Western Europe was divided between numerous separate political powers, not only kingdoms such as England, Scotland, France and Naples (that is, the southern part of the Italian peninsula) but powerful duchies – above all that of Burgundy – and city states such as Florence and Venice. The spiritual authority of the Pope on the other hand was acknowledged throughout Western Europe. The most significant minority who did not acknowledge it were the Jews, who were alternately tolerated and persecuted.

The 'Infidels', of Muslim faith, were driven out of the Spanish peninsula in these centuries and contained in Eastern Europe and the Mediterranean, even enjoying some trading and diplomatic links with Venice and other Italian states. In 1453 Constantinople fell to the Infidel Turks, an event which marked the end of the Byzantine Empire (although the Greek Church survived). The rise of the Islamic Turkish Ottoman Empire led the great European powers to plan a revival of the Crusades and to unite in defence of Christendom. The idea of a united Christian Europe in the West was always a powerful one and whatever internal discord there was, the international institutions of the Church and the common language of the learned, Latin, ensured that there was more unity in practice than it is easy for us to conceive.

The great Western European rulers, whether the Duke of Burgundy, the Doge of Venice or the King of Aragon, all regarded their authority as sanctioned by, if not derived from, Christ. A few of them were officially accepted as saints – Saint Louis, King of France, Saint Elizabeth, Queen of Hungary, for example. The greatest of these rulers in theory, but by no means always in practice, was the Holy Roman Emperor, who regarded himself as vice-regent of God, co-regent with the Pope. His authority was traced back through Charlemagne, who was widely regarded as a saint (and painted as such – Fig. 1), to Constantine, the first Roman Emperor to adopt the Christian Faith. Constantine was also the predecessor of the Eastern Emperor, ruling in Constantinople, the new Rome which he had founded. The Holy Roman Emperor never ruled from Rome, although he often played an active part in Italian politics. In this period he was for the most part the head of a federation of German princes who elected him, and his court was north of the Alps.

For the Popes it was essential to assert not only their spiritual power but also their temporal power, and to do this not only within Italy, large parts of which – the Papal States – were ruled by the lords who were, ostensibly at least, the Pope's 'Vicars' (or substitutes), but throughout Christendom. Far away from Italy in Westminster Abbey, the King of England received cap and sword sent by the Pope from Rome and was anointed and crowned by the Archbishop of Canterbury. The Popes themselves crowned the Holy Roman Emperors, regarding the Empire as a 'fief of Saint Peter', and claimed that the first Christian Emperor, Constantine, had yielded his imperial authority to them.

From the twelfth century the Popes had been elected by the cardinals, generally also bishops, who formed the 'sacred college'. Usually numbering between twenty and thirty, they were the councillors of the Pope and the highest dignitaries of the

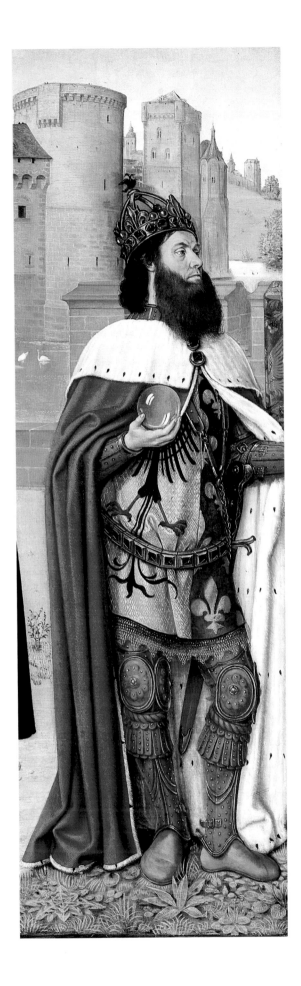

Church. The great secular rulers constantly strove to influence the elections and their success in doing so led to there being, in the late fourteenth and early fifteenth centuries, more than one claimant to the Papacy. Throughout much of the fourteenth century the Papal court was at Avignon rather than Rome.

The Pope was not only Supreme Pontiff – head of the Church – but the Bishop of Rome. His peers, at the head of the hierarchy of the Church, were the bishops, whom he addressed as 'venerable brothers' (Fig. 2). Bishops had the sole right to anoint kings,

LEFT Fig. 1. The Master of Moulins, detail showing Charlemagne, from *Charlemagne and the Meeting of Saints Joachim and Anne at the Golden Gate, c.*1500 (see No. 58).

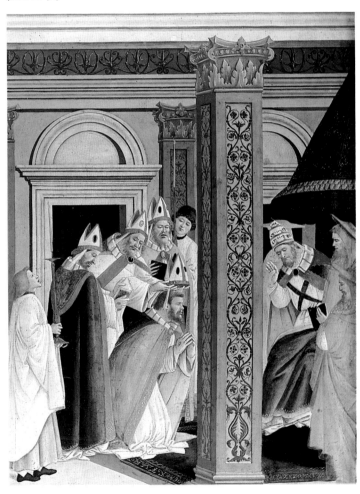

Fig. 2. Sandro Botticelli, detail showing Saint Zenobius being consecrated Bishop of Florence by the Pope, from *Four Scenes from the Early Life of Saint Zenobius* (see Fig. 152). The Pope wears a papal tiara and is attended by two cardinals. Other bishops attend Zenobius as a mitre is placed upon his head.

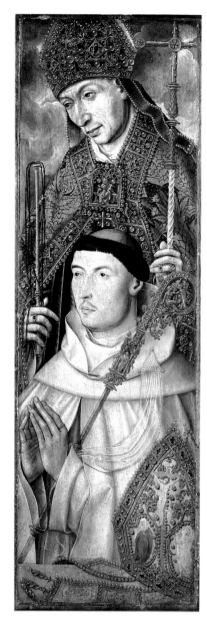

Fig. 3. Netherlandish School, *Saint Ambrose with Ambrosius van Engelen*(?), *c.*1520. Oak, painted surface, 72.5×23cm (NG 264). Saint Ambrose, as bishop, wears a mitre. The kneeling donor, although an abbot, holds a bishop's crozier.

confer Holy Orders (that is, ordain priests), and consecrate altars. The thrones (or *cathedrae*) of bishops, distinguished (as were those of kings) by canopies, were placed next to the altars of their cathedral churches, which dominated the cities. The method of electing or nominating bishops varied greatly and was a source of much contention, since the great rulers constantly attempted to secure their allegiance. Bishops enjoyed great wealth and considerable secular power – some indeed were among the Electors of the Emperor and the Vicars of the Pope.

Originally subject to the jurisdiction of a bishop and often chosen by him were the abbots who ruled the monastic Orders, the communities of monks and nuns, in their abbeys and priories

(the latter originally offshoots of the former). But some abbots were exempt from this control and were permitted many of the powers and insignia (mitre, ring and gloves) of the bishops (Fig. 3). The oldest of the monastic Orders were the Benedictines, founded in the sixth century by Saint Benedict of Nursia at Monte Cassino in Italy. By the early fifteenth century there were more than 15,000 Benedictine abbeys in all parts of Europe. They were self-supporting communities, in seclusion from the world, often in locations far remote from the towns. Some of them acquired a prosperity which modified the original arduous ideals of their founder, to which, however, successive reformers strove to return. In the late tenth and in the eleventh century a number of new Orders were founded – among them the Carthusians in France and the Camaldolese in Italy – which revived the hermit's life of solitary meditation and penance which had played such a large part in the early history of the Church and was exemplified in particular by Saint Jerome. Others followed, some of them established only in small areas – for instance the Hieronymites (followers of Saint Jerome) founded in the early fifteenth century at Fiesole near Florence – but most Orders were international.

This was true too of the Orders of the Friars, the *fratres*, brothers of all men, who although they had communal residences (convents) were not withdrawn from the world like the monks but active in it, preaching, teaching and performing acts of charity – particularly in the great cities. The Friars were 'mendicants' (literally, beggars) because originally they owned no land and had no fixed sources of income, although later exceptions came to be made, mainly to enable them to build and maintain their great urban churches.

The two original and most important Orders of Friars were the Franciscans, founded by the Italian Saint Francis of Assisi, who died in 1226, and the Dominicans, founded by the Spanish Saint Dominic of Castile, who died in 1221. Just as the monastic Orders had female branches so did the Friars, those of the Franciscans being known as Poor Clares, followers of Saint Francis's disciple Saint Clare. In general Saint Francis was associated with moral reform and a novel spiritual ideal, and Saint Dominic with theology and doctrine and combating heresy. The Dominicans later became famous as a teaching Order. The Franciscans were more obviously popular in their appeal, but both Orders met with rapid success. Something of the extraordinary revolution which they effected in the life of the Church can still be felt in Southern Europe, and especially in Italy where the most imposing churches in any city, after the cathedral, tend to be those which they built.

THE
USES OF
PAINTING

CHRISTIAN WORSHIP AND IMAGERY

ALTARS, SAINTS AND RELICS

Christian worship centred upon the Mass, in which the sacrifice of Christ on the Cross was re-enacted: through the Crucifixion alone would mankind, fallen from grace, be redeemed. The Mass was celebrated by a priest at the altar, which was a table, usually of solid and durable material, securely fixed, and approached by steps. Each altar was furnished with a cross or crucifix (that is, a cross with Christ hanging upon it). During the Mass, Christ's body and blood were received by the faithful in the form of bread and wine – the sacraments of the Eucharist – which had been consecrated by the priest. Until about 1100 the laity (those confirmed in the Christian Faith but not in Holy Orders) received both of these sacraments, but the practice of receiving the bread only came to prevail. It was enjoined by the council of the Church held at Constance between 1414 and 1418, and has remained the traditional practice in the Church of Rome ever since.

The laity did not receive the eucharistic bread frequently, but it was important that it was available not only in the church for them to worship but also for administration by a priest to anyone on his or her deathbed. For this reason the sacraments were 're-served' in a tabernacle – a locked ornamental cupboard generally, in this period, set into the wall of the church or its sacristy. Most tabernacles which have survived in Italy are of marble with gilded metal doors engraved with Christ offering his Body and Blood to the faithful (Figs. 4 and 5), but some were made of wood, painted and gilded. Giovanni Bellini's little panel, the *Blood of the Redeemer* (Fig. 6), probably originally served as a tabernacle door.

Altars were found in every church or chapel. A chapel could be a separate building, or an independent architectural unit, but also no more than a side altar in the aisle of a church. The high altar, which was at the east end, was not designed to be seen by the multitudes assembled in the church: its architectural canopy and rich furnishing were more to do honour to the mystery of the sacrament than to make it visible to a lay congregation. In most churches the entire east end was separated from the nave by a screen, often surmounted by a cross (or rood, hence rood screen). These screens frequently obscured the altar. In private chapels, including some large ones, access might be available only to the clergy which served in them and to the family which built them. These families owned the chapel (and the burial space below), although the church retained control over them. Church burial was an expensive privilege accorded only to the rich, who were often buried in vaults below the family chapel: an endowment would provide for the clergy to say Masses for the souls of those buried there and believed to be suffering in Purgatory preparatory to their reception in Heaven. The demand for such chapels led to a great increase in religious imagery and altarpieces in particular.

Chapels with altars were also found in hospitals erected for the care of the sick and dying and for the shelter of pilgrims or the destitute. The wards were made contiguous with the chapels, with the altar often designed to be visible from the beds. In such hospitals the reception of the sacraments was of far greater importance than any medical treatment. Palaces and great houses also frequently had their own chapel, with altars where a priest might say Mass, and there were usually chapels attached to town halls, where Mass was said before town council meetings.

In churches the altar might also serve as the tomb where the body of a saint was placed, sometimes in a state of miraculous

Fig. 4. Andrea Ferrucci, *Sacrament Tabernacle, c.*1490. Marble with traces of gilding. The arms of the Rucellai family are held by the eagle in the corbel. The Latin inscription reads: 'This is the Bread and Wine come down to us from Heaven.' London, Victoria and Albert Museum.

Fig. 5. Detail of Fig. 4, showing the engraved gilt copper door.

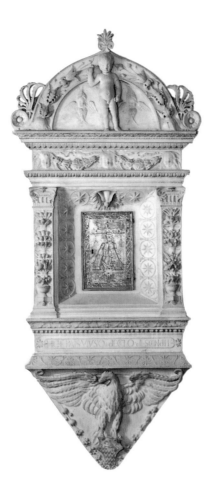

preservation. In some cases the body was placed in a crypt below the altar, in others it could be seen within the altar. More often the altar merely contained a relic – generally a part of the saint's body. The general council of the Church held at Nicaea in 787 not only sanctioned the veneration of relics (which had in fact long been established) but ordained that every altar should contain one.

The importance of relics originated with the veneration of those saints whose martyrdom had done so much to inspire and support the early Church. Gradually the number of saints expanded as they were adopted as patrons of kingdoms, cities, professions, crafts, institutions, and as protectors against diseases and disasters. The expansion was not fully controlled by the Church, which nevertheless did institute very strict procedures for canonisation (the process whereby someone is officially ack-

nowledged to be a saint). Saints were not to be worshipped but venerated: contemplated as inspiring examples and prayed to as intercessors between the faithful and God, like the Virgin Mary. Yet touching, or merely seeing, the body of a saint, or any relic of one, was thought to cure or save an individual and to protect a family or a city.

As an example of the way in which the veneration of relics evolved we can cite the case of Saint Hubert who was buried in 727 beneath the high altar of the church of St Peter in Liège in the Netherlands. He had been a dissolute courtier and had not scrupled to hunt during Holy Week in the Forest of the Ardennes. There he saw a stag with a crucifix between its antlers (Fig. 7). Moved to repent of his sins, he lived in the forest as a hermit. Eventually he was made Bishop of Liège, founding the church of St Peter where he was buried. In 743 his body was exhumed and

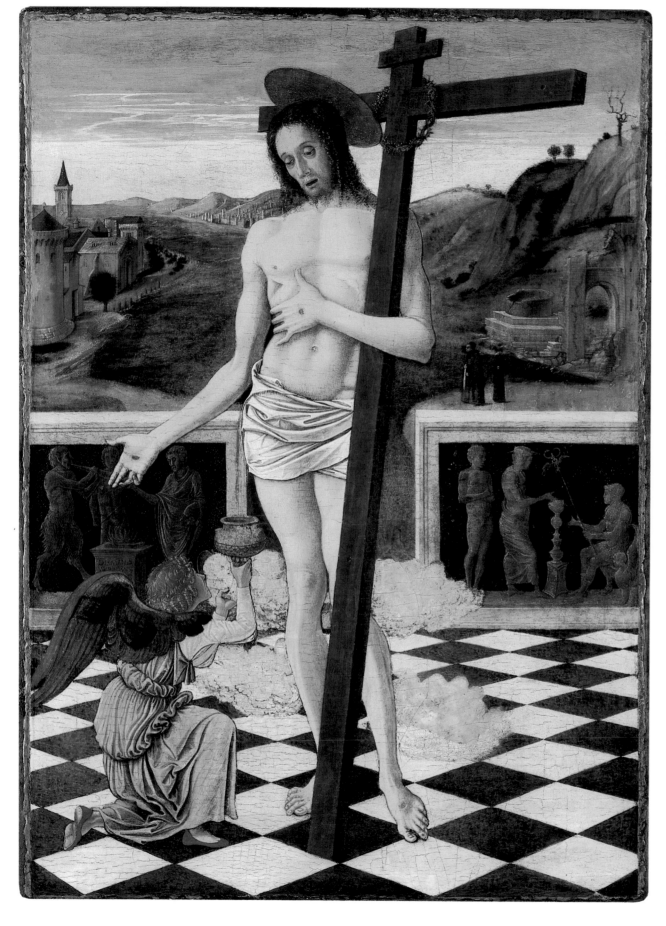

Fig. 6. Giovanni Bellini, *The Blood of the Redeemer*, *c*. 1460–5. Poplar, 47×34.3cm (NG 1233).

discovered to be perfectly preserved. It was re-exhumed again in 825 in the presence of Louis the Debonair, son of Charlemagne, and Walandus, Bishop of Liège, and removed to the Benedictine Abbey of Angadium. Thereafter known as Saint-Hubert-Les-Ardennes, the abbey became a centre of pilgrimage for victims of rabies, who took as a cure bread blessed at his shrine. The shrine also became the focus for the devotions of the military Order of Saint Hubert instituted in 1444 by Gerard, Duke of Jülich-Berg, after a battle won on Saint Hubert's Day. The episode of Saint Hubert's second exhumation was painted at about this date for the altar of a new chapel dedicated to the saint in the church of Ste Gudule in Brussels (Fig. 8).

Upon the altar in this painting there is a reliquary *châsse*, a casket of architectural character made of gold and studded with jewels. Such a container for relics would have been portable and need not always have been placed on the altar. The largest and central embossed figure represents Saint Hubert (although what relic of him the casket contained is not clear). Many reliquaries of a similarly sumptuous kind survive – an especially large and remarkable one, made by Nicolas of Verdun in the late twelfth century for the bones of the Three Kings or Magi, is to be found in the cathedral of Cologne. The possession of relics could confer great wealth on a church by attracting offerings from those whose prayers were answered there. And a whole city could prosper from the business generated by pilgrims, as Cologne did, and as did Santiago de Compostela in Northern Spain, from the shrine of Saint James (Iago), Padua in North West Italy, from the shrine of Saint Anthony, and Canterbury from the shrine of Thomas Becket.

IMAGES AND ALTARPIECES

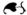

Images had been used in Christian worship and to adorn Christian churches over a very long period, often not without controversy. There was of course a distinction between worship and veneration, but whether this distinction was always clear to the laity may be doubted. In the eyes of the Church worshipping images of saints was tantamount to idolatry, which was specifically forbidden by the Bible. At various times the ecclesiastical authorities became particularly aware of the dangers of using images, and occasionally their use was proscribed and images were even destroyed.

During the period with which this book is concerned, however, religious images of all kinds flourished. They were used

Fig. 7. Master of the Life of the Virgin, *The Conversion of Saint Hubert*, c. 1485–90. Oak, 123.8×83cm (NG 252).

both to adorn churches and in other contexts. In churches there were not only images integral to the architecture and related to tabernacles and to altars (discussed below), but also various types of portable images. Paintings were hung from pillars by those whose prayers had been answered (*ex-votos*), or put up in support of a prayer (No. 39) and, especially in churches in Germany, there were also epitaph paintings representing the dead whose souls were to be prayed for. People also had small devotional images in their homes or places of work, particularly paintings or sculpted images of the Virgin and Child. The same subjects might be represented in ivory, in enamel work or in paintings, or in combination, as when painted shutters were used to protect images of precious metal, or indeed any sculpted image: the function of the image as an aid to devotion was all-important.

The National Gallery includes both small devotional paintings, which were almost certainly used in a domestic context, and large altarpieces, some of which are known to have come

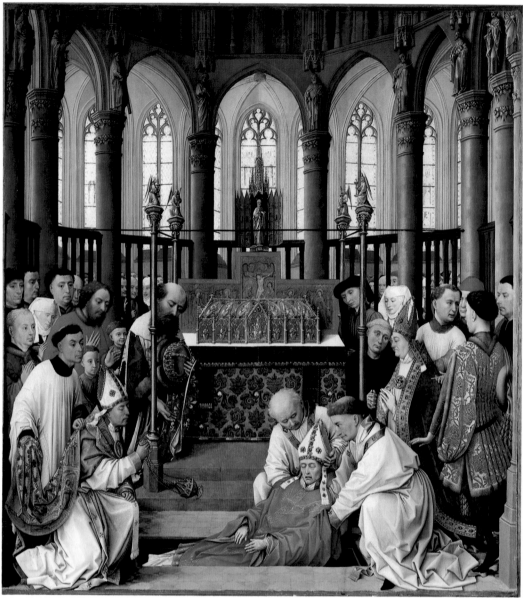

Fig. 8 Workshop of Rogier van der Weyden, *The Exhumation of Saint Hubert, c.* 1437.
Oak, painted surface 88×80.5cm (NG 783).

from specific chapels and churches. In addition, there are a number of paintings which may have been used as small altarpieces or may equally well have served as devotional paintings.

The churches of Western Europe during this period were full of images. These had proliferated first as mural paintings and, in parts of Italy, also as mosaics. The great mural narrative cycles developed in Italy and filling whole chapels are particularly associated with Giotto and his followers. North of the Alps, however, the new fashion for light Gothic architecture left much less wall space available for the painter. Accordingly stained glass, although found all over Europe, acquired an importance there analogous to that of murals in Italy. The churches were full of sculpture as well, especially the great cathedral portals where there were tier upon tier of statues of saints, prophets and angels

in niches, pinnacles, gables, and even in crockets and finials. As the altarpiece evolved it began to rival, although it never replaced, the murals, the stained glass and the portal as a place where sacred images and stories could be concentrated. Both in its form and in its subject matter the altarpiece was determined by earlier ecclesiastical imagery.

The history of the altarpiece begins with the increasing importance accorded to saints, their relics and their images, and the practice of placing relics on the altar, rather than within the altar. To Bernard of Angers visiting Auvergne in 1013 it came as a terrible shock to find upon the altar in place of the crucifix a reliquary image of Saint Gerald of Aurillac plated with gold and studded with precious stones. Saints' relics, not confined only to altars, multiplied. The Church (at the Synod of Trier) ordained

in 1310 that every altar should be labelled with an indication of which saint it was dedicated to, which suggests not only that more and more saints were requiring more and more altars but also that many altars had more and more relics associated with them. The labelling could be by a conspicuous image – a statue or painting – as well as by a text.

Altarpieces are images made to be placed upon an altar, or to rise behind it. They had to be visible, at least in part, behind the priest who officiated in front of the altar. The painting of the exhumation of Saint Hubert (Figs. 8 and 17) depicts a rectangular altarpiece painted with saints flanking a taller representation of Christ on the Cross between Mary and John. Above this there rises a tabernacle which encloses a statue of Saint Peter, a reminder that the episode takes place in the church of St Peter in Liège. The doors of this tabernacle are decorated with numerous small narrative paintings, presumably of the saint's life.

The altar in this painting is arranged in a manner which is perfectly possible in a church of the fourteenth or fifteenth century but quite impossible in the period when the events depicted are supposed to have taken place. It was only in the thirteenth century that the Mass began to be celebrated by the priest with his back to the congregation and on the congregation's side of the altar – in the position, that is, of Saint Hubert in a painting which shows an angel descending to bestow his bishop's stole upon him (Fig. 9). The development of European painting has perhaps been more stimulated by this liturgical alteration than by any other single event. Some of the richness of the decoration on the front face of the altar (the frontal or antependium), which was now partially obscured by the priest, was transferred to the altarpiece to form a backdrop against which the host – the bread of the Eucharist – was elevated. Frontals remained important and were lavishly decorated, often with luxury textiles or with paintings which simulated these, but imagery came chiefly to be found in the altarpiece.

In the painting the *Mass of Saint Giles* (Fig. 10), the saintly bishop elevates the host before the altar. Upon it is an altarpiece of gold, studded with gems, and embossed with saints and angels flanking a central arch filled by the larger figure of God the Father. The painting shows King Charles Martel kneeling in the Abbey of St-Denis, near Paris. The sins which the King could not bring himself to confess are delivered, written on paper, by an angel to Saint Giles. Unusually, the artist has documented the interior with great accuracy. The gold altarpiece was presented to the Abbey of St-Denis by King Charles the Bald (823-877). Originally it had served as an altar frontal but after the liturgical

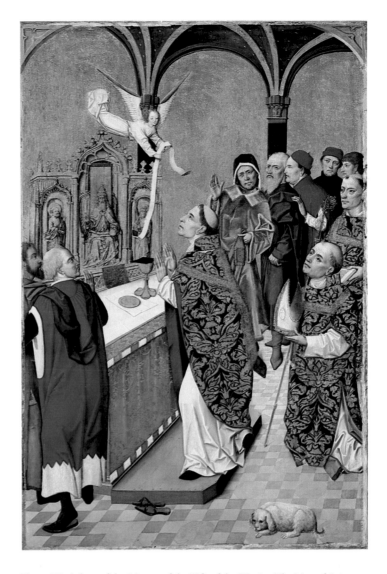

Fig. 9 Workshop of the Master of the Life of the Virgin, *The Mass of Saint Hubert. c.* 1485-90. Wood transferred to canvas, 123.2×83cm (NG 253).

change it was placed upon the altar as shown here. Above the altarpiece is a cross at the foot of which is a small reliquary marked in abbreviated Latin 'from the Cross of Our Lord'. Behind we can glimpse the gilt brass coffin of Saint Louis supported on tall columns, a gift of King Charles VI in 1398, while the mid-thirteenth-century tomb of King Dagobert I (died 639) is visible to the right. The painting reminds us of the veneration of relics at altars and the proximity of shrines and tombs to altars. It also demonstates the superimposition, to near congestion, of competing cult objects characteristic of the Church in this period.

Most of the earliest surviving painted altarpieces are of horizontal rectangular format and are known as *retables* (meaning behind the table) or *dossals* (meaning the back of the table). The example signed by Margarito d'Arezzo, probably of the 1260s, depicting the Virgin and Child in a *mandorla* (the almond-shaped frame) with narratives in compartments to either side, is typical

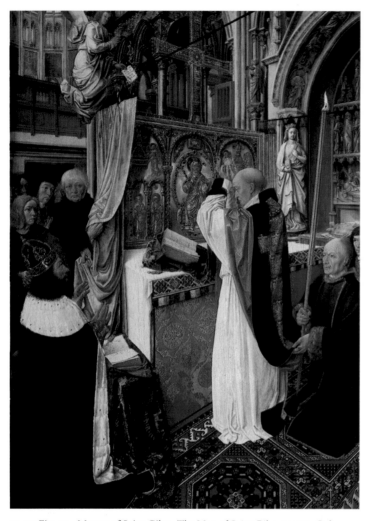

of Italian retables (Fig. 11 and No. 1). The ornamental borders imitate the patterns and even the colours of enamel work. This reminds us that the most highly valued retables were of gold or silver gilt, set with precious stones and enamels.

The more sumptuous Westminster Retable (Fig. 12), probably made for the high altar of Westminster Abbey in the 1270s under royal patronage, resembles the finest embossed and engraved metalwork and is studded with paste jewels and simulated enamel plaques. Christ holding a globe and raising his hand in blessing occupies the central position, with the Virgin and Saint John beside him; Saints Peter and Paul (the latter barely visible now) are represented in niches at either end; narratives are concentrated in between. The niches have painted arches on slender columns, steep crocketed gables, spires and finials, but these

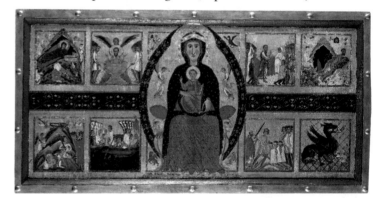

ABOVE Fig. 11. Margarito of Arezzo, *The Virgin and Child Enthroned, with Scenes of the Nativity and the Lives of Saints*, 1260s. Wood, 92.5×183cm, including frame (NG 564).

ABOVE Fig. 10. Master of Saint Giles, *The Mass of Saint Giles*, c. 1500. Oak, painted surface 61.5×45.5 (NG 4681).

BELOW Fig. 12. *The Westminster Retable*, 1270s. Oak, 95.8×333.5cm. London, Westminster Abbey.

Gothic architectural compartments, like the Romanesque arches in the retable in St-Denis (Fig. 9), are contained within the frame.

The painting retains the rectangular shape of an altar frontal. But artists were not necessarily restricted by this format. The retable of the Crucifixion on the altar in the painting of Saint Hubert's exhumation (Fig. 8) also projects upwards in the centre. The arched centre of the gilt sculptural altarpiece before which Saint Hubert celebrates Mass (Fig. 9) does so too. Such retables remained popular throughout Europe. Although simple, they were capable of great elaboration. The frame around the late fourteenth-century retable of the Virgin and Child, with narratives connected with the Immaculate Conception (Fig. 13), is not

original. It must have had a higher arched centre and is likely to have been of a Gothic character. Yet in essence the scheme is little different from the Margarito.

Some of the earliest images placed on altars were statues, and in Italy an alternative to the low horizontal retable was a vertical one with small-scale narratives flanking a large single full-length standing saint (Fig. 14) – a painted version of a standing statue. In

Fig. 13. Dalmatian School, *Altarpiece of the Virgin Mary*. c. 1400. Poplar, centre panel 73.5×45.5cm, painted surfaces of side panels, approximately 30×26.5cm (NG 4250). The narratives concern miracles associated with the Feast of the Immaculate Conception and the story of the Virgin's conception and birth.

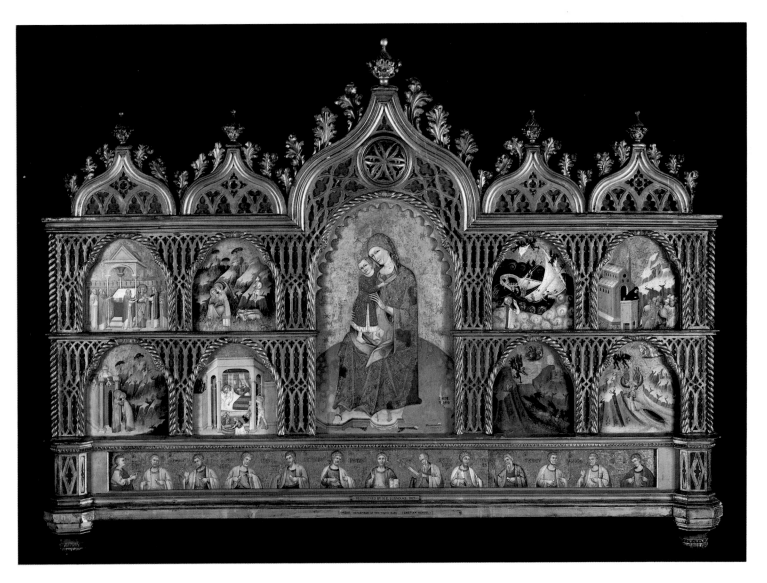

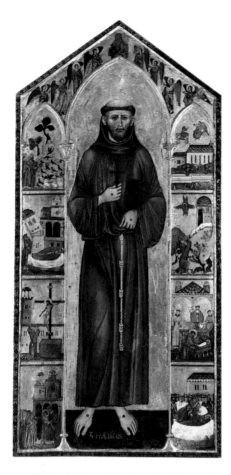

Fig. 14. Follower of Guido da Siena, *Saint Francis and Scenes from his Life*, *c.*1280-90. Wood, 237×113cm. Siena, Pinacoteca.

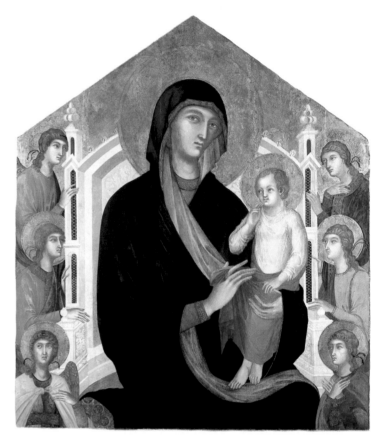

Fig. 15. Master of the Casole Fresco, *The Virgin and Child with Six Angels*, *c.*1317. Transferred from wood, 188×165cm (NG 565).

Tuscany in the late thirteenth century very large vertical gabled altarpieces became popular, the subject was almost always a *Maestà* – that is, an image of the Virgin and Child enthroned in majesty. Famous examples were painted by Duccio, Giotto, Cimabue and their followers (Figs. 15 and 173).

Images were often protected by curtains. These were sometimes sumptuously decorated. So too were shutters which, north of the Alps, were usual on both large and small altarpieces. In Italy shutters seem to have been common only on small paintings (see No. 4 and Figs. 47 and 143). They not only protected an image but made its display a special event. In addition, they multiplied the opportunities for the representation of imagery, especially when the shutters were double and were decorated back and front. The original form of such altarpieces is seldom apparent today, but the marks of hinges may be seen, for example, on the frame of the early fifteenth-century Austrian *Trinity* (Fig. 16). Paintings made up of three distinct parts, like this *Trinity*, are

known as triptychs. Sometimes the more elaborate altarpieces were furnished with shutters which could not in fact be moved, as seems to have been the case with the high altarpiece of the Abbey of Liesborn (No. 43). An alternative arrangement to the triptych which was popular for small images was the diptych – a painting consisting of two hinged parts which could open like a book – of which the Wilton Diptych (No. 10) is an example. There is evidence that these sometimes served as altarpieces.

The development of a more complex form – the polyptych, a painting of more than three distinct parts – seems in the North to have been greatly stimulated by the invention of elaborate architectural tabernacles for sculpture, such as that encasing the statue of Saint Peter above the altar in the painting of the Exhumation of

Fig. 16. Austrian School, *The Trinity with Christ Crucified*, *c.*1410. Silver fir, painted surface 118.1×114.9cm (NG 3662). The top and sides of the frame are original; the bottom is a modern replacement.

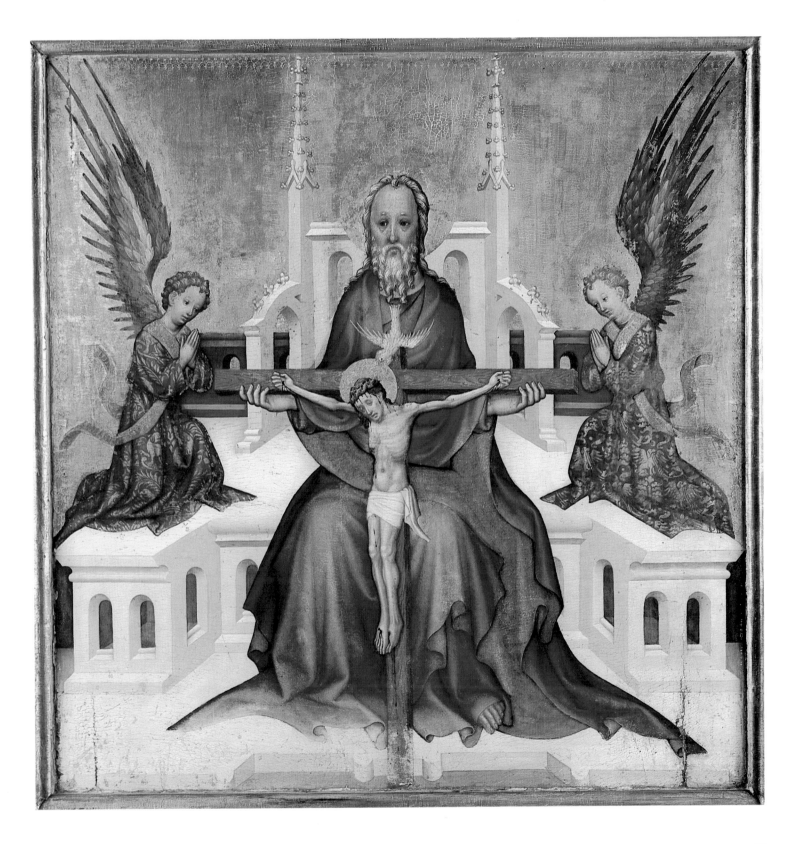

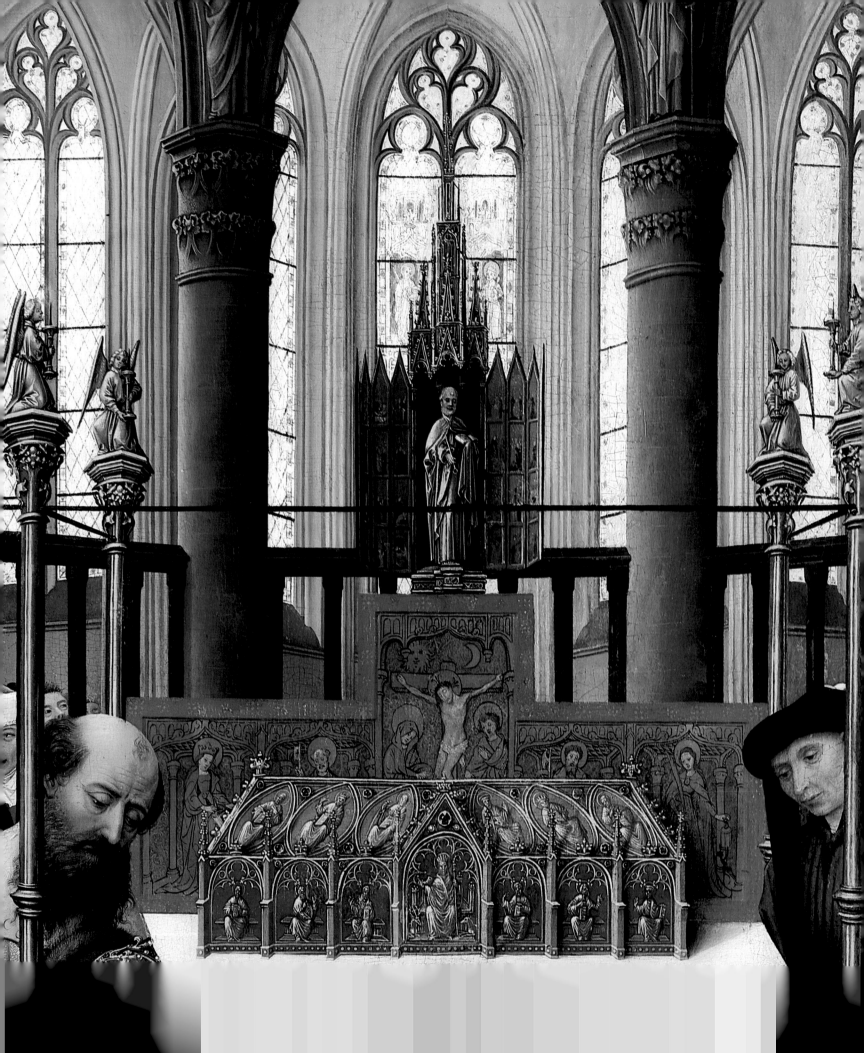

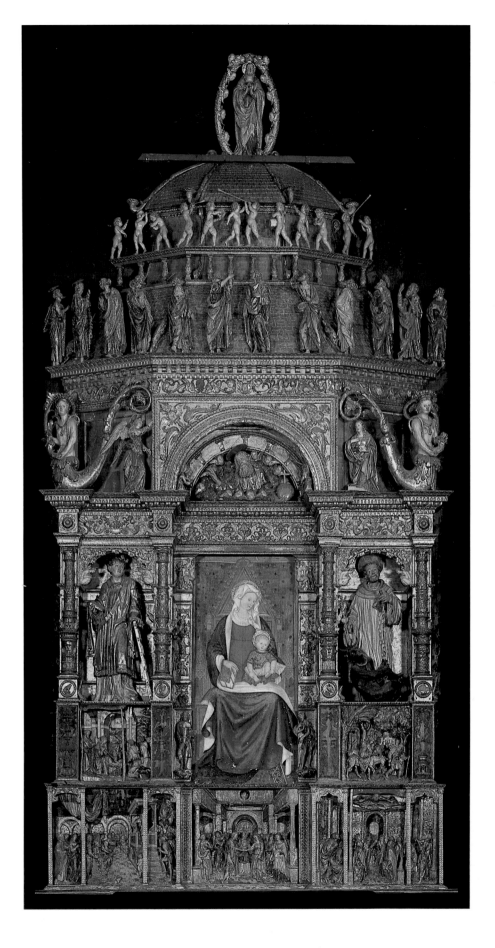

LEFT Fig. 17. Detail of *The Exhumation of Saint Hubert* (Fig. 8). Damage caused by a split in the panel means that part of the figure of Christ is a modern reconstruction.

RIGHT Fig. 18. Angelo del Maino and Gaudenzio Ferrari, High Altarpiece, the Church of the Assumption of the Virgin, Morbegno, 1516–26. Polychrome wood carving surrounding fresco.

Saint Hubert, a design which can be matched in surviving works (Fig. 17). Such combinations of sculpture and painting were not unusual, and in fifteenth-century Germany especially, massive altarpieces were erected which combined painting and sculpture into architectural structures which were triumphs of engineering.

Sculptured altarpieces, although very costly, were also popular: some in North Italy were made of marble, some in France of limestone. In England alabaster ones, framed in oak, were made (and exported), whereas in much of Germany and the Netherlands, in the Tyrol and Lombardy, large carved wooden altarpieces were favoured. Painting was involved not only because the carvings were gilded and coloured but because such altarpieces also had painted compartments, most commonly as shutters, but also sometimes as the central image (Fig. 18). The most expensive altarpieces would often involve work in gold. The fragments of paintings by the Netherlandish painter Simon Marmion, decorated with spires on one side and celestial scenes on the other (Figs. 19-23), were originally the highest parts of the pair of shutters for a precious metalwork sculpture on the high altar of the Abbey Church of St Bertin at St-Omer. Even when Netherlandish or other Northern European altarpieces were entirely painted, we are reminded of their relationship with sculpture by the simulated marble, alabaster or ivory images on the sides of the shutters visible when they are closed (No. 42).

In Italy the fashion for Gothic architectural forms, often transmitted by ornamental metalwork, must have stimulated the popularity of the polyptych with arches, wings, gables and pinnacles. The polyptych form, moreover, was well adapted to the cult of saints, each of which could be given a separate compartment, as in the great polyptychs painted by Ugolino and Sassetta (Nos. 5 and 19). The one by Sassetta is also double sided, a rare but important arrangement found in Italy. An altarpiece might be double sided because the clergy sat behind it in the choir. In Spain, however, the high altar was set against the east

TOP LEFT Fig. 19. Simon Marmion, *A Choir of Angels*, *c.* 1459. Oak, painted surface 57.5×20.5cm (NG 1303).

TOP RIGHT Fig. 20. Simon Marmion, *The Soul of Saint Bertin carried up to God*, *c.* 1459. Oak, painted surface 57.5×20.5cm (NG 1302).

BOTTOM LEFT Fig. 21. Reverse of Fig 19.

BOTTOM RIGHT Fig. 22. Reverse of Fig 20.

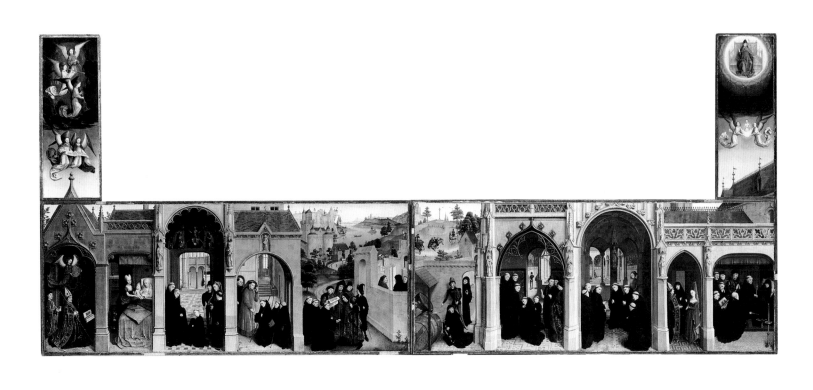

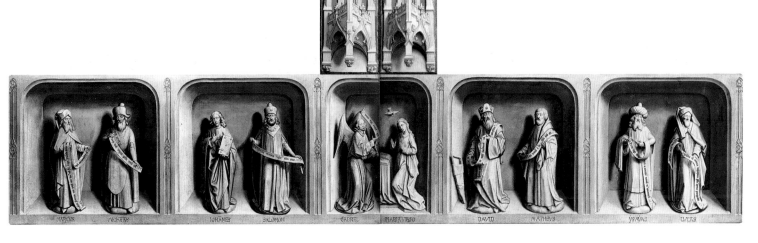

Fig. 23. TOP Simon Marmion, *The Life of Saint Bertin*,
reconstruction of the St-Omer Altarpiece with shutters open,
including panels at the Staatliche Museen, Berlin, painted
surface each 56×147cm, and fragments in Figs. 19-22.
BOTTOM Reconstruction with shutters closed.

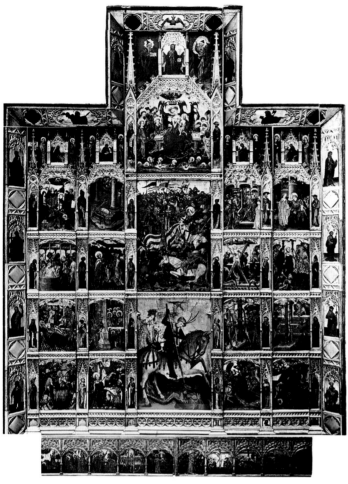

wall and so the altarpiece, which no longer had to be self-supporting, could spread out with a multiplicity of parts unequalled anywhere else in Europe (Fig. 24).

Altarpieces were generally supported by a plinth, or *predella* as it was known in Italy. The predella could be painted with saints (Fig. 13), or with an image of the dead Christ (Fig. 25) or some emblem of the Passion appropriate for the eucharistic sacraments placed on the altar immediately in front of it, although this does not seem to have been the practice in the Netherlands. In Germany the plinth of sculptural altarpieces, known as the *Sarg*, was often protected with shutters painted with eucharistic imagery. In Spain the part of the predella (or *banco* as it was known there) which was decorated in this way often incorporated a tabernacle for reserving the sacrament. This arrangement is also sometimes found in Italy (Fig. 26). In Italy, however, the predella came to be the chief place for narrative scenes during the fifteenth century. These scenes related to the figures immediately above in the main tier – episodes from the lives either of the Virgin and Child, or of the saints (as in Figs. 54 and 56 and Nos. 5, 15 and 65).

A factor which helped to modify the shape, if not the fundamental nature, of many altarpieces in Italy towards the mid-fifteenth century was the new taste for the antique. The fascination with reviving the forms and ornaments of ancient Roman buildings – the proportional system and harmonic schemes of Classical architecture as recorded both in ancient literature and in Roman remains – was first particularly evident in Florence. Altarpieces consisting chiefly of a single compartment known as

ABOVE Fig. 24. Ascribed to Marzal de Sas, *Altarpiece of Saint George, c.* 1410-20. Pine, 660×550cm. London, Victoria and Albert Museum

BELOW Fig. 25. Filippino Lippi, *Man of Sorrows*, detail of centre of predella of altarpiece with the *Virgin and Child with Saints Jerome and Dominic* (NG 293). See also No. 48.

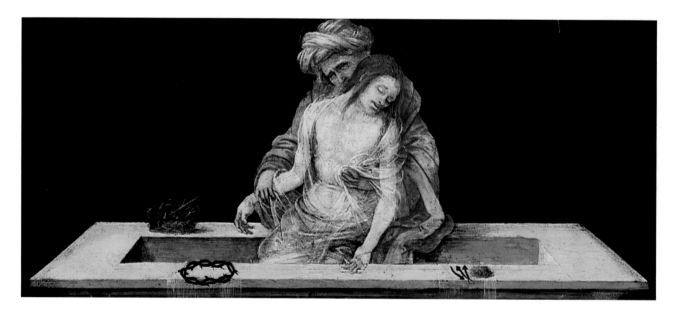

the *pala* had long existed in Italy, but in Florence these gradually became popular for types of altarpiece which had previously been compartmentalised. The taste for the antique encouraged the use of large rectangular or segmentally arched panels, with the frame surrounding the altarpiece rather than interpenetrating it as in the Gothic polyptych.

A painting such as Pesellino's altarpiece of the Trinity (Fig. 57) would have had just such a tabernacle frame – with columns or pilasters supporting a cornice in the style of Roman architecture, not unlike the imitation Renaissance frame it has today. Within this sort of scheme, however, some compartmentalisation could be retained (in this case, not unusually, the predella remained), and although the polyptych went out of fashion in Florence it remained popular elsewhere in Italy, with antique ornament easily substituted for Gothic.

Fig. 26. Ercole de' Roberti, *The Last Supper, c.* 1485. Wood, painted surface 30×21cm (NG 1127). The painting is likely to have served as the door of a sacrament tabernacle set in the centre of a predella.

CHRIST, THE VIRGIN MARY AND THE HEAVENLY HIERARCHY

By 1260 the two most popular religious images were the Virgin Mary with the infant Christ and the Crucified Christ, reflecting the two most significant aspects of Christian doctrine: Christ's Incarnation – in which God became man, at first in the form of a child; and Christ's sacrifice on the Cross. As has been pointed out, altars had to be furnished with a cross or crucifix. In addition, representations of the Crucified Christ and of the Virgin and Child often served as images for altarpieces. Both subjects were also frequently used as private devotional images.

Through much of this period, religious imagery remained constant with relatively little variation, whether a painting originated in Italy, Spain, Germany or the Netherlands. This began to change towards the end of the fifteenth century, as we shall see, when painters' preoccupations with the depiction of space and action introduced new pictorial possibilities which impinged on the meaning of the subjects they were portraying. At the very end of this century, licence in interpretation was accorded to a few great artists.

Narrative representations of Christ's Incarnation, or of his sacrifice, in depictions of the Nativity and the Crucifixion were common. However, these narrative religious images were not intended to be regarded merely as illustrations of a story; rather they were to act as reminders and embodiments of the most basic Christian doctrines. Other images in which narrative was subordinated to a direct evocation of, for example, the sufferings of Christ or the nature of the Virgin's perfections were also used to inspire the devotions of the worshipper.

Representations of the Crucifixion were generally of two distinct types, both of which included Christ on the cross with the Virgin Mary and Saint John the Evangelist (identified with John, Christ's 'beloved disciple' of the Gospels) standing beside it. In narrative treatments of this subject, incident and detail proliferated. Frequently Golgotha (the hill where Christ was crucified), the thieves who were crucified with him, the soldiers dicing for his clothes, Longinus with his lance, and other incidents from the Biblical narrative, and devotional literature, were included (Figs. 27 and 28). But the Crucifixion could also be represented with no other indication of the setting or narrative, and with Mary and John often flanked by saints who play no part in the Gospels but were included because of their importance to the patrons commissioning the image (Nos. 43 and 61). Many crucifixes were

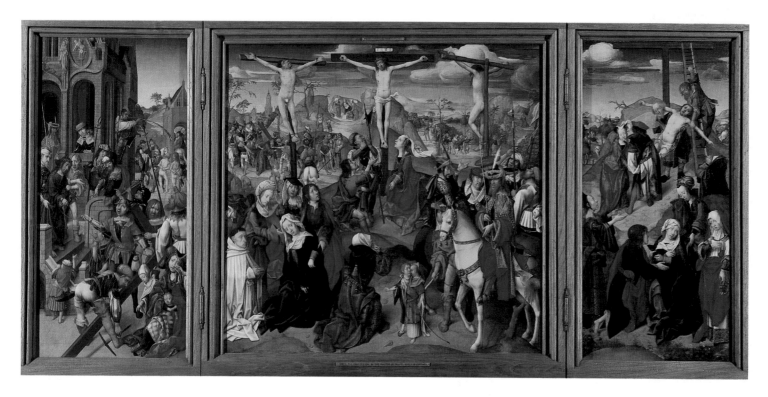

ABOVE Fig. 27. Master of Delft, *Scenes from the Passion, c.* 1500. Oak, painted surfaces, centre panel 98×105.5cm, shutters 102.5×49.5cm (NG 2922). The frame is modern.

RIGHT Fig. 28. Jacopo di Cione (and Workshop), *The Crucifixion, c.* 1368. Poplar, 154×138.5cm (NG 1468).

painted panels in the shape of a cross and these often incorporated Mary and John together with other figures and symbols in sub-ordinate areas (Fig. 29). Sometimes the Crucified Christ was re-presented with God the Father and the Holy Ghost, or Spirit (in the form of a Dove), as in the type of image known as the Throne of Mercy (*Gnadenstuhl*) (Fig. 16) which occurred both in large painted altarpieces and in small devotional images north of the Alps. Similar symbolic representations of the Trinity (the Father, Son and Holy Ghost) are also found in Italian altarpieces, both as the main subject (Fig. 57) and in the crowning panels of polyp-tychs (No. 9).

Other episodes from the Crucifixion narrative came to be given prominence, sometimes even to be the main subjects of altarpieces, in particular the Descent from the Cross (No. 62) , the Lamentation over Christ's Body, and the Dead Christ sup-ported in the Tomb (No. 44a and Fig. 30). The subject known as the *Pietà*, in which the Virgin holds the body of Christ on her lap, was one which translated particularly well to small devotional images (see Fig. 83), and was common in Northern Europe. All these subjects were frequently included in altarpieces made in north-east Italy in the fifteenth century, where they formed a separate rectangular or lunette-shaped compartment at the top.

There was evidently also a great demand for images of Christ which did not show him suffering on the cross, but recalled his sufferings and sacrifice by other, symbolic means: thus Christ was represented as the Man of Sorrows, usually at half-length, with the wounds received on the cross prominently displayed and wearing the crown of thorns; some or all of the 'instruments of the Passion', the nails, the lance and so on, might also be in-cluded. In one painting in the National Gallery the Virgin places her finger upon the wound in his side: some of the instruments of the Passion are on the reverse (Figs. 31 and 32).

Towards the end of the fifteenth century, paintings depicting only the head of Christ crowned with thorns were popular, often forming a diptych in combination with a depiction of the suffer-ing Virgin Mary (Figs. 33 and 34). These images (see No. 12) were in part inspired by the image of Christ which had mirac-ulously appeared on the handkerchief of Saint Veronica (the *suda-rium*) after she had used it to wipe the sweat from Christ's face

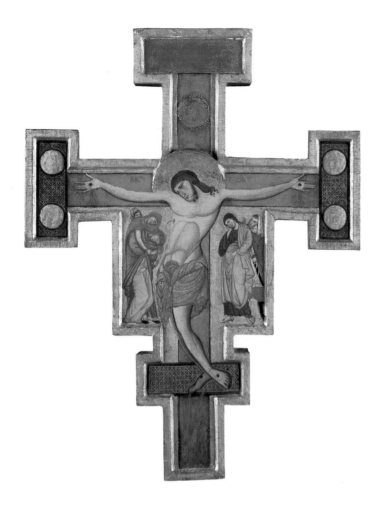

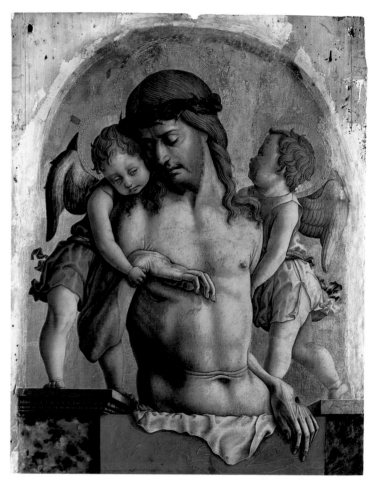

ABOVE LEFT Fig. 29. Master of Saint Francis, *Crucifix, c.* 1280. Poplar, 92.1×71cm (NG 6361).

ABOVE RIGHT Fig. 30. Carlo Crivelli, *The Dead Christ, c.* 1475. Poplar, painted surface 72.5×55.5cm (NG 602).

RIGHT Fig. 31. Florentine School, *The Dead Christ and the Virgin*, second half of the fourteenth century. Wood, painted surface 58.5×38.5cm (NG 3895).

FAR RIGHT Fig. 32. *Instruments of the Passion*. Reverse of Fig. 31.

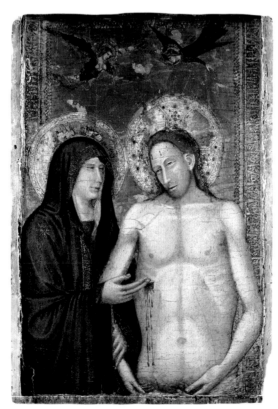

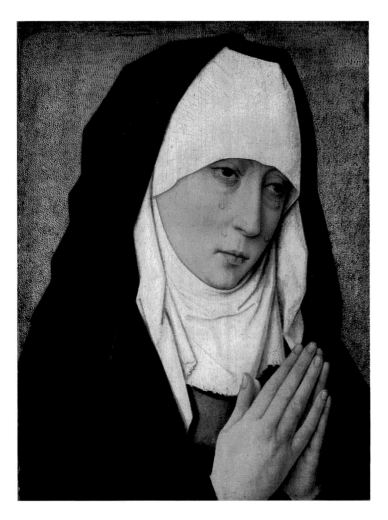

Fig. 33. Workshop of Dieric Bouts, *'Mater Dolorosa'*, last quarter of the fifteenth century(?). Oak, painted surface 36.5×27.5cm (NG 711).

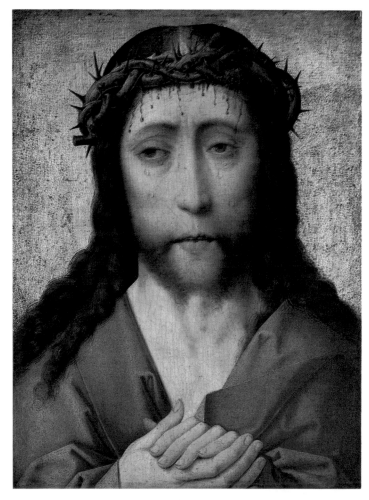

Fig. 34. Workshop of Dieric Bouts, *Christ crowned with Thorns*, last quarter of the fifteenth century(?). Oak, painted surface 36.5×27.5cm (NG 712).

when she saw him carrying the cross on the way to Calvary. This handkerchief was preserved as a relic in a church in Rome. These paintings also drew on the imagery of the Man of Sorrows, which derived from the miracle of the Mass of Saint Gregory, when the figure of the Redeemer appeared to Pope Gregory (compiler of the liturgy of the Mass; died 604) while he was celebrating Mass (Fig. 35). The image of the bleeding Christ which appeared to him was believed to be recorded in a painting in Santa Croce in Gerusalemme in Rome, and many versions of it were therefore made, among them Fig. 36. Popular religious texts exhorted the pious to share Christ's sufferings. Such images were particularly suitable for private devotions. They were also found on tabernacles and on the predellas of large altarpieces.

Throughout the period surveyed here the cult of the Virgin Mary flourished: churches were dedicated to her and devotions made to her all over Europe. She was depicted at half-length holding the infant Christ in the manner popularised in icons (images) from Constantinople (Byzantium) or painted in the Byzantine style, many of which were still venerated in Western European churches, as well as in narratives of particular episodes in her life. Sometimes altarpieces with compartments for narrative scenes were devoted to the Life of the Virgin (No. 3) as others were to the Life or Passion of Christ.

One of the most significant episodes from the Virgin's life was the Annunciation, when the Angel Gabriel announced to Mary that she would conceive the Son of God. It was often the principal

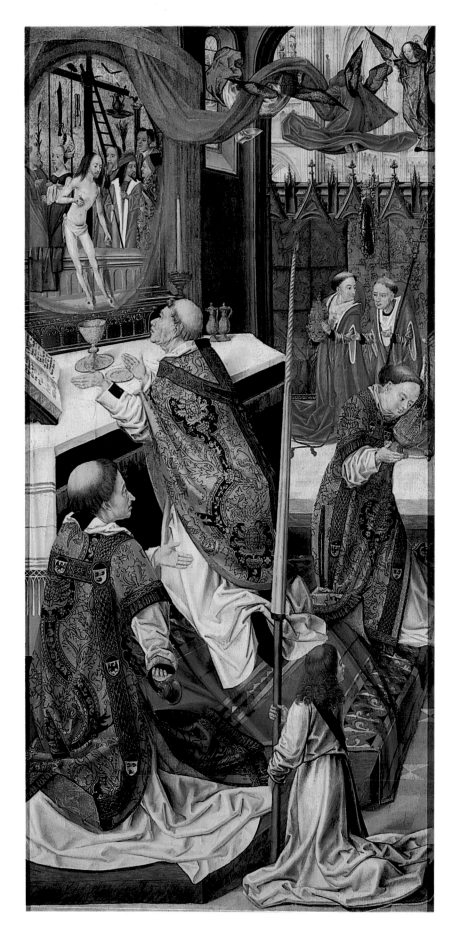

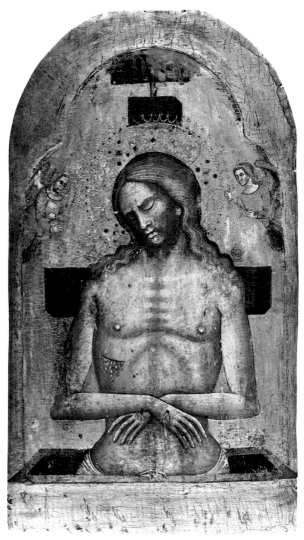

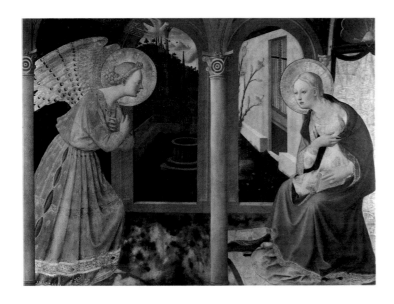

subject of an altarpiece (Fig. 37), tabernacle or small devotional picture. But more frequently it was found on subordinate parts of altarpieces. Since the subject involved two figures, it was not inappropriate to divide it in two, and as the representation of the very moment of the Incarnation, it formed a suitable prelude to the major religious image of the altarpiece which it covered or framed. Thus the Annunciation was often depicted on the outside of the shutters of altarpieces in Northern Europe, and in the spandrels of arches or in separate pinnacle panels (Figs. 38 and 39), as well as in the predellas, of Italian ones.

A subject frequently favoured for the main part of an altarpiece was the Nativity, in which the Virgin was often shown kneeling in adoration before her new-born child in front of the stable where he was born, with Joseph, the ox and ass and sometimes the shepherds looking on (No. 36). This subject is close to and often confused with the Adoration of the Shepherds – also a

ABOVE Fig. 37. Follower of Fra Angelico, *The Annunciation, c.* 1450. Wood, 103.5×142cm (NG 1406).

RIGHT Fig. 38. Giovanni del Ponte, *The Angel Gabriel*, early fifteenth century. Pinnacle panel from an altarpiece, painted surface 42.5×24cm, with the frame (original but regilded) 68×34cm (NG 580A).

FAR RIGHT Fig. 39. Giovanni del Ponte, *Virgin Annunciate*, early fifteenth century. Pinnacle panel from an altarpiece, painted surface 42.5×24cm, with the frame (original but regilded) 68×34cm (NG 580A).

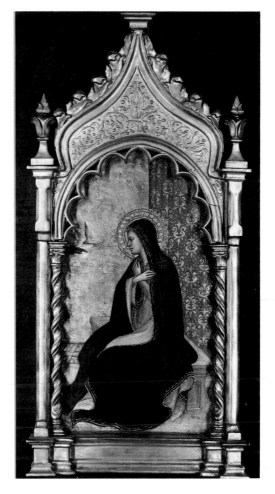

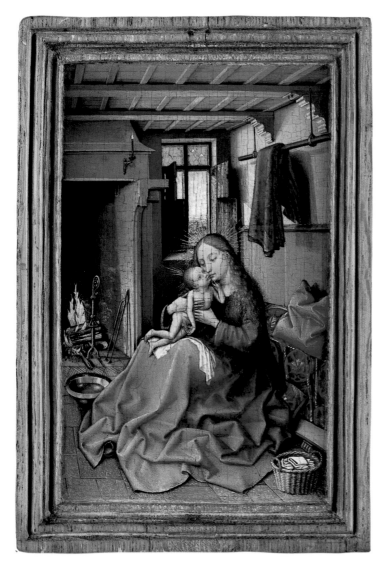

Fig. 40. Robert Campin, *Virgin and Child in an Interior*, first quarter of the fifteenth century(?). Oak, painted surface 18.7×11.6cm (NG 6514). The frame is original.

popular theme, although less so than the Adoration of the Kings, which is found in many domestic devotional paintings (No. 38 and Figs. 75, 89, 236) as well as in altarpieces (Fig. 96).

In the Netherlands in the early fifteenth century some images of the Virgin associated with Robert Campin (Fig. 40 and No. 13) showed her with her Child in domestic settings, as though an episode from the early life of Christ. These images emphasise both the humble and the extraordinarily exalted task of the Virgin as the mother of Christ. She is sometimes represented seated on the ground (Nos. 7 and 57), a type of painting known as the Virgin of Humility and first found in the early fourteenth century. In a painting of this type by Lippo di Dalmasio (Fig. 41) the Virgin is shown according to the description in the Book of Revelations of a woman clothed with the sun, the moon beneath her feet and her head surrounded with twelve stars.

The Virgin could also be represented in Heaven enthroned in majesty and crowned, as in Italian altarpieces of the *Maestà*, to

which reference has already been made (see p. 30). Her throne in these works is surrounded by angels. She could be shown in the act of ascending bodily to Heaven (the Assumption) or in the act of being crowned.

Her exalted position was commonly conveyed by seating her on a sumptuous throne made of precious marble, with some sort of canopy or arch above and behind it – either architectural or consisting of textiles or both. The cloth of gold and the oriental rug exactly described in paintings by Dieric Bouts and Gentile Bellini (Figs. 42 and 43) were commodities available relatively recently on the luxury market, with a value well known to those who prayed before these images. Costly textiles acquired for secular display were bequeathed for use on or at the altar as frontals or as priestly robes. In Bellini's painting, though not in that by Bouts, the Virgin is shown crowned. A number of small devo-

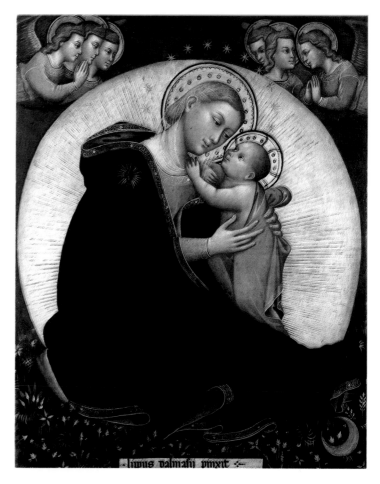

Fig. 41. Lippo di Dalmasio, *The Madonna of Humility*, end of the fourteenth century. Canvas, 110×87cm (NG 752).

Unlike the Annunciation, the Assumption and Coronation of the Virgin are not mentioned in any Gospel, but in the Apocryphal lives of the Virgin. The Coronation, which first became a prominent subject on carved cathedral portals in thirteenth-century France, was widespread in art throughout Christian Europe, well in advance of any theological consensus on the fact of the Virgin Mary's bodily assumption into Heaven which it presupposes. There was considerable variation in the manner in which the Coronation was represented (Figs. 46, 47, 172 and Nos. 9, 11). The Trinity could preside, and it was usual in

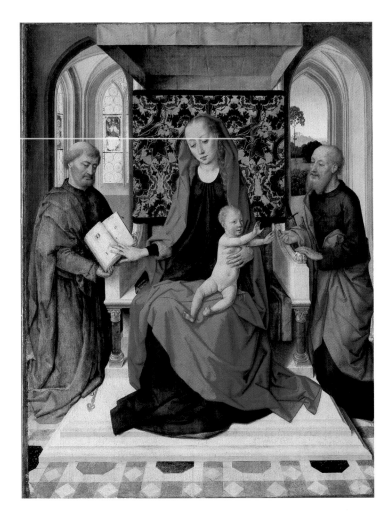

Fig. 42. Dieric Bouts, *The Virgin and Child with Saints Peter and Paul, c.* 1460. Oak, painted surface 68.5×51.5cm (NG 774).

tional images of the Virgin enthroned from the fifteenth century, particularly those painted in the Netherlands influenced by Jan van Eyck, show angels hovering over her head with a crown (No. 52); this motif is also found in the small painting of the Virgin and Child perhaps by Antonello da Messina (Fig. 44).

The Assumption of the Virgin was frequently represented in altarpieces – sometimes in association with the Coronation. Some representations of this event include the Virgin's girdle being lowered to Saint Thomas (Fig. 45), who doubted that she had really gone to Heaven, just as he had earlier doubted that Christ had risen from the dead. This incident was especially popular in Tuscany for the girdle was preserved in the cathedral of Prato.

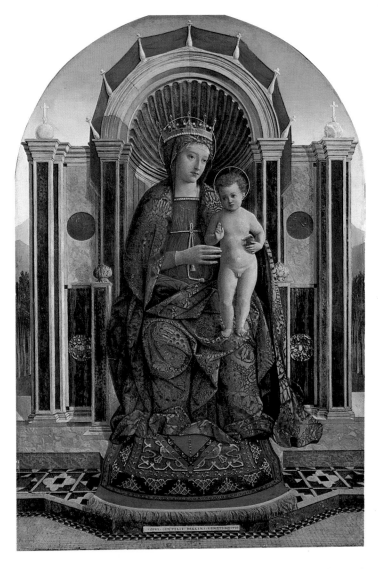

Fig. 43. Gentile Bellini *The Virgin and Child Enthroned, c.* 1470. Signed. Wood, painted surface 122×82.5cm (NG 3911).

paintings of this subject made north of the Alps for God the Father to hold the crown together with Christ. Sometimes Mary kneels to be crowned, and sometimes, although enthroned, she is seated at a slightly lower level than Christ.

It is clear that zeal to promote the status of the Virgin Mary was accompanied by some anxieties as to the theological implications of this. Such anxieties were more marked over the doctrine of the Immaculate Conception, which held that the Virgin was entirely untainted by Original Sin. This doctrine was fervently advocated

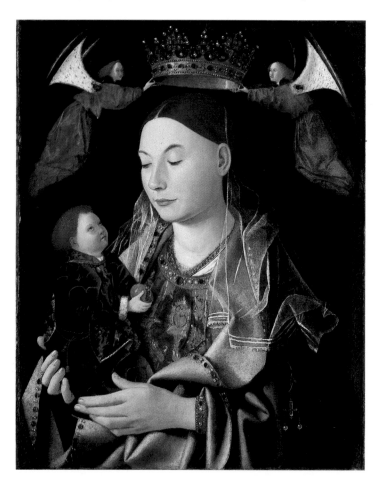

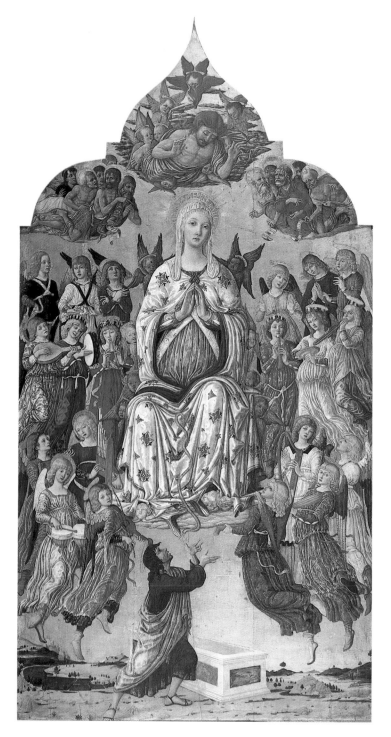

ABOVE Fig. 44. Antonello da Messina, *The Virgin and Child*, *c.* 1470–80. Wood, painted surface 43×34.5cm (NG 2618).

RIGHT Fig. 45. Matteo di Giovanni, *The Assumption of the Virgin*, 1474. Wood, 331×173cm (NG 1155).

FAR RIGHT Fig. 46. Master of Cappenberg (Jan Baegert), *The Coronation of the Virgin*, first quarter of the sixteenth century. Oak, painted surface 97.2×70.5cm (NG 263).

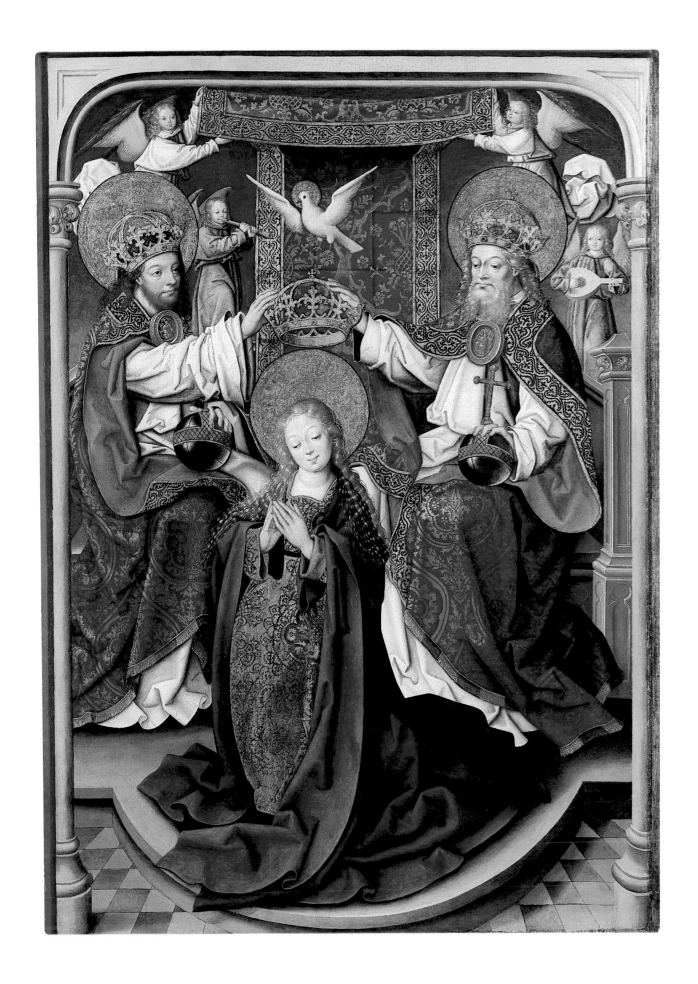

47

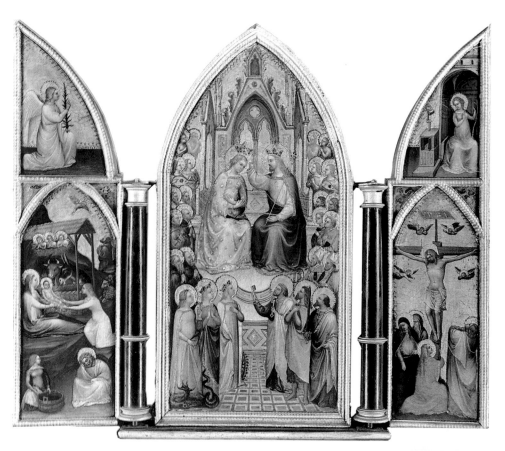

by the Franciscans, who commissioned altarpieces in support of it, but contested by the Dominicans. At the end of the fifteenth century these altarpieces generally included Old Testament prophets holding inscriptions which were thought to allude to the doctrine. Earlier, they merely included, beside the Virgin, narratives of associated miracles (Fig. 13).

In many paintings of the Coronation of the Virgin, particularly large ones, and in some paintings of the Assumption, Heaven is shown populated by throngs of saints, prophets and angels, frequently arranged in a hierarchy reflecting their importance. Occasionally other subjects also called for the representation of the Court of Heaven, such as Fra Angelico's predella of Christ in Glory (Figs. 48 and 49). Here the Virgin Mary and Saints Peter and Paul are placed in the top row nearest to the angels on Christ's right-hand side. The other Apostles follow, with Popes who had been made saints singled out for inclusion in the highest placed ranks, along with the Fathers of the Church such as Saints Jerome and Augustine. On Christ's left-hand side, beyond the rows of angels nearest him, are ranked the prophets who foretold the coming of Christ, including Saint John the

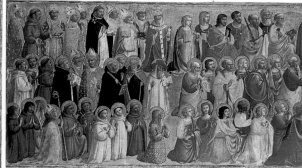

TOP LEFT Fig. 47. Giusto de' Menabuoi, *The Coronation of the Virgin*, with the *Annunciation, Nativity* and *Crucifixion* in the shutters. Signed and dated 1367. Poplar, central panel 48×25cm (NG 701). The frame is modern.

ABOVE Fig. 48. Fra Angelico, *Christ Glorified in the Court of Heaven*, before 1435. Wood, centre panel 32×73cm, inner left and right panels 32×63.5cm, outer panels 32×22cm (NG 663).

TOP Fig. 49. Panels from Fig. 48.

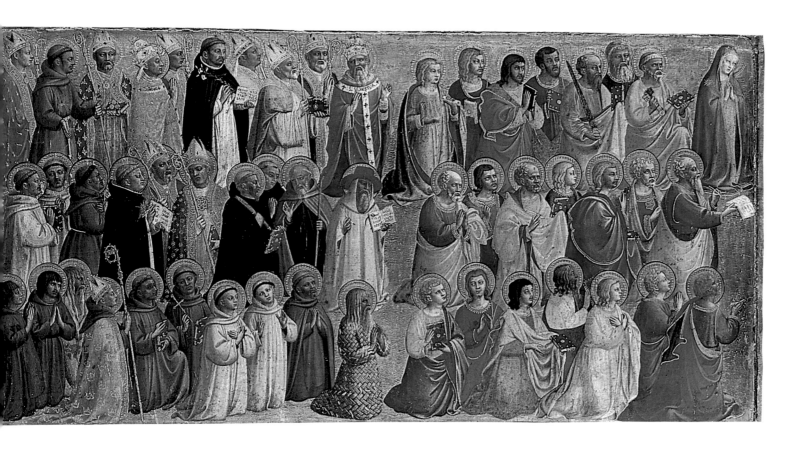

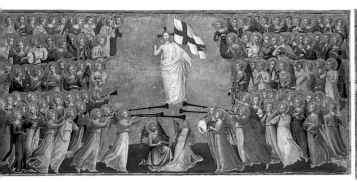
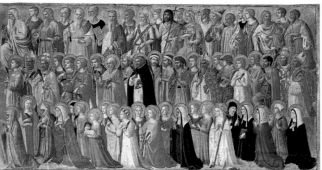

Baptist and King David, and the martyr saints holding the palms symbolic of their martyred status, male martyrs ranked neatly above female ones.

Angels were divided into three hierarchies, each further subdivided into three, forming a total of nine choirs, following the writings of Dionysius the Areopagite, who was believed to have been instructed by Saint Paul. While Fra Angelico did not follow the convention of the three hierarchies, he still divided his angels into two groups of four to either side of God, with a ninth in front. Not all paintings had room for such a complete depiction of the heavenly hierarchy: that shown by Matteo di Giovanni (Fig. 45) is much abbreviated. The fuller representations of Heaven are generally found only in large mural paintings, but in Botticini's *Assumption of the Virgin* (Figs. 50 and 99), a painting of unusual size (and especially unusual width), the nine choirs are clearly grouped into three hierarchies. Moreover, each one forms

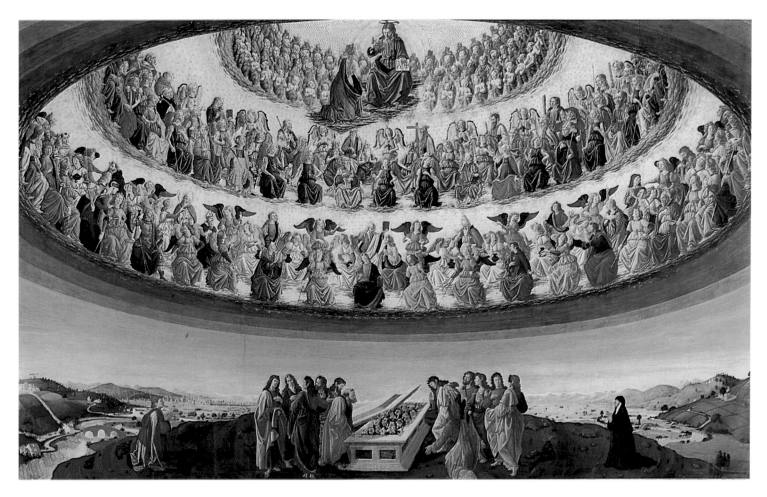

a circle – as in *Il Paradiso*, the third part of Dante's great four-teenth-century poem the *Divina Commedia* – a remarkable feat of perspective hard to imagine in a painting before the fifteenth century.

The three choirs nearest to God consist of the angelic councillors – Seraphim, Cherubim and Thrones. These are often represented as heads or busts only, but with four, six or eight wings. The next three choirs consist of the angelic governors – Dominions, Virtues and Powers. Then follow the angelic ministers – Principalities, Archangels and Angels. Botticini has distinguished each choir by colour and by attributes (sceptres, jars, arrows, candles and so on).

What is unorthodox about Botticini's painting is the way that the angels are interspersed with saints and ancestors of Christ, who had been kept distinct by Fra Angelico and Matteo di Giovanni. One of the two donors in the painting, Matteo Palmieri, who kneels on the left, wrote a poem in imitation of Dante in

Fig. 50. Ascribed to Francesco Botticini, *The Assumption of the Virgin*, c. 1475. Wood, 228.5×377cm (NG 1126).

which he developed the heretical theory that the souls of mortals were in origin angels who had remained neutral at the time of Lucifer's rebellion. This theory may be reflected in the painting, if the saints and ancestors are not just taking up their places in Heaven but are returning to their position among the angels with whom they had once been numbered.

The heads of the Cherubim, Seraphim and Thrones could be red or blue, or an attempt was made to render them as transparent and as part of the celestial light around God, as in the painting by Marmion (Fig. 20). Such an attempt to make angels embodiments of light suggests the metaphorical way in which heavenly beings were described in devotional literature.

In Italian paintings the Cherubim were generally infantile and child angels also became popular (No. 30), sometimes nude or

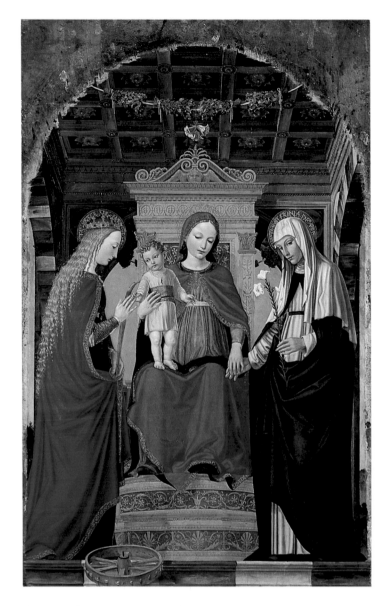

Fig. 51. Ambrogio Bergognone, *The Virgin and Child with Saints Catherine of Alexandria and Siena, c.* 1490. Poplar, 187.5×129.5cm (NG 298). The haloes are inscribed with the names of Catherine of Alexandria and Catherine of Siena and with a prayer to the Virgin.

The saints, whether represented in Heaven or on earth, are distinguished by haloes – round discs or glories (radiant gold lines) presumably indicators of heavenly light emanating from their heads – which were also given to all persons of the Trinity, to the prophets and to angels. In the early part of our period the halo was invariably represented parallel with the plane of the picture as a gilded disc behind the head. During the fifteenth century they were sometimes represented (especially in Italy) as if they were flat discs of metal above rather than behind the head, foreshortened and occasionally reflecting the top of the head, and sometimes only by an inconspicuous single gold line. In the Netherlands they were frequently omitted. Christ's halo is often distinguished by having a cross within it. That of the Virgin Mary sometimes includes a few words of prayer to her, taking up the words with which she was greeted by the Archangel Gabriel, 'Ave Maria Gratia(e) Plena', 'Hail Mary, full of Grace' (as in No. 15). The names of saints are sometimes inscribed in their haloes as in an altarpiece by Bergognone (Fig. 51) and in that by the Master of Liesborn, although this is no longer clear (No. 43). Names are also found written on a frieze below, especially when, as in Botticini's altarpiece, the saints are somewhat obscure (Fig. 56).

In Italy, the beatified (blessed) men and women who were recognised as of exceptional holiness, but who had not, or not yet, been canonised, were distinguished from saints by having glories as distinct from haloes. Artists often promoted the cause of the beatified by showing them in the company of saints, sometimes even giving them haloes. In the far left and right compartments of his predella (Fig. 48) Fra Angelico included groups of his fellow Dominicans who had been beatified. Not all of them were easily identified by their attributes and their names were neatly written on, probably after Fra Angelico's death.

SAINTS, PROTECTORS AND PATRONS

For the most part, saints in religious paintings are recognisable by their attributes. These are usually the instrument by which they were martyred or an object which played a significant role in their legend. In addition, a martyr was frequently represented holding a palm. Thus Saint Paul is shown with the sword with which he was executed, and Saint Catherine of Alexandria with the wheel on which she was tortured. Saint Peter is shown with the keys to Heaven and Hell, Saint Mary Magdalene with the pot of ointment with which she anointed the feet of Christ, and Saint Jerome with the lion which in legendary accounts of his life

nearly nude and obviously of the male sex. They appeared first in Italy and were partially inspired by the cupids and genii of ancient art. They were not suggested by theologians, but seem not to have excited their censure. The dress of Italian angels in the fifteenth century could also be influenced by the draperies of female personifications – Victories especially – and nymphs in antique sculpture (Nos. 27, 36, 56), whereas throughout the century angels in paintings north of the Alps wore long gowns covering their feet (Figs. 19, 21 and No. 52). The similarities are, however, as remarkable as the differences. Wherever they were painted, angels tended to be equipped with musical instruments of the most modern kind.

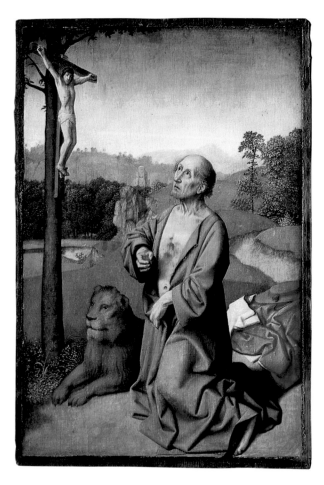

Fig. 52. Workshop of Gerard David, *Saint Jerome in a Landscape, c.* 1480-1500. Oak, painted surface 35×23cm (NG 2596).

Fig. 53. Cima da Conegliano, *Saint Jerome in a Landscape, c.* 1500-10. Wood painted surface 32×25.5cm (NG 1120).

became his faithful companion after he had removed a thorn from its foot. The four Evangelists have their own particular attributes: Saint Mark a lion, Saint Luke an ox, Saint Matthew an angel, and Saint John an eagle. Saint John is also very frequently shown with a serpent in a chalice, referring to his feat of drinking from a poisoned cup without harm; and Saint Luke, the patron saint of painters, is sometimes shown painting a picture of the Virgin (Figs. 178 and 179), who appears to him for the purpose.

Some saints were represented with more than one attribute and the same saint may, in addition, take on a different aspect, according to the context. Saint Jerome is shown either dressed as a cardinal or as a hermit (although his lion accompanies him in the former case and in the latter a cardinal's hat will often be seen by his side). He never was a cardinal (the office did not exist in his time and he refused all rank), but he was retrospectively

honoured because of his authority as one of the four Latin 'Fathers' or 'Doctors' of his Church – the others (Ambrose, Augustine and Gregory) were all bishops, and one (Gregory) also a pope. These men through their writings supported the Church and illuminated its doctrines – hence the emblematical church with light shining from it that Jerome, like the other Fathers, sometimes holds. In some small devotional paintings he is shown in his study as the translator of the Bible into Latin (No. 41), an inspiration to scholars; in others he is depicted as a peni-tent in the wilderness, beating his bared breast with a stone as he contemplates the Crucifixion (Figs. 52 and 53). Some saints are shown dressed in a special manner or in colours particular to them: Saint John the Baptist, for example, is usually easily re-cognisable from the animal skin he wears, as well as from his long, unkempt hair; in Italian paintings Saint Peter wears yellow

and blue and, in Netherlandish paintings, Saint John the Evangelist wears red.

Saints Peter and Paul, chief among the Apostles, are found on altarpieces all over Europe: flanking Christ in the Westminster Retable (Fig. 12), beside the Baptism of Christ in the altarpiece ascribed to Niccolò di Pietro Gerini (Fig. 54), flanking the Virgin and Child in the painting by Bouts (Fig. 42), in a gilded triptych represented in one of the panels of the Life of Saint Francis by Sas-

setta (No. 19 and Fig. 55), and on either side of God the Father in a gilt triptych represented in the *Mass of Saint Hubert* (Fig. 9).

Some lesser saints enjoyed still greater popularity – Saint Catherine of Alexandria, Saint Roch (or Rocco) and Saint Sebastian, for instance, were venerated as protectors against the plague, and Saint Christopher then as now was widely prayed to by travellers. But many saints were venerated only in one area, or perhaps venerated there in a special way. Saint Hubert (Fig. 7) is not a

Fig. 54. Ascribed to Niccolò di Pietro Gerini, *The Baptism of Christ, with Saints Peter and Paul*, 1387. Wood, 237.5×200cm (NG 579).

Fig. 55. Sassetta, *The Funeral of Saint Francis and the Verification of the Stigmata*, completed 1444. Wood, 88×53cm (NG 4763). See No. 19.

mine the presence of the saint in the altarpiece. Thus the fact that Saint Matthias's remains were preserved in the Basilica of Santa Maria Maggiore in Rome explains the presence of this saint in the altarpiece there by Masaccio and Masolino (No. 16). A relic could also suggest the subject of the altarpiece. The arm bone of Saint Sebastian was preserved in the oratory of that saint in the church of the SS Annunziata in Florence, and a reliquary for it was commissioned from Benedetto da Maiano shortly after the great altarpiece was commissioned from the Pollaiuoli (No. 40).

If the popularity of Saint Sebastian was largely owing to his powers as a protector against the plague, that of Saint Jerome was chiefly because he was the exemplar of all penitents. His popularity was reflected in the prevalence of the name of Jerome - Girolamo in Italian. Girolamo di Piero di Cardinale Rucellai, a member of the powerful Florentine family, chose to be buried in the church of the Hieronymites, the Hermits of Saint Jerome of Fiesole, near the original location of the altarpiece by Botticini (Fig. 56). His decision must have been connected with his name. He is likely to have commissioned the painting when he acquired the burial rights in the church – well in advance of his death perhaps, as would not have been unusual. He probably also paid for the tabernacle in the church (Fig. 4). The Hermits had adopted a grey habit with a leather belt in 1460, and this is worn by the saints in the altarpiece flanking the central image of the penitent Jerome, whose life was the inspiration of the Order: Saint Damasus was the Pope who instructed Jerome to translate the Bible; Saint Eusebius of Cremona was a friend and fellow polemicist; Saint Paola was the abbess of a nunnery which Jerome founded in Bethlehem; and Saint Eustochium was her daughter and successor, and also a pupil of Jerome.

In this case we can conclude that Jerome was the subject of Botticini's altarpiece both because he was the patron saint of the religious Order in whose church it was placed and because he was the name saint of the patron. It is exceedingly rare for us to know how decisions were reached concerning which saints were to be included in an altarpiece. However, the records of the deliberations of the company of the Priests of the Trinity at Pistoia when they commissioned an altarpiece from Pesellino (Fig. 57) on 10 September 1455 happen to have survived. They wanted the painting to represent the Trinity which they honoured; they wanted it to include Saint Zeno, who was patron of the clergy of Pistoia, and Saint James the Great, who was patron of Pistoia, and Saint Jerome. They agreed also to include the juvenile martyr Saint Mamas, who stands to the extreme left of the painting with a pack of lions behind him. (In the predella below we see the lions

saint commonly met with in Italian altarpieces, but he was much venerated in the Netherlands where, as we have seen, his body was preserved. Likewise Saint Donatian, a fourth-century Bishop of Reims, was chiefly venerated at Bruges where his relics were transferred in the ninth century (Fig. 58).

Saints were most commonly represented in altarpieces standing beside the crucified Christ or beside the Virgin and Child enthroned. A saint could also, however, be the central subject of an altarpiece, either in isolation or as part of a narrative. Veneration for Saint John the Baptist might occasion an altarpiece of the Baptism of Christ (Fig. 54), and in a chapel dedicated to Saint Thomas one might find an altarpiece painted with him placing his hand on the wound in the side of the risen Christ (Fig. 72).

The presence of a relic in a church would often of course deter-

Fig. 56. Francesco Botticini, *Saint Jerome in Penitence with Saints and Donors, c.* 1490. Wood, 235×258cm, including the original frame (NG 227).

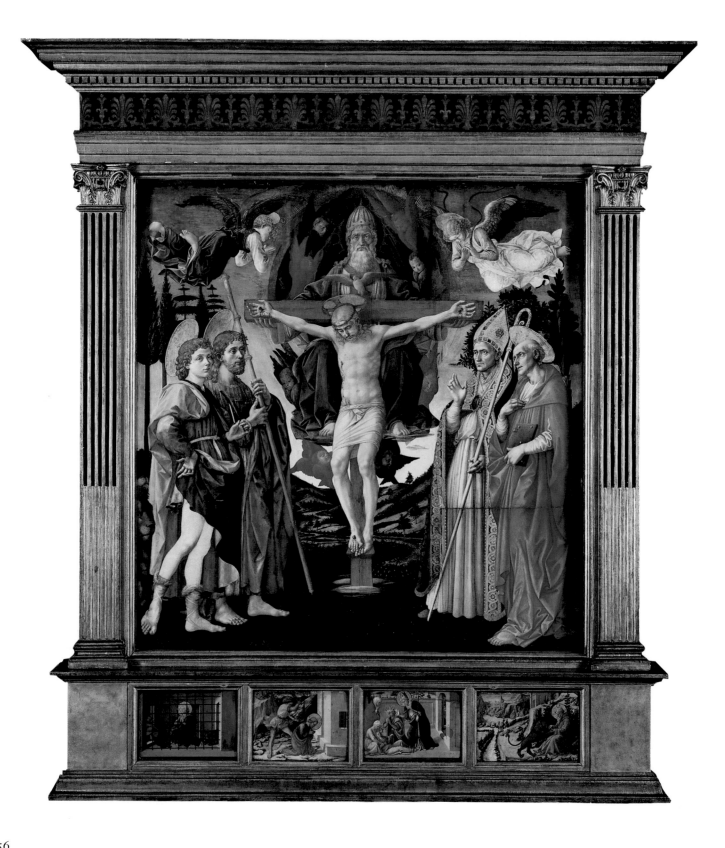

LEFT Fig. 57. Pesellino, *The Trinity with Saints*, commissioned 1455; completed 1460 in the studio of Fra Filippo Lippi after Pesellino's death in 1457. Wood, main panel 184×181.5cm (NG 727, 3162, 3230, 4428, 4868A-D; one fragment on loan from Her Majesty The Queen). The frame and the part of the painting to bottom right are modern reconstructions.

RIGHT Fig. 58. Gerard David, *Canon Bernardinus de Salviatis and Three Saints, c.* 1501. Oak, painted surface 103×94.5cm (NG 1045). Saint Donatian is the saint to the right.

released into his cell but amiably licking him instead of devouring him.) Without the documents it would be hard to identify this very obscure saint. He was included at the special request of the company's treasurer Piero ser Landi, the driving force behind the commission and, it seems, the major contributor to its cost. But when the painting was nearly completed, it became clear that the treasurer was in fact guilty of fraud, and he was disgraced. The presence of his personal saint in the altarpiece must have been a cause of considerable irritation to the rest of the company.

Personal saints were most commonly name saints, and that presumably is why both Saint John the Baptist and Saint John the Evangelist appear in the shutters of the altarpiece by Memlinc, the former pointing towards Sir John Donne, who kneels before the Virgin and Child in the central panel (No. 42). Canon Bernardino Salviati (Bernardinus de Salviatis), who kneels in one

shutter of an altarpiece by Gerard David, has three saints standing behind him, Martin, Bernardino and Donatian – all seem solicitous for his welfare but it is his name saint whose hand hovers above his shoulder (Fig. 58). The Canon's father, who belonged to one of the leading Florentine mercantile families, may well have attended open-air sermons given by Saint Bernardino, a Franciscan preacher from Siena who became Vicar General of his Order. He was known as the Apostle of Italy and encouraged devotion to the Holy Name (the letters IHS, an abbreviation of the Greek for Jesus, appear on the book he holds in the painting). He died in 1444 and was canonised in 1450, about the date that Bernardino Salviati was born.

Sir John Donne and Canon Bernardino are the same size as the saints in these altarpieces. This was usual in the Netherlands in the fifteenth century and by then common in Italy as well,

Fig. 59. Carlo Crivelli, *The Virgin and Child with Saints Francis and Sebastian.*
Signed and dated 1491. Poplar, painted surface 175×151cm (NG 807).

Fig. 60. Detail of Fig. 59 showing the donatrix Oradea, widow
of Giovanni Becchetti.

although the older convention of diminutive portraiture did persist there. Oradea, widow of Giovanni Becchetti, for instance, appears as a small figure by the feet of Saint Francis in one of Crivelli's altarpieces (Figs. 59 and 60). In Germany these portrait figures remain smaller in scale throughout the fifteenth century (Fig. 67). Such portraits are generally called donor portraits. However, altarpieces were not always given to the Church (although this does seem to have been the case with Canon Bernardino's) and it was as common for them to be erected in private burial chapels, perpetuating the memory of an individual for whose soul in Purgatory prayers should be offered and Masses said. Monumental effigies of the deceased were often placed in the same chapels. Like the painted portraits, they were generally commissioned in the lifetime of the person represented, and generally showed him or her in an attitude of prayer.

ORDERS, CONFRATERNITIES AND THEIR SAINTS

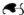

The founders of the great religious Orders were of course their patron saints, who were usually included in altarpieces erected in the churches and chapels of their Orders. As has been mentioned, the oldest monastic Order was the Benedictine. The central panel of the high altar of the Benedictine monastery church at Liesborn (No. 43) shows Christ upon the cross. On either side of the cross stand the Virgin Mary and Saint John; beside the former are Saints Cosmas and Damian, to whom the monastery was dedicated, and beside the latter Saint Benedict, founder of the Order, and his sister Saint Scholastica, both of whom wear the black Benedictine habit (Fig. 61).

Among the Orders of the tenth and eleventh century which revived the ideal of the hermit's solitary meditation and penance were the Camaldolites in Italy. The painter Lorenzo Monaco (literally Lorenzo the Monk) took his vows (and his name) in 1391 at the Camaldolese monastery of Santa Maria degli Angeli in Florence. His large altarpiece of the Coronation of the Virgin (No. 11) was probably made for the Camaldolese monastery of San Benedetto fuori della Porta a Pinti, just outside Florence; it closely resembles one which he made for his own monastery, Santa Maria degli Angeli itself (Fig. 62). The most prominent figure among the saints in the right-hand side of the altarpiece is Saint Romuald, the founder of the Order (died 1027), wearing a white habit, but in an equivalent position on the other side of the altarpiece is Saint Benedict. The Camaldolites, as reformed

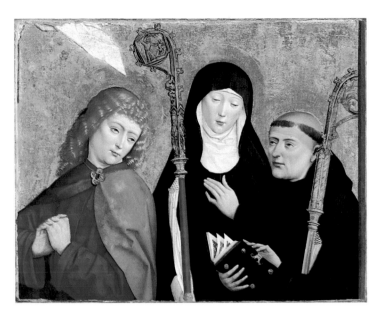

ABOVE Fig. 61. Master of Liesborn, *Saints John the Evangelist, Scholastica and Benedict, c.* 1465-1490. A fragment transferred from oak, 55.9×70.8cm (NG 260). See No. 43.

Benedictines, regarded Benedict as the real founder of their Order and in their imagery gave him their white habit rather than his usual black one. The same pair of saints flank the predella of the altarpiece of the Baptism of Christ by Niccolò di Pietro Gerini (Fig. 54).

Chief among the mendicant Orders (see p. 20) were the Franciscans and Dominicans. A Franciscan altarpiece of course usually includes Saint Francis himself, as for instance the altarpiece by Crivelli (Fig. 59) from San Francesco, the Franciscan church of Fabriano, and the triptych of the Crucifixion by Niccolò di Liberatore (Fig. 63), probably made for the Franciscan nuns of Santa Chiara (Saint Clare) at L'Aquila, in which Saint Francis fervently embraces the foot of the cross. A Dominican altarpiece will usually include Saint Dominic. A small dossal, probably associated with Santa Maria Novella, Florence, also includes the two major Dominican saints, the great theologian Thomas Aquinas and Peter Martyr (Fig. 64).

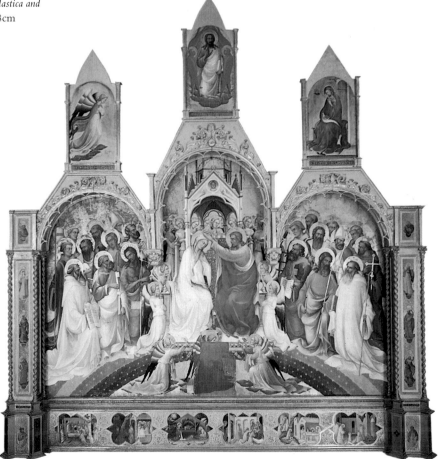

RIGHT Fig. 62. Lorenzo Monaco, *The Coronation of the Virgin*. Signed and dated 1414. Wood, 512×450cm. Florence, Uffizi.

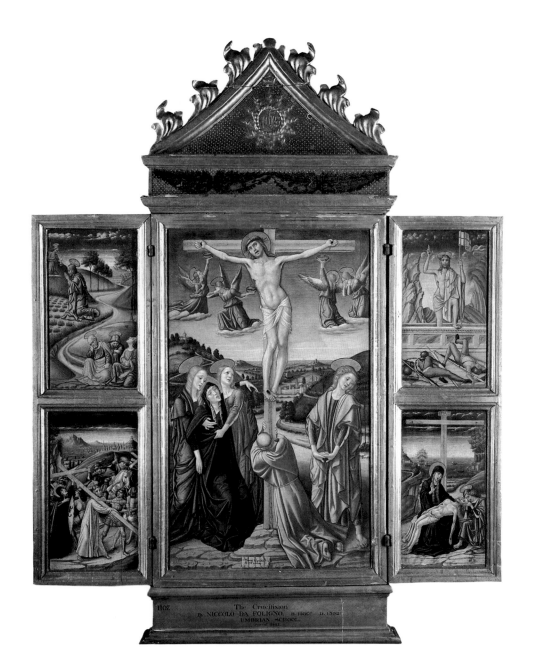

LEFT Fig. 63. Niccolò di Liberatore, *Christ on the Cross and Other Scenes*. Signed and dated 1487. Wood, painted surface, central panel, 92.1×57.8cm (NG 1107). The frame is original.

BELOW Fig. 64. Ascribed to Andrea di Bonaiuto da Firenze, *The Virgin and Child with Ten Saints*, *c*. 1367. Wood, 28×106cm (NG 5115).

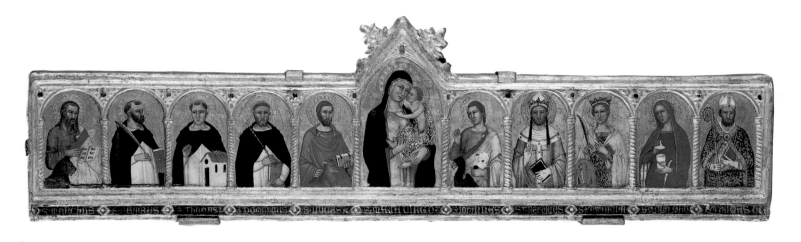

The Orders of Friars came to be rivals and were bitterly divided over some matters, above all the doctrine of the Immaculate Conception of the Virgin Mary. Nevertheless, Saint Francis is included with Saint Dominic in some Dominican altarpieces (Fig. 71 and No. 46a). He is also conspicuous among the hosts of saints in the predella which the Dominican artist Fra Angelico painted for his own convent of San Domenico at Fiesole (Fig. 49). Nor, in the early 1470s, did Francesco Sassetti, who owned the rights of patronage in the Cappella Maggiore of the chief Dominican church in Florence, Santa Maria Novella, regard it as absurd to propose that it be decorated with murals of the life of his name saint, Saint Francis. But unsurprisingly perhaps the Dominicans refused.

Sometimes Saint Francis himself was the main subject of an altarpiece (Fig. 14). He might be shown displaying or receiving the stigmata (see No. 19) – the five wounds which Christ received on the cross from the nails in his hands and feet and from the spear wound in his side. These were miraculously impressed upon Saint Francis's body as he prayed, and indicated how closely identified he was with Christ. Saint Dominic and other Dominican saints, such as Saint Peter Martyr, Saint Thomas Aquinas and Saint Vincent Ferrer, could also be the subjects of altarpieces. Vincent Ferrer, who died in 1418, had been one of the greatest preachers in Europe, converting Jews, Moors and heretics in France and Spain, and preparing Christians all over Europe for the Second Coming. He was canonised on 29 June 1455 and again – with more publicity – in 1458. Cossa's altarpiece, made for a new chapel in Bologna, depicting him in full authority with his halo, is an early response to this (No. 35). Some of those who prayed before this painting may have remembered what Saint Vincent looked like. The Franciscans were even prompter in promoting Saint Bernardino, who was canonised a mere twelve years after his death; many representations of him correspond with his death mask and may be considered as portraits (Fig. 58).

Painters could play a part in the promotion of the beatified to the status of saints, and of venerated holy men to the status of the beatified. The Blessed Raniero was a lay brother of the Franciscan Order, and when he died in 1304 his body was embalmed and placed beneath the high altar of San Francesco in Sansepolcro. Over a century later Sassetta was commissioned to paint a large altarpiece (No. 19) for this high altar. The principal panels on the back depicted Saint Francis, that on the front the Virgin and Child. Raniero featured prominently in the altarpiece and is given a glory (although he was not beatified until 1802); episodes of his life were depicted in the predella.

Fig. 65. Carlo Crivelli, *The Vision of the Blessed Gabriele, c.* 1489. Signed. Poplar, painted surface 141×87cm (NG 668).

A similar promotion is associated with Crivelli's painting of the Franciscan friar, the Blessed Gabriele (Fig. 65), superior of the Convent of San Francesco ad Alto, Ancona, who died in 1456. Pope Innocent VIII permitted the transfer of his body from its humble friar's grave to a marble tomb in the convent church in 1489 and this tomb was treated as a shrine, with Crivelli's painting, which was made in the same year, hanging above it.

Fig. 66. Master of Delft, *Scenes from the Passion*, *c.* 1500 (Fig. 27). Detail from the *Crucifixion* showing the donor.

Gabriele is shown with a glory, although he was not beatified until 1753, praying before a vision of the Virgin and Child in a mandorla in the wood beside his convent.

To join a religious Order of monks or friars was to reject personal wealth and earthly ties, and often indeed one's name, so it may seem surprising that portraits of monks and friars do sometimes occur in devotional paintings. In practice, however, the original rules of the Orders were often relaxed. Moreover the giving of works of art was one way in which the richer members of the monastic community could appropriately dispose of their wealth and both commemorate themselves and benefit the com-

munity as they did so. Abbots and other senior monks may also have felt that they were representing the whole of their community when they appeared as 'donors'.

An example of such a monastic donor is the kneeling figure to the left of the Crucifixion painted by the Master of Delft (Fig. 66). He has a tonsure and wears a white habit, perhaps that of a Carthusian monk, perhaps that of a Premonstratensian Augustinian canon. Canons were priests who lived a semi-monastic life adapted from the Rule of Saint Benedict, but whereas Augustinian canons renounced all personal wealth and held property in common with their community, the canons attached to cathedrals or collegiate churches seldom practised the 'poverty of the Apostles'. Bernardino Salviati (Fig. 58) and Richard de Visch de la Chapelle (No. 69), the former a canon and the latter a cantor of the Collegiate Church of Saint Donatian in Bruges, evidently possessed great wealth.

The religious Orders often had attached to them lay Orders, men and women observing many of the same rules but not bound by the same vows. The Franciscan Order was divided into three: the second order consisting of nuns, the third – the Tertiaries – of the laity. Lay associations were also involved in managing hospitals and other religious institutions.

The most eminent of lay Orders were the military Orders. The Knights of Saint John of Jerusalem (properly the Knights of the Order of the Hospital of Saint John of Jerusalem) were founded in the First Crusade in the late eleventh century to protect a hospital for pilgrims to the Holy Land. Later they moved their base to Rhodes and subsequently to Malta – to continue to protect Christian interests in the Mediterranean. They accumulated vast wealth and privileges and property all over Europe. In Cologne they were associated with the church of Sts John and Cordula, and we find one of the knights represented kneeling in an altarpiece by Lochner perhaps for that church (Fig. 67 and No. 20).

Throughout Europe associations of the laity who devoted themselves to some special cult or to some special penitential service or act of charity – public flagellation, tending the sick, burying the dead – were known as confraternities. Some of them were powerful and influential groups of citizens. This was certainly the case with the Confraternity of the Centenar de la Ploma in Valencia in Spain which originated in a company of one hundred archers founded in 1365. By the end of the fourteenth century it comprised five hundred men and six hundred women. Its status is suggested by the fact that it had custody of the banner of Valencia and, in addition to its chapel in the church of St George, had an oratory nearby for which the massive altarpiece of Saint

George (Fig. 24) was painted in about 1420. The central panels show Saint George fighting the dragon, Saint George helping James I of Aragon defeat the Moors, and the Virgin and Child enthroned, while the numerous legends of the saint are represented in the smaller compartments.

The confraternities often reflected the most topical forms of religious fervour. The *Disciplinati*, confraternities of flagellants who did penance, whipping themselves in public procession, developed in the thirteenth century. A large canvas banner painted on both sides by Barnaba da Modena in about 1370 is one of the few processional banners belonging to one such confraternity to have survived from the fourteenth centry (Figs. 68 and 69). On one side Christ is depicted crucified with the Virgin and Saint John standing on either side of him. Saint Anthony Abbot is shown embracing the foot of the cross. Banners of the fifteenth century often follow very similar patterns. On the other side of the banner are Saint Anthony Abbot and Saint Eligius, with kneeling worshippers below them wearing the white habit and hood, with a circle cut out of the back, adopted by penitential confraternities (the hole enabled them to lacerate the skin on their backs). It has been plausibly conjectured that this banner belonged to the Genoese confraternity dedicated to Saint Anthony. Saint Eligius, patron of goldsmiths, was probably represented here because he was associated with the burial of the

ABOVE Fig. 67. Stephan Lochner, *Saints Ambrose, Cecilia and Augustine with the Donor Heinrich Zeuwelgyn, c.* 1445. Oak, painted surface 86×58cm. Cologne, Wallraf-Richartz Museum.

RIGHT Fig. 68. Barnaba da Modena, *The Crucifixion with the Virgin, Saint John and Saint Anthony Abbot, c.* 1370. Canvas, 197×128cm. London, Victoria and Albert Museum.

FAR RIGHT Fig. 69. *Saint Anthony Abbot and Saint Eligius.* Reverse of Fig. 68.

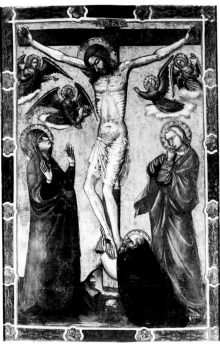

Fig. 70. Giovanni di Paolo, *Saint Fabian and Saint Sebastian, c.* 1465. Wood, painted surface 84.5×54.5cm (NG 3402).

dead, which was one of the confraternity's duties. The Crucifixion may be explained by the fact that the most important of the public processions in which the confraternity participated was that of the Invention (that is, the discovery) of the Holy Cross. The same format, with two saints to whom miniature hooded members of a confraternity kneel, is found in panel paintings (Fig. 70).

Confraternities were generally fostered by a religious Order and had a meeting place and chapel within the church of that Order or its conventual buildings. They were particularly en-

couraged by the Dominicans and Franciscans, with their important missions to the towns. The Confraternity of Saint Anthony in Genoa was attached to the church of San Domenico, a Dominican church.

The Compagnia di Santa Maria della Purificazione e di San Zanobi (a boys' confraternity, also known as the Compagnia dei Fanciulli, which often performed plays and was closely associated with the Medici), having built a new oratory attached to the Dominican church of San Marco in Florence, commissioned for it the altarpiece of the Madonna and Child enthroned by Benozzo Gozzoli in 1461 (Fig. 71). The saints depicted here are the confraternity's patron, Saint Zenobius, Bishop of Florence, an important local saint, Saint John the Baptist, patron of Florence, Saint Dominic, patron of the Order, and Saints Peter, Jerome and Francis. Each one is boldly named on a halo for the benefit of the children. The contract specified that the panels flanking the predella (which is no longer attached to the altarpiece) were to depict boys holding the confraternity's emblem.

The penitential confraternity (or Scuola, as Venetian confraternities were commonly called) of San Tommaso dei Battuti attached to San Francesco in Portogruaro commissioned the altarpiece of the Incredulity of Saint Thomas, their patron saint, from Cima da Conegliano probably in 1497 (Fig. 72). Although this was a Franciscan confraternity, the nature of its devotions was not as obviously coloured by Franciscan ideas as were those of the confraternities of the Immaculate Conception. One of these was established in 1475 in Milan under Franciscan sponsorship and in response to the fervent preaching of Fra Stefano di Oleggio, at a moment when the Pope (Sixtus IV, himself a Franciscan) was giving his approval to the doctrine of the Immaculate Conception, to the dismay of the Dominicans. Such was the success of the confraternity that it was able three years later to build and decorate sumptuously a new chapel attached to the church of San Francesco, and then in 1480 to commission an elaborate wooden altarpiece for which Leonardo da Vinci's *Virgin of the Rocks* was painted (No. 68).

To obtain the necessary funds this confraternity must have enjoyed the support of very wealthy citizens. Fragments of a banner painted by a Milanese artist at about this date show groups of citizens (perhaps portraits), sexually segregated, probably the members of such a confraternity and some of them apparently of great wealth (Figs. 73 and 74).

In Florence the confraternity which enjoyed the most conspicuous support from the prominent and wealthy during the fifteenth century was the Compagnia de' Magi. They staged

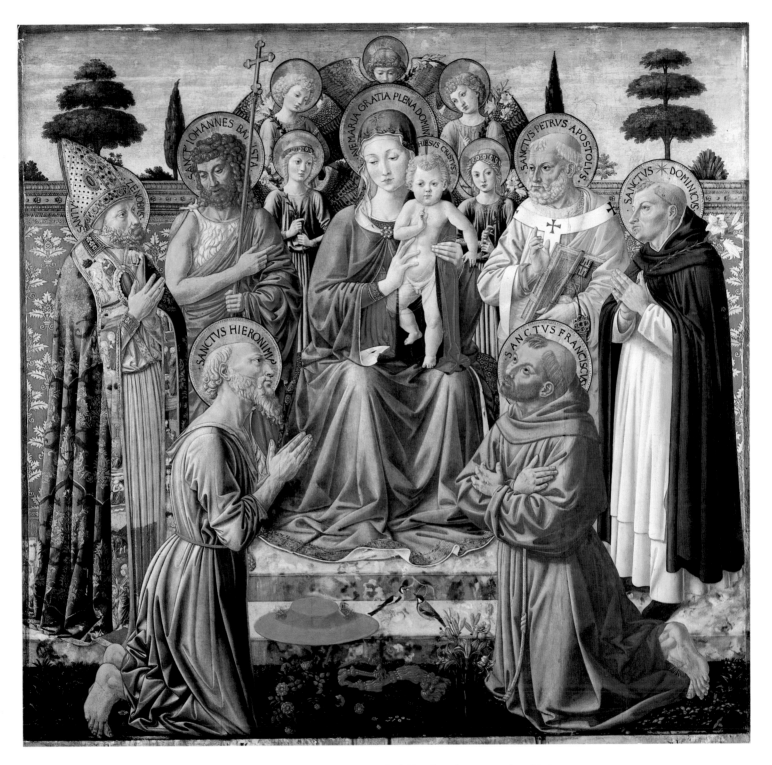

Fig. 71. Benozzo Gozzoli, *The Virgin and Child Enthroned among Angels and Saints*,
commissioned 1461. Wood, painted surface 162×170cm (NG 283). See also Figs. 165 and 175.

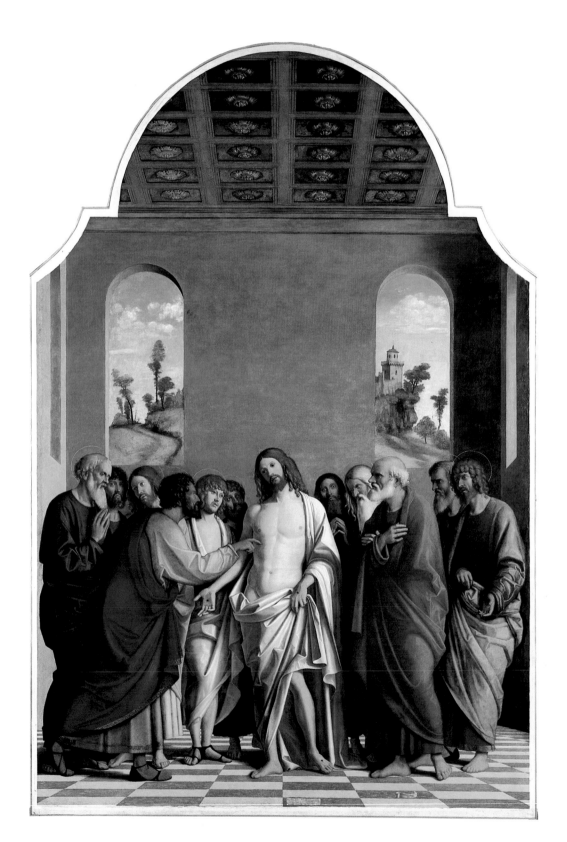

LEFT Fig. 72. Cima da Conegliano, *The Incredulity of Saint Thomas*. Signed and dated 1504. Transferred from wood to synthetic panel, painted surface 294×199.5cm (NG 816).

CENTRE Fig. 73. Ascribed to Ambrogio Bergognone, *Male Members of a Confraternity*(?), *c.* 1500. Fragment. Silk or linen, mounted on wood, painted surface 64.5×42cm (NG 779).

RIGHT Fig. 74. Ascribed to Ambrogio Bergognone, *Female Members of a Confraternity*(?), *c.* 1500. Fragment. Silk or linen, mounted on wood, painted surface 64.5×42cm (NG 780).

BELOW RIGHT Fig. 75. Sandro Botticelli, *The Adoration of the Kings*, 1470. Wood, painted surface 50×136cm (NG 592). The frame is possibly original.

magnificent public processions and theatricals on the Feast of the Epiphany, especially during the 1440s, 1450s and 1460s, during which they dressed up as the Three Kings and their retinue. This may explain the great popularity of paintings of the Adoration of the Magi in Florence (Fig. 75; also Fig. 89 and No. 38), some of which are known to have contained portraits, and many of which may include recollections of the spectacular costumes and lively cavalcades which were a feature of these celebrations.

COMMERCE, CONVENTION AND INNOVATION

Not all religious paintings were destined for churches. Many individuals, including those of relatively modest means, had small religious paintings at home. Francesco Datini, for instance, the so-called Merchant of Prato, who died in 1410, had sacred pictures in his bedroom, guest rooms and office. Such paintings would often have been bought either on the open market or ready-made from a painter's workshop, rather than being specifically commissioned from an artist, as was the case with altarpieces and tabernacle paintings. Datini and his contemporaries traded in religious paintings in this way, and there was also a market in such paintings in Northern Europe (see p. 107). The most popular subjects were, it seems, the Crucifixion and the Virgin and Child. Datini when in Avignon asked a friend in Italy to supply him with a triptych: 'Let there be in the centre Our Lord on the Cross, or Our Lady, whichever you find – I do not care, so long as the figures are handsome and large, the best and finest you can buy, and the cost no more than 5½ or 6½ florins.'

Tradition and authority, central to the idea of the Church, encouraged the imitation of form as well as content. Religious images for the home obviously tended to be smaller in size than those in churches, but they were very similar in other respects and indeed were sometimes miniature replicas of a larger and famous image. One fourteenth-century painting of the *Maestà* (Fig. 76) belongs to this category. Such repetitions were obviously convenient for the artist, but they might also have reflected a patron's desire to possess a version of an image which had answered prayers or which had special associations. Saint Bernardino was so devoted to the lost fresco, probably by Simone Martini, of the Assumption of the Virgin above one of the gates of his native Siena upon which he had loved to gaze as a child, that he commissioned a copy of it; others imitated him, for his sermons had made the painting still more famous. The com-

Fig. 76. Follower of Duccio, *The Virgin and Child with Four Angels, c.* 1315. Wood, 41×28cm (NG 6386). The composition reflects that found in monumental paintings of the *Maestà*.

position of the Virgin and Child devised by Giovanni Bellini for his great altarpiece of 1505 in the church of San Zaccaria was adopted by Francesco Bissolo for a smaller work (Fig. 77). Nor was Bellini himself above recycling his own ideas in this way. His *Virgin and Child* (Fig. 78) would seem to be a truncated version of a larger group, doubtless made for a large altarpiece. The Virgin's knees would never have been given such positions by Bellini had he invented the composition for the reduced format, but they are admirably suited to a full-length enthroned group recorded in a copy by a painter working in Venice (Fig. 79).

Fig. 77. Francesco Bissolo, *The Virgin and Child with Saint Paul and a Female Martyr*, c. 1505-15. Wood, painted surface 78×117.5cm (NG 3915).

Most people who bought images would not have expected them to vary from a traditional pattern any more than they expected the words of the Mass to vary, but they must often have wanted to make the imagery more personal, even if only in a marginal way. We know that in Northern Europe small religious triptychs were often produced with the shutters blank so that the purchaser could add personal saints, coats of arms and even portraits of himself and his wife at prayer. Looking at Bartolomeo Vivarini's *Virgin and Child with Saints Paul and Jerome* (Fig. 80) we cannot fail to be struck by the way that the saints are

Fig. 78. Giovanni Bellini, *The Virgin and Child, c.* 1490. Signed. Poplar, 91×65cm (NG 280). Adapted from a larger composition reflected in Fig. 79.

Fig. 79. Francesco Tacconi, *The Virgin and Child*. Signed and dated 1489. Lime, painted surface 100×53cm (NG 286).

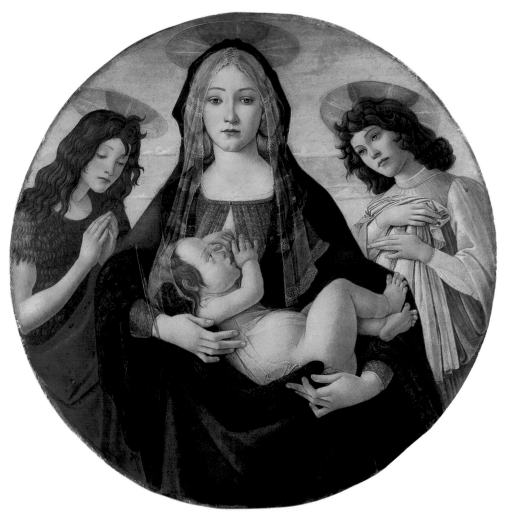

ABOVE Fig. 80. Bartolomeo Vivarini, *The Virgin and Child with Saints Paul and Jerome, c.* 1460–5. Signed. Wood, painted surface 95×63.5cm (NG 284).

RIGHT Fig. 81. Workshop of Sandro Botticelli, *The Virgin and Child with Saint John and an Angel, c.* 1490. Wood, painted surface, diameter 84.5cm (NG 275).

squeezed in. This is best explained by a customer ordering a standard Virgin and Child and then asking for these extras to be added.

Something similar may well have happened with the round picture (*tondo*) of the Virgin and Child with Saint John and an Angel from the workshop of Botticelli (Fig. 81). There are other versions of this composition (which must be based on a design by Botticelli) in which there are two angels. It seems unlikely that Botticelli himself, if commissioned to paint this subject, would have made Saint John symmetrical with, and hence equivalent to, an angelic attendant, for John is an important saint and, moreover, related to the Holy Family. But it is easy to imagine a customer requesting that a Saint John be inserted into such a painting at no – or little – extra cost, and the workshop devising this solution.

Similarly, one of the customers of the Memlinc workshop whose portrait as a donor occurs in the painting of the Virgin and Child with Saint George (Fig. 82) may have chosen the image of the Virgin and Child from a range of images there. The painting would then have been made up to incorporate his portrait, which may even have been copied from another picture which he supplied. The Christ Child's pose and gesture recur in other works from Memlinc's workshop, such as the Donne Triptych (No. 42) and *The Virgin of Jacques Floreins* in the Louvre. There, however, they make perfect sense, whereas in this inferior work they look odd and unbalance the composition. A customer such as Sir John Donne would presumably have paid more to obtain the personal attention of the master and a work in which the central motif, even though not unique, was properly integrated into the composition.

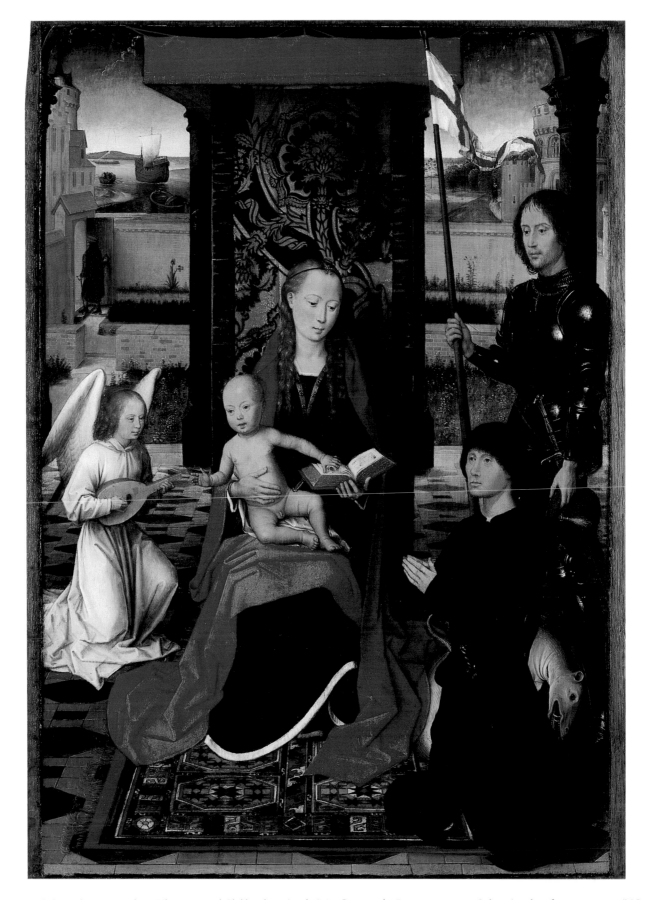

Fig. 82. Workshop of Hans Memlinc, *The Virgin and Child with an Angel, Saint George and a Donor. c.* 1465–80. Oak, painted surface 54×37.5cm (NG 686).

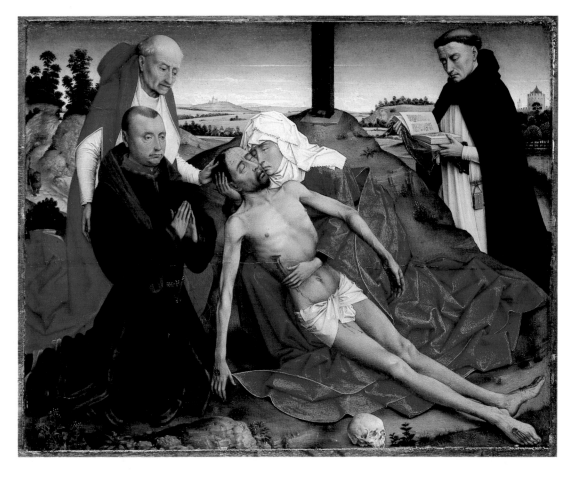

LEFT Fig. 83. Workshop of Rogier van der Weyden, *Pietà, c.* 1450–60. Oak, painted surface 35.5×45cm (NG 6265).

RIGHT Fig. 84. Rogier van der Weyden, *Pietà*, central panel of the Miraflores Altarpiece, c. 1445. Oak, painted surface 71×43cm. Berlin, Staatliche Museen.

The *Pietà* from van der Weyden's workshop (Fig. 83) is based on the central panel of one of his finest works, the triptych of scenes from the Life of the Virgin (Fig. 84), and appears to have been adapted as a small devotional picture for the unidentified donor. In the National Gallery's picture the figures of the Virgin and Christ are reversed and varied slightly. Joseph of Arimathea and Saint John have been banished, to be replaced by the kneeling donor, thus slightly lessening the drama of the original grouping. Saint Jerome and another saint, perhaps Dominic, are presumably included because they reflect the names or the affiliations of the donor. The spatial relationship between the two groups in the adapted composition is awkward and the linking role played by Saint Jerome, whose right hand just touches the donor's sleeve, appears a little forced. This does, however, make a more satisfactory composition than another later version (Berlin, Staatliche Museen) in which the donor appears in the position of the second saint, just behind the central mound.

This repetition with variations of an established composition is typical of the manner in which Netherlandish painters' workshops would adapt a pattern from one picture to another scale more suited to individual devotions. The survival of numerous religious images of the same type, and clearly from the same workshop, suggests that some workshops operated what amounted to a production line, and that the resulting images were often sold directly to the public. Devotional images of different types of the suffering Christ originating in the workshop of Dieric Bouts, which continued under his sons (Fig. 85), were evidently constantly reproduced according to patterns kept in the workshop and probably handed on from father to son (see p. 143). Often smaller, domestic images were made from parts of images which had appeared in larger compositions, as in the Memlinc workshop's *Virgin and Child* (Fig. 86), which follows very closely the pattern of the Virgin in the Donne Triptych. Exactly the same process can be observed in some Florentine workshops.

In the cases we have been considering, the requirements of the pious and the convenience of the busy workshop can be seen to

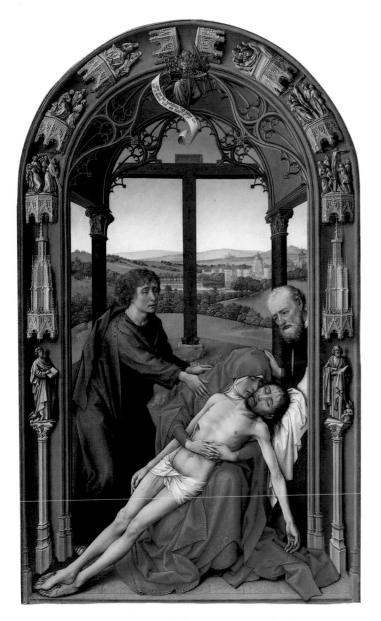

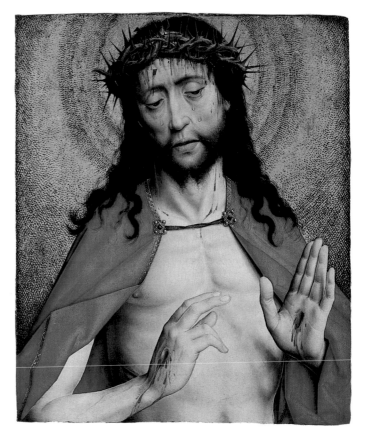

ABOVE Fig. 85. Style of Aelbrecht Bouts, *Christ crowned with Thorns*, late fifteenth or early sixteenth century. Wood, transferred to canvas, 43.5×36.8cm (NG 1083).

have conditioned minor modifications to standard images. But these factors cannot explain a major change to the nature of the image itself.

As we have seen, certain religious images enjoyed particular popularity for devotional purposes during the fifteenth century – heads or half-lengths of the suffering Christ and the *Pietà*, for instance. In some cases this popularity may have derived from devotional texts in wide circulation, or even from the sermons of particularly forceful preachers. The subject of the Adoration – the Virgin kneeling before the infant Christ – which seems rapidly to have replaced the older depiction of the Nativity (see No. 1) in which the Virgin reclines, as is normal after labour, seems to have been inspired by Franciscan devotional texts. Rays of light emanating from the Child may indicate the influence of the fourteenth-century mystic Saint Bridget of Sweden. In her account of her vision of the birth of Christ, the Virgin knelt immediately after her painless and rapid delivery to adore the newly

born child, from whom radiated a light of such brilliance that it outshone the candle held by Joseph.

It was not until the late fifteenth century, however, that the coincidence of Saint Bridget's subject matter and a painter, almost certainly the great Netherlandish artist Hugo van der Goes, who was strongly interested in the depiction of contrasts of light and darkness, produced paintings in which the outshining of the candle became central rather than a subordinate detail. No such painting by Hugo van der Goes survives, but a number of pictures which appear to be derived from one are known (Fig. 87; see also No. 49).

In this instance it is the interests and abilities of the painter which have determined the new presentation of the image. But there are other examples of the ways in which religious subject matter in the fifteenth century was given new emphases by the preoccupations of the painter. Fifteenth-century devotional paintings generally reflect a novel interest in the representation of

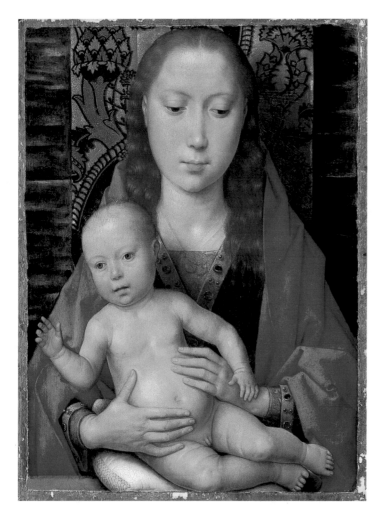

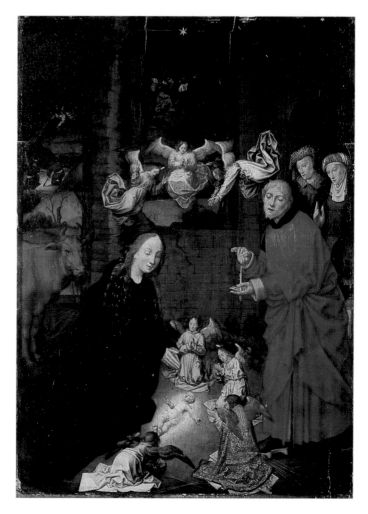

Fig. 86. Hans Memlinc and Workshop, *The Virgin and Child, c.* 1465-80. Oak, painted surface 37.5×28cm (NG 709).

Fig. 87. After Hugo van der Goes, *The Nativity at Night, c.* 1500 or later. Oak, original painted surface (corners cut) 62×46cm (NG 2159).

space: to look at a painting was like looking through a window. The depiction of landscape distance, with aerial perspective, and the sense of peeping into a room – these were achievements especially associated with the great artists of the Netherlands. Then in the early fifteenth century artists in Florence discovered the principle of single-point perspective, of foreshortening forms with a system based on a single vanishing point – the fulfilment of a long tradition of experiments with linear perspective in Tuscan art. Simultaneously the representation of naturalistic light, which had also interested artists in the fourteenth century, became one of the great achievements of European painting.

All the figures in a painting could now be shown in a naturalistic relation to each other and in a naturalistic setting. Dieric

Bouts does not merely paint Saints Peter and Paul beside the throne of the Virgin, he places them within the same room, in a space which we feel that we can measure (Fig. 42). The four saints in Pesellino's altarpiece of the Trinity (Fig. 57) do not merely flank the cross upon which Christ hangs but are arranged around it, overlapping but not obscuring each other, within the same landscape. Saints are now free to relate to the Madonna and Child, holding her book or giving him a flower, and free to debate the nature of the theological mystery of the Trinity before them. New forms of narrative were also made possible by the interest in depicting space.

In small paintings the saints who previously would have occupied the foreground begin to be found in the distance. The little

painting of the Virgin and Child (Fig. 88), probably half a diptych, by Paolo da San Leocadio, an Italian-born artist working in Spain, depicts, behind the Virgin, a delightful walled garden in which the saints have gone for a walk. In a painting by Filippino

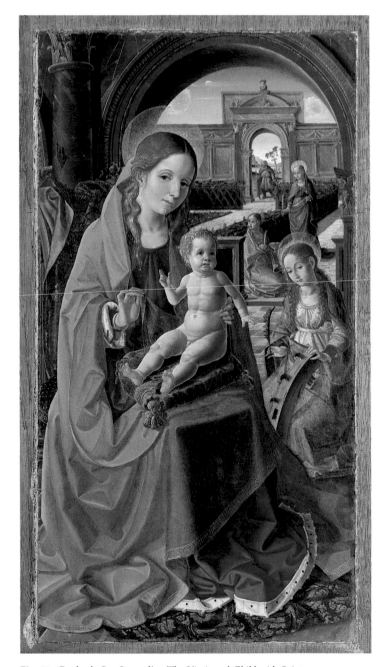

Fig. 88. Paolo da San Leocadio, *The Virgin and Child with Saints, c.* 1490-1500. Signed. Oak, painted surface 43.5×23.3cm (NG 4786).

Lippi of the Adoration of the Kings (Fig. 89), the extensive landscape is not only occupied by the retinue of the Kings but by miniature representations of the saints and their miracles (Fig. 90), among them Saint Francis, Saint Jerome, Mary Magdalene and Tobias and the Angel. In these examples the new skills of the painter enhance the religious content. Nevertheless, it is possible that the beautiful garden and architecture in the Paolo da San Leocadio and the fanciful landscape in the Filippino Lippi were enjoyed and admired for their own sake.

By the end of the fifteenth century some patrons certainly valued the skills of the artist above the nature of the imagery upon which such skills were lavished. Isabella d'Este, Marchioness of Mantua, was disappointed in the winter of 1502 to find that Giovanni Bellini was dithering over painting an *istoria* (narrative) for her, so she said she would be content to have a *presepio* (Nativity) by him which should include a Saint John and the animals near 'Our Lady, Our Lord God and Saint Joseph'. Bellini wanted to know whether he should make this Nativity as large as the projected *istoria*, but Isabella thought not since it was her intention to place it in her bedroom. She added that if he wanted to do some other of his 'new inventions of the Madonna' she would be quite content, but she would be more content with a Nativity. Bellini did not consider it fitting to insert a Saint John into a Nativity so he proposed to paint a Madonna and Child with Saint John and with landscape distances (*luntani*) and other *fantasie* which would be suitable. Isabella agreed but wanted a Saint Jerome to be included as well. Then she changed her mind again and asked for the Nativity but without Saint John. The painting finally arrived (after threats to withdraw the commission) in the summer of 1504. Bellini had at one point (January 1504) used the new excuse available for workers in oil paint: the picture would not dry in the winter. In telling Isabella that it was at last ready, her agent pointed out that if she did not want it Bellini had another buyer for it. Bellini also offered to have a beautiful frame made for it – the implication here being that Isabella might have wanted to have this done herself and also that the price (50 ducats) did not include the cost of a frame.

It is rather extraordinary to find Bellini instructing the Marchioness of Mantua in what was or was not proper in a devotional painting. He may well have felt that anachronism – which was quite normal in a Madonna and Child with saints – was wrong in a true narrative painting, but many other artists would have been happy to comply, and Bellini's objection may have arisen from his desire to use, or to adapt with only minor alterations, a pattern he had already worked out. However, his disinclination to

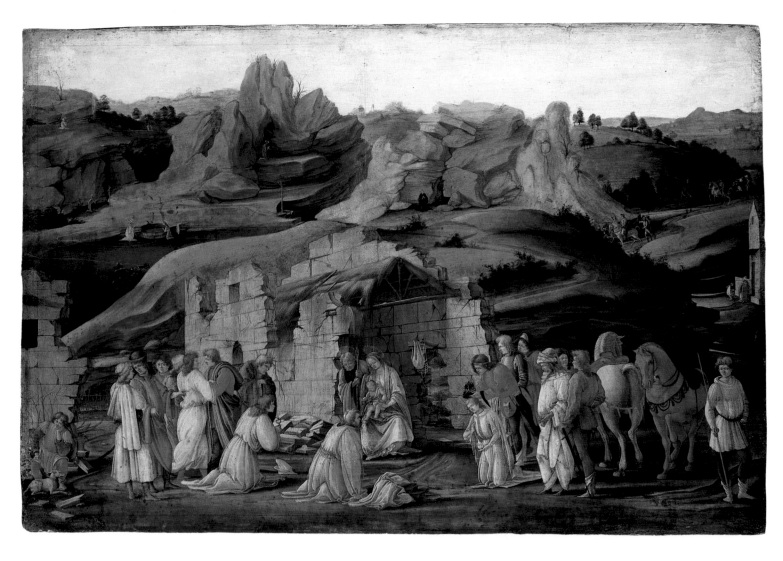

Fig. 89. Filippino Lippi, *The Adoration of the Kings, c.* 1480. Wood, 57×86cm (NG 1124).

depart from convention is less striking than the licence he was permitted. Throughout the negotiations, his patron's chief concern was to obtain a work characteristic of Bellini's genius. Indeed Isabella had at first thought of a devotional subject because it was something which Bellini painted well and in a new way.

Leonardo da Vinci was even more noted for his 'new inventions' and was, it seems, permitted even greater licence. He painted for the Confraternity of the Immaculate Conception in Milan an altarpiece (No. 68) with a subject which seems to have perplexed them (another artist added attributes which clarified which figure was intended for Saint John). The paintings which he planned to make of the Virgin and Child with Saint Anne – one large finished drawing for which survives in the National Gallery (No. 66) – replace the conventional frontal composition of the Virgin holding Christ on her lap as she sits in Saint Anne's lap, with a complex active group engaged in an intense if unspoken dialogue such as had never previously been seen in art.

Fig. 90. Detail of Fig. 89.

CIVIC, DYNASTIC
AND DOMESTIC ART

CIVIC ART

Above the fortified walls which encircled almost all European towns in the thirteenth, fourteenth and fifteenth centuries, domes, towers and spires were visible from afar (Figs. 91 and 92). Once through the gates the numerous ecclesiastical buildings revealed the priorities of the inhabitants: it has been calculated that in 'hilliges Köln' (holy Cologne), there were 450 altars, or one for every eighty-eight inhabitants, and that around one third of the city's population were either clerics or in lay Orders and were attached to its vast but incomplete cathedral, its twenty-nine churches (many of comparable size), its abbeys, hospitals and other religious foundations.

Images providing a focus for prayer were not confined to churches in these towns. Tabernacles with painted or sculpted religious images could also be found in the streets at strategic locations, particularly at important junctions, and major artists were sometimes employed in painting them. One of the most impressive in Florence must have been the tabernacle at the Canto de' Carnesecchi at the confluence of the roads to the old and new Piazza of Santa Maria Novella, which was painted by Domenico Veneziano probably in about 1440 (Fig. 93). The hieratic and static presentation of the Virgin and the stark geometric simplicity of the composition were presumably designed to tell from afar – the effect of the foreshortened throne created by the system of single-point perspective must have been startling when this image was first seen from the street.

Every town had one or more patron saint who acted as its protector. The principal patron saint of Venice was Saint Mark, that of Florence Saint John the Baptist, while Siena claimed, among others, the Virgin Mary (Fig. 94) since 1261, when a victory over the Florentines was won by the Sienese with, they believed, her aid. Her image thus signified the town's liberty and independence. The patrons of Cologne were the Three Kings, whose bones the town held as much venerated relics. The choice had great political significance, for it was customary for the Holy Roman Emperor to visit the relics of the Kings, whom he considered as predecessors, after his coronation at Aachen, and they were thus associated with Cologne's importance in the Holy Roman Empire.

Another instance of political status finding expression in religious imagery is provided by a painting made for one of the Papal States, the town of Ascoli Piceno. In 1482 Pope Sixtus IV granted its citizens limited self-government under the general control of their bishop, Prospero Caffarelli. News of this privilege reached them on 25 March, the Feast of the Annunciation, and thereafter a procession went every year on that day to celebrate at the church of the Annunciation. Crivelli's altarpiece (No. 51) of 1486 was painted for this church and the circumstances explain why it represents not just the Annunciation but also Saint Emidius, a local martyr and the town's patron (also invoked against earthquakes), holding a miniature model of the town and the inscription 'Libertas Ecclesiastica' (Fig. 95).

By the late fifteenth century Florence and Milan had nearly 80,000 inhabitants, Venice had reached 100,000, while Paris numbered 200,000 and Naples even more. German towns were smaller, and Cologne with 40,000 and Nuremberg with 20,000 were exceptional. Many towns had never recovered from the Black Death of 1348 (Florence, for instance, had more inhabitants in 1300 than in 1500) and many were also in economic decline in the fifteenth century. The towns enjoyed considerable political

LEFT Fig. 91. Ascribed to Botticini, *The Assumption of the Virgin* (Fig. 50), detail showing the city of Florence.

ABOVE Fig. 92. Rogier van der Weyden, *Saint Ivo*(?), detail second half of the fifteenth century. Wood, 45×34.8 cm. (NG 6394).

RIGHT Fig. 93. Domenico Veneziano, *The Virgin and Child Enthroned, c.* 1440. Signed. Fresco transferred to canvas, 241×120.5cm (NG 1215).

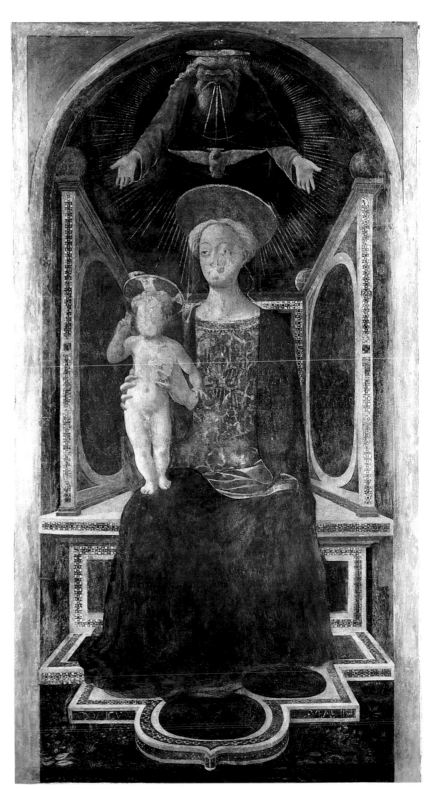

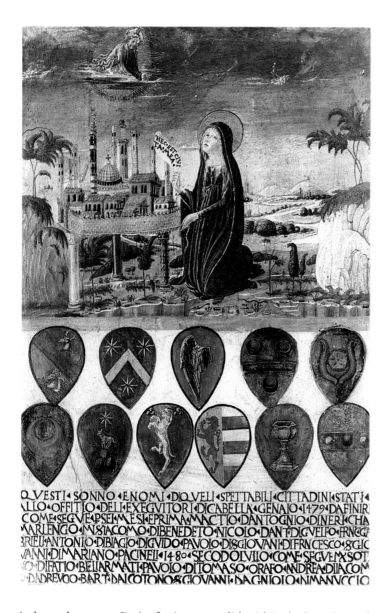

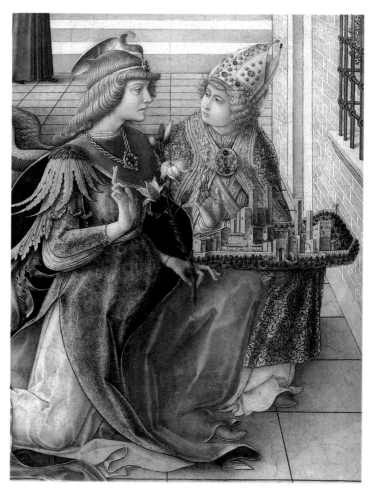

LEFT Fig. 94. Neroccio di Bartolommeo, *The Virgin recommending Siena to Christ*, 1480. Book cover. Siena, Archivio di Stato.

ABOVE Fig. 95. Carlo Crivelli, *The Annunciation with Saint Emidius*, 1486, detail showing the saint holding the city of Ascoli Piceno (see No. 51).

independence – as Paris, for instance, did within the kingdom of France, and Cologne did as part of the Holy Roman Empire, and Ascoli Piceno as one of the Papal States. And more strikingly, some towns in Italy were separate republican or oligarchic states.

It was common for guilds – the associations regulating and protecting trades and crafts – to play a part in the government of a town. They provided services which complemented those of the town authorities, religious Orders and confraternities, administering hospitals, burying the dead, maintaining churches. The town halls in which the governing councils met, the Magistrate's Court and many of the Guildhalls were lavishly decorated on the exterior, although more so north of the Alps than in Italy where such buildings were generally fortified. Inside they were painted with imaginary portraits of heroes – ancient Romans in the Palazzo Pubblico in Siena and the Banker's Guildhall (the *Cambio*) in Perugia; ancestors of the ruling princes in Ghent and Ypres – with battles and glorious episodes in the city's history (especially, it seems, in Italy), with allegories of virtuous rule, with exemplary scenes of Justice (especially in the Netherlands), and with paintings of the Last Judgement. Lochner's *Adoration of the Magi* (Fig. 96) was made for the chapel of the town hall of Cologne; Filippo Lippi's *Adoration* (Fig. 97) was made for the

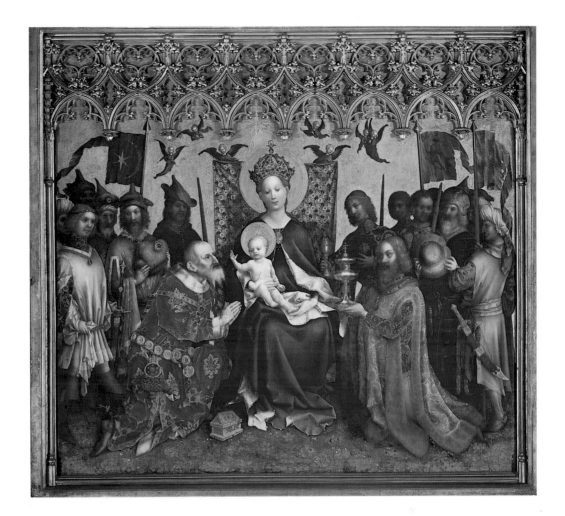

RIGHT Fig. 96. Stephan Lochner, centre panel of the triptych *The Adoration of the Magi*, 1440s. Oak, painted surface 238×263cm. Formerly Cologne Town Hall, now Cologne Cathedral.

BELOW RIGHT Fig. 97. Filippo Lippi, *The Virgin adoring the Child*, c. 1459(?). Wood, 127×116cm. Berlin, Staatliche Museen.

Medici but confiscated to adorn one of the altars in the Palazzo Vecchio, the town hall of Florence, whose patron, Saint John the Baptist, was included in the picture.

The town's rulers controlled many of the spectacles of city life, including executions and the related exhibition of corpses – and the commissioning of painted effigies of executed traitors (a type of painting which engaged both Castagno and Botticelli in Florence) – and festive events such as ceremonial entries and triumphs in which artists also played a large part. The principal festivities of a town were, however, religious. The feast days of the town's patron saints were particularly important occasions. So too were those of the patron saints of the guilds. The statutes of some Italian painters' guilds make reference to these observances. In Perugia, for example, painters were particularly enjoined to take part in the processions with candles on the Feast of the Assumption of the Virgin, and to keep the Feast of Sant' Ercolano, patron saint of the city.

Outdoor and indoor theatricals played an important part in devotional life, and the guilds and confraternities of the towns were often responsible for them. The scene paintings devised for them are lost, but sometimes a reflection of these events may be detected in a painting. The *Assumption and Coronation of the Virgin* painted by Gerolamo da Vicenza in 1488 (Fig. 98), in which the

Fig. 98. Gerolamo da Vicenza, *The Assumption and Coronation of the Virgin*. Signed and dated 1488. Wood, painted surface 33.5×22.5cm (NG 3077).

Virgin is represented both lying on an elevated bier in a piazza and raised to Heaven on (or in front of) a circular banner with a scalloped edge, is one such example.

No doubt the decor and sets owed more to paintings than vice versa, but in scale and ambition some of the shows surpassed any mural. The Florentine architect Brunelleschi was responsible for inventing much stage machinery. Vasari in his life of the fifteenth-century Florentine engineer Francesco d'Angelo, 'Il Cecca', described the canvas sky which Cecca contrived in the Piazza del Duomo. He also explained how Christ was raised by a

cloud of angels on the Feast of the Ascension in the church of the Carmine, how there was another heaven over the principal tribune formed by ten wheels with lantern stars, and how angels were attached at the waist to pulleys on cables going up to the choir loft. The machinery was concealed by clouds formed of wool (the angels were of course the local boys). In reading this it is hard not to think of Botticini's huge painting of the Assumption of the Virgin (Figs. 50 and 99).

PALACE DECORATION

All families of any substance, that of the prosperous merchant no less than that of the prince, included dependants and retainers organised in a hierarchy known as the household. In order to attend to their various properties, to hunt, or simply to find cooler, healthier air in summer, households – and especially the households of rulers – were frequently on the move. This could be a massive logistical operation. Moving the household of Philip the Good, Duke of Burgundy, from his palace at Dijon to those at Arras and Lille in 1435 took nearly a month. Seventy-two horse-drawn carts were needed, of which five were for the Duke's jewels, four for his tapestries, another two for the Duchess's tapestries, and two for the toys of the future Charles the Bold.

On arrival the household expected to adapt its surroundings to the requisite degree of grandeur and to a variety of purposes. There were no simple distinctions between private living quarters and those open to all; rather there were degrees of privacy and openness according to rank and role, which were at their most complex at the courts. In a large household, the men and women might occupy separate areas of a building.

The interiors of palaces and grander houses were frequently adorned with painted decoration of one form or another. Narrative scenes, simple patterns, heraldic devices, as well as painted decorations of a temporary kind, quickly made and not intended for permanent display, were as often used in court ceremonies as in civic ones. Yet painting was not by any means the most prestigious form of interior decoration in this period. Tapestries, which began to be woven on a large scale during the fourteenth century, for the most part in the Netherlands, were at the height of fashion throughout Europe by the fifteenth. A room hung

RIGHT Fig. 99. Detail of *The Assumption of the Virgin*, ascribed to Francesco Botticini (see Fig. 50).

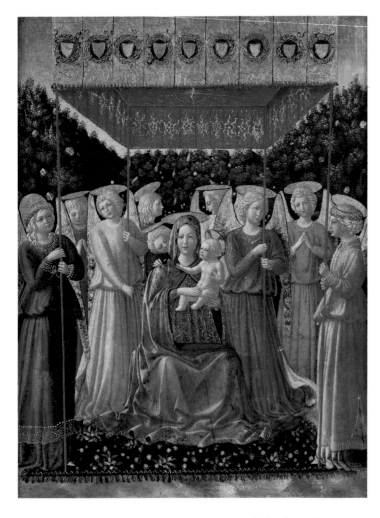

Fig. 100. Follower of Fra Angelico, *The Virgin and Child with Angels, c.* 1450. Wood, 30×22.5cm (NG 5581).

that the dense patterns of leaves and flowers often favoured as a background for the Virgin and Child were influenced by the popularity of tapestry with this design. In *The Virgin and Child with Angels* painted by a follower of Fra Angelico (Fig. 100) one can tell from the fringe that the painter intended to represent textile flowers rather than real ones. The canopy held above the Virgin – evidently a cloth of gold, which the artist has been very careful to imitate – is typical of a whole range of luxury textiles used not only to protect great people from the elements but to project their magnificence whenever they appeared in state.

The painted decoration of rooms was not confined to the walls. Window frames, shutters, fireplaces, ceilings and architectural features such as columns were often brightly painted with various patterns and decorative finishes. Simulated marbling or textiles, like those which survive as the dado or *basamento* of numerous Italian chapels were also common. Portable pictures and smaller paintings, especially portraits, also often have backs decorated with marbling (Figs. 101 and 102), and with coats of arms (No. 10) or mottoes. They were therefore not always hung on the walls as is the modern practice. Instead they were often kept in bags or chests to be admired from time to time, or were suspended by means of rings so that the backs might be viewed as well as the fronts. In other words, they were valued both as precious belongings and as portable furnishings. Elsewhere in the room there might be furniture with painted decoration, but brightly coloured, often richly woven cloth, whether in the form of tapestries, bed hangings, canopies or cushions (luxury items at this period; see Fig. 103), would have been at least as important, and would probably often have made the dominant visual impression.

There was considerable competition between the courts over which ruler had the greatest household, the grandest palaces and the most extensive territories. The courts of the Dukes of Burgundy, who during the fifteenth century were rulers of much of modern Belgium, Holland, Luxemburg and northern and eastern France (see map, p. 15), were probably the most admired in Europe. In Italy they were rivalled by the courts of the Aragonese and Angevin kings in Naples, and by those of the Visconti and Sforza Dukes of Milan. Even a ruler of far smaller dominions, such as Federico da Montefeltro, Lord of Urbino from 1444 to 1483, who achieved great prosperity from his mercenary army, had a considerable court; while Duke Galeazzo Maria Sforza of Milan had forty chamberlains in the 1470s (the Burgundian court had 101 but only a quarter of them were in active service at any one time). The ambitious plans for the decoration of Galeazzo

with them would be colourful, decorative and warm, and would furthermore give gratifying evidence of the wealth and magnificence of the owner, since the silk and precious metal threads of which they were woven were extremely costly – far more so than paintings. Painted cloths which imitated tapestries were sometimes substituted for them, particularly in summer in warm climates; and, sometimes, the walls were painted in imitation of tapestry, as happened, for example, in grand houses and palaces in Pavia and Mantua, and at Hesdin in Artois in the Netherlands, and London. Mural paintings tended to have a similar decorative function, even when they did not actually imitate tapestries.

A measure of the prestige of Flemish tapestry is the extent to which it is reflected in Italian painting. It is likely, for instance,

ABOVE Fig. 101. Marco Zoppo, *Dead Christ with Saints John the Baptist and Jerome, c.* 1470. Wood, painted surface 26.5×21cm (NG 590).

ABOVE RIGHT Fig. 102. Reverse of Fig. 101 showing imitation marble.

RIGHT Fig. 103. Master of Liesborn, detail from *The Annunciation* (see No. 43).

Fig. 104. *The Deer Hunt, c.* 1440-5. 407×867.4cm. From the Devonshire Tapestries, London, Victoria and Albert Museum.

Maria's palace at Pavia, which may have been begun previous to his assassination in 1476, included numerous portraits of him and his family in their public and private capacities. In one room the Duke was to appear with his falcons, in another at a deer hunt, and in a third holding an audience.

In this scheme the subjects of the paintings were closely related to the functions of the rooms. The Duke and Duchess, together with their infant son, his nurse and his wet-nurse, were to be painted in what was probably the nuptial chamber. Palace rooms seldom retained the same function for long and the mobility of tapestries was better suited to this fact. But it is striking how similar was the subject matter in both murals and tapestries (Fig. 104).

Among the subjects favoured for both were the triumphs of Love, Chastity, Fame and Death – allegorical compositions inspired by the *Trionfi* of Petrarch (1304-74), the most admired and influential poet in Europe. The Ages of Man and the Five Senses were other popular themes. So too were illustrations of the four seasons or the twelve months – the labours of the months in the fourteenth-century murals at Longthorpe Tower, the labours and recreations in the late fourteenth-century castle at Trent. There were also cycles devoted to David or Solomon (appropriate for royal residences), the Trojan War, the life of Caesar (painted in the castle of Vaudreuil, Normandy, for Charles V of France when he was a prince) and the adventures of Jason

(painted for the Duke of Burgundy at his castle of Hesdin, where there were also machines to evoke the thunder, lightning, snow and rain conjured up by Jason's wife, the enchantress Medea). Relatively few paintings of this kind have survived, and those that have, being murals, have generally remained *in situ*. The National Gallery does, however, have three severely damaged frescoed scenes detached from one of the principal rooms of the Palazzo Magnifico in Siena which was built for Pandolfo Petrucci who ruled the city between 1503 and 1512.

One of these scenes (Fig. 105), by Pintoricchio, shows Penelope at her loom with several suitors surrounding her, while her husband Odysseus returns through the doorway disguised as a pilgrim – his great bow hangs above his wife's head. The exact episode represented is not easy to identify (the most prominent of the male figures has been thought to be Odysseus' son Telemachus) and the painter's source is unlikely to have been Homer but rather some vernacular version of the legend. As with most paintings of ancient subjects known to us from the fourteenth and fifteenth centuries, there is nothing ancient – let alone ancient Greek – about setting, furnishings or clothes.

Fig. 105. Pintoricchio, *Scenes from the Odyssey, c.* 1509. Fresco, transferred to canvas, 125.5×152cm (NG 911).

By about 1500, however, and in Italy especially, an interest in archaeology and indeed philology had begun to be reflected in a number of paintings. It is best exemplified by the paintings of Mantegna (No. 64), but it can also be seen in another fresco from the Petrucci palace, Signorelli's depiction of Coriolanus. Exiled from Rome, and now General of the Volscian army besieging Rome, Coriolanus is urged by his mother Volumnia and a delegation of matrons, including Virgilia his wife, to spare the city (Fig. 106). The artist's ancient source, the historian Plutarch, is followed very carefully and warriors are dressed in armour and

matrons in robes not unlike those which Signorelli had studied on Roman relief carvings. The third of the scenes from the palace, also by Signorelli, is a Triumph of Chastity with Love disarmed and bound in the foreground, but unlike earlier artists illustrating Petrarch's *Trionfi*, Signorelli has emphasised the presence of Caesar and Scipio. They wear Roman armour and the chaste heroines (Lucretia and Penelope among them) are dressed in the flowing draperies found on ancient sculptures of nymphs (Fig. 107).

The room, which was on the first and principal floor of the palace (the *piano nobile*), was approximately 6.25 metres long and 6 metres wide. The walls were decorated with eight scenes, each framed with carved wooden pilasters, two scenes to each wall.

Fig. 106. Luca Signorelli, *Coriolanus persuaded by his Family to spare Rome*, c. 1509. Signed. Fresco, transferred to canvas, 125.5×125.5cm (NG 3929).

Carved wooden wainscotting incorporating benches ran round the entire room below and, like the pilasters, was the work of the great woodcarver, Antonio di Neri Barili. The ceiling was made of ornamental stucco compartments in gold, red and blue, inset with twenty-four small frescoes of the pagan gods, with the Petrucci coat of arms in the centre. The floor was of elaborately patterned majolica tiles (Fig. 108), again including the Petrucci arms, but also those of the Piccolomini. A great marriage was often the pretext for major redecoration and this room may be associated with that between Borghese Petrucci and Vittoria Piccolomini in 1509.

Coats of arms remained an important part of decorative schemes throughout this period and beyond it, in both North and South. Classical motifs, including *putti* (which here support the Petrucci arms), swags, trophies and dolphins, are derived from ancient Roman carving, and on the painted majolica especially, fine tendrils, candelabra vases and harpies, sphinxes and other hybrid monsters are inspired by newly discovered Roman

wall paintings. Such antique motifs began to predominate in Italian decorative schemes in the second half of the fifteenth century, and to replace the simpler decorative motifs of, for instance, stars and fleurs-de-lis which had been favoured earlier.

Although it is impossible to reconstruct the scheme behind the selection of narratives and allegories in this room of the Petrucci palace, it was clearly intended to be edifying as well as entertaining. The episodes may relate to the marriage and to the recent dramatic events in the family history. More generally, each episode seems to illustrate the victory of virtue over passion. In this respect they resemble the narratives found in town halls. Indeed, much decoration found in palaces could have been designed for town halls, for example the portraits of great ancestors, ancient sages and heroes (there were sets of these executed in the fourteenth century for Charles IV at Karlštejn, for the Duke of Berry's château at Bicêtre, for the Duke of Milan's castle at Pavia, and for the Royal Palace at Naples), and the paintings of battles.

Traces of a large battle fresco painted by Pisanello for the castle

RIGHT Fig. 107. Luca Signorelli, *The Triumph of Chastity: Love Disarmed and Bound, c.* 1509. Signed. Fresco, transferred to canvas, 125.5×133.5cm (NG 910).

BELOW RIGHT Fig. 108. Majolica tiles from the Petrucci Palace (Palazzo del Magnifico), Siena, *c.* 1509. London, Victoria and Albert Museum.

in Mantua in the 1440s survive, but many earlier examples, including a duel between Richard I of England and the Muslim leader Saladin – an episode from the Crusades painted at Clarendon Palace for King Henry III – are known only from documents. Three paintings by Paolo Uccello, probably dating from the 1450s, represent a battle between the Florentines and the Sienese in 1432, one of which is in the National Gallery (No. 26). Although they are on panel they are so large that they must have been considered as wall decorations. In Italy such decorations were generally executed on the walls themselves, but the use of panels for this purpose may have been more common north of the Alps.

An inventory of the Medici Palace made in 1492 records Uccello's paintings in a room together with a story of Paris (presumably from the Trojan War) and a battle of dragons and lions (presumably from a Romance), both also by Uccello, and a hunt by Pesellino. Uccello and Pesellino (Fig. 109) were enthusiasts for the science of linear perspective particularly associated with

Fig. 109. Pesellino, detail of *David and Goliath* (Fig. 145).

Florentine art, and their paintings are filled with ostentatious foreshortening – recumbent figures viewed feet first and horses with their rumps facing us. But their paintings also have a busy surface pattern and are compilations of marvellous specimens of flora and fauna – hounds, horses, fruit trees, song birds, exquisite flowers, strange monsters – as well as gold and silver armour and splendid banners, in a manner that is very similar to many of the tapestries made in the Netherlands. The immensely valuable tapestry of the Duke of Burgundy hunting (11.6 metres long and 3.5 metres high), which was kept in a chest in the same room as these paintings in the Medici Palace, would not have looked incongruous beside them when on feast days and festive occasions it was taken out and exhibited.

PORTRAITS

The tapestry of the Duke of Burgundy hunting may have been presented to the Medici by one of the Dukes. Certainly smaller painted portraits were often sent as diplomatic presents from one court to another in the fifteenth century; so too were medallic portraits, a new type of miniature sculpture inspired by the superior coinage of the Romans. Giovanni da Oriolo's portrait of

Lionello d'Este, Marquis of Ferrara (Fig. 110), may well have been made for presentation; like other Italian portraits of the mid-fifteenth century it resembles a medal in its profile format (and also, in this case, in its prominent Latin inscription). The Este family were in fact patrons of Pisanello, one of the greatest and earliest medallists (Figs. 111 and 112).

While rulers liked to control the dissemination of their portraits they did not always succeed in doing so. By the early sixteenth century the likenesses of great rulers were certainly being avidly sought out by people with no special allegiance to them. Like maps of the world, specimens of natural history or coins of the Caesars, such portraits were objects of curiosity. The

Fig. 110. Giovanni da Oriolo, *Lionello d'Este, c.* 1447(?). Signed. Wood, painted surface 54.5×39.5cm (NG 770).

several versions of a profile portrait (Fig. 113) of the Turkish Sultan Mehmet II, which may have originated in a likeness made by the Venetian artist Gentile Bellini when serving as the Sultan's court artist in Constantinople, were probably made to meet such a demand.

Court portraitists were required to make a dignified likeness, but there was one circumstance in which candour was essential. From the late fourteenth century, if not before, they were sometimes called upon to supply an accurate record of a possible spouse. For such a mission the artist had to be exceptionally reliable and trustworthy. Jan van Eyck, who enjoyed especially close relations with his patron Philip the Good, Duke of

RIGHT Fig. 113. Ascribed to Gentile Bellini, *The Sultan Mehmet II*, late fifteenth century. Canvas, 70×52cm (NG 3099).

BELOW RIGHT Fig. 112. Reverse of Fig. 111.

BELOW LEFT Fig. 111. Pisanello, *Marriage Medal of Lionello d'Este*. Signed and dated 1444. Cast bronze, diameter 10.2cm. London, Victoria and Albert Museum.

Fig. 114. Netherlandish School, *Philip the Fair and his Sister Margaret of Austria,*
c. 1493-5? Oak, painted surfaces each 23.5×15.5cm (NG 2613).

Burgundy, was sent by him in 1428 to paint Isabella, daughter of
the King of Portugal, whom the Duke married two years later.
Marriage negotiations concerned much more than appearances.
The backgrounds of the portraits of Philip the Fair and Margaret
of Austria, children of the future Holy Roman Emperor Maxi-
milian, painted probably during the negotiations previous to
their marriages in 1495, are covered with coats of arms indicative
of the great titles and vast territories of their family (Fig. 114).

Portraits of wealthy townspeople also seem to have been much
in demand in the first half of the fifteenth century, certainly in the
Netherlands. The earliest dated portraits in the National Gallery
probably all belong to this category – they are those by van Eyck,
dated 1432 (Fig. 115), 1433 and 1434 (Nos. 17 and 18), and the pair
by Campin (No. 14) of about the same date. But portraits of this
kind are documented as being produced a good century earlier in
the Netherlands.

The most remarkable and the most famous of the early
Netherlandish portraits in the Gallery is van Eyck's Arnolfini
portrait (No. 18). This is unusual in being full length, but there
were certainly full-length portraits on a large scale – as tomb
effigies and as part of wall paintings especially. However, the
most favoured format seems to have been a portrait of the upper-
most part of the body with or without hands.

Portraits, like those by Campin, which showed the heads and
shoulders only of the sitters in three-quarter face are the most
common type of Netherlandish portrait to have survived from
this period. In Italy, for much of the fifteenth century, sitters
seem to have favoured a profile view of themselves, as in the por-
trait of Lionello d'Este (Fig. 110) or Baldovinetti's portrait of a
lady (Fig. 116).

Attachment to this convention is surprising, especially among
Italian painters who were so interested in the problems of fore-
shortening, and who took every opportunity to show that they

Fig. 115. Jan van Eyck, *Portrait of a Young Man*. Signed and dated 1432. Oak,
painted surface 33.4×19cm (NG 290).

could draw a horse from behind or from in front rather than in
profile. Any prejudice that there might have been in favour of the
profile portrait was no doubt reinforced by the popularity of this
format on the medals which owed much to ancient coinage. Per-
haps the profile was regarded as rather like an heraldic device:
distinctive, easily recognised, unchanging. There is such a device
upon the sleeve of the lady painted by Baldovinetti. It is modified
by the folds of her dress and by the curve of her shoulder, but it is
a flat, sharply cut-out shape. Her figure also has the effect of a sil-
houette, although the volumes of her body and face are carefully
defined by light meticulously recorded as tiny points of white
paint.

Fig. 116. Alesso
Baldovinetti, *Portrait of
a Lady in Yellow,*
c. 1465. Wood, painted
surface 63×40.5cm.
The frame is original.
(NG 758).

Fig. 117. Antonello da Messina, *Portrait of a Man, c.* 1475. Poplar, painted surface 35.5×25.5cm (NG 1141).

Fig. 118. Sandro Botticelli, *Portrait of a Young Man, c.* 1480–5. Wood, painted surface 37.5×28.2cm (NG 626).

perhaps took the idea from some of the portrait figures in his narrative paintings – those in the foreground of his *Adoration of the Magi* (No. 38), for instance. He has taken pains to avoid the sitter's stare directly confronting the viewer by employing an unusually low viewpoint, and by turning the eyes to one side and placing the head off-centre. But the original impact is hard to reconstruct since the portrait has almost certainly been cut down. Other frontal portraits by Botticelli include the arms.

A similar format is found in the portrait of Alexander Mornauer painted in Germany (Fig. 119), which was always intended as a head and shoulders portrait. Here too the strongly characterised head is placed off-centre and is turned slightly to one side; the sitter's eyes appear to turn to meet the viewer's gaze. The uncompromising frontality of the pose is emphasised by the central position of the hand. Mornauer's bulk seems all the greater because of the manner in which his body extends beyond the

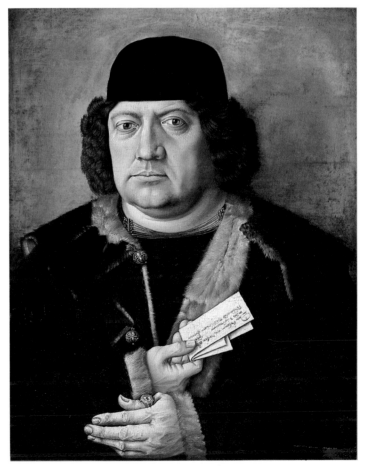

Fig. 119. Master of the Mornauer Portrait, *Portrait of Alexander Mornauer, c.* 1470–80. Softwood, 45.2×38.7cm (NG 6532).

The profile convention was abandoned in the last quarter of the century by Giovanni Bellini, Antonello da Messina and Botticelli among others. Antonello's portrait of a man (Fig. 117) adopts the format preferred in Netherlandish painting, which he must certainly have known. The face not only gains greatly in volume by comparison with profile portraits but the portrait gains in mobility and expression. It has the potential to relate more closely to the beholder, as Antonello seems to have realised as he worked on this portrait, for X-radiographs reveal that the eyes were not originally turned towards us.

Botticelli's portrait of a young man (Fig. 118) is more unusual in that it is rare in surviving fifteenth-century portraiture anywhere in Europe for the face to be presented frontally. Botticelli

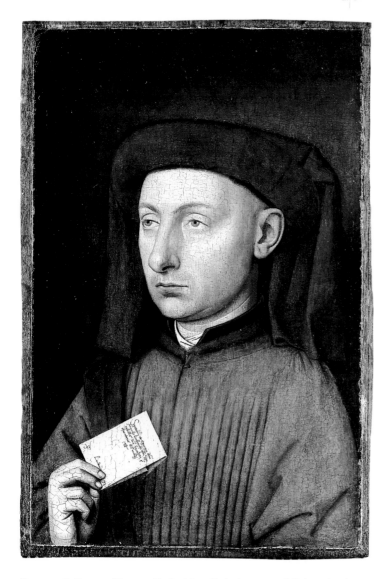

Fig. 120. Follower of Jan van Eyck, *Marco Barbarigo, c.* 1449? Oak, painted surface 24×16cm (NG 696).

boundary of the painting's edge. In this, and in the frontal pose, the artist anticipates German portraiture of the sixteenth century, in particular the work of Holbein.

Plain backgrounds were common in fifteenth-century portraiture in the Netherlands and in Italy. This fixes the viewer's attention on the features and expression of the sitter. The artist had then to reconcile the emphasis on the features with the depiction of the costume, through which the sitter may have wished to display his or her social position or personal symbolism. The hands could also provide a rival point of attention.

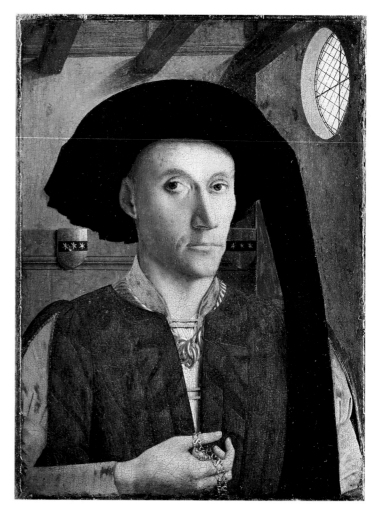

Fig. 121. Petrus Christus, *Edward Grimston*. Signed and dated on the reverse 1446. Wood, 36×27cm. Collection of Lord Verulam (on loan to the National Gallery).

In one of the pair of portraits by Campin part of the sitter's hand is included as a stop to the lower edge of the composition. Van der Weyden often uses a similar format (see No. 29, where both hands are included), but one of the most popular ways of underlining this type of composition was by the device of the parapet, such as van Eyck uses in his portrait of 'Timotheos' (Fig. 115). The parapet could include an inscription, either carved on the parapet itself, or in the form of a small piece of paper or parchment (*cartellino*) pinned to it. The cartellino was especially popular with Venetian artists and artists who worked in Venice, such as Antonello. It was generally used to incorporate the artist's name and the date.

Sometimes the sitter was depicted at greater length, with his hands resting on the parapet (which later developed into a table), and holding a piece of paper on which an inscription relating to the sitter could be included. The portrait of the Venetian patrician and future Doge, Marco Barbarigo, painted possibly when he was Venetian consul to the English court in 1449 (Fig. 120), is shown holding a letter addressed to him, in Italian. The painting was perhaps commissioned to be sent home to Venice to remind

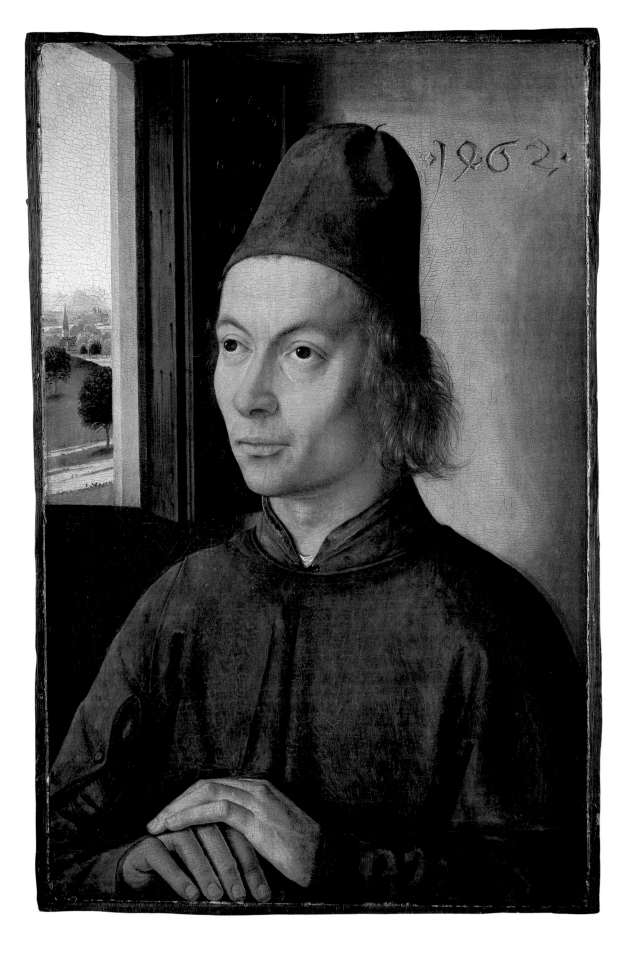

Fig. 122. Dieric Bouts,
Portrait of a Man, dated 1462.
Oak, painted surface
31.5×20.5cm (NG 943).

Fig. 123. Ascribed to Raffaellino del Garbo, *Portrait of a Man, c.* 1490. Wood, painted surface 51.5×35cm (NG 3101).

windows were common in Netherlandish painting (such as No. 13) and they found their way into Italian portraits soon afterwards, probably on account of the popularity of paintings by Memlinc. In the Bouts, the device of the painting itself as a window, or opening, is employed as well, for the fingers of the right hand of the sitter appear to rest on the edge of the frame as if on a ledge.

In the portrait ascribed to Raffaellino del Garbo (Fig. 123) there are actually two open windows, with landscapes visible through them, as well as a ledge or parapet in front, and framing curtains at the top. The effective disposition of these elements may have caused the artist some difficulty, for the curtains seem to have been a late addition, perhaps to add clarity and symmetry.

Fig. 124. Attributed to Granacci, *Portrait of a Man in Armour, c.* 1505. Wood, 70.5×51.5cm (NG 895).

his family and friends – those who might write such a letter to him – of his appearance.

When descriptive or symbolic backgrounds were included, as became more widespread in the second half of the fifteenth century, first in the Netherlands and then elsewhere in Europe, the task of composition became more complex. Edward Grimston, as depicted by Petrus Christus in 1446 (Fig. 121), seems tightly confined in a chamber, a high window of which lets in the light. Other portraits showed a view through a window. By 1462, when Dieric Bouts dated his portrait of a man (Fig. 122),

Fig. 125. Andrea Solari, *A Man with a Pink, c.* 1495. Poplar, painted surface 49.5×38.5cm (NG 923).

The Raffaellino portrait, with its half-turned pose and darting glance, and the portrait ascribed to Granacci (Fig. 124), in which the sitter appears to be either drawing his sword or sheathing it, date from the very beginning of the sixteenth century. They introduce into Italian portraits the more complex poses and sense of motion apparent in narrative painting at this period.

The background in the Granacci portrait is not an anonymous landscape, of the type made popular by Memlinc, but a specific depiction of the Piazza della Signoria in Florence, presumably included at the request of the sitter. As he has not been identified, the significance of this escapes us. It was not unusual for sitters to wish to allude to personal circumstances in their portraits, and this was often effected by some form of symbolism. Thus the

man with a pink in Andrea Solari's portrait (Fig. 125) probably holds the flower as a symbol of his betrothal. The woman of the Hofer family by an unknown Swabian artist (Fig. 126) also holds a flower – this time a forget-me-not. While these symbols are likely to be related to the sitters' private life, the chain of office which runs over the raised hand of Edward Grimston (Fig. 121) represents his loyal service to his monarch, for he was acting as ambassador of Henry VI in Calais and Brussels when this portrait was made.

Other symbols in portraits of this period are less easy to interpret. The mysterious emblem of rain falling from the clouds which appears in the background of the portrait of a young man holding a ring by an unknown Netherlandish artist (Fig. 127),

Fig. 126. Unknown Swabian artist, *Portrait of a Woman of the Hofer Family, c.* 1470. Silver fir, painted area 53.7×40.8cm (NG 722). See No. 34.

ABOVE Fig. 128. Detail of *The Bear and Boar Hunt* from one of the Devonshire Tapestries, *c.* 1430–5. 405.13×1021cm. London, Victoria and Albert Museum.

LEFT Fig. 127. Netherlandish School, *A Young Man holding a Ring, c.* 1450–60. Oak, painted surface 18×12cm (NG 2602).

and recurs again on the sleeve of a huntsman in the so-called Devonshire tapestries (Fig. 128), has still to be explained. The unknown lady painted by Baldovinetti (Fig. 116) has, as we have seen, a device of palm leaves displayed very prominently on her sleeve. This device, again, has not been deciphered. It may well be that of her betrothed rather than that of her own family.

Frequently such devices were painted on the backs of portraits rather than on the fronts. The portrait of a lady by a follower of Botticelli (Figs. 129 and 130) has on the back an angel holding a sphere and a scroll, presumably a moral allegory. Plants were often used as symbols in this manner: the portrait of the Burgundian Guillaume Fillastre by a follower of Campin has a sprig of holly on the reverse and the motto, which also appears on the original frame, 'ie hais ce que mord' ('I hate that which bites')

(Figs. 131 and 132). On the back of the portrait of a man painted by Jacometto Veneziano (Figs. 133 and 134) are crossed sprays of myrtle, and a Latin inscription from Horace on the good fortune of those who are permanently united with their beloved. The reverses of medals carried similar messages. The lion, standing for Lionello, is taught by Cupid the manners of love, for the medal celebrates Lionello's marriage (Fig. 112). Such devices and mottoes were no doubt often deliberately cryptic – wittily coded messages delighted courtiers – and sometimes perhaps truly private and personal and so designed to be inaccessible to us.

The presence of painted backs serves as a reminder that portraits were not necessarily hung against a wall, but were brought out for viewing from time to time, much as family photographs are today. As we have seen, such pictures were often kept in

RIGHT Fig. 129.
Follower of Sandro
Botticelli, *A Lady in
Profile, c.* 1490. Wood,
painted surface
59×40cm (NG 2082).

FAR RIGHT Fig. 130.
Reverse of Fig. 129.

RIGHT Fig. 131.
Follower of Robert
Campin, *Portrait of
Guillaume Fillastre,
c.* 1440–50. Wood,
painted surface
33.7×23.5cm.
London, Courtauld
Institute Galleries,
Princes Gate
Collection.

FAR RIGHT Fig. 132.
Reverse of Fig. 131.

Fig. 134. Reverse of Fig. 133.

Fig. 133. Jacometto Veneziano, *Portrait of a Man, c.* 1480–90. Wood, painted surface 26×19cm (NG 3121).

Fig. 135. Hans Memlinc, *A Young Man at Prayer, c.* 1475. Oak, painted surface 39×25.5cm, overall size 48×34.5cm (NG 2594). The frame may be original.

chests or wardrobes and protected by means of bags, curtains or painted covers; when displayed they may have hung freely so that both back and front were visible. The portrait of Guillaume Fillastre (Fig. 131) still has the original ring from which it was suspended.

For someone who was not a ruler to have a portrait painted might invite accusations of immodesty, if not sinful pride. To counteract this, some portraits reminded the sitter of his or her mortality. The portrait of a woman (No. 29) from the Van der Weyden workshop shows her in the type of dress fashionable at the Burgundian court for which van der Weyden himself probably worked. On the back of the portrait, however, negating

thoughts of worldly grandeur and vanity, is a devotional image of the head of Christ crowned with thorns (No. 29a). The portrait is thus associable with the small diptychs for devotional use in which the figure of a sitter at prayer was joined to a sacred image, usually of the Virgin and Child. An early example of such a portrait is that of Richard II in the Wilton Diptych (No. 10). The half-length portrait of an unknown man by Memlinc (Fig. 135) and the portrait of an unknown ecclesiastic by David (Fig. 136), which were both probably joined to other panels to form diptychs for domestic devotional use, are typical of the manner in which this type of portrait evolved in the fifteenth century.

In altarpieces donors were often represented with their name saints or patron saints (see p. 57). An even closer association was sometimes possible in a portrait. Giovanni Bellini's painting of a Dominican friar holding a lily and a book marked Saint Dominic

Fig. 136. Gerard David, *An Ecclesiastic Praying, c.* 1500. Oak, painted surface 34×26.7cm (NG 710).

Fig. 137. Giovanni Bellini, *Saint Dominic*. Signed and dated 1515. Canvas, 63×49.5cm (NG 1440).

Fig. 138. Workshop of Giovanni Bellini, *A Dominican with the Attributes of Saint Peter Martyr, c.* 1510. Signed. Poplar, painted surface 59×48cm (NG 808).

(Fig. 137) was once thought to be a portrait of Saint Dominic himself, but an early, possibly original, inscription identifies it as a portrait of Fra Teodoro da Urbino, Brother Theodore from Urbino. The inscription may merely record a tradition that Teodoro (who is recorded in the Convent of SS Giovanni e Paolo in Venice in 1515) served as Bellini's model, but it is possible that a portrait of the friar, with the attributes of the founder of his Order, whom he strove daily to imitate, was intended. Another painting of a Dominican by Bellini's studio (Fig. 138) has the attributes of Saint Peter Martyr added to it – martyr's palm, sword in the chest, hatchet in the head and halo.

PAINTINGS FOR THE 'CAMERA'

The most common type of small painting was not the portrait but the domestic devotional image, with which some portraits were, as we have seen, associated. Many such paintings were bought ready-made, either from the artist or from dealers. There is evidence of the trade in them in Italy in the late fourteenth and early fifteenth centuries (see p. 68). The lack of evidence need not be taken to suggest that they were rare before then.

Small devotional paintings are also recorded in the fourteenth

and fifteenth centuries elsewhere in Europe, and can frequently be seen in Northern paintings which include domestic interiors. In the background of the *Annunciation* by the Master of Moulins (Fig. 139) a small image of the head of Christ as Salvator Mundi is attached to the bed curtains. A similar image, of the type which was usually represented on Saint Veronica's handkerchief, is depicted in the background of the portrait of an unknown man

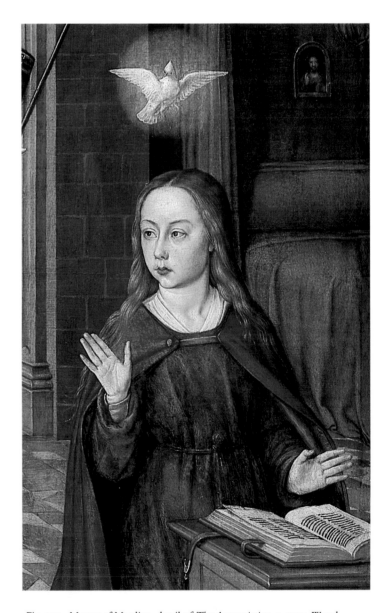

Fig. 139. Master of Moulins, detail of *The Annunciation, c.* 1500. Wood, 72×50.2cm. Art Institute of Chicago, Mr and Mrs Martin A. Ryerson Collection.

LEFT Fig. 140. Petrus Christus, *Portrait of a Young Man, c.* 1450–60. Oak, painted surface 35.5×26.3cm (NG 2593).

RIGHT Fig. 141. Workshop of Gerard David (after Hugo van der Goes?), *The Virgin and Child, c.* 1480–1500. Oak, including original frame, 48×35cm (NG 3066).

BELOW Fig. 142. Master of the Saint Bartholomew Altarpiece, *The Virgin and Child with Angels, c.* 1480–95. Oak, 52×38cm (NG 6499).

by Petrus Christus (Fig. 140). Evidently the work of an illuminator and painted on vellum, this image is attached by means of pins and a strip of red ribbon to a panel hung from a nail in the wall. It includes a prayer to Saint Veronica, which indicates how these small images were used for private devotion at home.

Small Netherlandish panel paintings incorporating prayers are also known, such as the triptych by Gerard David, probably after a design by Hugo van der Goes, which shows the Virgin and Child in the centre, while the shutters include a prayer to the Virgin (Fig. 141). These pictures were a counterpart to devotional books, in particular the illuminated Books of Hours which proliferated in the fifteenth century. The early history of individual pictures of this type is for the most part unknown (unlike larger altarpieces which can frequently be associated with specific churches and often with donors of distinction). However, it is a reasonable assumption that such small pictures as Campin's *Virgin and Child* (Fig. 40) and possibly the *Virgin and Child with Angels* (Fig. 142) by the Master of the Saint Bartholomew Altarpiece were all produced for the domestic market.

The same applies to numerous small Italian paintings of the fifteenth century and to several of an earlier date. Many of these were the work of mediocre artists. The chief subject was the Madonna and Child and Vasari called the artisans who specialised

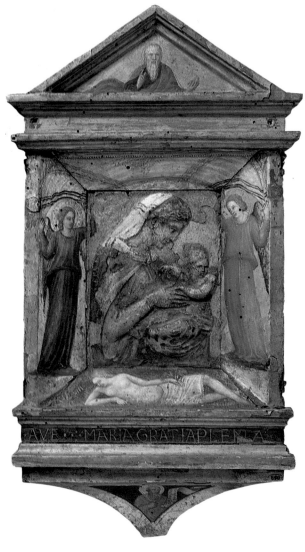

LEFT Fig. 143. *The Virgin and Child,* 1435-40. London, Victoria and Albert Museum. The relief is cast in stucco after a model (probably in terracotta) by Donatello. Paolo di Stefano painted the relief and the angels in the sides of the tabernacle with God the Father in the canopy, Eve in the sill beneath the relief group (the Virgin was the 'Second Eve'), and a prophet in the corbel. The relief was originally protected by a shutter, the hinge marks for which survive on the right.

BELOW Fig. 144. Giovanni di Paolo, detail of *The Birth of Saint John the Baptist* (NG 5453). See No. 25.

in producing them *Madonnieri.* The accounts of Neri di Bicci, a Florentine painter of the third rank, show that between 1453 and 1475 his workshop painted eighty-one domestic devotional pictures – Madonnas 'da camera' – some exported to a dealer in Rome, others to a dealer in the Marches, and some sold locally. In addition to painted Madonnas, there were reliefs in gesso set in tabernacles, of which examples survive by other Florentine artists (Fig. 143).

In Florence these paintings were generally found in the *camera.* This was simply a principal chamber of the house. As in other European countries, such rooms always had beds in them, but they were by no means as private as a modern bedroom and are likely to have been used for many purposes which we would now associate with a sitting room or drawing room. In Tuscany there were other types of painting found in this room – there were *deschi da parto*, 'birth plates', painted trays upon which food was presented to women after childbirth (those trays that survive seem not to have suffered from such a practical purpose and the food was probably omitted). Above all there were ornamental marriage chests, *cassoni da nozze* (or *forziere*), which came with a bride and her dowry to her new home. After about 1420 *cassoni* were generally decorated with rectangular paintings on the front and sides. In addition there was a convention for the wainscot of the room, and in particular the *spalliera* (backboard) behind benches and chests, to incorporate paintings of a similar long, horizontal format. Beds might also incorporate painted panels,

as can be seen in Giovanni di Paolo's *Birth of Saint John the Baptist* (Fig. 144 and No. 25). Similarly, the lunette-shaped *Annunciation* and its pair, an assembly of patron saints of the Medici family (No. 23), by Filippo Lippi may perhaps have been placed above the heads of beds – a *mezzo tondo* is described in one document as

Florentine archives not only reveal in which rooms many of these paintings were kept but also the manner in which they were commissioned. The usual occasion for expenditure on such items in the life of a prosperous man was his marriage, which tended to be when he was about thirty years old. He would then acquire,

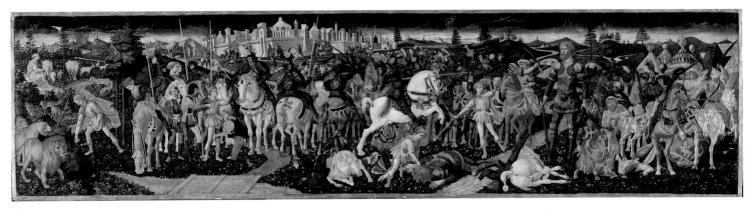

Fig. 145. Pesellino, *David and Goliath, c.* 1440-1450. Wood, 43.2×177.8cm. Private Collection (on loan to the National Gallery).

Fig. 146. Pesellino, *The Triumph of David, c.* 1440-50. Wood, 43.2×177.8cm. Private Collection (on loan to the National Gallery).

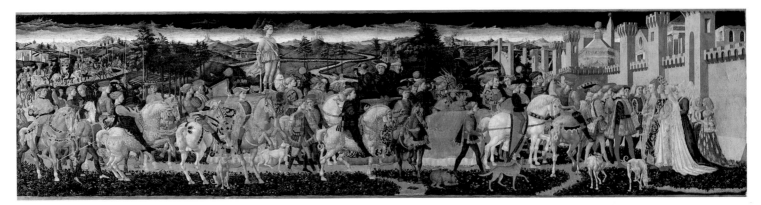

commissioned for just such a situation. While some of the imagery in the *camera* was always religious, much of that which was made in the second half of the fifteenth century was secular.

There was a strong tradition of painted furniture in Tuscany, with special types of painting connected with this. Archival evidence suggests that there was a great increase in the demand for paintings for the *camera* among the many prosperous merchant families in Florence during the fifteenth century and this may not have been paralleled elsewhere in Italy. It would be rash, however, to suppose that there was more painting, or even more secular decoration, in Florence than there was in Bruges, for example, given the poor survival rate of the painted hangings and other works documented in the Netherlands at this date.

often within the family palace, his own *camera* and a suite of lesser rooms. For the *camera* he would buy a Madonna and perhaps some other religious images, a pair of *cassoni*, sometimes with back panels attached (as *spalliere*), a *letto* and a *lettuccio* (a bed and a bench), perhaps with built-in chests, a *cassapanca* (a high-backed bench also serving as a chest), and other furniture.

By the mid-fifteenth century it is clear that the *cassoni* were often bought by the bridegroom rather than the bride or her family, as would seem to have been the case originally. This makes the choice of subject matter for them less surprising. Panels painted by Pesellino with the story of David and Goliath and the Triumph of David (Figs. 145 and 146) must originally have decorated a pair of *cassoni*. Of less high quality are the *cassoni*

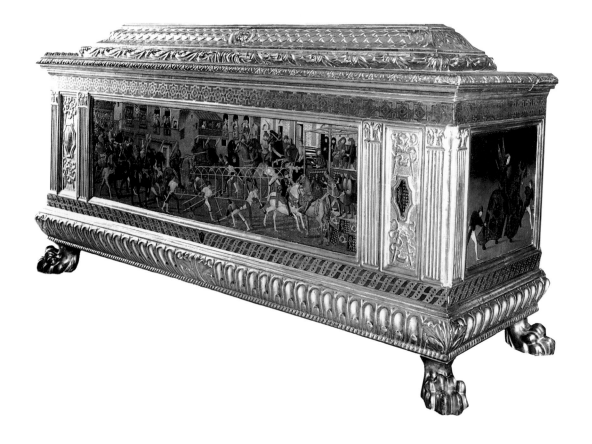

LEFT Fig. 147. Florentine School, *Cassone* with a *Tournament Scene.* Wood, total size *c.* 103×203×66cm (NG 4906).

RIGHT Fig. 148. Zanobi di Domenico, Jacopo del Sellaio and Biagio d'Antonio, *Cassone* and *Spalliera,* 1472. London, Courtauld Institute Galleries (Lee Collection). (A pair with Fig. 149.)

FAR RIGHT Fig. 149. Zanobi di Domenico, Jacopo del Sellaio and Biagio d'Antonio, *Cassone* and *Spalliera,* 1472. London, Courtauld Institute Galleries (Lee Collection). (A pair with Fig. 148.)

in the National Gallery which retain their original decoration – one showing a tournament (Fig. 147) and the other the story taken from Livy of the schoolmaster of Falerii who tried to betray a besieged city to the Romans. Allegorical triumphs of Love and Chastity were also featured on *cassoni,* as well as scenes from the Trojan War and the story of Cupid and Psyche – this last doubtless being considered appropriate for marriage. These subjects were also popular on tapestries.

The only *cassoni* which have survived with their *spalliere* still attached are a pair made for Lorenzo di Matteo di Morello, on the occasion of his marriage with Donna Vaggia di Tanai di Francesco de Nerli in 1472, by the carver Zanobi di Domenico and painted by Jacopo del Sellaio and Biagio d'Antonio (Figs. 148 and 149). The narratives are taken from Livy: Mucius Scaevola plunging his hand in the fire; the schoolmaster of Falerii; Horatius defending the bridge; Camillus defying the Gauls. The sides are illustrated with personifications of the cardinal virtues – Justice, Fortitude, Temperance and Prudence. Because of the carv-

ing and gilding, as well as the painting, the price paid for these two chests was very high – as much as a framed altarpiece by a leading painter. This, however, was very much less than a wedding dress, especially one made of damask such as that which the artists have depicted in the *spalliere.*

Deschi da parto, like the *cassoni,* often included the coats of arms. In the National Gallery's example (Figs. 150 and 151) they are suspended from very heraldic orange and lemon trees, with a bird (probably an egret) in a field of flowers below and a stylised sun above. On the other side Love rides in triumph in a chariot, while Phyllis rides on the back of Aristotle and Samson is shorn by Delilah. These stories of great minds and great strength destroyed by Cupid (or by women) were commonplace in the poetry of the period.

The long paintings which decorated the *spalliere* could be religious. It would seem likely that Botticelli's two panels decorated with the life and miracles of the popular Florentine Saint Zenobius (Figs. 152 and 153) originated as *spalliere*

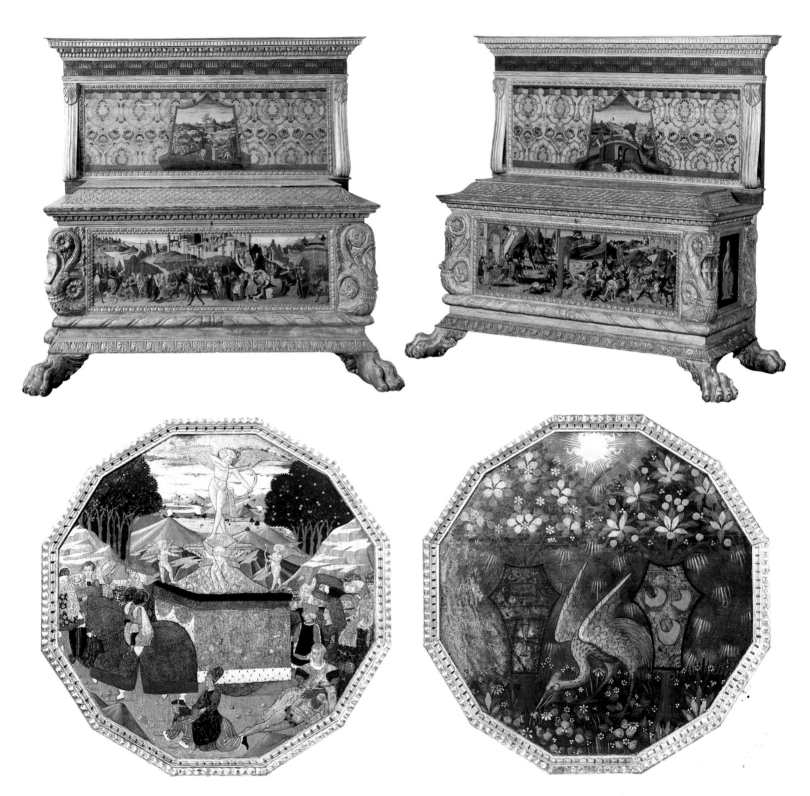

Fig. 150. Master of the Cassoni, *Desco da Parto* (Birth Plate) with *The Triumph of Love*. Wood, diameter including frame 68.5cm (NG 3898. On loan to the Victoria and Albert Museum). The frame is original.

Fig. 151. Reverse of Fig. 150.

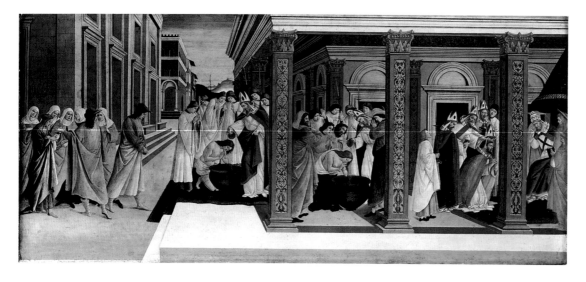

ABOVE LEFT Fig. 152. Sandro Botticelli, *Four Scenes from the Early Life of Saint Zenobius,* *c.* 1500. Wood, painted surface 66.5×149.5cm (NG 3918).

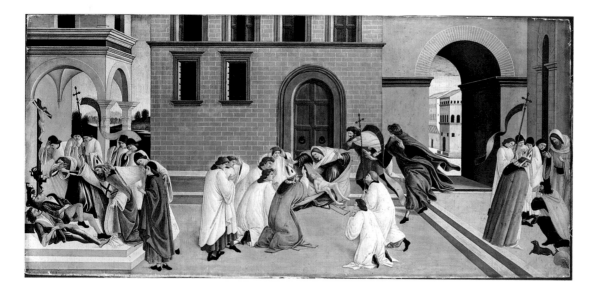

LEFT Fig. 153. Sandro Botticelli, *Three Miracles of Saint Zenobius,* *c.* 1500. Wood, painted surface 65×139.5cm (NG 3919).

BELOW Fig. 154. Master of the Griselda Story, *The Story of Patient Griselda, c.* 1500. Wood, painted surface 61.5×154.5cm (NG 913). The second of a series of three panels.

Fig. 155. Follower of Fra Angelico, *The Rape of Helen by Paris, c.* 1450. Wood, painted surface 51×61cm (NG 591).

decorations: they are certainly too large to be predella paintings. Other paintings of this type are secular, although they are also intended to be edifying. For instance, a series illustrating the story of 'patient Griselda' who was subjected to gratuitously humiliating tests by her husband – a story made popular in the tales of the Florentine writer Boccaccio – would have served to remind a bride of her duty to obey her husband (Fig. 154).

Other narratives likely to have been painted for the *camera* towards the end of the fifteenth century are openly pagan in subject (Nos. 47 and 54) and are among the earliest modern European paintings in which the naked body is exhibited as something beautiful and graceful, as in so much antique art. It outraged the

great Dominican preacher Savonarola, who briefly dominated Florentine political and devotional life in the late fifteenth century, that brides should find the infidelities of Mars and Venus, rather than the deeds of holy women, depicted upon the furniture of the room in which they slept.

The painted or marquetry fields in early fifteenth-century *cassoni* had often been round or octagonal or lozenge-shaped. The delightful octagonal panel of the Rape of Helen (Fig. 155) by a close follower of Fra Angelico looks as if it must have been set in a piece of furniture. *Deschi da parto* had also been either round or octagonal. This may have stimulated the popularity of larger circular-shaped narrative paintings in Florence later in the century and especially in the work by Botticelli and his workshop (No. 38). These paintings are also likely to have been displayed originally in the *camera* – certainly paintings of this shape and

Fig. 156. Cosimo Tura, *An Allegorical Figure*, 1450s. Poplar, painted surface 116×71cm (NG 3070).

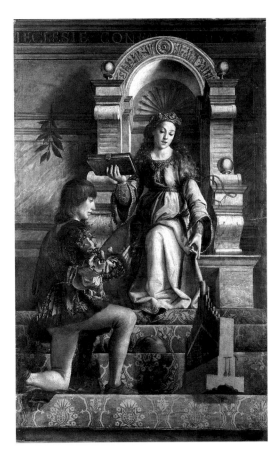

FAR LEFT Fig. 157. Attributed to Justus of Ghent (Joos van Wassenhove), *Rhetoric, c.* 1476. Poplar, painted surface 157×105cm (NG 755).

LEFT Fig. 158. Attributed to Justus of Ghent (Joos van Wassenhove), *Music, c.* 1476. Poplar, painted surface 155.5×97cm (NG 756).

with the same subjects (the Holy Family and the Adoration of the Kings) are recorded in contemporary inventories.

PAINTINGS FOR THE 'STUDIOLO'

In the Villa of Belfiore near Ferrara a room – the *studiolo* – was created for Lionello d'Este (Figs. 110 and 111). The decorations, which continued under Lionello's brother and successor Borso, included a series of paintings of the Nine Muses who, in Greek and Roman mythology, preside over the Arts. In 1447 Lionello wrote to his former tutor, Guarino of Verona, for advice as to how they should be represented – what attributes and inscriptions were appropriate. The exercise was a literary one, for representations of the Muses in ancient sculpture or painting had not then been identified. The *Allegorical Figure* by Cosimo Tura (Fig. 156) is almost certainly one of the Muses from this room, on which Tura is documented as working from 1459 to 1463. X-radiographs have revealed that beneath the present image is an

earlier version showing a female figure seated on a throne apparently constructed of organ pipes. She may have been intended as Euterpe, the Muse of Music. In revised form she holds a branch of cherries and is seated on a marble throne decorated with fantastic metalwork fish. Whether she has been converted into another Muse or into another personification is not clear, but this is not surprising, for the erudite riddles embodied in paintings of this kind – like the witty devices on the reverses of medals – were not designed to be easy to grasp. Moreover, it is hard to tell in Tura's work what is curious emblem and what is fantastic ornament.

The idea of decorating a room with a series of classical personifications was not especially Italian – the Liberal Arts were painted all over Europe – but the paintings at Belfiore were the first in which the Muses had been revived. And it was in Italy that the ancient Roman idea of the villa as a place where, having escaped the cares, business and heat of court or town, one could be refreshed by means of the Muses, was revived in the fifteenth century.

Fig. 159. Panelling with *intarsia* from the *Studiolo* at Gubbio. New York, Metropolitan Museum of Art.

Within an Italian palace at this date similar ideas of retirement and privacy and artistic recreation were reflected in the creation of a room, often of fairly small size, also called a *studio* or *studiolo*, in which the prince might relish beautiful objects, listen to poetry or music, and entertain the learned as if they were equals. Here too the Muses or Liberal Arts might be painted, as they were in the *studiolo* at the Palace of Gubbio decorated for Federico da Montefeltro, Duke of Urbino. The National Gallery's paintings of Rhetoric and Music (Figs. 157 and 158) with courtiers kneeling in homage before them, attributed to Justus of Ghent, came from this small room, and were originally set above superb marquetry (*intarsia*) panelling well over two metres high, which represented benches and cupboards and lecterns with the Duke's armour, musical instruments and books (Fig. 159). Along the top of this panelling and below the paintings ran a Latin inscription on how great and learned men kneel before their spiritual mother. The lighting in the paintings is adapted to that in the room, and the perspective of the thrones, as is also the case with Tura's *Allegor-*

ical Figure, is calculated for their high position on the wall.

Isabella d'Este, Marchioness of Mantua, niece of Lionello and Borso d'Este, commissioned paintings by Mantegna for her *studiolo* in the palace of Mantua, a room created shortly after her marriage in 1490. She kept her collection of ancient medals, gems, statuettes and reliefs there, together with modern imitations of such works. She brought to her patronage of paintings the mentality of a collector, valuing variety as well as harmony, pursuing rarity as well as quality, and before long, although it had probably not been her original intention, she was striving to obtain paintings by all the leading artists in Italy – Perugino, Bellini and Leonardo – to join those of Mantegna.

Perugino was asked to paint a Battle of Love and Chastity, the sort of theme common on Florentine *cassoni*, but here the allegory was extraordinarily elaborated. The mythologies painted for her by Mantegna, and by his successor as court painter, Costa, were also allegories with complicated meanings. Indeed those by Mantegna have never been convincingly elucidated.

Isabella's pleasure in elaborate and recondite content in paintings is surely related to her passion for collecting antiquities, with their obscure personifications and difficult inscriptions and hints of mysteries. It would, however, be a mistake to suppose that she always put subject matter first: she was prepared to accept any *istoria* (narrative) painted by Bellini or Leonardo (see pp. 75-6).

As it happens, neither artist obliged, although she did obtain a devotional painting from Bellini. In her discussions of this, the landscape distances (*luntani*) and other inventions (*fantasie*) which Bellini would add to the painting were obviously of great importance for her. It was essential that the work represented his special skills and his originality. At an earlier date – in 1456 – a lost painting by van Eyck of a woman bathing, which included

LEFT Fig. 160. Giovanni Bellini, detail from *The Blood of the Redeemer*, *c*. 1460-5 (Fig. 6).

BELOW Fig. 161. Andrea Mantegna, detail from *The Agony in the Garden* (NG 1417). See No. 30.

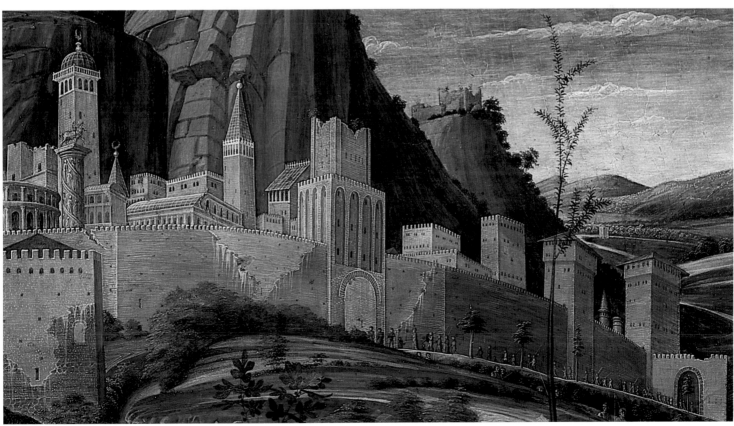

FAR LEFT Fig. 162. Andrea Mantegna, *The Vestal Virgin Tuccia with a Sieve,* *c.* 1490. Poplar, painted surface 72.5×23cm (NG 1125A).

LEFT Fig. 163. Andrea Mantegna, *Sophonisba drinking Poison, c.* 1490. Wood, painted surface 71.2×19.8cm (NG 1125B).

RIGHT Fig. 164. Andrea Mantegna, *Samson and Delilah, c.* 1490. Linen, 47×37cm (NG 1145).

candlelight, a distant view seen through a window, a dog lapping the water, and reflections both in water and in a mirror, was recorded in the collection of an Italian cardinal. The description suggests that the painting was regarded as a van Eyck first, and that the subject mattered only as much as it illustrated his miraculous skill.

Art collecting gradually became more widespread in the fifteenth century, but most of the zeal which in subsequent centuries went into the pursuit of Old Master paintings was devoted to acquiring small antiquities. Cameos and gems especially had never ceased to be prized, and not only in Italy, where most of them were to be found, but also in the treasuries of great Benedictine abbeys such as St-Denis in France and at courts such as that of the Holy Roman Emperor Frederick II Hohenstaufen in the early thirteenth century or that of Jean, Duc de Berry, in the early fifteenth. The Duc de Berry also owned modern cameos and medals of Roman Emperors influenced by ancient examples, but the painters at his court worked in a style which was little affected by their knowledge of such things. With later collectors, such as Pope Paul II and, still more, Lorenzo de' Medici, one can trace the influence of the antiquities they owned upon the sculptors and, to a lesser extent, upon some of the painters associated with them. But the painter above all who was influenced by these collections of antiquities was Mantegna.

In Mantegna's early paintings, and in those by his brother-in-law Giovanni Bellini, there are imitations of ancient relief sculpture which (unlike actual antique marble reliefs, but like antique cameos) have coloured backgrounds (Fig. 160). There are also fantastic archaeological reconstructions (Fig. 161). When he was established as a court artist Mantegna made whole paintings which were simulated reliefs of gilt bronze (Figs. 162 and 163) or

marble (Fig. 164 and No. 64), examples of which were in Isabella d'Este's *studiolo*. The idea of doing this was not without precedent. But the backgrounds of his reliefs reflect the patterning of jaspers, agates and alabasters such as the Romans had prized so highly – wittily imitating those in which nature seemed to emulate the pattern of the sky. And the style was also influenced by that of ancient relief sculpture, even mimicking its limitations – for instance in the somewhat stunted tree and the ambiguous scale of distant foliage (Fig. 164). The subject matter of some of these works too was exceedingly erudite (No. 64).

These paintings resemble in their limited colour the highly finished drawings which Mantegna made, and these in turn are closely associated with his engravings. The drawings are among the first ever made to be appreciated in their own right, and the engravings the first to be made by a great artist of his own inventions. These engravings, like those of Dürer slightly later, were of novel – and obscure – subjects as well as familiar devotional ones. They were works for collectors, many of whom had learned interests, for the sort of people who collected medals and printed books, as well as for the princes who had cameos and commissioned illuminated manuscripts.

Leonardo is one of the first artists whose drawings were sought after by great collectors. Some of these were made as finished works of art like those by Mantegna or Dürer, but even those presumably made as preparations for paintings (No. 66) were also preserved – because collected – as works of art in their own right. At the very end of the period, attitudes which eventually led to the creation of such institutions as the National Gallery were emerging. Leonardo's first version of *The Virgin of the Rocks* (No. 68a), designed to assist the devotions of a confraternity, was diverted to the art collection of the King of France.

THE
MAKING
OF
PAINTINGS

CRAFT
AND PROFESSION

RANGE AND STATUS

Painters did not confine their work to chapel and palace walls, to altarpieces and smaller devotional panels, to portraits and decorated furniture. They also gilded candlesticks; painted book covers (Fig. 94); decorated the curtains protecting paintings and organs; gilded and decorated leather for saddlers (who sometimes belonged to the same guild) as well as sculpture of wood, terracotta, gesso (Fig. 143), stone and alabaster.

Painters and sculptors were also involved in other arts. In those in which there was an obvious division between conception and execution – between model or drawing on the one hand and the task of embroidery, weaving, glass-making or metal casting on the other – it was understandable that the model or drawing should be made in another workshop, and sometimes in the workshop of a painter or sculptor.

The panels illustrating scenes from the Life of the Virgin and of Christ on the cope of Saint Zenobius as painted by Benozzo Gozzoli (Fig. 165), or those on the cope of Saint Martin as painted by Gerard David (Fig. 166), are examples of the kind of work which painters often designed. In David's painting the crozier and morse of Saint Martin and the cross and morse of Saint Donatian, all of which include figures (Figs. 167 and 168), represent the sort of goldsmiths' work likely to have been designed by painters in the Netherlands.

There was often friction over the definition of areas of competence, reflected as we shall see in the guild regulations. The relationship between painters and sculptors – more particularly between painters and woodcarvers – was especially liable to be difficult in those parts of Europe where altarpieces consisted of

both polychrome sculpture and painting. One solution was for both arts to be practised by the same man, or at least in the same workshop – as was the case in Michael Pacher's workshop in the Tyrol. Alternatively some sort of partnership like those found in Augsburg in the late fifteenth century could be adopted.

In Florence in the fourteenth century Andrea di Cione (Orcagna) produced both painting and sculpture. In the following century the Pollaiuolo brothers were probably more active as sculptors than painters, and this was certainly true of Verrocchio whose bronze sculptures were among the most famous in Italy. These sculptors were not principally woodcarvers, but the terracotta sculpture which they made was often painted, which may explain the origin of their involvement in painting. Their painting could certainly be affected by their experience as modellers. The executioners in the *Martyrdom of Saint Sebastian* reflect the three-dimensional models in dynamic poses which the Pollaiuolo brothers popularised as studio aids (Fig. 169).

The distinction between art and craft would not have been recognised in the thirteenth, fourteenth and fifteenth centuries, but the origins of the distinction can be traced back to Italy and in particular to Florence in the fifteenth century. Writers extolling the powers of narrative painting and expounding the science of perspective made claims for painters, sculptors and architects as the rivals – and equals – of historians, poets and mathematicians. This elevated intellectual status could be matched by social eminence, especially when a famous painter was attached to a court.

It was part of the magnificence of a ruler that he had poets, historians, mathematicians, musicians, painters and sculptors in his protection. It was also useful to have at hand people who could greet a visiting prince in Latin, defend dynastic claims, devise siege machinery, report on a possible bride, make an equestrian

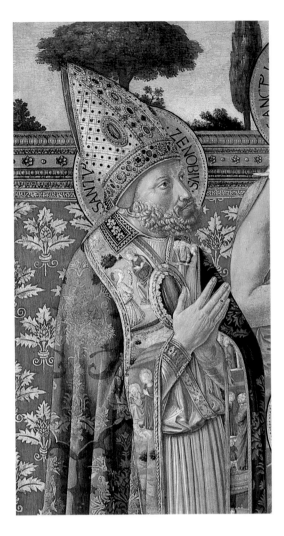

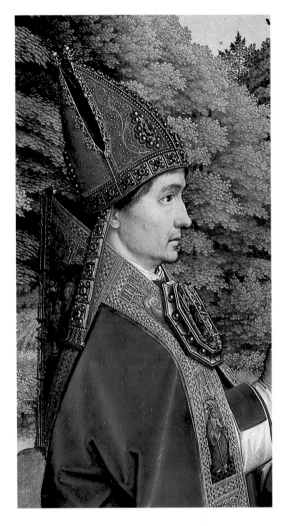

ABOVE LEFT Fig. 165. Detail of cope from *The Virgin and Child Enthroned among Angels and Saints* by Benozzo Gozzoli (Fig. 71).

ABOVE RIGHT Fig. 166. Detail of cope from *Canon Bernardinus de Salviatis and Three Saints* by Gerard David (Fig. 58).

BELOW LEFT Fig. 167. Detail of Saint Martin's crozier from *Canon Bernardinus de Salviatis and Three Saints* by Gerard David (Fig. 58).

BELOW RIGHT Fig. 168. Detail of Saint Donatian's morse from *Canon Bernardinus de Salviatis and Three Saints* by Gerard David (Fig. 58).

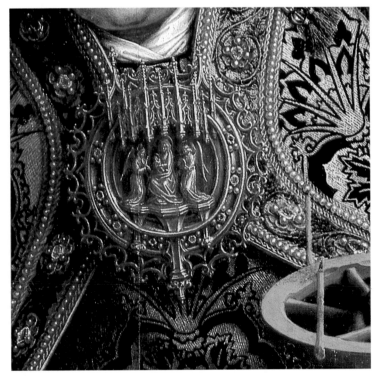

statue, supervise the casting of cannons, and supply appropriate decorations and music for ceremonial events. Giotto was not merely paid by the King of Naples but appointed *familiaris*, one of his 'family' or household; Pisanello a century later also served at the court of Naples, and at those of Mantua and Ferrara. Jan van Eyck, having worked for John of Bavaria, Count of Holland, was in 1425 attached to the court of Philip the Good, Duke of Burgundy, with the post of *valet de chambre*. Later in the fifteenth century we find Cosimo Tura and Andrea Mantegna enjoying privileged positions as the court artists of Ferrara and Mantua respectively, and Leonardo doing so more briefly in Milan.

These artists were among the most highly esteemed of their day and they were granted great privileges and freedom (for instance, to accept outside commissions) but, like the lesser artists who were also attached to the courts, they might be asked to work under pressure on special occasions. When Philip the Good died in 1467, 136 large and 1,030 small coats of arms had to be supplied in five days by the court painter. Still greater, but less hasty, work went into receptions and weddings. The processions required arches, table decorations and musical entertainment of fantastic elaboration in which the court artists were much involved, but of this little remains except for some drawings by Leonardo for costumes, machines and ornamental monsters.

Something of the high importance attached to armorials and devices is reflected in the Wilton Diptych (No. 10) with its banner, its badges, its arms and livery (Fig. 170). Much of the work for which Gilbert Prince, court painter to Edward III and Richard II, was paid was of this character – decorations for a bed and for the pennants of trumpets, for example – and this was not unusual for court artists anywhere in Europe. Among Cosimo Tura's documented work for Duke Borso d'Este were designs for arms and devices to be woven by a Flemish tapestrymaker, and golden lilies for the *coperta* of a horse in a tournament.

The attraction of a position at court lay in the prestige, the marks of distinction (including knighthood), the salary (even if it was often in arrears), the perquisites, and the freedom from the pressure and competition of the marketplace. It also provided an escape from guild regulations, which were especially restrictive in some towns north of the Alps. Towns themselves, however, sometimes employed artists in a similar manner and even had official positions for them.

Rogier van der Weyden, although a native of Tournai, held the

LEFT Fig. 169. Antonio and Piero del Pollaiuolo, detail from *The Martyrdom of Saint Sebastian*, 1475. See also No. 40.

Fig. 170. French School(?). The reverse of the Wilton Diptych, *c.* 1395, showing the Royal Arms of England impaled with the arms of Edward the Confessor. Oak, 53×37cm (No. 10).

post of Town Painter at Brussels from 1435 to 1464. As well as an annual salary and a special robe of office, the painter – like the town's mason, carpenter and tiler – was entitled to be paid for the work he carried out; unfortunately, the accounts do not survive to demonstrate what this work was. Although van der Weyden's international fame had undoubtedly reflected well on the town, it was decided that, after his death, the town would not be able to afford a successor in this post.

Elsewhere in Northern Europe, in Germany for instance, the office of Town Painter is sometimes documented, but a painter might be regarded as pre-eminent in a town without this title. Stephan Lochner not only painted *The Adoration of the Magi* (Fig. 96) for the chapel of the town council in his adopted Cologne, but devised the decorations in honour of the visit of the Emperor Frederick in 1442.

In Italy something similar to the position of Town Painter existed in Venice. Gentile Bellini was extensively employed as a painter in the Doge's Palace, working on the great canvas paintings of Venetian victories. When in 1479 he went to Constantinople – at the behest of the Venetian Senate – in order to paint portraits (see p. 91) and other pictures for Sultan Mehmet II, his brother Giovanni Bellini was voted into the job of continuing

with the decoration in the Doge's Palace. For this Giovanni was promised his expenses, an annuity, a remunerative perquisite and, when this turned out to be an insufficient incentive, the official title of painter to the state, freedom from other obligations, and exemption from paying fees to his confraternity.

THE GUILDS

Most artisans in this period were town dwellers, and most – painters included – were organised into trade associations or guilds, of which there might be only a few within a single town, each comprising a number of trades. By the end of the fifteenth century, however, most guilds represented a single craft.

The guilds often played an important role in town government, with guild representatives serving on city councils. Nuremberg, where there were no guilds but the city council had direct control of the various crafts, and Venice, where confraternities were the most socially and politically significant associations, were important exceptions. Florence was unusual in that guild membership was not compulsory. The guilds served two major functions: to keep the crafts profitable, especially by limiting competition, and to provide social benefits – such as loans, financial support for the old and sick, and funerals and Masses for the dead. In some towns, where the painters were members of large guilds comprising several crafts they also organised themselves into confraternities of Saint Luke, the painters' patron saint.

Guild regulations which survive for towns in both Northern and Southern Europe shed light on the painters' training, materials, professional conduct and also on the social and economic forces with which they had to contend. The similarities in the regulations are perhaps more striking than the differences, and the differences are not always along geographical lines. Thus Florence, Nuremberg and Antwerp were more liberal in allowing outsiders to practise their crafts within the city boundaries than Siena, Cologne and Bruges. And similar regulations concerning materials are found both north and south of the Alps: in Florence in 1315/16 and in Munich in 1461, for instance, the substitution of the inferior blue pigment azurite for the more expensive ultramarine is prohibited. Almost all guilds had regulations concerning training and, as with most of the regulations, there were fines for contravening them. The periods of apprenticeship were laid down here: three years were prescribed in Florence and Louvain, but between five and seven in Venice, and up to six in Cologne – although these changed and were not always adhered to.

The number of apprentices employed by each master was also regulated and was often limited to as few as two at a time, or even one, as in Florence, Bruges and Brussels. Presumably too many apprentices in a single workshop could have led to inadequate training and a decline in the quality of work in a particular town. More important, it could have resulted in there being more masters in a town than was comfortable for those established in the profession. But not all apprentices became masters with their own workshops: of the seventy apprentices registered in Tournai between 1440 and 1480 less than a third ever became masters there. Some may have started workshops elsewhere but many would have remained journeymen – that is, trained artists, often itinerant, who were not masters. The number of journeymen which a master could employ was not restricted, but their activities were watched vigilantly. In Germany they were not allowed to take on commissions without their master's permission, and often not allowed to carry out such work outside the master's premises. Journeymen seem, however, to have prospered at the large annual fairs in the Netherlands where the guilds had no control.

To become a master involved a substantial payment to the guild and, in some cases, the submission of a masterpiece – a work of prescribed character representing an official test of skill. These conditions again were designed to limit the number of workshops in the town. Masterpieces were not always insisted upon – by the fifteenth century especially – but in early sixteenth-century Strasburg painters had to submit three of them and the fees were also exceptionally high. Unsurprisingly, a major concern was to prevent 'foreigners', that is, artists from other towns, establishing workshops. In Padua, Cologne and Bruges very strict measures were taken to discourage such competition. In Bruges a foreigner had to pay nearly thirty times as much as the son of a local master (sons commonly enjoyed preferential rates). In Cologne the guild statutes of 1449 declared that only those who served four years apprenticeship there, or paid a fee, could become a master. By contrast in Antwerp, and in Nuremberg where, as has been mentioned, there were no guilds, foreigners were not discouraged. In Florence there were double fees for foreigners and they were not permitted to hold office in the guild, but in 1346 there were forty foreign painters inscribed in the guild and the town remained open throughout the fifteenth century to talent from elsewhere in Italy and beyond the Alps.

In addition to keeping foreign painters out of the town, there

was the problem of keeping foreign paintings out. The Paduan guild was particularly concerned to prevent the import of paintings. This perhaps helps to explain the partnership formed by the Venetian Giovanni d'Alemagna and the Paduan Antonio Vivarini, which presumably circumvented this prohibition. Venice too was worried by imported paintings. An altarpiece brought to the city by a German merchant was confiscated in 1457, although numerous smaller paintings by Netherlandish painters are recorded there by the end of the century. The most easily transported paintings were those on cloth, produced in specially large numbers in Bruges. Fifteenth-century inventories reveal that many such paintings were found in Italian homes and *The Entombment* by Bouts (No. 32), a painting on cloth has, perhaps significantly, an Italian provenance. They were also exported to London.

In Bruges the painters on panel were represented in a separate section of their guild from that of the painters on cloth, and in 1458 they went to law to stop the painters on cloth from exhibiting or selling their work other than in their homes or workshops. They were evidently worried by the popularity of lighter and presumably cheaper alternatives to panel painting since they had in the previous year endeavoured to prevent the illuminators selling unbound sheets which might be hung on a wall like paintings (Fig. 140). In 1463 it was agreed that the painters on cloth were permitted to exhibit their work for sale, but they were expressly forbidden to work in oil paint on cloth. Furthermore, it would appear that painters on cloth were not only taking, or threatening to take, business away from the painters on panel (who worked in oil), but were encroaching on the monopoly of panel painters by themselves producing and selling paintings not only on cloth but also on panel.

When the guild in Brussels forbade tapestry weavers from drawing cartoons that was to protect the monopoly of the painter as designer. The preoccupation with boundary disputes of this kind is reflected in lists of materials and tools specific to a particular craft, such as are found in the statutes of the Tournai guild of 1480. Whether or not the painter worked on cloth or panel was, as we have seen, crucial in Bruges. The tension between sculptors and painters is also often evident. German painters for instance were concerned to prevent sculptors employing journeymen painters. One response to this was to permit painters to compete on equal terms by employing journeymen sculptors. The guild regulations of Basel in 1463 and of Munich in 1475 allowed for precisely this solution.

The control of the raw materials of the craft also features in guild statutes. One aspect particularly insisted upon was the purity of materials, especially the most expensive – ultramarine and gold. As we have seen, there were special prohibitions on the use of substitutes for ultramarine. The regulations of the Cologne painters' guild, drawn up in 1371, begin with a ban on the secret sale of raw materials, which, when scarce, provided opportunities for profiteering. To avoid this, communal purchasing was frequent. Stockpiling raw materials which might then be sold was also feared because this could strike at the independence of the craftsman. Indeed some crafts, particularly those associated with metalwork and cloth production, were drawn into a factory system in this period. Under this system both the supply of raw materials and the labour were controlled by merchants, who profited from the consequent large scale of production. Painters hoped to maintain their independence and their prosperity by preventing such a situation from arising. Uncomfortable competition must often have stimulated combinations, resulting in very large workshops producing both sculpture and painting, such as that of Michael Pacher in the Tyrol for instance, or associations between workshops.

In Florence one of the leading painting workshops of the late fifteenth century was run by Verrocchio, who was primarily a sculptor. There is no evidence there of the sort of demarcation disputes involving painters which were so prevalent elsewhere and indeed there was a tradition of painters moving easily from one craft to another. There seems to have been no move to prohibit or limit the import of popular Netherlandish paintings on cloth. Foreign painters, as we have seen, were also present in high numbers. Indeed in Florence in the second half of the fifteenth century there is some reason to suppose that the Arte dei Medici e Speziali, the guild of the physicians, apothecaries and spice-merchants (who also sold artists' pigments) to which painters, along with saddlers, barbers, stationers and some other crafts, were affiliated, was more or less dormant, at least as regards painters. Botticelli is not entered as a paid-up member of the guild until 1499, although he had been one of the town's leading painters for a quarter of a century and certainly had a large workshop. The fact that Perugino was recorded as a member in the same year has been taken to indicate that the guild had suddenly been revived.

Perugino was a foreigner and may well have maintained a workshop in both Florence and Perugia. He not only had important commissions in both towns and also for major centres elsewhere, but he is said to have produced numerous works for the export market. In reviewing Perugino's work, the decline in

quality becomes apparent and may be connected with a decision to mass produce work for the marketplace rather than seek to satisfy exacting patrons.

CONTRACTS AND COMMISSIONS

Many painters in this period probably made their living from the supply of uncommissioned paintings, and even workshops which received prestigious commissions, such as Perugino's, are likely to have had a line in ready-made pictures. Commissioned works were less usual than is sometimes supposed today; but most of the major works of art, and almost all of the altarpieces of this period in the National Gallery, fall into this category. When a commission was received it was likely to be the subject of a contract, particularly when the work was to be made for an institution. The survival of contracts is sporadic: more survive

from the fifteenth century than from earlier centuries, and far more from Italy and southern France than from elsewhere in Europe because in these areas the notaries who drew up the contracts had to keep their records.

Contracts survive for several of the Italian altarpieces of which the whole or parts are in the National Gallery Collection. A few were drawn up after work had begun, as with Duccio's *Maestà* for Siena Cathedral (No. 3), and as was probably the case with the Pisa Polyptych by Masaccio (No. 15). But most, as was usual, were for initial commissions, as with Sassetta's high altarpiece for the church of San Francesco, Sansepolcro (No. 19), undertaken in 1437; Piero della Francesca's high altarpiece for Sant'Agostino, also at Sansepolcro (No. 33), contracted for in

BELOW Fig. 171. Dieric Bouts, *Altarpiece of the Blessed Sacrament,* 1464-7. Wood, centre panel 180×150cm, each shutter 86.5×71.5cm. Louvain, St Peter's.

1454; Benozzo Gozzoli's altarpiece for San Marco in Florence (Fig. 71), agreed in 1461; and the first version of Leonardo's *Virgin of the Rocks* (No. 68a). On the other hand, no contracts survive relating to the Netherlandish and German paintings in the National Gallery, and only a single contract is known which can be associated with any surviving painting from the Netherlands in this period, that for Dieric Bouts's altarpiece of the Sacraments for the church of St Peter's, Louvain (Fig. 171).

Most contracts were concerned with four principal matters: the materials to be used, the subject matter to be depicted, the time in which the painting was to be completed, and the manner in which the painter was to be paid. The amount of detail in which these matters are treated in individual contracts varies greatly, especially where subject matter is concerned. Here particularly there may quite often have been separate discussions between painter and patron, resulting in an unrecorded oral agreement. Misunderstandings could be avoided by reference to an agreed drawing, which is usually a standard feature in German contracts, and is mentioned from time to time elsewhere.

Some agreements may never have been put in writing – the fifteenth-century Florentine painter Neri di Bicci records taking on a commission in this way – but probably most patrons, and most painters too, preferred the security of a legal document which had been signed by both parties and witnessed. It was by no means unusual for a patron to resort to the remedy of the courts if it was felt that the painter had departed from the contract. Thus an agreement to produce a painting was little different from any other agreement to supply goods or services by a particular date.

Most contracts show evidence of the patron's concern for the quality of the work to be produced. The best materials were to be used and sometimes the clients ensured this by supplying them themselves. The two materials most commonly mentioned in contracts as well as by the guild regulations (see p. 126) are the two most expensive – the pigment ultramarine blue (lapis lazuli) and gold (see p. 175). The main concern was that cheap substitutes for these materials should not be used, although substitutes were occasionally permitted for less important parts of the picture. Thus Neri di Bicci records between 1453 and 1475 numerous agreements with clients where the Virgin's robe is to be ultramarine and the remaining blues azurite. Similarly, in the unusually detailed contract of 1453 for the *Coronation of the Virgin* altarpiece by Enguerrand Quarton for the Carthusian monks in Villeneuve-lès-Avignon (Fig. 172), the blues in the main part of the altarpiece were to be painted with ultramarine, while the

Fig. 172. Enguerrand Quarton, *The Coronation of the Virgin,* 1453-4. Oak, 183×220cm. Villeneuve-lès-Avignon, Musée de l'Hospice.

blues in the frame were to be 'fine German blue', that is, azurite, a cheaper blue pigment.

The type of gold to be used is also generally mentioned in contracts. Usually the painter contracted to use pure gold, which was beaten from coinage: Hungarian gold was particularly favoured in Germany because of its purity. Contracts also sometimes specify that different types of gold, such as gold alloy or gilded silver or even tin, may be used for minor parts of the painting, usually the frame. In Northern Europe contracts frequently insist that the gold leaf used in the most important parts of the picture should be burnished, not left matt (see pp. 174-5). In the fifteenth century, when oil began to replace egg as a medium, its use was sometimes specified in the contract, for example in that for the altarpiece of 1453 by Quarton.

The other major physical aspect of the painting which had to be considered was its frame and, if it was a panel painting, its wooden support. This wooden structure would often be very large, and could include an elaborately carved surround (see p. 155). Altarpieces in particular usually had to fit a specific site, and therefore measurements were sometimes written into the contract. Rogier van der Weyden, however, made his lost triptych for the abbot of St Anton in Cambrai bigger than had been specified, 'for the good of the work'. Fortunately no specific site

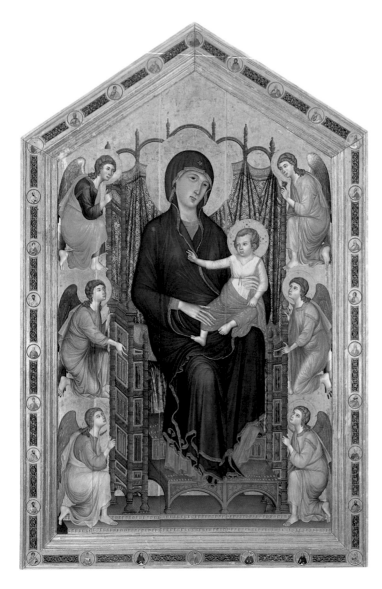

Fig. 173. Duccio, *The Rucellai Madonna*, commissioned 1285. Poplar, 450×292cm. Florence, Uffizi.

seems to have been laid down, and the triptych was exhibited on trestles in various parts of the abbey church so that the abbot could decide where it looked best. But this was a most exceptional case, perhaps revealing some of the special engineering problems involved in triptych shutters, and certainly showing the high esteem in which the artist was held.

The painter did not always play a part in the design of the wooden structure. In Italy the contracts quite frequently state that an altarpiece is to be made and then handed over to the painter for painting. In the case of Piero della Francesca's polyptych for Sant'Agostino in Borgo Sansepolcro (No. 33) in 1454,

one of the patrons, Angelo di Giovanni di Simone, provided a structure which had already been constructed by a carpenter. It was given to Piero for painting and gilding (although there is in fact no gilding on the surviving fragments). The wooden structure formed a substantial part of the cost of an altarpiece, and that is probably why it was sometimes made and paid for before any other work. In 1395 the nuns of Santa Felicità in Florence had an altarpiece made by two carpenters and the wood alone cost 80 florins; it was not until 1399 that they commissioned three artists, Spinello Aretino, Niccolò di Pietro Gerini and Lorenzo di Niccolò, to paint the panel (now in Florence, Accademia) for the sum of 100 florins. On the other hand, some painters did subcontract the making of the wooden structure.

Some contracts are very explicit in describing what subject matter was required. For example, a contract of 1372 for the high altarpiece for the monastery of Passignano, to be painted by Jacopo del fu Mino, il Pellicaio, is particularly detailed in its description of the subject matter of each panel in the main tier, predella and gables, and even of the poses, attributes and colours of the robes of the figures. The monks were clearly leaving nothing to chance. The contract for the *Coronation of the Virgin* by Enguerrand Quarton (Fig. 172) is similarly explicit. It describes in detail every part of the altarpiece – including the exact inscriptions to be carried by the prophets, Abraham and Moses – and specifies the expressions of joy to be on the faces of the angels, and of sadness on the faces of the devils at seeing souls being carried to paradise – but to each item is added that it shall be according to the judgment of the painter.

More frequently, contracts are vague concerning the subject matter of the work being commissioned. In the contract for Duccio's *Rucellai Madonna* (Fig. 173) painted for Santa Maria Novella, Florence, in 1285, Duccio agreed to paint the Virgin and Child and other figures according to the wishes and pleasure of the patrons, but nothing more is described. Sassetta agreed that the subject matter of the Borgo Sansepolcro altarpiece (see No. 19) would be chosen by the friars, and the exact details may have been recorded separately. A separate specification of this sort seems to have been supplied for Piero della Francesca's altarpiece for Borgo Sansepolcro, commissioned in 1454. He agreed 'to paint, compose and decorate with good and fine pigments and gold and silver and other forms of ornamentation those images and figures about which it has been written' ('pingere et imaginare et ornare de bonis et finis coloribus et auro et argento et aliis ornamentis et de illis ymaginibus et figuris de quibus scriptum est'). The subject matter of the altarpiece of the Blessed

Sacrament commissioned for St Peter's, Louvain, in 1464 from Dieric Bouts (Fig. 171), which is not laid down in detail in the contract, had to be approved by two theologians in what must have constituted a separate agreement. This was certainly because the subject matter was unusual, and there is no reason to suppose that theologians were commonly involved.

Contracts might avoid lengthy specifications of subject matter in two principal ways: by use of a separate written instruction or drawing, or by the inclusion of a clause stating that the work was to resemble another 'in manner and form' ('modo et forma'). There are several reasons why such a clause might be used. The first and most obvious is when the work being commissioned was required to replace one already extant, as with Piero's altarpiece of 1445 for the Confraternity of the Misericordia in Borgo Sansepolcro. Similarly, his banner for the Confraternity of the Annunciation in Arezzo was to replace one already in existence, presumably worn out, and therefore Piero was required to paint one of exactly the same proportions. When Sassetta was commissioned to paint the altarpiece of the Life of Saint Francis for the church of San Francesco in Sansepolcro, he was asked to make the altarpiece the same height, breadth and form as an altarpiece which had been constructed and even gessoed, but then abandoned because the painter who had signed an earlier contract in 1430 did not carry out the work, for reasons unknown today. According to the contract of 1430, that altarpiece was to be similar to the high altarpiece of the Badia at Sansepolcro.

Sometimes a religious community might want a repetition of a painting which had been commissioned by another branch of the same Order. An instance of such an imitation may be the *Coronation of the Virgin* by Lorenzo Monaco (No. 11). When the members of the Dominican confraternity, the Compagnia di Santa Maria della Purificazione e di San Zanobi, commissioned an altarpiece from Benozzo Gozzoli in 1461 (Fig. 71), they asked that the enthroned Virgin should precisely resemble that by Fra Angelico in the high altarpiece (Fig. 174) of the Dominican convent of San Marco – although in the event the resemblance was not all that close (Fig. 175). Such a clause was not uncommon north of the Alps: in 1444 in Ghent the painter Nabur Martins contracted with a burgess of Ghent to execute a Last Judgement 'comparable in execution and figures' to a painting of the same subject hanging in the hall of the Bakers' Guild.

In many cases the subject matter or composition may have been clarified by a drawing. Relatively few identifiable contract drawings survive, although there are many references to them in contracts from both Northern and Southern Europe. A drawing which Filippo Lippi sent to Giovanni di Cosimo de' Medici in 1457 was intended as a model for the patron to consider (Fig. 176). There were no doubt also pre-contract drawings, giving patrons an idea of the sort of models available. The treasurer of the Company of Priests which commissioned Pesellino's altarpiece of the Trinity (Fig. 57) had obtained drawings in Florence in advance of the meeting at which his fellow members decided to commission the painting and discussed what it should depict.

Patrons expected the artist to do the very best he could and this was often written into the contract. Contracts sometimes say that the painting is to be very beautiful. In the altarpiece for Borgo Sansepolcro, for instance, Sassetta agreed to work 'with all his powers of invention and skill of execution to make the finished work as beautiful as he was able', ('secundum subtile ingenium et sue artis pictorie peritiam et quanto plus venustius sciet et poterit').

In many contracts these rather general exhortations are made more explicit by the introduction of a clause specifying that the painter was to carry out the work with his own hands ('de suis manibus'). It is unlikely that this required the painter to do the work entirely by himself, which in the case of large works would have been unrealistic. Rather it was a formula to ensure the active participation of the master and to prevent subcontracting between workshops, a practice which had become common in the Netherlands and in Germany in the fifteenth century. The clause is also found in Italy in a document concerning Duccio's *Maestà* (see No. 3), where the painter agreed to work on the altarpiece with his own hands, and in the contract for Piero della Francesca's Madonna della Misericordia altarpiece, where he agreed that no other painter would work on it. The evidence of the paintings themselves strongly suggests that the artist's workshop did assist in their production.

One anxiety frequently expressed concerns the length of time the work would take, particularly if the painter was in great demand. In Germany and the Netherlands it was usual to find a year specified, even for a painting of great size and complexity, and fines were commonly insisted on if the deadlines were not met. In the case of both Duccio's *Maestà* and Masaccio's Pisa altarpiece of 1426 (see No. 15) the undertaking not to work on anything else seems to have been part of an interim agreement, and suggests that the artists were busy on other things when work on the altarpieces was already underway, making it necessary to extract a commitment. Similarly, in the contract for the altarpiece of the Blessed Sacrament in 1464, Bouts agreed not to undertake another major work until it had been completed.

Getting a painter to keep a contract was not necessarily easy. Sassetta agreed to complete the Borgo Sansepolcro altarpiece within four years but he in fact delivered it only after seven years. And this is not unusual. There were predictable problems with painters who lived in different cities from their patrons, or indeed in different states. The Confraternity of the Immaculate Conception in Milan must have despaired of settling their differences with Leonardo when he moved to Florence, and indeed it was only when he returned to Milan that they could be sorted out (No. 68). The Certosa at Pavia was in Milanese territory but two Florentine painters, Filippino Lippi and Pietro Perugino, agreed to make altarpieces (No. 59) for the Carthusian monks there. This was in about 1496. On 10 October of that year, Jacopo d'Antonio, a Florentine woodcarver who had agreed to furnish frames for the altarpieces, wrote to Fra Gerolamo at Pavia in exasperated terms: 'You say you haven't had any reply from me. I tell you I have written many times. I've had no reply whatever.' He said he could certainly do the job but only when he got the money, 'And the same goes for the painters.' The best way of getting things done in a case like this was to get a powerful individual to exert

LEFT Fig. 174. Fra Angelico, *The Virgin and Child enthroned with Angels and Saints, c.* 1438–40. Wood, 220×227cm. Florence, Museo di San Marco.

Fig. 175. Benozzo Gozzoli, detail from *The Virgin and Child Enthroned among Angels and Saints.* See Fig. 71.

some political pressure. Evidently the guild was not asked to intervene.

The monks must have appealed to the Duke of Milan, Lodovico il Moro, who wrote on 1 May 1499 to his representative in Florence, Taddeo Vicomercato. Lodovico was angry because he had recommended the artists in the first place: 'It seems now that three years have gone by since we made the agreement (*convenzione*) and little evidence there is to be seen of the perfection of the said painter. To the brothers and to us he has done wrong.' He instructed Taddeo to fix a firm deadline and retrieve pay-

ments made if it was not adhered to. The affairs of the monastery were 'dear to his heart'. Lodovico was driven out of Milan later that year and taken captive by the French in April 1500, so his threat would not have had much effect, and Filippino at his death in 1504 had hardly started his painting. Perugino did finish parts of his altarpiece (see No. 59), probably in about 1500, but other parts seem to have been by another artist to whom the desperate monks were forced to apply.

The distance of some churches from the city where the painting was likely to be made often involved special problems and

Fig. 176. Filippo Lippi, *Sketch of an Altarpiece,* 1457. Pen on paper. Florence, Archivio di Stato (Med. av. Pr., VI, no. 258).

expenses to which contracts refer. Sometimes the painter agreed to deliver the altarpiece to the site, since the setting up of large and cumbersome altarpieces required considerable skill. A hoist had to be hired for the San Pier Maggiore altarpiece (No. 9). In 1437 Sassetta agreed to deliver his altarpiece to San Francesco in Borgo Sansepolcro from Siena and make good any damage incurred during transport. In 1471 Pacher agreed to have his massive altarpiece (Fig. 177) brought from Oberhall to Braunau; from there the patrons agreed to have it carried to the small pilgrimage church of St Wolfgang, near Salzburg, at their own cost and risk, although Pacher agreed to repair any damage. The patrons also undertook to provide his meals and drink while he completed and set up the altarpiece, as well as any ironwork necessary, and to help with the loading. The payments in 1504 for Cima's altarpiece of the Incredulity of Saint Thomas (Fig. 72) include 8 soldi to the porters who carried the altarpiece to the site and a 2 lire tip for Cima's assistants ('per pagar lo beveraso alli garzoni del magistro').

As was usual in commissions which involved a major commitment of time and materials, payments were made in three instalments. The initial payment enabled the painter to buy those materials which were not supplied by the patron, an interim sum enabled him to pay for food and lodging, and the final payment was made on delivery of the work. The initial payment had the advantage of securing the artist's attention and putting him under an obligation. This tactic was essential for private commissions. Once Isabella d'Este had persuaded Perugino and Giovanni Bellini to accept such a payment she was in a much better position to bully them to produce the pictures she wanted for her *studiolo,* however reluctant they might be. Cases in which the artist had been paid but done nothing, or not finished the work, are more frequently reported than are failures to pay, but such failures certainly occurred.

The Confraternity of San Tommaso dei Battuti in Portogruaro voted to commission the altarpiece (Fig. 72) for their chapel in San Francesco on 28 May 1497. Presumably Cima da Conegliano was approached soon afterwards. Payments seem to have commenced in 1502, and in 1504 the altarpiece was reported as nearly ready but deliberately left incomplete by the artist because he had not been paid. It was completed and installed later that year, although the artist was still owed more than half his fee. He had to resort to legal action to extract the rest from his patrons and did not secure it all until 1509.

Provision was often made for the final sum paid to be varied, according to the painter's performance. Fra Angelico was to be paid 190 gold florins for the tabernacle he made for the Linaiuoli (the Linen Weavers' Guild), or less, according to his conscience – perhaps because he was a friar. The prior of the Ospedale degli Innocenti reserved the right to pay Ghirlandaio less than the agreed sum for an altarpiece commissioned in 1485 if he, the prior, judged it right. Sometimes a painter could receive a bonus for good work, and sometimes painters were paid according to the judgement of fellow artists. This was standard practice in the Netherlands, and also common in Germany. The contract of 1471 with Pacher for the St Wolfgang altarpiece refers to the appointment of assessors chosen in equal numbers by each side.

Sometimes the payment, or part of it, was made in kind. Piero della Francesca was paid 320 florins and a piece of arable land for the Sant'Agostino altarpiece commissioned in 1454 (see p. 130). Baldovinetti was paid on separate occasions in 1470 and 1472 with barrels of olive oil. Some of the payments made by the Confraternity of the Company of Priests of the Trinity in Pistoia to Filippo Lippi for completing the altarpiece begun by Pesellino (see p. 54) were in the form of grain, and the banker who looked after the altarpiece for them after Pesellino's death was paid with trout, presumably trapped in their streams.

The painter's obligations did not always end with the completion and installation of the altarpiece. Piero agreed to guarantee the condition of his Sant'Agostino altarpiece for ten years. The Ghent painter Cleerbout van Witevelde contracted in 1456 to guarantee an altarpiece for the church of Wachtebeke, which he had retouched, for twenty years. Leonardo also agreed to guarantee *The Virgin of the Rocks.*

Finally, if either party was dissatisfied he could go to arbitration, and this again entailed other painters assessing another painter's work. In the case of Duccio's *Rucellai Madonna* the confraternity reserved the right to refuse the painting if it did not please. In 1436 Uccello was required to erase his first version of a

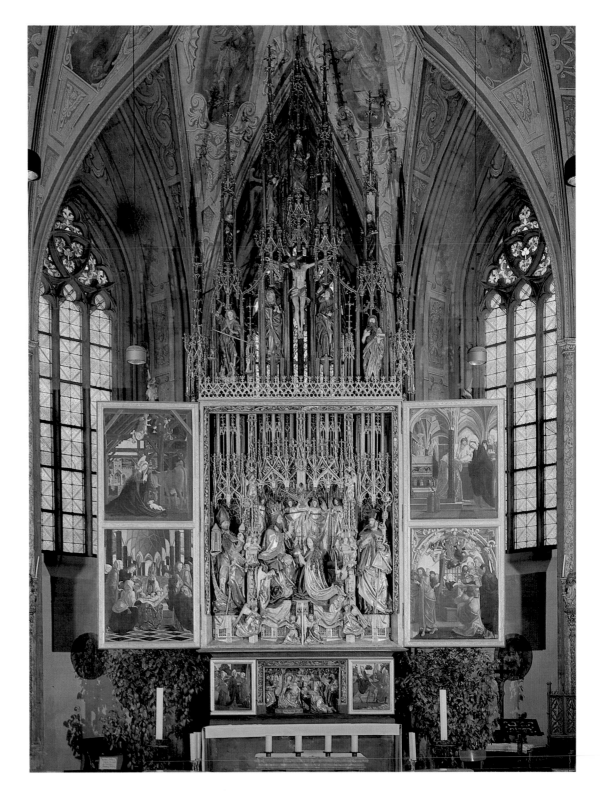

Fig. 177. Michael Pacher, *St Wolfgang Altarpiece*, completed 1481. St Wolfgang, Parish Church.

fresco of Sir John Hawkwood because it was not as it should have been, and start again. In 1476 the Tournai painter Philippe Truffin was sued for producing a sub-standard altarpiece which he had agreed to produce in 1474 'all perfect and finished' ('tout parfait et achevé').

Inevitably contracts were principally concerned with such matters as good materials, payment and delivery on time. But patrons and painters who thought that was all that needed to be considered might have had their priorities shaken by the preacher Jakob of Lausanne (died 1321) who remarked in a sermon: 'whoever makes an image for a fixed price is thinking more about its completion than its beauty, but he who waits for his payment for the sake of beauty cares more about beauty than about the speed of execution.'

THE WORKSHOP

THE WORKSHOP MEMBERS

The members of a workshop might include apprentices, journeymen and other assistants, and sometimes even fellow masters. Most painters probably took on an apprentice and their names were entered in guild registers. Regulations varied: in Florence the apprentice had to be over fourteen but not older than twenty-five. The relationship between master and apprentice was controlled by the guild statutes, and both the painter and the apprentice, or his parents, entered into an agreement concerning the conditions of work and the obligations on each side. A number of Florentine contracts from the end of the thirteenth century list the master's obligation to feed and clothe the apprentice, who in turn promises to serve the master faithfully and not to steal or run away. Similar conditions occur in Northern European contracts of apprenticeship; in addition, the apprentice often seems to have paid fees to the master during the early years of his apprenticeship, the position only being reversed towards the end of the term, when the apprentice was presumably reasonably useful and productive.

As has been pointed out, the length of an apprenticeship as stipulated by the guilds of the different towns varied: generally it was about four years, but it could be as little as two or as many as eight years. It is doubtful whether such regulations were always strictly enforced. In Florence, Neri di Bicci records an agreement in 1456 with a certain Cosimo di Lorenzo who was taken on for only one year to learn the art of painting; he had to work whenever the master wished, day or night (although the latter was forbidden in guild regulations), even on holidays if so required. The agreement also mentions the fact that Cosimo (who not surpris-ingly left before the completion of his term) had already worked for Neri in the past.

Similarly, the painter Jacques Daret seems to have spent at least ten years in the Tournai workshop of Robert Campin before he was eventually registered as an apprentice in 1428. Although Daret was evidently practising as a painter before his registration (suggesting considerable irregularities in the Tournai guild registers at the time), sometimes boys may have begun their careers more as servants, employed to perform menial tasks such as the cleaning of the workshop, leaving the apprentices free to concentrate on learning their craft. Certainly, in the sixteenth century, when Lorenzo Lotto took on a fourteen-year-old boy, he was to spend the first three years helping in the house as well as the workshop, doing the cleaning, cooking and shopping; after that he would be 'more free to study the art'.

Little is known about the teaching of apprentices, but initially priority seems to have been placed on learning how to draw. In fifteenth-century Tournai an apprentice who wished to study drawing had to serve only one or two years, whereas if he wanted to paint as well he had to serve for four years. Cennino Cennini, in his famous treatise, *The Craftsman's Handbook*, written at the end of the fourteenth century, recommends that a trainee painter should first spend a year drawing, presumably to see if he has any aptitude for the profession, followed by six years learning to grind colours, prepare panels and to apply gold leaf (keeping up his drawing all the while). Only then can he begin to paint. To master the techniques of fresco and tempera painting would apparently take a further six years. Cennino himself claims to have spent twelve years with his master, Agnolo Gaddi, but in his efforts to promote his craft he is almost certainly guilty of exaggerating the time necessary to learn the various skills.

Towards the end of the period, particularly in Italy, there may have been a change of emphasis in the training of painters. An agreement of 1467 between the Paduan artist Francesco Squarcione – teacher, and adoptive father of, among others, Mantegna – and a certain 'master Guzon, painter', specifies that the latter's son is to be taught subjects such as perspective, foreshortening and the measured proportions of the naked human body. As the son of a painter, the boy had probably been apprenticed to his father and had therefore already learnt the practical details of his craft. A period of further study on completion of the official term of apprenticeship is likely to have been quite usual and guild records show that very few painters immediately registered as masters. Indeed those young painters who were not the sons of painters and therefore did not benefit from preferential rates of entry to the guilds may have needed to work as assistants for several years to raise the sums of money necessary to become a master. And many probably never did become masters.

It is assistants, and not, as is frequently thought, apprentices, who are likely to have been the most numerous members of a workshop staff. As assistants were not required to be registered with the guilds, it is seldom known how many were in a workshop at any one time. For decorative projects at Lille in 1454 and at Bruges in 1468 Jacques Daret had four and three assistants respectively; an important painter like Rogier van der Weyden may well have had many more. Masaccio, when he was working on the Pisa altarpiece (No. 15) in 1426, had at least two assistants – his brother Giovanni and a certain Andrea di Giusto, both of whom had previously worked in the shop of Bicci di Lorenzo – and possibly a third, unnamed assistant who on one occasion collected a payment due to Masaccio. Again, an artist like Verrocchio, running a workshop engaged in the production of painting, sculpture and goldsmiths' work, is likely to have had a larger workshop staff; many of the painters who are thought to have been associated with Verrocchio at various times may have worked as assistants rather than as apprentices. For some painters a relatively short spell with a master in the capacity of an assistant may have had more influence on their development as an artist than their several years of apprenticeship with a previous master. In spite of the fact that in his early works Raphael seems to have completely absorbed the manner of Perugino, there is no evidence that he was ever apprenticed to him (see No. 61).

In 1504 Raphael was proposing to go to Florence 'to study'. He was by then well established as a painter, but the idea of assistants using the interim period between being an apprentice and a master to further their experience is suggested by the Florentine

Giusto d'Andrea, who, writing in about 1440-57, describes how he worked as an assistant to Neri di Bicci for two years at a salary of 12 florins the first year and 18 florins the second, as well as a pair of hose a year. He was then self-employed for a year and earned well, but in order to improve his skills in fresco painting he went to work for Benozzo Gozzoli.

In Northern Europe and especially in Germany there was a tradition of travelling assistants or journeymen in many crafts, and the young craftsman was encouraged to travel when he had completed his training. Dürer, on completion of a three-year apprenticeship in Nuremberg with the painter Michael Wolgemut, travelled in the Upper Rhineland and possibly Holland. He followed this with visits to Colmar (where he had hoped to meet the painter and engraver Martin Schongauer) and Basel before returning to Nuremberg.

The part played by these assistants – and also perhaps by the more precociously talented apprentices – in the production of paintings would have varied greatly. Sometimes they may have been responsible for virtually the entire execution of a painting, even if it was then sold under the name of the master painter and perhaps signed by him. The painting techniques of the fourteenth and fifteenth centuries, with their carefully planned designs invariably divided into distinct colour areas, allowed many opportunities for collaboration. With the aid of scientific and photographic methods of examination, it is sometimes possible to suggest ways in which the labour may have been divided (for example see p. 188 and No. 3), but often, particularly in the case of the multi-layered techniques of early oil painting, the contribution of the workshop assistant may no longer be discernible.

Another important duty of the workshop would have been to assist in the laborious preparatory stages in the production of a painting, for example the application of grounds to panels (see pp. 162-4), and the grinding and mixing of pigments to make paint (Fig. 178). While learning to prepare colours was clearly an important part of an apprentice's training, there is evidence that in some workshops more experienced assistants may have been employed as specialist colour makers. A surprising number of apprentices named in guild records never seem to have registered as masters (although some may have moved to towns where no records survive); perhaps through lack of talent or initiative they were condemned to work in this essential but subsidiary role. The accounts for frescoes painted in the chapel of San Jacopo in the cathedral at Pistoia in 1347 show that an assistant, described as a painter by profession, was taken on at much the lowest daily rate of pay solely to grind colours; and in 1493 Francesco

LEFT Fig. 178. Niklaus Manuel Deutsch, *Saint Luke painting the Virgin*, 1515. Wood, 121.5×84.2cm. Bern, Kunstmuseum. On the left are some of Saint Luke's painting materials. In the background an apprentice or assistant has been grinding colours and is setting them out on a palette.

RIGHT Fig. 179. Follower of Quinten Massys, *Saint Luke painting the Virgin*, early sixteenth century. Oak, painted surface 113.7×34.9cm (NG 3902).

Gonzaga, Duke of Mantua, had a 'master who makes [that is, prepares] ultramarine blue, and other perfect colours' brought from Venice to work with Mantegna. Whether this master was a master painter is not stated, but it was very common for a painter to collaborate with a fellow master, particularly on large and complex projects – a fresco cycle, for example, or a major altarpiece.

The accounts for the San Pier Maggiore Altarpiece (No. 9), one of the largest altarpieces to be produced in Italy in the second half of the fourteenth century, suggest that from the initial design to the final installation took little more than a year. This would have been impossible without close and efficient collaboration between the principal masters involved, Jacopo di Cione and Niccolò di Pietro Gerini; a third master may well have been responsible for the gilding and its decoration. Jacopo and Niccolò are documented as having worked together on other occasions. Niccolò also collaborated with a number of Florentine painters. Sometimes, it would seem, he was responsible for the design rather than for the actual execution of the commission. Similarly, guilds in Northern European towns often acknowledged a master's need to subcontract to another master, or even to commission work from him.

In Italy master painters could enter into a *compagnia* whereby painters shared their profits without necessarily collaborating on the same work. Sometimes the partnership involved sharing the same premises, but the fact that in many towns painters, like other trades and professions, tended to congregate in particular areas also facilitated collaboration between neighbouring workshops. In Florence, for example, the legal problems caused by Pesellino's death while working on the Trinity Altarpiece (see Fig. 57) were further complicated by the fact that in 1453 he had entered into a partnership with three other painters who had workshops in the same street, the Corso degli Adimari (now Via dei Calzaiuoli).

PREMISES, TOOLS AND EQUIPMENT

In this period most depictions of artists at work are in fact representations of Saint Luke, patron saint of painters, who is shown either drawing or painting a portrait of the Virgin (Fig. 179). However, this was a mainly Northern European tradition and no contemporary Italian illustrations of painters' workshops exist. Although Saint Luke is usually given a comfortable domestic setting, often on what appears to be an upper floor, most work-

shops must have been a great deal more functional. Illustrations of medieval shops and workshops (for crafts other than painting) show that they opened on to the street. This was useful for selling things and gave a good light and facilitated access for large paintings. Inventories show that painters sometimes lived in the premises above the shop, their household effects being itemised together with the contents of the workshop.

When a painter was working away from his home base, or perhaps employed on very large panels and altarpieces, temporary arrangements were sometime made. Thus when the authorities responsible for the church of San Giovanni Fuorcivitas in Pistoia decided to commission an altarpiece in 1345 and found that they would have to employ a visiting painter, part of the church was partitioned off to make a temporary workshop. This enclosure was furnished with straw mats, almost certainly not for the comfort of the painter, but rather to keep down the dust and dirt. Dust and grit would have been injurious to any painting of the fourteenth and fifteenth centuries, particularly to gilding and to slow-drying oil paint; while to retain the brilliance and purity of colours, containers and utensils would have had to be scrupulously clean, a point stressed by the anonymous German author of the fifteenth-century treatise known as the Strasburg Manuscript.

Good light must have been a constant problem. Leonardo, with his preoccupation with light, seems to have been the first to recognise the qualities of light from a north-facing window, subsequently favoured by most painters. If a south light was unavoidable he suggested that the window be screened with fabric to reduce its harshness; to produce a flattering light for portraits a linen awning should be set up. In Northern Europe the shortness of winter days would have severely restricted working hours. The weather too had some effect on working practices: for the application and decoration of gold leaf, humid winter weather was, as Cennino observed, more suitable. On the other hand, to accelerate the drying of an oil-based paint or varnish, warm dry conditions or even direct sunlight were needed. Bellini's excuse to Isabella d'Este that he could not finish a painting in the winter (see p. 75) was not entirely fabricated.

At any one time a painter is likely to have had several projects under way and at various stages of completion. The imaginary Netherlandish workshop described by Jean Lemaire de Belges in his allegorical poem of 1504-5 is full of finished and unfinished paintings; and the inventory made of the contents of Filippino Lippi's workshop on his death in 1504 records works in every state: from bare wooden panels, panels prepared with gesso alone,

a gessoed panel with a drawing of the Virgin – presumably an underdrawing in preparation for painting (see pp. 164ff.) – through to panels listed as begun but not finished, including another Virgin, a Saint Francis and a Saint Bernardino.

On some pictures splashes and sagging droplets of paint indicate that they were painted in a vertical position. In representations of Saint Luke where he is shown painting as opposed to drawing, the portrait of the Virgin is always on a simple three-legged wooden easel, usually with pegs to adjust the height of the picture. An inventory of the workshop stock inherited by the Brussels painter Vrancke van der Stockt from his father Jan in 1444 lists no fewer than seven wooden easels, all evidently needed since eighteen panels were in the workshop at the time. When the Venetian painter Jacobello del Fiore had his property auctioned in 1439 it included a curious easel apparently made of metal. Large panels may simply have been propped up against a wall, but some form of platform or scaffolding would have been needed to reach the upper parts. Scattered about the ground floor of Filippino Lippi's house were several narrow planks of pine, a wood not normally used for painting on in Italy (see p. 152). As they were each some eleven *braccia* (nearly 6.5m) long they are most likely to have been used for scaffolding.

Filippino's workshop was furnished with stools and benches, and with trestle tables, so that panels could be laid flat for the application of the gesso and any gilding. In addition, a table would have been needed for the preparation of colours for painting. Two porphyry slabs on which pigments were ground (see p. 187) are listed in the inventory. The Sienese painter and sculptor Neroccio de' Landi who died in 1500 owned at least six porphyry slabs of various sizes, together with several mullers – the stones with flat bottoms and dome-shaped tops used for the grinding of pigments.

When the Florentine painter Maso di Banco had his property sequestrated in 1341 he lost not only his stone slab but also his box of colours. Small chests containing little boxes and jars of pigments are recorded in the inventories of both Neroccio and Filippino, confirming that painters are likely to have had a basic stock of pigments. Indeed, some may have dealt in pigments as a side line: for example, in 1366 the Sienese painter Luca di Tomme sold pigments to the Sienese cathedral authorities for the decoration of the Baptistery. For major commissions, however, special supplies would have been bought in, or were sometimes provided by the patron (see p. 183).

As containers for the prepared paint, painters could use either mussel shells, like those listed by Jean Lemaire de Belges and

illustrated in some manuscript illuminations showing painters at work, or small earthenware pots. Fifty such pots were paid for as part of the expenses incurred in the execution of the San Pier Maggiore Altarpiece. Oil paints could be stored for a short while in jars covered with a membrane made from pigs' bladders. When ready to paint, the painter would set the colours out on a wooden palette (see Fig. 178). The palettes shown in depictions of Saint Luke are much like those in use today, differing only in that some have a handle like a paddle instead of a hole cut for the painter's thumb. For oil painting, a useful additional tool would have been a mahlstick, a long stick with a padded end which could be lent against the picture so that the painter could support and steady his hand when painting fine details.

Paint brushes were made of hairs from the tips of the tails of the minever (or ermine). The hairs were bunched together and inserted into cut sections of quills, the size of the quill determining that of the brush. A wooden handle could then be fitted to the other end of the quill. Larger, stiffer brushes of hogs' bristles were made in much the same way. They were used in wall painting and for the application of gesso but also, on occasion, in oil painting for the blocking in of backgrounds and underlayers (see Fig. 265). Cennino gives detailed instructions on the manufacture of brushes, and the accounts for a chapel at Brescia decorated by Gentile da Fabriano in 1414-19 include payments for bristle and cord for brushes, but it seems that, in major art centres at least, they could also be bought ready-made. For example, in the careful accounts Baldovinetti kept for the frescoes of 1471 in the Gianfigliazzi Chapel in Santa Trinità, Florence, he records buying fifty-eight brushes of various sizes from a brushmaker.

The application and decoration of gilding required further items of equipment. The inventory of Neroccio's workshop includes his gilder's cushion – the padded leather cushion on which the gold leaf is cut to size – and several burnishers, the smooth polished stones used to burnish the gilding (see p. 174). Equally important were the tools used for drawing. Neroccio owned a special desk for drawing, and Jean Lemaire de Belges has equipped his imaginary workshop with charcoal, drawing chalks, brushes, quill pens and metalpoints, all employed in drawing during the fifteenth century.

DRAWINGS AND PROPS

Drawings would have been an important part of a workshop's equipment, although few have survived from the fourteenth century, and none that can be linked with any known panel painting. The chief reason for this is that until the mid-fifteenth century, paper was expensive and was not manufactured in sufficient quantities for painters to use it to any great extent. Many drawings may have been lost to us because they were drawn on re-usable surfaces, such as a wooden block. Cennino describes how such a block, preferably of boxwood or some other close textured wood, should be prepared with a thin coating of ground bone. Alternatively he suggests erasable 'tablets which tradesmen use' of parchment, prepared with gesso and lead white in oil, and presumably obtainable ready-made. Later, paper coated with different coloured pigments incorporated into the preparation to tint the surface was employed. The drawing would be made with a metalpoint, usually of silver, which deposited on the slightly rough surface a thin coating of metal which rapidly tarnished, producing a fine grey line, in appearance rather like that of a hard graphite pencil. The only way to shade a metalpoint drawing is to build up the tones by repeated hatched strokes. As this technique is analogous to the careful hatched application of paint when working in egg tempera (see p. 188), drawing in metalpoint was an excellent training for the tempera painter, which was one reason why Cennino insisted on the trainee painter's need to keep 'drawing all the time, never leaving off, either on holidays or workdays'.

Of those few drawings which have survived from the fourteenth and early fifteenth centuries, some are on paper but most are on parchment. Parchment is prepared from the skins of calves, sheep and goats, with the finest quality, vellum, being made from the skin of young animals. Drawings on parchment are usually in pen and ink, and are detailed and highly finished, often with washes in watercolour (Fig. 180). Although some survive only as single sheets, originally they were bound into volumes known as pattern or model books. These pattern books contained collections of designs, motifs and individual figures to be referred to in assembling a composition for a painting. A pattern book known as the 'Vienna Vademecum', which was probably compiled by a Bohemian or Austrian painter in the late fourteenth or early fifteenth century, includes heads of different types (among them figures intended for use in a Crucifixion), each carefully drawn in metalpoint on prepared paper pasted to thin wooden panels (Fig. 181).

Jacopo di Cione had to depict forty-eight different saints in the San Pier Maggiore Altarpiece (No. 9). At first sight the heads seem individually characterised, but they are unlikely to have been painted, or drawn, directly from life. They are probably

taken from types stored in a pattern book (or in the artist's memory). Some in fact are mirror images, so that the features of the youthful Saint Stephen in the front row on the left reappear, reversed, for Saint Lawrence in the same position on the right, while the saints in Jacopo's *Coronation of the Virgin* painted for the Zecca (the mint) in Florence in 1372-3 bear a close resemblance to their predecessors in the San Pier Maggiore Altarpiece. The battered condition of most surviving pattern books indicates that they were in constant use, and the often variable quality of the drawings suggests that apprentices and other members of the workshop added to the compilation of drawings, filling in any blank spaces. Those that survive should therefore be regarded as anthologies of useful ideas rather than a collection of personal inventions.

Most pattern-book drawings give the impression of having been copied from other drawings, However, it is sometimes possible, particularly in the case of studies of animals, to trace them back to a drawing which has so much more sense of life that it can be taken as the original on which the others are based. Drawing was of course the only way that artists could record the work of their predecessors and contemporaries, and until the introduc-

LEFT Fig. 180. Lombard School, *Two Cheetahs, c.* 1400. Brush drawing and watercolour on parchment, 15.6×11.5cm. London, British Museum.

BELOW Fig. 181. Austrian School(?), *Heads from a model book (the 'Vienna Vademecum')*, first quarter of the fifteenth century. Metalpoint on prepared papers pasted to wooden panels, each panel 9.5×9cm. Vienna, Kunsthistorisches Museum.

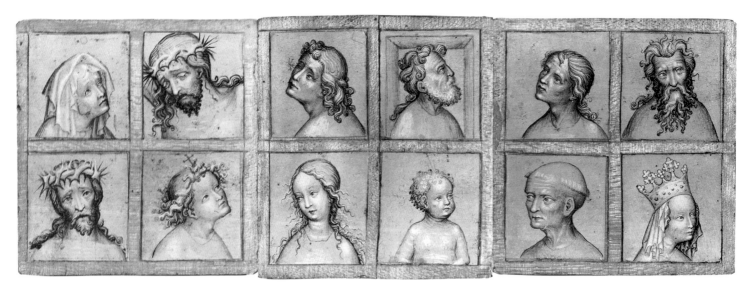

Fig. 182. Workshops of Gentile da Fabriano and Pisanello, *Drawings after one of Altichiero's frescoes in the Oratorio di San Giorgio, Padua, and Giotto's Navicella, Rome*, late 1420s or early 1430s. Pen and ink with wash on parchment, 23×36cm. Milan, Ambrosiana.

tion of printmaking in the later fifteenth century there was no other way of transmitting visual ideas and information. Cennino discusses the difficulties of drawing in an ill-lit church. Drawings from a travel sketchbook, probably associated initially with the workshop of Gentile da Fabriano and then taken over on his death in the late 1420s by Pisanello, include a careful record of one of the frescoes by Altichiero in the Oratorio di San Giorgio at Padua (Fig. 182), together with a copy of the *Navicella*, Giotto's famous mosaic in Old St Peter's in Rome – drawn by other artists as well – and several studies from antique sculpture which seem to have been made on the spot. In 1469 when arrangements were being made for Cosimo Tura to see the chapel at Brescia painted by Gentile da Fabriano some fifty years previously (see p. 141), it was suggested that he would need three or four days 'to enjoy it' but also, no doubt, to make drawings as a record.

A group of German drawings of the late fifteenth century, generally associated with an artist known as the Master of the Coburg Roundels, seem to have been made to record the appearance of works of art, including the now dismembered altarpiece by Rogier van der Weyden, of which *The Magdalen Reading* may be a fragment (see No. 22). The designs may also have been intended for adoption by the painter. In the Netherlands the use of patterns continued well into the sixteenth century. Models based on designs by leading painters like Rogier van der Weyden and Hugo van der Goes could be assembled and reassembled in what amounted to mass production of religious images (see p. 72). Among the items concerned in a legal dispute of 1519-20 at Bruges between the Italian painter Ambrosius Benson and Gerard David – a dispute which resulted in a brief spell in jail for the elderly and distinguished David – were several patterns, some of which Benson claimed as his; others had been borrowed for a fee from another painter, Aelbrecht Cornelis.

Patterns were sometimes left in wills as part of a workshop stock. Vrancke van der Stockt, who had inherited his workshop from his father (see p. 140), in turn left his sons his 'patterns and everything else that is drawn on paper'. Dieric Bouts divided his workshop contents, including presumably patterns, between his sons. When Goosen van der Weyden had to represent a figure in old-fashioned dress for his *Donation of Kalmthout* of about 1511 he seems to have had recourse to a drawing made for, or after, a portrait by his grandfather Rogier. Jacopo Bellini's books of drawings, which survive still in their original bindings, were bequeathed by his widow in 1471 to their son Gentile. However, these drawings, which consist mainly of elaborate architectural and landscape settings, often involving tiny narratives, are perhaps not so much patterns but rather a series of compositional ideas for paintings.

Before any paint was applied to a medieval or early Renaissance panel or canvas the design had almost always been carefully planned. Working out a composition during the process of painting was inadvisable for several technical reasons. The egg tempera medium used in the fourteenth and much of the fifteenth centuries cracks and flakes if it is built up too thickly, making repeated alterations impossible. At the same time, the oil painting techniques which evolved in the Netherlands in the early fifteenth century depend for their effects on retaining some of the reflective properties of the underlying white ground, easily lost when too many layers of colour are applied. Furthermore, if

gilding was to be used it was first necessary to establish those areas to be gilded, since this was an entirely separate process from painting. In a drawing for an altarpiece attributed to Cosimo Tura (Fig. 183), each of the areas of the architectural background to be gilded have been indicated by the word 'horo' (gold).

In the absence of surviving drawings by fourteenth-century Italian painters, the only clues as to how they may have gone about designing and composing a panel painting are supplied by *sinopie* – charcoal and brush drawings made on the *arriccio*, the first rough plaster applied to a wall for fresco painting. These drawings are then covered by the *intonaco*, the finer plaster on which the mural is actually painted; they are revealed to us only when the *intonaco* has to be detached for conservation reasons. Some of these *sinopie* are astonishingly free and sketchy, the painters apparently working out much of the design on the wall surface. While infra-red examination (see p. 164) does not suggest that such a process took place on panel paintings, rough sketches in charcoal, later erased in the way suggested by Cennino, may have existed. Instead paper or re-usable blocks were probably employed.

Pisanello is the earliest painter with enough surviving drawings to give some idea of their role in the creation of his medals, panels and wall paintings. They include rough compositional sketches, such as that for a scene in a meeting hall squeezed into a blank space on a sheet of studies of dogs; some surely drawn from life; others perhaps sketched from memory (Fig. 184). Some of the drawings for the *Vision of Saint Eustace* (No. 24) may have been made specifically for that work (for example No. 24c), but

Fig. 185. Jan van Eyck, *Drawing for the Portrait of Cardinal Niccolò Albergati,*
c. 1438s. Metalpoint on paper prepared with chalk (some traces of colour),
21.4×18.1cm. Dresden, Kupferstich-Kabinett.

Fig. 186. Jan van Eyck, *Portrait of Cardinal Niccolò Albergati,* probably 1438.
Panel, painted surface 32.5×25.5cm. Vienna, Kunsthistorisches Museum.

others, and in particular the study of a hare (No. 24b) – which, significantly, appears in reverse – still retain the character of pattern-book drawings.

The survival of drawings is not a reliable indication of how many were actually made, but it does seem that many more types of drawing, if not many more drawings, were produced in the second half of the fifteenth century than before. Certainly the making of drawings as studies for specific paintings became more common, particularly in Italy. Little is known about developments among the more innovative of the painters in Northern Europe as so few drawings have survived there. A notable exception is the preliminary study, with notes on colours to be used in the painting, by Jan van Eyck for the portrait of Cardinal Albergati (Figs. 185 and 186).

There are several reasons for the increase in the variety of drawings and in the purposes they served: standard pattern-book drawings could not easily be adapted to the more naturalistic approach taken by many painters; consistent and unified lighting meant that the fall of light over each figure and piece of drapery had to be worked out afresh; the anatomy of a figure had to be more convincingly represented, while the use of perspective led to difficult foreshortenings; and a growing appreciation of novelty and the widening of the repertoire to include secular and complex narrative subjects discouraged the adoption of traditional schematic compositions.

For architectural settings, accurate perspective studies needed to be ruled and drawn (Fig. 187) and towards the end of the period an increasing number of topographically accurate land

LEFT Fig. 187. Leonardo da Vinci, *Perspective study for the Adoration of the Kings, c.* 1482. Pen and ink over metalpoint on paper with wash and white heightening, 16.5×29cm. Florence, Uffizi.

LEFT Fig. 188. Albrecht Dürer, *Study of water, sky and pine trees*, probably 1495 or 1496. Watercolour and bodycolour on paper, 26.2×36.5cm. London, British Museum.

scape drawings seem to have been made. Many of these were probably drawn with the backgrounds of paintings in mind – in marked contrast to Cennino's idea of copying mountains 'from nature' by basing them on small rocks and stones brought into the studio. However, by the end of the fifteenth century, Dürer seems to have been drawing landscapes while on his travels purely to record locations, weather conditions and so on (Fig. 188). It is easy to suppose that studies of this kind had been adapted by painters such as Bouts or Pollaiuolo (Nos. 32 and 40) at an earlier date for the backgrounds of their paintings.

In Italy studies from life were often made using members of the workshop as models, for example that by Perugino for Tobias and the Angel from the altarpiece for the Certosa di Pavia

Fig. 189. Perugino, *Studies for Tobias and the Angel, c.* 1500. Metalpoint with white heightening (oxidized) on prepared paper, 23.8×18.3cm. Oxford, Ashmolean Museum.

(Fig. 189 and No. 59). The nude figure was also drawn, either from life or from antique sculpture: listed in Neroccio's workshop inventory are three plaster casts of Apollo, together with casts of heads and a foot, all presumably from the antique. For difficult subjects such as babies and flying angels, models made from wood, clay or plaster would have been employed. Models which could be suspended are mentioned among the contents of Fra Bartolommeo's workshop in the early sixteenth century, and the eight 'models for painting figures' owned by Neroccio may have served similar purposes. The Florentine sculptor and architect Antonio Filarete in his treatise compiled in 1460–4 describes the use of jointed wooden figures, which could be dressed in linen soaked in glue and then allowed to dry so that the arrangement of the folds could be studied.

Studies of draperies stiffened with dilute gesso were made by members of Verrocchio's workshop, in particular Lorenzo di Credi and Leonardo. It is perhaps significant that Verrocchio, like Filarete, was a sculptor, for this practice may have been suggested by the methods of making ephemeral statuary. These studies were often on fine linen rather than paper, using brown and white pigments applied with a brush (Fig. 190), a technique not unlike the monochrome undermodelling seen on Leonardo's panel paintings (see pp. 171 and 203). For sketches and some studies, quill pens and ink – usually iron-gall writing ink which, although black when first applied, discolours to brown through age and exposure to light – were still employed, but metalpoint was gradually being replaced by black drawing 'chalk', a carbonaceous shale which came, according to Cennino, from Piedmont. The advantages of black chalk (and red chalk, introduced at the very end of the fifteenth century) were that the paper no longer needed to be prepared and the drawn lines could be smudged in a way that suggests parallels with the softer, more blended effects obtainable with oil paint. The soft modelling of the drawing *Portrait of a Man* attributed to Giovanni Bellini (Fig. 191) can be compared with that in Bellini's painted portrait of Doge Leonardo Loredan (No. 60).

These specific studies could at any time become patterns if re-used by the painter or a member of the workshop. Thus there is often disagreement now as to whether a drawing is a study for a painting or whether it has been made after the painting (or after a study for it). This is the case with the drawings of saints associated with Pesellino's Trinity Altarpiece, while those drawings which must once have existed for the foreshortened flying angels seem to have been employed as patterns in a *Nativity* (Paris, Louvre) variously ascribed to members of Pesellino's circle.

Fig. 190. Leonardo da Vinci, *Drapery study, c.* 1470–80. Brown and white pigments applied with a brush on linen, 28.3×19.3cm. London, British Museum.

Fig. 191. Attributed to Giovanni Bellini, *Portrait of a Man, c.* 1495. Black chalk with grey wash on paper, 39.2×28cm. Oxford, Christ Church.

Similarly, the drawing which must have been made by Giovanni Bellini in revising the poses of Saint Peter and his assailant in the *Assassination of Saint Peter Martyr* (Fig. 192) has been re-used, and on exactly the same scale, in a variation of the composition in the Courtauld Institute collection (Fig. 193).

Some of the naturalistically painted objects and details which appear in fifteenth-century paintings, first in the Netherlands and later in Italy, may have been painted directly from studio props either belonging to the painter or borrowed for the purpose. The 'polished marbles as clear as beryl' in the imaginary workshop described by Jean Lemaire de Belges may possibly be poetically described and unusually clean grinding stones, but they can also be interpreted more literally as pieces of polished marble and

translucent stone kept for copying in paint, and resulting in the astonishingly convincing representations of marble to be seen in paintings by, among others, Gerard David (Fig. 194 and No. 69). Other props would have included textiles – even the highly stylised patterns of fourteenth-century cloths of gold executed by the technique of *sgraffito* (see p. 176) were originally based on real textiles; precious oriental carpets – those shown in paintings being a crucial source of information for their early history; and jewellery.

For a goldsmith and sculptor like Verrocchio, finding suitable jewellery for copying would not have been a problem. The identical brooch worn by the Virgin and by one of the angels in *The Virgin and Child with Two Angels* (Figs. 195, 196, 197) is likely to

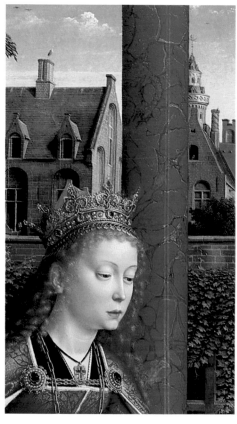

TOP Fig. 192. Ascribed to Giovanni Bellini, *The Assassination of Saint Peter Martyr, c.* 1510. Wood, painted surface 99.7×165cm (NG 812).

ABOVE Fig. 193. Workshop of Giovanni Bellini, *The Assassination of Saint Peter Martyr, c.* 1510. Wood, 63.6×100.4cm. London, Courtauld Institute Galleries (Lee Collection)

RIGHT Fig. 194. Gerard David, detail from *The Virgin and Child with Saints and Donor.* See No. 69.

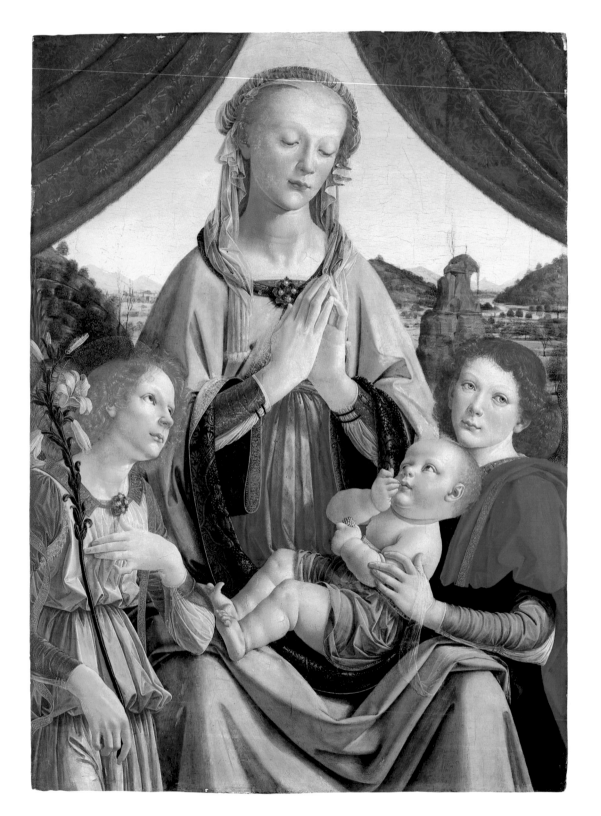

TOP Fig. 196. Detail of the brooch worn by the Virgin in Fig. 195.

ABOVE Fig. 197. Detail of the brooch worn by the Angel in Fig. 195.

Fig. 198. Raphael, *Studies of the Virgin and Child, c.* 1507-8. Pen and ink over red chalk on paper, 25.4×18.4cm. London, British Museum.

have been copied from a real one available in the workshop. Giovanni Bellini, on the other hand, working in Venice where there was not the same tradition of painters practising the other arts, had to borrow a silver crown from the Dominicans of SS Giovanni and Paolo presumably for a painting of the Virgin.

However, the artist in the late fifteenth century, especially in Italy, was interested in painting much that could be studied only outside the workshop. The new concern to represent movement in the human figure and in nature gave greater importance to drawings made quickly. A wriggling baby, a rearing horse or a turbulent river can only be recorded in this way, and sketchy

drawings were also essential for working out compositions in which every figure was active, as in a Holy Family by Leonardo – or by Raphael (Fig. 198) after he had studied Leonardo's work. Leonardo's concept of pictorial unity also entailed a revolution in the nature of drawing, for it meant that a composition could not be compiled out of separate parts but had to evolve in an organic sense. The loose compositional sketch, instead of being merely preliminary, came to possess a new importance. In Leonardo's drawing of the Virgin and Child with Saint Anne and the infant Saint John (No. 66), for example, passages which are exploratory and vague are preserved beside others which are highly finished.

TECHNIQUES

PANELS

Most surviving paintings from the thirteenth to the early six-teenth centuries are on wooden panels. The type of wood depended on the available trees. In Italy the wood most com-monly used was poplar – then usually the white poplar – which grows to a considerable size, yielding very large planks. Owing to its rapid growth, however, poplar has many faults: it is soft and weak, so the planks have to be cut thickly for strength; its grain is erratic, and it is particularly susceptible to damage by woodworm and to warping with changes in humidity. Never-theless, deforestation, and the need to use the quality timbers for more important purposes such as shipbuilding, left Italian painters with little choice. Occasionally they obtained panels of better quality woods such as walnut. Although walnut was employed mainly for making furniture, Leonardo mentions its use and it has been identified as the support for a few works in the Louvre by Leonardo and his followers and for some of the Mila-nese paintings from the late fifteenth century in the National Gal-lery. Other alternatives to poplar included lime – suggested by Cennino and used by Antonello for his *Saint Jerome in his Study* (No. 41) and by Crivelli for some, but curiously not for all, of the panels of the Demidoff Altarpiece (No. 46) – and cypress, a rare example being Pollaiuolo's *Apollo and Daphne* (Fig. 257).

North of the Alps painters had access to a wider range of timbers. In the Netherlands, France and England strong and dur-able oak panels were generally used. Even though oak is in-digenous to these countries it was still worth importing supplies from the Hansa towns on the Baltic. In 1467 the carpenter who made the panels for *The Last Judgement* and the two scenes show-ing the Justice of Otto painted by Dieric Bouts for the town hall at Louvain went to the port of Antwerp to obtain timber for work on the church of St Bavo, and also to buy forty-five large planks of oak suitable for painting. In Germany and Austria, as well as oak (used mainly for North German panels), lime, beech, chestnut, cherry, and softwoods such as pine and silver fir were employed. Similarly, in the Spanish peninsula several different woods were used but with regional variations so that, for example, chestnut was common in Portugal and the western regions of Spain, poplar in Catalonia, and pine in Valencia, Castile and Aragon.

To make panels, planks of wood were glued together, some-times with wooden dowels or other devices to reinforce the joins. Large panels, and Italian altarpieces in particular, were strengthened with battens nailed to their backs (Fig. 199), both to restrict warping of the panel and to support the structure when it was set up on an altar. Few of these battens have survived on the panels in the National Gallery: at best only the nails and the clean marks left by the battens remain to provide clues as to the original construction. Large Netherlandish and German panels – of which comparatively few survive intact and none in the National Gallery – do not seem to have needed such extensive reinforce-ment, probably because of the greater strength and stability of the oak used in their construction.

If they were not intended to be visible, the reverses of Italian panel paintings were usually left rough: faults in the wood such as knots and small splits were often ignored, and in raking light the marks made by the tools used to work the timber can be seen. (Fig. 200). Northern European panels, on the other hand, even when large, are generally beautifully crafted and finished: the planks were cut from the more dimensionally stable parts of the

Fig. 199. Francesco Botticini, *Saint Jerome in Penitence, with Saints and Donors* (Fig. 56). Reverse of the main panel.

Fig. 200. Jacopo di Cione, *The San Pier Maggiore Altarpiece* (No. 9). Reverse of the right panel of the main tier in raking light.

Fig. 201. Gerard David, *An Ecclesiastic Praying* (Fig. 136). Reverse of the panel.

log, the edges often neatly bevelled for insertion into the frame (Fig. 201), and the backs planed smooth and occasionally coated to reduce the dangers of the wood warping and splitting. Panels originating from Brussels and Antwerp were often marked with a stamp indicating their place of origin and, presumably, a certain approved level of craftsmanship.

Small panels of simple construction may sometimes have been made up in the painter's workshop. The inventory of Neroccio's workshop lists several planks of poplar and one of walnut, while that of Filippino Lippi includes a number of wood-working tools, among them a plane and two saws. However, contracts and payments (see p. 130) show that for large altarpieces, particularly those incorporating complex framing elements (see below), specialist carpenters and woodcarvers were almost always employed, either directly by the patron or through subcontracting by the painter. The names of many carpenters and woodcarvers are recorded. The surviving panels of the Monte Oliveto Altarpiece painted by Spinello Aretino in 1384-5 are actually inscribed with the names of the carpenter and the gilder, and all three craftsmen were party to the original contract.

Fig. 202. Francesco Botticini, *Saint Jerome in Penitence, with Saints and Donors* (Fig. 56). Detail from reverse of the main panel (Fig. 199).

Sometimes the carpenters were distinguished craftsmen in their own right. The panel and frame of the Trinity Altarpiece painted by Pesellino (see Fig. 57) were ordered from Antonio Manetti, disciple and biographer of Brunelleschi and at the time responsible for important construction work on the Duomo and other major churches in Florence. A monogram impressed into the back of the panel of *Saint Jerome in Penitence with Saints and Donors* painted by Francesco Botticini may well be that of the carpenter (Fig. 202). This altarpiece is rare among those at the National Gallery in having retained not only the battens which reinforce the panel but also a substantial part of its original frame.

FRAMES

Throughout the period under discussion the frame was frequently treated as an integral part of the construction of the panel. For a portrait or for a small diptych or triptych the whole frame might be attached to the panel before painting. Fifteenth- and early sixteenth-century representations of Saint Luke painting the Virgin invariably show him at work on a panel already in its frame. Indeed, sometimes panel and frame consisted of a single piece of wood. Early retables – although not that by Margarito (No.1) – often have the painted surface carved out and recessed into the front face of the panel, leaving a plain flat moulding with a bevelled inner edge to act as the frame. This practice survives in the Wilton Diptych (No. 10) and in some small Netherlandish panels of the early fifteenth century, among them

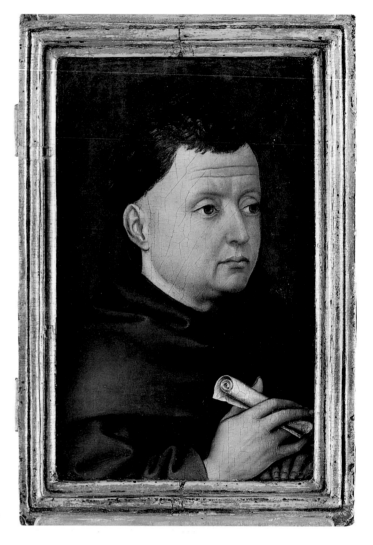

Fig. 203. Workshop of Robert Campin, *Portrait of a Man*, early fifteenth century. Oak, 22.7×15.2cm (including frame) (NG 6377).

The Virgin and Child (see Fig. 40) and the portrait of a monk painted in the workshop of Robert Campin (Fig. 203), where the more complex framing mouldings are carved from the same plank as the picture surface.

The vertical mouldings of the frame of Jan van Eyck's *Man in a Red Turban* (No. 17) are also part of the same plank as the painting support, but in this case the horizontal mouldings have been made separately and attached to the front of the panel by means of round wooden pegs or dowels. The explanation for this lies in the far sharper character of the mouldings which van Eyck pre-

ferred. These could only have been made with a plane but this could not cut across the oak grain. While dowelling of separately carved frame mouldings to the panel seems to have been quite common in the Netherlands, in Italy it was more usual to secure the mouldings with nails. However, a series of round holes in the unpainted borders of Antonello's *Portrait of a Man* (Fig. 117) suggests that the original frame (now lost) may have been pegged in place, perhaps in imitation of a Netherlandish example.

Double-sided Netherlandish and German panels, such as the shutters of altarpiece wings or paintings with decorated backs, were often slotted into frames built around the side and back edges of the panel, so that the reverse as well as the front was framed by a simple moulding. In the case of altarpieces, if the centre panel was large, cross battens could be fixed to the frame rather than to the panel, giving the panel support without restricting its movement. These larger altarpieces were not necessarily painted in their frames: only on completion was Bouts's *Last Judgement* inserted into its frame (which had, in fact, previously contained another painting).

This was also the practice for most Italian altarpieces of the fifteenth century. But in the previous century, particularly in Tuscany, as much of the frame as possible was built on to the panels of large multi-sectioned altarpieces before they were gilded and painted (see, for example, No. 5). Only a few framing elements, for example columns and crockets, needed to be added – partly to hide the joins between sections – once the altarpiece was in position. In Northern Italy, on the other hand, where a taste for flamboyant and highly ornamented architecture led to correspondingly elaborate polyptych designs, it was more practical to construct the frame separately and to insert the panels after they had been painted. Panels made for insertion into this type of polyptych frame can usually be recognised by the fact that the gesso ground (see below) extends into and sometimes over the spandrels of the arched tops to be covered by the frame (Fig. 204). Conversely, if the frame was originally built on to the panel and subsequently removed, only bare wood remains in the spandrels.

When, in the fifteenth century, altarpieces began to be painted on large unified surfaces and the frames confined to the border, the frames were almost always constructed separately. How-

LEFT Fig. 204. Dalmatian School, *Altarpiece of the Virgin Mary* (Fig. 13). Inner left panel: top, *The Angel appearing to Saint Joachim*; bottom, *The Birth of the Virgin*. Paint splashes and a sketch for the architecture(?) can be seen in the spandrels which would have been covered by the frame.

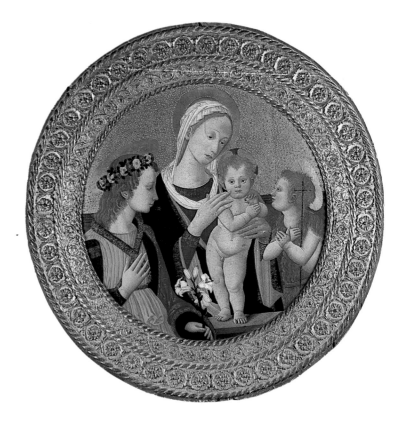

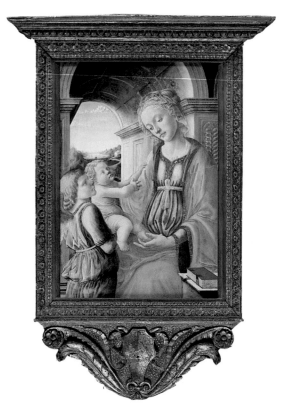

Fig. 205. Florentine School, *Tondo: The Virgin and Child with Saint John the Baptist and an Angel*, second half of the fifteenth century. Wood, diameter of the painted surface 69.9cm (NG 1199).

Fig. 206. Follower of Botticelli, *The Virgin and Child with an Angel, c.* 1480. Poplar, painted surface 69.9×48.3cm (NG 589). The frame is on loan from the Victoria and Albert Museum.

ever, there was still close consultation between the painter and the woodcarver or stonemason who made the frame and sometimes the panel itself (see p. 154). Contracts and payments show that a considerable proportion, sometimes as much as a half, of the cost of an altarpiece lay in the frame. Even in Venice, where painters were traditionally little involved in the sister arts, the relationship between the altarpiece and the architectural frame was often carefully worked out – as in some altarpieces by Giovanni Bellini, for example – so that the real flanking pilasters could be repeated within the painting and thus appear to belong to the same space. This would seem likely to have been the case with the altarpiece by Cosimo Tura (No. 44).

The continued use of built-in frames on smaller Italian panels is suggested by the fact that traces of bole and gilding from the frame are often visible around the edges of panels which have lost their frames; in 1464 Mantegna refused to varnish some panels on the grounds that the frames had not yet been gilded – presumably he was afraid of the gold leaf sticking to the still-tacky varnish. A

plain narrow moulding has survived around three sides of the late fifteenth-century *Portrait of Costanza Caetani* by a follower of Ghirlandaio (NG 2490); and the more ornate carved frame on Baldovinetti's *Portrait of a Lady in Yellow* (Fig. 116) also appears to be original, although completely regilded.

Round panels – *tondi* – too, often had integral frames. The frame of the Florentine School *tondo The Virgin and Child with Saint John the Baptist and an Angel* (Fig. 205) has been built up on the panel using both carved wood and patterns of raised gesso or *pastiglia* (see p. 177). On the other hand, the *tondo* of the same subject from the workshop of Botticelli (Fig. 81) must have always had an independent frame. Inscribed in a contemporary hand on the reverse of the panel is the name of Giuliano da Sangallo, the architect and sculptor. This has been taken to indicate that he was the first owner of the *tondo*, but it is much more likely that the inscription was a note to record that the panel was to be sent to Giuliano for framing. He is known to have made frames for altarpieces by Domenico Ghirlandaio and Botticelli: Giuliano

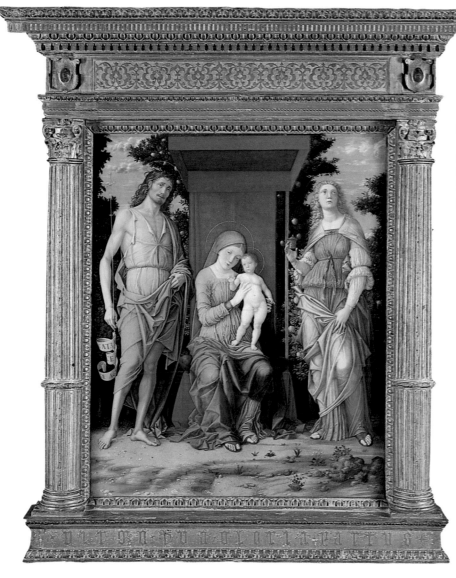

Fig. 207. Andrea Mantegna, *The Virgin and Child with the Magdalen and Saint John the Baptist, c.* 1500. Canvas, 139.1×116.8cm (NG 274). The frame, although of the period, is not original.

was paid nearly as much for the frame of an altarpiece of 1485 for Santo Spirito, Florence (now in Berlin), as Botticelli was for the painting.

Most National Gallery paintings are not in their original frames, but some are in frames from other paintings of their period. One of these, a painting by a pupil or follower of Botticelli, is in a tabernacle frame (Fig. 206), superbly carved, especially in the feathery acanthus which sweeps up under the fluted scrolls of the corbel support. It is typical of frames of devotional paintings hung in the Florentine *camera* (see p. 108). It may be compared with the frames used for sculptural tabernacles – the gesso *Virgin and Child* (Fig. 143) and the marble eucharistic tabernacle (Fig. 4).

On a larger scale the altarpiece by Mantegna of the Virgin and Child with the Magdalen and Saint John the Baptist (Fig. 207) has a carved and gilded frame with finely carved capitals and exquisite ornamental lettering in *pastiglia,* but the columns have been shortened to make it fit. Neither of theNational Gallery's

original frames on altarpieces of the fifteenth century, the *Saint Jerome* by Botticini (Fig. 56) and the *Madonna della Rondine* by Crivelli (Fig. 208), show this degree of sophistication in design or execution. Both are tabernacle frames with the carved and gilded relief patterns on the flanking pilasters and crowning cornice set against a background of dull blue, probably azurite as suggested in certain contracts (see p. 129). The Crivelli altarpiece is further ornamented along the predella with painted bands of pink, green, red and maroon, speckled and flecked to imitate porphyry and other coloured stones.

In the fifteenth century smaller frames, both in the Netherlands and in Italy, were sometimes marbled – as were the backs of panels (see Fig. 102). Some frames in Northern Europe were coloured, often with vermilion decorated with quatrefoil ornament, a scheme of decoration typical of the fourteenth century which can be seen on the altarpiece represented in the *Exhumation of Saint Hubert* (Fig. 17). It remained in favour in some towns such as Cologne during the fifteenth century. Borders dividing parts

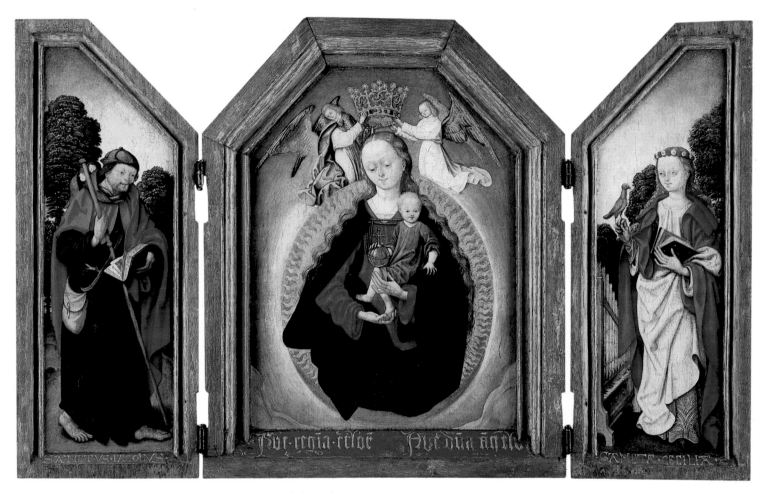

ABOVE Fig. 209. Workshop of the Master of the Saint Bartholomew Altarpiece, *The Virgin and Child with Saints, c.* 1480-95. Oak, central panel 28.5×21.6cm, shutters each 31.7×10.1cm (NG 6497). The frame is original.

LEFT Fig. 208. Carlo Crivelli, *The Virgin and Child with Saint Jerome and Saint Sebastian (The Madonna della Rondine), c.* 1490. Poplar, main panel 150.5×107.3cm (NG 724).

of the Liesborn Altarpiece (such as that visible beside Saint Bene-dict in Fig. 61) almost certainly reflect the colour of the original frame. When frames were gilded they could often be coloured as well. The gilded *all'antica* ornament of fifteenth-century Italian frames was often contrasted with blue, as in the altarpiece by Cri-velli and the tabernacle frame of *The Virgin and Child* (Fig. 206), whereas black frames with the gilding confined to a few mould-ings were favoured in the late fifteenth century in the Nether-lands.

The frame of the small triptych from the workshop of the Master of the Saint Bartholomew Altarpiece (Fig. 209) is largely original and retains traces of its vermilion colour. The lower edge is a flat sloped sill which contrasts with the hollowed vertical and top mouldings. Such sills were common in frames made north of the Alps and derive from the window surrounds of Gothic archi-tecture. The surface they provided was also suitable for lettering, used in this case to identify the saints in the shutters and to praise the Virgin Mary. Such inscriptions, popular on frames of all sorts (see Fig. 143), could of course also be found in the painting itself (see p. 51). The beautifully chiselled letters on the frame of van Eyck's *Man in a Red Turban* (No. 17) are not chiselled at all but painted. Van Eyck displays the same illusionistic skill in the let-tering of the parapet which is included in his painting *Portrait of a Young Man* (Fig. 115). It is generally the case that frames, whether

159

Fig. 210. Andrea Mantegna, *The Virgin and Child with the Magdalen and Saint John the Baptist. See Fig. 207.*

integral or not, were thought of as intimately related to the image they contained; moreover in some Netherlandish frames the painting was permitted to spill out on the sloped sill (see No. 28) thus deliberately confusing these categories.

CANVAS PAINTING

Of the few fourteenth- and fifteenth-century paintings in the National Gallery which are not on wooden panels, a handful are fragments of frescoes and the remainder have been painted on fabric supports, in one instance possibly silk (Figs. 73 and 74), but more often a linen canvas. The small number of canvas paintings which survive might suggest that canvas was seldom used at this time. Documentary sources, however, demonstrate that canvas paintings were common. Many of them may not have been intended to have any permanence: descriptions of festivals and threatrical events in both Northern Europe and Italy show that the scenery and other ephemeral decorations supplied by the painters (see p. 125) were often painted on canvas. For reasons of weight, canvas was also a suitable support for painted banners to be carried in religious processions (see p. 63). The earliest surviving canvas painting in the National Gallery, the much damaged and repainted *Madonna of Humility* by Lippo di Dalmasio (Fig. 41), may have been one such banner. In addition, as has been pointed out earlier, paintings on canvas were exported in large quantity, especially it seems from the Netherlands in the fifteenth century.

Perhaps stimulated by the influx of Netherlandish paintings on canvas, certain Italian painters seem to have turned with increasing frequency to canvas as a support for works intended to serve similar functions to works painted on panel. This development may have begun in north-east Italy: an altarpiece of 1446 by Antonio Vivarini and Giovanni d'Alemagna showing the Virgin and Child enthroned with Saints (Venice, Accademia) is on canvas, and one of the earliest painters whose surviving output includes a relatively high proportion of canvases is Mantegna. In a letter he commented on the convenience of canvas for works to be transported since it 'can be wrapped around a rod'. His works on canvas range from small paintings such as *Samson and Delilah* (Fig. 164), painted on a canvas so finely woven that it appears more like a handkerchief or bed linen, to large and important altarpieces like the *Trivulzio Madonna* (Milan, Castello Sforzesco) and the *Madonna della Vittoria* (Paris, Louvre). In fifteenth-century Venice, where the damp environment was not

ideal for the preservation of wall-paintings nor indeed of wooden panels, canvas began to be used extensively for large-scale works and in particular for the cycles of paintings which decorated the meeting halls of the Scuole (confraternities). Unfortunately, the National Gallery's few early Venetian canvases – for example the large votive *Madonna with Doge Giovanni Mocenigo* and those attributed to Carpaccio and to Gentile Bellini (Fig. 113) – are in such poor condition that little can be determined of their technique.

While double-sided canvas paintings, such as organ shutters, and processional banners like that by Barnaba da Modena (Figs. 68 and 69), have obviously always been stretched over a wooden framework or stretcher, there is evidence that when a canvas was to be used as an alternative to a panel it may have been painted on a temporary stretcher, but when ready for installation it was pinned out over a solid wooden support. Mantegna's altarpiece

Fig. 211. Quinten Massys, *The Virgin and Child with Saints Barbara and Catherine*, first quarter of the sixteenth century. Canvas, 92.7×110cm (NG 3664).

The Virgin and Child with the Magdalen and Saint John the Baptist (Fig. 210) was described soon after its acquisition in 1855 as having escaped lining and as being nailed to a panel, apparently of chestnut. Sadly it was immediately lined and the panel lost. However, another of his canvases, *The Presentation in the Temple* (Berlin, Staatliche Museen), has retained what appears to be its

ABOVE Fig. 212. Andrea Mantegna, detail of Fig. 210 showing the painted border. The twill weave of the canvas is also visible.

original supporting panel, as have a few works of the sixteenth century, particularly in Spain.

Netherlandish canvases are also documented as having sometimes been stretched over panels; and woodworm exit holes scattered over the entire surface of *The Virgin and Child with Saints Barbara and Catherine* by Massys (Fig. 211) indicate that it must once have been over a panel, since woodworm could not have infested a canvas suspended over a stretcher. Mantegna's National Gallery altarpiece has the remains of a painted border, black, flecked with red, presumably in imitation of porphyry (Fig. 212), and many early canvas paintings, including *The Entombment* by Bouts (No. 32), have similar painted borders. These may have been partly decorative, perhaps reflecting the borders of the tapestries for which some early canvas paintings were substitutes, but they would also have served to guide those responsible for stretching the canvases over panels when they reached their des-

tinations. The nails were obviously to be inserted outside the borders, but, equally important, the painted lines would have ensured that the canvas was re-stretched evenly without cusping and distortions being introduced into the main field of the composition. The rows of nails and some of the painted border would then have been covered by the frame.

GROUNDS

With the exception of certain canvases (discussed below), all the fourteenth- and fifteenth-century paintings in the National Gallery have had some form of preparatory layer applied as a ground

for subsequent layers of paint and gilding. Untreated wood is too rough and absorbent for painting upon, while if gilding was to be used it was essential for the surface to be ivory smooth to emulate the effect of solid gold. To this end Cennino gives detailed instructions on the application of grounds to panels: having filled or cut out and plugged any knots or flaws on the front face of the panel, the surface was to be sized with an animal-skin glue and then covered with fine linen canvas (Fig. 213). This would have further disguised the faults in the panel and reinforced any joins. It may also have improved the adhesion of the ground layers and delayed or reduced later cracking. X-radiographs confirm that most fourteenth-century Italian panels have been covered with canvas, either in large pieces or as torn strips and scraps as suggested by Cennino. During the fifteenth century the canvas began to be omitted, so that by the end of the century it is seldom found and then only when used to reinforce joins or to cover particular faults in the wood.

Fig. 213. Ugolino di Nerio, *Santa Croce Altarpiece* (No. 5). Detail of an Angel. The canvas has been exposed by the removal of the gesso and gilding from the area below the arch, originally the top of one of the saints from the main tier of the altarpiece.

The ground described by Cennino, and identified on all Italian panel paintings so far examined, consists of layers of gesso. Gesso is made by combining the powdered white mineral hydrated calcium sulphate, commonly called gypsum, with an animal-skin glue. The Italian for gypsum is *gesso*, hence the name for this type of ground. Cennino applied his ground in two stages: the first consisted of *gesso grosso*, a coarse anhydrite form of calcium sulphate made by roasting the raw gypsum in a kiln;

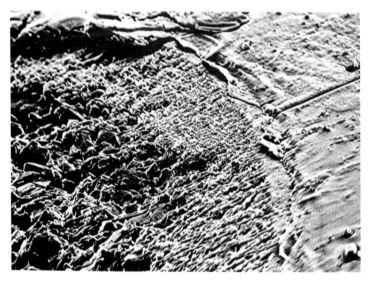

Fig. 214. SEM micrograph of a sample of gesso and gilding from the San Pier Maggiore Altarpiece (No. 9). Four layers are visible: from left to right, *gesso grosso; gesso sottile*; bole; and gold leaf. Magnification, 1000×

and the second of *gesso sottile*, where the calcium sulphate is slaked by prolonged soaking in water until it is 'soft as silk'. Examination by the high magnification scanning electron microscope (Fig. 214) and analysis by X-ray diffraction of samples of gesso from fourteenth-century Tuscan panels have confirmed that both forms of gesso were indeed used.

In the fifteenth century, however, painters may have begun to dispense with one form or other. Neri di Bicci actually records having prepared one crucifix with *gesso grosso* and another with *gesso sottile*; and analysis of samples shows, for example, that north of the Apennines, particularly in Venice and Ferrara, the gesso is nearly always of the dihydrate form, suggesting that either slaked *gesso sottile* alone or possibly even mineral gypsum in its raw state was used. As the amount of gilding was reduced there was no longer a need for a flawlessly smooth surface; gesso

Fig. 215. Sandro Botticelli, detail from *Portrait of a Young Man* (before cleaning). See Fig. 118.

combined with a glue size and brushed on and scraped smooth in much the same way as Cennino's *gesso sottile*. Because of the initially smoother surface of, for example, an oak or lime panel when compared with poplar, canvas does not often seem to be have been applied (except occasionally to cover the joins), and the grounds are seldom as thick as those on Italian panels.

As so few canvas paintings have survived from this period it is impossible to generalise about their preparation; indeed, judging by those that have been examined, practices may have varied considerably. Neither of the National Gallery's early Netherlandish paintings on canvas, *The Entombment* by Bouts (No. 32) and *The Virgin and Child with Saints Barbara and Catherine* by Massys (Fig. 211), has a true ground. Instead they have been prepared with a simple coat of glue size, probably slightly coloured with an umber earth pigment in the case of the Bouts. Some of Mantegna's canvas paintings, including his simulated relief sculptures (Fig. 164 and No. 64), appear to have been treated in a similar fashion, but the altarpiece, *The Virgin and Child with the Magdalen and Saint John the Baptist* (Fig. 210), has been prepared with a thin application of gesso.

Cennino gives directions for grounding a linen canvas with *gesso sottile*, to which he added a little starch or sugar to increase its flexibility. He recommends that it be sufficiently thick just to fill the interstices of the canvas weave. Similar grounds were used by Botticelli for his canvas paintings, including *The Birth of Venus* (Florence, Uffizi) and the *'Mystic Nativity'* (No. 56), and by Uccello for *Saint George and the Dragon* (Fig. 216). However, Uccello then added no fewer than three further layers of priming: the first of an orange-red colour consisting of red iron oxide and red lead in a glue medium; the second of a carbon black, again in glue; and finally a layer of lead white, apparently in an oil medium. It is not clear how unusual it was to prepare a ground of such complexity.

UNDERDRAWING

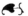

Since the painting techniques of the fourteenth and fifteenth centuries demanded precision of execution, some form of preliminary underdrawing of the design was generally carried out. Underdrawing on a white ground can sometimes be discerned by the naked eye. It can usually be detected by infra-red photography and reflectography, providing that the drawing has been executed with a material which contains carbon, such as charcoal or black 'chalk', or with a carbon-based paint or drawing ink.

grounds tend to become thinner and less carefully applied. Some contain too high a proportion of glue, leading to extensive cracking and flaking, while others, notably those on the *Portrait of a Young Man* by Botticelli (Figs. 118 and 215) and the *Ansidei Madonna* by Raphael (No. 65), are marred by small pitted marks caused by air bubbles trapped in the gesso during its application.

Northern European panel paintings also have smooth white grounds, but instead of calcium sulphate the inert white component is invariably calcium carbonate (chalk). In high magnification examination of chalk grounds, fossilised coccoliths indicating the natural origin of the chalk can often be seen. As there is no known surviving Northern European equivalent of Cennino's treatise, exact details of the methods of application of chalk grounds are not known, but it can be assumed that the chalk was

Fig. 216. Paolo Uccello, *Saint George and the Dragon*, *c.* 1460. Canvas, 56.5×74.3cm (NG 6294).

Occasionally paint layers are too thick for penetration by infrared, particularly when certain infra-red absorbing pigments such as azurite and verdigris have been used. If the design has been drawn with an iron-gall ink – the writing ink of the time used by, for example, Cima on *The Incredulity of Saint Thomas* (Fig. 72) – it will produce only a faint image; if a coloured material like red 'chalk' has been employed it will not be detected at all. Therefore when no underdrawing can be seen it does not necessarily mean that none is present.

The technique, style and extent of underdrawings revealed by infra-red are to some extent individual to each artist, so they can be of assistance in problems of attribution. However, there is often considerable variety in the underdrawing within the output of a single painter. This may be accounted for by such factors as workshop participation, the complexity of the subject being drawn, and the existence of previous models and preliminary studies on paper. Some beautiful but perhaps unnecessarily detailed underdrawings may even be the result of the artist becoming carried away by the process of drawing on the inviting white surface of a gesso – or chalk-covered – panel.

No comprehensive study of underdrawings has yet been undertaken at the National Gallery, but some general observations can be made. Of the fourteenth-century Italian painters whose works have been investigated by infra-red, Duccio has been found to have an especially distinctive underdrawing style (Fig. 217). In some parts of the angel's drapery from the *Annunciation* (No. 3), the drawn lines are soft and fluid suggesting the use of ink applied with a brush, but in others the lines are abrupt, broken and scratchy, frequently showing the characteristic double line of the split nib of a quill pen. An identical drawing style occurs on other panels from the *Maestà* and on *The Virgin and Child with Saints* (Fig. 218 and No. 4).

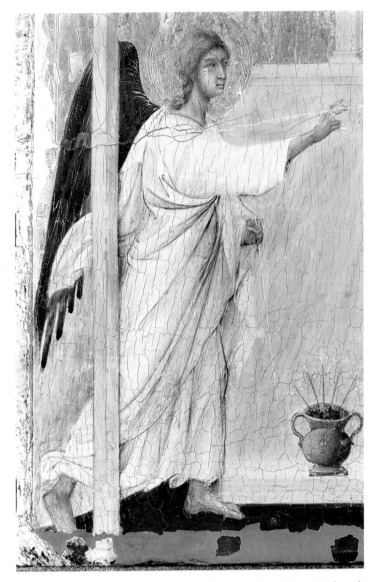

Fig. 217. Duccio, detail of the Angel from *The Annunciation* (No. 3). Infra-red photograph.

Fig. 218. Duccio, detail of the Child's drapery from *The Virgin and Child with Saints* (No. 4). Infra-red reflectogram.

ABOVE Fig. 220. Infra-red photograph detail of Saint John the Baptist.

RIGHT Fig. 219. Nardo di Cione, *Saint John the Baptist with Saint John the Evangelist(?) and Saint James*. Wood, 159.5×148cm (NG 581). The frame is modern.

Drawing executed with a quill pen also appears on *Saint John the Baptist with Saint John the Evangelist(?) and Saint James* by Nardo di Cione (Figs. 219 and 220). Here the volume of the figures and the main areas of shadow have been defined using parallel hatched strokes, sometimes linked in a series of calligraphic loops. Such extensive underdrawing seems to be unusual in early Italian painting in spite of Cennino's exhortation to 'shade your drawing so carefully that you come out with such a handsome drawing that you will make everyone fall in love with your production'. More often underdrawing at this time seems to consist of a basic outlining, sometimes with a few strokes of hatching to place a fold or to indicate a shadow.

A simple but meticulous outlining of forms and details can be seen on the Wilton Diptych (Fig. 221 and No. 10), the only Northern European painting dating from the fourteenth century in the Collection. The drapery folds have been indicated but in a linear and schematic fashion. This contrasts with the elaborately shaded underdrawing usually found on works by Jan van Eyck. Areas of the Arnolfini double portrait (No. 18) have been drawn in immense detail (Fig. 222), although, in common with many of van Eyck's works, the drawing has not always been followed closely in the painting (Fig. 223). On the *Man in a Red Turban* (No. 17) no trace of drawing can be detected, illustrating the

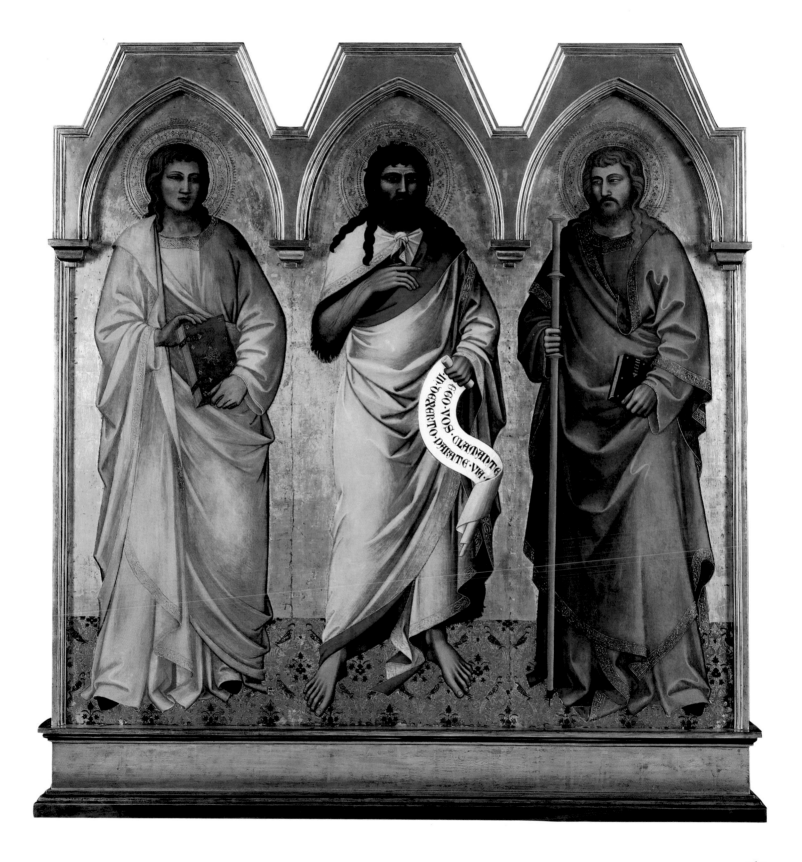

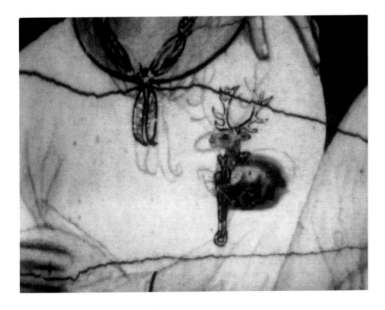

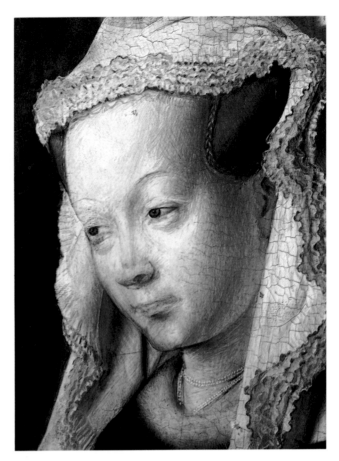

ABOVE Fig. 221. French School(?), detail of the Angel with folded arms to the right of the Virgin from *The Wilton Diptych* (No. 10). Infra-red reflectogram.

ABOVE RIGHT Fig. 222. Jan van Eyck, detail of the head of Giovanna Cenami from *The Arnolfini Portrait* (No. 18). Infra-red photograph.

BELOW RIGHT Fig. 223. Jan van Eyck, detail showing changes to the position of Giovanni Arnolfini's right hand from *The Arnolfini Portrait* (No. 18). Infra-red photograph.

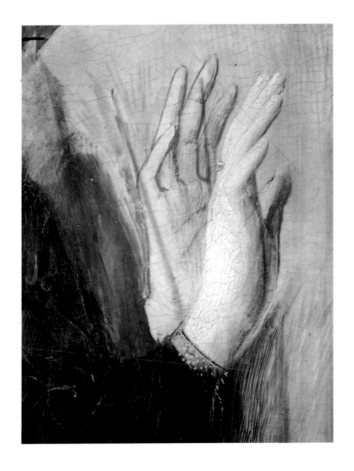

point that artists are seldom absolutely consistent in their under-drawing practices. The apparent lack of underdrawing here may be connected with the fact that it is a portrait and is therefore likely to have been painted from life or from a detailed drawing. Other Netherlandish portraits, including van Eyck's *Portrait of Cardinal Albergati*, for which a study on paper survives (see p. 145), have been found to have simple, quite summary under-drawings when compared with more elaborate compositions featuring areas of drapery, architecture and so on. The extent and complexity of the underdrawings found on many Netherlandish and German paintings suggest that underdrawing played an im-portant part in early oil painting techniques.

The methods adopted by Italian painters of the first half of the fifteenth century were essentially those of their predecessors. They included the use of a generally linear and unshaded under-drawing, even for a relatively complex form such as the flutter-ing drapery (Fig. 224) in Sassetta's *Saint Francis renounces his Earthly Father* (No. 19). Piero della Francesca, in spite of his in-

Fig. 224. Sassetta, detail of Saint Francis's father (on the left) from *Saint Francis renounces his Earthly Father* (No. 19). Infra-red reflectogram.

Fig. 225. Piero della Francesca, detail of the drapery of the angel on the far left from *The Baptism of Christ* (No. 27). Infra-red reflectogram.

terest in representing light and volume, still favoured a simple outline, visible, for example, on the unfinished and also damaged areas of *The Nativity* (Fig. 276 and No. 36). For a particularly elaborate series of pleats and folds in the costume of the angel on the left in *The Baptism of Christ* (No. 27), he transferred the design using a full-scale pricked cartoon. The pounced black dots can just be seen with the naked eye but they are enhanced in infra-red photographs and reflectograms (Fig. 225).

Pouncing – the dusting of powdered charcoal or other dry pigments through holes pricked along the lines of the cartoon so that the dots of powder are transferred to the surface beneath – is almost certainly an ancient method of transferring designs. It is described by Cennino but only in conjunction with transferring the repeats of a pattern in the execution of *sgraffito* textiles (see p. 176). In the mid-fifteenth century, as paper became more widely available, the technique seem to have been increasingly used, especially in Florence, to transfer drawings from one sheet to another and from paper to panel (or to plaster as in the case of wall painting). It is associated with certain workshops, among them Perugino's. Pounced dots can often be detected by infra-red on works by Perugino himself (No. 59) and by Raphael. Some of the latter's pounced drawings have survived and by using infra-red techniques it is sometimes possible to confirm

that they were used for the associated paintings (Figs. 226, 227, 228).

Underdrawings with a degree of complexity more typical of those of Northern Europe begin to feature in some Italian works from about the mid-fifteenth century onwards. The most striking examples are the bold but rigorously hatched underdrawings (Figs. 229 and 230) of Cosimo Tura, an artist who demonstrably had contact with Netherlandish painting (see p. 198). Giovanni Bellini, especially in works from the 1480s and 1490s, often produced underdrawings which were so detailed that in 1548 his 'extreme diligence' was held up as a warning by the Venetian writer Paolo Pino, who was advocating the freer and more painterly approach of his own contemporaries. While none of the paintings by Bellini examined by infra-red at the National Gallery has such an underdrawing, detailed drawing can be seen on Cima's *Christ Crowned with Thorns* (Figs. 231 and 232). Here the paint is so thinly applied that the carefully hatched shadows of the underdrawing must have been intended to play a part in the modelling of Christ's features.

A similar use of underdrawing as an undermodelling has been noted on the mature works of Gerard David. As well as shading his underdrawings with strokes of parallel hatching, he seems also to have used washes of dilute ink or paint (Figs. 233 and 234).

LEFT Fig. 226. Raphael, *Cartoon for An Allegory ('Vision of a Knight')* (No. 63). Iron gall ink on paper pricked for transfer, 18.2×21.4cm (NG 213A).

BELOW LEFT Fig. 227. Raphael, detail from *An Allegory* (No. 63). Infra-red reflectogram. The pounced dots have mostly been brushed off so they are difficult to detect, but the line used to join them is noticeably hesitant. Other more fluent lines which do not appear on the cartoon have evidently been drawn freehand.

BELOW RIGHT Fig. 228. Raphael, detail from the *Cartoon for An Allegory ('Vision of a Knight')* (No. 63).

LEFT Fig. 229. Cosimo Tura, *Saint Jerome*, c. 1475. Fragment. Wood, 101×52.7cm (NG 773).

While the use of lightly tinted priming layers to modify the brilliance of the white ground has been discovered on paintings by, among others, the van Eycks and Rogier van der Weyden (see p. 196), there is no evidence as yet that the layers were modulated to indicate shading and form. Judging from paintings examined to date, wash underdrawing appears to belong more to sixteenth-century practice, but it is not impossible that it originated in fifteenth-century Italy and specifically in the work of Leonardo da Vinci. However, in the unfinished passages of Leonardo's many incomplete paintings, it is not really possible to separate underdrawing as such from the painted monochrome undermodelling which was to play such an important part in the techniques of subsequent centuries.

Another process in the fixing of a design on a panel is the incising of lines into the gesso or chalk with a metal stylus. When gold or silver leaf was to be used, lines were scored into the ground to demarcate those areas to be gilded (Fig. 240). Any straight lines or arcs needed for the depiction of architectural features were also usually incised. An incised line provides a better guide than a drawn one if crisp edges are to be achieved in the application of the paint. In *Jesus open the Eyes of a Man born Blind* from Duccio's *Maestà* (No. 3), the lines of the architecture have not only been ruled and incised at the underdrawing stage, but on completion of the painting they were reinforced by repeating the process using a lead-point stylus (Fig. 235). Such precision does not seem to be a characteristic of Duccio's own draw-

171

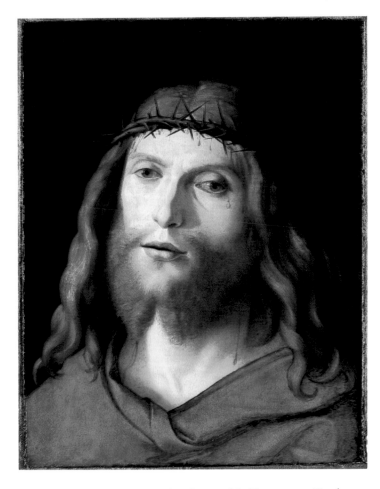

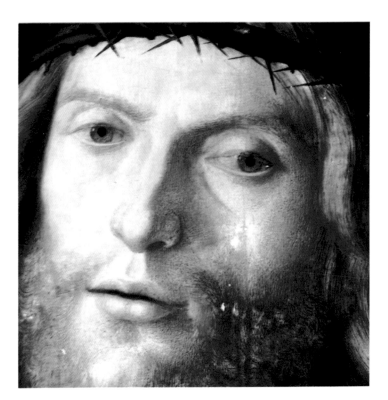

ABOVE Fig. 232. Infra-red photograph detail (taken after cleaning, before restoration) of Fig. 231.

LEFT Fig. 231. Cima da Conegliano, *Christ Crowned with Thorns, c.* 1510. Wood, painted surface 36.8×29.2cm (NG 1310).

BELOW Fig. 233. Gerard David, *The Adoration of the Kings, c.* 1515. Wood, painted surface 59.7×58.4cm (NG 1097).

Fig. 234. Detail of Fig. 233. Infra-red reflectogram computer assembly.

ing and painting of architecture (for example, that in *The Annunciation*), so the architectural background of this scene is now thought to have been executed by a member of his workshop, perhaps Pietro Lorenzetti.

In fifteenth-century Italy the increased emphasis on accurate rendering of perspectival recession made the use of incised lines virtually essential. The perspective lines and arcs of the complex architecture of Botticelli's *Adoration of the Kings* (No. 38) have been scored into the gesso, as have the outlines of the broken lances used to indicate the recession in Uccello's *Battle of San Romano* (No. 26). Incised lines occur less frequently on Netherlandish and German paintings, but they can be seen on works by Bouts, one of the first Northern painters to use something approaching the single-point perspective system. Perhaps the most elaborate example in the National Gallery of a painting where incised lines have been employed as an aid to constructing

ABOVE Fig. 235. Duccio and Workshop, detail in raking light from *Jesus opens the Eyes of a Man born Blind* (No. 3), showing ruled and incised lines across a capital from the loggia.

RIGHT Fig. 236. Bramantino, *The Adoration of the Kings, c.* 1505. Poplar, painted surface 56.8×55cm (NG 3073).

173

Fig. 237. Raking light detail of Fig. 236 (taken after cleaning, before restoration). The convergence of the incised orthogonals has been indicated in white.

a perspective setting is the *Adoration of the Kings* by Bramantino (Fig. 236). The incised orthogonals (the parallel lines which appear to converge), meeting just below the Virgin's knees, and the carefully ruled receding grid (Fig. 237), are a copybook exercise in the perspective constructions first described by Alberti in his *De Pictura* of 1435.

GILDING

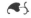

Gold and silver leaf are particularly associated with Italian panel paintings of the fourteenth century, but they continued to be widely used in the fifteenth century, in Northern Europe as well as in Italy. Although Massys's *Virgin and Child Enthroned* (No. 52) is one of only a few Netherlandish works of the period in the National Gallery with extensive gilding, painters like Campin, van Eyck, van der Weyden and van der Goes all used gold leaf on major altarpieces. Gilding played an important part in Spanish and German painting until well into the sixteenth century and remained in use in Italy for a surprisingly long time, not just on works by painters such as Crivelli, who was employed by provincial and perhaps rather conservative patrons, but also on works by Raphael. Indeed Raphael only reduced the amount of

gilded decoration on his panel paintings some time after his arrival in Rome, most probably when he came into contact with the techniques of sixteenth-century Venetian painters.

On Italian panel paintings the areas to be gilded were usually prepared with an application of bole, a greasy red-brown clay which provides a smooth cushioned surface against which the gold leaf can be burnished and which imparts a warm rich colour to the gold. This was considered necessary because gold leaf is so thin that it is slightly transparent. If laid directly over the gesso, the white ground shines through, giving the gilding a cool, slightly green colour. Occasionally, however, painters seem to have desired this effect: Giotto chose green earth instead of bole for *The Pentecost* (No. 2) and for several other works (including the dispersed fragments of the dossal of which *The Pentecost* is part). In many Italian panels of the thirteenth century, including the earliest work in the Collection, *The Virgin and Child Enthroned* by Margarito (No. 1), and in several Northern European paintings, for example *Saints Matthew, Catherine of Alexandria and John the Evangelist* by Lochner (No. 20), the gold leaf is applied directly on the white ground.

Gold leaf was beaten, usually from coins, by specialist gold-beaters. Their close association with painters is reflected by the fact that they were often members of the same guild. Records of payment often list the price and the exact number of pieces of gold leaf employed for a particular work. Masaccio, among his many debts, is recorded as owing 6 florins to his gold-beater. The leaf was, if necessary, cut to size on a gilder's cushion (see p. 141) and then laid in overlapping pieces over the bole or ground. To reactivate the glue contained in the bole or ground the area to be gilded was first wetted, hence the term 'water gilding'. With time the overlaps between the pieces of gold often become visible: they are particularly clear on *The Virgin and Child* by Masaccio (No. 15). When gold leaf is first applied it appears crumpled and matt. To achieve the deep lustre of solid gold it has to be burnished with a tooth or a polished stone such as an agate so that it bonds with the smooth surface beneath. On fourteenth- and fifteenth-century panels much of the original effect of the burnished gilding has been lost due to abrasion during cleaning and to the inevitable cracking with age of the ground and bole.

The burnishing of gold leaf is a delicate and time-consuming operation, and some German contracts of the fifteenth century, while specifying that certain areas must be burnished, allow for the use of unburnished matt gold, laid using an oil-based adhesive rather than by water gilding, for less important parts of the work. However, on the *Coronation of the Virgin* (Fig. 238) by the

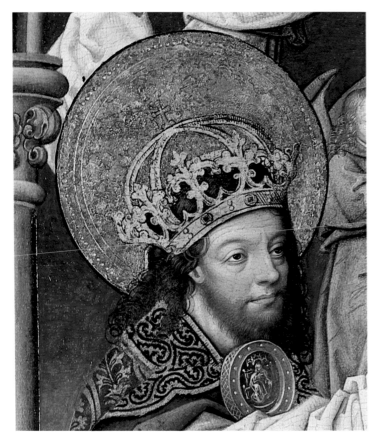

Fig. 238. Master of Cappenberg (Jan Baegert), detail from *The Coronation of the Virgin* (Fig. 46). The halo is water-gilded whereas the crown is oil gilded.

Master of Cappenberg (Jan Baegert), where the haloes (now much damaged) are water gilt but the crowns and the brocades of the canopy and the Virgin's robe are oil gilt, the use of burnished and matt gold seems to have been for variety of effect rather than for economy of effort.

There were also alternatives to the costly gold leaf. These included alloys of inferior metals – principally tin or copper – and white metals lacquered with yellow-tinted oil-resin varnish to imitate gold leaf. Their use was proscribed in some guild statutes north and south of the Alps. A contract of 1453 with Hans Stettheimer for an altarpiece for the church of St Nicholas near Innsbruck insists on the use of pure, burnished gold and not matt gold or imitation 'coloured gold'. Neri di Bicci, on the other hand, records commissions where he could use alloyed metals or yellow-glazed silver or tin on the frames. Traces of tin have been detected on a now greenish-black band of decoration on the predella of Crivelli's *Madonna della Rondine* (see Fig. 208), but it is not clear how it was originally coloured.

As well as being used as a substitute for gold, silver was valued for its own decorative qualities despite its known propensity to tarnish. The best example of its use on a fourteenth-century painting in the National Gallery occurs on the panels of the San Pier Maggiore Altarpiece by Jacopo di Cione (No. 9). Many of the attributes carried by the saints and the musical instruments played by the angels now appear as a dull blackish-brown colour, but originally they were gleaming silver. Silver leaf has also been identified on Northern European paintings. White metal – probably silver, although it is surprisingly untarnished – has been used for Saint Catherine's sword in the panel by Lochner (No. 20). In Italy it continued in use throughout the fifteenth century: for example, for some of the patterned textiles in Sassetta's *Scenes from the Life of Saint Francis* (No. 19); for the armour in Uccello's *Battle of San Romano* (No. 26); for the arrowhead of Saint Sebastian in the *Madonna della Rondine* by Crivelli; for the lettering of the artist's name and for the silver moon which accompanies the gilded sun in Raphael's *Crucifixion* (No. 61).

Gold leaf could also be backed with foil beaten from a cheaper, white metal, either silver or, more commonly, tin. The lamination was achieved either by beating the two metals together or by using an oil-resin varnish as an adhesive. While more thinly beaten gold could be used, thus saving on the cost of the gold, payments suggest that the more complex process resulted in gilded tin costing more than pure gold leaf. The advantage of the laminated leaf was its greater thickness and durability; in Italy it seems to have been used mainly for murals.

In Northern Europe in the fifteenth century, however, laminated leaf was employed in both painting and sculpture, especially for the execution of applied relief brocades. It appears to have been used, for example, for the cloth-of-gold fabrics on the panels of the Liesborn Altarpiece (Fig. 239 and No. 43). The raised patterns of the brocades were made by moulding sections of the pattern before they were applied to the surface of the painting or sculpture. Wooden moulds into which tin leaf had been pressed were filled with hot chalk and glue or sometimes wax mixed with resin and oil. When cool the squares or rectangles of brocade were removed from the moulds and glued to the surface to be decorated. Gold leaf was then laid over the tin using an oil-based adhesive and the coloured parts of the design painted on. Occasionally the gilding and painting were applied to the pieces of moulded brocade before they were attached to the painting or sculpture.

To distinguish details such as haloes from the gilded background, and to give surface interest to the gold, gilding was often tooled with incised and punched patterns. The edges of the indented lines or punchmarks catch the light – which would originally have included flickering candlelight – making the gold sparkle and shimmer. Incised foliate patterns appear on some of the earliest paintings in the National Gallery, including the *Cruci-*

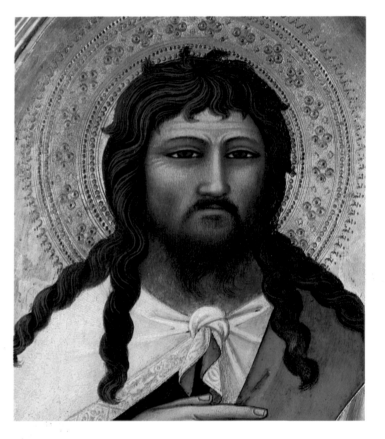

LEFT Fig. 239. Master of Liesborn, detail of the Angel in *The Annunciation* from the Liesborn Altarpiece (No. 43). The striations are absent where the applied relief brocade has not been cut quite accurately enough – for example around the hair and in the angle between the brocade and the scroll.

ABOVE Fig. 240. Nardo di Cione, detail showing Saint John the Baptist from *Saint John the Baptist with Saint John the Evangelist(?) and Saint James* (Fig. 219).

fix by the Master of Saint Francis (see Fig. 255) and the triptych (No. 4) and panels from the *Maestà* by Duccio (see Fig. 249 and No. 3). Although Duccio made some use of punches on other works, the decoration of gilding with complex motif punches seems to have been developed by the next generation of Sienese painters and in particular by Simone Martini and Ugolino di Nerio. For the haloes in the fragments of Ugolino's Santa Croce Altarpiece (No. 5) no fewer than eleven different punches have been employed.

It is thought that punching tools may have been passed from workshop to workshop: some of the punchmarks seen on the haloes of Nardo di Cione's altarpiece (Fig. 240) appear to have been made using tools brought to Florence from Siena in 1363 by the painter Giovanni da Milano. However, some of the most ornate punched decoration of all, that on the main tier panels of the San Pier Maggiore Altarpiece (No. 9), has been executed using only the simplest of ring and indenting punches, yet each of the forty-eight saints has been given a halo of a different design. In the fourteenth century punching also played an important role in the representation of cloth-of-gold textiles using the technique of *sgraffito*, in which egg tempera paint is applied over the burnished gold leaf and then scraped away according to the design to reveal the gold parts of the textile. These were then made to

shimmer and sparkle by punching with small stippling punches (Fig. 241).

In fifteenth-century Italy rather less use was made of punching, although Masaccio's Virgin from the Pisa Polyptych of 1426 (No. 15) still has a halo richly decorated with punching, which contrasts oddly with the much cruder, but admittedly damaged, punching of the angels' haloes and with the quite different and more three-dimensional rendering of Christ's halo. Often decoration consisted of incised lines, sometimes radiating to form a halo or aureole as in many Florentine works of the 1430s and 1440s, for instance those of Fra Angelico and Filippo Lippi (Fig. 242). Incised lines also seem to have replaced punching for representing the gold threads in a cloth of gold, for example that on the

ABOVE Fig. 241. Nardo di Cione, detail from *Saint John the Baptist with Saint John the Evangelist(?) and Saint James* (Fig. 219).

RIGHT Fig. 242. Filippo Lippi, detail showing Saint John the Baptist from *Seven Saints* (No. 23).

canopy above the throne in *The Virgin and Child with Angels* by a follower of Fra Angelico (Fig. 100) and those on the back of the Virgin's chair in Filippo Lippi's *Annunciation* (No. 23 and Fig. 243). By changing the direction of the parallel incisions it was possible to indicate the weave of the fabric or the fall of the textile over a step, for example, much more successfully than with the punched decoration of the previous century.

In general the decoration of the gilding on the Northern European paintings in the National Gallery has not survived in particularly good condition. Notable exceptions are the Wilton Diptych (No. 10) with its fine stippled patterns, even used to indicate modelling (Fig. 244), and the panel by Stephan Lochner (No. 20) with its delicate stippled haloes, here set against a backdrop of vertical lines carved into the ground in imitation of a brocade hanging.

This technique of carving patterns into the ground before gilding was probably better suited to the harder surface of chalk grounds than to the gesso employed in Italy. For the same reason, when punching does occur on Northern works it is not so deeply indented as on Italian panels, and it is therefore more discreet in effect.

As well as decoration by punching and incising, gilding could be ornamented by raised patterns of *pastiglia*. In this technique the raised lines of gesso or chalk bound with glue are built up before the application of any bole or gilding. It was commonly used on both panels and frames in Northern Europe, Italy and especially Spain throughout the thirteenth, fourteenth and fifteenth centuries. In fourteenth-century Italy, *pastiglia* was often combined with punched decoration, for example the predella and frame of the *Crucifixion* by Jacopo di Cione (Fig. 245)

Fig. 243. Filippo Lippi, detail from *The Annunciation* (No. 23).

Fig. 244. French School(?), detail from *The Wilton Diptych* (No. 10).

Fig. 245. Jacopo di Cione, detail of the predella from *The Crucifixion* (Fig. 28).

Fig. 246. Crivelli, detail of Saint Peter from *The Demidoff Altarpiece* (No. 46).

and the spandrels of the *Marriage of the Virgin* by Niccolò di Buonaccorso (No. 8). Fifteenth-century examples include works by the Vivarini, Foppa and above all Crivelli. The panels of the Demidoff Altarpiece (Fig. 246 and No. 46) with their tooling, *pastiglia* and carved and gilded ornaments inset with coloured glass represent some of the most elaborate craftsmanship to be seen in the Collection. Among Northern European painters, Campin, in the Seilern Triptych (Fig. 247) and elsewhere, made striking use of gilded backgrounds decorated with *pastiglia*.

The Virgin and Child with Angels and Saints attributed to Michael Pacher (Fig. 248 and No. 45) appears at first sight to be the only non-Italian panel in the National Gallery with a raised *pastiglia* background, but it has in fact been executed by a quite different method. An exceptionally thick ground has been applied, and the relief pattern has been carved deeply into it, leaving the painted surface proud of the gilded background. While this technique seems particularly appropriate to a work produced by a painter-sculptor, it does occur on other fifteenth-century German panels, but usually in combination with applied raised *pastiglia*.

A more illusionistic way of using gold favoured by Northern European painters, particularly towards the end of the century, is as a base for painted decoration and for applied architectural details, for example the hatched black lines used to depict the throne on the panel by Massys (No. 52). A similar technique has

ABOVE Fig. 249. Giovanni Bellini, detail from *The Agony in the Garden* (No. 31). RIGHT Fig. 250. Andrea Mantegna, detail from *The Agony in the Garden* (No. 30).

been employed to create the architectural framework around the compositions of the Master of the Saint Bartholomew Altarpiece (Fig. 142 and Nos. 62 and 67).

On completion of the painting, further gilded decoration could be added. There were two methods: mordant gilding and 'shell gold'. The mordant used for the first of these methods can be any substance to which metal leaf will adhere. The mordant is painted on in lines and patterns and when it is almost dry, but still slightly tacky, pieces of gold leaf are applied. They should adhere to the mordant but not to the surrounding paint surface. In fourteenth-century Italy oil mordants were commonly employed. They vary in their composition: that used by Giotto consists of little more than a drying oil with a small amount of lead white. Where the gold has been rubbed the mordant can be seen to have formed a virtually colourless and barely raised line. The mordants used by Duccio and Ugolino, on the other hand, contain large amounts of pigments such as lead white and verdigris which accelerate the drying of the oil, producing a thick sticky mordant with which it was possible to achieve the raised lines characteristic of the decoration of the draperies on the *Maestà* (Fig. 251). Raised oil mordants were also used in Northern Europe, for example by the van Eycks on the Ghent Altarpiece, and occasionally in Italy in the fifteenth century, notably on highly decorated works by Milanese painters such as Bergognone (see Fig. 51) and Foppa. By then, however, most painters seem to have preferred colourless and now undetectable mordants, like the one based on garlic juice mentioned by Cennino and other writers. An early example of such a mordant occurs on Jacopo di Cione's *Crucifixion*, and they may have been used by Raphael on his altarpieces.

As an alternative to mordant gilding, painters could apply the gold (or silver) powdered and made into a paint. This is called 'shell gold' because traditionally it was kept in a mussel shell. The earliest examples of its use noted at the National Gallery are on the altarpieces by Jacopo di Cione: on the San Pier Maggiore Altarpiece it is sometimes a substitute for mordant gilding; and on the *Crucifixion* powdered silver, now tarnished, was used for the weapons and armour of the soldiers. In the fifteenth century, as gilded decoration tended to become more discreet, 'shell gold' generally replaced mordant gilding both in the decoration of draperies and for the simple, linear haloes still often retained by painters who otherwise made little use of gold. For the most effective use of 'shell gold', however, it is necessary to turn to North Italian works of the fifteenth century and especially to those of Mantegna and the young Giovanni Bellini. Rather than

Fig. 251. Duccio, detail from *The Transfiguration* (see No. 3c).

restricting its use to the embroidered borders of robes, in their respective versions of the *Agony in the Garden* (Nos. 30 and 31) both artists highlighted Christ's draperies with delicate touches of powdered gold to suggest the light of the early morning sun (Figs. 249 and 250). The figures of Tuccia and Sophonisba in the panels by Mantegna (see Figs. 162 and 163) have been modelled almost entirely in 'shell gold' to achieve a painted illusion of gilded bronzes in a marble setting.

PIGMENTS

The range of pigments used by the medieval or Renaissance painter was limited when compared with that available today. The painter was responsible for binding the pigments together with a medium to make a paint, and he may even have made a few of the pigments himself. Cennino describes the digging up and washing of earth pigments and the preparation of black pigments from charred vine twigs, almond shells and peach stones, and the collection of condensed soot to make lamp black. Most pigments, however, were obtained either from the apothecaries, who supplied many crafts and professions – and in Florence, for example, belonged to the same guild as the painters – or from

FAR LEFT Fig. 252. Jacopo di Cione, detail from *The San Pier Maggiore Altarpiece* (No. 9), showing the use of ultramarine and lead-tin yellow.

LEFT Fig. 253. Dieric Bouts, detail from *The Virgin and Child* (No. 28).

ABOVE Fig. 254. Cross-section of the Virgin's blue robe in Fig. 253 (photographed in transmitted light), showing the use of azurite as an underpaint for ultramarine. 135×

specialist sources. Cennino recommends buying vermilion from the friars, while in Florence in the fifteenth century the Order of the Gesuati supplied pigments, including ultramarine, to many leading painters, among them Botticelli, Perugino, Leonardo and Filippino Lippi.

Some pigments, such as lead white, lead-tin yellow and vermilion, were manufactured, but others came from natural sources. These include dyestuffs and the mineral and earth pigments. One mineral pigment, ultramarine, the rich purple blue extracted from lapis lazuli (Fig. 252), was so expensive that it cost more than gold. Stipulations were sometimes written into contracts concerning the quantity and quality of the ultramarine to be used and even where it was to be applied (see p. 129). Its expense was due partly to the laborious extraction process but also to the fact that until the discovery of the Americas all lapis came from a group of mines centred on a single deposit in Afghanistan. The origin of the pigment is implied by the name which it is given in Italian sources, *azzurro oltremarino*, that is, blue from across the seas. In some Spanish contracts, and also in the contract for Quarton's *Coronation of the Virgin* for Villeneuve-lès-Avignon (see p. 129), it is called Acre blue. Acre, now in the modern state of Israel was, until the rise of the Ottoman Empire, one of the ports on the trade routes from the Orient with which Venetian merchants had particular dealings. Lapis therefore entered Europe principally through Venice. As a result Venice became

the centre of the pigment trade, and it is probably no coincidence that the most extensive range of pigments to have been identified on a fourteenth- or fifteenth-century work in the Collection is that for a Venetian altarpiece, Cima's *Incredulity of Saint Thomas* (Fig. 72).

Painters often sent to Venice for pigments – in 1518 Raphael sent an assistant all the way from Rome to buy colours – or even went in person. In 1469 Tura bought pigments in Venice before embarking on the decoration of the chapel at the d'Este castle of Belriguardo. In 1496 Isabella d'Este sent her agent in Venice a list of pigments and a box of samples which were to be matched in quality, confirming that patrons as well as painters at the end of the fifteenth century continued to be concerned about the quality and brilliance of pigments. Indeed it may have been quite common for patrons to supply the more expensive colours: the inventory of Filippino Lippi's workshop records in his office several little leather bags of ultramarine, together with 'green blue [perhaps malachite, see below], lead-tin yellow [see below] and things of lesser value', all in a box sealed with the ring of a member of the del Pugliese family for whom Filippino was working when he died.

Northern European artists were obviously not so well placed to obtain supplies of lapis, but ultramarine of high quality does feature on the works of major painters like van Eyck, Campin (see Fig. 40), van der Weyden and Bouts (Fig. 253). However,

they usually economised on its use by underpainting with the cheaper blue pigment azurite (Fig. 254). This technique later became increasingly common in Italy, occurring on paintings by, among others, Tura, Bellini, Cima, Filippino, Leonardo, Perugino and Raphael.

Azurite, an ore of copper, came mainly from Germany, hence its Italian name *azzurro dell'allemagna*. In the accounts for the frescoes for the Gianfigliazzi Chapel (see p. 141), Baldovinetti records buying azurite from a German and from a Pole, while further supplies came from a glazier, Giovanni d'Andrea, who had bought it in Venice. It was used as a blue pigment in its own right for both Northern and Italian works. It has a greener hue than the purple-tinged ultramarine, which can have a considerable effect on the colour relationships in a painting. The difference is illustrated by comparing a predella panel from Ugolino's Santa Croce Altarpiece (No. 5), for which azurite was chosen as the sole blue pigment, with one from Duccio's *Maestà* (No. 3), where the highest quality ultramarine has been used.

Just as ultramarine might be underpainted with azurite, so azurite was itself occasionally underpainted with the less costly, but still far from cheap, blue pigment indigo. Although it is mentioned in, for example, the Sienese guild statutes, paintings in the National Gallery which have been found to include indigo come from further north and east in Italy – including works by Giovanni d'Oriolo, Tura, Cossa (in this case as an underpaint for ultramarine) and especially Crivelli. Crivelli also used indigo mixed only with lead white for the bands of pale blue and gold decoration on the throne and steps in *The Virgin and Child with Saints Francis and Sebastian* (see Fig. 59).

Smalt, another blue pigment which was cheap by comparison with ultramarine, was probably first used in the fifteenth century. It is a pulverised glass coloured blue with cobalt oxide. The colour of smalt is not particularly intense, and when it occurs on *The Entombment* by Bouts (No. 32) it is combined with both ultramarine and azurite. In the glue medium used for that work (see p. 188) smalt would have appeared reasonably bright, but presumably it is there mainly to extend the more expensive pigments. Smalt has been reported fulfilling a similar role on Bellini's Pesaro Altarpiece (see p. 199), but in general it was not much used until the sixteenth century.

Green pigments presented some difficulties, both for their colour and for their stability. A satisfactory green colour could be made by combining blue and yellow pigments. For example, the pale green robe of Saint John the Evangelist on Nardo di Cione's altarpiece (see Fig. 219) consists of ultramarine, lead-tin yellow

Fig. 255. Master of Saint Francis, detail of the head of Christ from the *Crucifix* (Fig. 29). Small areas of 'copper resinate' survive on the gilded halo.

and lead white, while the greens on Jacopo's altarpieces (see Fig. 28 and No. 9) contain azurite, yellow lake and lead white. Leonardo describes a similar combination in his notes on colour mixing, but mixed greens seem to feature more often on fourteenth-century works. Some fourteenth-century painters, notably Duccio and Ugolino, had access to an unusually intensely coloured green earth and made use of it for drapery painting as well as in its usual role as an underpaint for flesh (see p. 192). When green earth was no longer employed in the painting of flesh in the second half of the fifteenth century it fell into relative disuse and did not find favour again until the seventeenth century.

In the fifteenth century painters had the choice of natural malachite, artificial malachite and verdigris. The first is a mineral pigment closely related to azurite and often found in the same lump of rock, but of a pale, cold green colour with poor tinting strength and therefore seldom seen, except in mixtures with other pigments. Artificial malachite, a synthetic version, is characterised microscopically by its spherical particles and found at the National Gallery on a handful of works, always in an egg tempera medium, by Sassetta, Uccello, Bellini, Tura and Cossa. Verdigris is a copper acetate, formed by exposing sheets of copper to acetic acid (vinegar) fumes. This last pigment tends to be a

ABOVE Fig. 256. Cima da Conegliano, detail from *The Incredulity of Saint Thomas* (Fig. 72), showing well-preserved 'copper resinate' glazes over an underpaint of verdigris, lead-tin yellow and lead white.

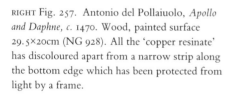

RIGHT Fig. 257. Antonio del Pollaiuolo, *Apollo and Daphne, c.* 1470. Wood, painted surface 29.5×20cm (NG 928). All the 'copper resinate' has discoloured apart from a narrow strip along the bottom edge which has been protected from light by a frame.

cold, rather blue green so it usually occurs mixed with yellow and white, often as a base for transparent green glazes of the 'copper resinate' type. To make 'copper resinate' the verdigris is dissolved in a natural resin, usually combined with a drying oil. 'Copper resinate' type glazes have been noted on one of the earliest works in the Collection, the *Crucifix* by the Master of Saint Francis (Fig. 255), and their use, generally to decorate gilding, has been reported on a few fourteenth-century panels. It was only in the fifteenth century, with new developments in oil painting, that 'copper resinate' became an important part of the palette. It does, however, have one major drawback. When newly made and applied the glazes are a bright emerald or bottle green, but when they are exposed to light they gradually discolour to a warm reddish brown. If the glaze is sufficiently thick and if there is a substantial green underpaint the area of 'copper resinate' may still appear reasonably green in colour, as, for

185

example, in the sleeve of Saint Thomas in Cima's altarpiece (Fig. 256); but if the glazes are thin and are applied over a light undercolour, as when leaves are painted over a pale blue sky, the green will often discolour completely (Fig. 257).

Vermilion, the only opaque bright red pigment available in the fourteenth and fifteenth centuries, was also sometimes unstable. Although it does occur in a natural mineral form as cinnabar, most vermilion was made artificially by the heating and sublimation of sulphur and mercury. If the pigment is not thoroughly bound and protected by the paint medium the exposed particles can change to a purplish-black colour. The vermilion on the altarpieces by Nardo and Jacopo di Cione (Figs. 219 and 28 and No. 9) has discoloured in this way. When used in oil, vermilion is more stable, particularly as it is often protected further by glazes based on red lake.

Red lakes consist of dyestuffs extracted from a number of insect and vegetable sources and precipitated on to a colourless substrate, commonly hydrated alumina or a naturally occurring calcium salt such as ground egg shells or marble. These substrates become transparent when combined with an oil, allowing lake pigments to be used for glazing. In tempera, with its different optical properties, they are at best only semi-transparent. The identification of dyestuffs is still a difficult process. Of the successful analyses made so far at the National Gallery, a high proportion of the fourteenth- and fifteenth-century samples have turned out to derive from the scale insect kermes, or from lac, the secretion of the related Asian scale insect *Kerria lacca*, and therefore another significant material imported from the East. At this date red lakes from Italian paintings are rarely based on dyestuffs extracted from the madder plant, although there is evidence that madder may have been more widely used in Northern Europe. Nevertheless, the name madder is often applied incorrectly to all red lakes regardless of their source.

Transparent yellow lakes were also much used. Recipes show that they were derived from various plant sources, including weld, broom and buckthorn, but their precise identification is not yet possible. This is partly due to the fact that the amount of yellow lake in any sample is likely to be small. Since they are rather cold and acid in hue, yellow lakes tend to occur in mixtures with other pigments, either to make green (see above) or to lift and brighten the sometimes rather dull earth pigment yellow ochre. Yellow lakes were used for this purpose in both tempera and oil: for example, they have been found on the borders of the robes in both the San Pier Maggiore Altarpiece (No. 9) and Cima's *Incredulity of Saint Thomas* (Fig. 72).

The main opaque yellow pigment used throughout the period was lead-tin yellow. It could be made by two slightly different processes. The process in use in the fourteenth century appears to be associated with glass making. The product, now confusingly named lead-tin yellow 'type II', is usually a bright daffodil yellow, seen at its best on the robe of Saint Peter (Fig. 252) in the San Pier Maggiore Altarpiece. The second process, that for lead-tin yellow 'type I', was perhaps linked with the glazing of ceramics and may have been developed in Northern Europe at the beginning of the fifteenth century. Because it was easier to make, it seems to have rapidly displaced 'type II' everywhere (except, on occasion, Venice), despite the fact that it is seldom as brilliant in colour, appearing more often as a pale lemon yellow.

Another opaque yellow, sometimes mentioned in sources, is orpiment. It is an arsenic-based mineral and Cennino warned

Fig. 258. Cima da Conegliano, detail of Saint Peter from *The Incredulity of Saint Thomas* (Fig. 72), showing the use of orpiment and realgar.

against its use because of its very poisonous nature. The only work of the period in the National Gallery where orpiment has been identified is Cima's altarpiece (Fig. 258). It appears, shaded with the closely related orange pigment realgar (they are often found together in the same way as azurite and malachite), on the robe of Saint Peter, making this the earliest example in the Collection of a technique and colour combination which was to become a feature of sixteenth-century Venetian painting. The only other orange pigment, red lead, was also, like all the lead pigments, poisonous. Nevertheless, it was popular in fourteenth-century Florence, particularly for the execution of *sgraffito* textiles (see p. 176 and Fig. 241) where its density and covering power must have made it well suited for application over gold leaf. In the fifteenth century it seems to have been used mainly as an underpaint for vermilion, for example on the *Crucifixion* by Antonello and on the first, painted-out, version of Tura's *Allegorical Figure* (see p. 115), but it does occasionally appear as a pigment in its own right, notably for the oranges in Uccello's *Battle of San Romano* (No. 26).

For different shades of brown, painters could use naturally occurring earth pigments like the brown umbers and the various red and yellow ochres. When used in tempera these can make very satisfactory colours; indeed for the *Maestà* (No. 3) Duccio has used a red earth of such brightness that where it appears mixed with white for the pink architecture it could be taken for vermilion. In oil, however, painters often seem to have preferred to mix their browns, using principally black and vermilion, with admixtures of lead white and sometimes small amounts of ochre. Such mixed browns have been identified on Netherlandish paintings by van der Weyden and Bouts, and on several Italian works, including those by Bellini, Cima and Raphael. A possible reason for this may be that when used in oil, the earth pigments – then as now, despite modern paint technology – displayed their propensity to 'sink' and dry with a matt and uneven finish. Towards the end of the fifteenth century some Italian painters seem to have experimented with the use of transparent brown pigments to increase the range of possible glazes. These are difficult to identify, but analysis suggests that Cima used a brown softwood tar, a by-product of charcoal production and perhaps a modified version of the Greek pitch mentioned in a sixteenth-century treatise by Armenini. As applied by Cima this has made a very satisfactory pigment, whereas the bituminous browns liberally employed by the Pollaiuoli on the *Martyrdom of Saint Sebastian* (Fig. 283) have dried poorly, resulting in characteristic bubbling and cracking.

The plant-derived black pigments (sometimes called vegetable

blacks) described by Cennino generally have a blue-black tinge. Bone black, made from charred animal bones, has a contrastingly warmer, slightly brown colour. The difference is more apparent when they are combined with white. With one exception, *The Entombment* by Bouts (No. 32) – where the distemper medium has allowed the use of chalk – the only white pigment found is lead white, a basic lead carbonate formed when metallic lead is exposed to acetic acid fumes in the presence of carbon dioxide. A feature of lead white valuable to us today is that it absorbs X-rays, and appears white on an X-ray film. Since painters constantly added white to modify their colours and to model their forms, the image seen in an X-radiograph usually bears a close relationship to that of the painting itself.

To make a paint the pigments were ground on a hard stone slab using a muller (see p. 140). For oil painting the pigments were ground in the chosen painting oil; but if they were to be used in a water-based medium like glue distemper or egg tempera they were ground in water and the medium added only immediately before painting. The purpose of the grinding was both to combine the pigment and the medium thoroughly, which was particularly important in the case of oil painting, and to break up any lumps and agglomerations, reducing, if necessary, the particle size of the pigment. Careful judgement was needed since some of the precious mineral pigments can lose their intensity of colour if their particle size becomes too small through over-grinding.

GLUE–SIZE PAINTING

The most straightforward of the easel-painting techniques of the fourteenth and fifteenth centuries was that using a medium of glue size or distemper on canvas. The pigments (previously ground in water) were simply combined with the same animal-skin glue used to size canvases or panels and to bind gesso or chalk grounds. Because the technique did not involve the use of a ground the paint seems to have partially soaked into the canvas, the pigment particles becoming to some extent incorporated into the fibres of the fabric. This can lead to the appearance of an image on the reverse of the canvas, sometimes visible even when the painting has been lined. The retention of moisture by the canvas allowed a certain amount of blending of the brushwork, enabling the painter to achieve smooth transitions in the modelling. The placing of wool cloths beneath the canvas to absorb and retain moisture during painting would have furthered this purpose, as well as preventing the bleeding of the colours into one

another. This practice is described in the collection of manuscripts on painting techniques compiled and revised by Jehan Alcherius from 1398 to 1411, and apparently taken from cloth painters in London. A legal decision of 1458 resolving a dispute between the panel painters and the cloth painters of Bruges (see also p. 127) actually stipulated that the latter should only work on the linen 'while wet in the threads'. However, any subsequent application of paint, including details such as facial features and strands of hair or superimposed patterns on textiles and marbled stone, would have had to be applied with a lighter touch so as not to redissolve and disturb the first, by then dry, paint layer. This would account for the hatched shading, almost like drawing, to be seen, for example, on the faces in Bouts's *Entombment* (Fig. 259) and on the draperies in the canvas by Massys (see Fig. 211).

Because of the optical properties of the size medium, all pigments appear more or less opaque, even those pigments transparent in oil like the lakes or indeed the chalk used as a white pigment by Bouts. Chalk in an oil medium would become colourless and quite invisible. For similar optical reasons the expensive mineral pigments, and in particular azurite and ultramarine, appear at their most brilliant in a glue medium, and there is evidence that glue size may occasionally have been used for these pigments on works which are otherwise in oil or egg tempera.

The relative opacity of pigments in a glue medium results in good coverage with a reasonably thin layer of paint, an advantage if a canvas was to be rolled for transport. But as soon as a varnish is applied it is absorbed by the inherently lean and dry paint, and many of the colours will become dark, saturated and unintentionally translucent. Evidently these glue-size canvas paintings were not supposed to be varnished, and the National Gallery is fortunate in that the canvases by Bouts and Massys have escaped later varnishing. However, because of the absence of a protective coating and the fact that the glue medium remains permanently soluble in water, these early canvas paintings are very vulnerable to damage. Therefore the surviving examples, with a few notable exceptions, represent little more than the shadowy remains of the original paintings.

EGG TEMPERA PAINTING

Paintings in the National Gallery executed in egg tempera are often astonishingly well preserved, especially considering that they include the oldest works in the Collection. According to Cennino only the yolk of the egg was used, whole egg being re-

served for wall painting on dry plaster, but analytical results suggest that some painters may have preferred to use both parts of the egg. To make a paint, Cennino instructed that the egg should be combined with an approximately equal volume of the wet paste of ground pigment. This produces a workable paint which dries to the correct velvety sheen. Exact proportions vary slightly depending on the pigment.

Egg yolk is an emulsion of fatty material suspended in a matrix of egg proteins in water. The first stage in its drying is the evaporation of the water, followed by the setting of the egg proteins to a hard and eventually waterproof film. While the water evaporates quickly, the second stage is a slow and gradual process. This affects the handling properties of the medium. Unlike oil paint it cannot be blended and worked when wet because the partially set paint will constantly redissolve and peel away from the surface, lifting with it any previously applied paint layers. Nor can it be thickly painted with textured and brushmarked impasto: since the egg contains a high proportion of water the evaporation of the water causes the paint to shrink rapidly, resulting in premature cracking and subsequent flaking of the paint. Therefore the paint film has to be built up gradually, with repeated thin applications of colour. As in glue-size painting, to avoid disturbing the underlying paint layers the paint must be applied with the lightest of touches, hence the hatched or stippled brushwork which is a necessary convention of tempera painting (Fig. 260).

Another consequence of the way in which egg tempera dries is that once the medium has been combined with the pigment the paint will not keep. A colour must be used before it has begun to dry out in the dish or pot. This has implications for workshop practice. To avoid wastage, particularly of expensive pigments like ultramarine, the painter had to be able to assess accurately the amount of pigment needed to paint any one area. In painting an altarpiece, it seems likely that instead of concentrating on a single figure at a time, the painter may have moved from colour to colour. When attempting to distinguish between the work of different artists on paintings where there is evidence of workshop collaboration, it is sometimes possible to divide the execution by colour rather than by assigning particular figures, or indeed whole panels or scenes of complex polyptychs, to one painter or another.

RIGHT Fig. 259. Dieric Bouts, detail of the head of Saint John from *The Entombment* (No. 32).

Fig. 260. Ugolino di Nerio, greatly enlarged detail of Saint John the Evangelist from *The Deposition* from the Santa Croce Altarpiece (No. 5).

Fig. 261. Lorenzo Monaco, detail of Christ's draperies from *The Coronation of the Virgin* (No. 11).

Cennino describes a system of colour modelling for draperies which seems to have been followed by most painters working in tempera and also in fresco. This system was only to change with the introduction of the radically different approach to colour modelling associated with early Netherlandish oil painting. Since in egg tempera the colours cannot be blended and modelled on the surface of the painting itself, each tone, from the shadows through to the highlights, has to be mixed and prepared in advance. For the shadows the pigment has to be at its purest and most saturated, that is, mixed with little or no lead white. For the highlights a high proportion of lead white could be used. A mid-tone was made by mixing equal amounts of the colour prepared for the shadows with that for the highlights; further intermediate tones could then be made by combining the mid-tone with the shadow and so on. These pre-mixed shades were systematically applied, beginning with the shadows and working through to the highlights. The process was repeated over and over again, the initially sharp transitions between the tones becoming gradually softened by the intermeshing of the hatched brushstrokes (Fig. 261).

The fact that the first application of paint was to the shadows suggests a possible reason for the general lack of elaborate hatched underdrawing in tempera paintings. The shading of the underdrawing is in a sense redundant since right from the begin-

ning the painter is thinking in terms of the relief and the modelling of the forms. As a result, figures and draperies painted in this way can appear convincingly three-dimensional, especially when seen in the low light levels for which they were designed. This may account for the survival of this essentially fourteenth-century approach to colour modelling in many works of the fifteenth and even sixteenth centuries, above all in the frescoes and panel paintings of Michelangelo.

However, the convention whereby the deepest shadows are depicted by the brightest, most saturated colours is highly artificial. In reality, the colour of a draped piece of, for instance, red fabric, will usually appear at its brightest, that is at its most purely red, at a point somewhere between the mid-tone and the highlight. Moreover, different pigments at full saturation vary greatly in tone, so that vermilion or lead-tin yellow, for example, can never be as deep and dark in tone as ultramarine. The only ways to intensify the tone are by the admixture of black or other dark pigments, resulting in murky, muddy shadows, or by the superimposition of other deeper-toned pigments. However, the latter is possible only to a limited extent because, although egg tempera has a higher refractive index than glue size, it is still too low to form a truly transparent glaze like those formed in oil, even with low refractive index pigments such as the red lakes. Nevertheless, red lakes were sometimes used to reinforce the

TOP Fig. 262. Ugolino di Nerio, detail of Moses
from *The Santa Croce Altarpiece* (No. 5).

ABOVE Fig. 263. Cross-section of flesh paint shown
in Fig. 262, showing the layer of green earth underneath.
The sample was taken where the flesh overlaps the gilded
background, so some gold leaf can be seen. Magnification 250×

TOP Fig. 264. Jacopo di Cione, detail from
The Crucifixion (Fig. 28).

ABOVE Fig. 265. Cima da Conegliano, *The Incredulity of
Saint Thomas* (Fig. 72). Top surface of a paint sample from
Christ's arm showing the addition of malachite to the flesh
tints. Embedded in the sample are two brush hairs:
the coarser one probably from a bristle brush used
to lay in the underlayers and the finer one from a
minever brush used for the detailed modelling.
Magnification 105×

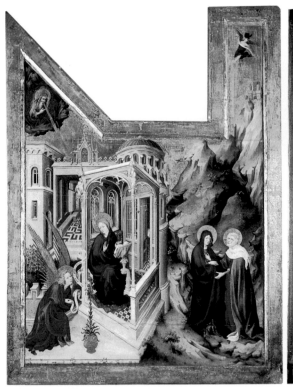
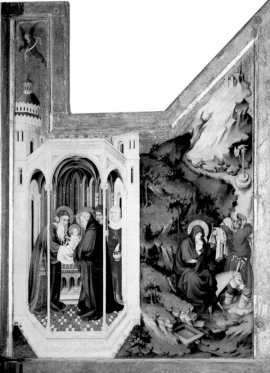

Fig. 266. Melchior Broederlam, *The Annunciation and the Visitation* and *The Presentation in the Temple and the Flight into Egypt*, outer shutters of the sculpted altarpiece for the Charterhouse at Champmol, *c.* 1399. Oak, each panel 150·6×108cm (with original frames). Dijon, Musée des Beaux-Arts.

shadows of vermilion draperies, and similarly yellow ochre, perhaps with some yellow lake, was used to model the folds of a lead-tin yellow fabric.

The only fourteenth-century painter to have been investigated at the National Gallery whose works show any degree of optical complexity is Ugolino. In his case the superimpositions of different pigments, and in particular the extensive modelling of colours with a semi-transparent layer of azurite, sometimes mixed with yellow lake, seem intended to achieve unusual and varied colour effects, rather than to extend the limited tonal range of the egg tempera medium.

The one area of an early Italian tempera painting where a multiple layer structure can be expected is in the painting of flesh. Instead of being applied directly over the white ground, flesh colours were laid over an unmodulated underpaint of green earth. This can vary in colour from the cold blue-green seen on paintings by Duccio and Ugolino (Figs. 262 and 263), to the warm, almost golden colour which occurs on, for example, the altarpieces by Jacopo di Cione. For the shadows a greenish-brown mixture of pigments – called by Cennino *verdaccio* – was generally used and for the highlights lead white tinted with vermilion or earth pigments, depending on the age and complexion of the figure to be depicted. To paint the flesh of a dead man, for example the Crucified Christ, the red pigments were omitted because, as Cennino pointed out 'a dead person has no colour' (Fig. 264). The green underpaint was not completely obscured but was allowed to show through to some extent in the shadows and mid-tones. The greenish cast to the flesh is now often exaggerated by damage and by the increased transparency with age

of the upper paint layers, but the original effect would not have been so very unnaturalistic. Later, when underpainting with green earth had gone out of use, Italian painters sometimes added green pigments to flesh colours to achieve a cool, olive tint: for example, malachite contributes to the pallor of Christ in Cima's *Incredulity of Saint Thomas* (Fig. 265), and Leonardo, in his lists of colour mixtures for the painting of shadows, highlights and midtones in flesh, recommends the addition of a little green pigment. The cold tints often seen in Leonardo's flesh painting may well be due to the use of some green pigment.

Green underpainting of areas of flesh also occurs on some of the very rare surviving Northern European panel paintings of the late fourteenth century, among them the Wilton Diptych (No. 10). While this is on oak with a chalk ground, indicating a likely Northern origin, its technique includes several apparently Italian elements, not just the green earth but also the egg tempera medium, the *sgraffito* textiles, and the green draperies mixed from azurite and yellow lake. Similarly, the shutters of the altarpiece for the Charterhouse (the Carthusian monastery) at Champmol, near Dijon, by Melchior Broederlam (Fig. 266), are painted mainly (but not entirely – see below) in egg tempera. The gilding is lavishly decorated, mostly by stippling as on the Wilton Diptych, and the flesh underpainted with green – curiously with verdigris and lead white rather than green earth. With so few extant works we can only speculate, but it does seem likely that leading French and Netherlandish painters were influenced technically as well as stylistically by the Italian panels, especially those by Duccio and Simone Martini, known to have been in France and Burgundy at the time.

OIL PAINTING IN THE NETHERLANDS

Given the striking difference in appearance between works such as the Wilton Diptych and the Broederlam shutters and those produced only twenty or so years later by the van Eycks and their contemporaries, it is not surprising that from an early date writers, including Vasari in 1550, attempted to explain the change as the result of a sudden technical innovation. Thus the legend of the van Eycks as the inventors of oil painting began. However, treatises and other documentary sources, including financial accounts, show that drying oils were familiar painters' materials at least as far back as the eighth century. They were the principal components of mordants for oil gilding on both panels and wall paintings, and of *vernice liquida*, the oil–resin varnish applied to protect and make glossy the surfaces of paintings and many other artefacts besides.

When combined with pigments, drying oils were used for the painting of stone and glass. Providing that the pigments were those which are transparent in oil, like 'copper resinate' and the red and yellow lakes, they could be used to decorate and to colour metal leaf, including the coating of white metals with yellow glazes in imitation of the more expensive gold leaf (see p. 175). Examples of thirteenth- and fourteenth-century paintings at the National Gallery with coloured glazes of 'copper resinate' – a pigment which can function as a true glaze only in oil paint since it is dissolved in the oil together with some resin – are the *Crucifix* by the Master of Saint Francis (Figs. 29 and 255), where traces of green decoration can be seen on Christ's halo, and further glazes, now hidden by later repaint, were applied to the green trellis pattern on the cross; and the *Crucifixion* by Jacopo di Cione (see Fig. 28), where the gold leaf of the lining of the Virgin's robe was glazed with green, unfortunately now discoloured to a blackish brown.

It has been thought that at first paints bound with drying oils were used principally for decorative works which were comparatively crude in their execution, and that egg tempera was reserved for the more refined effects needed in panel painting. This was because many of the early recipes for the preparation of drying oils suggest that the oils may not have dried or, to be more precise, set and hardened, particularly well. According to these sources, panels and other objects which had been newly varnished or painted with oils had to be placed in the sun to dry. The prolonged boiling of oils is described, which, while it would accelerate their drying, would also make them thick, sticky and

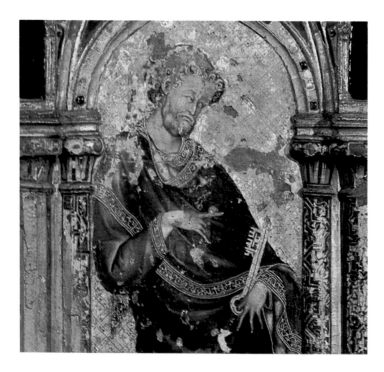

Fig. 267. Detail of Saint Peter from *The Westminster Retable* (see Fig. 12).

difficult to paint with. However, analytical results have revealed that oil paint has been used with considerable expertise in several Northern European works of the thirteenth century, notably a group of painted altar frontals from various churches in Norway and, most important, the magnificent retable of *c.*1270 which was probably once on the high altar in Westminster Abbey (see p. 28 and Fig. 267).

English paintings of the early fourteenth century, including the retable and frontal of *c.*1335 now divided between the church of Thornham Parva, Suffolk, and the Musée de Cluny, Paris, are also thought to have been painted in oil. Too few works have survived to be sure, but it is not impossible that oil, and specifically linseed oil, was the indigenous panel painting medium in Northern Europe and that it was only temporarily displaced in the fourteenth century by a fashion for more Italianate tempera paintings.

While there may have been some improvements in the refining and preparation of drying oils around the beginning of the fifteenth century (by then recipes often include lead and zinc compounds which act as driers for the setting of the oil), it would seem that no single technological breakthrough can account for the apparent transformation in the appearance of easel painting. However, a possible clue as to the evolution of Netherlandish oil painting lies in the altarpiece for the Charterhouse at Champmol referred to above. As well as painting the shutters, Broederlam contracted to gild and paint the wooden figures carved for the central part of the altar by the sculptor Jacques de Baerze. Scientific tests have shown that some of this polychromy, which includes glazing over gold leaf, has been executed in oil. Although

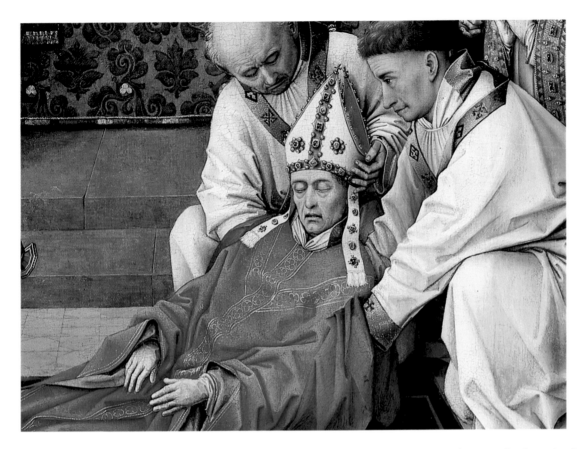

ABOVE Fig. 269. Cross-section of the red cope of Saint Hubert in Fig. 268, showing how the folds have been modelled with transparent glazes of red lake over an opaque underpaint of vermilion, red lake and lead white. The paint sample is from a relatively light area so the glaze is quite thin. Magnification 220×

LEFT Fig. 268. Workshop of Rogier van der Weyden, detail from *The Exhumation of Saint Hubert* (Fig. 8).

the shutters are essentially tempera paintings, a small amount of oil may sometimes have been added to the egg, and in places oil has been used to glaze over the tempera, principally in the deepest shadows of the red drapery folds, and for the green and brown glazes in the landscapes. From this partial glazing it is not such a great step to the full exploitation of the transparency of certain pigments in an oil medium, which is the basis of the painting techniques of the van Eycks and other Early Netherlandish painters. Their achievement seems to have been to see the optical possibilities of extending glazes over most of the painted surface, exchanging the systematic premixed colour modelling of tempera painting for an equally disciplined system in which forms are modelled and colour effects obtained by applying transparent glazes of varying thickness over opaque and semi-opaque underlayers (Figs. 268 and 269).

The opaque underlayers normally consist of pigments related in colour to the glaze, so that red lake is underpainted with vermilion, 'copper resinate' with opaque mixtures of verdigris, lead-tin yellow and lead white, and so on. Some underpainting is necessary to increase the resonance of the colour and because glazes will tend to appear thin and streaky if applied directly over the white ground. However, the underlayers should not be so thick as to obscure totally the reflective properties of the ground.

The extent to which the underpaint is modelled varies from painter to painter: with van Eyck it appears to be quite flat, with relatively little variation in tone. Almost all the relief is built up in the glazes, from the thinnest smear of paint in the highlights to the many layers of colour in the intense deep-toned shadows. The forms, therefore, are modelled from light to dark, the exact opposite to traditional tempera painting.

As a consequence of the extension of the tonal range of colours by glazing, a greater degree of naturalism was possible. For example, in the folds of the red turban in van Eyck's *Man in a Turban* (Fig. 270 and No. 17) and in the green dress in the *Arnolfini Marriage* (No. 18), the brightest, purest colours occur not in the shadows, as in tempera painting (Fig. 271), but where they are in reality, somewhere between the highlights and the midtones. The shadows are as deep and dark as is necessary for the relief, but because the pigments are transparent they are still red or green, and not murky and opaque as they would be if they were modelled by the admixture of black.

Because the deepest tones are built up by repeated glazing they can become noticeably thick and raised on the surface of the painting. This contrasts with the flesh painting, which on Early Netherlandish paintings is invariably extremely thin. No undercolour is used and the flesh colours are applied in the thinnest of touches over the luminous white ground. In X-radiographs areas of flesh usually appear almost black; only the most prominent highlights contain sufficient lead white to register an X-ray image (Figs. 272 and 273).

Another factor contributing to the realism of Early Netherlandish painting is that the transparency of the oil medium made it possible to paint convincing cast shadows (Fig. 274). This was difficult in tempera owing to its relative opacity. Generally no

ABOVE LEFT Fig. 270. Jan van Eyck, detail from *A Man in a Turban* (Fig. 17).

ABOVE RIGHT Fig. 271. Lorenzo Monaco, detail from the right panel of *The Coronation of the Virgin* (No. 11).

RIGHT Fig. 272. Dieric Bouts, *The Virgin and Child* (No. 28). X-radiograph of the Virgin's head.

FAR RIGHT Fig. 273. Dieric Bouts, detail of the Virgin's head from *The Virgin and Child* (No. 28).

Fig. 274. Jan van Eyck, detail from *The Arnolfini Portrait* (No. 18).

attempt was made to represent cast shadows and where they have been tried, by, for example, Masaccio in *The Virgin and Child* (No. 15), they are not entirely successful.

Lastly, because oil paint does not dry by evaporation but rather sets by a slow and gradual process, there was no need for the stippled and hatched brushwork characteristic of tempera painting. It remains soft and workable for long enough to be manipulated with a brush, so that transitions in the modelling can, if necessary, be softened and blended. To obscure further any traces of brushwork, the paint can be blotted with a rag or with a finger tip without lifting off the lower paint layers as would happen in tempera. Fingerprints in the glazes of the green robe in the *Arnolfini Portrait* show that van Eyck has done just that.

Analysis of samples has confirmed that painters sometimes added small amounts of natural resins to the drying oils for the glaze layers. This would have made the paint even more transparent and perhaps easier to apply. It has sometimes been suggested that an innovation at the time of the van Eycks was the use of a volatile diluent such as naphtha, distilled turpentine or oil of spike lavender to make the paint less viscous. However, there are no records of the use of diluents until the sixteenth century, and their presence cannot be detected by scientific analysis since no trace would now remain in the paint. The fine details on an Early Netherlandish painting, for example the flickering touches of lead-tin yellow used to represent the gold threads of a brocade, are often slightly raised, suggesting a full-bodied paint rather than one thinned with diluents. Hand-ground oil paint is not as stiff and buttery as modern paint, made to be stored in tubes and with a texture more suited to painting with impasto; and the

anonymous author of the Strasburg Manuscript, the only known fifteenth-century Northern treatise to touch on oil painting, states that the paint should be made 'to the consistency of a soft paste', with the addition of extra oil after grinding if necessary. Moreover, painters were used to dealing with intractable materials like oil mordants: with a fine enough brush and great patience even the most detailed effects are possible.

The medium used for the opaque underlayers seems to have varied. Analyses made at the National Gallery indicate that certain painters, including Campin, Bouts, Gerard David and the Master of Saint Giles, used some egg tempera, particularly in the lower layers. This has an obvious practical advantage in that it dries rapidly, allowing immediate application of the glazes. Other Netherlandish works appear to be entirely in oil. No analysis has been carried out on works in the Gallery by van Eyck, but studies of his celebrated altarpiece, *The Adoration of the Lamb*, painted for the church of St Bavo, Ghent, and completed in 1432 suggest that for most colours oil was the principal medium. X-ray and infra-red images of paintings by van Eyck show that his underpainting was often surprisingly free and brushmarked in a way that is unlikely with tempera. Furthermore, on the Ghent Altarpiece the underpainting has been applied over a layer consisting principally of a drying oil, a greasy surface to which tempera would not successfully adhere.

The practice of preparing the ground with a layer of oil to reduce its absorbency suggests an interesting connection with techniques for painting on stone. A similar layer, sometimes of glue size or perhaps egg tempera, has been noted on many Early Netherlandish paintings. In the case of the Ghent Altarpiece, and also certain paintings by van der Weyden and his workshop, including the *Descent from the Cross* (Madrid, Prado), *The Magdalen Reading* (No. 22) and the *Exhumation of Saint Hubert* (Figs. 268 and 269), paint cross-sections show that the priming has been lightly tinted with black and red earth pigments. This is reminiscent of the *primuersel*, the transparent flesh-coloured priming described in 1604 by Carel van Mander as a characteristic of Early Netherlandish oil painting.

It is not clear whether there was ever any modelling in this layer in addition to that indicated in the underdrawing. The elaborately shaded and hatched underdrawing seen in the draperies on most Early Netherlandish paintings was needed to fix and define the modelling of the forms to be painted. The drawing was probably intended to remain just visible through the paint of the underlayers, providing a guide for the application of the glazes. A half-finished, unglazed piece of drapery painting would

have appeared relatively formless; without the detailed drawing there would have been a danger of the painter losing sight of the forms he was representing, particularly if, as seems likely, use had been made of workshop assistants in the blocking-in of the underlayers.

OIL PAINTING IN ITALY

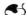

The sequel to the traditional story of the invention of oil painting by Jan van Eyck as described by Vasari, is that Antonello da Messina, on seeing a panel by van Eyck in Naples, went to Bruges to study with van Eyck and on his return to Italy was responsible for the transmission of the technique to Venice (where he is known to have been in 1475-6), and thence to the rest of Italy. However, Vasari's chronology of events was impossible: van Eyck was active from 1422 and died in 1441; Antonello was active from 1456 and died in 1479 and there is no evidence that he ever visited the Netherlands.

Works by several Northern European painters in oil were to be seen at the Naples court of Alfonso I of Aragon in the 1440s and 1450s and must have been known to Antonello. Little is known about painting in Naples in the mid-fifteenth century because so few works have survived. Those attributed to Colantonio, described as Antonello's master in a letter written from Naples in 1524 by Pietro Summonte, have certain Netherlandish features and may well have been painted in oil, but they show little understanding of van Eyck's methods of modelling by glazes.

That Antonello did paint in oil is confirmed by the identification of walnut oil as the medium of the *Salvator Mundi* (Fig. 275) and *Saint Jerome in his Study* (No. 41); but the interpretation of the date on the cartellino on the former is problematical – it has usually been taken to mean 1465 but it could be as late as 1475 – and the *Saint Jerome*, although often regarded as an early work, may well also date from about 1475. This painting, in particular, is Netherlandish in its minuteness of detail but, since we can now demonstrate that by the 1460s paintings executed in oil in a Netherlandish manner were being produced near Venice (see p. 198), it is not impossible that Antonello, far from being responsible for the introduction of oil painting to Venice, may actually have developed and modified his own technique while in Northern Italy.

Certainly the transition from tempera to oil painting in Italy was not a sudden event. Rather it was a gradual and complex process which, while it may be clarified as increasing numbers of paintings are examined by modern scientific methods, will never be fully understood owing to the low survival rate of works from many important centres of painting.

Virtually simultaneously, similar changes in technique were taking place in Spain. Initially Spanish painters, including, surprisingly, Luís Dalmau who had the benefit of a stay in the Netherlands in the 1430s, seem to have used oil paint in a rather opaque way. It was not until the late 1460s that artists like Bartolomé Bermejo began to explore the possibilities of transparent glazing. In addition, tests indicate that the altarpieces produced in southern France in the 1450s by Enguerrand Quarton are in oil. The fact that the contract for the *Coronation of the Virgin* (see p. 129) expressly states that it is to be painted in oil suggests that the technique may still have been relatively novel. Some diffusion

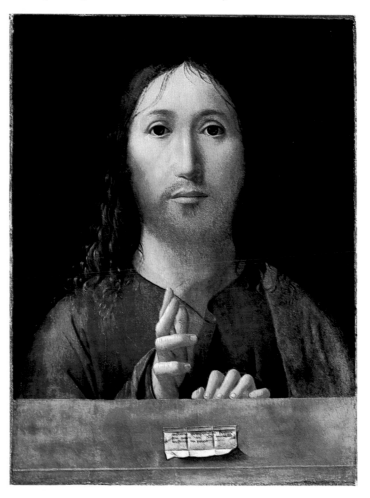

Fig. 275. Antonello da Messina, *Salvator Mundi*, apparently dated 1465. Wood, painted surface 39×29.5cm (NG 673).

Fig. 276. Piero della Francesca, detail from *The Nativity* (No. 36).

into northern Italy of oil painting techniques from France and also perhaps Austria and Switzerland is therefore a possibility.

However, the principal stimulus for the change must still have been the works of Netherlandish painters known and admired in several Italian cities other than Naples. As has been mentioned (p. 117), a painting by Jan van Eyck of a woman emerging from a bath was recorded in Italy in the 1450s and a bathing scene by Rogier van der Weyden was known to be in Genoa around this time. From 1461 to 1463 the Milanese court portrait painter Zanetto Bugatto was sent to Brussels to study with Rogier, and by 1473 Justus of Ghent was in Urbino.

Even before the arrival of Justus, Piero della Francesca seems to have begun to work in oil. The medium of the *Baptism of Christ* (No. 27), an undoubted early work, has been identified as egg tempera, although a little oil may have been used for the green glazes of the foliage. Many of the traditions of tempera painting, including the colour modelling, the underpainting of flesh with green earth and the hatched application of the paint, are present. However, judging by the wide drying cracks (impossible in tempera) to be seen on the central panel of his polyptych for the Confraternity of the Misericordia in Borgo Sansepolcro, Piero must have been using oil by the time he finished this work, probably in 1454. In a contract of 1466 he agreed to paint a banner in oil for the Confraternity of the Annunciation in Arezzo. The *Saint Michael* (No. 33) from the high altarpiece of Sant' Agostino in Sansepolcro, commissioned in 1454 but again protracted in its execution and not fully paid for until 1473, has been firmly identified as having been painted in walnut oil. The green underpaint has been replaced by a brown undermodelling, also visible in the unfinished or damaged heads of the shepherds in the *Nativity* (Fig. 276). On both these pictures, and several other works, the paint surface shows wrinkling and drying defects indicative of a faulty use of the oil medium. Piero was evidently influenced by North-

ern painting in many ways, but his oil paintings are not particularly Netherlandish as regards the use of glazes. These are reserved mainly for certain colour effects and to reinforce the deepest shadows of the folds. Therefore, while there is more contrast in the modelling, his oil paintings are often nearly as light in tone as his earlier works in tempera.

To find a more systematic and Netherlandish use of glazing it is necessary to turn to Ferrara. In 1449 an altarpiece, now lost, by Rogier van der Weyden was shown by Lionello d'Este to the writer and antiquary Ciriaco d'Ancona. According to Ciriaco (and corroborated by Bartolommeo Fazio in 1456), it represented a Deposition and a Fall of Man. The next year Rogier was paid for various pictures for Lionello d'Este, via a d'Este agent in Bruges. Rogier's style and simpler, more economical technique was almost certainly more accessible to Italian painters than the almost miraculous technical perfection of Jan van Eyck.

The best surviving example of a work influenced by Rogier is undoubtedly Cosimo Tura's *Allegorical Figure* (Figs. 156 and 277) from the *studiolo* at Belfiore and therefore probably dating from the later 1450s (see p. 115). Beneath the present image is another enthroned figure, perhaps originally a different Muse, which does not seem to have progressed much beyond an underpainting before it was abandoned. Analysis has revealed that this first painting was executed in egg tempera. The revised design was drawn over it with the bold hatched graphic technique seen on all Tura's later works, and then painted, this time in oil and using a two-phase system of opaque underlayers modelled with glazes of varying thickness. On the pink robes the glazes can be seen to cover even the highlights. The sumptuous cloth-of-gold sleeves, strikingly like those of one of the Three Kings in Rogier's Columba Altarpiece (Fig. 278), a work probably close in date to the lost Ferrara paintings, have been executed using a sequence of paint layers like that to be found in depictions of equivalent textiles in Netherlandish paintings. There are none of the drying defects seen on the oil paintings of Piero and, indeed, on many other early essays by Italian painters in oil. Tura's command of the technique extends to the use of the paler, less yellowing walnut oil for the light colours and linseed oil (with added resin) for the dark glazes, a distinction later recommended by Vasari.

It is difficult to believe that Tura could have used oil paint so successfully without direct instruction. It has been suggested that Rogier may have visited Ferrara during the pilgrimage to Rome he is supposed to have made in 1450, but evidence for this pilgrimage is vague and anecdotal. Perhaps a member of his workshop went to Ferrara to escort the altarpiece and to make good

ABOVE Fig. 278. Rogier van der
Weyden, detail from *The Adoration
of the Kings* (The Columba
Altarpiece), *c.* 1455. Munich,
Alte Pinakothek.

RIGHT Fig. 277. Cosimo Tura,
detail from *An Allegorical Figure*
(Fig. 156).

any damage. Alternatively, the d'Este, like the Sforza of Milan, could have sent a painter to the Netherlands. This was not necessarily Tura himself, since Angelo da Siena (Maccagnino), the mysterious figure who was his much-admired predecessor as court painter and from whom he inherited the project at Belfiore, is described by Ciriaco as being the imitator of van der Weyden, presumably in his use of oil paint as well as in his love of detail.

In a later work, the Roverella Altarpiece (No. 44), Tura still used oil but over a tempera underpaint and without such extensive deep-toned glazing as on the *Allegorical Figure*. While Costa, perhaps a pupil of Tura, seems to have worked mainly in oil, the National Gallery's panels by the other Ferrarese painters, Cossa (No. 35) and Ercole de' Roberti (Fig. 26), have been found to be in egg tempera, but used in such a way, with little admixture of white, as to achieve the richest, most saturated colours obtainable within the limitations of the medium. Tura may have

chosen to guard his knowledge – documents often record his works as being 'ad olio' as though they were special – but given the closeness of Ferrara to Venice and the fact that he visited Venice on more than one occasion (see p. 183), it seems likely that the techniques of oil painting could have already been known in Venice by the time Antonello arrived in 1475.

Whether Antonello played any significant role or not, it was in Venice that the Netherlandish approach to oil painting seems to have gained its strongest hold in Italy and initially in the works of Giovanni Bellini. Analysis has confirmed that the altarpiece of the Coronation of the Virgin which he painted for Pesaro in about 1475 is in an oil medium. Perhaps because of his original training as a tempera painter, however, Bellini seems often to have continued to use a tempera underpainting, with the modelling firmly established in the underlayers as well as the glazes. This tendency is illustrated by the back of the paint film exposed

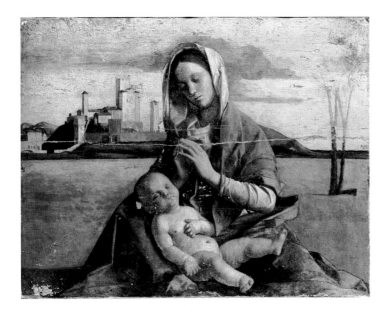

Fig. 279. The back of the paint film of *The Madonna of the Meadow* by Giovanni Bellini (No. 57) exposed by the removal of the original panel and gesso ground during the transfer of the painting to a new support in 1949.

ABOVE Fig. 280. Cima da Conegliano, detail showing the Apostle on the left from *The Incredulity of Saint Thomas* (Fig. 72).

by the removal of the gesso during the transfer of *The Madonna of the Meadow* in 1949 (Fig. 279 and No. 57). The glazes are used for the fine detail and to intensify the colours as much as to build up the modelling of the drapery folds. Similarly, infra-red photographs suggest that the undermodelling of the face in the portrait of Doge Loredan (No. 60) was built up with cross-hatched strokes as in tempera painting and the modelling softened and blended, often with the fingertips, only in the final oil glazes.

A more strictly Netherlandish technique can be found in the works of Cima. On many of the draperies in the *Incredulity of Saint Thomas* (Fig. 72) the underpainting is only slightly modulated, the relief being achieved almost entirely by the application of glazes. For example, the maroon robe of the Apostle on the left has been underpainted with a mixture of lead white and haematite (a crystalline form of iron oxide, rarely found as a pigment) and then modelled with red lake glazes of varying thickness (Figs. 280 and 281). To make the Apostles at the back of the group recede to an appropriate extent, Cima has even experimented with superimposing different coloured glazes so that, for example, the deep green robe of the Apostle to the right of Christ has been completed with a glaze of red lake over the layers of green. This has the effect of deepening the colour, but without making it opaque and muddy as would happen if he had used a less transparent pigment such as a black. Analysis shows this altarpiece to have been painted entirely in linseed oil, but even in smaller scale works such as *The Virgin and Child with a Goldfinch* (Fig. 282), where some tempera is present in the light colours and as an underpaint, Cima shows himself to be perhaps the most Netherlandish of all Italian painters in his methods of painting.

In Florence artists seem at first to have been less ready to adopt a Northern approach to oil painting. There is evidence that painters like Filippo Lippi and Fra Angelico may have seen, and to some extent been influenced by, Netherlandish paintings at an early date and yet their technique seems to have been little affected. In his confused account of the introduction of oil painting Vasari mentions Domenico Veneziano, Castagno, Pesellino and Baldovinetti, although the last named appears only in connection with experiments in wall painting. The large quantities of oil bought for Domenico Veneziano's murals at St Egidio in 1438 might suggest that some form of oil technique was

Fig. 281. Cima da Conegliano, *The Incredulity of Saint Thomas* (Fig. 72). Cross section from the maroon sleeve showing the remodelling of the folds with glazes of red lake over an underpaint of haematite and lead white. Some underdrawing can be seen between the underpaint and the white gesso ground. Magnification 220×

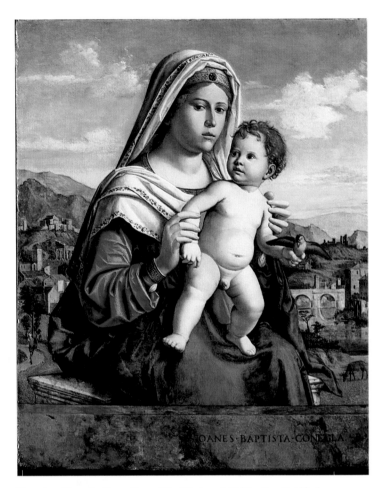

Fig. 282. Cima da Conegliano, *The Virgin and Child with a Goldfinch, c.* 1505. Poplar, painted surface 53.5×43.5cm (NG 634).

Fig. 283. Antonio and Piero del Pollaiuolo, detail from *The Martyrdom of Saint Sebastian* (No. 40).

employed. However, it is equally likely that the oil was used for making mordants. Traces of gilding on the very damaged *Virgin and Child* from his Carnesecchi tabernacle (see Fig. 93) suggest that his earlier mural paintings may have been lavishly decorated with such gilding.

Little is known of the technique of Castagno's few surviving easel paintings. The *Assumption of the Virgin* (Berlin, Staatliche Museen) of 1449-50 is notably rich and deep in colour, but the brushwork has the hatched application of tempera painting. While some oil may have been used in the glazes of the landscape, the possibility that the techniques of Netherlandish painting have been imperfectly understood is suggested by the use of black shadows to intensify the modelling of some of the drapery folds.

The Trinity Altarpiece begun in 1455 by Pesellino and completed on his death in the workshop of Filippo Lippi (see Fig. 57) shows a similar increase in depth of tone. Here analysis has revealed that a small amount of oil has been added to the egg tempera, probably to make the paint slightly more transparent and saturated. However, this enriched emulsion, aptly named by the Italians *tempera grassa* (fatty tempera), still presents some of the handling problems of egg tempera so the hatched brushstrokes of tempera painting are normally visible. *Tempera grassa* has been

identified on several Italian paintings of the second half of the fifteenth century, both as an underpaint for oil glazes and as the principal paint medium. At the National Gallery it has been found especially on works by Crivelli, a painter who can be said to have made a positive virtue of the need for a hatched application of the paint.

The landscape of the Trinity Altarpiece is richly glazed with 'copper resinate', which has almost completely discoloured, perhaps because there is no real underpainting with opaque green as there would be in a Netherlandish work. Indeed, for the foreground, Pesellino, like Uccello and Botticelli, has retained the fourteenth-century practice – described by Cennino and used, for example, by Jacopo di Cione in the San Pier Maggiore Altarpiece – of underpainting areas of green foliage with black.

Discoloration of 'copper resinate' also affects the landscapes in the panels by the Pollaiuoli. While these landscapes may well have been influenced by Northern examples, the way in which the Pollaiuoli used oil paint – confirmed by analysis as bound with walnut oil – is very different from most Netherlandish paintings. In the foreground of the *Martyrdom of Saint Sebastian* (Fig. 283) the glazes of 'copper resinate' and bituminous browns do not seem to have been built up carefully layer by layer, but

rather as a single thick application. The consequent drying problems have led to the raised, bubbling paint with wide drying cracks more often associated with eighteenth- and nineteenth-century paintings. The figures, although also in oil, have not been modelled by glazing so much as by premixed colours, as in tempera painting. The application of the paint is remarkably free and bold, with the long sweeps and strokes of the brushes clearly visible. On the evidence of this and other large-scale works, particularly those attributed to Piero, the Pollaiuoli would appear to have been among the first to explore the possibilities of using the oil medium for a rapid, more direct method of painting.

By contrast, paintings produced in the Verrocchio workshop are notable for the meticulous precision with which they have been executed. While there is little agreement as to how much and indeed what Verrocchio himself actually painted, there is no doubt that he expected the highest technical standards from his apprentices and associates. This is exemplified by the extraordinary delicacy and refinement of the brocades and embroidered patterns – where both paint and 'shell gold' are used – on *Tobias and the Angel* (No. 39) and *The Virgin and Child with Angels* (Fig. 195). His followers also seem to have been technically versatile, able to work in both oil and tempera. Their approach to oil painting varied considerably. Lorenzo di Credi, even when using oil, continued to apply his colours more in the manner of a tempera painter, mixing his tones – graded with 'needless regularity' according to Vasari, who clearly found his technique irritatingly precise – and glazing only to achieve certain colour effects, usually for dark 'copper resinate' greens.

A similar tempera-orientated application of oil paint can be seen on many Florentine works of the late fifteenth century. The arrival in Florence in 1483 of the monumental Portinari Altarpiece, painted in the Ghent workshop of Hugo van der Goes, seems to have had less impact on technique than might be expected considering the size and importance of the altarpiece. Analysis has shown that painters like Ghirlandaio, Filippino Lippi and Botticelli, in his very late work on canvas the *'Mystic Nativity'* (No. 56), did use oil, often in combination with tempera for lighter colours or for underpainting, but they seldom exploited glazes, except for dark greens and reds and occasionally for the reinforcement of shadows. A possible reason for the persistence of modelling by mixed tones is that Florentine painters, unlike their Venetian contemporaries, still had to be equally competent at fresco painting, where glazing was obviously im-

possible, and the colours had to be applied in a systematic sequence from shadow to highlight, exactly as in traditional tempera painting.

Leonardo was without doubt the most inventive graduate of the Verrocchio workshop in his use of oil paint. As early as his *Adoration of the Kings* (Florence, Uffizi), left unfinished on his departure for Milan in 1482, Leonardo had evolved his method of modelling the forms in monochrome browns, blacks and greys before the application of any colour. A similar undermodelling can be seen on the unfinished parts of the National Gallery's version of *The Virgin of the Rocks* (Fig. 284 and No. 68), and black, brown and grey layers related to this undermodelling feature in the few paint samples from the work to have been studied to date. The outlines and rough placement of the figures seem to have been indicated in black, almost certainly with paint rather than a drawing ink, and the modelling and distribution of light and shade with washes of brown paint, probably based on earth pigments but perhaps containing some of the transparent bituminous brown mentioned by Leonardo in his writings. That the medium for these underlayers was exceptionally liquid is suggested by the runs and dribbles in the paint, especially on the rocks in the right foreground. Here a diluent may have been used, either naphtha (*olio di sasso*), or the oil of spike lavender referred to in sixteenth-century sources and implied by Vasari's anecdote concerning Leo X's complaint about Leonardo wasting time on the distillation of herbs and oils before beginning to paint. Tests indicate that the medium of *The Virgin of the Rocks* is oil, while more precise analysis of samples from one of the angels which form the shutters of the altarpiece (No. 68c, d) has identified walnut oil, the extraction of which Leonardo describes in detail in his notebooks. The flexibility of the oil medium has allowed Leonardo to blend and soften the modelling, using his fingertips, like van Eyck, Bellini and many others, to achieve the desired *sfumato* (smoke-like) effect.

The muted colours are due partly to the dark underpainting, but also to the choice of pigments: the lining of the Virgin's robe is painted with a dull ochre rendered more transparent by the addition of a yellow lake. Only the highlights are a brighter lead-tin yellow. The blue robe has become darker owing to the poor drying of the paint, but it can never have been bright: the azurite in the underpaint is of a marked green tinge, while the ultramarine of the upper layer is so thinly glazed that it seems no more than a gesture towards the 'fine colours' stipulated in the original contract. Where the blues are intended to have greater brilliance, in the azurite sea and sky and the ultramarine rocks for instance, a

LEFT Fig. 284. Leonardo, detail from *The Virgin of the Rocks* (No. 68).

203

Fig. 285. Raphael, detail from *The Crucifixion* (No. 61).

Fig. 286. Raphael, detail from *The Virgin and Child with Saint John the Baptist and Saint Nicholas of Bari* (No. 65).

Fig. 287. Raphael, detail from *Saint John the Baptist Preaching* (predella panel to No. 65).

lead-white layer has been applied over the yellow-brown under-modelling to provide a more luminous base for the blue. Similar lead-white layers occur in many fifteenth-century Netherlandish and Italian oil paintings to increase the reflectance of the ground, and perhaps to reduce the visibility of obtrusive underdrawing.

Perugino may also have developed his oil painting technique while in the Verrocchio workshop. However, the thin translucent flesh painting and the rich jewel-like glazes seen on some of the draperies on the panels from the Certosa di Pavia Altarpiece (No. 59) suggest that his tendency to use a more Netherlandish type of paint layer structure may have been reinforced by his visit to Venice in 1495. His methods were taken over by Raphael for his early altarpieces. The flesh in the *Crucifixion* (Fig. 285) is so thinly painted that it appears embedded in the surrounding draperies and landscape. The foreground of the landscape – painted in linseed oil, whereas the pale blue sky is in walnut – has been boldly, even crudely, blocked in; and in the draperies Raphael has often reinforced the shadows with hatched strokes of paint, perhaps as a short cut to reduce the need for a gradual building up of glazes to produce the required depth of tone. The main panel of the Ansidei Altarpiece (No. 65), although so far not analysed, is evidently also in oil and here a more careful blending of the glazes can be seen, especially on the crimson robe of Saint John the Baptist (Fig. 286). The predella panel from the same altarpiece, however, has a very different appearance. Apart from the 'copper resinate' glazes in the foliage, analysis has shown the medium to be egg tempera. The paint has been applied so that the characteristic hatching of tempera is virtually undetectable, but the draperies, including the robe of Saint John the Baptist, have been modelled in the tempera fashion by the admixture of white, any glazing being applied only to the deepest shadows of the folds (Fig. 287). In the dim light of a church the resultant brighter tonality would evidently have improved the legibility of small-scale and detailed predella scenes such as this.

The use by Raphael of different media and methods of application for works which differ in scale and function not only demonstrates his particular versatility, but also illustrates the complex and varied state of painting techniques in Italy at the beginning of the sixteenth century. The transition to oil painting was far from complete. Within the span of his own short career Raphael's technique was to be affected by the further innovations of sixteenth-century Venetian painters, innovations which were to combine the flexibility of handling initially explored by Leonardo and the Pollaiuoli with the optical brilliance of the coloured glazes of Perugino, Bellini and Cima.

PAINTING AND THE SISTER ARTS

The prestige which great painters enjoyed at the end of the period surveyed here affected the status of the art of painting generally. In consequence earlier painters have often been given a distinction which their contemporaries would not have understood. In Italy especially painting was claimed as one of the liberal arts. The idea is found in the most important work of art theory to have survived from this period, *De Pictura*, written in Latin in 1435 by Leon Battista Alberti (1404-72) and translated by him into Italian by the following year. According to Alberti, the ancient Greeks were taught the art of painting 'together with letters, geometry and music', and ancient Romans, princes and the common populace alike, delighted in the public exhibition of paintings carried to the city in triumph.

For Alberti it was an understanding of optics and geometry which ensured the painter's rank among the liberal arts, and which proved that he was more than a craftsman; and it was his command of narrative – *istoria* – which enabled him to be considered akin to orator or poet. But these ideas spread slowly and surely cannot have determined the high esteem with which Giotto, Simone Martini and Jan van Eyck were regarded at the courts of Naples, Avignon and Burgundy. It was for their exquisite sense of design, for their ability to imitate the natural world, and for their skilful craftsmanship, that their art was prized.

Established as heroes worthy of Alberti's praise, as equivalents to the artists of the Greek and Roman world, painters had their biographies written and their fame guaranteed. This first happened in Italy where the *Lives* of Vasari, published in the mid-sixteenth century, set a standard which was to be imitated for several centuries – the earliest Northern European equivalent, the *Lives* of van Mander, was not only later in date (it was published in 1604) but more modest in scope. Vasari presented the history of painting as a progression, but while he depicted painters as gaining in skill and knowledge until the time of Raphael and Michelangelo, he nevertheless distorted the way in which the art of their predecessors had been received.

We know that the preparatory drawing which Leonardo made for an altarpiece in Florence in 1501 was admired by art lovers, and perhaps it is true, as Vasari later claimed, that people of all social classes came to admire it, like the ancient Romans as described by Alberti – although this does not seem likely. Far less probable is Vasari's interpretation of the procession mentioned in his Life of Cimabue in which that painter's altarpiece was carried through the streets of Florence as a personal triumph. Such processions did take place, but the point of them, as is clear from that which accompanied Duccio's *Maestà* (No. 3) to its position on the high altar of Siena Cathedral, was to honour the Virgin Mary. If this was a novel type of popular ceremony in the thirteenth century then that was because huge and costly altarpieces were new, rather than because artists had suddenly become popular heroes.

The evidence of the artist's name on paintings is also easily misinterpreted. They are found on paintings – small private ones as well as large public ones – throughout this period. That of Margarito of Arezzo (No. 1) in the thirteenth century is as prominent as any of the early sixteenth century. We need not suppose that an artist signed a painting to show that it was truly and entirely his work – a 'genuine' Margarito – as a signature is used today. It may have been more like a label on a product, intended at once as a guarantee and an advertisement. It was certainly also often a way of being remembered in prayers and of being associated with a holy image. Duccio's *Maestà* is inscribed: MATER SCA

DEI/SIS CAUSA SENIS REQUIEI/SIS DUCCIO VITA/TE QUIA PINXIT ITA ('Holy Mother of God be thou the source of peace for Siena and life to Duccio because he painted thee thus').

Artists, most obviously the leading court artists, did, of course, often enjoy great reputations, and these were reflected in poetry – indeed promoted by poetry, as when Petrarch praised the work of Simone Martini. But the fame which Petrarch himself enjoyed, fame which led to him being crowned with laurels in revival of an antique ceremony and to him addressing his poetry to a distant posterity, was not something which painters were familiar with before the fifteenth century, and very seldom even then.

Giotto and his possible master Cimabue were both mentioned in the *Divina Commedia* by their fellow Tuscan, Dante, although not in a passage which inspires confidence in durable posthumous glory:

Credette Cimabue nella pittura
 Tener lo campo, ed ora ha Giotto il grido,
 Si che la fama di colui è oscura. PURGATORIO XL, 94

Cimabue thought he led the field
 of painters. Now Giotto takes the prize
 And the former's fame is quite concealed.

This passage is often cited out of context. It comes in a lament made to Dante by the shade of Oderisi Agobbio (Oderisi from Gubbio in Umbria), one of the leading manuscript illuminators of his day. When Dante hails him as a great man, he hastens to depreciate his own work with the humility he has learnt since his death, and to praise work by his rival Franco of Bologna. It is clear that Dante expected his readers to be at least as familiar with Oderisi and Franco as with Giotto and Cimabue, indeed apparently more so.

Throughout this period paintings were among the small portable works of devotional art owned by the rich and powerful, but they were seldom as highly prized or as avidly sought after as enamels, ivories and illuminated books. On a larger scale – above all as altarpieces – paintings were not, in the thirteenth and fourteenth centuries, regarded as the highest available art form. The painters' materials were not inherently as valuable as those employed in metalwork and textiles, and thus paintings, as religious offerings, were less precious.

There is good reason to suppose that painting was often thought of as an art which in addition to imitating the visible world and, more importantly, representing the invisible, higher, world, imitated work in precious metal and textiles. Imitation could mean providing a substitute which deceived on a slight acquaintance, or which served as a cheaper equivalent. This was the case with the imitations of marble or hangings found on the backs of panels, the dados of chapel walls or on *spalliere* (p. 110), and with the painted cloths which we know to have hung in lieu of costly tapestries (p. 84). The earliest paintings on gilded panels – and especially altarpieces and crosses – may also have been regarded in this way. But often imitation meant the devising of similar effects to those of embossed and tooled metal, or cloth of gold or damask – effects achieved by sophisticated techniques of punching and incising the gold ground, by *sgraffito, pastiglia* and moulding, described in the previous section. Although appreciated for their own sake these effects were still ones suggested by the sister arts. Even the splintered lines of mordant gilding on the Virgin's red robe, and the thread-like gilt hem of her cloak, in Duccio's *Annunciation* (No. 3), resemble and surely imitate the gold divisions or 'cloisons' of Byzantine enamels created a century and a half before.

Recognition of this encourages appreciation of the priorities which determined the nature of such painting. The representation of volume, light and space in the work of Giotto, together with the cogency of his narratives, provided a model by which artists were inspired for more than a century, but the ornamental conception of the art, stronger in panel painting than in mural painting, limited the degree to which painters at first imitated him. It is in the representation of space that this is most obvious. That an effect of depth could be created by converging parallel lines, especially in the pattern of a tiled floor or paved piazza, was widely known, although only a few fourteenth-century artists – most notably Ambrogio and Pietro Lorenzetti in Siena (No. 6) – had the ability to create a consistently receding architectural space. The three-dimensional effect established by the tiles in the foreground of the *Coronation of the Virgin* by Lorenzo Monaco (No. 11) and by the fragile pierced architecture of the throne here, or in the earlier painting of the same subject by Jacopo di Cione (No. 9), has little impact on the character of the whole painting. By contrast the imposing throne in the Austrian School painting of the *Trinity* (Fig. 16) seems far more substantial, but its solidity is contradicted by the flat gold ground and the uncertain volumes of the figures.

Spatial effects, in painting of the fourteenth and early fifteenth century, are commonly devised in such a way that they do not unduly disturb the two-dimensional pattern of the painting. Thus in the Wilton Diptych (No. 10) the arms and wings of the angels in the foreground to the right form a line across rather than

into the picture space. The importance of two-dimensional pattern is still more evident in Lorenzo Monaco's *Coronation* where the curve of an arm or the loop of a robe echoes the line of a halo.

This ornamental conception of painting was much enhanced by the value attached to a two-dimensional pattern with a flowing line. But some of the paintings of the second half of the fifteenth century share similar values even though they are by artists who devised startling effects of foreshortening and favoured aggressive angularity of form.

When painting *Saint Michael* (No. 46) Carlo Crivelli rendered the archangel's embossed armour of gold and silver by building up the gesso and using metal leaf, and for precious stones he set glass ones into the gesso – all of which would have been particularly magical when it gleamed in the candlelight from the altar. For Piero della Francesca when painting the same subject (No. 33), the armour and jewels are no less important, but he had a different conception of imitation: gems and armour are represented not with metal leaf or paste but with colours, and the light upon them comes from within the painting. The representation of light and of space is indeed one of Piero's chief concerns. Behind his Saint Michael is a low marble wall and blue sky, whereas behind Crivelli's there is a gold ground incised with a pattern imitating brocade. For Crivelli the space is conceived of as if the saint were a sculpture in a niche. Piero's sky and wall on the other hand extend beyond the picture. Such a comparison may make Crivelli sound like an archaic artist, which is misleading, for his style was as novel and as inventive as Piero's. But Piero's conception of painting was part of a revolution in European art, a revolution which occurred in some parts of Italy in the early fifteenth century and at much the same date in the Netherlands.

The painting of Saints Peter and Dorothy by the Master of the Saint Bartholomew Altarpiece (No. 67) looks like a witty commentary on this revolution, for he presents his saints against a golden cloth such as might have formed a uniform background, but he shows that it is flexible and permits a distant landscape to appear above it. He also includes a column beside the saints, such as might once have come between them in earlier paintings.

The revolution may be clearer to us now than it was at the time, and there are many paintings which seem to seek some compromise position. Both the Master of the Life of the Virgin in Germany (No. 37) and Matteo di Giovanni in Siena (Fig. 45), for instance, were interested in representing pictorial space, and yet they retain in place of the sky a gold background. Attitudes towards gold are indeed often the most valuable index of the changing conception of the art of painting.

The most important text concerning this comes towards the end of the second book of Alberti's treatise:

> Some there are who employ gold immoderately supposing that it gives their painting majesty. This I don't applaud at all. Even if I wished to depict Virgil's Dido with her quiver of gold, her hair bound up in gold, her mantle fastened with a golden clasp, driving her chariot with gold reins, and all else about her resplendent with gold, I would try to represent all this wealth of shining metal that almost blinds the beholder's eyes which ever way they turn with colours rather than gilding. Not only is the use of colour more worthy of praise and admiration but gold on a flat panel plays false so that what should appear light and reflective seems dark while other areas that should be darker may seem brighter.

He adds that nevertheless he considers it appropriate for paintings to be fitted with frames of gold or silver – solid gold and silver, not gilded wood, and in the form of the tabernacle *all'antica*, with bases, columns and a pediment.

The passage must not be regarded as immediately influential, but it is of great significance. Within twenty years there were leading Italian artists who were using very little gold – most notably Piero della Francesca and Cosimo Tura. The fifteenth-century Italian artists whom it is easiest to imagine painting Dido in her chariot are perhaps Botticelli and Mantegna. Neither of them would have denied themselves the use of gold, but it would have taken the form of 'shell gold' rather than gold leaf (see p. 182). The first great Italian painter to apply Alberti's precepts wholeheartedly was Leonardo da Vinci at the very end of the century. He also made his own observations on this subject in his notebooks, decrying not only the value attached to gold but that attached to blue – ultramarine blue made, as we have seen, from the precious mineral lapis lazuli, which Cennino Cennini, describing the practice of the fourteenth century, had claimed surpassed in its intrinsic quality the merit of anything that an artist could do with it.

Whereas this passage by Alberti must seem prophetic when considered, as it always has been, in relation to Italian painting, it has a very different significance if considered in relation to European painting as a whole. The painting of the *Exhumation of Saint Hubert* by the workshop of Rogier van der Weyden (Fig. 8) may well date from only a few years after Alberti's treatise. It is hard to imagine a subject more different from that of Dido in her chariot, but it is no less filled with shining precious metals – vest-

ments stiff with gold thread, gilt copper croziers, the gold reliquary, the gold of the altarpiece – and all of them are depicted with colours. The leading artists in the Netherlands had by then often chosen to dispense with gold.

One of Alberti's objection to gilding was the disruptive effect that it had on the painting as a representation of three dimensions – for gold leaf always tends to draw attention to the flat picture surface. Much of his treatise concerns optics and the science of perspective whereby three dimensions could be effectively and consistently depicted in two. It was in Florence that painters took most interest in these subjects. Alberti's treatise was dedicated, in its Italian version, to the Florentine architect Filippo Brunelleschi and the dedicatory epistle mentions his friends Donatello, Ghiberti and Masaccio. It is natural that Alberti's writing has been related to the fascination with foreshortening geometric shapes found, for example, in the architectural painting by Masaccio and Fra Angelico or their followers (No. 15 and Fig. 155) and in Uccello's painting of pieces of armour (No. 26).

For Alberti the creation of pictorial space depended upon adherence to the science of linear perspective with a single vanishing point such as he and other Florentines propounded. But it is striking that the European painters in the period when Alberti was compiling his treatise who were most impressive in their representation of architectural interiors were Netherlandish artists such as van Eyck and Campin (Nos. 18 and 13 and Fig. 40). Alberti seems not to have known their work, but some Florentine painters, most notably Filippo Lippi (see No. 23), may have done so by the 1440s. The idea of a painting as a window or a mirror – which is invoked (or implied) by Alberti – is better illustrated by Netherlandish paintings of the early fifteenth century than by any Italian ones. It came to be very important for Italian paintings, such as those by Antonello da Messina, but these were clearly painted under Netherlandish influence (No. 41).

Alberti was said to have perfected a device, some sort of *camera oscura*, into which people peered and were amazed to find, in miniature, a city square or a distant landscape. A similar claim was made for his friend Brunelleschi. In such machines the view became, for the first time, a work of art – or science – or magic. One of the great achievements of European painting over the succeeding four centuries was to capture upon a flat surface, which we know we can touch, something which seems to be a mile or more away. In early fifteenth-century Florentine art perhaps the most remarkable achievements in the representation of distance were made in very low-relief sculpture in marble or bronze by Ghiberti and Donatello. Florentine painters of the time

who had a sophisticated grasp of how to represent architecture of a convincing scale in perspective using Alberti's rules, often had little interest in the observation of landscape distance. The four mountains – or rather large rocks – in the *Rape of Helen* (Fig. 155), painted in about 1450 by a Florentine follower of Fra Angelico, are not very different from those in the narratives of Ugolino di Nerio over a century earlier (No. 5), except that they overlap and diminish in size and the one furthest away is pale blue. By contrast, Pollaiuolo in his *Martyrdom of Saint Sebastian* (No. 40) and his *Apollo and Daphne* (Fig. 257) a quarter of a century later was painting something that all Florentines would have recognised – a panorama of the Arno valley. Again Alberti may seem like a prophet. But the sort of landscape view shown in his machine was being painted during his lifetime in the Netherlands – and it must have been the example of such paintings that inspired Pollaiuolo.

Alberti's rules were, of course, of enormous value, but it is wrong to think that they possessed the fundamental importance which Vasari ascribed to them when he likened them to the invention of printing. Not only are they of little value for painting landscape distances but the room depicted in van Eyck's Arnolfini portrait (No. 18) would be less impressive if Alberti's rules had been adhered to. Moreover, many artists, such as the Master of the Life of the Virgin (No. 37), who were especially interested in pictorial space and highly effective and sophisticated in their representations of it, did not employ these rules.

Just as Alberti wished to find rules for the representation of space so he also sought rules for the proportions of the human figure and its movement (noting, for instance, that when the weight is on one foot that foot will tend to be beneath the head). His recommendation that the human figure should be thought of as a skeleton and then as a naked body even when it is to be represented clothed is typical of his analytical mind. As a prescription for artistic practice it may have had some influence in Florence later in the century, and Raphael in the early sixteenth century seems to have begun to plan paintings in this manner. What is more significant, however, is that Alberti had begun to conceive of the human figure as something dynamic and articulate, and many painters – especially in Italy – shared this concern. The real weight of the figure and how it was supported had been alien to most art of the fourteenth century: the Virgin in the Wilton Diptych is not unusual in finding her child so easy to carry and the painting is typical in that the feet are mostly concealed and, when revealed, are not obviously load-bearing.

For Alberti, painters must represent space, light, weight and

volume, but to be considered on a par with poets they must also depict an *istoria*, an heroic narrative, and that meant inventing a composition, as well as depicting action and expression. Among exemplary works of this order Alberti singles out two which were 'much praised in Rome': a burial of Meleager in which the distress and strain are evident in the limbs as well as the faces of those carrying the hero's body, and in which death pervades all the limbs of Meleager himself; and a mosaic in Old St Peter's known as the *Navicella* (now lost, but see Fig. 182) showing 'the boat in which the eleven disciples were represented by our Tuscan painter Giotto, each petrified with fear and amazement at the spectacle of their fellow disciple walking on the water'. In the narratives the action was presented in a manner at once vivid and cogent.

Representations of strong emotions had been characteristic of art throughout this period, but during the fifteenth century artists began to experiment much more with expression. The attempts to record the features of someone singing are typical of this (see Nos. 36 and 50). And Alberti's observation that 'only those who have tried it can believe how hard it is in attempting to represent laughter on a face to avoid making the person tearful rather than merry' is perfectly illustrated by the agonised look which Tura gave to one of the angels he intended to be radiant (No. 44). Alberti, however, was concerned that emotion should be expressed by the whole body not merely by the face. In the second half of the fifteenth century we do begin to find many figures of the kind which Alberti commended: the straining bodies of ferocious executioners (No. 40); the dropped limbs and gaping mouths of sleeping men (No. 30); sudden and violent moral revulsion expressed with face and hands (No. 25). These examples are from Italian paintings. The bodies broken with grief and twisted with strain and faces covered in tears in a painting by the Master of the Saint Bartholomew Altarpiece (No. 62) – to list only one work made north of the Alps, by a German artist much influenced by Netherlandish art – are no less remarkable, but the work might not have met with Alberti's approval on account of its distortion of anatomy.

Although heroic narrative painting was central to Alberti's treatise, as to so much subsequent theoretical writing on art, it was not central to the activity of many painters. One of the most important subjects in art was the Virgin and Child enthroned with saints. This was not a narrative, although it could, as we have seen (p. 74), be turned into one. The saints were prayed to separately and so remained as separate in some of the altarpieces by Mantegna and Raphael (Fig. 210 and No. 65) as in that by

Duccio (No. 4). There was no obvious need for the saints to reveal strong emotions or to engage in physical action, and a sweet and gentle demeanour and attitude, an elevated but gracious ideal, as evident in the work of the Master of Liesborn as in that of Perugino (Nos. 43 and 59), were admired as well.

In discussing compositions Alberti commended variety. A painter should be praised for including old and young men, matrons and maidens, domestic and wild animals, buildings and landscapes. This passage, which so strongly suggests the exciting crowded compositions of Florentine panels of the Adoration of the Magi or frescoes of the Birth of the Virgin, may well have been conventional. Alberti's own taste was probably better conveyed by his ensuing recommendation that an artist should try to limit the number of figures he employs, just as the tragic and comic poets – he meant those of classical antiquity – restricted themselves to a few actors in the interest of dignity and clarity. Gravity of speech came, he noted, from brevity.

These standards by which Alberti recommended judgement of a painting were derived from rhetoric and from poetry. The narratives which he held up for special admiration were not paintings but a sculpture (the *Burial of Meleager* was a relief carving on a Roman sarcophagus) and a mosaic (Giotto's *Navicella*). However, at the end of the fifteenth century painting was sometimes contrasted with the other arts, with poetry of course, but also with sculpture: which is more powerful, delightful, skilful, noble and durable, Leonardo asks in his notebooks. And the same questions are debated in *Il Cortegiano*, the treatise on the ideal courtier, written by Raphael's friend Baldassare Castiglione in the form of a dialogue set at the court of Urbino in the early years of the sixteenth century. The competition behind the *paragone*, as this sort of comparison came to be known in Italy, may seem tedious. Some of the points scored may seem unworthy, as when Leonardo, anxious to show that painting was a liberal art, fit for gentlemen (as it had been, according to Vasari, in antiquity), notes that the painter, unlike the carver in marble, keeps his clothes clean. But the debate provided a valuable way of asserting what had come to be regarded as special to the art of painting.

The sculptor, explains Castiglione himself in the dialogue, cannot so well imitate the colour of the world which changes all the time – the light dancing in an amorous eye or on golden curls, 'nor the glistning of armor, nor a darke night, nor a sea tempest, nor those twinklings and sparkes, nor the burnings of a Citie, nor the rysing of the morning in the colour of Roses, with those beames of purple and golde'. The candle-flame painted by Cam-

pin and van Eyck (Fig. 40 and No. 18), the reflections in the armour worn by Perugino's *Saint Michael* or in van Eyck's mirror (Nos. 59 and 18), the stars above the shepherds' fire in the nocturne by Geertgen (No. 49), the dawn clouds in Bellini's *Agony in the Garden* (No. 31), the golden curls of the angel in Leonardo's *Virgin of the Rocks* (No. 68): those are the parts of the fifteenth-century paintings in the National Gallery which such a passage calls to mind.

Almost all these paintings are in oil paint (the exception being Bellini's *Agony*), and one might suppose that the medium made it possible not only to depict volatile flames and highlights on metal, but consistent shadows in drapery and in a dark interior, and the atmospheric softening of distant hills. But it may also be that the desire to paint such things encouraged the exploitation of oil paint. Whatever the case, it is clear that the revolution in portraying the world which is found in the art of this period is inseparable from the history of technique. It is clear too that, although most of the valuable contemporary literature on art is Italian, it is a revolution which is best understood if European art is regarded as a whole.

PAINTINGS IN THE NATIONAL GALLERY

PLATES WITH COMMENTARIES

A NOTE ON THE PAINT MEDIA

WHERE THE IDENTIFICATION OF THE PAINT MEDIUM HAS
BEEN CONFIRMED BY SCIENTIFIC ANALYSIS (I.E.
CHROMATOGRAPHY AND MASS SPECTROMETRY) OR BY
TESTING (E.G. STAINING, HEAT OR SOLUBILITY TESTS),
THIS IS SPECIFIED. OTHERWISE THE MEDIUM INDICATED
IS CONJECTURAL, BUT BASED AS FAR AS POSSIBLE ON
RESULTS FROM OTHER COMPARABLE WORKS BY THE SAME
PAINTER.

1 The Virgin and Child Enthroned,
with Scenes of the Nativity and the Lives of Saints 1260s

Egg tempera on poplar, 92.5 x 185cm (NG 564)

Margarito, who was active around 1262, is one of the earliest known Tuscan painters. Vasari, who called him Margaritone, made much of him, since he came from Vasari's home town of Arezzo in central Italy, praising his miniaturist style and in effect crediting him with the invention of the craft of panel painting in Italy. Several paintings by him survive, most of them similar in shape and design to the National Gallery painting.

This is the earliest Italian painting in the National Gallery. It dates from the 1260s when the art of painting on panel was becoming widespread in Italy. It could have been an altar frontal but is more likely to have been an altarpiece (see p. 27). Many of the surviving paintings from the thirteenth century remain anonymous. However, this panel bears a Latin inscription naming the painter: MARGARITO DE ARITIO ME FECIT (Margarito of Arezzo made me).

In the centre is the imposingly hieratic Virgin seated on a lion-headed throne (see also No. 13). She resembles the Virgins of Byzantine icons, which were probably fairly widespread in Italy, and her crown with its angular rim and dangling jewels is oriental. In her lap she holds the Child looking like a manikin rather than a baby, fully clothed and holding a scroll. On either side angels swing censers. The figures are contained within a mandorla, with the symbols of the four Evangelists at the corners (see p. 52).

The eight small-scale narrative scenes on either side of the main compartment have Latin inscriptions describing what is shown. In the upper left-hand corner is the Birth of Christ, and to its right Saint John the Evangelist being freed by an angel from a cauldron of boiling oil. In the top tier to the right of the centre is Saint John the Evangelist again, raising Drusiana from the dead, and at the top right-hand corner Saint Benedict fights

the temptations of the flesh by throwing himself naked into thorny bushes. In the bottom left-hand corner Saint Catherine is beheaded and her soul carried to Heaven by angels, and to the right Saint Nicholas warns pilgrims that they have been given deadly oil by the devil. Saint Nicholas appears again, right of the centre, saving three youths from execution, and in the bottom right-hand corner Saint Margaret behind prison bars is bursting from the belly of the dragon which swallowed her.

What determined the choice of scenes? They may reflect the dedication of the church or altar from which the work comes, or the personal selection of the person who commissioned it. Neither the patron nor the original location is known, although the emphasis given to Saints John the Evangelist and Nicholas could be a clue.

Margarito's painting of figures is to the modern eye schematic, and his use of colours, with its limited palette dominated by black and red, unrealistic. The work was acquired in Florence in 1857, when, according to Sir Charles Eastlake, then Director of the National Gallery: 'The unsightly specimens of Margaritone and the earliest Tuscan painters were selected solely for their historical importance, and as showing the rude beginnings from which, through nearly two centuries and a half, Italian art slowly advanced to the period of Raphael and his contemporaries.'

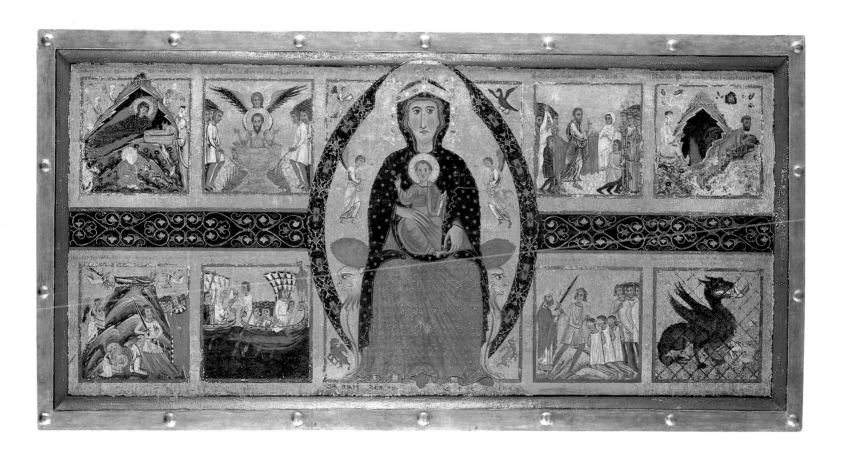

2 Pentecost *c*.1306–12

Egg tempera on poplar, 45.5 x 44cm (NG 5360)

Giotto was probably born in 1266/7 and died in 1337. His undisputed works are the frescoes in the Arena Chapel, Padua, of c.1305, and those in the Bardi and the Peruzzi Chapels in Santa Croce, Florence. He also worked in Rome and Naples and probably Rimini and Milan. He had a large workshop. None of the three altarpieces inscribed with his name is unanimously agreed to be by him. The extent to which he was himself involved in the various cycles in San Francesco, Assisi, or indeed whether he painted there at all, remains the subject of debate. Giotto's contemporaries, such as Dante, recognised his pre-eminence.

This panel comes from an altarpiece attributed to Giotto and his workshop. It shows the Pentecost as described in Acts II, verses 1–13: the twelve Apostles were gathered together after Christ's Ascension; tongues of heavenly fire appeared on their heads; they were filled with the Holy Ghost, and men from every nation marvelled at hearing the Apostles' words in their own tongue. It belongs with a series of six other panels which are similar in style and dimensions. In all of them the gold leaf has been laid over green earth rather than the red bole which was more usual in fourteenth-century Italy (see p. 174). The six other panels, showing scenes from the Life of Christ, are: the *Nativity with the Epiphany* (New York, Metropolitan Museum), the *Presentation* (Boston, Isabella Stewart Gardner Museum), the *Last Supper* and *Crucifixion* (both Munich, Alte Pinakothek), the *Entombment* (Settignano, Berenson Collection, I Tatti), and the *Descent into Limbo* (Munich, Alte Pinakothek).

X-radiographs confirm that the seven scenes were originally painted on a single plank and were therefore part of a single horizontal structure (Fig. a). It is unlikely that they formed a predella, but more probable that they were an independent altarpiece – a long low dossal of exceptional width (at least 305cm). Because of the presence of Saint Francis at the foot of the Cross in the *Crucifixion*, it is likely that the altarpiece came from a Franciscan church. San Francesco in Borgo Sansepolcro has been suggested (see also No. 19), since Vasari describes an altarpiece by Giotto painted with small figures as having been in that town. Another possibility is that the altarpiece came from San Francesco, Rimini, which was in effect the burial church of the Malatesta family, and that it was commissioned by a member of that family.

The uneven quality of the figures suggests the collaboration of at least two artists. The two foremost figures, bulky yet graceful, are almost certainly by Giotto himself. He probably designed the whole altarpiece after the completion of the Arena Chapel in Padua, possibly between 1306 and 1312, and then left the execution largely to his assistants.

Vasari said that Giotto translated painting from Greek to Roman, meaning that he no longer looked to Byzantine icons but to classical antiquity for inspiration.

Fig. 2a. Reconstruction of Giotto's altarpiece including the *Pentecost*.

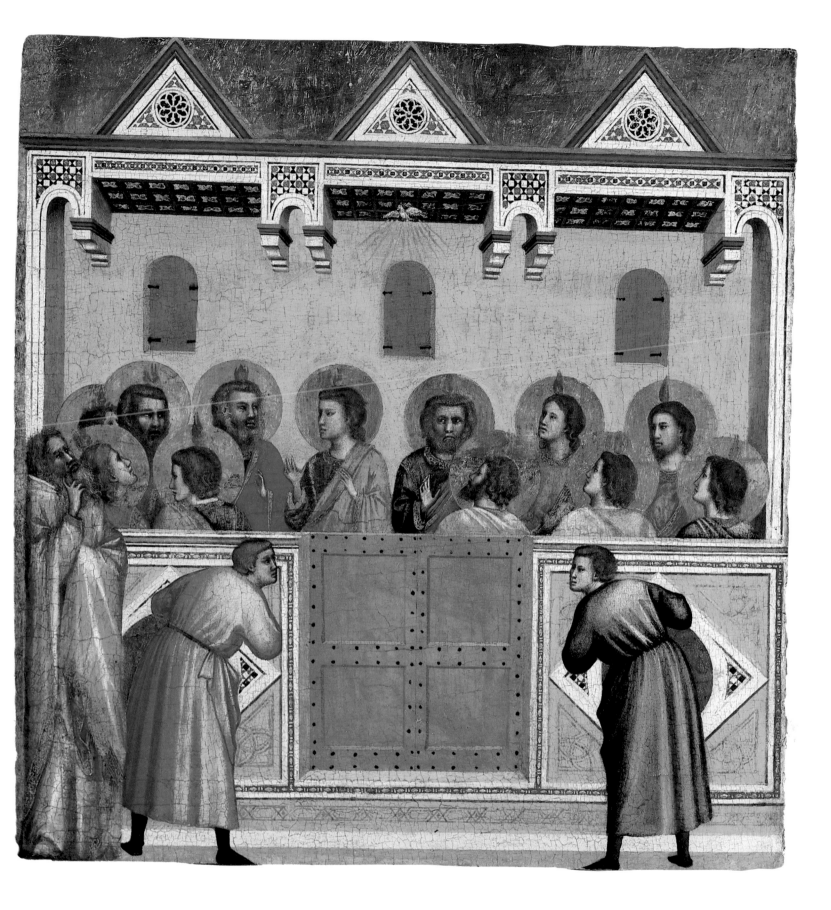

3 The Annunciation completed 1311

Egg tempera (analysed) on poplar, 43 x 44cm (NG 1139)

Jesus opens the Eyes of a Man born Blind completed 1311

Egg tempera (analysed) on poplar, 43.5 x 45cm (NG 1140)

During the late thirteenth and early fourteenth centuries, painting in Siena was dominated by Duccio and his workshop. He contracted to paint the Rucellai Madonna *for Santa Maria Novella, Florence, in 1285, and completed the* Maestà *(see below) in 1311 for Siena Cathedral. He had died by 1319. He had a large number of pupils and followers, including perhaps Ugolino di Nerio (see No. 5), Simone Martini, and Ambrogio and Pietro Lorenzetti (see No. 6), although their collaboration with Duccio's workshop is not documented.*

The *Annunciation* shows the moment described in the Gospel of Saint Luke (I, 26ff.) when Gabriel tells the Virgin that she is to bear the Son of God, as foretold by the prophet Isaiah in the text which she holds. The lilies symbolise her purity and the white dove the Holy Spirit.

This panel opened the narrative cycle of the front predella of Duccio's most famous work, the *Maestà*, which was carried in procession from his workshop to the high altar of Siena Cathedral in 1311. It was a massive altarpiece painted on both sides. The front main panel (Fig. a) shows the Virgin and Child enthroned with angels and saints. The predella showed small narrative scenes from Christ's childhood; above were scenes from the last days of the Virgin. The back (Fig. b) was divided into over thirty small-scale scenes showing the Ministry

and Passion of Christ, dominated by the *Crucifixion*. Taken down in 1506, the altarpiece was sawn into pieces in 1771 and parts sold. However, most of it is still in the Cathedral Museum in Siena.

Although the altarpiece can be approximately reconstructed, the precise arrangement and subject of some of the missing panels, and the nature of the frame, remain unknown. The *Maestà* is the only surviving work by Duccio which bears his 'signature', the inscription on the base of the Virgin's throne: MATER SCA DEI/SIS CAUSA SENIS REQUIEI/SIS DUCCIO VITA/TE QUIA PINXIT ITA (Holy Mother of God, be thou a source of peace for Siena and life to Duccio because he painted thee thus). In an interim contract of 1308 (see p. 128) Duccio promised to work continuously on the altarpiece, not to accept any other commissions in the meantime and to work on the altarpiece with his own hands. A further undated document concerning payment for 'thirty-four histories' and for 'the little angels above', agreed that the cathedral authorities would supply the materials and the painter 'all that which pertains to the craft of the brush'.

The vast altarpiece was not achieved by a single hand: unevenness of execution suggests the participation of assistants (see below). However, the quality of the draughtsmanship and the refined colour modelling in the *Annunciation* and its position as the opening narrative suggest that it is by Duccio himself. Infra-red examination reveals – particularly in the drapery below the angel's arm (see Fig. 217) – forceful underdrawing made with a quill pen, almost certainly by Duccio.

Collaboration could lead to misunderstandings. Below the angel's wing is an anomalous area of orange. This was probably intended for gilding since a

Fig. 3a. Reconstruction of Duccio's *Maestà* (front) after John White.

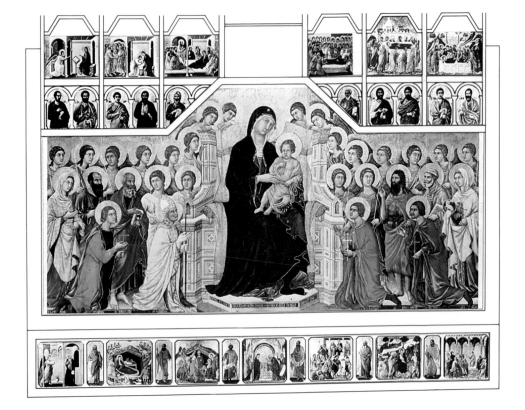

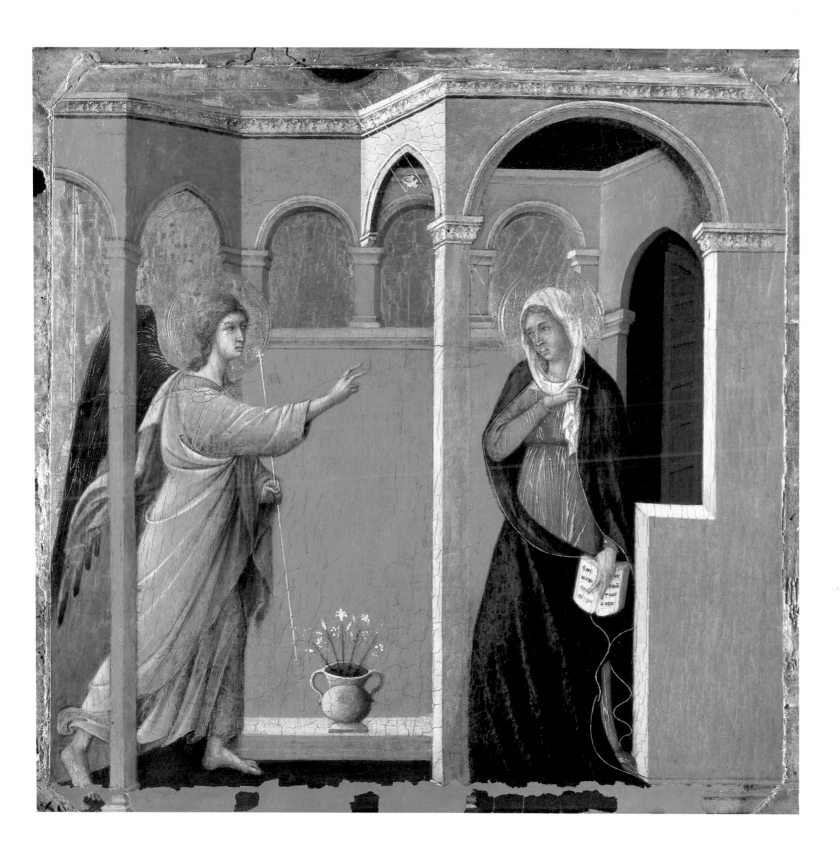

layer of red bole lies beneath, but Duccio, or an assistant, apparently forgot to gild it and finally painted it over.

Jesus opens the Eyes of a Man Born Blind, set in a typical Tuscan town, combines two incidents in the Gospel of Saint John (IX, 1ff.): Jesus smeared a blind man's eyes with mud and spittle; the man then washed his eyes in the pool of Siloam and his sight was restored. The two stages of the miracle are linked by the man's stick. This panel from the back predella of the *Maestà* was immediately followed by the *Transfiguration* (Fig. c): the man, no longer blind, looks up in gratitude at Christ in the adjacent scene.

The panel is a fascinating example of the collaborative methods of a medieval workshop (see p. 139). At least two painters of equal calibre worked on it, each responsible for certain areas. The division of labour was complex, but was apparently as follows. First the figures were sketched in. To the left of the blind man at the fountain, level with his hips, a thick dark stroke was made, probably with a quill pen, and presumably by Duccio, to show where the base of the architecture was to be. The panel was then passed to a second painter whose meticulous approach to architecture is in striking contrast to that of Duccio as seen in the *Annunciation*. All the straight lines of the architecture were ruled and incised with a metal stylus (see Fig. 235). Often the horizontals and verticals were extended further than necessary. It seems

that the buildings were considered too plain, for capitals and lunettes over the doors were drawn on, presumably by Duccio, with thick freehand strokes very different from the thin ruled lines of the rest of the architecture. These additions were ignored by the painter of the architecture, who painted over them. Once they had been painted, the main architectural lines were ruled yet again with a metal stylus over the paint before it had fully hardened.

After the painting of the buildings came the painting of the figures. The difference in quality between the Apostles and the other figures suggests that there was possibly a third painter.

The pose of the blind man at the fountain went through several variations at the underdrawing stage: initially he was shown bending over, washing his eyes in the fountain, but finally looking up and raising his right hand. The change may have been made to link with the adjacent *Transfiguration*.

The identity of Duccio's chief collaborator remains an open question, although Pietro Lorenzetti (see No. 6) is a plausible suggestion.

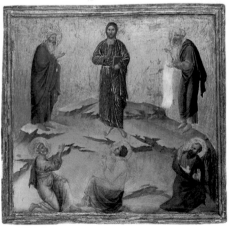

Fig. 3b. Reconstruction of Duccio's *Maestà* (back) after John White.

Fig. 3c. Duccio, *The Transfiguration*. Wood, 49×51cm (NG 1330).

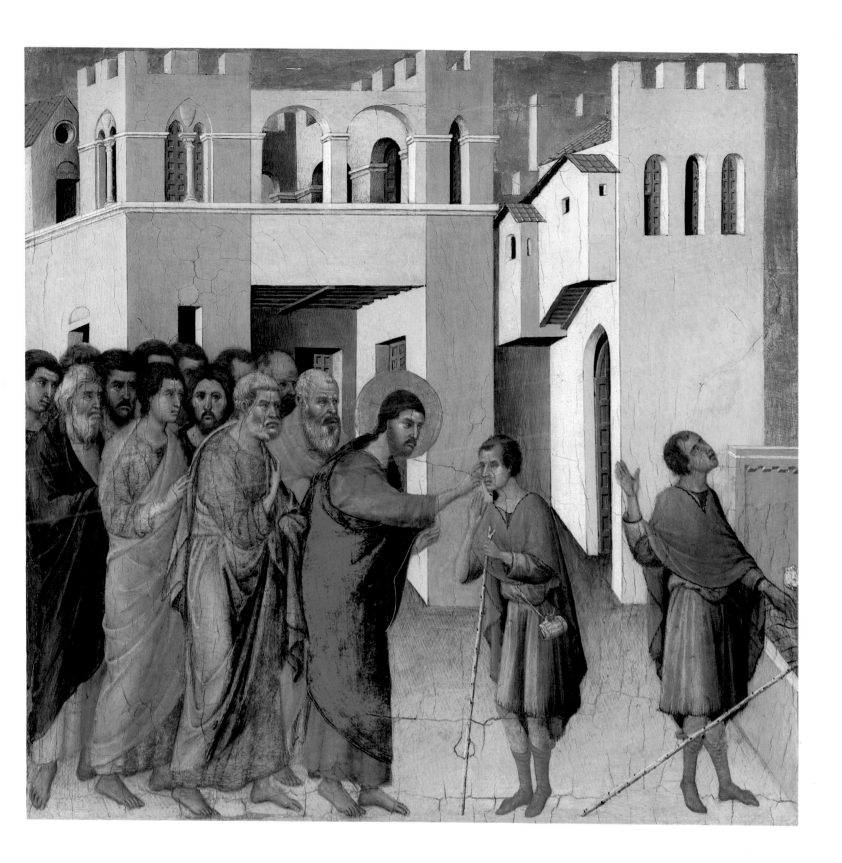

4 Triptych: The Virgin and Child with Saints *c.*1315

Egg tempera on poplar. Central panel 61.5 x 39cm (NG 566)

For his biography see No. 3.

Fig. 4a. Duccio, *The Virgin and Child with Saints* (NG 566). Shutters closed.

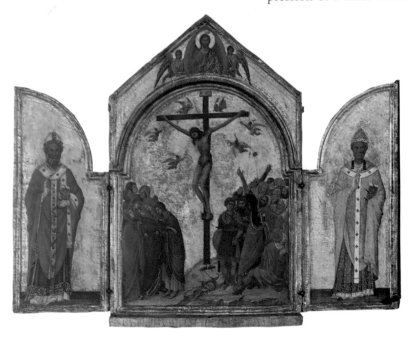

Fig. 4b. Duccio and Workshop, *The Crucifixion* with *Saints Nicholas and Gregory*. Central panel 61.5×39cm. Boston, Museum of Fine Arts.

Few private devotional paintings survive from the beginning of the fourteenth century (see p. 68). The saints in the shutters of this triptych, probably painted in about 1315, provide a clue as to who might originally have commissioned the painting. The presence of Saint Dominic in the left shutter suggests that the patron may have been a Dominican. The saint in the right shutter is Saint Aurea, a comparatively obscure saint who was drowned at Ostia with a millstone around her neck. She is rarely shown and her presence may indicate that the patron was the Dominican cardinal Niccolò da Prato, who was promoted Cardinal Bishop of Ostia in 1298 and would therefore have had good reason to venerate Saint Aurea; he is known to have owned three altarpieces. He died in 1321.

The triptych would have been portable and intended for private worship. The exterior of the shutters (Fig. a) is marbled and has an imitation geometric inlay. The outer edge has been painted with shadows and highlights, to create the impression of a three-dimensional mould-ing – almost as if the shutters were made of stone and the whole were like a small chapel that could be opened for worship. The geometric patterns painted on the shutters prompt the worshipper as to the correct order of opening them without damaging the triptych. When closed, the right-hand shutter lies over the left-hand one. If the latter were to be lifted first the right-hand shutter would bang down. The right-hand shutter must be lifted first and is therefore shown with the two squares not interlocking, that is, *open*; whereas in the left-hand shutter they are shown interlocking. The same subtle reminder is also found in another triptych (Fig. b), which has identical proportions and similarly painted exterior shutters, but different subject matter. The two triptychs, which were evidently designed by the same hand and probably prepared by the same carpenter (see p. 153), are different in style and may have been painted by different hands in Duccio's workshop.

The triptych with the Virgin and Child is generally accepted as having been painted by Duccio. It was at the very least designed by him, since the drapery of the Child has the same distinctive emphatic underdrawing (see Fig. 218) done with a quill pen as that found in the *Maestà* (see No. 3).

Compared with, for example, the *Virgin and Child* by Margarito (see No. 1) of about fifty years earlier, the child is now shown as a baby and the relationship between mother and baby is intimate: the Christ Child plays with his mother's veil as they look into each other's eyes. The modelling of the faces and draperies is more naturalistic, although the green undermodelling of the Virgin's face shows through more than was originally intended (see p. 192).

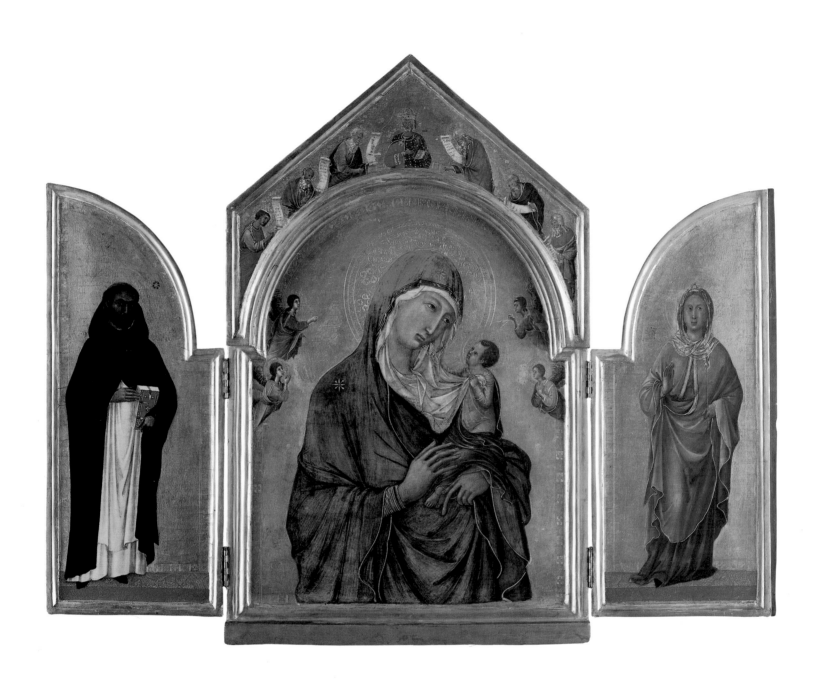

5 Panels from the Santa Croce Altarpiece *c.*1325

Saints Simon and Thaddeus 70.5 x 62.5cm (NG 3377)

Two Angels 26 x 53cm (NG 3378)

The Betrayal 40.5 x 58.5cm (NG 1188)

The Way to Calvary 40.5 x 58.5cm (NG 1189)

All the panels are egg tempera (analysed) on poplar.

The Sienese painter Ugolino di Nerio, active from 1317 to 1327, was one of Duccio's most gifted followers and may have been his pupil (see No. 3). He worked for Florentine patrons during the 1320s, and is said to have died in either 1339 or 1349. Very few works by him survive.

Ugolino painted at least two polyptychs for Florentine churches: one for the high altar of the Dominican church of Santa Maria Novella before 1324, and one for the high altar of the Franciscan church of Santa Croce in about 1325.

The National Gallery has several fragments from the Santa Croce Altarpiece, which was probably paid for by the Alamanni family since it originally bore their coat of arms on the predella. The altarpiece was dismantled in 1566-9 to make way for a ciborium designed by Vasari. However, its original appearance (Fig. a) can be reconstructed on the basis of surviving fragments, which are dispersed in several collections. What is missing can be deduced from descriptions made of the altarpiece in the eighteenth century, when it was seen in the friars' dormitory, and in the nineteenth century, when the surviving fragments were in England in

the collection of William Young Ottley, and also from an eighteenth-century drawing (Fig. b).

X-radiographs showing the pattern of the wood grain of all the surviving fragments have made it possible to establish their original position. Each vertical unit consisted of a main tier compartment, upper tier compartments and a pinnacle. The seven vertical elements were each painted on a single separate plank of poplar, dowelled together at the sides, and joined together at the back by an ingenious system of interlocking battens. The whole stood on a predella painted on a single horizontal plank of wood and was probably supported on the altar itself by massive lateral buttresses that reached to the floor on each side. The way in which the altarpiece was constructed allowed it to be painted in separate units, and it is possible that Ugolino painted it

Fig. 5a. Reconstruction of surviving fragments of Ugolino di Nerio's Santa Croce Altarpiece.
Surviving fragments (from left to right)
PINNACLE PANELS
Isaiah, David, Moses, Daniel
UPPER TIER
Saints Matthew and James Minor, Saints Bartholomew and Andrew, Saints James and Philip, Saints Simon and Thaddeus, Saints Matthias and Elizabeth
MAIN TIER
Saint John the Baptist, Saint Paul, Spandrel Angels, Saint Peter, Spandrel Angels
PREDELLA
The Last Supper, The Betrayal, The Flagellation, The Way to Calvary, The Deposition, The Entombment, The Resurrection

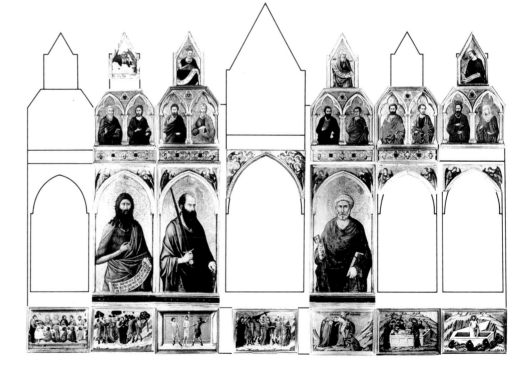

in his workshop in Siena, and then transported it to Florence to assemble on the altar, just as Sassetta painted an altarpiece (see No. 19) in Siena and transported it to Borgo Sansepolcro.

The main tier of the Santa Croce Altarpiece showed at the centre the half-length figures of the Virgin and Child, flanked by Saints Paul, John the Baptist and Anthony on the left, and Saints Peter, Francis and Louis of Toulouse on the right, with angels in the spandrels (see NG 3378 and Fig. 213). In the tiers above were Apostles (see NG 3377), saints and prophets.

The predella showed scenes from Christ's Passion (including NG 1188 and 1189), starting with the *Last Supper* and ending with the *Resurrection*. The *Way to Calvary* was at the centre, below the Virgin and Child, which originally bore the inscription 'Ugolino de Senis me pinxit' (Ugolino of Siena painted me). The *Crucifixion* was removed from its normal

place in the Passion cycle and given the place of honour in the pinnacle above the Virgin and Child, reflecting the dedication of the church to Santa Croce (the Holy Cross). The cross had special significance for the Franciscans because their founder, Saint Francis, in his stigmatisation received on his body the wounds which Christ suffered on the cross (see No. 19). The X of the cross carried by Christ in the *Way to Calvary* falls at the very centre and was thus the spiritual and compositional pivot of the entire altarpiece. Ugolino showed Christ carrying the cross himself, emphasising not only the cross, but with it the burden of his humiliation.

Ugolino adapted the narrative compositions of Duccio's *Maestà* (see No. 3), in which he himself may well have collaborated. He simplified and clarified the scenes, thereby intensifying their dramatic impact. He derived the *Betrayal* closely from Duccio, but omitted the

group of fleeing disciples, thus concentrating the central action. In the *Way to Calvary*, also derived from Duccio, Ugolino again reduced the number of figures, focusing on the sorrow of the Virgin and Christ as they are roughly parted. Ugolino was also profoundly influenced by Duccio's style, although the technical differences between them are instructive. Most interesting, perhaps, is the fact that where Duccio widely used a rich and expensive ultramarine, Ugolino preferred the greenish tones of azurite. In the case of the Santa Croce Altarpiece, which was a major commission, this cannot have been for economy, and must have been for colouristic reasons.

Fig. 5b. Eighteenth-century drawing of Ugolino di Nerio's Santa Croce Altarpiece. Rome, Biblioteca Vaticana, Vat. Lat. 9847, f. 92r.

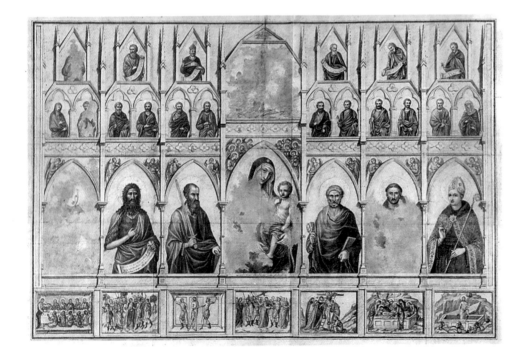

OPPOSITE *The Betrayal* and *The Way to Calvary*.

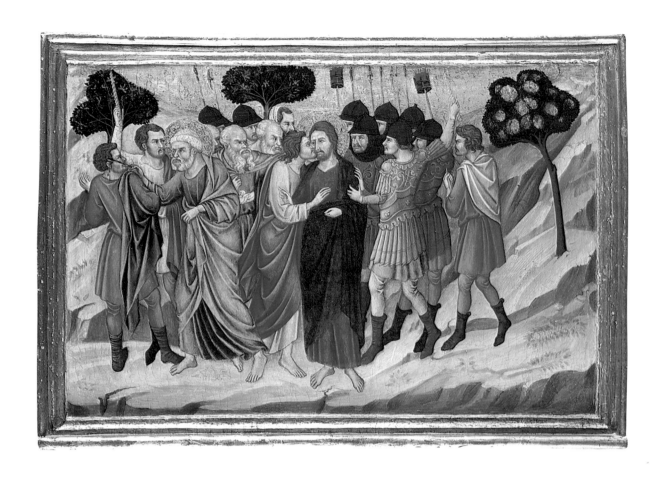

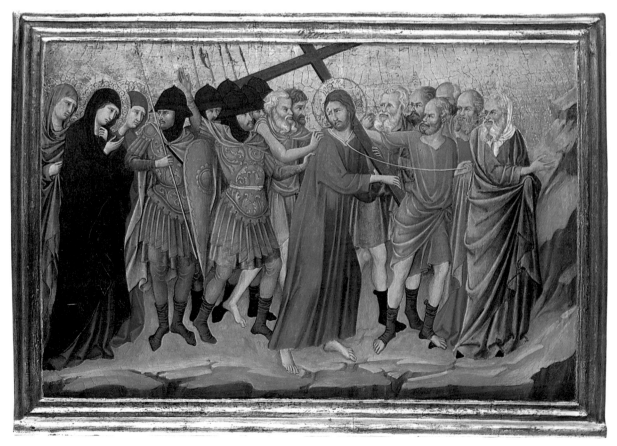

6 Saint Sabinus before the Governor probably completed 1342

Egg tempera on poplar, 37.5 x 33cm (NG 1113)

The Sienese painter Pietro Lorenzetti is first documented in 1320. He was chiefly active in Siena, but also worked in Assisi. Unlike his brother Ambrogio, he is not documented as having worked in Florence, although he was familiar with Florentine works, and was influenced by Giotto. He probably died of the Black Death in 1348. He was much praised by Vasari.

This panel is thought to show Saint Sabinus, one of the four patron saints of Siena, and his two deacons, appearing before Venustianus, the Roman Governor of Tuscany, and refusing to worship an image of Jupiter. However, the idol looks more like a statue of a woman holding a golden ball than Jupiter, and may in fact be Venus, with the golden apple given her by Paris. There may be some connection with the name of the Governor, Venustianus.

The shape of the panel indicates that it comes from a predella, probably from one of four narrative altarpieces dedicated to the patron saints of Siena commissioned in the 1330s by the cathedral authorities. Each altarpiece featured an incident from the Life of the Virgin, and was flanked by two standing saints, including one of the four patron saints of Siena – Ansanus, Crescentius, Sabinus and Victor – to be placed on altars dedicated to those saints. Pietro Lorenzetti's *Birth of the Virgin* (Fig. a), completed in 1342, was flanked by two standing saints – Sabinus and Bartholomew – and had a predella of which the National Gallery panel may be the only surviving part.

The altarpieces were innovative in featuring a narrative scene in the principal panel. This formula was taken up by later Florentine artists such as, for example, Niccolò di Pietro Gerini in his *Baptism* of 1387 (see Fig. 54). Interest in the creation of pictorial space was paramount in the work of both Lorenzetti brothers. Even in the small scale of this panel, Pietro achieves a complicated spatial setting: the scene takes place within two vaulted aisles looking through Gothic windows in the background, while the Governor is shown with his back to the spectator. The columnar figures have an imposing monumentality which suggests the influence of Giotto (see No. 2); his influence is even more evident in the main panel of the altarpiece.

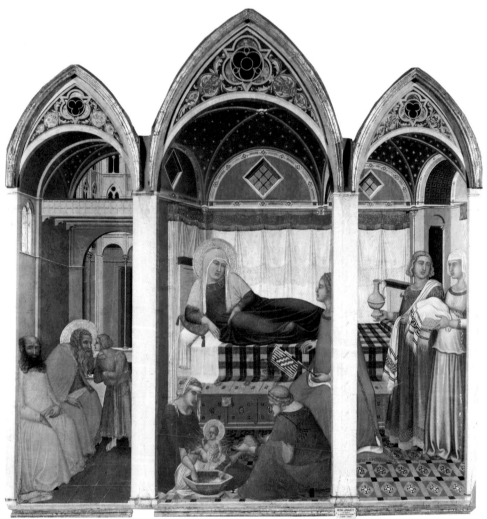

Fig. 6a. Pietro Lorenzetti, *The Birth of the Virgin*, 1342. Wood, 187×182cm. Siena, Museo dell'Opera del Duomo.

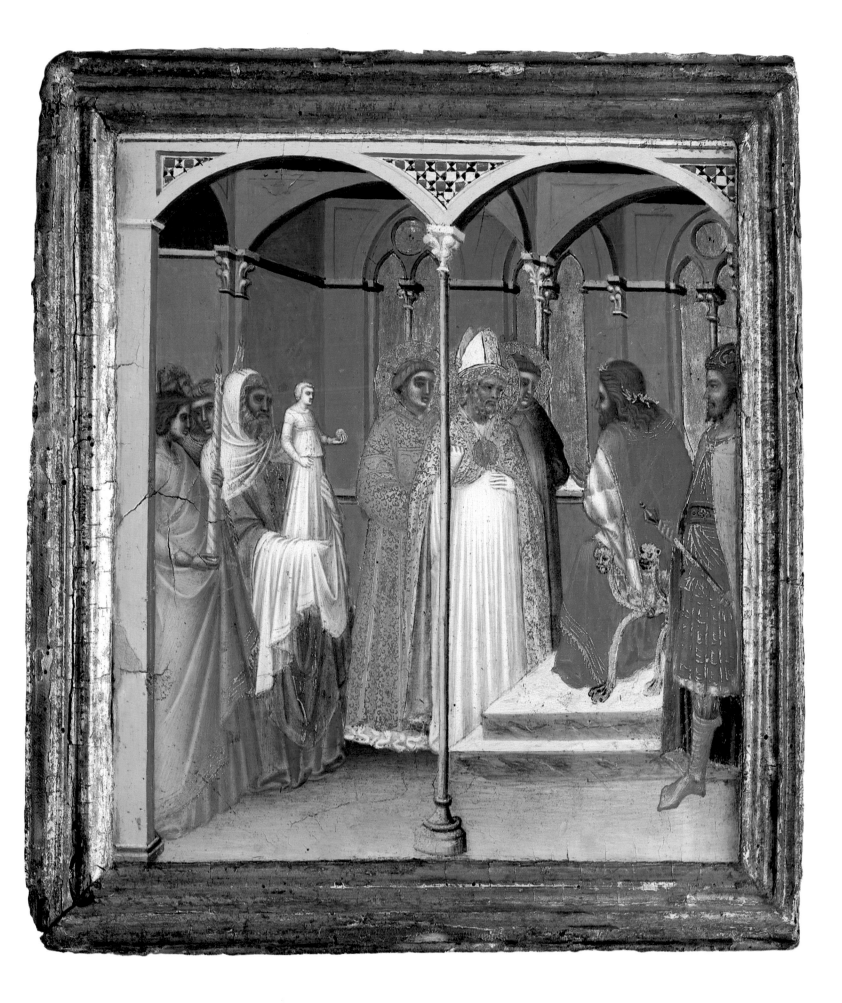

7 The Madonna of Humility with Saints Mark and John the Baptist second half of the 14th century

Egg tempera on poplar, 31 x 57.5cm (NG 3897)

Lorenzo Veneziano was chiefly active in Venice and its Italian provinces (the Veneto) from 1356 to 1372. Numerous signed and dated works survive, including the Lion Polyptych of 1357-9 (Venice, Accademia) and the de Proti Polyptych of 1366 (Vicenza Cathedral).

This small panel is a rare example of a fourteenth-century Venetian painting in the National Gallery Collection. The frame is typical of the Venetian Gothic with its cusped arches and thick twisted columns. On the left is Saint Mark identified by an inscription, and on the right is Saint John the Baptist holding his usual scroll inscribed: 'Ecce Agnus dei Ecce qui tolis pecata mundi. Miserere'. (Behold the Lamb of God. Behold who takes away the sins of the world. Have mercy.) In the centre is the Virgin seated on the ground, suckling the Child. The central part is inscribed: S[AN]C[T]A MARIA D'LAU-MILITADE, which was presumably intended for DE HUMILITATE. The Madonna of Humility, seated on the ground with the crescent moon at her feet and suckling her child, may be associated with the Immaculate Conception (see Fig. 13): the sun and stars radiate around her and there are faint traces of a brooch with a sun at her breast. This image was a common one in Venetian painting of the second half of the fourteenth century, particularly in the works of Lorenzo Veneziano.

A very similar work attributed to Lorenzo also shows the Madonna of Humility at the centre (Fig. a), and it is possible that his workshop produced a number of variants. Both paintings are almost certainly independent works made for private devotion, rather than parts of a larger altarpiece. They may have been made for ready sale (see p. 68), rather than commissioned by a particular patron. In this panel the presence of Saint Mark, who was the patron saint of Venice, suggests that it was made for the Venetian market.

Little is known about this painter except that he was Venetian and that he worked mainly in Venice and the Veneto, but also for patrons in Bologna and Verona. His work is typical of Venetian painting of this date, which still strongly reflected Byzantine influence in the stylisation of the figures, and was largely resistant to the new naturalism of Florentine painting which had been brought to the north by Giotto working in the Arena Chapel in Padua in about 1305.

Fig. 7a. Lorenzo Veneziano, *The Madonna of Humility with Saints Blaise and Helen*(?). Wood, 26×46.5cm. The Hague, Dienst Verspreide Rijkscollecties.

8 The Marriage of the Virgin second half of the 14th century

Egg tempera (analysed) on wood, 51 x 33cm (NG 1109)

Niccolò di Buonaccorso was inscribed with the Guild of Sienese Painters in 1355. Apart from a polyptych for Santa Margherita, Costalpina, outside Siena, signed and dated 1387, which is now in fragments, No. 8 is Niccolò's only surviving signed painting. He died in 1388.

Fig. 8b. The reverse of *The Marriage of the Virgin*.

Fig. 8a. Reconstruction of *The Marriage of the Virgin* (NG 1109), with *The Presentation of the Virgin*, Florence, Uffizi (left), and *The Coronation of the Virgin*, New York, Metropolitan Museum of Art, Robert Lehman Collection (right).

This painting shows Saint Joseph placing the ring on the Virgin's finger. In apocryphal lives of the Virgin, her suitors had to present rods at the temple and the suitor whose rod flowered was to be the chosen one. Saint Joseph holds a rod which has blossomed in the form of a dove. To the left are the unsuccessful suitors, one of whom breaks his rod across his knee. In the background are the Virgin's parents, Joachim and Anne, each with a halo.

This painting is part of a triptych: the other panels are the *Presentation of the Virgin*, also showing Joachim and Anne, and the *Coronation of the Virgin* (Fig. a). The backs of all three panels (Fig. b) are decorated with silver and a dark red porphyry-like colour and punched with a geometric pattern. The chronology of the scenes places the *Marriage of the Virgin* at the centre with the signature: NICHOLAUS: BONACHURSI: DE SENIS: ME PINXIT (Niccolò di Buonaccorso of Siena painted me).

The triptych may have been painted for Santa Maria Nuova in Florence: we know the *Presentation* came from that church, and the National Gallery painting was bought in Florence in the nineteenth century. The charm of this small painting owes much to the brilliance of its colours and to its anecdotal detail. Niccolò is particularly adept at inventing marble – green and yellow veined for the floor, and pink and blue set into the architecture. Much attention is paid to costume, especially the use of *sgraffito* for brocade robes and the *cangiante* modelling of draperies. The palm tree in the centre may be a reference to the Song of Songs (VII, 7), where the beloved is compared to the tree: 'Thy stature is like to a palm tree.' In keeping with the overall theme is the swallow flying back to its mate in the nest under the eaves. Other details enliven the composition, such as a pot plant on the ledge of a window, the eager onlookers hanging out of the window to watch the festivities, and the musicians playing their instruments. The carpet is one of the earliest known representations in a painting of a Turkish pile carpet.

The chubby child watching in the foreground is a motif found in numerous Sienese paintings, introducing an almost quaint note to otherwise solemn proceedings, such as scenes of the Crucifixion.

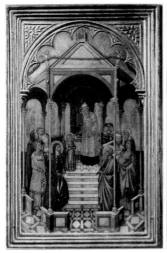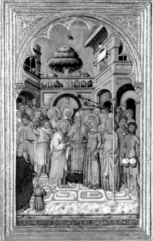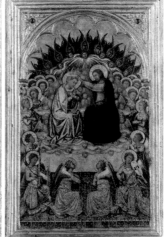

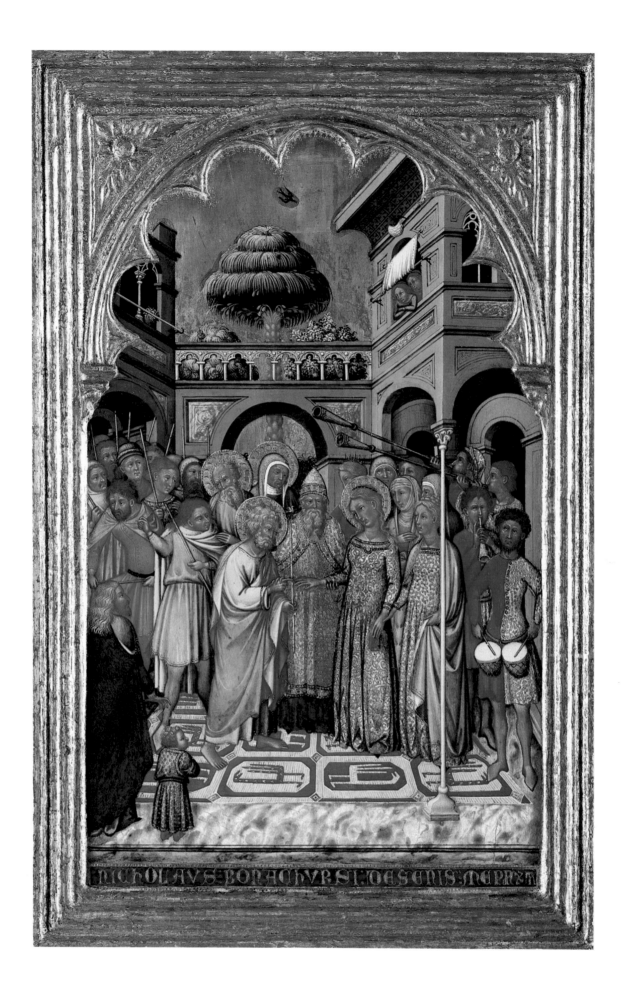

NICholAVS BORAChVS ... DCS ... GRIS ...

ATTRIBUTED TO
JACOPO DI CIONE

9 The Coronation of the Virgin with Adoring Saints (The San Pier Maggiore Altarpiece) 1370-1

Central panel, 206.5 x 113.5cm. Side panel, 169 x 113cm. Both panels are egg tempera (analysed) on poplar. (NG 569)

Jacopo di Cione was the youngest of four brothers, three of whom – Andrea (known as Orcagna), Nardo and Jacopo – were painters, and their workshops dominated Florentine painting during the second half of the fourteenth century. Jacopo's first surviving documented commission was the completion of the Saint Matthew triptych (Florence, Uffizi) in 1368 which his brother Andrea was too ill to finish. He matriculated with the Arte dei Medici e Speziali in 1369. He died between 1398 and 1400.

These are the main centre and left-hand panels of an altarpiece (Fig. a) in which Christ is shown crowning the Virgin, watched by angels and saints local to Florence, as well as by those of universal fame. It is very unusual to find the Three Kings (wearing crowns) present in this scene: their inclusion may be connected with the annual procession which took place in Florence on the feast of the Epiphany (see pp. 64-8). In the tier above were scenes from the Childhood of Christ, his Resurrection and events after the Resurrection.

The Coronation of the Virgin was an extremely popular subject in Florence in the second half of the fourteenth century (see also No. 11). It provided a pretext for assembling a large number of spectator saints. The most prominent saint here is Saint Peter (see Fig. 252), shown holding a model of the church of San Pier Maggiore in Florence for which the altarpiece was painted. The church was destroyed in the eighteenth century. The predella, which is now dispersed in several collections, showed scenes from the Life of Saint Peter. By the nineteenth century the altarpiece had been dismembered; all of the panels were altered in shape, and they are now shown in nineteenth-century frames.

The altarpiece was originally one of the largest and most prestigious Florentine commissions of the second half of the fourteenth century. It was probably paid for by the Albizzi, a leading Florentine family who were to become extremely powerful in the early fifteenth century before giving way to the Medici. They effectively controlled the patronage of San Pier Maggiore. What was probably the final payment for the altarpiece was made in 1383, although it had been finished in 1371. Surviving accounts

show that it was begun in 1370 when a certain 'Niccolaio dipintore', almost certainly Niccolò di Pietro Gerini (see Fig. 54), was paid for the fourteen working days which it took to design the altarpiece. Complex wooden structures like this required considerable architectural and engineering skills. Niccolò's painting style does not appear in the altarpiece, although it is possible that he designed the elaborate canopy above the Virgin and Christ.

By the end of the fourteenth century large Florentine workshops frequently collaborated with each other in order to fulfil major commissions such as this. Fragmentary accounts for the San Pier Maggiore Altarpiece survive which give some clues regarding the distribution of labour. They appear to follow a fairly logical sequence and from them it is possible to deduce that the design, carpentry, gilding and punching, and painting were done by different specialised craftsmen. The style of the actual painting is similar to that found in altarpieces documented as being by Jacopo di Cione, although Jacopo is not mentioned in the surviving accounts for the San Pier Maggiore Altarpiece. He and Niccolò di Pietro Gerini are documented as having collaborated on a number of occasions.

Jacopo's painting is characteristic of Florentine painting of the second half of the fourteenth century when many painters seem to have lost the interest in naturalism and the convincing depiction of three-dimensional space explored by Giotto. The features tend to be severe, offset by the interest in decoration, particularly of rich fabrics executed in *sgraffito*, elaborately tooled haloes, and ornamental frames decorated with *pastiglia* and glass imitations and also semi-precious stones.

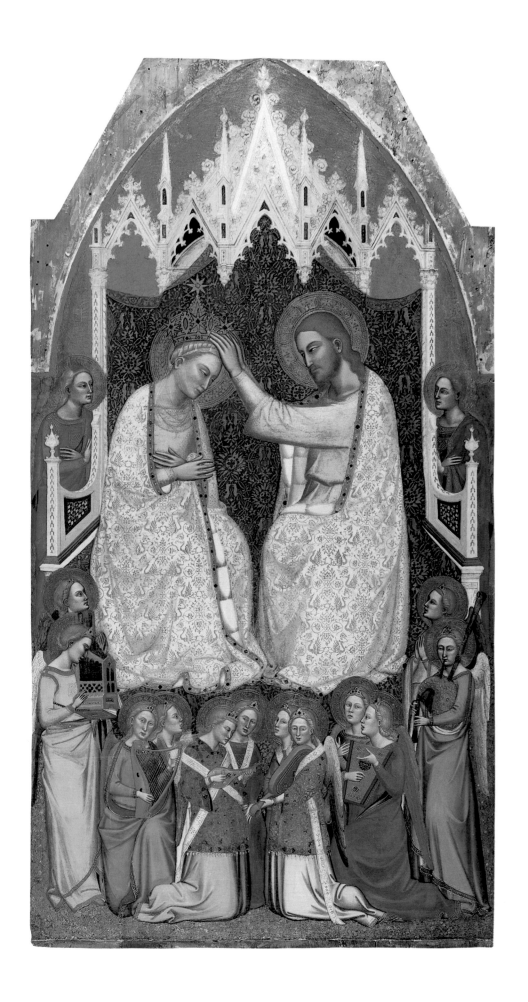

Fig. 9a. A photomontage reconstruction by Jill Dunkerton of the San Pier Maggiore Altarpiece based on evidence obtained from the examination of the twelve panels in the National Gallery. MAIN TIER: *The Coronation of the Virgin, with Adoring Saints*; SECOND TIER: *The Nativity, The Adoration of the Magi, The Resurrection, The Maries at the Sepulchre, The Ascension,* and *The Pentecost*; PINNACLES: *The Trinity* with on either side *Seraphim, Cherubim and Adoring Angels*; PREDELLA PANELS: from left to right, missing, but probably *The Calling of Saint Peter, The Taking of Saint Peter, Saint Peter in Prison* and *The Liberation of Saint Peter, Saint Peter raising the Son of Theophilus* and *The Chairing of Saint Peter at Antioch, The Last Meeting of Saints Peter and Paul in Rome* (only a fragment), *The Crucifixion of Saint Peter*, and at the base of the pilaster, *The Beheading of Saint Paul*.

OPPOSITE *Adoring Saints*

10 The Wilton Diptych *c.*1395

Egg tempera (tested) on oak, each wing 53 x 37cm (NG 4451)

The Wilton Diptych is so-called because it was once at Wilton House in Wiltshire, home of the Earls of Pembroke from whom it was bought in 1929. How it came to be there is not known.

The diptych is for modern scholars one of the most enigmatic pictures in the National Gallery, despite the apparent simplicity of the subject matter. In the right wing are the Virgin and Child with eleven angels, one carrying a banner which may be that of Saint George or that sometimes carried by Christ (see No. 5a). The angels wear the livery of King Richard II, and stand in a flowery meadow, in contrast to the wasteland and woods of the left wing in which the king kneels. Richard, who was crowned in 1377 at the age of ten, was deposed in 1399 and probably murdered in 1400. At his breast he wears a jewel of the white hart, his personal device from about 1390 onward. The hart is also painted on the exterior of the diptych, opposite the arms of Edward the Confessor (choughs) impaled with the royal arms (lions and lilies)

which Richard used around 1395, the likely date of the painting.

Presenting the king to the Virgin and Child are three saints – Edmund, Edward and John – who were of particular significance to Richard's kingship; all three saints had chapels in Westminster Abbey sited in the same sequence across the transept as the order in which they are placed in the diptych. On the extreme left is King Edmund holding the arrow shot by a Dane which killed him in 869. In the centre is King Edward the Confessor (died 1066) holding the ring he is supposed to have given a pilgrim who turned out to be Saint John the Evangelist: Richard was particularly devoted to Edward and prayed at his shrine in the abbey in times of crisis. Touching the king's shoulder is Saint John the Baptist, on the vigil of whose feast Richard acceded to the throne.

The composition emphasises the theme of kingship: it presumably is an allusion to the Epiphany, with Richard kneeling to the Christ Child like one of the Three Magi, while two kings stand behind him.

The rest of the imagery is obscure. One of the main questions is why prominence should have been given to broomcods (pods of the broomplant) as well as to the livery of the white hart: broomcods encircle the hart in the embroidery of the king's robe and he also wears a collar of broomcods. The angels wear similar but simpler collars. Broomcods were the livery of the kings of France. In 1396, after the death of his first wife, Anne of Bohemia, in 1394, Richard married the daughter of King Charles VI of France who gave him a collar of broomcods. But this does not fully explain the emphasis on broomcods in the diptych. English kings also made claims to the French

Fig. 10a. Detail of Richard II from his tomb effigy, 1394-5. Gilt copper. London, Westminster Abbey.

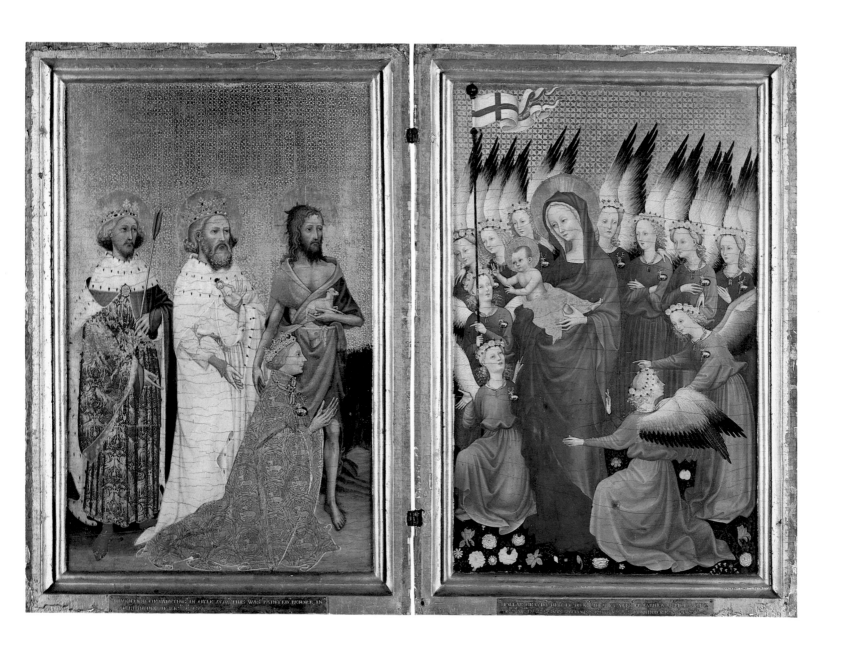

throne: Richard, in particular, who was born in Bordeaux, styled himself Richard of Bordeaux and, for example on his seals, King of France and England. The broomcods may perhaps be there to underline this.

Many interpretations of the diptych have been proposed, and indeed several may have been intended. The diptych was perhaps meant to be read from right to left *and* from left to right. In the first reading Richard's divine right to be king is being confirmed by the Child blessing him and possibly about to hand him the banner of Saint George, hence the emphasis on kingship. In the second he is being received by the Virgin into Heaven to join the company of angels: the Child's halo contains the unusual motifs of three nails and a crown of thorns, and the inclusion of what is, in this context, Christ's banner reminds the viewer that

Man, and therefore also the king, has been redeemed by Christ's Passion. It is likely that Richard commissioned the diptych for private devotion, both for use in, and as a reminder of, Westminster Abbey, where he was crowned and where he would be buried. At about the same time he commissioned for the abbey both a portrait of himself enthroned and his tomb effigy (Fig. a), that is, monuments relating to his kingship and death.

A final problem concerns the identity of the painter, whose technique is so outstanding. The brushwork is extremely delicate in the hatching which builds up the features and describes the angels' ringlets, their rose chaplets, their feathery birds' wings, the Virgin's fluted white veil, and the beards and eyebrows of the saints. Almost all the gold is finely stippled – the modelling of the Child's

robe, the motif of the crown of thorns and three nails within his halo, the crowns, the gold patterns of the robes done in *sgraffito*, and the backgrounds which have a different pattern in each wing. The painter has been careful to distinguish the king's jewel of the hart, painted in thick lead white like the pearls in the crowns, from the flatter badges of the angels' harts.

The white hart on the exterior of the diptych could have been done from life, since in 1393 Richard was given a white hart which he kept in the Forest of Windsor.

Although much of the imagery is Italian – deriving particularly from Sienese painting – and the medium is egg tempera (p. 188), the support is oak and the ground is chalk, both typical of Northern paintings (pp. 152 and 164). While the grace and refinement of the style can be matched in contemporary French manuscript illumination – a strikingly close parallel is an opening of a Book of Hours made for the Duc de Berry (Fig. b) – nothing exactly comparable can be found among the few surviving French panel paintings. Nor is there anything comparable in the few English panel paintings which survive from the later Middle Ages. Court painters to King Richard II were Gilbert Prince until 1396, and then Thomas Lytlington, but as nothing by them survives we have no way of assessing the possibility of their authorship. The painter has so far eluded identification.

Fig. 10b. Unknown French painter, *The Duc de Berry being presented to the Virgin and Child by Saints Andrew and John the Baptist, c.* 1390, Brussels, Bibliothèque Royale, MS 11060-1, ff. 10 and 11.

OPPOSITE *The exterior of the Wilton Diptych.*

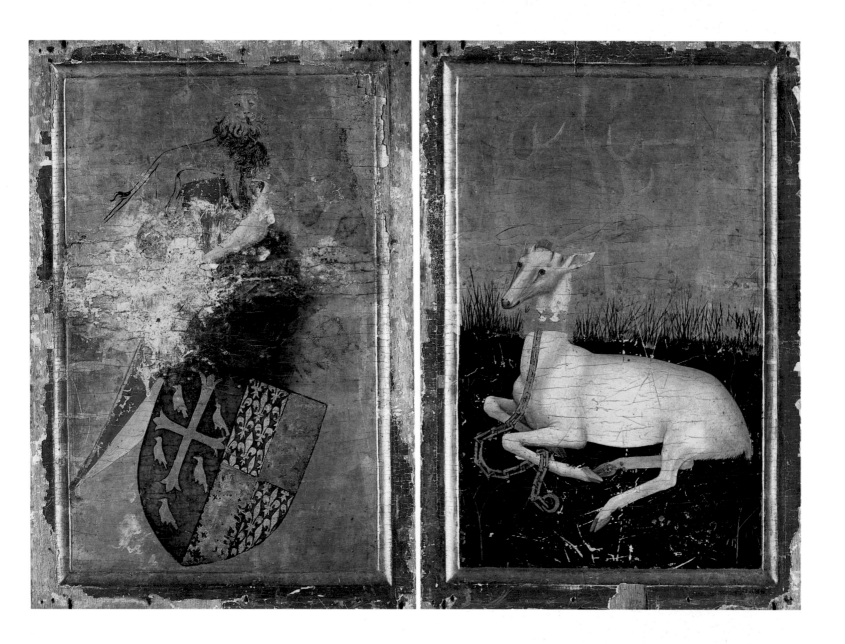

11 The Coronation of the Virgin *c.* 1414

Egg tempera on poplar, painted surface 181.5 x 105cm; 217 x 115cm; 179 x 101.5cm (NG 215, 1897 and 216)

In 1391 Lorenzo Monaco took his vows at the Camaldolese monastery of Santa Maria degli Angeli, Florence. He is first recorded as a painter in 1399. He painted frescoes in Santa Trinità, and perhaps also manuscript illuminations as well as panel paintings. He died not later than 1424, probably in 1422.

Fig. 11a. Lorenzo Monaco, *Saint Benedict Enthroned*, *c.* 1414. Pen and ink on paper, 24.5×17.5cm. Florence, Gabinetto dei Disegni e Stampe, No. 11E^v.

The Coronation of the Virgin was an extremely popular subject in Florence (see also No. 9) This *Coronation of the Virgin* by Lorenzo Monaco came originally from the church of San Benedetto fuori della Porta a Pinti (now destroyed) in Florence. A surviving drawing (Fig. a) seems to indicate that Lorenzo Monaco initially intended to show Saint Benedict enthroned, since the church was dedicated to him. However, it may be that the monks changed the commission and asked for a different central image, possibly because they wanted a Coronation of the Virgin like the one (now in the Uffizi, see Fig. 62) which Lorenzo Monaco painted in 1414 for the high altar of Santa Maria degli Angeli, where he was a monk. The church belonged to the same Order as the monastery of Santa Maria degli Angeli, and it was common for members of a religious community to want an altarpiece which resembled that in another church of the same Order (see p. 131). It is, however, impossible to say definitely which version came first. The National Gallery painting is far simpler, with fewer figures, a less elaborate canopy above the Virgin and Christ, and the figures are placed on a tiled floor, rather than on the starred rainbow of the Uffizi version, which there emphasises the heavenly nature of the event.

The National Gallery altarpiece no longer has its original frame. In its complete form it probably resembled the Uffizi version in having gables and a predella. A Virgin Annunciate (Fig. b) has been proposed as the gable; small panels with Scenes from the Life of Saint Benedict (NG 2862, 4062 and private collec-

Fig. 11b. *Virgin Annunciate, c.* 1414. Wood, 80×45cm. Pasadena, Norton Simon Museum.

tion loan) and an Adoration of the Magi may have been part of the predella.

Lorenzo Monaco's delight in colour is evident in the painting of the draperies with their linings in brilliant blues, yellow, pinks and greens. The female martyr on the left, for instance, wears a pink robe lined with blue over a green skirt with yellow highlights. Although the receding orthogonals of the tiled floor are evidence of an incipient interest in the depiction of three-dimensional pictorial space, the figure style is archaicising and the use of colour decorative rather than realistic, and there is no attempt at a rational lighting scheme.

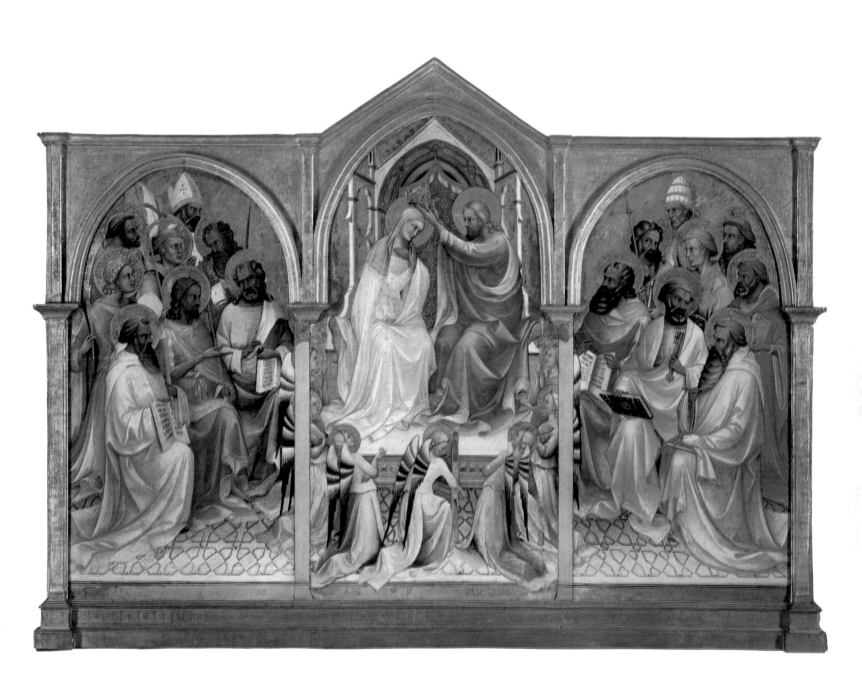

12 Saint Veronica with the Sudarium *c.* 1420

Walnut, painted surface 44.2 x 33.7cm (NG 687)

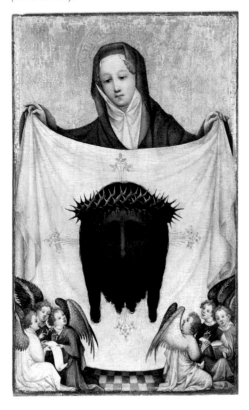

The artist is named from the picture of Saint Veronica with the Sudarium *at Munich (Alte Pinakothek), and is presumed to have been active in Cologne in the early fifteenth century. The Master was the leading painter there before the arrival of Stephan Lochner (see No. 20).*

Fig. 12a. Master of Saint Veronica, *Saint Veronica with the Sudarium, c.* 1420. Fir, painted surface 78.1×48.2cm. Munich, Alte Pinakothek.

According to the legend of Saint Veronica, the saint used her handkerchief (or *sudarium*) to wipe the brow of Christ when she saw him fall while carrying the cross on the way to Calvary: the image of his face was then found to have been miraculously imprinted on the handkerchief. A handkerchief alleged to have been Saint Veronica's was kept as a relic at St Peter's in Rome, and seems to have inspired a number of images of the face of Christ, mainly of the type seen in this devotional picture, where Christ's head is shown frontally (see pp. 38-41 and compare Fig. 140).

The National Gallery's painting is closely comparable to a painting at Munich (Fig. a) of the same subject and is apparently by the same artist. Both pictures were probably painted in about 1420. They differ, however, in some details. The Munich picture includes painted angels seated on the ground, while in the National Gallery picture small angels, not painted but executed

with small dots created by punches on the gold background, once flew on either side of Saint Veronica's head; they are now worn and difficult to see clearly. The use of such stippled punching on gold (compare Nos. 4, 10, 20) is generally more extensive in the London picture, which, as well as a punched border identical to that of the Munich painting, has gold haloes for both Christ and Saint Veronica in which their names are inscribed. In the Munich picture Christ is shown with the dark face common in such paintings of the saint's handkerchief, and wearing the crown of thorns, an image of the suffering Christ which in the fifteenth century often replaced the traditional one associated with Saint Veronica.

Like many paintings of Saint Veronica and her handkerchief, the National Gallery's picture is both simple and conventional, but it has been invested with a subtle elegance and a sense of restrained emotion. The folds of the saint's headdress and handkerchief are sensitively painted but do not detract from the large central image of Christ's head, to which attention is drawn by the saint's tilted head and downcast eyes.

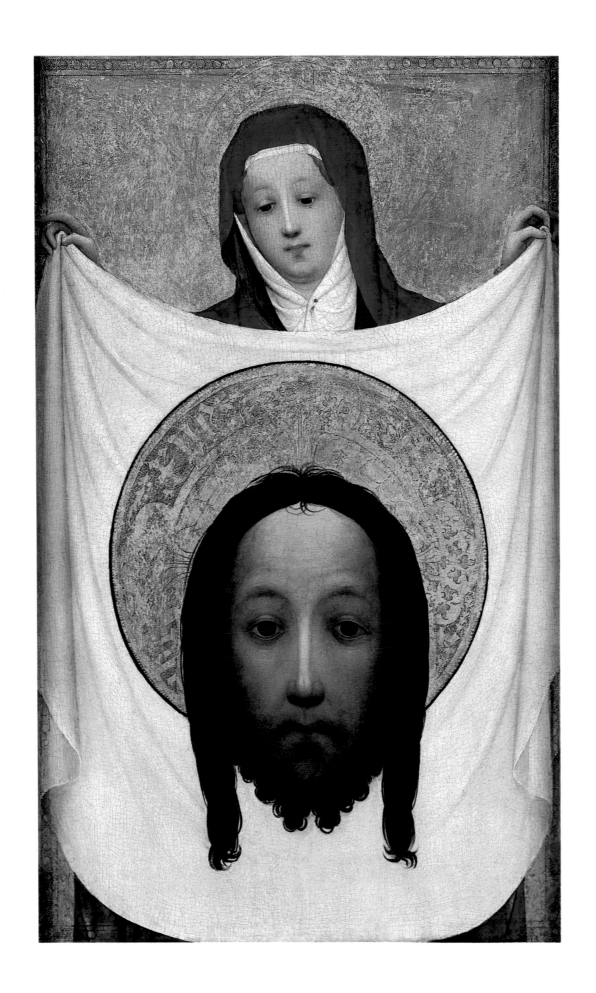

13 The Virgin and Child before a Firescreen

first quarter of the 15th century

Oil, probably with some egg tempera, on oak, painted surface 63.5 x 49.5cm (all the original edges have been cut and there are modern additions to the upper edge and the right-hand side) (NG 2609)

An artist named Robert Campin was active at Tournai from 1406, and died there in 1444. No documented pictures by him are known, but he is usually assumed to be identical with the so-called Master of Flémalle under whose name a number of paintings have been grouped. If Campin's name is rightly associated with these pictures he was one of the most important and influential painters working in the Netherlands in the early fifteenth century.

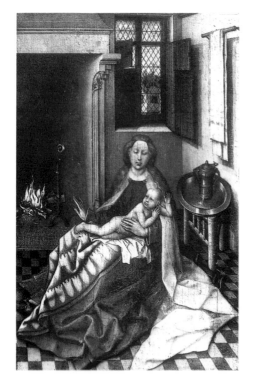

Fig. 13b. Robert Campin, *Virgin and Child before the Fireplace*, part of a diptych, early fifteenth century. Oak, painted surface, 28.5×18.5cm. Leningrad, State Hermitage Museum.

Fig. 13a. Detail of window from No. 13.

The picture is one of a number of small devotional images of the Virgin and Child probably painted by Campin and his workshop. The Virgin is shown in a domestic setting, a townscape visible through the window. Seated in front of a fire, the flames of which can just be seen above the large wicker firescreen – which also suggests the shape of a halo – she is either about to suckle her child or has just finished doing so. The cupboard on the right-hand side, on which a chalice is placed, is the work of a nineteenth-century restorer, and is unlikely to be an accurate reflection of the original composition: the right-hand sides of the fireplace and of the bench have been misunderstood. A painting (present location unknown) which may echo the original includes a metal basin, similar to those shown in other paintings of this type, standing on an undecorated cupboard.

The picture may appear to modern eyes to show the Virgin in a homely setting, in contrast to the splendid thrones and canopies which are often included in other fifteenth-century paintings of her. However, the lions carved on the wooden settle (see No. 1), the cushion

with its gold thread embroidery, the large illuminated book with its impressive jewelled clasp, and the fur lining and bejewelled and embroidered hem of the Virgin's robe are all indications that this is no ordinary home, and no ordinary mother and child.

The view through an open window (Fig. a) is a characteristic feature of Early Netherlandish painting, and the earliest known instances of its use are found in paintings associated with Robert Campin. The scale on which this townscape is painted is so small that some of its details are not easily visible with the naked eye, but one can just make out the signs over the shopfronts, where goods are displayed for sale.

This and similar paintings of the Virgin and Child, such as the small painting attributed to Campin also in the National Gallery (Fig. 40), were probably produced as devotional images for the home (see p. 105). Another painting of this type attributed to Campin (Fig. b) forms a diptych with a painting of the Trinity, but there is no evidence that either of the National Gallery pictures would have formed such a diptych.

These and other paintings associated with Campin (for example No. 14) share many characteristics, from the weighty figures to the particularly precise delineation of folds of skin, here especially noticeable on the body of the infant Christ. There are variations in quality, as would be expected if the workshop played a large part in their production. But there are also variations in style of a kind which suggest the contribution of accomplished assistants as well as apprentices (one of whom is thought to have been Rogier van der Weyden, see No. 22), or the possibility that Campin collaborated with other masters.

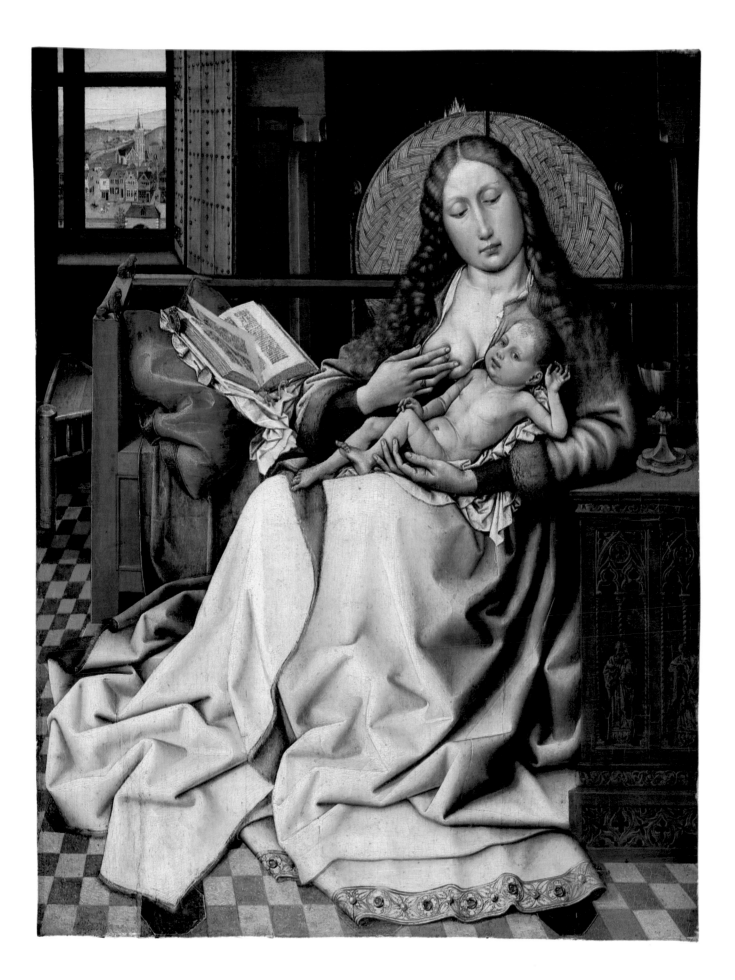

14 Portraits of a Man and a Woman *c.*1420-30

Oil, with some egg tempera (analysed), on oak, painted surface 40.7 x 27.9cm (NG 653A, 653B)

For his biography see No. 13.

These paintings form one of the earliest surviving examples of a pair of portraits, presumably of man and wife. They were perhaps intended when in their original frames to be joined together as a diptych. Their backs are marbled, so the portraits were probably displayed with these visible (see pp. 84, 100-3).

The identity of the sitters is unknown, but it has been deduced from their dress that they are not courtiers but probably prosperous townspeople. The man wears a fur-lined gown and his red headdress (similar to that worn in No. 17) has been made from a piece of red fabric wound around his head with two ends hanging down. The woman also wears a fur-lined gown, and her headdress consists of several thicknesses of white cloth held together with pins.

Whether whole figures or merely head and shoulder portraits, Campin's figures tend to be on a larger scale than those of his contemporary van Eyck. It is noticeable that the faces of these portraits take up far more of the picture surface than van Eyck's do (compare No. 17), the man's face being larger than the woman's. Campin does not favour the strong contrasts of deep shadows and intense light used by van Eyck: his sitters are evenly lit – although the faces are strongly modelled – and neither the faces nor the headdresses blend into the shadows of the background. The portraits are carefully designed, and the bold and potentially distracting depiction of large areas of folded red and white fabric in the headdresses is held in balance with the painting of the faces. However, Campin's ability to animate the faces of the sitters ensures that the effect is far from merely decorative.

The female sitter appears much more youthful than the man. In his face very subtle variations of colour are used to suggest wrinkles – especially around the eyes – reddening of the skin, and veins showing faintly under the surface. In the companion portrait the woman is shown with a smooth, alabaster-like complexion. Whether this reflects her actual age or is inspired by conventional ideals of female appearance is hard to say. The contrasting manner in which the eyes of the two sitters are painted is particularly remarkable. The eyes of the woman sparkle. Campin has put two catchlights in the left eye, so that the whites as well as the pupil shine, and her eyelids turn up at the corners, suggesting animation. The eyes of the man are duller: the whites lack the healthy blue-white colour of his companion and appear slightly bloodshot. The light reflected in his eyes is a mere glint, represented by tiny dots, while the graduated tones of the irises – from dark brown to a tawny hue – give the impression of light glowing from within. Character is conveyed almost imperceptibly by Campin's extraordinary powers of observation and handling of paint.

15 The Virgin and Child documented 1426

Egg tempera on poplar, 135.5 x 73cm (NG 3046)

Masaccio was probably born in 1401. His real name was Tommaso di Giovanni. He was active in Florence in the 1420s, and collaborated with Masolino (see No. 16), particularly on frescoes in the Brancacci Chapel in Santa Maria del Carmine. Few panel paintings by him survive. He died in Rome, probably in 1428. Masaccio's greatness was recognised by his contemporaries and he was particularly praised by Alberti, and later by Leonardo.

Originally part of an altarpiece, this painting is the only documented work by Masaccio. Sadly its condition obscures the magnificence of the original work. The panel has lost its original frame, and has been cut substantially at the base and trimmed at the edges; the damaged picture surface is disfigured by discoloured retouchings. The altarpiece was once extremely decorative. The Virgin's dress is a translucent red over silver leaf, which

has probably now dulled, and little is left of her transparent veil. Furthermore, the painting has been detached from the accompanying panels which formed part of the same altarpiece.

The Virgin and Child is identifiable as the centre panel of an altarpiece described by Vasari in 1568 as being in the chapel of St Julian in the church of Santa Maria del Carmine in Pisa. The inclusion of certain saints, particularly Saint Julian, suggests that this was the altarpiece commissioned by Ser Giuliano di Colino degli Scarsi da San Giusto, a Pisan notary, who between 1414 and 1425 acquired the patronal rights of the chapel immediately to the right of the choir in the Carmine. Saint Nicholas in the main tier probably refers to the patron's parents (Ni)Colino and (Ni)Cola, who were buried in the chapel, and Saint Peter to his grandfather.

Ser Giuliano's account books show that he commissioned the altarpiece and made a number of payments to Masaccio between 19 February and 26 December 1426. The wooden structure was made by a Sienese carpenter, Antonio di Biagio, probably according to Masaccio's design.

The pensive Virgin with her volumi-

Fig. 15a. Reconstruction of surviving fragments of Masaccio's altarpiece for Santa Maria del Carmine, Pisa (after C. Gardner von Teuffel).
UPPER TIER PANELS: *Crucifixion, Saint Paul, Saint Andrew.*
PREDELLA PANELS: *Scenes from the Life of Saints Julian and Nicholas, The Adoration of the Magi, Scenes from the Life of Saint Peter.*
PILASTER PANELS Left: *Saint Jerome, Saint Augustine, A Carmelite Saint.*
Right: *A Carmelite Saint.*

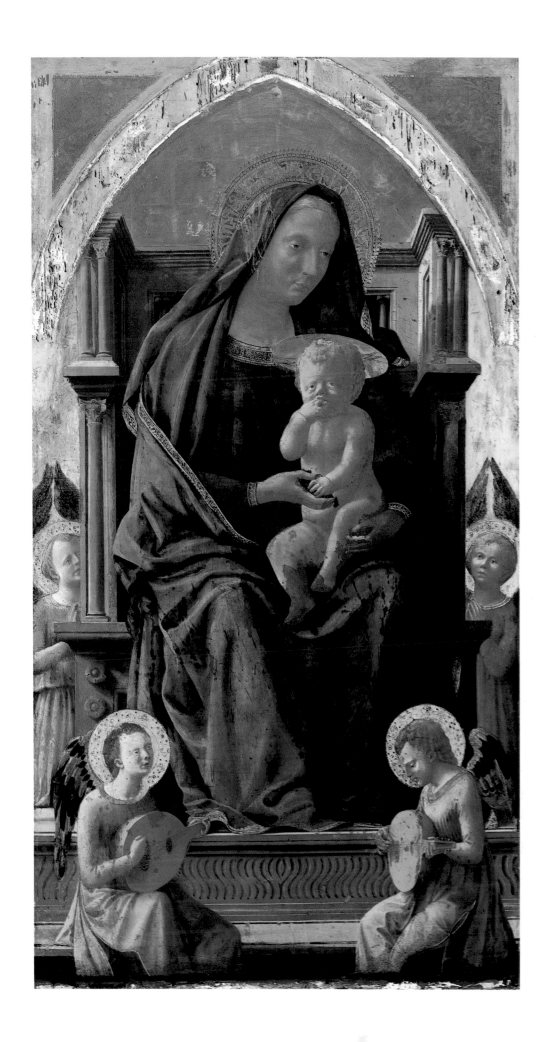

nous ultramarine cloak and 'Ave Gratia Plena' (Hail [Mary], full of Grace) punched as a pattern in her halo, descends from the Virgins of fourteenth-century painting, but her bulk derives from the study of classical sculpture. The naturalistic motif of the Child sucking his fingers after eating a grape also occurs in an altarpiece of 1422 from San Giovenale, Cascia, attributed to Masaccio, but the figure of the Child may have been studied from an antique sculpture. Masaccio's interest in sculpture may owe something to the sculptor Donatello, who on one occasion collected payments for the altarpiece on Masaccio's behalf.

This is one of the earliest altarpieces to demonstrate the newly discovered rules of single-point linear perspective. The throne and the two lutes, surely studied from life, are drawn according to those rules. The Child's halo is not a flat punched disc like those of the angels and the Virgin, which are rendered in the traditional medieval way, but reflects the innovatory interest in perspective: it is drawn as an ellipse, accentuating the Child's three-dimensionality and establishing his position in his mother's lap. The gold background, traditional in fourteenth-century altarpieces, is almost obscured by the monumental classical throne incorporating columns of the Corinthian, Ionic (shown sideways) and Composite orders, and reflecting the novel interest in classical idiom of the contemporary Florentine architects, Ghiberti and Brunelleschi. The pattern of the throne step is taken from classical sarcophagi. The allusion to death in that motif is likely to have been intentional. The Child eating grapes alludes to the eucharistic wine of the Mass and thus denotes the blood shed on the cross. The symbolism was reinforced by the central episode of the Passion, the Crucifixion, which was originally placed immediately above. Masaccio has gone to extreme lengths to emphasise the viewpoint of the spectator looking up, and thus to involve him, foreshortening the figure of the Virgin in the main tier, and also the Apostles in the upper tier, and more exaggeratedly the Crucifixion scene.

The question of whether this was a polyptych (Fig. a) composed of several separate compartments, or a *pala* (Fig. b) with a unified picture surface, has been the subject of debate. Whatever its original design, Masaccio was manifestly intent on unifying the monumental composition with a strongly directional light flooding from the upper left giving volume to the Virgin's knees and form to the Child's head. This interest in uniformly consistent light is also found in the work of van Eyck (see No. 18). But a comparison between his work and Masaccio's clearly demonstrates the limitations of egg tempera as opposed to the potential of oil in the depiction of three-dimensional form.

Fig. 15b. Reconstruction of Masaccio's altarpiece for Santa Maria del Carmine, Pisa, by John Shearman.

Fig. 15c. Detail of No. 15.

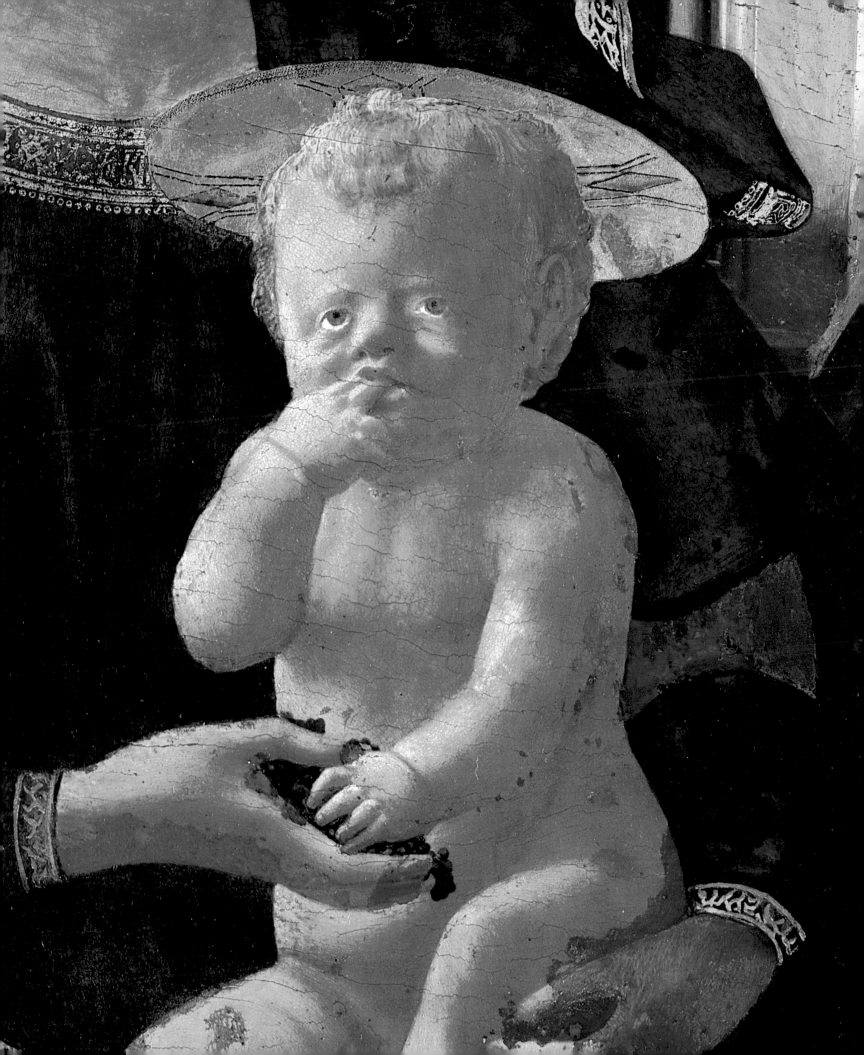

16 Saints Jerome and John the Baptist *c.* 1428(?)

Egg tempera on poplar, 114 x 55cm (NG 5962)

Saints Liberius (?) and Matthias *c.* 1428(?)

Egg tempera on poplar (transferred to synthetic panel), 114.5 x 55cm (NG 5963)

Masolino, whose real name was Tommaso di Cristoforo Fini da Panicale, may have been an assistant of the great Florentine sculptor Ghiberti from 1403 to 1407. He was inscribed with the Arte dei Medici e Speziali in Florence in 1423. From 1425 to 1427 he was in Hungary. He collaborated with Masaccio (see No. 15) on the Brancacci Chapel, Santa Maria del Carmine, Florence. The exact date of his death is not known; it was almost certainly after 1432. There have been a number of explanations for the nicknames of Masolino and Masaccio. One possibility is that the collaboration between the two painters made it necessary to distinguish between 'little' Thomas (Masolino) and 'big' Thomas (Masaccio).

The two panels were once the front and back of a single panel, which formed part of a double-sided triptych (Figs. a and b). They no longer have their original frames. One side, probably the front, consisted of the *Assumption of the Virgin*, flanked possibly on the left by Saints Jerome and John the Baptist (NG 5962) and on the right by Saints Martin and John the Evangelist (Philadelphia, Johnson Collection). The other side, probably the back, facing the choir, showed the *Miracle of the Snow*, flanked possibly on the left by Saints Paul and Peter (Philadelphia, Johnson Collection) and on the right by Saints Liberius(?) and Matthias (NG 5963).

The original location of the altarpiece in the Roman church of Santa Maria Maggiore is indicated by the subject matter. The *Miracle of the Snow* represents the foundation of Santa Maria Maggiore.

According to legend the Virgin ordered Liberius (Pope from 352 to 366) to build a church on the ground where snow miraculously fell in August: he is shown tracing the ground plan in the snow. It is unusual for an altarpiece to show Saint Matthias, but his presence can be explained by the fact that his body was the principal relic of Santa Maria Maggiore. Similarly, Saint Jerome is buried in the church. Finally, the three principal feasts celebrated at Santa Maria Maggiore were Christmas Day, the Feast of the Snow and the Assumption – the latter two events featured on the altarpiece.

The altarpiece was probably originally placed on the high altar where it was designed to be viewed against the apse mosaics showing scenes from the Life of the Virgin. These were executed by Jacopo Torriti in the 1290s, and included the Virgin's Death and Coronation but omitted her Assumption. The altarpiece was seen by Vasari in 1568 in a chapel belonging to the Colonna family, after it had probably been moved: Vasari mentions only four saints and the Madonna of the Snow, which implies that only one side was then visible, and that it was therefore not then in the site for which it was originally intended. A member of the powerful Roman Colonna family – probably Pope Martin V (died 1431) – was almost certainly involved in the commission at some stage: the orphrey of Saint Martin's cope is embroidered with the Colonna arms, and his face is apparently a portrait of Pope Martin V, who was elected Pope on Saint Martin's Day. Furthermore, the cross which Saint

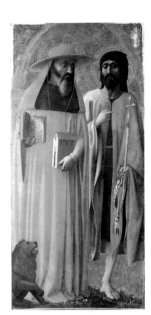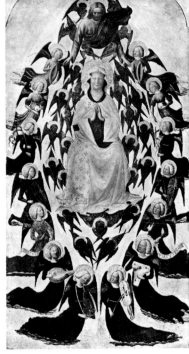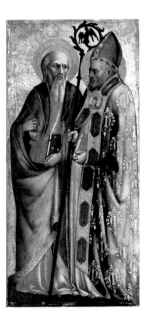

Fig. 16a. Reconstruction of altarpiece by Masaccio and Masolino for Santa Maria Maggiore, Rome (front). *Saints Jerome and John the Baptist, The Assumption of the Virgin,* and *Saints Martin and John the Evangelist.*

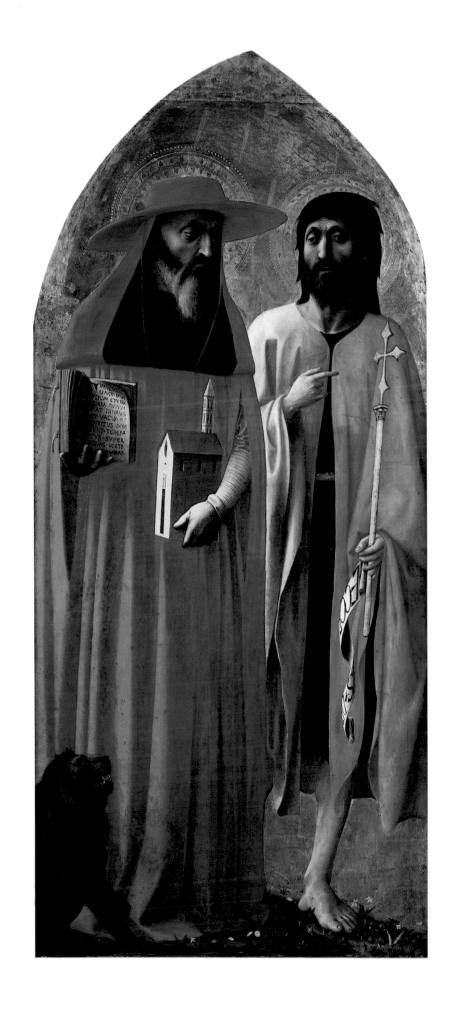

Fig. 16b. Reconstruction of altarpiece by Masaccio and Masolino for Santa Maria Maggiore, Rome (back).
Saints Peter and Paul, The Miracle of the Snow, Saints Liberius(?) and Matthias.

OPPOSITE *Saints Liberius (?) and Matthias.*

John the Baptist holds is extremely unusual in being supported on a column – a clear reference to the Colonna arms (Colonna = column).

The original altarpiece would have been spectacular. Unfortunately, the panel with Saints Liberius and Matthias in particular has suffered over the years: the robe of the Pope was once silver, patterned with a translucent red; and Matthias's hatchet was also probably silver.

Scholars are divided as to how much of the panels can on stylistic grounds be attributed to Masolino, and how much to Masaccio, and indeed whether the painters collaborated on it at all. Alternatively, the altarpiece may have been begun by one painter and then completed by the other. The altarpiece has some curious features: at some stage the identities of the saints in the Johnson Collection were switched. The incisions in the gesso, and infra-red reflectography, show that a sword was laid in silver leaf under the robe of Saint Peter and that golden keys lie under the robe of Saint Paul. Moreover, their hands and feet are painted in a different style from their faces. There are also peculiarities within the two National Gallery panels. Broadly it seems as if Masaccio was responsible for the side with Saints Jerome and John the Baptist, while Masolino undertook the side with Saints Liberius and Matthias. However, within both paintings there are discrepancies which remain to be analysed, such as the difference in flesh tones between the Baptist's face and his hands and feet.

Some of the changes and differences in the panels have been explained by the argument that Masaccio began the altarpiece, and died when it was underway, since it is known that he died in Rome in 1428. The altarpiece was then probably completed by Masolino who is known to have worked in Rome on a chapel in San Clemente.

17 A Man in a Turban 1433

Oil, perhaps with some egg tempera, on oak, painted surface 25.7 x 19cm,
with the original frame 33 x 25.8cm (NG 222)

Van Eyck is recorded from 1422 to 1424 as working for John of Bavaria in The Hague and from 1425 for Philip the Good, Duke of Burgundy, mainly in Bruges; he died in 1441. Although renowned throughout Europe for his artistic skill, and one of the greatest painters of his time, van Eyck's influence on his contemporaries and successors was limited.

Fig. 17a. Jan van Eyck, *Margaretha van Eyck,*
1439. Oak, painted surface 37.6×25.8cm. Bruges,
Groeninge Museum (Stedelijk Museum voor
Schone Kunsten).

This is one of the few fifteenth-century portraits which survives in its original frame (see pp. 154-5). It is inscribed along the top: AΛC.IXH.XAN (As I can) in Flemish, using Greek letters, and along the lower edge in abbreviated Latin JOH̄ES. .DE.EYCK.ME.FECIT (Jan van Eyck made me), and the date 21 October 1433. The inscription on the top of the frame occurs in other works by van Eyck and appears to be taken from a Flemish proverb. A pun on the words 'IXH' (I) and 'Eyck' may be intended: 'As I [Eyck] can but not as I [Eyck] would'.

Van Eyck's preoccupation with the effects of light and shadow – also seen in the Arnolfini portrait (No. 18) – makes this a dramatic portrait. The sitter seems to be turning away from a brilliant light to meet our gaze. The contrast between the shadowed side of his face and the intensity of the lighting is extreme, and throws into strong relief the veins standing out on the left temple, the crows-feet wrinkles at the corner of the eye and the indentation below the high cheekbone.

The stubble of the sitter's face is painstakingly reproduced, as are the veins in the bloodshot left eye. Although the background appears to be black, in strong light it can be seen to be a deep blue.

This picture has often been referred to as a self portrait. It was described as such as long ago as the seventeenth century. Whether this is an accurate description or not there is no means of ascertaining today, as no securely identified portrait of van Eyck survives. Van Eyck did paint a portrait of his wife Margaretha six years later in 1439 (Fig. a), which also includes on the frame the punning inscription of this picture, but the two portraits do not seem to make a pair. The direction of the sitter's glance towards the viewer suggests he might have been looking at himself in a mirror, but other portraits survive which are not self portraits in which the sitter looks out in a similar manner. Nevertheless, the contention that this is a self portrait should perhaps not be dismissed out of hand. The motto on the frame would be especially appropriate if van Eyck had portrayed himself here. Apparently self-effacing, it serves to draw attention to his extraordinary skills as an artist.

18 The Portrait of Giovanni(?) Arnolfini and his Wife Giovanna Cenami (?) ('The Arnolfini Marriage') 1434

Oil, perhaps with some egg tempera, on oak, painted surface 81.8 x 59.7cm (NG 186)

For his biography see No. 17.

Most surviving fifteenth-century portraits show only the head and shoulders of their sitters, but full-length portraits were probably not unusual. This painting, however, must always have seemed miraculous, for there were few if any fifteenth-century artists who could have rivalled van Eyck in his utterly convincing depiction of a room, as well as of the people who inhabit it. It is a representation so close to our own familiar perceptions of walls, windows and floors that it is slightly surprising to find this room occupied by unusual objects and people wearing strange and elaborate clothes. For the fifteenth-century viewer, who would have felt only recognition, the pictorial illusion must have been all the more extraordinary.

Van Eyck's contemporaries marvelled at his virtuosity in the handling of oil paint (see pp. 193–6) and especially the way in which he used it to depict reflections (a mirror was included in one of his lost paintings as well as in this one), highlights created by light falling on objects, and shadows cast by them. Although today we are struck by the exquisite painting of such details as the light catching the polished brass of the chandelier and emphasising the rotundity of the oranges (an Italian luxury) near the window, we tend to take for granted van Eyck's revolutionary achievement. This lay not so much in the rendering of isolated special effects, but rather in the creation of illusion through his unifying depiction of light. The depictions of an interior of a room with a bed behind the Virgin in Filippo Lippi's *Annunciation* (No. 23) and of a bedchamber with a fire burning in Giovanni di Paolo's *Birth of Saint John the Baptist* (No. 25) shows how this sort of subject was also of interest to van Eyck's Italian contemporaries. Both Italian artists were concerned with representing special effects of light, but neither displays van Eyck's ability to use it for the definition and evocation of space.

The direction of the shadows cast throughout the room are entirely consistent with the direction of the light which enters both through the window on the left and through the doorway reflected in the mirror. Van Eyck, assisted by the facility to blend colours and the transparent glazes offered by oil paint, has been able to create the most subtle and minute modulations in the intensity of light and to give the illusion of a precise equivalent to our own everyday experience of light falling on the objects in a room. With complete assurance, he ranges from the whiteness of the daylight visible through the window to the deep shadow of the beamed ceiling above, and seems to encompass every variation between them. The painting of the complex slashed and stitched decoration of Giovanna Cenami's green sleeve alone offered the opportunity for innumerable differentiations of tones.

Van Eyck's Arnolfini portrait was already famous early in the sixteenth century, less than a hundred years after it was completed. At that date, when in the possession of Margaret of Austria, an art collector of note, it had protective shutters painted with the coat of arms of the previous, Spanish, owner. It was described as the portrait of 'Hernoult le Fin', or 'Arnoult Fin', and his wife, from which it has been deduced that van Eyck's sitters were in all probability Giovanni di Arrigo Arnolfini (died 1472), a merchant from Lucca who was frequently resident in Bruges, and his wife Giovanna Cenami.

The portrait today is popularly known as 'The Arnolfini Marriage', although the

actual date of Giovanni Arnolfini's marriage is unknown, and it is by no means certain that the painting does show a marriage taking place. The Latin inscription above the mirror, which may be translated as 'Jan van Eyck was here/1434', has been interpreted as the painter's witness to the marriage, but it may simply be a witty means of testifying to his authorship of the picture; other paintings of his include particularly prominent inscriptions on the frames (compare No. 17). In the mirror two figures are reflected standing at the entrance to the room. They might be witnesses to a marriage (even, it has been suggested, van Eyck himself) but were perhaps included simply to draw attention to van Eyck's extraordinary skill at depicting reflections in a mirror.

The illusion of reality that van Eyck has created in this picture is indeed so vivid that there is a danger that we may too easily bring modern assumptions to bear on it. The bed, for instance, is not necessarily the Arnolfinis' marriage bed, because beds were commonly kept in most rooms of a fifteenth-century house.

Van Eyck's figures are painted with rather less fidelity to the realities of human construction than one might assume from the apparent solidity of his walls, floor and window. The Arnolfinis have tiny heads in proportion to their bodies. Giovanni Arnolfini has almost grotesquely large features for the size of his head, while Giovanna Cenami has, by contrast, facial features of an unnatural minuteness, as well as a stomach so large as to suggest advanced pregnancy. However, comparison with other representations of women in the fifteenth century, as well as descriptions in praise of them, suggest strongly that small features, elongated limbs and a swollen stomach were all regarded as signs of beauty.

What conventions governed gestures in fifteenth-century Europe is harder to discover. The couple in this portrait are certainly gesturing in a manner that seems to us today to demand an explanation. The way in which Giovanni Arnolfini raises his hand has suggested to modern minds that he must be taking an oath. We know from infra-red photographs (see Fig. 223) that van Eyck altered this hand to make it less upright, which might indicate that he was trying either to make an important and specific gesture more exact, or to make it less distracting. Whether this gesture, or the way in which the couple join hands at the centre of the composition, is specific to marriage or betrothal ceremonies is difficult to establish. Nor do we know how common it was to find in a room like this objects such as a mirror with a frame decorated with scenes of the Passion, furniture with carved figures of Saint Margaret, brushes and rosary beads. Certainly the presence of a single lighted candle in daylight seems odd. It might have been customary at the making of marriage contracts, as it seems to have been at the making of some other legal agreements, but we do not know for sure. The painting appears to celebrate the Arnolfini marriage, but whether or not it depicts the original marriage celebration remains unknown.

Fig. 18a. Detail of No. 18.

19 Scenes from the Life of Saint Francis completed 1444

Saint Francis leaving to become a soldier and giving his clothes to a poor knight; and Saint Francis dreaming of the Order he is to found Egg tempera (analysed) on poplar, 87 x 52.5cm (NG 4757)

The Stigmatisation of Saint Francis Egg Tempera (analysed) on poplar, 87.5 x 52.5cm (NG 4760)

His real name was Stefano di Giovanni. He was born probably in Siena in 1392. Between 1426 and his death in 1450 he is recorded as working mainly in Siena, where he remained until he died in 1450. With Giovanni di Paolo (see No. 25), he was one of Siena's leading painters in the fifteenth century.

These two scenes from the Life of Saint Francis come from a now dismembered double-sided altarpiece (Figs. a and b) originally in the church of San Francesco in Borgo Sansepolcro (see also No. 2). The altarpiece was one of the most expensive commissions in Sienese fifteenth-century painting. Sassetta was paid 510 florins for it, according to the contract dated 1437 (see pp. 128ff.). It was to be painted in Siena and Sassetta agreed to deliver it to the Franciscan friars within four years. In the event, a document of receipt shows that he delivered it seven years later on 5 June 1444.

On the basis of style and iconography the following scenes have been identified

as having come from the altarpiece. The front main tier consisted of *The Virgin and Child with Saints*. According to an inscription of 1304 on the altar table, a much venerated local Franciscan, the Blessed Raniero (shown in the main tier) was buried beneath the altar, and the front predella showed scenes from his life, three of which have been identified. The back showed *Saint Francis Triumphant* standing on Insubordination, Luxury and Avarice. Eight scenes from his life (of which seven are in the National Gallery) were ranged in two tiers on either side. The altarpiece was crowned with gables and pinnacles. Scenes from the Life of Christ have tenta-

Fig. 19a. Reconstruction (based on K. Christiansen) of surviving fragments of Sassetta's altarpiece for San Francesco, Borgo Sansepolcro (front).

1. *The Annunciation.*
2. *Saint Augustine.*
3. *Blessed Raniero.*
4. *Saint John the Baptist.*
5. *The Virgin and Child Enthroned with Six Angels.*
6. *Saint John the Evangelist.*
7. *Saint Anthony of Padua.*
8. *Blessed Raniero predicts the Soul of the Miser of Citerna will be carried away by Demons.*
9. *Blessed Raniero freeing the Poor of Florence from Prison.*
10. *The Apparition of Blessed Raniero to a Cardinal.*

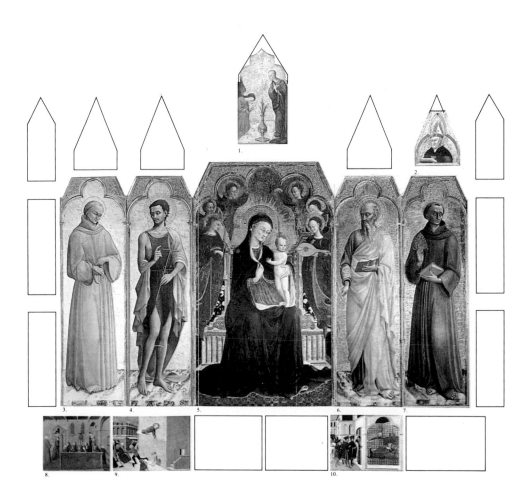

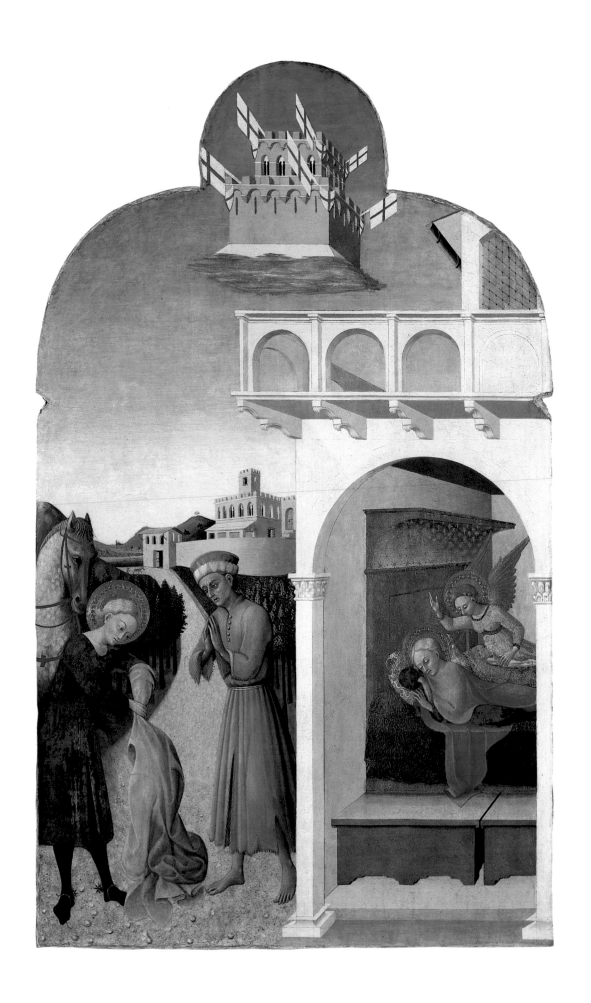

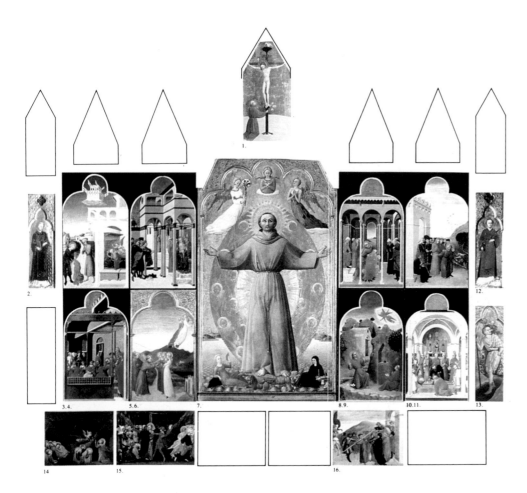

tively been proposed as having formed the back predella. The front of the altarpiece presumably once bore the name of the painter, since the back originally carried a date of 1444 and an inscription naming the friars who commissioned the panel, 'Christoforus Francisci Fei' and 'Andrea Iohannis Tanis', both named in the documents of 1437 and 1444. The contract specified that the figures and scenes were to be chosen by the friars. They probably derive from the Life of Saint Francis by Saint Bonaventura, and follow the sequence of his text.

The design of the back was an updated version of the thirteenth-century formula, also used by fourteenth-century painters, showing a standing saint with scenes from his or her life on either side (see Fig. 14). The idea of having the altarpiece double-sided most likely came from the friars themselves: Sassetta would of course have known Duccio's *Maestà* (No. 3), but a more likely prototype for the arrangement existed in the

Franciscan church of San Francesco al Prato in Perugia, where a double-sided altarpiece dated 1403 had been painted by the Sienese painter Taddeo di Bartolo.

The altarpiece was probably painted in five separate vertical units, dowelled together, and one horizontal unit, for ease of transport from Siena to Borgo Sansepolcro, to be assembled only on the altar (see also No. 5).

Like Giovanni di Paolo (see No. 25), Sassetta was greatly influenced by the style of previous Sienese painters, such as Duccio and Ugolino (see Nos. 3, 4, 5), as well as by the growing interest in representing the natural world which characterises the work of his contemporaries. Thus his interest in the effects of light is combined with an interest in the decorative effects possible on the paint surface, particularly the use of gold and silver leaf. In the scene of Saint Francis giving up his cloak to a poor knight, the pale yellow sunset in the distance catches the inside of the arches on the balustrade;

Saint Francis later lies dreaming of the Order he is to found: he sleeps in a golden bed, like that in the predella panel by Giovanni di Paolo (see No. 25 and Fig. 144), rendered with gold leaf which has been densely stippled and painted; the starred canopy is decorated in *sgraffito*.

In the *Stigmatisation* Sassetta is careful to record the shadows thrown by the supernatural light emanating from the crucified Christ, the shadows cast by the cord of Saint Francis's habit, and by his fingers above his shoulder. In order to emphasise that this is a miraculous event, the cross set in a niche cut in the rock has begun to bleed. Saint Francis was regarded as the *alter Christus* (other Christ) and it was common to show him in scenes which drew parallels with Christ, such as the renouncing of his earthly father and the verification of the stigmata (see Fig. 55).

OPPOSITE *The Stigmatisation of Saint Francis.*

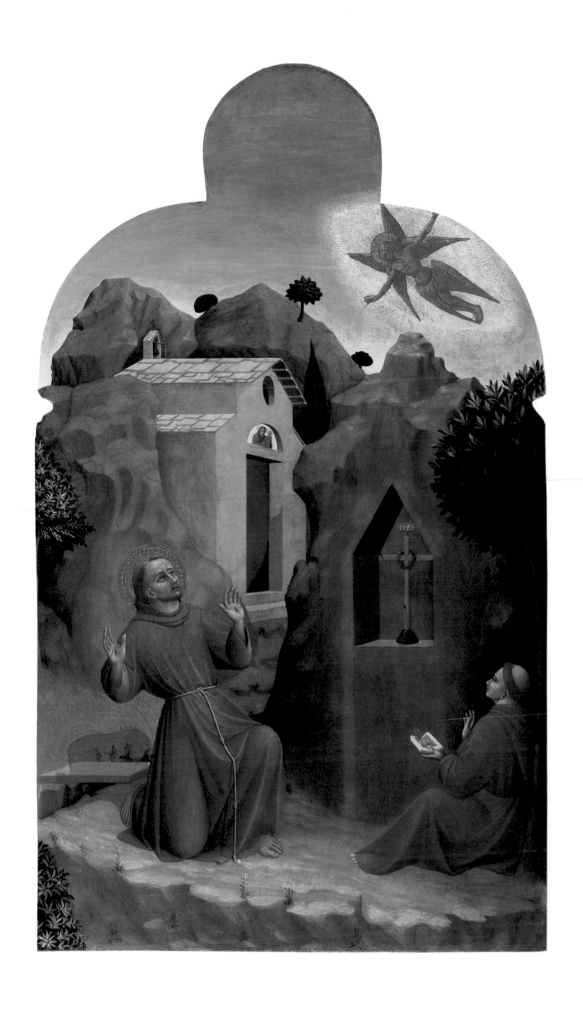

20 Saints Matthew, Catherine of Alexandria and John the Evangelist *c.* 1445

Oak, 68.6 x 58.1cm (cut at top and bottom) (NG 705)

Lochner is first documented in Cologne in 1442 where he was the leading painter, and he died there in 1451. Dürer's note that 'Meister Steffan' was responsible for the great altarpiece of the Adoration of the Magi for Cologne Town Hall chapel (now in Cologne Cathedral, Fig. 96) has made it possible to identify Stephan Lochner as the painter of this and other works.

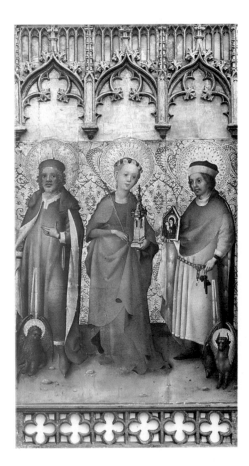

Fig. 20a. Stephan Lochner, *Saints Mark, Barbara and Luke, c.* 1445. Oak, painted surface 105×57.5cm. Cologne, Wallraf-Richartz Museum.

Fig. 20b. Stephan Lochner, reverse of No. 20, *Saints Jerome, Cordula(?) and Gregory, with an unidentified Knight of the Order of Saint John.*

This is the inside of the left-hand shutter from a small altarpiece of which the central panel is lost; the outside of the shutter (Fig. b) is badly damaged. The inside and outside of the right-hand panel in Cologne, which is similarly double-sided, have been divided to make two separate pictures (Figs. a and 67). The panel which would originally have formed the inside of the right-hand shutter shows Saints Mark, Barbara and Luke. The two shutters thus include depictions of all four Evangelists, identifiable by their attributes (see p. 52 and No. 1). The Cologne panel still retains the carved tracery above and below the figures of the interior panels. This tracery presumably reflects elements in the lost central panel; this may well have been a sculpted scene rather than a painting, although Lochner's altarpiece of the Adoration of the Magi (Fig. 96) has similar tracery over the central painting.

The shutters are each painted on the outsides with figures of two of the four Fathers of the Church and with a female saint: thus the London panel (Fig. b) has Saints Jerome and Gregory and a female

figure carrying a martyr's palm who may be Saint Cordula, while the Cologne panel has Saints Ambrose, Augustine and Cecilia (Fig. 67). These figures would have been visible when the altarpiece was closed; also included are two kneeling donors. Both donors wear the cross identifying them as members of the Order of Saint John of Jerusalem, and from the inscription surviving on the Cologne panel one can be identified as Heinrich Zeuwelgyn, the son of a prosperous family in the Cologne area.

The London panel is said to have come from the church of the Order in Cologne, which is that of Sts John and Cordula; if so, the female martyr represented on the back of the London panel is indeed likely to be Saint Cordula, who was one of the eleven thousand virgins who accompanied Saint Ursula to Cologne, where they were martyred; Saint Cordula is said to have hidden in fear when her companions were martyred but subsequently to have revealed herself and gone bravely to her death.

The small figures of these panels are dressed in Lochner's characteristic combination of bright apple green and deep pink: the robe of Saint Catherine is painted with a lining of the same green as that used for the shadows of the robe of Saint Matthew on the left. Just as the colours are at once varied and united, so the pose of each saint both echoes and answers that of the neighbouring one. The figures also relate to each other in their facial expressions, animated in a manner which is made more explicit by a later Cologne painter, the Master of the Saint Bartholomew Altarpiece (see No. 67). Their expressions remind us that Lochner was also a painter of dramatic subjects such as *The Last Judgement* (Cologne, Wallraf-Richartz Museum).

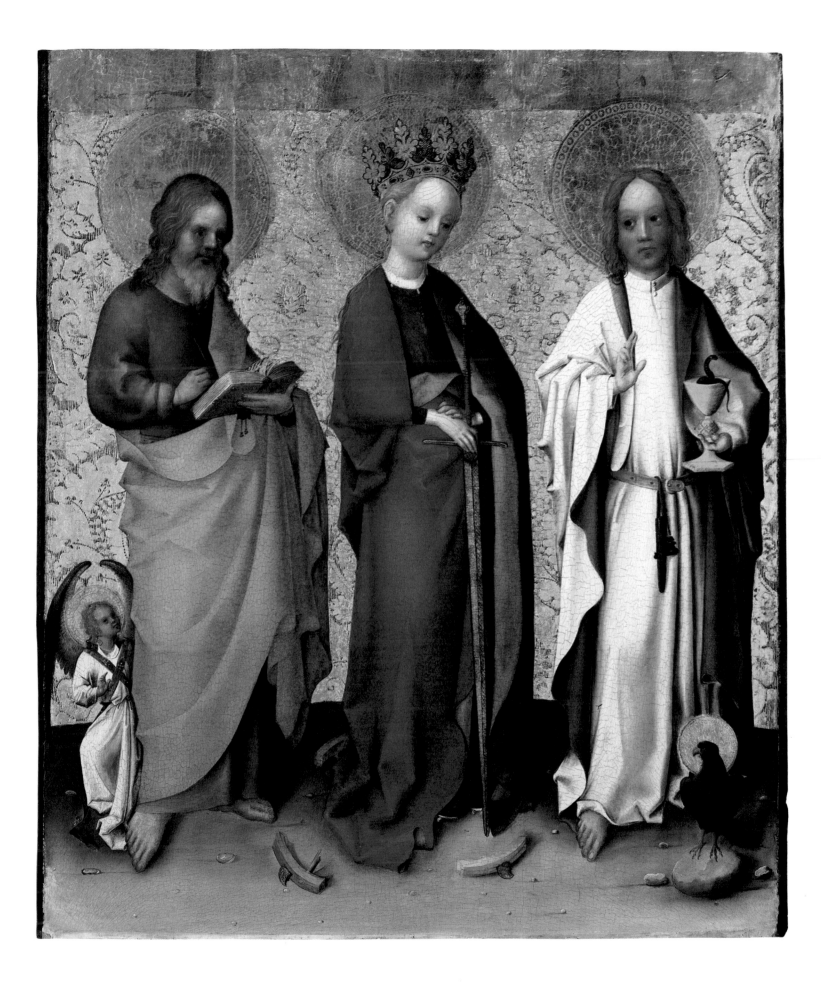

21 The Virgin and Child with Saints George and Anthony Abbot mid-15th century

Egg tempera on poplar, 47 x 29cm (NG 776)

Pisanello was born in about 1395 and probably died in 1455. He was famous in his lifetime as a medallist. Few of his paintings survive. He may have trained in Verona. He was from at least 1438 onward mainly occupied as court artist to the d'Este family in Ferrara, and the Gonzaga family in Mantua, but he also worked in Venice, Rome and Naples. In his many medallions he always signs himself 'Pisanus pictor' (meaning 'depictor from Pisa'). It may have been a misreading of this signature which led Vasari to think his name was Victor.

This is the only signed painting by Pisanello: the signature 'Pisanus pi[nxit]' (Pisanus painted it) is subtly integrated with the plants of the foreground. However, the panel was substantially restored in the nineteenth century; for example, the silver armour of Saint George was completely renewed. It cannot therefore be used as a touchstone for attributions to Pisanello.

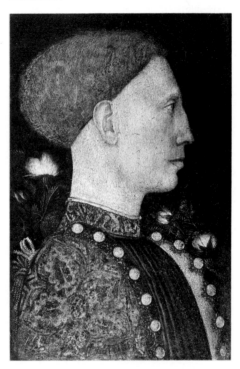

Fig. 21a. Pisanello, *Lionello d'Este,* 1441. Wood, 28×19cm. Bergamo, Accademia Carrara.

Saint Anthony Abbot is shown with a hog and a bell. He acquired these attributes probably because the Order of the Hospitallers of Saint Anthony rang little bells to attract alms and the Order's pigs were allowed to roam the streets freely. Saint George, who is shown with the dragon he vanquished when he rescued a princess, wears a wonderful wide-brimmed straw hat, perhaps as protection from the sun, for the Virgin and Child are encircled by the rays of the sun, a motif which may refer to the Woman and Child in the Apocalypse (*Revelation* XIII) who were clothed with the sun. Why these particular saints were chosen is obscure.

The painting was probably intended for domestic use. It may not be a coincidence that it was bought in the nineteenth century from Ferrara (Costabili Collection), a city where Pisanello was regularly employed by the d'Este family from 1438 onward (see also No. 24). A portrait of Lionello d'Este (Fig. a) came from the same collection in Ferrara. It could be said that the face of Saint George with its distinctive curly hair resembles Lionello d'Este.

The frame, which is known to be nineteenth century, incorporates a copy of a medallion showing Lionello (see Fig. III) by Pisanello.

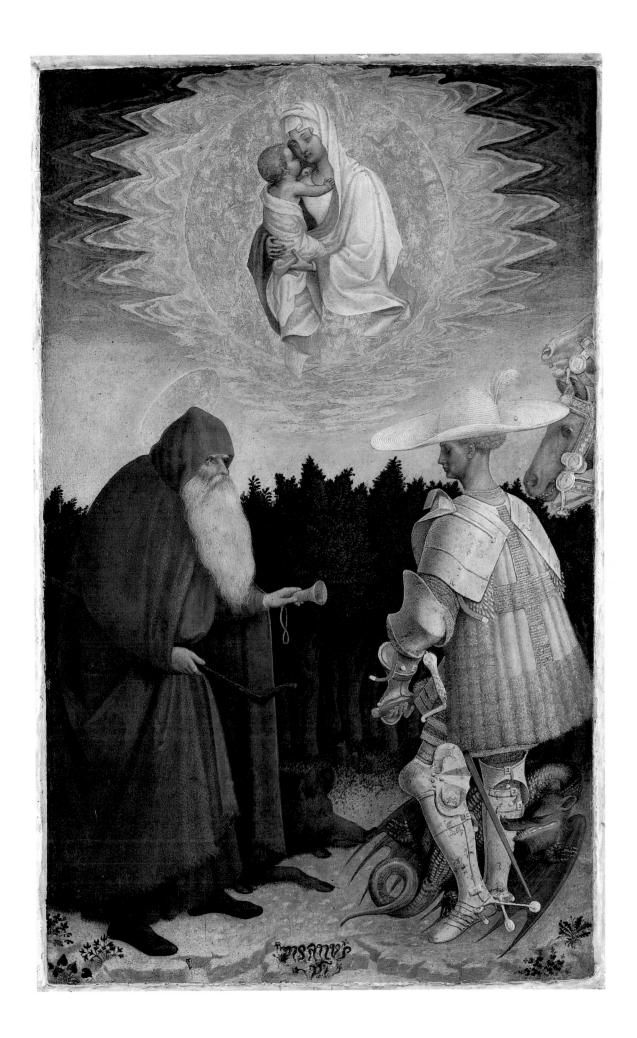

22 The Magdalen Reading *c.* 1440-50

Oil, perhaps with some egg tempera; transferred from its original panel to mahogany,
painted surface 61.5 x 54.5cm (a fragment) (NG 654)

The outstanding Netherlandish painter of his time, renowned throughout Europe, Rogier van der Weyden appears to have headed a very large workshop; his influence on Netherlandish painting was considerable, and endured for long after his death in 1464. Probably the 'Rogelet de le Pasture' ('Weyden' is the Flemish equivalent of 'Pasture', meadows) apprenticed to Robert Campin in 1427-32 (see No. 13), he was active at Brussels from 1435 where he was the Town Painter, and also seems to have been patronised by the Burgundian court.

This depiction of the Magdalen, who is identified from her jar of ointment and rich clothes, is a fragment cut from a larger painting of the Virgin and Child with saints. This was presumably an altarpiece, which has been estimated to have been about one metre high and one and a half metres or more in width. Two more, smaller fragments survive, a head, apparently of Saint Joseph, whose body appears behind the Magdalen, and a head of a female saint, probably Saint Catherine (Figs. a and b).

Rogier van der Weyden is known to have produced other paintings of the Virgin and Child with saints, but none has survived which could be compared with this fragment. The carved wooden cup-board suggests that the scene was set in a contemporary domestic interior, rather than in the very richly decorated ecclesiastical buildings in which Jan van Eyck set similar compositions. In this, parallels can be drawn with the works associated with Robert Campin (see No. 13), to whom Rogier van der Weyden was apprenticed. Indeed, close parallels have been drawn between the figure of the Magdalen and figures in works attributed to Campin. This might suggest that this is a relatively early work by van der Weyden. Unfortunately, the condition of the painting has in places obscured the delicacy of the original handling of the paint, although the characteristic control of detail can still be appreciated in the

Fig. 22a. Rogier van der Weyden, *Saint Catherine*. Wood, 20×17cm. Lisbon, Calouste Gulbenkian Foundation.

Fig. 22b. Rogier van der Weyden, *Saint Joseph*. Wood, 20×17cm. Lisbon, Calouste Gulbenkian Foundation.

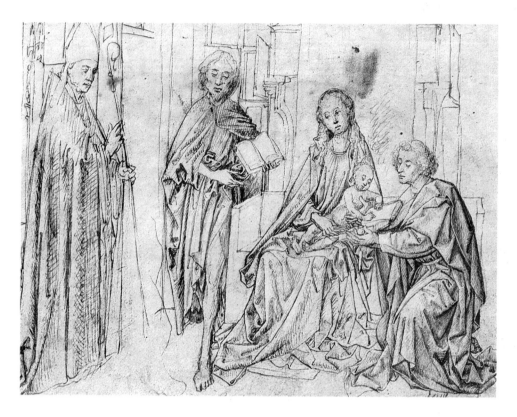

Fig. 22c. The Master of the Coburg Roundels, *Virgin and Child with Saints*, late fifteenth century. Pen and ink on paper, 22.5×16.7cm. Stockholm, National Museum.

have included an extensive landscape with a meandering river, swans and passers-by, of a type seen in other paintings by van der Weyden.

A related composition is recorded by a drawing (Fig. c). It does not show Saint Mary Magdalene or either of the figures in the other fragments. Moreover, the Virgin is shown off-centre, suggesting that the composition is incomplete in the drawing. But it does include the figure of Saint John the Evangelist, part of whose robe and foot appear on the left-hand edge of the National Gallery fragment. It is not entirely clear whether this drawing records the altarpiece to which these fragments belonged, or a similar work.

In the drawing, the Virgin and Child are surrounded by saints: John the Baptist, an unidentified bishop saint and John the Evangelist. It has been suggested that the composition the drawing records may even have been a triptych, as the figure of the bishop saint seems somewhat detached from the scene and might have been placed on the left-hand shutter. Saint John is holding an inkwell and supporting a book for the infant Christ to write in, which probably symbolises the divine inspiration of Saint John's Gospel. Saint John the Baptist in the drawing and the Magdalen in the painting also hold books, but the particular circumstances of the altarpiece which may have inspired such a literary emphasis are unknown.

rendering of the Magdalen's highly patterned brocade underskirt.

The fragment of Saint Catherine, which appears to belong to the lower left-hand area of the original altarpiece, includes the side of a window with a view of a landscape. Parts of another similar window appear behind both fragments from the right-hand side of the picture, the National Gallery Magdalen fragment and the figure thought to be Saint Joseph: the background therefore must originally

Fig. 22d. Detail of No. 22.

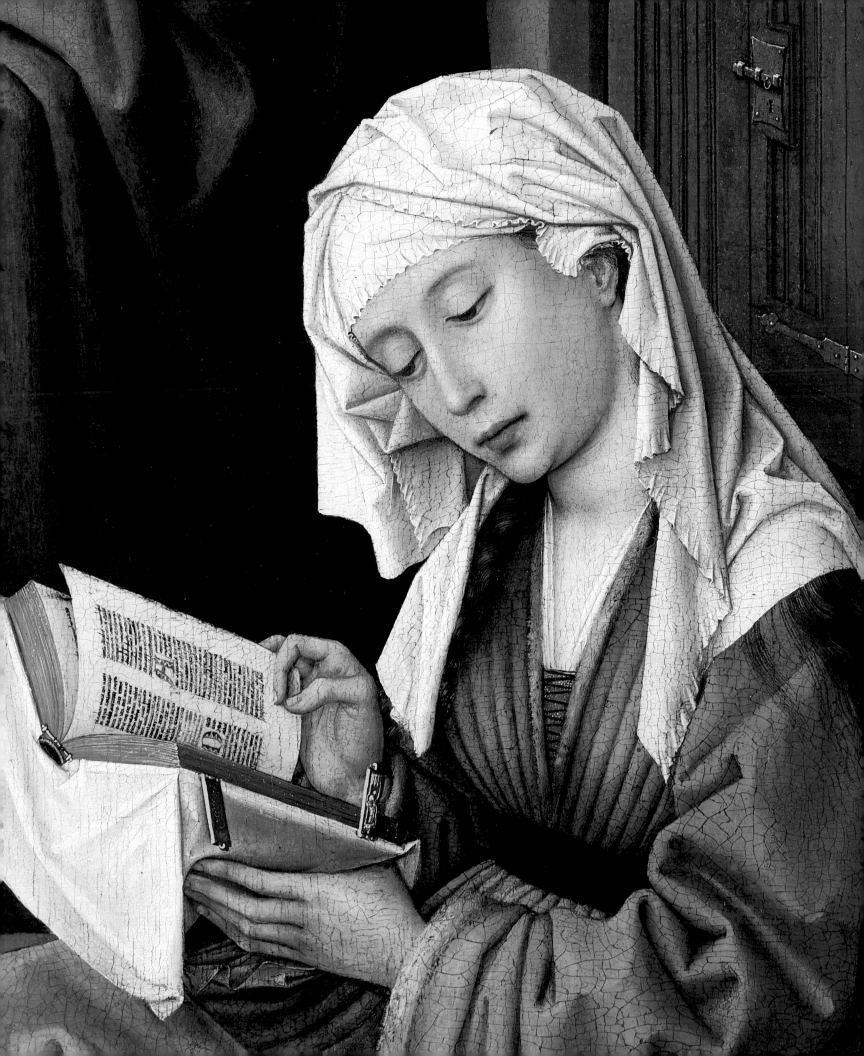

23 Seven Saints *c.* 1448-50

Egg tempera on wood, 68 x 151.5cm (NG 667)

The Annunciation *c.* 1448-50

Egg tempera on wood, 68.5 x 152cm (NG 666)

Fra Filippo Lippi was probably born in about 1406. He took his vows at Santa Maria del Carmine in Florence in 1421, and remained there eleven years, although he was totally unsuited to the religious life. He is first mentioned as a painter in 1431. He was much patronised by the Medici, who eventually obtained special dispensation for him to marry a nun. She gave birth to his son, Filippino Lippi (see No. 48), in about 1457. Filippo Lippi worked in Padua, Florence, Prato, and from 1467 to 1469 in Spoleto, where he died.

The shape and subject matter of these two panels suggest that they may have been part of the *camera* or bedchamber furniture.

The two panels came originally from the Palazzo Medici (now Palazzo Riccardi; see also No. 26) and were almost certainly painted for the Medici, Florence's ruling family – who were also Lippi's greatest patrons – since all the seven saints are connected with the Medici. The paintings may have been commissioned by Piero (known as Peter the Gouty, 1416-69), whose name saint, Peter Martyr, with a hatchet in his head, appears at the extreme right. Piero's grandfather was Giovanni (John) Bicci de' Medici (1360-1429), who was considered to have established the family fortunes, hence the presence of his name saint, John the Baptist, at the centre. The four saints on either side of him are the name saints of Giovanni's four sons. To his immediate left and right are Saints Damian and Cosmas, who are shown with their boxes of medicine on the ledge behind them. They were physicians and were patron saints of the Medici family (*medici* = doctors), but they are also there because Giovanni's sons were called Damiano (died 1390) and Cosimo, the latter known as *Pater Patriae* (1389-1464). To the left is Saint Lawrence with the grid on which he was martyred; he is there for Lorenzo (died 1440). Opposite him is Saint Anthony Abbot with his hermit's staff, who is there for Antonio (died 1398). Three generations of Medici are therefore represented. Piero's father-in-law was called Francesco, and so Saint Francis, with the stigmata indicated in gold, may have been included as a reference to his wife's family. Such associations are reinforced by the fact that the same seven saints are included in an altar-

piece (Fig. a) painted for the Medici by Baldovinetti, but with the addition of Saint Julian for Piero's second son, Giuliano, born in 1453.

The dynastic implications of the panel with seven saints also occur in its companion panel, the *Annunciation*. This has the Medici device of three feathers within a ring painted in relief on the parapet. Piero was married to Lucrezia Tornabuoni and their son Lorenzo the Magnificent was born in 1449.

Although companion pieces, the two paintings are not similar enough to suggest that they were intended to be seen together. It is more likely that they were for two separate but related rooms. The dynastic theme makes a suitable subject for bedroom furniture, such as the painted bed-heads seen in a painting by Giovanni di Paolo (see No. 25 and Fig. 144), or the panels could have been situated immediately above the sort of bed seen in the *Annunciation* itself. This would not have been unusual (see p. 108).

Filippo Lippi's *Annunciation* is refined in the treatment of the subject: the elegant angel is seen in profile with magnificent peacock wings. The dove flies in a glittering spiral directly towards the Virgin's womb which has a small scattering of golden rays emanating from it, much like the stigmata of Saint Francis in the companion painting. Filippo Lippi was particularly adept at rendering transparent veils; here the veil lightly swathes the Virgin's head and falls over her shoulders. The walled garden (*hortus conclusus*) symbolises her perpetual virginity (see also No. 69). Her purity is further alluded to in the lilies held by the angel; the motif is skilfully incorporated in the urn which sits precariously on the parapet, and also in the intarsia which decorates the bedstead.

Fig. 23a. Alesso Baldovinetti, *The Virgin and Child with Saints, c.* 1454. Wood, 176×166cm. Florence, Uffizi.

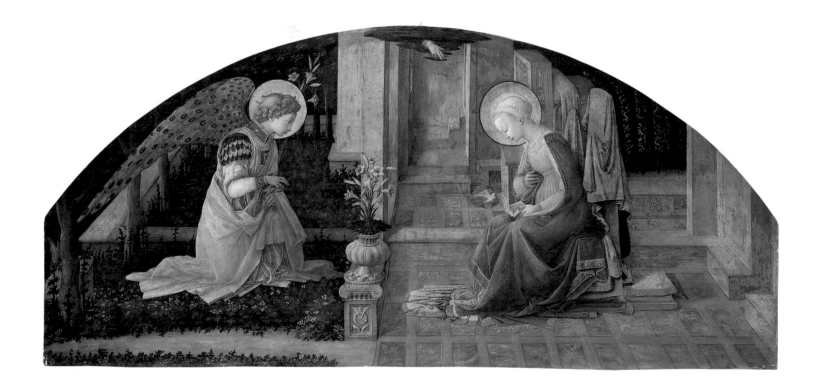

24 The Vision of Saint Eustace mid-15th century

Egg tempera on wood, 54.5 x 65.5cm (NG 1436)

For his biography see No. 21.

Fig. 24a. Pisanello, *Domenico Novello Malatesta*, reverse, *c.* 1445. Bronze cast, diameter 8.5cm. London, Victoria and Albert Museum.

Fig. 24b. Pisanello, *Study of a Hare*, second quarter of the fifteenth century. Pen, black chalk and watercolour on paper. 13.9×22.5cm. Paris, Louvre, Vallardi Codex (N.2445).

This small hunting scene with a religious theme was probably made for domestic use. The story is told of Saint Eustace (and also of Saint Hubert – see p.23) that while out hunting he had a vision of a stag with a crucifix between its antlers. As a result he was converted to Christianity. Saint Hubert was rarely shown in early Italian art and the painting therefore most likely represents Saint Eustace. Pisanello has used the scene as a pretext for numerous naturalistic studies of animals and birds dotted about the landscape in a purely decorative way. Drawings of them from pattern books (Fig. b) as well as from life (Figs. c and e) were almost certainly used for this painting (and see also pp. 144-5). Like Uccello (see No. 26), Pisanello combines an interest in the natural world with an interest in surface decoration: he too has used real gold for the horse's harness, the hunting horn, and the spurs, which are built up in *pastiglia*, and gold leaf incised with a pattern and highlighted with white for the saint's tunic.

The saint, seen here in contemporary courtly attire, could be a portrait of the patron. His profile relates to those of medallion portraits (see Fig. III). Pisa-

nello was famous in his lifetime as a portrait medallist and made a number of medals for the d'Este family in Ferrara (see also No. 21). The crucifix resembles that in the scene of a knight in armour embracing the crucifix on the reverse of a medallion portrait of Domenico Novello Malatesta (Fig. a), and the same study (Fig. d) may have been used for both.

The date of the *Vision of Saint Eustace* has been much debated: some scholars have considered it an early work, while others have put it late in Pisanello's career. The *cartellino* or scroll in the foreground is unlikely ever to have been painted: it is improbable that an inscription could have been removed without leaving any trace. It was surely not Pisanello's intention to leave it blank; it may have been designed to bear a motto which for a reason unknown was never provided by the patron.

Fig. 24c. Pisanello, *Study of a Hound*, second quarter of the fifteenth century. Black chalk on paper, 18.3×21.9cm. Paris, Louvre, Vallardi Codex (N.2429ᵛ).

BELOW LEFT Fig. 24d. Pisanello, *Study of a Crucifix*, second quarter of the fifteenth century. Black chalk on paper. 19.5×26cm. Paris, Louvre, (N.2368ᵛ).

Fig. 24e. Pisanello, *Study of a Deer*, second quarter of the fifteenth century. 15.8×20.8cm. Pen and black chalk on paper. Paris, Louvre (N.2490).

25 Scenes from the Life of Saint John the Baptist *c*. 1454(?)

The Birth of Saint John the Baptist Egg tempera on poplar, painted surface 30.5 x 36.5cm (NG 5453)

Saint John the Baptist retiring to the Desert Egg tempera on poplar, painted surface 31 x 38.8cm (NG 5454)

The Baptism of Christ Egg tempera on poplar, painted surface 30.8 x 44.5cm (NG 5451)

The Feast of Herod Egg tempera on poplar, painted surface 31 x 37cm (NG 5452)

Together with Sassetta (see No. 19), Giovanni di Paolo was one of Siena's leading painters in the fifteenth century. His first signed and dated work is of 1426. He died in 1482.

These paintings show scenes from the Life of Saint John the Baptist. In the first panel his mother Elizabeth reclines on a bed after giving birth, while his father Zaccharias, who has lost the power of speech, writes down what the child's name is to be. In the second, Saint John leaves home and goes into the desert to lead an austere life. In the third, he baptises Christ. In the fourth, Herod is brought the head of the Baptist: Salome had so pleased Herod by her dancing that he had offered her anything she wished, whereupon she asked for the head of the Baptist on a platter.

The four panels were almost certainly once part of a predella formed of at least five panels. The *Baptism* is slightly wider and therefore was probably at the centre. The altarpiece from which the predella came cannot be securely identified. It has been suggested that it was one showing *The Virgin and Child with Saints* (Fig. a) which includes Saint John the Baptist in the main tier, and which is signed and dated 1454.

Giovanni di Paolo constantly re-used parts of his compositions (see Figs. b and c), or harked back to the works of earlier Sienese painters. He was also profoundly

Fig. 25a. Giovanni di Paolo, *The Virgin and Child with Saints*, 1454. Wood, 210×237cm. New York, Metropolitan Museum of Art.

Fig. 25b. Giovanni di Paolo, *Saint John the Baptist retiring to the Desert*, mid-fifteenth century. Wood, 68.6×36.2cm. Art Institute of Chicago, Mr and Mrs Martin A. Ryerson Collection.

Fig. 25d. Ghiberti, *The Baptism of Christ*, 1425-7. Gilt bronze. Font, Baptistery, Siena.

Fig. 25e. Donatello, *The Head of Saint John Brought to Herod*, 1423-7. Gilt bronze, 60×60cm. Font, Baptistery, Siena.

Fig. 25c. Giovanni di Paolo, *The Head of Saint John brought before Herod*, mid-fifteenth century. Wood, 68.6×40cm. Art Institute of Chicago, Mr and Mrs Martin A. Ryerson Collection.

influenced in the *Baptism* and *Feast of Herod* by the equivalent scenes made by Ghiberti and Donatello respectively for the bronze font for Siena Baptistery (Figs. d and e), which were delivered in 1427, although the font itself was not completed until several years later.

In common with that of his contemporaries, Giovanni di Paolo's work was concerned with reconciling the residual influence of the previous generation of painters, particularly their decorative effects, with the realistic creation of three-dimensional space and observation of the natural world. The scene of the Baptist retiring to the desert is old-fashioned in combining two episodes in a single scene (see No. 3). Parts of several of the scenes are richly decorative – the fire where a midwife dries a cloth in the *Birth of the Baptist*, the brocade curtain in the *Feast of Herod*, and the cherubim and seraphim in the *Baptism* are all rendered with gold leaf overlaid with red or

orange. The use of colour is primarily decorative with brilliant orange set against brilliant blue, and pale pink against pale green. Some of the landscape is almost fairytale with mountains and miniature castles. But Giovanni di Paolo, like Uccello (see No. 26), is also interested in using the principles of linear perspective to convey different kinds of pictorial space and depth – a view along a sharply receding tiled floor through a complicated suite of rooms; the neat geometric patchwork of vineyards contrasting with a stony desert which leads to a wispy distant horizon of snow-capped mountains; an archway leading to a lush garden beyond the dramatic horror of Herod's banquet which the guests cannot bear to contemplate.

There is a strange anomaly of viewpoint in the flowers of the borders which are seen from below and the bird's eye viewpoint of the adjacent narrative scenes viewed from above.

OPPOSITE *The Baptism of Christ* and *The Feast of Herod*.

26 The Battle of San Romano *c.* 1450s(?)

Egg tempera, perhaps with some oil, on poplar, 182 x 320cm (NG 583)

Uccello's real name was Paolo di Dono. He was called Uccello because of his love of birds (uccello = bird), and his house was filled with pictures of birds and animals. He was probably born in 1397 and was an assistant in Ghiberti's workshop in 1407. In 1414 he joined the confraternity of Saint Luke in Florence and in 1415 he was admitted as a painter to the Arte dei Medici e Speziali. He was chiefly active in Florence, but worked as a mosaicist in Venice from 1425 to 1427. He died in 1475.

The Battle of San Romano was a victory over the Sienese in 1432 by the Florentines led by their captain, Niccolò da Tolentino (died 1435). Although in reality the battle seems to have been merely a minor skirmish, Uccello has presented the event as heroic. At the centre Niccolò da Tolentino in a gorgeous hat of gold decorated with red, rides a prancing white charger. Behind him his standard bearer, a fresh-faced youth, carries Niccolò's banner with his device of the knot of Solomon. The other knights, sinister in the anonymity of armour, carry lances, blow golden trumpets, or clash with the enemy, against a lush background of foliage with red and white roses, glowing oranges and over-ripe pomegranates. The effect is intentionally decorative, as of a tapestry (see pp. 89ff.), to enrich the walls of a palace.

Together with its two companion pieces in Florence and Paris showing separate incidents in the battle (Figs. a and b), this painting may have been commissioned by Cosimo de' Medici, intent on glorifying Niccolò da Tolentino, who

had been a powerful friend and ally. The knight in front of Niccolò da Tolentino has a helmet with three distinct plumes, which may allude to the device of the Medici (see also No. 23), and the oranges may have been exaggerated to resemble the Medici 'palle', an emblem of balls. The three panels came from the Palazzo Medici (Riccardi), where they were listed in an inventory of 1492. At that time they were described as being in the room of Lorenzo the Magnificent. However, their precise original location is not known, nor is their original arrangement, although their landscapes link up if the National Gallery's painting is placed first followed by the one in Florence, then the one in Paris. The argument for this order is strengthened by the probability of the scene bearing the signature (Fig. a) having been at the centre. All three paintings have been made up at the top corners, and may have been initially intended to fit below vaults. In the case of the National Gallery's painting, technical evidence suggests that the additions at the corners are possibly contemporary and may have been made by Uccello himself. It is possible that the destination of the paintings changed while they were still in production. They may initially have been intended for the first Medici palace (now Pucci), but were then adapted for the Palazzo Medici which was in the course of construction from 1444 to 1452. The battle scenes were probably being made around the same date. The frescoed equestrian portrait of Niccolò da Tolentino in Florence Cathedral was commissioned from Andrea dal Castagno in 1455 and also reflects contemporary promotion of Niccolò.

According to Vasari, Uccello was so obsessed by perspective that he would stay up all night studying vanishing

Fig. 26a. Paolo Uccello, *The Unhorsing of Bernardino della Carda,* 1450s. Signed. Wood, 182×220cm. Florence, Uffizi.

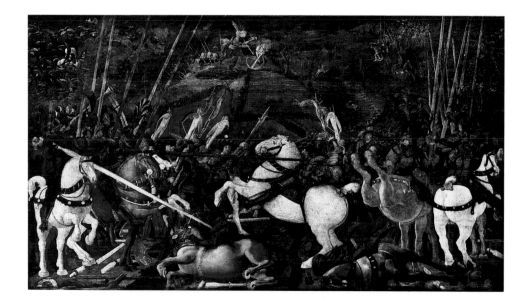

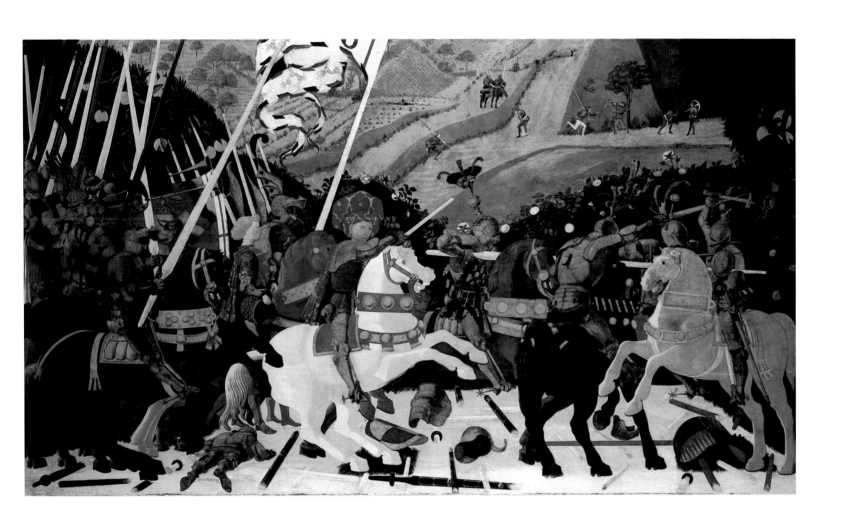

points, ignoring his wife's calls to come to bed. Although perspective is normally a tool for realistic representation of recession in space, Uccello's use of it in this work does not further a coherent illusion of reality. The broken lances are arranged artificially on the pink ground to lead towards a single vanishing point, which does not, however, lie on the horizon as it should in nature. Irregular shapes like the horses, fallen bodies and Niccolò da Tolentino's hat have been foreshortened

according to mathematical principles. The artificiality of the perspective heightens the decorative character of the panels, already established through the background motifs and use of gold and silver. The soldiers' armour of silver leaf is now tarnished but was once realistically metallic. The colourful saddles of the horses and the punched gold leaf of their harnesses are a reminder that such objects were in reality often decorated in painters' workshops (see p. 122).

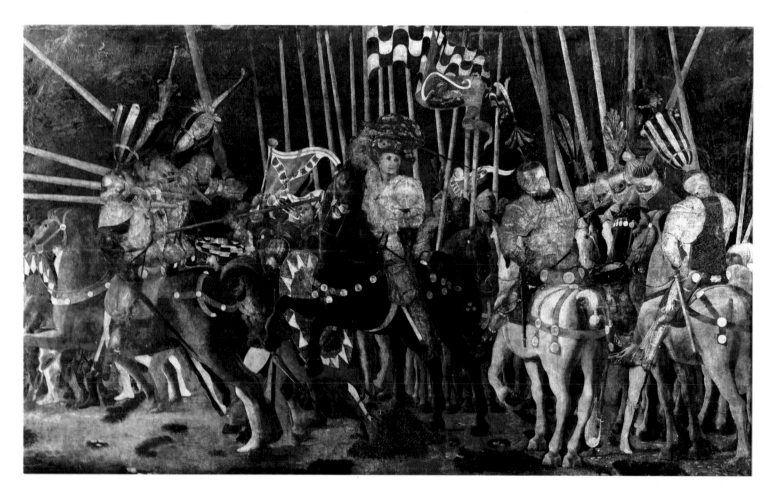

RIGHT Fig. 26c. Detail of No. 26.

Fig. 26b. Paolo Uccello, *Michelotto da Cotignola attacking the Sienese Rear,* 1440–50(?). Wood, 180×316cm. Paris, Louvre.

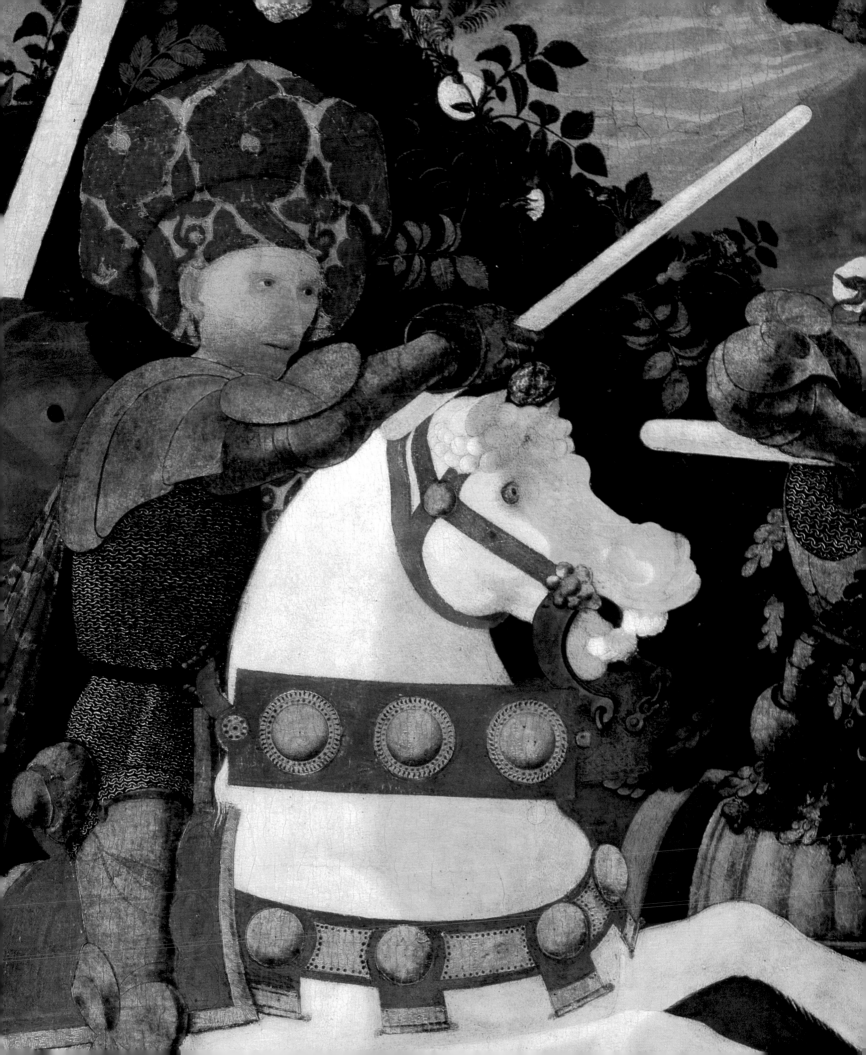

27 The Baptism of Christ 1450s

Egg tempera (analysed) on poplar, 167 x 116cm (NG 665)

Piero was born in Borgo Sansepolcro (in Tuscany) and seems to have lived and worked chiefly there. He is recorded in Florence in 1439 as an assistant of Domenico Veneziano. He enjoyed a high reputation with his contemporaries and worked for the courts of Ferrara, Urbino, Rimini and Rome. His greatest surviving works are the frescoes in the choir of San Francesco in Arezzo. He wrote books on perspective and geometry and it is likely that he devoted his later years, when his eyesight had failed, to these studies. After his death in 1492 he was soon forgotten. Connoisseurs in the second half of the last century appreciated his work, but he achieved the great fame he now enjoys only about fifty years ago.

Christ is represented at the moment when the water from the river Jordan, poured from the basin held by his cousin Saint John the Baptist, touches his head. A pure white dove hovers above – foreshortened into a shape like the clouds beside it – representing the Holy Spirit. Heavenly light in the form of very fine lines of gold (originally more apparent but probably never obvious) falls from behind the tree upon the dove and upon Christ's head. This illumination seems to have attracted the bearded men dressed in imposing priestly robes on the banks of the river, one of whom points emphatically upwards. In front of them, by a bend in the river, a young man prepares for baptism. Christ stands with both feet in the river, and John with one foot in it, but at a point where the reflections in the surface of the water cease. It may be that it was originally more obvious that their toes at least were covered. To the left, as was conventional in representations of this subject (see for instance Fig. 54), three angels attend with drapery to dry and cover Christ – the drapery reduced in this case to the pink cloth over the shoulder of the angel in a lavender robe. The principal figures seem poised in suspense. The raised hands of the figures in profile (the angel on the left and John the Baptist) contribute to this. The only movement in the foreground is that of the minute trickle of water; the river itself is as still as glass.

The painting is generally regarded as one of the earliest by Piero to have survived and has usually been dated to the late 1440s or to the 1450s. Piero's experience of Florentine painting is very obvious here – the drawing of eyes, lips, hands and feet is very similar to that of Domenico Veneziano (see, for example, Fig. 93), and the sculptural folds of the drapery (of the angel in profile especially) are reminiscent of Masaccio (for example the Virgin, No. 15). Special to Piero are the large geometrically simplified forms, lit so as to seem light in weight as well as clear in definition, and animated with details of exquisite delicacy – the curls of the angels' fringes and of John's belt of weeds; and the tiny pleats of drapery under a breast or wrinkled over the head of the undressing youth.

The painting seems originally to have served as an altarpiece for a chapel dedicated to Saint John in the abbey (Badia) of the Camaldolese Order (for which see p. 58) in Piero's native town of Borgo Sansepolcro, and to have been incorporated, probably in the 1460s, into a triptych. The side panels and predella were painted by Matteo di Giovanni (or his workshop) in a painfully discordant style and without reference even to the size of Piero's figures. There is evidence to suggest that Piero worked very slowly but it is not known whether he had originally undertaken to paint the rest of the altarpiece himself – plans may have changed. The distant city seen just beside Christ's loincloth and partly overlapped by the (now transparent) blue wing of the angel may be meant for Borgo Sansepolcro. The landscape certainly evokes the local scenery.

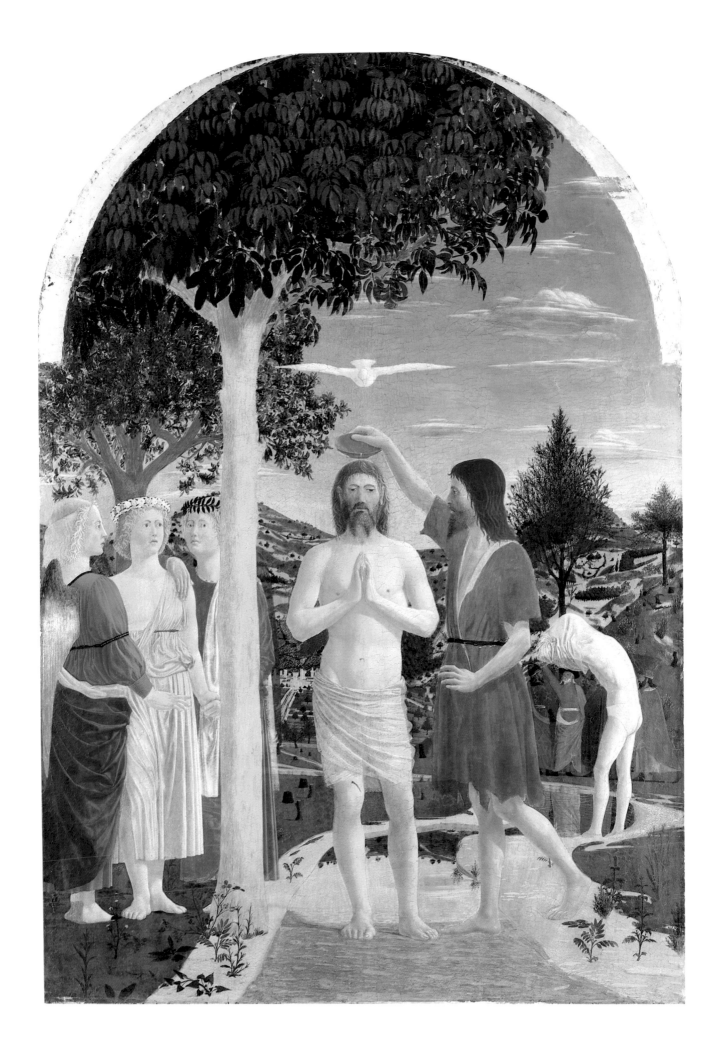

28 The Virgin and Child *c.* 1460

Oil, with some egg tempera (analysed), on oak, painted surface 37 x 27.5 cm (NG 2595)

Bouts was active at Louvain from 1457 and probably earlier; he died there in 1475. He painted the altarpiece of the Holy Sacrament for the church of St Peter there as well as scenes on the theme of Justice for the Town Hall. One of the leading Netherlandish painters of this period, he was heavily influenced by the style of Rogier van der Weyden.

Although many such half-length images of the Virgin and Child were produced in the Netherlands for the purposes of private devotion, relatively few survive which can be associated with Dieric Bouts, of which this is the most outstanding in quality.

Behind the Virgin is a brocade hanging of a type against which she is often depicted, particularly when enthroned, and an open window. A similar open window occurs in Bouts's portrait of a man of 1462 (see Fig. 122), but such windows were included in paintings of the Virgin and Child much earlier than this, as Campin's *Virgin with the Firescreen* demonstrates (No. 13). The Virgin and Child are, however, not merely shown as though in a room with a window. They themselves are shown appearing at a window-opening: the merry-looking infant Christ, his hand raised as though in greeting or blessing, is perched on a window ledge, supported by his mother, who gazes down at him, offering him her breast. The Child's body casts a shadow on the stone slabs to the right, and the strongly foreshortened and shadowed left arm of the Child and left hand of the Virgin, which are particularly beautifully drawn and painted, add to the sense of recession. The spatial effects thus created are dramatic: the viewer looks through the window to the Virgin, who is standing in the room, and through the window behind her to the landscape outside with the spires of a city prominent in an intensely blue distance.

Many Netherlandish painters called attention to the potential ambiguities created by representing three-dimensional space on a flat surface by the depiction of frames within the picture, echoing or contrasting with the actual frame. These painters must have been all the more aware of such ambiguities since most, like Bouts, worked with their panels already framed (see p. 154), although in this case the original frame has not survived. The use of the window to create a sharply recessed frame for the Virgin and Child is particularly effective, especially in combination with the way the cushion juts over the window ledge and the cloth on which the Child sits trails over the edge. It is probable that the painting of the cloth extended over the original frame, to complete the illusion created.

Bouts's depiction of the Virgin and Child, like most of his work (see No. 32), was strongly influenced by Rogier van der Weyden, although it was not based on any known painting of his. Technical examinations have revealed that Bouts first drew his composition freehand on his panel, as was usual with Netherlandish paintings of this period: areas such as the Virgin's hands and the Child's legs show hatching to indicate where shading was to go in painting, especially important in this composition.

The painting was executed in the characteristic Netherlandish technique of layers of transparent coloured oil glazes over opaque underpainting. Scientific tests have indicated that in some areas, such as the dark green cushion, this underpainting is based on egg tempera. The Virgin's blue robe, like that of many Early Netherlandish paintings, consists of an underpainting of the cheaper azurite with a final thick layer of the expensive lapis lazuli (see p. 183 and Fig. 254).

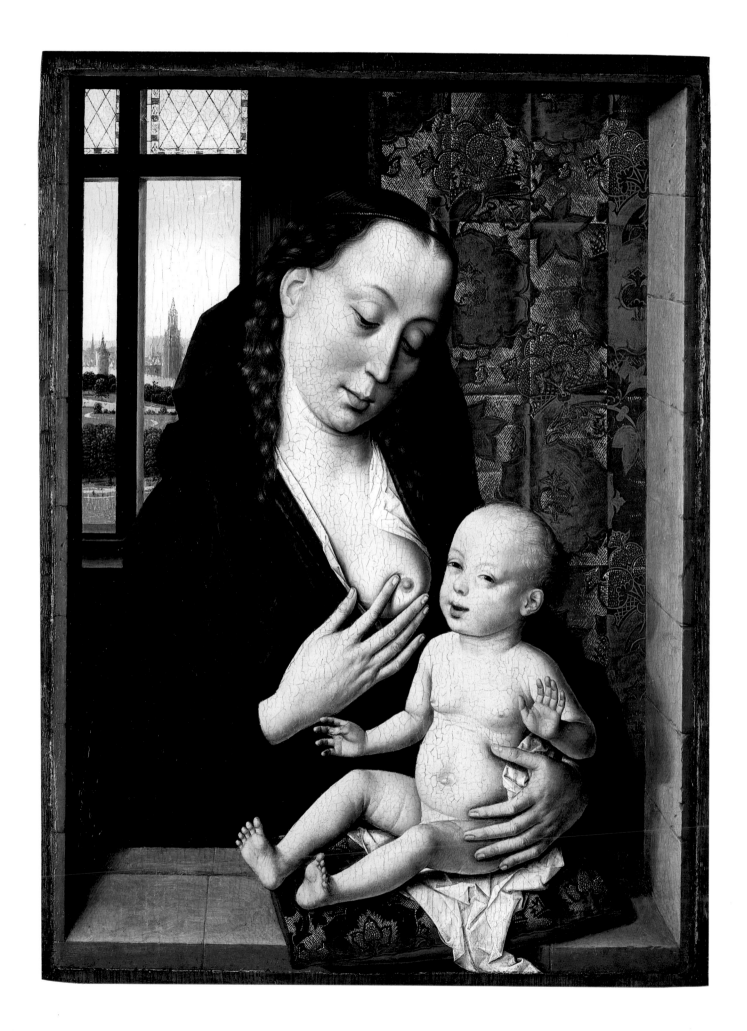

29 Portrait of a Lady *c.* 1460

Oil, perhaps with some egg tempera, on oak, painted surface 36.5 x 27cm (NG 1433)

For Rogier van der Weyden's biography see No. 22.

The sitter has not been identified, although the style of her dress and head-dress indicates that she is probably to be associated with a court, most likely that of Burgundy, for which Rogier van der Weyden seems to have worked. Her hair-line has been plucked, as was fashionable, to give her a very high forehead, and her hair is enclosed in a band of a basket-weave design, over which a semi-transparent veil has been attached with pins.

The sitter's hands are clasped, rather than joined in prayer, so there is no reason to suppose that the portrait was part of a diptych, but on the back of the picture is a painting of the head of Christ crowned with thorns (Fig. a). Such pictures were popular devotional images in the fifteenth century, and were produced by a number of painters' workshops: this is the only example known of a type which can be associated with the workshop of van der Weyden.

The portrait itself, though greatly superior in execution to the image on the reverse, is of slightly lesser quality than other portraits which are certainly by van der Weyden himself. The lower edge of the painting is damaged, but the original areas of paint on the bodice of the dress and on the hands are rather flatly painted. The depiction of the features, including the eyes, and of such details as the folds of the veil over the hair ornaments, lacks van der Weyden's crisp particularity and again suggest that the portrait may have been executed by a member of his workshop working closely with him. It is likely to date from about 1460.

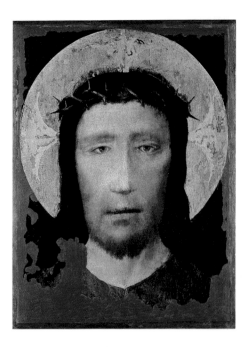

Fig. 29a. Workshop of Rogier van der Weyden, *Christ Crowned with Thorns.* Reverse of No. 29.

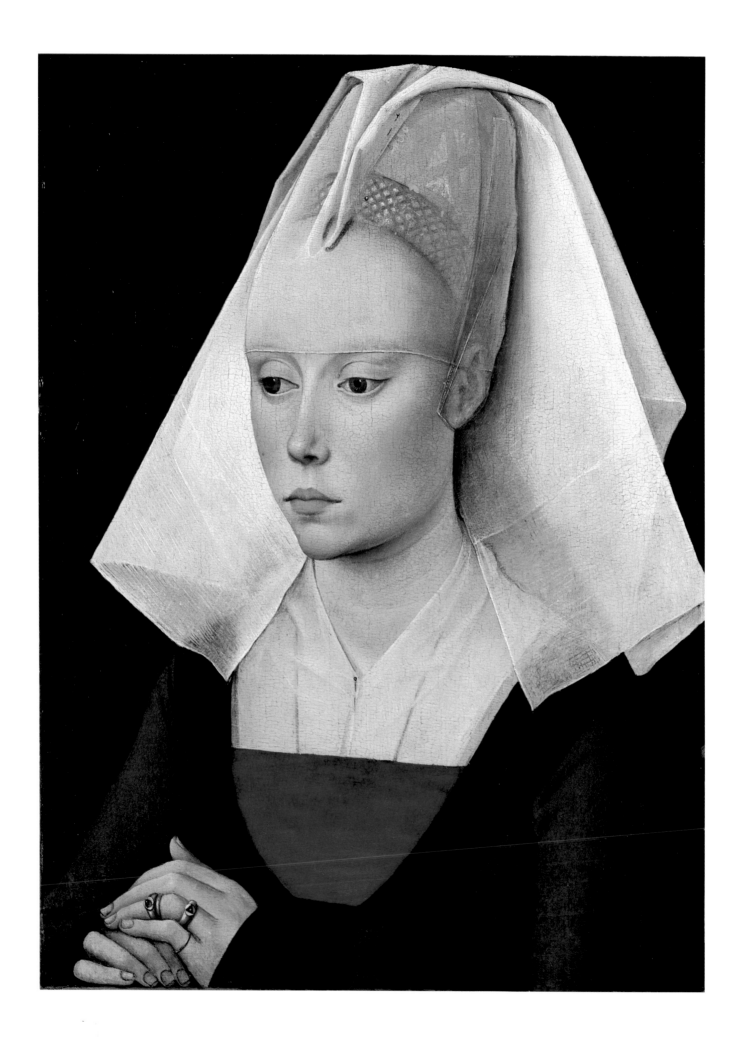

30 The Agony in the Garden *c.*1460

Egg tempera, perhaps with some oil, on wood, 63 x 80cm (NG 1417)

Mantegna was born in 1430 or 1431 near Padua, where he was adopted and educated by the artist and antiquarian Francesco Squarcione. He made a precocious reputation as a painter in Padua and in 1453 married the daughter of Jacopo Bellini – the sister of Giovanni and Gentile. In 1459 he left Padua for the Mantuan court in whose service he died in 1506. He was one of the most celebrated artists in Italy and, through his prints, one of the most influential in Europe.

Christ kneels in prayer and angels appear to him bearing the instruments of his imminent Passion. The three disciples whom Christ asked to sit and pray with him, lie asleep. On the track behind them Judas conducts the Roman soldiers who will arrest Christ. They come from Jerusalem, the walled city in the distance. The painting, which is too large to be from a predella of an altarpiece, must have been made as an independent narrative painting intended for private use (see Nos. 52 and 53), like the paintings of Saint Jerome in penitence, which it resembles in that it also requires a landscape setting.

Mantegna may also have worked as a miniaturist. Parts of this painting are rendered in very minute detail – for instance the tiny uptorn roots of the tree which has been felled to form a bridge, the marks of successive axe-blows in its bark, and, in the distance, the wall of Jerusalem in which may be discerned the different colours of stone and the dribbling of the new mortar where it was repaired after the Roman siege. Roman

Jerusalem includes spectacular monuments, including something very like the Colosseum and a column with a spiral relief crowned with an equestrian statue (Fig. 161). Mantegna was noted for his passionate study of Roman antiquity and this has also influenced the hard, sculptural character of his draperies. The equestrian statue has been picked out in 'shell gold', as has the light falling on Christ's shoulders. The painting is inscribed in Latin on the rocks OPVS/ANDREAE MANTEGNA (the work of Andrea Mantegna) and must date from about 1460. It has been suggested that it is the small work he made for the Venetian Giacomo Antonio Marcello in 1459, the subject of which is not, however, recorded.

In the *Introduction of the Cult of Cybele* (No. 64), painted by Mantegna at the very end of his life, the drapery has the same small sharp creases, the hair has a similar wiriness, and he again reveals his interest in mineralogy, manifest there in the patterns of marble rather than in the structure of rock.

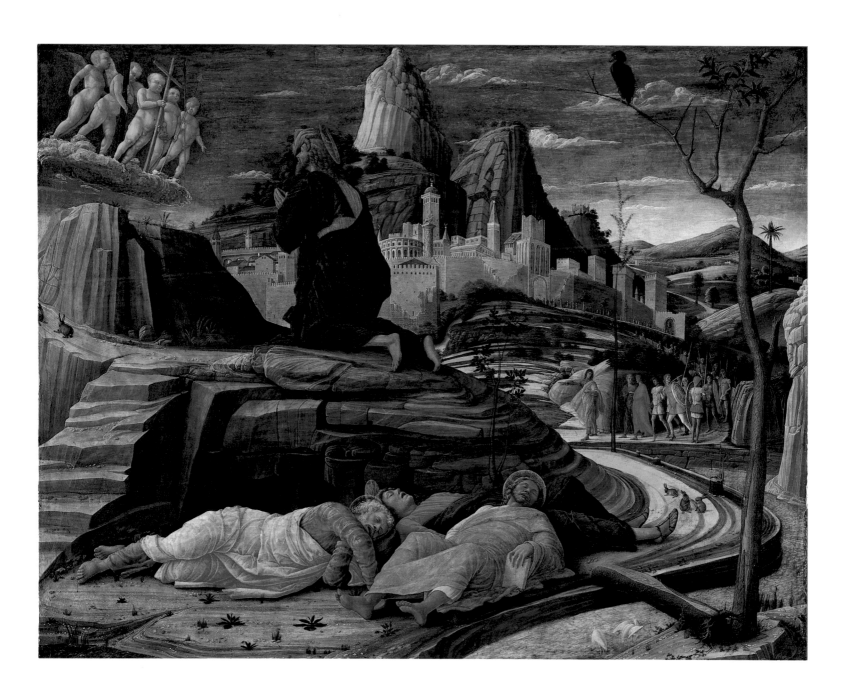

31 The Agony in the Garden *c.* 1465

Egg tempera (analysed) on wood, 32 x 50cm (NG 726)

Giovanni was the son of Jacopo and the brother of Gentile Bellini – both eminent painters in Venice – and the brother-in-law of Andrea Mantegna (see No. 30). He was probably born in about 1435. He was active as an independent artist in the 1460s, and by the 1470s enjoyed a high reputation. Twenty years later, he was one of the most famous artists in Italy. He died in 1516 in Venice, where he had, it seems, always lived.

Christ kneels in prayer while the disciples with him sleep. The composition may owe something to a drawing of this subject by Jacopo Bellini, but the debt to Mantegna is more obvious and it is tempting to suppose that this work was painted in homage to – perhaps partly in competition with – Mantegna's painting (No. 30). They have much in common: the tight twisting rhythm of the hills; the stunted trees; the bizarre rocks; the intricate folds and sharp edges in the drapery; the row of ringlets on Christ's neck; the foreshortening of one of the sleeping disciples; the colours (especially the red cloak with nearly white highlights); the light recorded on Christ's blue outer garments with fine hatched lines of gold (see Figs. 249 and 250); and the tiny pebbles peppering the barren ground and rendered with a spatter of paint such as can be achieved with a thumb and a stiff brush (a technique to which Mantegna remained attached – see Fig. 210).

Bellini seems always to have revered Mantegna as his master, which he may well have been. This painting probably dates from about 1465. It is, anyway, unlikely to have been painted after 1470. Thirty years or so later Bellini expressed anxiety that a painting of his if seen in Mantua might be outshone by those by Mantegna. Yet already in this painting Bellini shows himself to be a different kind of painter. Mantegna supplies no clear indication of the time of day, but in Bellini's picture dawn is breaking, the undersides of the clouds are orange and yellow and the shadows seem just to be departing from the hills. No Italian artist had painted cloud structures with greater precision or sunrise more effectively.

It is not only light and air but also water which Bellini paints with novel conviction. The network of fine lines which he casts over his river describes its choppy surface, whereas Mantegna's river seems to have dried up and the similar pattern of lines there might be mistaken for the veins of a mineral bed. Bellini's hills are less harsh than Mantegna's, his rocky outcrops less crystalline. They seem more distant, and yet there is a more fluent relationship between foreground and background. Mantegna's tree cuts aggressively across the forms behind it, whereas the pollarded branches of Bellini's are confused with the steep paths on the hill. The angels bearing the instruments of the Passion which appear to Christ in Mantegna's painting seem no less corporeal than the other figures in the painting, while the angel bearing a chalice in the Bellini seems to be fashioned out of the transparent glass for which Venice was by then already famous, no more substantial than the clouds and, like them, lit by the rising sun.

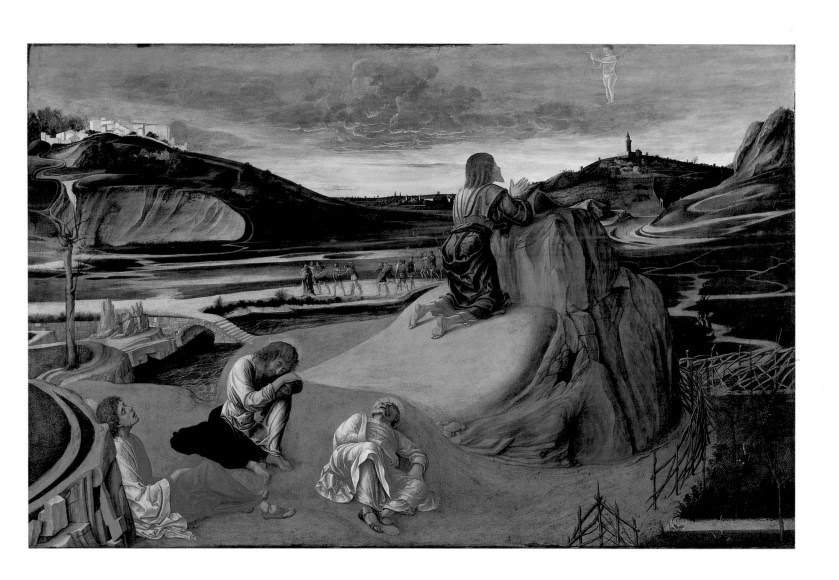

32 The Entombment *c.* 1450–60

Glue size (analysed) on linen, painted surface 90.2 x 74.3cm (NG 664)

For his biography see No. 28.

Fig. 32a. Dieric Bouts, *The Resurrection*. Linen, painted surface 90×74.3cm. Pasadena, Norton Simon Museum.

Fig. 32b. Dieric Bouts, *The Annunciation*. Linen, painted surface 90.2×74.3cm. Malibu, J. Paul Getty Museum.

The Virgin, with Saint John and two of the three Maries behind her, holds the hand of the dead Christ, while a bearded man, presumably Joseph of Arimathea, places his body in the tomb which he has provided, assisted by a man and woman, almost certainly Nicodemus and Mary Magdalene.

The *Entombment* is the only surviving example of a painting by Bouts of this subject, and was almost certainly part of a series of scenes from the Life of Christ. It is recorded in an Italian collection in the nineteenth century with an Annunciation, an Adoration and a Presentation. Three paintings of similar size have recently been associated with it – Figs. a and b and an unpublished *Adoration of the Kings* – and were perhaps part of a large shuttered altarpiece. Less plausibly a *Crucifixion* (Brussels) has been proposed as the centrepiece of this ensemble. The *Entombment* and its companions may have been painted for export to Italy; the linen support would have facilitated this. The painted border might have assisted those re-stretching the picture on arrival (see p. 162).

This picture is an example of the use of pigments mixed in a glue medium for painting on linen cloth (see pp. 187-8). Such cloth paintings are known to have been extremely common in Northern Europe in the fourteenth and fifteenth century, although few examples have survived. The paint layers were applied very thinly, without a ground, so that they sank into the fabric, leaving the surface matt as it would be in a watercolour on paper. Such paintings would never have had the saturated colour of works in oil, and lacking protective varnish they are vulnerable to damage. In places the pigment survives only in the interstices between the threads of the canvas, and not on the fibres themselves.

The *Entombment* is one of the most important examples of religious paintings by Bouts to survive. As elsewhere in his work the influence of Rogier van der Weyden is inescapably strong, both in the composition and in the powerful depiction of the emotions of the figures. These figures, and in particular the heads, are all extremely carefully arranged to create a sense of variety and also to heighten the communication of grief. Thus the three Maries are shown from the front, from the left and from the right. One apparently wipes tears from her eyes, one covers her mouth, while the third is helping to place Christ's body in the tomb. The eyes of all three Maries are downcast, whereas the other, male, figures in the painting look directly at Christ (see Fig. 259).

The landscape of distant green hills and trees in the upper right-hand corner contrasts with the barren and rocky areas of the foreground and middle ground. It would probably originally have been more bluish in colouring, by analogy with the discoloration of blue pigment which has occurred in the sky: parts of the sky which have been protected at some time by the frame are more blue than those exposed to view, which have accumulated surface grime. The continuity from middle distance to horizon is achieved without any of the devices found in the more schematic landscapes of Memlinc or other artists. The eye is drawn effortlessly by means of subtle transitions into an immense distance enveloped and softened by an atmosphere which seems particularly appropriate to the medium – closer to the effects found in watercolour rather than in oil painting.

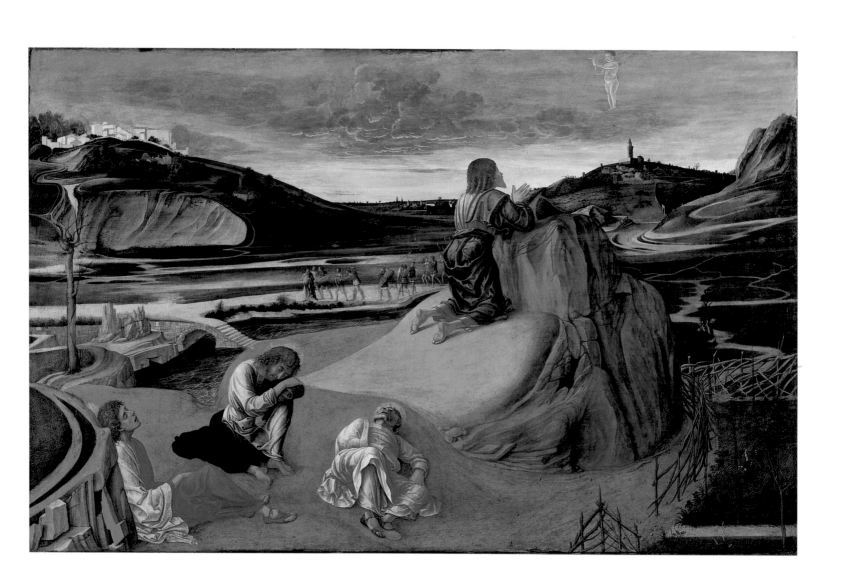

32 The Entombment *c.* 1450-60

Glue size (analysed) on linen, painted surface 90.2 x 74.3cm (NG 664)

For his biography see No. 28.

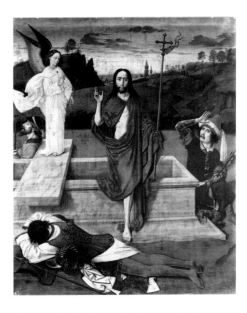

Fig. 32a. Dieric Bouts, *The Resurrection*. Linen, painted surface 90×74.3cm. Pasadena, Norton Simon Museum.

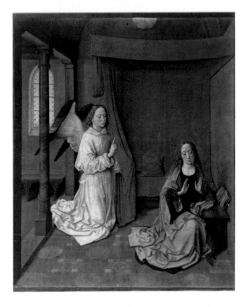

Fig. 32b. Dieric Bouts, *The Annunciation*. Linen, painted surface 90.2×74.3cm. Malibu, J. Paul Getty Museum.

The Virgin, with Saint John and two of the three Maries behind her, holds the hand of the dead Christ, while a bearded man, presumably Joseph of Arimathea, places his body in the tomb which he has provided, assisted by a man and woman, almost certainly Nicodemus and Mary Magdalene.

The *Entombment* is the only surviving example of a painting by Bouts of this subject, and was almost certainly part of a series of scenes from the Life of Christ. It is recorded in an Italian collection in the nineteenth century with an Annunciation, an Adoration and a Presentation. Three paintings of similar size have recently been associated with it – Figs. a and b and an unpublished *Adoration of the Kings* – and were perhaps part of a large shuttered altarpiece. Less plausibly a *Crucifixion* (Brussels) has been proposed as the centrepiece of this ensemble. The *Entombment* and its companions may have been painted for export to Italy; the linen support would have facilitated this. The painted border might have assisted those re-stretching the picture on arrival (see p. 162).

This picture is an example of the use of pigments mixed in a glue medium for painting on linen cloth (see pp. 187-8). Such cloth paintings are known to have been extremely common in Northern Europe in the fourteenth and fifteenth century, although few examples have survived. The paint layers were applied very thinly, without a ground, so that they sank into the fabric, leaving the surface matt as it would be in a watercolour on paper. Such paintings would never have had the saturated colour of works in oil, and lacking protective varnish they are vulnerable to damage. In places the pigment survives only in the interstices

between the threads of the canvas, and not on the fibres themselves.

The *Entombment* is one of the most important examples of religious paintings by Bouts to survive. As elsewhere in his work the influence of Rogier van der Weyden is inescapably strong, both in the composition and in the powerful depiction of the emotions of the figures. These figures, and in particular the heads, are all extremely carefully arranged to create a sense of variety and also to heighten the communication of grief. Thus the three Maries are shown from the front, from the left and from the right. One apparently wipes tears from her eyes, one covers her mouth, while the third is helping to place Christ's body in the tomb. The eyes of all three Maries are downcast, whereas the other, male, figures in the painting look directly at Christ (see Fig. 259).

The landscape of distant green hills and trees in the upper right-hand corner contrasts with the barren and rocky areas of the foreground and middle ground. It would probably originally have been more bluish in colouring, by analogy with the discoloration of blue pigment which has occurred in the sky: parts of the sky which have been protected at some time by the frame are more blue than those exposed to view, which have accumulated surface grime. The continuity from middle distance to horizon is achieved without any of the devices found in the more schematic landscapes of Memlinc or other artists. The eye is drawn effortlessly by means of subtle transitions into an immense distance enveloped and softened by an atmosphere which seems particularly appropriate to the medium – closer to the effects found in watercolour rather than in oil painting.

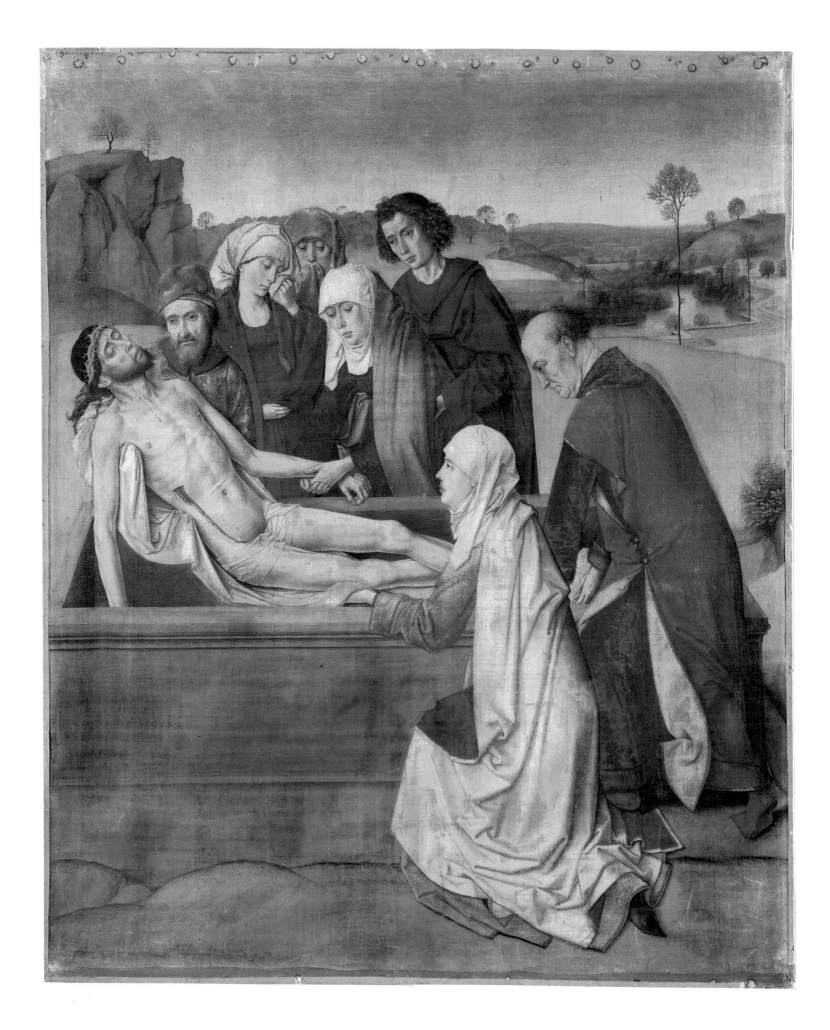

33 Saint Michael completed 1469.

Oil (analysed) on poplar, 133 x 59cm (NG 769)

For his biography see No. 27.

Fig. 33a. Piero della Francesca, *Saint Augustine*. Wood, 132×56cm. Lisbon, Museu Nacional de Arte Antiga; No. 33; *Saint Peter*. Wood, 131×57cm. New York, Frick Collection; *Saint Nicholas*. Wood, 136×59cm. Milan, Museo Poldi Pezzoli.

The saint is the Archangel Michael, captain of the heavenly hosts, who conquered Lucifer (Satan), here represented in the form of a serpent. Although the figure is static, or at least poised, with alert eyes and parted lips, the creature below his feet still writhes (as snakes do long after they have been beheaded), and blood drips from the severed neck and open mouth of its head, which Michael holds up by one of its ears. The Archangel has wings accurately modelled on those of a swan (unlike the more fanciful ones Piero had earlier favoured – see No. 27). There is a garland, a pagan crown, beneath his halo, and his armour is based on that of Roman warriors, suggesting no less than the crisp palmette frieze and the Corinthian pilasters of the wall behind, Piero's careful study of antique sculpture. Roman armour, however, was not studded with pearls, sapphires and rubies as this armour is. The same stones also ornament his necklace and bracelets, which serve as collar and cuffs for an undergarment of the finest stocking silk, such as no earthly warrior has ever worn.

Piero's painting formed part of a polyptych on the high altar of Sant' Agostino in Borgo Sansepolcro which the artist contracted to paint on 4 October 1454 for the Augustinian Friars and for Angelo di Giovanni di Simone (who was acting also on behalf of his deceased brother Simone). Eight years were allowed for the execution, but it was not completed until 1469, and it was only in 1473 that Piero received final payment.

Three other paintings, of similar size, survive from the same altarpiece (Fig. a) – a *Saint Augustine* and a *Saint Nicholas of Tolentino*, a recently canonised Augustinian friar, both obvious saints for an Augustinian church, and a *Saint Peter*. The Archangel (Angelo) and Peter (Simon Peter) were name saints of the donors. Piero is unlikely to have chosen to divide his saints into the separate divisions of a polyptych but he had no option – the contract specified that it had already been carpentered. However, he made the low marble wall continuous in all four panels. There must have been a central panel of the Virgin and Child enthroned and he permitted her throne to impinge on the side panels – its steps may be discerned beside the left foot of Michael with brocade falling over it, perhaps from the Virgin's robes. Small paintings set in the sides and predella of the frame also survive, but these were evidently painted by assistants.

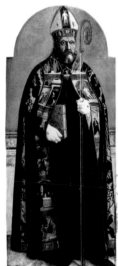

34 Portrait of a Woman of the Hofer Family *c.* 1470

Oil, perhaps with some egg tempera, on silver fir, painted surface 53.7 x 40.8cm (NG 722)

An unidentified artist working in Swabia, the area of southern Germany of which the main town is Ulm.

The sitter holds in her hand a sprig of for-get-me-not, presumably as a symbol of remembrance. On her large white head-dress, adorned with rows of stitching, is a fly. The viewer is surely intended to puzzle over whether the fly is part of the painting or whether it could be a real fly which has landed on the surface of the picture. By drawing attention to the painted surface in this way, the artist reminds the viewer of the skill which has been necessary to create this apparently three-dimensional image on a flat panel. In later German portrait painting such witty reminders of the imitative concerns of painting were often made in inscriptions. An alternative explanation for the fly's presence – that the short-lived fly serves as a symbol of mortality – is less convincing in a portrait of this period.

The portrait is inscribed GEBORNE HOFERIN (Born a Hoferin), but the sitter has not been identified further, and Hofer was a common name in southern Germany. The portrait can be dated from the costume to about 1470. It has been asso-ciated with a painter known as the Master of the Sterzing Wings, who was active in about 1460, and whose paintings include slightly attenuated figures with similar headdresses. The attribution has not been generally accepted, and the painter responsible for this portrait is possibly a slightly more sophisticated artist.

This portrait, like many others of this period (compare No. 14), maintains a subtle balance between depicting a convincing likeness and creating a satisfying and beautiful picture. Thus the Swabian painter has distorted the left eye of the sitter in order to provide a sense of depth, and by the use of shading in the headdress has created a sense of its rounded padding and ruched tucking, and given us the feel of the rich, self-patterned textiles of dress and background. But the painter has also carefully balanced the light areas of head, headdress and hands against the two dark patterned blues of the dress and background, to produce an arresting concentric design; against this the *trompe l'oeil* of the fly is even more startling.

GEBORNE HOFERIN.

35 Saint Vincent Ferrer *c.* 1473

Egg tempera (analysed) on poplar, 153.5 x 60cm (NG 597)

Cossa was born in 1436, the son of a stonecarver. He is first recorded in 1456 collaborating with his father, painting a carved altarpiece in Ferrara. In 1462 he is recorded in Bologna, but he seems to have been active chiefly in Ferrara where he worked, probably with Tura (see No. 44), on the frescoes in the Palazzo di Schifanoia. By 1472 he was working in Bologna and he died there in 1478. Soon after his death his identity as an artist was forgotten or confused and he was 'rediscovered' only in the middle of the last century.

The painting formed the central part of an elaborate altarpiece commissioned (it seems) by Floriano Griffoni for his family chapel in San Petronio, the principal Dominican church in Bologna. The chapel was dedicated to Saint Vincent Ferrer, the great Dominican preacher who died in 1419 and was canonised in 1455. He is represented wearing the Dominican habit, holding the Gospels open in one hand and elevated, as had become conventional. Here he is raised on a polygonal platform but other artists

set him on a bed of clouds (as in Bellini's painting in SS Giovanni e Paolo in Venice), perhaps because his followers had likened him to the Angel of the Apocalypse. Christ appears above his head in a mandorla, accompanied by angels holding the instruments of the Passion. Behind the saint, and almost entirely concealed by him, is a pillar supporting an entablature from which broken arches spring – the front one of which frames his head and halo. So close is the identification of saint and pillar that the latter may be meant as a metaphor for the strength and importance of the former. Architecture, and indeed stone generally, also play an important part in the background of the painting, reminding us that Cossa came from a family of stonemasons.

Beads are often used as decorative adjuncts on throne canopies in fifteenth-century altarpieces (see, for instance, No. 65), but the beads of coral and rock crystal suspended from the rods which extend from the springing of the arch here are so large, and stand out so splendidly against the blue sky, that they must have a special significance. They may be rosary beads, used to regulate the repetition of prayers, chiefly to the Virgin. Such beads were closely associated with the Dominicans, who maintained that the Virgin had appeared to Saint Dominic and presented him with a chaplet of them. However, in the form of rosary which had become orthodox by the end of the fifteenth century, the large beads were separated from each other by nine smaller ones, as in those seen in Nos. 22 and 51.

Paintings of Saint Peter and of Saint John the Baptist – the figures identical in size to Saint Vincent – are in the Brera, Milan (Fig. b). The pillars behind them are of the same design and linked by a

Fig. 35a. Drawing by Orlandi of 1725 showing the altarpiece of Saint Vincent Ferrer in its original frame by Agostino de' Marchi (Archivio Aldrovandi-Marescotti, busta n.230, Archivio di Stato, Bologna).

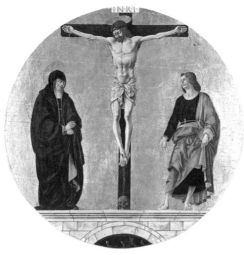

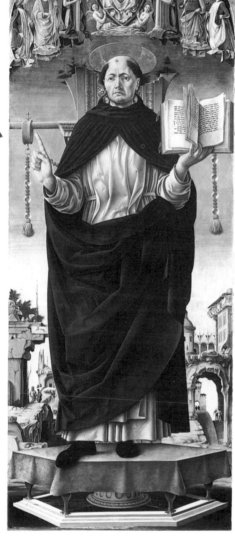
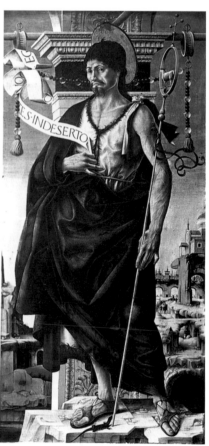

similar rod suspended with beads, so they must have come from the same altarpiece. A long narrow painting illustrating miracles of Saint Vincent now in the Vatican Museums served as the predella. It is full of fantastic rocks (often so angular in character as to be nearly architectural) and of fantasy architecture (sometimes incorporated into the rock) like the backgrounds of the three paintings above it (Figs. c and d). A pair of saints, one representing Florian (name saint of the donor) and the other Lucy (with martyr's palm and the eyes she removed to present to her infatuated pagan admirer), together with a *tondo* of the Crucifixion, were set on an upper register (Figs. a and b). Six small saints in niches were incorporated into each outer pilaster: small *tondi* of the Angel Gabriel and the Virgin Annunciate were set into the florid gables of the frame (Fig. a). Some of the painting, including the subordinate parts, was probably the work of Ercole de' Roberti. Payment for the frame was demanded on 19 July 1473 and the painting is likely to have been commenced about then.

Cossa's style of painting, like that of Cosimo Tura (see No. 44), seems to have been influenced by Mantegna's. The curious rocks of his background show this most clearly, but his forms are more rounded, his drapery less sharp and broken, and the type of statuesque monumentality embodied in this figure has more affinities with the work of Piero della Francesca (Nos. 27 and 36), some of which he must have seen in Ferrara.

LEFT Fig. 35b. Francesco del Cossa, Reconstruction showing *Saint Vincent Ferrer* (No. 35), with *Saint Peter* and *Saint John*, both wood, both 112×55cm. Milan, Brera; *Saint Florian* and *Saint Lucy*, both poplar, 79×55cm and 79×56cm respectively. Washington, National Gallery of Art; *Crucifixion*, poplar, diameter 63cm. Washington, National Gallery of Art. The three smaller paintings from the upper register, now in Washington, all have gilded backgrounds.

Fig. 35c. Ercole de' Roberti, perhaps after drawings by Cossa, Predella for the altarpiece of Saint Vincent Ferrer. Detail from the extreme left-hand side showing the healing of a sick woman. Wood, 27.5cm (height).

Fig. 35d. Detail of No. 35.

36 The Nativity *c.* 1470-5

Oil (analysed) on poplar, 124.5 x 123cm (NG 908)

For his biography see No. 27.

The *Nativity* was presumably intended as an altarpiece. The Virgin kneels in adoration before her new-born child, whom she has placed upon her outspread mantle. Five angels (without wings) attend – three of them playing stringed instruments, two of them singing. Joseph sits upon a saddle with two shepherds beside him, one of whom points upwards, perhaps indicating the star which guides the Magi – the star is not evident but the painting may possibly have been cut at the top.

The painting, which was long in the possession of the artist's descendants, is probably unfinished as well as damaged. The angels and the Virgin and Child are in reasonable condition, but much of the fine painting with which Piero would have picked out the curls on the angels' heads, the veil falling over the Virgin's head, the intricate carving of the sound holes of the lutes – and of course the strings of the lutes – has been lost or may never have been completed. In the animals the paint has become thinner and more transparent with time, so that the stable wall may be seen through the left leg and head of the ass, apparently braying, but perhaps tugging hay from the manger – hay which is lost or was never painted. It is clear that the shepherd pointing upwards (see Fig. 276) was not painted over the wall, although a part of his right sleeve was. Piero originally planned for his right arm and shoulder to be naked. The cream-coloured ground cannot have been intended to appear as it does – bare in some parts but with sparse vegetation and a few songbirds in others,

and some of this vegetation has been rubbed off.

In its present condition, the painting is highly revealing of the artist's working methods. The adjustment to the clothing of the shepherd is only one of many changes. For an artist whose finest compositions possess such clarity and finality it is surprising how much was improvised. The substantial folds of Joseph's rose cloak have no correspondence with those in the underdrawing which now shows through. The painting is full of strange collisions of form, some of which could have been avoided with more careful planning: the ox horn beside the lute peg box, the shepherd's foot beside the saddle. It is also surprising that an expert on perspective, creator of some of the most subtle pictorial architecture of the fifteenth century, should have made such little use of the diagonal alignment of the stable. The line of shadow on the wall does, however, help to draw attention to the brightly lit, pale face of the Virgin set off by the flank of the ox.

The *Nativity* is generally regarded as a late work and dated to the 1470s. There is much in it that is highly reminiscent of the *Baptism* (No. 27) – the colour scheme of light brown, rose, lavender, blue and white, the monumental grouping and drapery of the angels, the surprisingly free painting of the landscape, for example – but Piero is now painting in oils and he seems to have studied the work of Netherlandish artists using this medium. Both the face of the Virgin and the vulnerable body of the infant Christ are reminiscent of their work.

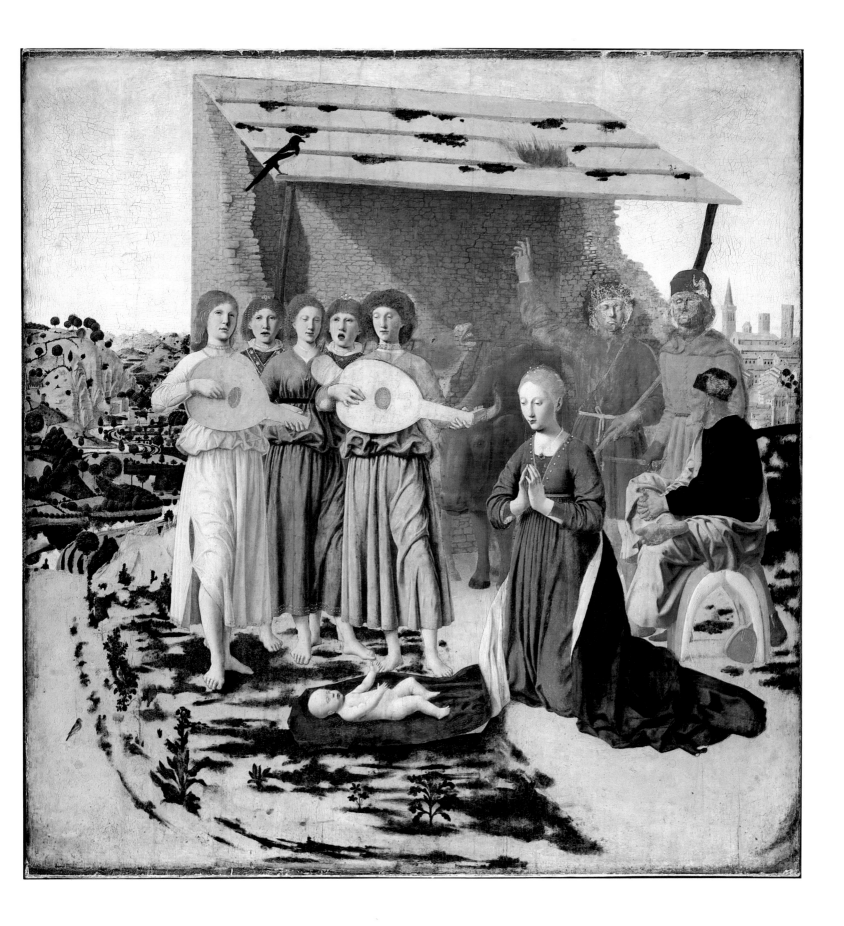

37 The Presentation in the Temple *c.* 1460-75

Oil, perhaps with some egg tempera, on oak, painted surface 84 x 108.5cm (NG 706)

The artist is named after a series of eight panels of which the National Gallery's painting is one, and was one of the leading painters at Cologne in the second half of the fifteenth century.

This picture originally formed part of an altarpiece painted with eight scenes from the Life of the Virgin, which was apparently in the church of St Ursula in Cologne in around 1500. One of the scenes, the *Visitation*, includes a donor figure with a coat of arms from which he has been identified as Dr Johann von Hirtz, who held various offices at Cologne from 1439 to 1467. A member of his family is said to have restored a chapel and its altar in St Ursula's, for which this altarpiece was presumably commissioned. Von Hirtz was a member of the Cologne Confraternity of the Holy Ghost, and is depicted wearing a collar identified as one worn by members. The panel probably dates from the 1460s, or a little later.

The altarpiece can be reconstructed as a triptych, with the central part made up of four scenes, and each shutter including two scenes, all arranged in two tiers (Fig. a). The shutters were also painted on the outsides with the *Crucifixion* and the *Coronation of the Virgin*, visible when the altarpiece was closed. The National Gallery panel would have occupied the lower right-hand corner of the central part of the triptych, and is one of those which has lost the original tracery which decorated the corners at the tops of the paintings. The remaining seven panels are all at Munich.

Although the altarpiece was divided into three vertical sections, the scenes ran in two sequences which read across the altarpiece from left to right. Thus the sequence began with the meeting at the Golden Gate, when the Virgin was conceived (see No. 58), and ended with the Assumption of the Virgin. On the exterior of the shutters (each now sawn in two) were painted the two emotional extremes of the sequence: the Virgin's

greatest sorrow at her son's Crucifixion, and her greatest joy at being crowned by him in Heaven.

The altarpiece was also arranged so that scenes which were above and below paralleled each other in nearly every case, both thematically and compositionally: thus above the *Presentation in the Temple* was the *Presentation of the Virgin*, in which the interior of the temple with its similar but not identical altarpiece is seen at a distance (see Fig. a).

In the *Presentation in the Temple* the Virgin is shown presenting Christ to Simeon. She has also come to the temple for purification after giving birth, as prescribed by Jewish law, and has brought traditional offerings of money, which Joseph is evidently drawing out of his purse, and doves. The painting combines both Jewish and Christian elements. The altar-cloth contains an inscription in Hebrew, while Simeon is dressed in the embroidered cope of a Christian priest and stands in front of a carved stone altarpiece in fifteenth-century style, showing Old Testament scenes. The naked boys cast in bronze acting as altar supporters are probably meant to suggest pre-Christian imagery.

The carvings on the altarpiece and the embroidery on Simeon's cope are not merely decorative, but serve both to emphasise the relationship between the old religion and Christianity, and to stress the role of Virgin. The altarpiece shows scenes of Cain murdering Abel, Abraham sacrificing Isaac and the drunkenness of Noah, all Old Testament stories which the Church cited as parallels to Christ's Passion. Simeon's cope is placed directly over the altar, and is embroidered with the Emperor Augustus's vision of the Virgin and Child, revealed by a sibyl (prophetess), when a heavenly

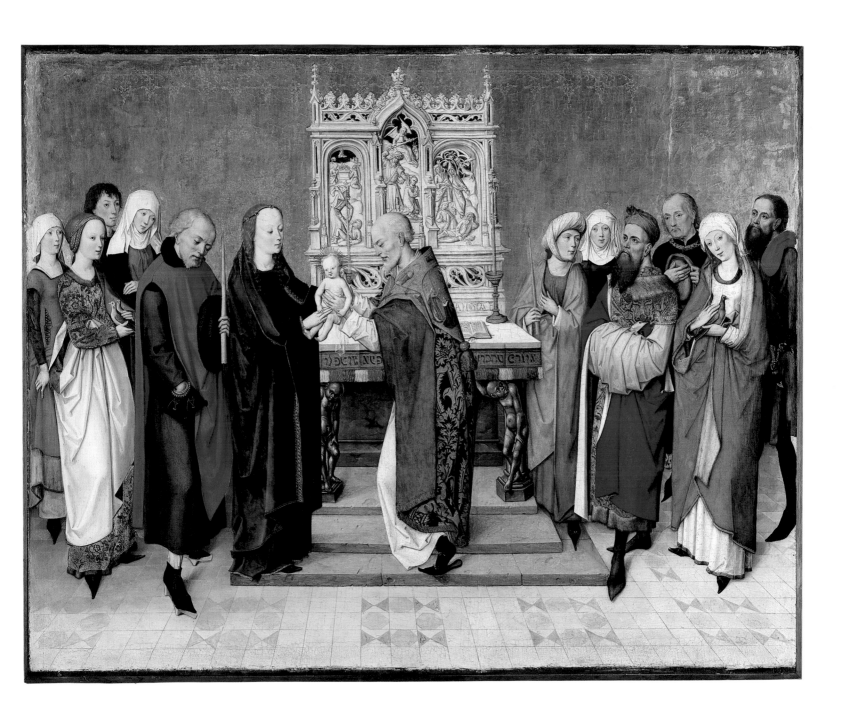

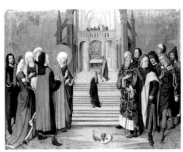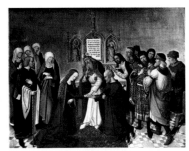
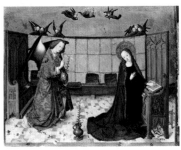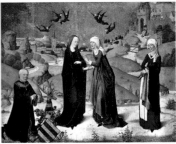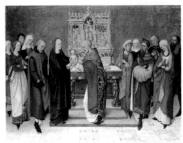

voice said, 'Behold the heavenly altar'. This vision informed the pagan Emperor of the existence of Christ, a greater ruler than he, and the scene is appropriately placed on the cope of Simeon, who, seeing the infant Christ and recognising the Saviour, said, 'Lord, now lettest thou thy servant depart in peace,' and soon after died. The female figure on the right wearing a turban of the type usually assigned to sibyls is probably the prophetess Anna, also mentioned in Saint Luke's Gospel, who had, like Simeon, waited to see the Redeemer. The man next to her would then be her husband. It is possible that the two figures in black, one young, one old, who stand at the back to the left and right of the central scene are intended

as portraits of other members of the von Hirtz family.

The Master of the Life of the Virgin was clearly very familiar with Netherlandish painting, especially the work of Rogier van der Weyden, whose Columba Altarpiece (now in Munich) was in a Cologne church. In addition the scene on Simeon's cope strongly resembles a scene in Rogier's Bladelin Altarpiece (now in Berlin), which the artist may have known, perhaps through a drawing. Such Netherlandish influence is characteristic of Cologne painting in this period: traffic on the Rhine would have made it easy for Cologne artists to know of the innovations of the artists of the Netherlands.

Fig. 37a. Reconstruction (after H.M. Schmidt) of the Altarpiece of the Life of the Virgin by the Master of the Life of the Virgin, with shutters open. Top row from left to right: *The Meeting at the Golden Gate, The Birth of the Virgin, The Presentation of the Virgin*, and *The Marriage of the Virgin*; bottom row from left to right: *The Annunciation, The Visitation, The Presentation in the Temple*, and *The Assumption of the Virgin*. Oak on panel. All (except *The Presentation in the Temple*) Munich, Alte Pinakothek.

OPPOSITE Fig. 37b. Detail of No. 37.

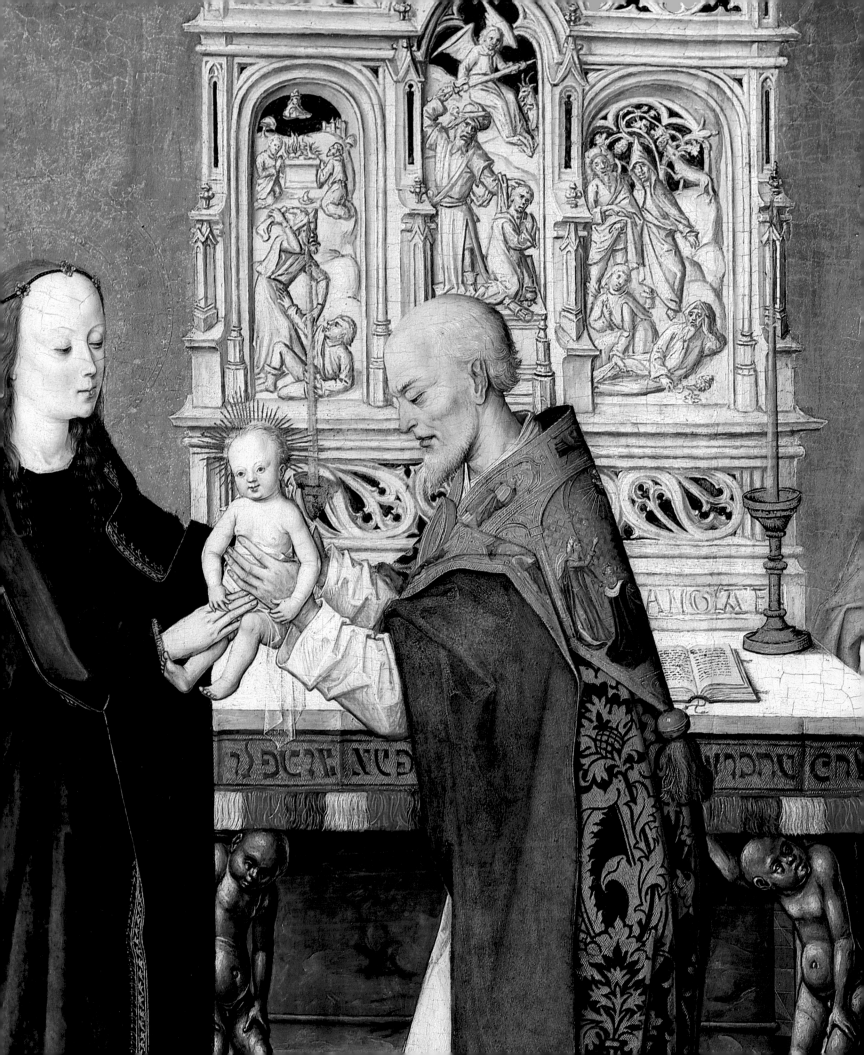

38 Tondo: The Adoration of the Kings *c.* 1470-5

Egg tempera on poplar, diameter of painted surface 131.5cm (NG 1033)

Alessandro Botticelli, son of Mariano Filipepi, was probably trained by Filippo Lippi (see No. 23). His earliest dated work is 1470. He was in Rome painting in the Sistine Chapel in 1481-2, but otherwise his activity was chiefly confined to Florence, where he had a large workshop and where he died in 1510.

Fig. 38a Fra Angelico and Fra Filippo Lippi, *The Adoration of the Kings*, mid-fifteenth century. Wood, diameter 137.2cm. Washington, National Gallery of Art, Kress Collection.

One of the Three Kings kneels and kisses Christ's foot, another kneels beside him, a third doffs his crown preparatory to kneeling. Their retinues mingle busily, quarrelling and conversing in the foreground. The shepherds clamber up on to the ruined classical temple to watch. This temple represents the old pagan order which Christianity will replace, but it bears more resemblance to new buildings being put up in Florence than to any old ones that had come down in Rome.

Paintings of a circular or octagonal shape had been popular since the early fifteenth century in the Florentine *camera* (see pp. 108-15) and the subject of the Adoration of the Kings (Magi) was popular with wealthy Florentines, many of whom belonged to the Confraternity of the Magi (see pp. 64-8) whose splendid processions are likely to be reflected in paintings such as this. It seems possible that some of the foreground figures are portraits, perhaps of members of the Pucci family for whom, Vasari informs us, Botticelli painted an important picture with this subject. Botticelli would have been aware of earlier *tondi* of the Adoration. Two are recorded in the Medici Palace in 1492 – one as by Fra Angelico, the other as by Pesellino. The latter may be the painting by Domenico Veneziano in the Staatliche Museen, Berlin, probably painted in the 1440s; the former is likely to be the painting partly by Fra Angelico but largely executed by Filippo Lippi in the National Gallery of Art, Washington, probably completed in the 1450s (Fig. a). Like Botticelli's *Adoration*, these *tondi* are busy and complicated

compositions filled with diverting incidents and luxury trappings – and they too feature a peacock (which was a symbol of eternal life on account of the fabled incorruptibility of its flesh). The chief difference springs from Botticelli's use of space and architecture.

Botticelli realised that he could give a special importance to the Virgin and Child by placing them in the centre, but if he did this then he could not have the procession of the kings advancing towards them from one side – as in the round paintings just mentioned, and in his own earlier rectangular one (Fig. 75). By an emphatic use of linear perspective, however, he could place the Virgin in the middle distance, diminishing her in size but not in importance, and have the kings advance towards her from the foreground – an entirely new idea which puts the beholder in the position of the retinue. The Virgin and Child become a focus like an altar in a church, but for this to work the architecture has to play a leading part so that its emphatic receding lines will direct the wandering eye. This must have required very careful calculations, as did the exact form of the arches where the rectilinear framework of the architecture echoes, rather than constrasts with, the shape of the painting. Many incised lines in the gesso at this point reflect the planning that Botticelli undertook.

Nowhere else in the Collection is the discipline of linear perspective more evident than in this festive and exuberant painting, probably an early work of the artist dating from the early 1470s.

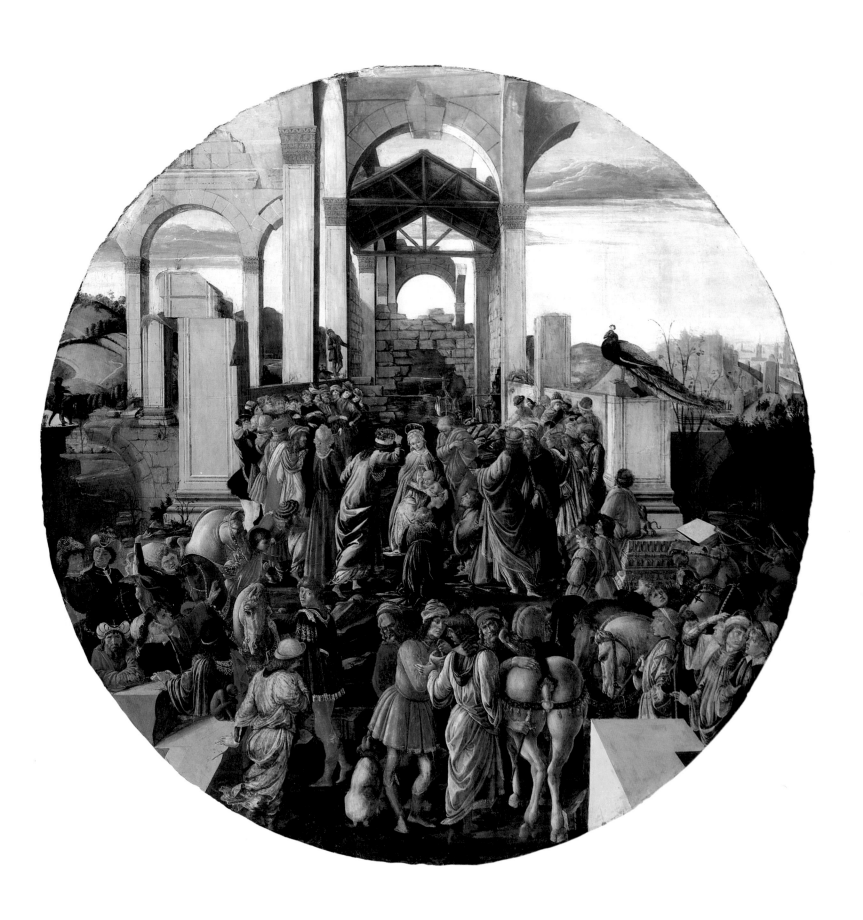

39 Tobias and the Angel *c.* 1470-5

Egg tempera on poplar, 33 x 26cm (NG 781)

Verrocchio (Andrea di Michele di Francesco Cioni) was probably born in 1433 or 1434. He was trained as a goldsmith and was a pupil (in some sense) of Donatello, whose successor he was as the most highly esteemed sculptor in Italy. He worked chiefly in Florence and was much patronised by the Medici. His workshop, in which Leonardo da Vinci among others was trained, certainly produced paintings, but what he painted himself is uncertain. He died in 1488.

The story comes from the *Book of Tobit* in the Apocrypha. Tobias was sent by his old blind father to collect a debt from a distant city. He was escorted on his journey by the Archangel Raphael who bade the boy extract from a fish (which had tried to devour him in the River Tigris) the heart, liver and gall, with which his father's eyesight could be restored. In this painting a thin line of crimson in the belly of the fish indicates that the operation has been undertaken and the bits may be presumed to be in the small metal box held by Raphael. The word *Ricord* [. . .] – for the debt – may be read on the scroll Tobias carries. The small size of the fish shows that the artist was not directly inspired by reading the story.

Paintings of this subject were very common in Florence between about 1450 and 1480 when a Confraternity of Raphael enjoyed great popularity there. Over a dozen are known, all very similar in composition (but sometimes extended to include two other archangels, Gabriel and Michael). In all of them both boy and angel wear fashionable clothes – which in this case suggest a date in the early 1470s, as does the style of hairdressing. One painting is adorned with a prayer in Latin urging the angel to 'stay by my side as you stayed by Tobias on his travels', which suggests that they were sometimes hung on a pier or wall in churches, near where a prayer was made for protection on a long or difficult journey. Raphael was also venerated as a healer.

In a few areas of the painting some of the thinner layers of paint have become worn and transparent with age. Thus only the thicker white lines with which the rippling hair of the dog to the left and the crisp edges of the stratified rocks to the right have been defined remain, making these elements seem less substantial than intended. But the artist's touch is delightfully evident here, as it is in the better preserved painting of fabric, stiff with glistening threads of precious metal. The borders of Raphael's cloak and Tobias's tunic and the brocade sleeves (Tobias's are unlaced presumably for fishing) are made of such fabric, and so are the patterned sashes which flutter in the wind – Raphael's is particularly long and makes its final curl between Tobias's legs.

Tobias's sweet and alert expression, as well as the shape of his face, his rolling curls and the border of decorative arabic lettering recall work certainly by Verrocchio. But some of these characteristics were common to other Florentine artists in the 1470s. In the *Assumption of the Virgin* (Figs. 50 and 99) attributed to Botticini the angels have an almost jaunty lightness and angularity of movement, bunched drapery below a high belt, a style and colour of wings, and carefully exhibited and beautifully drawn hands, very like those here.

The left hand of Raphael is identical to that of Tobias; their right hands are also very similar and may have been made from drawings, which were the property of more than one artist in the workshop and rapidly copied by artists outside it.

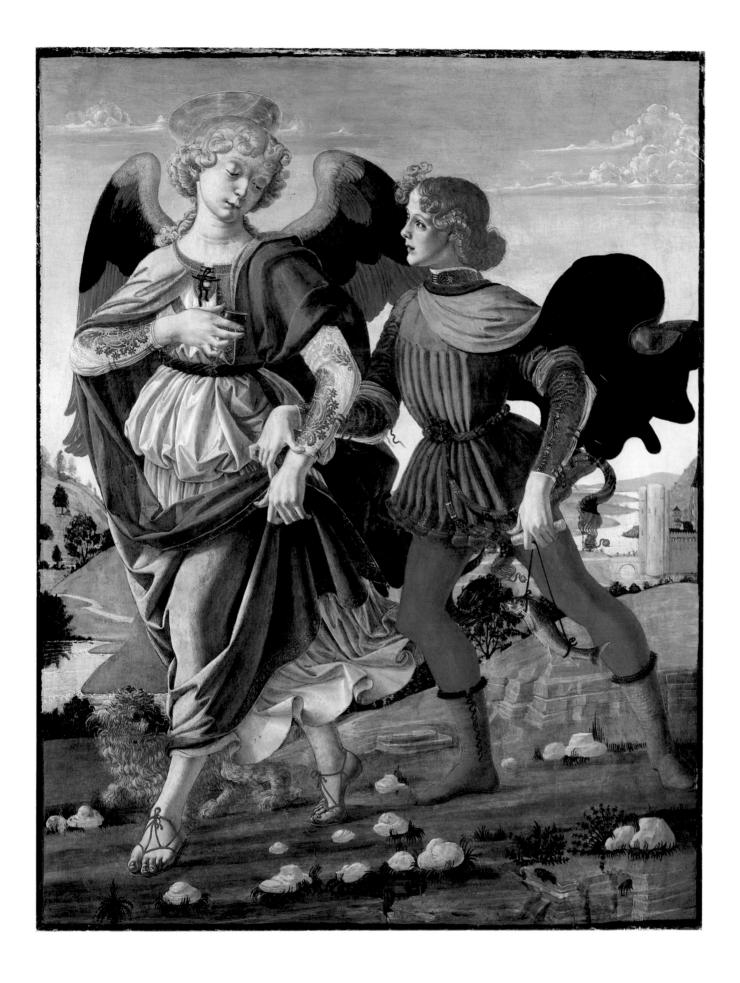

Oil (analysed) on poplar, 291.5 x 202.5cm (NG 292)

Antonio was born in about 1432, his brother Piero in about 1441. They both worked as goldsmiths, sculptors and painters and they seem to have collaborated, although how frequently and in what manner is uncertain. Sculptures which are certainly by Antonio are among the most powerful of the fifteenth century: paintings documented as by Piero alone are not of exceptional quality. It is reasonable to suppose that any painting associated with the brothers which is of such quality is likely to be in large part Antonio's work. They worked chiefly in Florence but also in Rome, where Antonio died in 1498 a few years after Piero.

Saint Sebastian is shot at by longbows and crossbows. (The arrows failed to kill him, although he was left for dead, but this episode in his martyrdom was the one almost always depicted by artists.) An ancient Roman triumphal arch appears in the background – appropriately, for Sebastian was a Roman centurion – but the executioners are equipped with fifteenth-century weapons and the knights on horseback in the middle distance are wearing plate armour. The landscape (like that in Fig. 257) resembles that of the Arno valley – a panoramic view familiar to the Florentines for whom the painting was made, and the model for the saint himself was also apparently recognised by them as Gino di Lodovico Capponi (1453–78), a beautiful, high-born Florentine youth. In a society in which religious processions featured floats with living youths posing as martyrs with swords and the like sticking convincingly into them, it is not surprising that a portrait could be discerned in a painting of this kind.

The painting served as the altarpiece of the Oratory of St Sebastian which was attached to SS Annunziata, the church of the Servites, a mendicant Order. The Annunziata was one of the most important churches in Florence. The Oratory seems to have been built in the 1450s by Antonio Pucci, a close ally of the Medici, on a site formerly occupied by a confraternity dedicated to Saint Sebastian, whose arm-bone was a precious relic belonging to the church. The altarpiece was, it seems, completed in 1475 for a price of 300 scudi.

Vasari singled out for particular praise the archer who bends down to load his crossbow, muscles straining, veins swelling, breath held as he does so. This figure and the three others in the immediate foreground are charged with the same dynamic energy as the little statuettes which were perhaps Antonio's greatest achievements. The use of small models did much to stimulate the idea of studying the same figure from different viewpoints, as seen here and in earlier Tuscan paintings. The figure of the saint has none of the expressiveness of the executioners and seems to be the work of Piero. Although regarded as a portrait, he looks much less like a specific individual than do the executioners.

The idea of the composition is remarkable – symmetrical and yet dynamic – but as realised it has neither an architectural unity nor an organic coherence. The foreground figures are very uneasily related to each other and the foreground generally is uneasily related to the background. The painting of the landscape, however, is as remarkable as that of the executioners, especially in the rendering of glimmering river and fading horizon. Many of the details, although painted with astonishing, perhaps unprecedented, freedom in oil paint (see p. 203), are very small in size. The way the river is broken into churning rapids, the relief sculpture of battles, also the emblem of the Pucci family (the Moors' heads) on the triumphal arch, and the distant city, were surely not calculated with the location of the altarpiece in mind (Fig. 283).

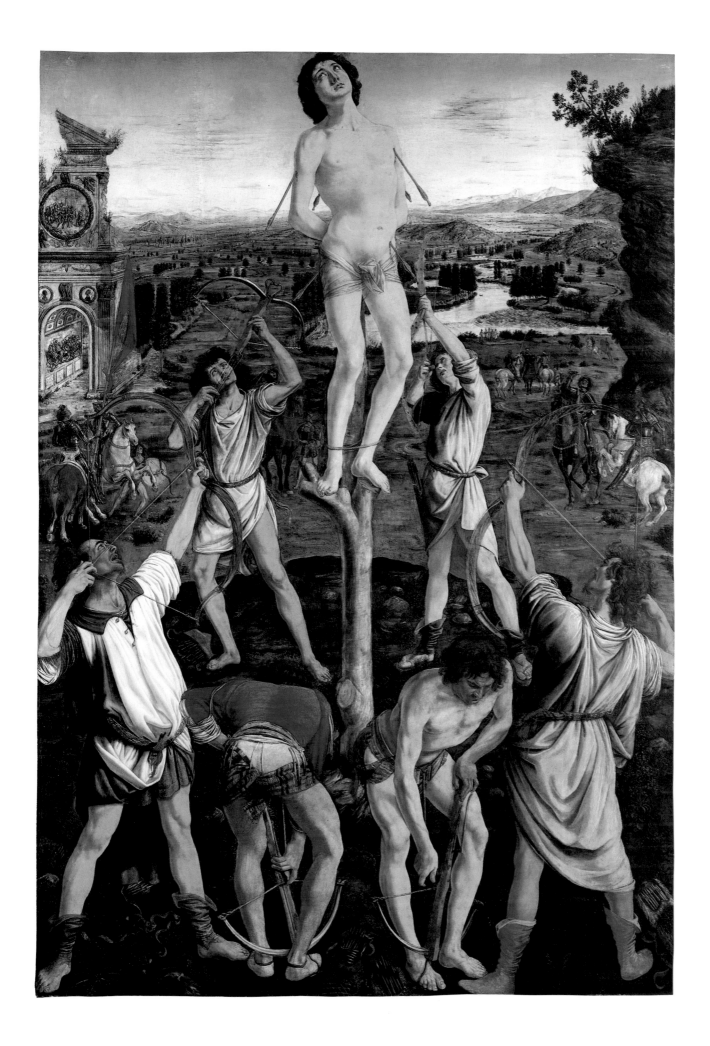

41 Saint Jerome in his Study c.1475-6

Oil (analysed) on lime, 45.7 x 36.2cm (NG 1418)

Antonello was active in Messina (in Sicily), part of the Kingdom of Naples, by 1456. He is said to have been a pupil of Colantonio who worked in Naples. In 1475 and 1476 he was in Venice working on a commission for a large altarpiece in the church of San Cassiano. He died in Messina in 1479.

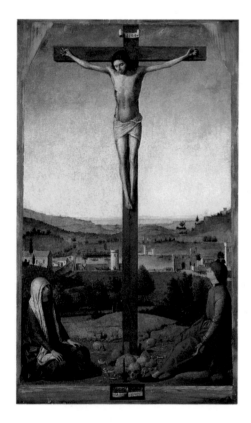

Fig. 41a. Antonello da Messina, *Crucifixion*, dated 1475. Wood, painted surface 41.9×25.4cm (NG 1166).

Small paintings of Saint Jerome in the wilderness, a pattern for penitents, were very popular throughout Europe in the fifteenth century. Paintings showing him in his study, an inspiration for scholars, were also popular. One of the most famous of such paintings was made by van Eyck and was probably known to Antonello in Naples. This painting by Antonello is described by the collector Michiel as being in a Venetian collection in 1529, when it seems to have formed the subject of a dispute between connoisseurs (one of the first such disputes ever recorded about a European painting): 'The little picture of St Jerome reading in his study in Cardinal's attire, believed by some to be by the hand of Antonello of Messina: but more, and with better judgement, attribute it to Jan van Eyck [*Gianes*] or to Memlinc [*Memelin*], the old master from the Netherlands, and it is in their manner, although the face [*volto*] is finished in the Italian style and therefore seems to be by the hand of Jacometto.'

The fifteenth-century idea of a painting as a view through a window is even more explicit in this painting than in *The Virgin and Child* by Bouts (No. 28), for not only is there a ledge and a complete surround, but these are immediately obvious. This surround, which resembles the pink stone arch in which the Master of Liesborn framed the *Annunciation* (No. 43), could be described as an arch (*volta* in Italian) and so might be what Michiel meant, although a *volto*

would normally mean a face. In any case, the surround is handled in a very distinctive manner: little dashes and scribbles have been made in the wet paint with a sharp instrument – a technique to render the flaws or veins of the stone, probably derived from some of the tricks used for imitating the patterns of coloured marbles. Less obviously, such lines are also incised between all the stone blocks in the interior of the Gothic hall in which the scholar's neat wooden cubicle is set. Beyond are other windows through which a landscape may be seen, including miniature figures in a rowing boat. This is the sort of view that was greatly admired in Netherlandish painting (see for instance Nos. 13, 22, 42) of a kind that Antonello must certainly have studied. He has represented the light entering the building both from the front – through the beholder's window – and from behind. It reflects on the surface of the ceramic tiles, whose pattern becomes gradually illegible. In the shadows to the right Jerome's lion pauses, his right paw raised, to consider the viewer peering into his master's privacy.

The painting may well date from Antonello's stay in Venice in 1475-6, or it may have been sold by him there and painted a year or so before. Many scholars prefer a much earlier date, but the stiff profile pose, the angular elaboration of the drapery, and the character of the landscape are very similar to the *Crucifixion* (Fig. a) which is dated 1475.

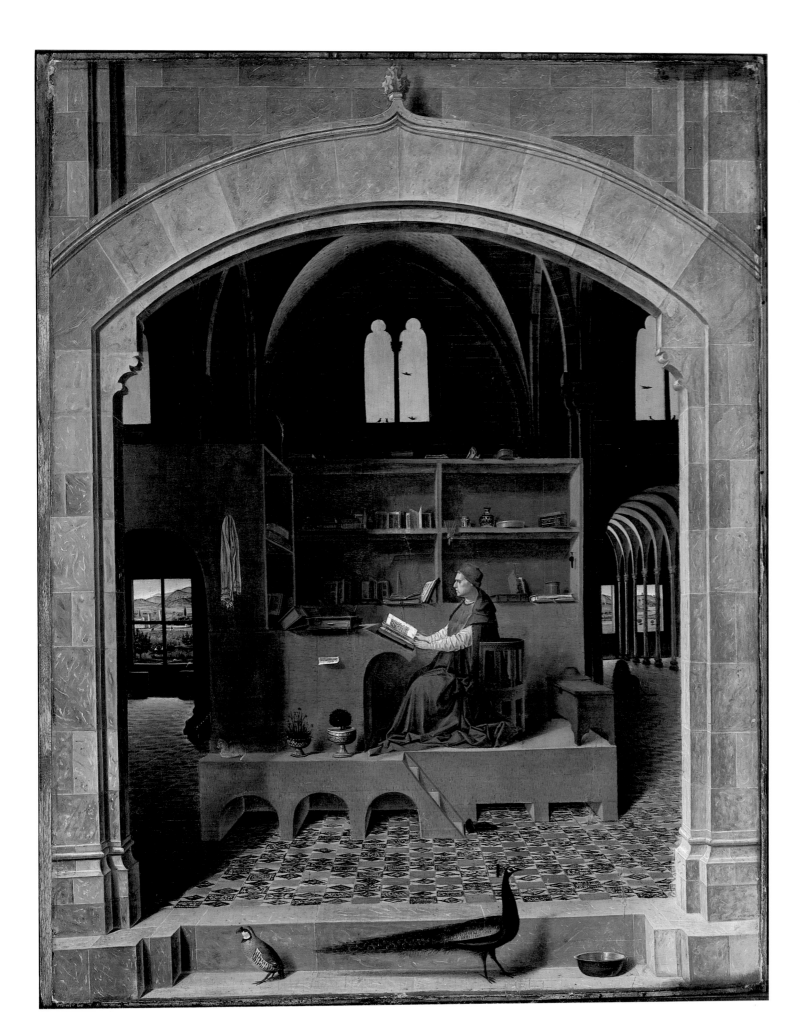

42 The Virgin and Child with Saints and Donors (The Donne Triptych) *c.* 1475

Oil, perhaps with some egg tempera, on oak, painted surface of central panel 70.7 x 70.5cm; shutters each 71 x 30.5cm (NG 6275)

A native of Seligenstadt near Frankfurt-am-Main in Germany, Memlinc was active from 1465 in Bruges, where he was the leading painter and had a large workshop, many of his pictures being exported to Italy. Several works by him were commissioned for the Hospital of St John at Bruges, where they survive. He died at Bruges in 1494.

Fig. 42a. Detail of No. 42.

Sir John Donne (died 1503), whose coat of arms appears on the capitals of the columns and on the stained-glass windows, is shown being blessed by the Christ Child; Saint Catherine stands behind him. On the right-hand side is Sir John Donne's wife Elizabeth, whom he married apparently between 1462 and 1465. She is shown with Saint Barbara and with one of her daughters. Saint John the Baptist on the left shutter, and Saint John the Evangelist on the right, are both presumably included as the name saints of the commissioner. On the reverses, painted in grisaille, are Saints Christopher and Anthony Abbot.

The painting is probably an altarpiece: its original destination is unknown, but its relatively small size indicates that it would have been as suitable for a domestic chapel as for an altar in a church. Sir John Donne is recorded as having visited Bruges, where Memlinc worked, in 1468 for the marriage of Margaret of York, sister of Edward IV, to Charles the Bold, as well as nearby Ghent in 1477. He was however often in Calais, then English territory, and would have had the opportunity of visiting Bruges quite frequently. Sir John and Lady Donne are both shown wearing collars of gilt roses and suns from which a lion hangs, thus indicating their loyalty to the Yorkist English king, Edward IV. The inclusion of only one of the Donne children suggests that the others had not yet been born, and that the child may be Anne, probably born after 1470; if so, as she looks at least five years old, the painting could not be earlier than about 1475.

Netherlandish painting was extremely popular in England in the later part of the fifteenth century. It is thus unsurprising, particularly in view of Sir John Donne's frequent presence on the Continent, that

he took the opportunity of commissioning a work from Memlinc. The subject of the Virgin and Child surrounded by saints and angels was one very frequently ordered from Memlinc and his studio, with variations, and the motif of the Child crumpling the page of a book while being offered a fruit by an angel appears in other paintings by Memlinc (see p. 70). This version, with the scene extending across the shutters is one of the most elaborate.

The scene appears to be taking place in a building, the door of which is seen ajar in the left shutter, and a window can be seen on the right. Behind the figures in the central panel, however, is an open loggia supported by columns, an improbable construction – though perhaps inspired by Memlinc's Italian clientele – but one which serves the dual function of allowing the Virgin's throne to be flanked with architecture of some grandeur and making visible one of Memlinc's most panoramic landscape backgrounds. The landscape, which extends across all three parts of the triptych, includes a number of rustic details (see Fig. a), such as the miller loading his sack of flour on to his donkey, centre left, as well as a river on which swim the swans so frequently included in Netherlandish landscapes (compare No. 22), and in which reflections are beautifully described. On the right is a barn with a partially ruined wall around it, on which a peacock sits, a symbol of eternity (compare No. 38). The landscape, with its distant hills a hazy blue and its bush-like trees painted with Memlinc's distinctive highlighting of individual leaves, is a typical though unusually elaborate example of his depiction of outdoor scenes, which strongly influenced the work of some Italian painters, notably Perugino and Raphael.

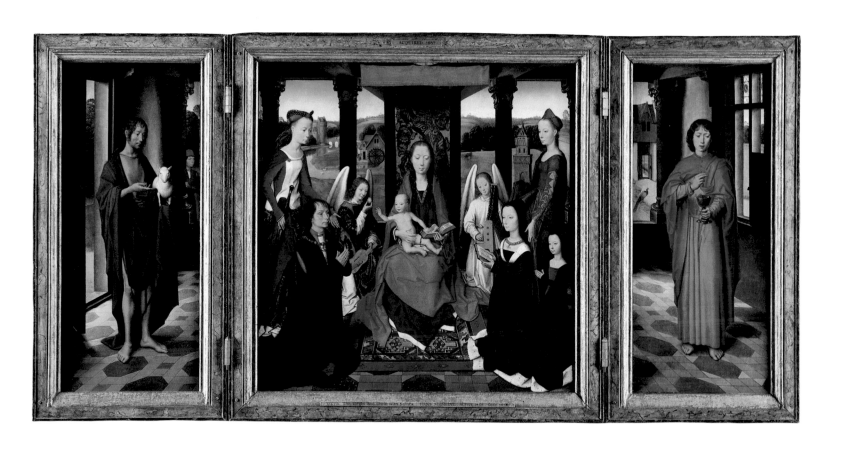

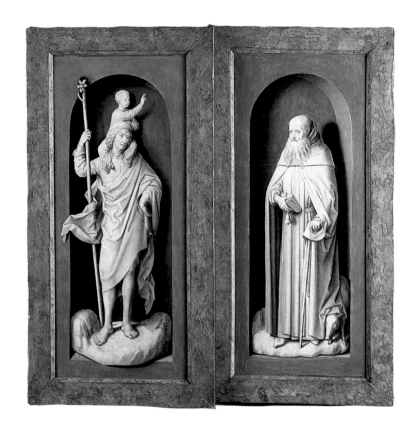

43 The Liesborn Altarpiece *c.1475*

The Head of Christ Crucified (transferred from oak, fragment 32.7 x 29.8cm; NG 259); *Saints John the Evangelist, Scholastica and Benedict* (transferred from oak, fragment 55.9 x 70.8cm; NG 260); *Saints Cosmas and Damian and the Virgin* (transferred from oak, fragment 55 x 72.1cm; NG 261), *The Adoration of the Kings* (oak, fragment 23.2 x 38.7cm; NG 258); *The Annunciation* (oak, 96.2 x 70.5cm; NG 256), *The Presentation in the Temple* (oil [analysed] on oak, transferred to canvas, 98.5 x 70.2cm; NG 257)

The artist was the leading Westphalian painter in the second half of the fifteenth century, and is named after the dismembered high altarpiece of the Benedictine abbey at Liesborn in Westphalia (to which the National Gallery fragments belong).

The altarpiece, painted for the high altar of the Benedictine abbey at Liesborn, Westphalia, survives only in fragments, but it would have been a grand and imposing structure, certainly larger than any other German altarpiece surviving in whole or in part in the National Gallery. It appears originally to have consisted of a central panel of the Crucifixion with two

shutters on either side, each made up of four panels. The fragments of the Crucifixion with the Virgin, Saint John the Evangelist and four saints in the National Gallery, together with further fragments of angels at Münster, make up what remains of the central panel (Fig. a). The *Annunciation*, *Presentation in the Temple* and the fragment of the *Adoration of the Kings* in the National Gallery belong to the shutters, of which parts of an *Adoration of the Shepherds* and further fragments of the *Adoration of the Kings* survive at Münster.

The high altar of the Benedictine abbey of Liesborn was dedicated in 1465 by the Abbot Heinrich von Cleve. The abbot commissioned pictures for all the altars of the abbey. He died in 1490, so the altarpiece of the high altar can be dated between 1465 and 1490, perhaps to the mid-1470s. The dedication of the high altar was to the Virgin, Saints Cosmas and Damian and Saint Simeon the Prophet, which would account for the presence of the first two saints in the central Crucifixion panel (see p. 37). Simeon naturally appears in the *Presentation in the Temple*, a scene commonly included in cycles of the Life of Christ.

A reconstruction of the altarpiece has been suggested with a left-hand shutter made up of scenes from the Life of Christ up to the Presentation, and incorporating all the surviving panels and fragments (Fig. b). The right-hand shutter might then have included scenes following the Crucifixion. Both shutters are assumed to have been fixed, and not to have been

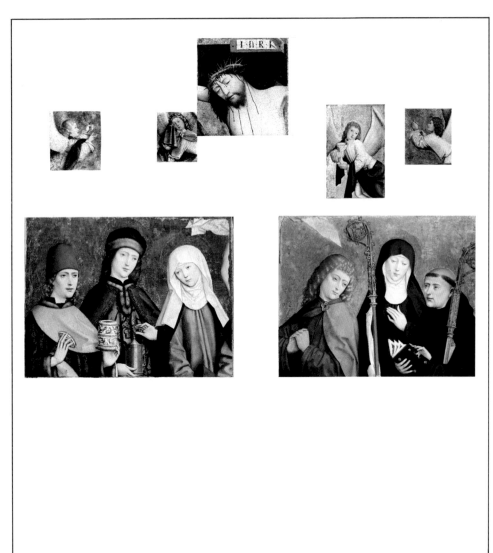

Fig. 43a. Reconstruction of the central panel of the Liesborn Altarpiece after Paul Pieper.

TOP RIGHT: *Saints Cosmas and Damian and the Virgin;*
BOTTOM RIGHT: *Saints John the Evangelist, Scholastica and Benedict* (No. 43).

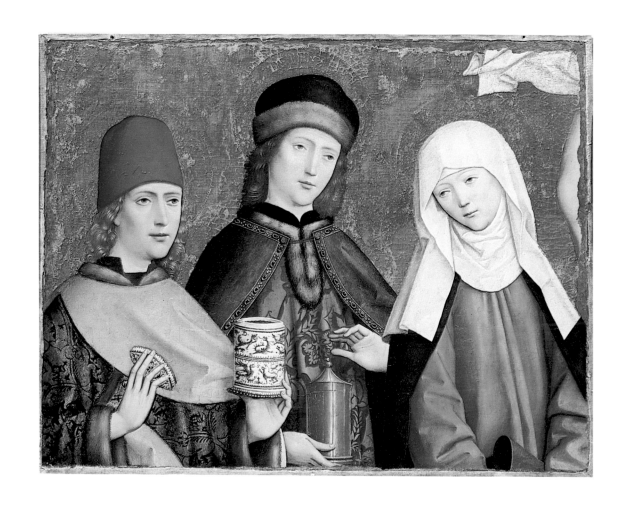

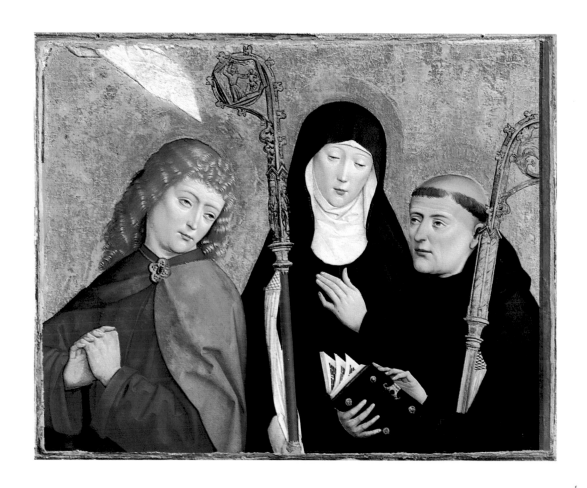

painted on the reverses. It is, however, slightly disturbing that the perspective of the floor of the *Annunciation*, receding to the left, is at odds with that in the *Presentation*, which recedes to the right. This suggests that the two panels might have been arranged on either side of the Crucifixion. In an altarpiece at Lünen, which appears in part to derive from the Liesborn Altarpiece, the composition of the *Annunciation*, which is on the left-hand side, is reversed so that the floor perspectives are aligned.

The *Annunciation* panel allows us to gain some idea of the style of the altarpiece. The panel, like others, has a red painted strip down the right-hand side and along the lower edge: as red painted frames were commonly used for paintings in Westphalia and Cologne (see p. 157) it is likely that these strips echo the framing elements of the altarpiece. The *Annunciation* itself (though not the other scenes) is framed by an arch with columns on which stand sculpted figures of Old Testament prophets who foretold Christ's birth; such framing devices are frequently found in Netherlandish painting, which had a strong influence on that of Westphalia, as on nearby Cologne.

The framing arch increases the sense of recession, which is intensified by the pattern of the floor tiles of the apparently narrow but deep room, from which windows open on to a landscape. Below the windows hangs a religious text (pinned to a board in the same way as the illumination in Fig. 140). A bench stands against this wall on which rest three cushions with golden bobbles and tassels at their corners. The textures of these are beautifully and convincingly described, the left-hand cushion clearly executed in tapestry work, the central one embroidered with gold thread on velvet.

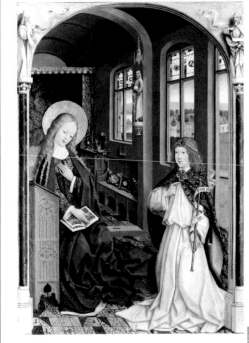

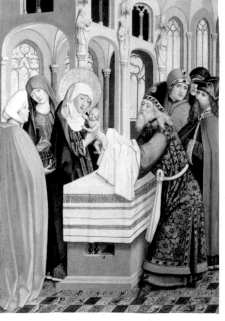

The device on the left-hand cushion – the stag which also appears on the floor tiles – and the coats of arms visible in the stained-glass window above may provide clues to the identity of those who contributed to the commissioning of the altarpiece. So far, however, although various suggestions have been made, none has proved entirely convincing.

The Annunciation scene shows the decorative and descriptive powers of the Liesborn Master at his best, and also ex-

Fig. 43b. Reconstruction of the left-hand shutter of the Liesborn Altarpiece after Paul Pieper.

RIGHT: *The Annunciation* (No. 43).

emplifies his distinctive use of colouring – particularly rose pink and a pale greeny blue – in a manner reminiscent of the soft rich colouring of the Cologne painters working earlier in the fifteenth century (see that used by Lochner in No. 20).

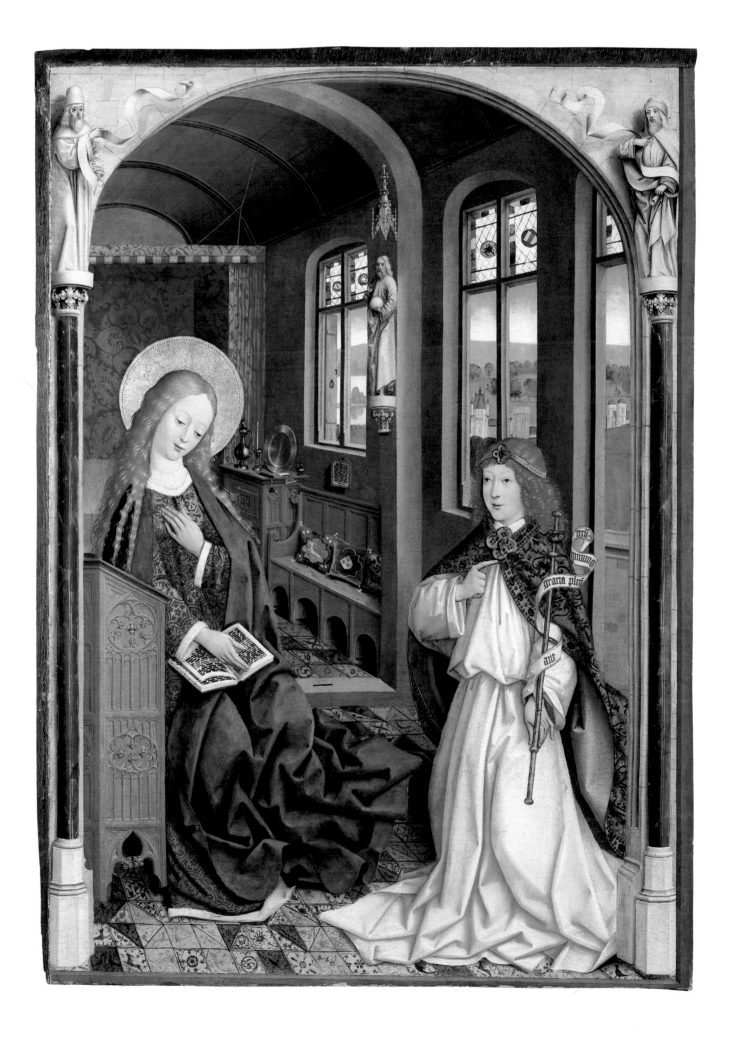

44 The Virgin and Child Enthroned *c.* 1475-6

Oil, with some egg tempera (analysed) on poplar, painted surface 239 x 102cm (NG 772)

Cosimo Tura, also known as Cosmè, was born shortly before 1431 and was recorded as working in Ferrara by 1451. He was appointed court artist to Borso d'Este in 1458 and also served Borso's successor, Ercole. He retired from court service in 1486 but was evidently still active as a painter. He died in 1495. Few works by him survive.

The Virgin holds the sleeping Christ, her right hand hovering above him. She looks down with concern at the angels below who make music to awaken him. On the sides of the throne are tablets inscribed in Hebrew with the Ten Commandments, the rule of law established by Moses, which will be supplemented by the rule of Christ himself. The throne is crowned with symbols of the four Evangelists who record Christ's life and sacrifice (see p. 52).

This panel formed the central part of an altarpiece in the chapel of the Roverella family in the church of San Giorgio fuori le mura (St George outside the city walls) at Ferrara belonging to the severe Benedictines of Monte Oliveto. It was one of the most imposing and elaborate altarpieces erected in Ferrara in the fifteenth century and reflected the prestige of the Roverella family – Lorenzo Roverella was Bishop of Ferrara and Niccolò Roverella was General of the Olivetan Order, prior of this church and responsible for its restoration.

To the right of the central painting stood Saint Maurelio, to whom the chapel was dedicated, and Saint Paul, together with a kneeling monk (probably Niccolò). To the left stood Saint Peter and Saint George with another kneeling figure (probably Lorenzo) – a fragment of the Saint George survives. A large lunette of the *Lamentation over the Dead Christ*, now in the Louvre, crowned the altarpiece: its figures are larger to compensate for the greater distance from the viewer (Fig. a). Saints Benedict and Bernard seem to have been represented high up on either side, and the predella apparently depicted episodes from their lives.

The architectural divisions of this altarpiece are not merely imposed by the frame, as in the traditional polyptych, but are also embodied in the spatial structure of the painting itself. The central coffered vault above the Virgin's throne is supported by two pillars in the painting and presumably by two outside the painting represented by the pilasters of the frame. The entablature was continued to either side to form two flat roofed aisles, again supported by pillars in the painting and by the pilasters of the frame. Much of Tura's surviving work features architecture of fantastic colours and ornamentation, calculated with great expertise in terms of linear perspective. Some of it is highly impractical: the stepped blocks supporting the Virgin's throne could not in fact support themselves let alone a throne. Pink and green stones are used in some parts of Italy (in Florence green serpentine from Prato and bleached red Tuscan marble for example are employed on the Campanile of the Duomo and elsewhere) but they never have the confectionary brilliance found here. The ornament, while inspired by antique Roman carvings, is highly original. When the symmetrical elements – child angels with upright horns of plenty in the capitals, child angels with reversed horns of plenty on the arch of the throne, infant heads in shell roundels – are examined obliquely, lines incised in the gesso, which are the same but reversed for each pair, are clearly visible: Tura would have presumably used two sides of the same preparatory drawing to achieve this effect.

In front of the steps (and in front of the sky which makes such a startling appearance here) an elegant portative organ is situated with its keyboard to the left and diminutive bellows to the right. On the front panel of this a few letters remain from an inscription which seems to have

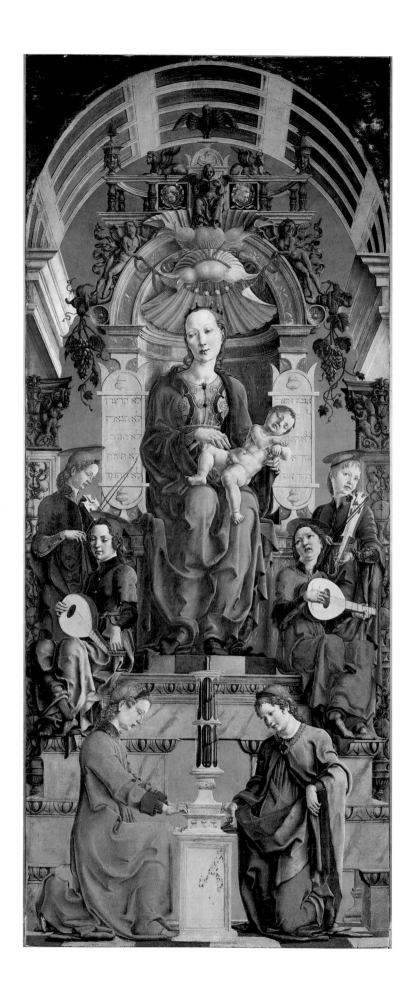

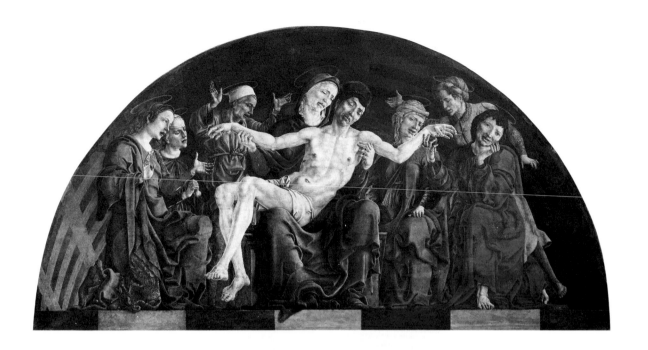

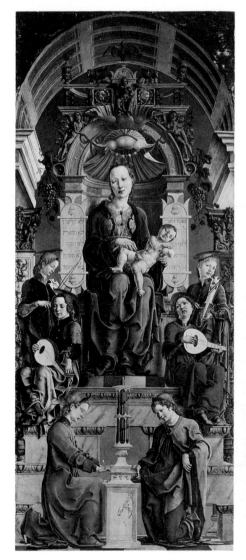

Fig. 44a. Cosimo Tura, *Saints Maurelius and Paul*.
Wood, 155×76cm. Rome, Palazzo Colonna;
Lamentation, 132×267cm. Wood, 132×267cm. Paris,
Louvre.

read: 'Imago Virginis excitātis filiū./ Surge puer. rouorella fores gens pultat. apertum/ Redde aditum. pulsa lex ait: intus eris'. The lines come from an elegy by Ludovico Bigo Pittorico (published in 1492). They bid the boy – that is, the Christ Child – to arise, for Roverella is knocking at the door, and let the door be opened so he can enter. This suggests that a member of the Roverella family had died and was requesting entry into paradise. An early and reliable account of the original painting describes the figure kneeling on the left as knocking for admission. This is an extraordinary idea – generally the donor is merely a beholder in an altarpiece – but then this altarpiece is full of extraordinary ideas – that of having the music of the angels relate to the sleeping of the child for instance – and it reflects in its imagery as in its ornament the extreme sophistication of Ferrarese court art.

If the member of the family depicted knocking was Lorenzo, who died in 1474 (and whose tomb in the same church is dated 1476), that would suggest a date for the painting in the mid-1470s, which accords well with what little is known of Tura's development as a painter. His earliest work was much influenced by Mantegna and his art possesses an analogous hardness – the folds of his drapery seem turned to glass, and his expressions turn into grimaces so that a look of rapture (on the face of one musical angel) comes close to the look of distress in his *Lamentation*. For a discussion of his technique see pp. 198-9.

Fig. 44b. Detail of No. 44.

45 The Virgin and Child Enthroned with Angels
and Saints *c.1475*

Oil on silver fir, painted surface 40.3 x 39.4cm (NG 5786)

Michael Pacher was active from 1467 at Bruneck (Brunico) in the Tyrol, where he ran a large workshop renowned for both painting and woodcarving of a very high quality; he died in 1498.

The subject and small size of the painting suggest that it was painted as a devotional picture. On the left of the Virgin is Saint Michael weighing souls (see No. 46) and trampling the devil; on the right is a bishop saint who has not been identified. On the pillars of the throne stand figures of the Archangel Gabriel (left) and the Virgin (right), forming an Annunciation, while four small angels are perched on the Virgin's throne. The two lower ones hold up fruit to the infant Christ, who bends down to reach one of the offerings.

The composition echoes larger works by Pacher, particularly in the form of the canopies projecting over the Virgin and saints. These canopies are very similar to those of Pacher's paintings of the four Fathers of the Church (Fig. a) and give a strongly sculptural, three-dimensional effect, which is reinforced by the carved decoration of the gilded background. The figure of Saint Michael shows similarities to carvings from Pacher's workshop of the same saint. The somewhat Italianate angel on the lower right also

strongly recalls Pacher's work: other paintings by him make it clear that he was familiar with North Italian painting, the innovations of Paduan and Ferrarese artists in particular.

Pacher must also have been familiar with the interest his Italian contemporaries showed in architectural decoration, which was a fantastic elaboration of that of the ancient Romans (see Nos. 35 and 44). He chose instead, however, in his painting as well as in his sculpture (Fig. 177), to revel in the novel inventions of late Gothic architecture, with its complex, linear and often vegetal forms. In this painting, the relief decoration of the background with its flowing leaf pattern seems almost continuous with the pattern of halo and crown superimposed upon it, and echoes the densely intersecting ogee tracery of the niches above.

The painting has usually been considered to be the work of someone close to Pacher, but not necessarily in the same workshop. However, the small scale of the picture makes it difficult to compare works certainly by Pacher, all of which are much larger. The qualities evident in the painting – its rhythmic composition, the carefully worked-out relationships between the figures with their deftly painted expressions which knit together the central action of the offering of fruit, the control in the painting of the heavily jewelled clothing worn by the main figures – all of this suggests an artist of considerable powers, perhaps even Pacher himself.

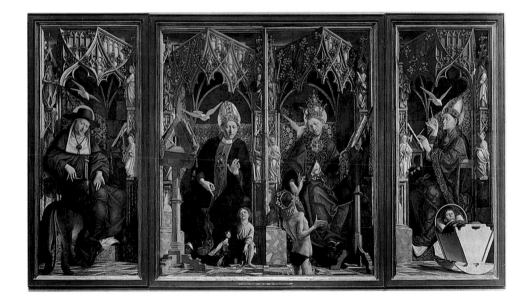

Fig. 45a. Michael Pacher, *Altarpiece of the Four Fathers of the Church, c.* 1480. Pine, painted surface, shutters 216×91cm, each centre panel 212×100cm. Munich, Alte Pinakothek.

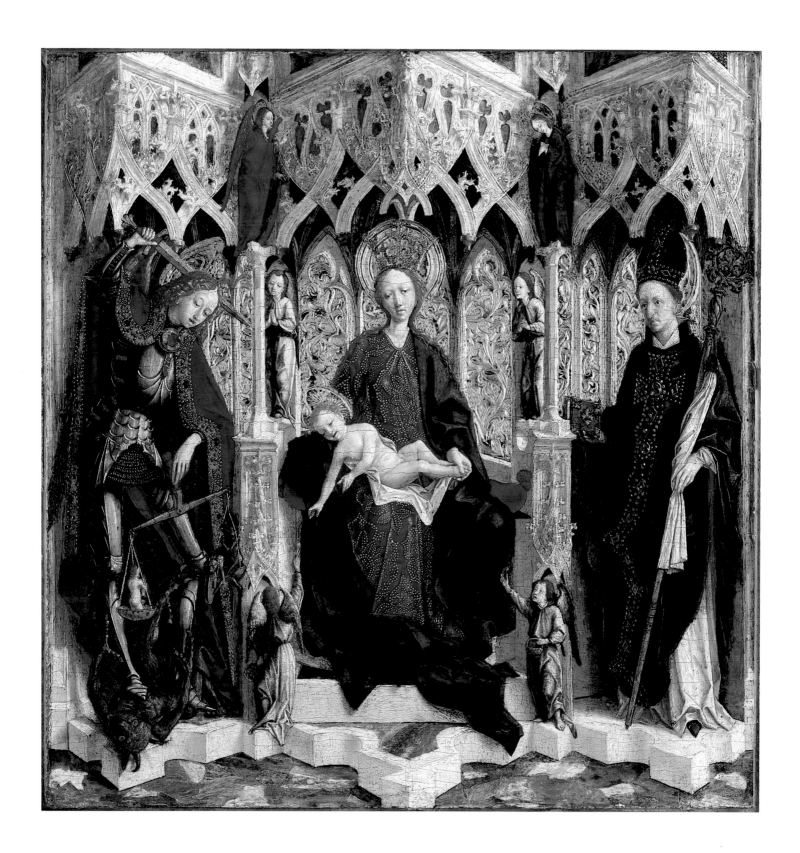

46 Saints Michael, Jerome, Peter Martyr, and Lucy *c.* 1476

Egg tempera, probably with some oil, on poplar, with the exception of *Saint Lucy* which is lime, 90.5 x 26.5cm (*Saint Michael* and *Saint Peter*); 91 x 26cm (*Saint Jerome*); 91 x 26.5cm (*Saint Lucy*). (NG 788.010–013)

Carlo was the son of Jacopo Crivelli, a little known Venetian painter. He was born in Venice in the early 1430s and in 1457 was sentenced to prison there, for adultery with a sailor's wife. In 1465 he was living at Zara. By 1468 he had settled at Ascoli Piceno and he was active mostly in the Marches. He was knighted in 1490 by Ferdinand II of Naples and had died by 1495 (probably in the previous year).

Fig. 46a. Carlo Crivelli, *The Virgin and Child Enthroned*. Wood, 106×56cm. Budapest, Szépmüveszéti Museum. Together with the panels in No. 46.

These four arched panels formed part of a polyptych altarpiece in a chapel dedicated to Saint Peter Martyr in the Dominican church of San Domenico in Ascoli Piceno. A pair of saints stood on either side of the Virgin and Child enthroned (Fig. a). Saint Jerome is represented with the lion, still wounded by a thorn and grimacing in agony. As translator of the Bible into Latin, he is shown holding a Bible. The model which he also holds stands for the Church, which he so illuminated with his learning – rays of light issue from its apertures. Saint Michael, as an archangel, has wings, and as the captain of the heavenly hosts he is elaborately armed and has raised his sword to smite Satan (Lucifer) who squirms below his feet. He holds a balance in which are the souls of virtuous men and women (there is one of each in one pan) for he is 'Lord of souls', and leads and protects the spirits of the dead. He is similarly represented in a work attributed to Michael Pacher (No. 45) where, however, the lead weight in the other pan is being put there by devils. Saint Lucy holds a martyr's palm and, upon a plate, the eyes which she removed and presented to an infatuated pagan admirer. Saint Peter Martyr (see No. 23) has the instruments of his martyrdom impaled in his head and chest.

Many of the surviving altarpieces by

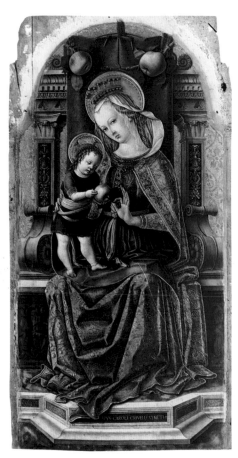

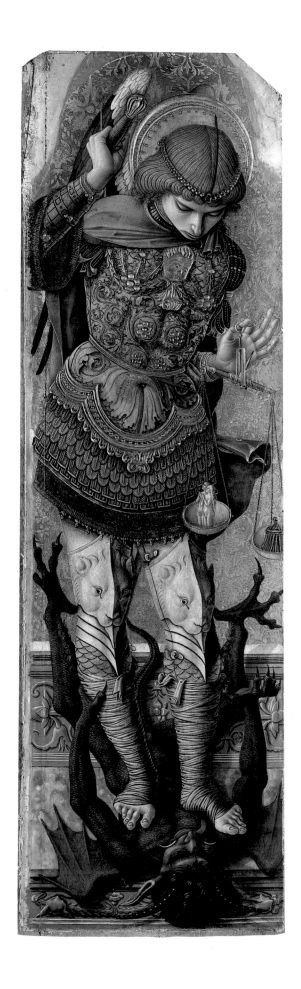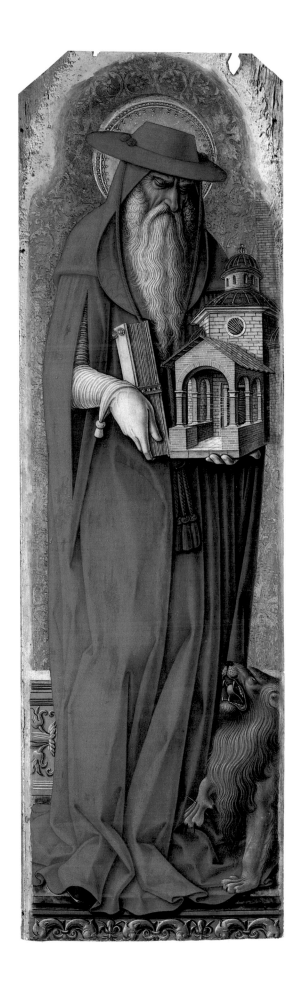

Fig. 46b. Carlo Crivelli, *The Virgin and Child with Saints* (The Demidoff Altarpiece), 1476. Wood, painted surface, central panel, 148.6×63.5cm (NG 788).

OPPOSITE *Saints Peter Martyr and Lucy.*

Crivelli are polyptychs and the backgrounds are of gold, often textured, as here, with a damask pattern. Because of this there is limited spatial interest in these paintings, but Crivelli is none the less keen to exhibit his skill at foreshortening, as in the sword and the lowered head of Saint Michael, the book and church of Saint Jerome, and the claws of Lucifer (with talons locked into Michael's knee armour). Crivelli's love of stiff, angular, ·bristling and tight forms, particularly evident in the figure of Saint Michael, is related to this foreshortening: thus Michael's left hand seems to appear from nowhere, and the central parting of his hair is given particu-

lar emphasis. Crivelli relishes the confinement of the figures in their compartments which not only gives a cramped pose to Saint Michael but to Jerome's lion. Some of Saint Michael's armour, and his sword handle and hair ornament, have been built up in gesso as well as being silvered and gilded (see pp. 175-9).

Crivelli also painted another polyptych for the same church, this time for the high altar. It seems to have consisted of a Virgin and Child enthroned with a pair of full-length saints, larger in size than the four discussed here, on either side and two more pairs, half length above. Also on the higher tier was a *Lamentation over the Dead Christ* above the Virgin and Child. All these panels survive in the National Gallery, except the *Lamentation* (now in the Metropolitan Museum, New York), but they are in an elaborate Gothic frame built for them in the 1850s when the polyptych was adapted for the chapel of Prince Anatole Demidoff's Villa San Donato near Florence. This frame has a baldachin above the Virgin and Child (in place of the *Lamentation*) and it lacks a predella (Fig. b). The four panels of saints constituting No. 46 which came from the other altarpiece were incorporated at that date as an additional crowning tier. They did not look entirely incongruous there because the same damask pattern in the gold background and the same type of halo were used in both altarpieces. Crivelli must have done this in order to give uniformity to paintings made for the same church – no doubt the two altarpieces both date from around 1476, which is the date inscribed on the step below the Virgin and Child from the high altar.

47 Venus and Mars *c.* 1485

Egg tempera and oil on poplar, 69 x 173.5cm (NG 915)

For his biography see No. 38.

Mars is asleep, naked; Venus in a light, loose gown watches. Her husband Vulcan is not present but satyr children play with the armour he made for Mars. Nothing can arouse Mars, not even a conch shell blasted in one ear or wasps in their nest buzzing by the other. So the God of War is utterly vanquished by the Goddess of Love and Beauty. Doubtless the painting also alludes to the proverbial exhaustion of men after sexual activity (a source of much merriment in lewd nuptial masques and poetry). Venus watching Mars asleep was also depicted in a

Fig. 47a. Style of Antonio Pollaiuolo, *Mirror frame decorated with Mars and Venus and sporting putti.* Painted and gilded stucco, diameter 50.8cm. London, Victoria and Albert Museum.

splendid sculptured mirror frame perhaps by Antonio Pollaiuolo (Fig. a) and in a painting, similar in shape and size to Botticelli's, by Piero di Cosimo, now in the Staatliche Museen, Berlin. Botticelli's painting is likely to date from the mid-1480s. It probably originally decorated a *spalliera* – the backboard of a bench or chest – and formed part of a Florentine *camera* decorated on the occasion of a wedding (see pp. 108-13 and No. 54). Large reclining nude figures of similar format, sometimes with pagan identities, were occasionally painted inside the lids of chests in such rooms.

Botticelli has not been much influenced by ancient art – gown and sword, breastplate, helmet and lance are all modern in style – but he, or his patron, may have been influenced by ancient literature, and in particular by Lucian's description of a famous painting of the Marriage of Alexander in which cupids fool around with the hero's armour. The way the god's foot is caught in the drapery must have been suggested by a similar feature in an antique statue of a sleeping hermaphrodite which was much admired in fifteenth-century Florence, and which the great Florentine sculptor Ghiberti cited as especially remarkable. The modelling of the flesh with fine hatching (see p. 188) is well preserved and particularly accomplished in Venus' right hand and in Mars' head. The background is perfunctory in treatment and the only indication that the upper band of green represents water is the faint presence there of ships – a reminder, together with a shell, that Venus was born in the sea. The wasps (*vespe*) may be a punning allusion to the Vespucci family for whom Botticelli is known to have worked.

48 The Virgin and Child with Saints Jerome and Dominic *c.*1485

Oil, with some egg tempera, on poplar, 203 x 186cm (main panel); 15cm (height of each predella compartment); 51.5cm (length of predella compartment of Saint Francis); 49cm (length of predella compartment of the Dead Christ supported in the Tomb); 50.5cm (length of predella compartment of Mary Magdalene) (NG 293)

Filippino (little Filippo) was the son of Filippo Lippi (see No. 23). He was probably born in 1457. By the early 1470s he was living, and presumably working, with Botticelli in Florence. His major commissions in Florence and Rome date from between 1480 and his death in 1504, in which period he enjoyed great fame and was much in demand all over Italy.

The altarpiece is illustrated together with its predella but without its frame (which is not original) – for a detail from the predella see Fig. 25. The painting came from a chapel in the church of San Pancrazio in Florence, apparently dedicated to Saint Jerome, who kneels in the painting clutching the stone with which he beats his breast in penance. Saint Dominic is present no doubt as the name saint or personal saint of a member of the Rucellai family, probably Domenico di Filippo di Vanni Rucellai who died in 1484. Rucellai arms appear at the ends of the predella, and an inscription on the floor of the chapel identifies it as the burial vault of the branch of the family descended from Filippo di Vanni, and gives the date 1485, when the church was also consecrated. The church belonged to the Vallombrosan Benedictines founded in Vallombrosa near Florence by San Giovanni Gualberto in the eleventh century and dedicated to penitence and contemplation.

Filippino's interest in landscape, which owed more to his father than to his probable master, Botticelli, is found in his early *Adoration* (Fig. 89). The wild landscape may have been his idea, although it would have been congenial to the Vallombrosans, for such a place was a proper setting for penitence. The theme of the Virgin seated nursing her child in a landscape was unusual in an altarpiece of this size. In the distance to the left it is just possible to make out Jerome kneeling before a cross deep in his cave. His invariable companion the lion defends this cave from a bear. To the right a rural dispensary appears to be represented. It may be relevant that Saint Dominic was associated with the hospital attached to San Pancrazio. A saint escorting an ass on a path on the central hill may be meant for Joseph, which perhaps indicates that the episode represented takes place on the flight into Egypt.

The predella was sometimes used for representing other saints of significance to the patron. It was also a place where an image of the dead Christ could be placed – immediately above the centre of the altar where the eucharistic sacraments would be set (p. 36). Filippino has combined these conventions, making his two extra saints, Francis and Mary Magdalene, lament the dead Christ. In the larger panel above, there is less narrative unity. The saints occupy the same landscape as the Virgin, and Jerome regards her with rapture; but the Virgin notices neither saint and Dominic is deep in his book.

Much of the liveliness of Filippino's painting comes from his expressive faces – that of Jerome is a particularly fine example – and from his flowing white lines – in the wild beard and hair of Jerome, for instance, and the white highlights on the veils winding around the Virgin's head and the body of Christ. The painting of transparent drapery and light hair had been something for which his father, Filippo Lippi, had also been specially noted (No. 23). Here they have a special emphasis from the black background of the predella and the dark shadows in the principal panel.

49 The Nativity, at Night *c.*1480-90

Oil on oak, painted surface 34 x 25cm (probably cut slightly on all edges) (NG 4081)

'Sint Jans' indicates that Geertgen lived with the Knights of the Order of Saint John, presumably of the Haarlem community. He is said to have died aged about twenty-eight sometime between 1485 and 1495. All accounts of his life and works depend on seventeenth-century sources; there are no known contemporary documents.

Geertgen's picture includes two separate scenes, which were frequently combined: the Annunciation to the Shepherds on the hillside in the distance, and the Nativity, which is the main subject. In each scene the darkness is broken by a supernatural source of light. The shepherds are shown shielding their eyes from the brilliant radiance of the angel announcing the birth of Christ, and the figures around the manger in which Christ lies – the angels, Mary and Joseph, the ox and ass – are all illuminated by the Christ Child himself.

In the subsidiary scene the shepherds have lit their own fire, to keep warm during the winter night, but the light from the flames is dim by comparison with the white phosphorescence of the angel. In the Nativity scene a similarly contrasting, less brilliant light source may have been included, but was perhaps lost when the picture was slightly reduced at the edges. This is suggested by comparison with a number of similar compositions, which probably reflect a lost picture by the great Netherlandish artist Hugo van der Goes. The *Nativity* (Fig. 87) by a follower of van der Goes is

one. There Joseph is shown holding a candle in his left hand and shielding it with his right. Geertgen's Joseph may also have shielded a candle with his right hand.

The dramatic contrasts of darkness and divine light around which Geertgen's picture is composed are an innovation in Netherlandish artists' treatment of the Nativity. But the idea of the radiance of the new-born child had appeared in Netherlandish and Italian painting from the beginning of the fifteenth century, and appears to be based on the visionary writings of the fourteenth-century mystic, Saint Bridget of Sweden. In her account of her vision of the birth of Christ she writes that from the new-born child 'radiated such an ineffable light and splendour, that the sun was not comparable to it, nor did the candle, that Saint Joseph had put there, give any light at all, the divine light totally annihilating the earthly light of the candle.' Only a century later did artists such as Geertgen develop an interest in rendering the contrasts of extreme light and shade, and contrive to give naturalistic, rather than merely symbolic, point to Saint Bridget's vision (see p. 73).

50 A Concert *c.* 1485–90

Oil on poplar, 95 x 75cm (NG 2486)

Costa died in 1535 aged seventy-five so he was born in 1459 or 1460. By 1483 he had settled in Bologna, but his early work is much influenced by Cosimo Tura (see No. 44) and by Ercole de' Roberti, both of Ferrara. By 1507 he was established in Mantua as court painter in succession to Mantegna and he died there.

The painting is very unusual in that it seems neither to be a narrative nor an allegory – nor is it a portrait, although it has been claimed as one. That the people represented are real individuals certainly looks likely, but commissioned portraits of this kind are not recorded at this date and such attitudes would probably have

been regarded as indecorous. It is more likely that the painting was part of a sequence of paintings, each incorporating singers with different musical instruments, designed for a room in which music would be played. Perhaps the other paintings represented the sister arts, in which case the room might have been a *studiolo*: the *intarsia* (marquetry) in such rooms often represented musical instruments and sometimes musicians (see Fig. 159).

The challenge of suggesting that which cannot be seen (in this case sound) and of representing the face transfigured by the act of singing greatly interested artists in the second half of the fifteenth century (the marble relief by Luca della Robbia for the choir of Florence Cathedral is a famous instance and so too is Piero della Francesca's *Nativity* [No. 36]). It demonstrated the artist's power to show expression, which made the art of painting or sculpture akin to poetry, which could describe feelings and thoughts.

The painting seems likely to have been made in the 1480s or 1490s – it is very similar in character to the Bentivoglio altarpiece (Bologna, San Giacomo Maggiore) which is dated 1488. The same hard precision of drawing is found in the heads of the saints in the altarpiece by Costa in the Collection (NG 1119). His softer later manner is represented by the musical angels below the throne of the Virgin in his altarpiece of 1505, where the wispy hair and dreamy faces are in perfect harmony with the thin trees and misty distance of the beautiful landscape behind (Fig. a).

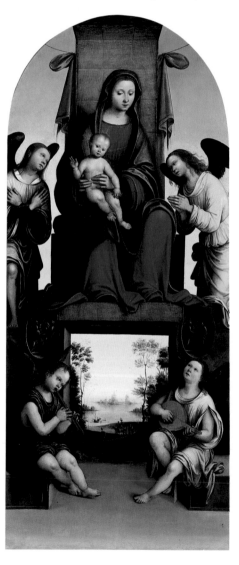

Fig. 50a. Lorenzo Costa, *The Virgin and Child with Angels* (central panel from a polyptych), dated 1505. Wood, transferred to canvas, 167.6×73cm (NG 629).

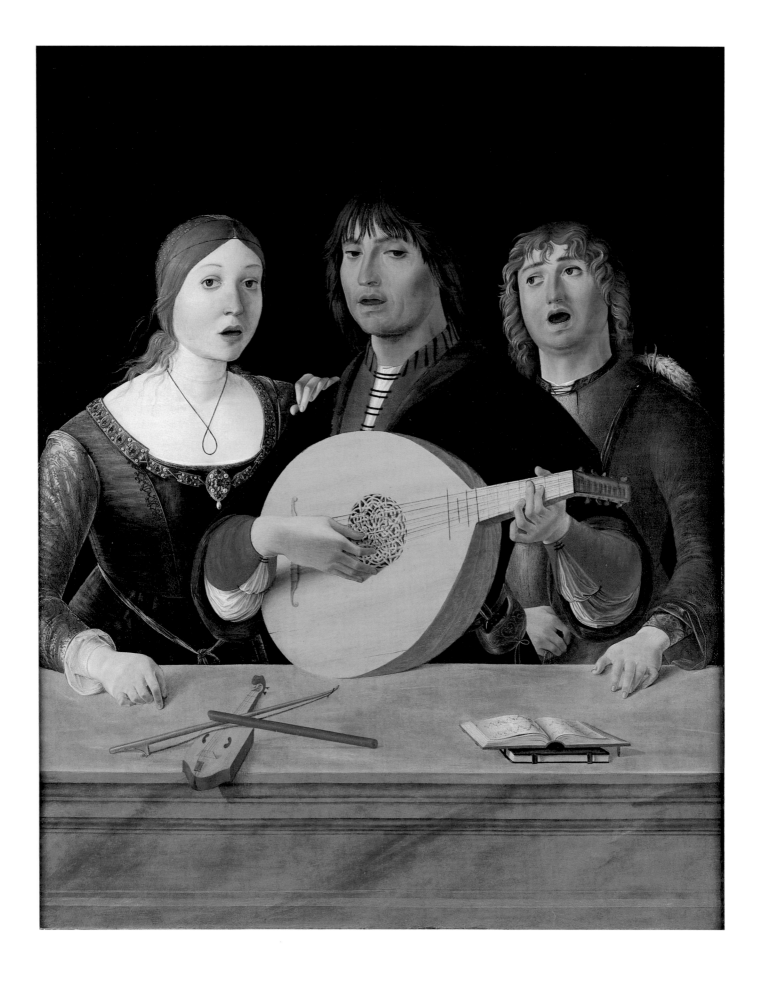

51 The Annunciation, with Saint Emidius 1486

Egg tempera with some oil (analysed), transferred from panel to canvas, 207 x 146.5cm (NG 739)

For his biography see No. 46.

Many of Crivelli's altarpieces were polyptychs with gold backgrounds (see for instance No. 46), but the subject of the Annunciation required an architectural setting and was frequently the pretext for elaborate linear perspective. This painting, an altarpiece for the church of the Observant Friars (the strict branch of the Franciscan Order) in Ascoli Piceno, is an astonishing exhibition of Crivelli's skill in this science and of his inventive and descriptive powers as an artist. Every surface is either patterned or ornamented and much of the detail is minute, for instance the dribbled mortar where the distant wall has been repaired. This is also found in Mantegna's *Agony in the Garden* (No. 30), reminding us that Mantegna's early Paduan work was a major inspiration for painting of this kind. Masonry and brick courses are all faithfully recorded in Crivelli's painting, some details demanding the most difficult feats of foreshortening – as do the apertures of the dovecote in the top left corner.

The fact that the vanishing point is not central is unusual in an altarpiece. It is explained by the fact that Crivelli took as his model a fresco of the Annunciation on the curved side wall of the choir in the cathedral of Spoleto painted by Filippo Lippi in the late 1460s. In that painting, however, in addition to the opening through which we see the Virgin, there is a side door which admitted Gabriel to her view. In Crivelli's painting the angel sees the Virgin through a window, which is partly blocked by a bushy herb growing from a majolica pot. It is also unusual for Gabriel to have alighted in a town street rather than in a private loggia.

The young man shading his eyes under the bridge in the distance, and the child (usually, but probably wrongly, taken for a girl) peeping round the wall on the top of the steps, appear to have seen the flash of light which marks the passage of the dove of the Holy Spirit on its way from the heavens to the Virgin Mary, through a convenient hole in the palace wall. The man on the bridge reads a message which has been delivered by the smaller man beside him deferentially holding his cap – evidently this has come by the carrier pigeon in the cage beside the smaller man and so is a witty secular analogy for the Annunciation itself. It may also refer to an important message which the citizens of Ascoli, one of the Papal States, received from the Pope on 25 March, the Feast of the Annunciation, in 1482 granting them limited rights of self-government. Certainly this is why the words LIBERTAS ECCLESIASTICA (the title of the Papal Bull) are inscribed on a step in front of the painting, together with three shields bearing the arms of the town, of the Pope (then Innocent VIII) and of the Bishop (Prospero Caffarelli), and why the patron saint of Ascoli, Saint Emidius, kneels beside Gabriel bearing a model of the city he protects. The citizens went in solemn procession to the church of the Annunciation on the feast day because of the freedom granted to them that day in 1482.

The painting is prominently inscribed as the work of Carlo Crivelli of Venice: OPVS.CARO/LI.CRIVELLI./VENETI on one pilaster and dated 1486 on the other.

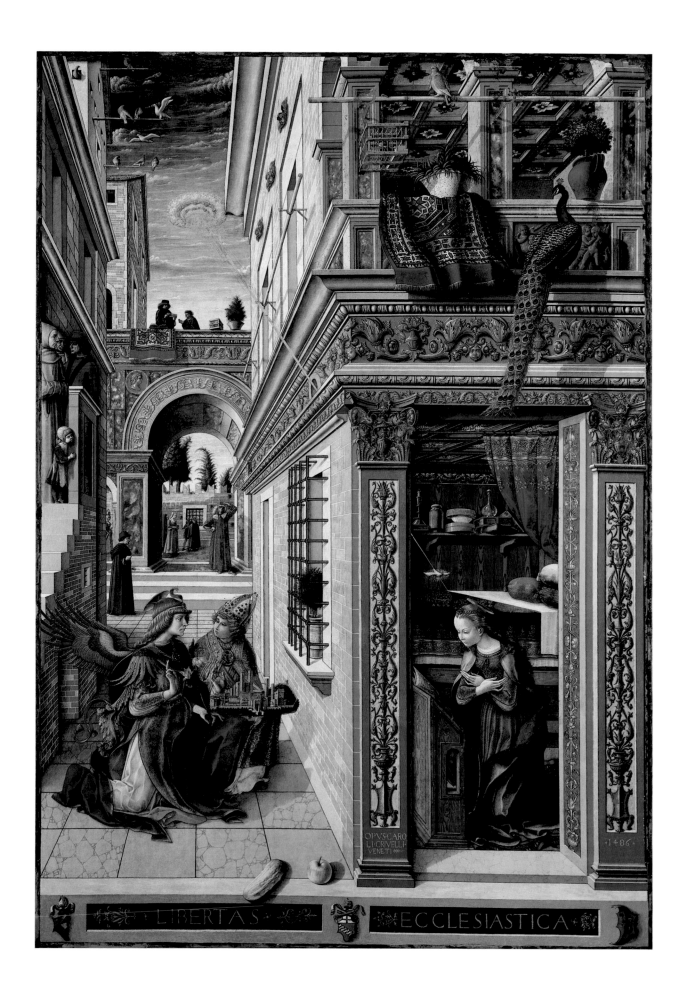

LIBERTAS · ECCLESIASTICA ·

52 The Virgin and Child Enthroned, with Four Angels *c.*1490-5

Oil on oak, painted surface 62 x 43cm (NG 6282)

Massys was born in Louvain, but was active at Antwerp from 1491, where he was the leading painter of his time; he died in 1530.

This small devotional painting was probably produced very early in Massys's career and is indebted to van Eyck, whose work was deliberately echoed and even copied by many painters working at the end of the fifteenth century. Here van Eyck's influence is evident in the gilded Gothic architecture of the Virgin's throne, in the carpet beneath, and in the crown carried by the angel on the right. The painting also resembles a composition which apparently originated in the circle of Robert Campin (Fig. a), in which the Virgin is shown standing in an apse, against a gilded throne similar to that in Massys's picture.

Fig. 52a. After Robert Campin(?), *The Virgin and Child with Two Angels*, early sixteenth century(?). Oak, painted surface 56×44cm (NG 2608).

In other small paintings of the Virgin by Massys, which are probably later in date, the thrones are, by contrast, of beautifully rendered marble – in the representation of which Massys was particularly skilled – and Gothic arches are replaced by rounded ones.

The painting is dominated by the gold leaf of the Virgin's throne, the volume of which has been created by painting hatched lines directly over the gold. Elsewhere in this picture, when gold might have been expected, and would certainly have been used at an earlier date, Massys has chosen to make his effects with yellow paint, in places particularly thickly applied. The rays of light making up the haloes of the Virgin and Child are, for instance, created out of long straight ridges of paint, and the crown consists of dots of paint imitating the effects of glancing light. Similarly, the 'gold' embroidery edging the Virgin's robe is merely yellow paint, applied discontinuously, so that its presence indicates light glancing off gold thread, while its absence mimics the dullness of gold when the folds of the robe fall into shadow.

Despite the overall grandeur of the theme of the Virgin as Queen of Heaven, as in other Netherlandish depictions of the Virgin and Child the infant Christ is shown behaving like a human baby (compare No. 42). Here he peers shortsightedly at the book held by his mother and plays with its bookmark.

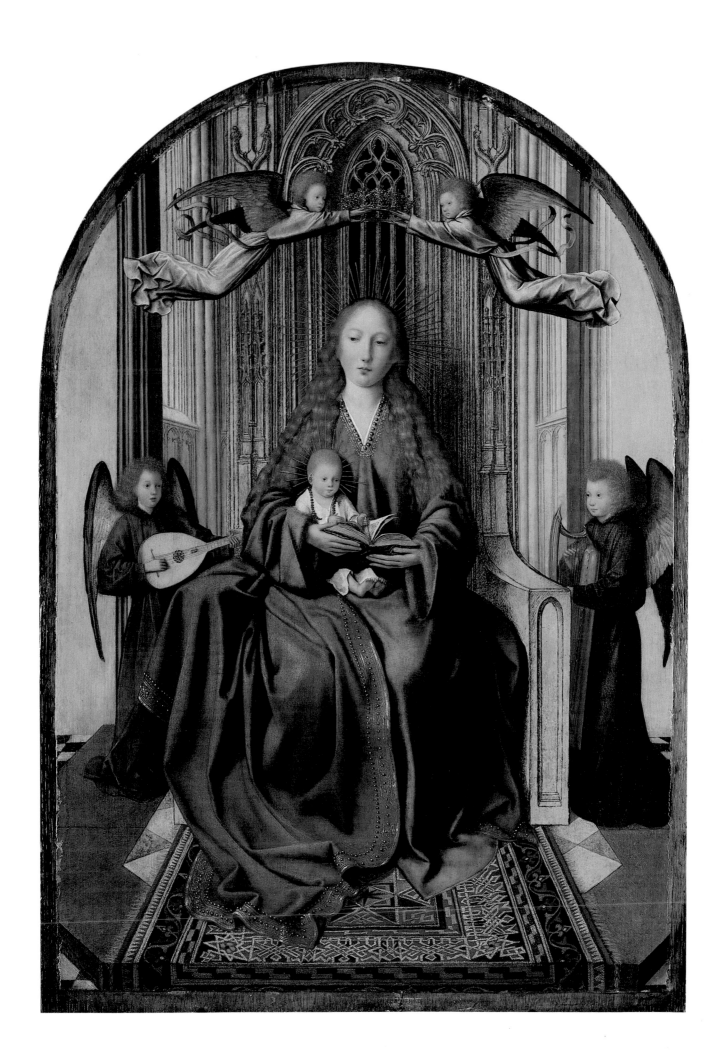

53 Christ Mocked (The Crowning with Thorns) *c.* 1490-1500

Oil on oak, painted surface 73.5 x 59cm (NG 4744)

Bosch is recorded at 's-Hertogensbosch (Bois-le-Duc) from 1474 and died in 1516. His name rapidly came to be associated with fantastic and demonic subjects, which constituted an important part of his work as an artist. His paintings were much admired by Italian and Spanish collectors in the sixteenth century.

Fig. 53a. Detail of infra-red photograph of No. 53.

Bosch painted a number of versions of this subject, in which the depiction of the mocking of Christ, often included in narrative cycles of the Passion, was turned into a devotional image for the beholder to meditate on Christ's suffering. A praying donor figure is included in a rendering of one of Bosch's compositions of this type by an unknown artist (Antwerp, Koninklijk Museum voor Schoone Kunsten), making the devotional purpose of the painting explicit.

Bosch was not the only artist to be producing such images at the end of the fifteenth century (compare Fig. 85): there seems to have been a considerable market for the theme of the suffering Christ. Bosch places his emphasis on the extreme contrast between the mild, passive Christ and the brutality of his tormentors, one of whom grasps the crown of exceptionally spiky thorns in an armoured fist, preparatory to forcing it down on Christ's head, while another prepares to tear his garment. The lack of any specific background and the employment of half-length figures are characteristic features of this kind of devotional image. It has been suggested that the National Gallery picture is the earliest of Bosch's paintings of this type.

The characterisation of the four tormentors is more than merely grotesque: specific attributes are given them which are a reflection of popular accounts of Christ's Passion circulating in the Netherlands in the fifteenth century. Christ's torturers were frequently compared to savage dogs, for instance, and the man shown top right wears a spiked

collar of the type worn by such dogs. The man lower left has a star and crescent on the end of his headdress: in paintings of the Passion at this period the tormentors of Christ are often shown wearing the yellow star marking them as Jews. The star and Islamic crescent may indicate that he is in every sense an infidel.

Bosch characteristically used a thinner, less richly glazed paint than his Netherlandish contemporaries, which, as can be seen here, was freely and rapidly applied. The transparency of the paint in some areas, particularly those of the flesh – as well as infra-red photography (Fig. a) – allows us to see the way in which he laid out the composition. Christ's body, for instance, has been rapidly sketched in with thick brushstrokes, as have the hands of the man seizing his garments. Some changes to Bosch's first ideas are visible: Christ's cloak was to have been fastened with a large clasp, perhaps rejected as too distracting, while the left hand of the man top right originally grasped Christ's shoulder. The man top left was to have had a moustache of a type seen in other paintings by Bosch. Two kinds of underdrawing seem to have been used, for as well as the broad brushed strokes there are some much finer, more tentative strokes. This is paralleled in the finished painting by some areas which have been executed very carefully with several layers of paint. The result is that certain details, such as the sprig of oak with acorns top right, appear almost to lie on the surface of the picture, as though Bosch had intended to paint them in *trompe l'oeil*.

54 A Mythological Subject *c.* 1495

Oil on poplar, 65 x 183cm (NG 698)

Piero di Cosimo, the son of a goldsmith, is recorded in 1480 as a pupil of a Florentine master, Cosimo Rosselli, after whom he was named. He died in 1515. He was noted for his highly inventive festival designs as well as for the fantastic ideas in his paintings.

The subject has not been identified, but it may relate to the story of Cephalus and Procris. According to Ovid, Procris received false reports of her husband Cephalus and spied on him when he was resting after the hunt. He heard a noise and threw a spear, supposing her to be a wild animal, mortally wounding her. The satyr mourning her is not mentioned in Ovid's version of the story but is included in a play by Niccolò da Correggio which was performed at a marriage ceremony at the court of Ferrara in 1486. This episode could be taken as a warning of the dangers of wifely jealousy and hence thought fitting also as part of the decoration of a Florentine *camera*, the occasion for which was so often a wedding (see pp.108–13). The painting would in any case probably have adorned a *spalliera* – the backboard of a bench or chest – in such a room. Such paintings were often made in pairs and the companion piece would perhaps have made the subject clear.

There is another *spalliera* painting by

Piero di Cosimo in the Gallery, representing the Fight between Lapiths and Centaurs (Fig. a). It is cruder in sentiment but also reveals a sympathy with the animal (or half-animal) world, which reminds us of Piero's eccentricities – he would not permit plants to be pruned and rejoiced in watching wild animals. Some of his other paintings have odd subjects of his own choosing, taken from the history or fables of primitive man. He was not alone in such interests, however, and charming and licentious satyrs and fauns became popular as the subjects of small bronze statuettes at the end of the fifteenth century when this painting was probably made.

The paint has become transparent with time and bold underdrawn lines can be seen: the dog in the foreground was once intended to have an open jaw; the poses of the other dogs were revised; strands of the satyr's hair fell down over the blue hill and his left hand was in a slightly different position. Much of the sky has been worked with the fingers.

Fig. 54a. Piero di Cosimo, *The Fight between the Lapiths and the Centaurs, c.* 1500. Poplar, 71×260cm (NG 4890).

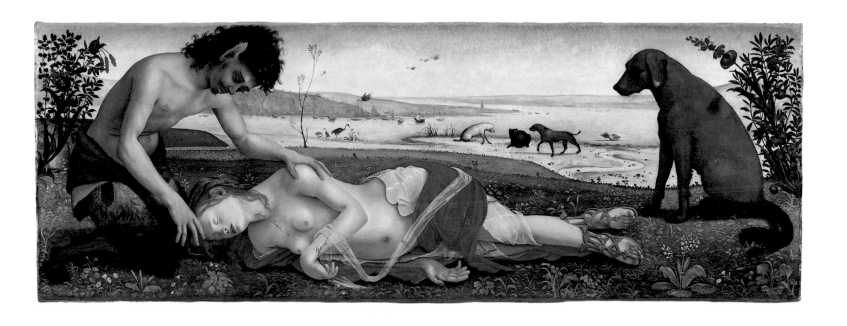

55 The Painter's Father 1497

Oil on lime, painted surface 51 x 39.7cm (NG 1938)

Dürer was born in Nuremberg in 1471. He was apprenticed to Michael Wolgemut in 1486-9 and worked in the city until his death in 1528, except for journeys to the Upper Rhineland in 1489-94, to Venice in 1506-7 (and perhaps earlier, in 1494-5), and to the Netherlands in 1520-1. A pioneer in the graphic arts as well as a painter and the author of theoretical writings on art, Dürer was one of the greatest European artists of his age.

Fig. 55a. Albrecht Dürer, *Portrait of Albrecht Dürer the Elder,* 1490. Wood, painted surface 47×39cm. Florence, Uffizi.

Dürer's father was a goldsmith of Hungarian origin who had settled in Nuremberg in 1455. Dürer first painted his portrait in 1490 (Fig. a). A copy of the National Gallery painting at Bamberg includes an inscription which suggests that this later image of his father was conceived in parallel with a self portrait, painted in 1498 and now in the Prado, Madrid (Fig. b), although not necessarily as a companion picture. The two portraits, though both half lengths – a format Dürer used often in his portraits – are different in pose and background. Dürer's self portrait shows him finely dressed, posed against an open window through which a landscape is visible. In the portrait of his father, Albrecht Dürer the Elder is shown against a streaky red background, wearing a plain fur-lined coat. Since the painting of the face is superior to that of the rest of the picture, it seems possible that this part alone was completed by Dürer, and that he may have intended a different type of background for the portrait, conceivably one which echoed in some manner the Prado self portrait. The Prado picture was presented to Charles I, King of England, by the city of Nuremberg in 1627, and the National Gallery picture is likely to have been the portrait of Dürer's father known to have been with it.

Dürer produced relatively few paint-

Fig. 55b. Albrecht Dürer, *Self Portrait,* 1498. Painted surface 52×41cm. Madrid, Prado.

ings during his career and did not consider himself primarily a painter. It is not surprising therefore that his paintings, and this one in particular, are executed in a technique which seems to have more in common with his drawings. The paint is thinly applied, and in order to create a strongly characterised individual Dürer places more emphasis on delineating the contours of the face and features, the curling locks, the individual hairs of the eyebrows and the sagging wrinkles, than on the creation of a sense of volume.

56 'Mystic Nativity' 1500

Oil (tested) on canvas, 108.5 x 75cm (NG 1034)

For his biography see No. 37.

The painting represents the Virgin (who is larger than the other figures) kneeling in adoration before the new-born Christ in front of the stable (in this case a thatched roof supported by rough tree trunks attached to a cave), watched by the ox and ass and by Joseph, while angels sing. The subject is essentially the same as in Piero della Francesca's painting (No. 36), but this is not an altarpiece: it is a private devotional work and it includes peripheral episodes, as well as an inscription across the top which hints both at the mystic significance of the Nativity and at some topical significance.

The three mortals to the left of the Holy Family must represent the Three Kings, the two figures to the right are obviously shepherds. The angels carry scrolls with Latin texts: those in the sky refer to the Mother of God, the Sole Queen of the World; those held by the angels escorting kings and shepherds must have read: 'Behold the Lamb of God which taketh away the Sins of the World', the words with which John the Baptist announced Christ (John 1, 29). The scrolls in the foreground combine with some in the sky to read: 'Glory to God in the highest, And on earth peace, goodwill toward men' (Luke 11, 14). The mortals are crowned with olive, an emblem of peace. Angels carry branches of it and seem to have presented the branches to two of the three mortals whom they embrace. Little devils scatter into holes as they do so.

At the top of the painting there is a text in Greek which has been translated: 'I Alessandro made this picture at the conclusion of the year 1500 in the troubles of Italy in the half time after the time according to the 11th chapter of Saint John in the second woe of the Apocalypse during the loosing of the devil for three and a half years then he will be chained in the 12th chapter and we shall see . . . as in this picture.' The word lost may be 'Heaven'. The 'half time after the time' has generally been taken to mean a year and a half before, that is, in 1498, when the French king invaded Italy and Cesare Borgia invaded Romagna, but it may mean a half millennium (500 years) after a millennium (1000 years), reinforcing the significance of the first date. Many felt that the world was likely to end, or that some great change in the world would occur after 1500. For the exact nature of this end or change people turned to the cryptic prophecies of the *Revelations* of Saint John.

Whereas the central part of the composition has a harsh and even ugly angularity (especially in the relationship of the roof to the cave and the trunks), in the circle of twelve angels dancing the angularity is essential to the complex, delightful and vital pattern. The diagonal of each figure crosses the horizontal bars of pale green and rose dawn clouds and overlaps with the diagonal of another figure, each diagonal complicated by flourishes of drapery and curls of scroll. 'Shell gold' is used extensively for the highlights not only on the clouds but also on the hay of the roof and on the drapery of the angels – enlivening the green robes (now much darker than the artist intended) to particularly fine effect.

57 The Madonna of the Meadow *c.* 1500-5

Oil and egg tempera (underpaint only analysed) on synthetic panel
(transferred from wood), 67 x 86cm (NG 599)

For his biography see No. 31.

Fig. 57a. Detail of No. 57.

Bellini and his workshop produced numerous domestic devotional paintings of the Virgin and Child, usually of a vertical format (see Fig. 78). The horizontal rectangle used here had the advantage of enabling the artist to include more landscape. The infant Christ, generally depicted as awake and active in the Virgin's arms or on the ledge which is commonly placed across the lower part of the painting, is here asleep, and the Virgin's hands are joined in prayer. In none of the other paintings of this type by Bellini and others, large or small, is the Virgin represented seated on the ground as in the Madonna of Humility (see p. 44). It has been supposed that the sleep of Christ (see also No. 44) may have been seen as foreshadowing his death.

The relationship between the Virgin and the landscape is not clear. The figure of the Virgin is equivalent to an equilat-eral triangle, the base of which fills most of the lower portion of the painting. A meadow gives way to a strip of barren terrain, and then there is cultivated land with a small hill town and more distant hills rising in the distance – a landscape typical of the flat alluvial mainland provinces of Venice from which the foothills of the Alps can be seen. In this landscape a large raven in a tree solemnly regards a large white wading bird in stately combat with a snake, which may be a symbolic episode, but was perhaps not an uncommon sight. At that time such birds may have been no more rare than the slow-moving cattle, the well, the fencing, the trees (stripped of all lower branches), the labourers, one of them seated on the ground (in the attitude Bellini later gave to Mars in his famous *Feast of the Gods*). None of these things possesses special intrinsic beauty or interest: it is the composition and the light which make them so attractive. Such painting must have been based on studies made from life and we may suspect that Bellini preferred to paint what he could see. When he was asked in the autumn of 1497 to represent the city of Paris (perhaps in a background) in a painting for the Marquis of Mantua he replied that he could not do it because he had not seen it.

The flesh, and to a lesser extent the drapery, in this painting is damaged, as is immediately apparent when it is compared with No. 60. Some of the stiffness of drapery in the *Agony in the Garden* (No. 31) is retained, but there is now none of the crinkling so beloved by Mantegna. Both the landscape and the drapery in Bellini's painting of the Baptism in San Corona, Vicenza – the frame for which was being assembled in 1502 – are very similar in character and this painting is likely to belong to the same period.

58 Charlemagne and the Meeting of Saints Joachim and Anne at the Golden Gate *c.*1500

Oil, perhaps with some egg tempera, on oak (a fragment), painted surface 72 x 59cm (NG 4092)

The artist is named after a triptych in Moulins Cathedral and is assumed to have been active from before 1483 to around 1500; it is now generally accepted that he is identical with the painter Jean Hey.

Fig. 58a. The Master of Moulins, *The Annunciation, c.* 1500. Wood, painted surface 72×50.2cm. Art Institute of Chicago, Mr and Mrs Martin A. Ryerson Collection.

This is one of two surviving fragments of what is presumed to have been a rectangular altarpiece. The other fragment (cut on the left edge) depicts the Annunciation (Fig. a) but the subject of the central part of the painting is unknown, and its appearance can only be guessed at. Some clues are provided by the fragments. Both of them include a patch of leafy grass, in the lower right-hand corner of the National Gallery fragment, and in the lower left-hand corner of the other picture. The National Gallery fragment also includes on the right-hand side a piece of brocade hanging. The central scene must therefore have been arranged against a background of brocade, with grass running underneath. On the right of the National Gallery picture is the figure of the Emperor Charlemagne (see p. 18), often included in altarpieces as though he were a saint, and it has been suggested that the figure which would presumably have appeared on the right-hand side could have been Saint Louis, the French king who is sometimes associated with Charlemagne in paintings.

On the right-hand edge of the National Gallery fragment is a narrow unpainted strip descending nearly halfway down the painting. The reason for this is unclear, but it may originally have been covered by part of the frame, which perhaps also helped to divide the painting into three separate scenes.

The meeting of Joachim and Anne, the parents of the Virgin, said to have taken place at the Golden Gate of Jerusalem – shown here as a medieval walled city with a gate decorated with the Italian-inspired motifs becoming popular in France – was frequently included in cycles of the Life of the Virgin. According to contemporary theologians the story illustrated her miraculous conception at the moment of her parents' embrace. Since the right-hand side of this painting depicted the Annunciation, usually taken as the moment at which Christ was conceived, it has been suggested that the altarpiece would have expounded the mysteries of the conception of the Virgin and of Christ, and that it might have been painted for the altar of the Conception in Moulins Cathedral. The central scene might have shown the Crucifixion, or the Virgin and Child.

Cleaning has revealed that the doubts about the quality of the painting, which had been held to be inferior to the right-hand fragment, are groundless, and that it is almost certainly the work of the Master of Moulins, Jean Hey, himself. Although the shadows created by the folds of Saint Anne's dress are damaged, so that it appears flat, the painting of Charlemagne's surcoat is particularly skilful. The brilliant green, scarlet and crimson used in the painting combine to dazzling effect.

59 The Virgin adoring the Child, the Archangel Raphael with Tobias, and the Archangel Michael *c.* 1500-5

Oil with some tempera (analysed) on poplar, central panel 127 x 64cm (cut down);
side panels 126.5 x 58cm each (cut down) (NG 288)

Pietro Vannucci who worked mostly in Perugia (after which town he was named Perugino) is likely to have been born in 1452 or a little earlier. He is listed in the Confraternity of Saint Luke in Florence in 1472 and may have worked for Verrocchio (see No. 39). His earliest dated work is of 1478. By the early 1480s, when he was in Rome, he was one of the most famous artists in Italy, and by the 1490s one of the most prolific as well, based both in Florence and Perugia and working in many other towns, with a large workshop. After about 1505 his work declined in reputation in Florence. His output did not diminish for another decade, but when he died in 1523 he was regarded as a minor and provincial painter.

The Archangel Raphael, venerated as a saint, is accompanied by Tobias whom he escorted on his travels as represented in independent paintings such as No. 39 (where the story is told). This panel was part of a polyptych and the saint stood to the right of the central one representing the Virgin adoring the Child. The painting of Saint Michael was placed to the left. These two archangels were commonly prayed to together. As usual (see Nos. 45 and 46) Michael is represented in armour – in this case contemporary plate armour but with a fanciful shield upon which he rests a commander's baton. The scales which were a traditional attribute (as explained under No. 45) are hanging on the branch of a tree nearby. Below the tree the painting is signed PETRVS PERV-SINV[S]/PINXIT.

All three of the Gallery's paintings have been cut down and only a small portion of Lucifer (Satan) is now visible at the bottom (it was overpainted when the painting was cut). Tobias's dog suffered similarly. The landscape background may have been continuous behind the divisions of the frame. The polyptych was originally composed of six parts. Above the parts so far described there was a lunette of God the Father in a mandorla with cherubim looking down at Christ, and to either side of this the Angel Gabriel and the Virgin forming an Annunciation.

The polyptych was probably commissioned in 1496 or shortly before for the Certosa, the Carthusian monastery near Pavia in the Duchy of Milan, together with an altarpiece by Filippino Lippi. Filippino (see No. 48) and Perugino were then probably the two most highly esteemed artists working in Florence. The commission was associated with, even if it did not come directly from,

Duke Lodovico il Moro, the ruler of Milan, whose palace was at Pavia and to whom the monastery was especially dear. He was displeased in May 1499 that the artists had not produced the paintings (see p. 133). Filippino had still not done so when he died in 1504. It is unlikely that Perugino completed his work on the altarpiece, for the two panels forming the Annunciation are by another painter.

The three works in the National Gallery are likely to date from the late 1490s when Perugino was at the height of his powers. The richness of the colours, which derives from the artist's use of oil paint (see p. 204), is remarkable but the attention to textures and to reflections is still more so. Perugino certainly made drawings from life but he did not usually paint what he saw, and yet here the pile of Tobias's tunic, the reflections of light (and of the curling central strap) in Michael's armour, and above all the reflections on the head and scales of the fish, look as if they have been studied from real velvet, metal and fish, as would be the case in a painting by one of the great Netherlandish masters.

Two careful preparatory metalpoint drawings exist for the paintings. One, in the Royal Library, Windsor, is a study for Saint Michael, – not for his pose (which is taken from Donatello's famous statue of Saint George in a niche at Orsanmichele in Florence) but for his armour. The other, in the Ashmolean Museum, Oxford, is for the group of Raphael and Tobias, for which an assistant and a boy in the workshop seem to have posed (see p. 147 and Fig. 189). In the painting the heads have been given the sweet and angelic 'air' which contemporaries so much admired. The finery and hairstyle do not reflect the latest Florentine fashions as closely as did

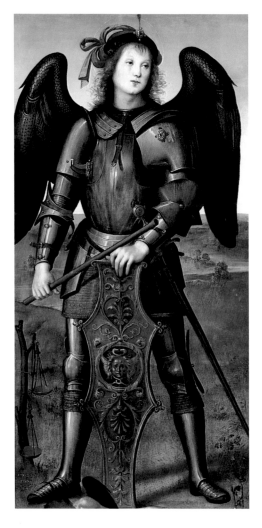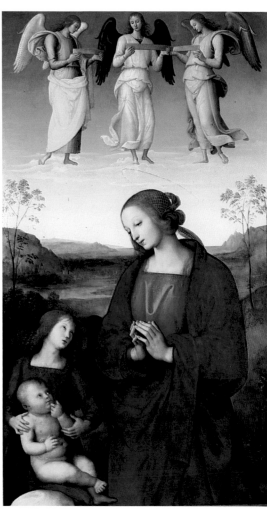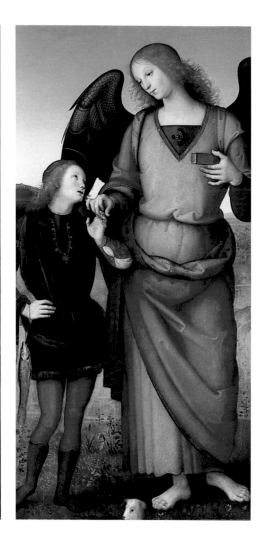

Fig. 59a. Detail of No. 59.

those in earlier Florentine paintings (such as No. 39), and so here too Perugino's creation of an ideal world is evident. It was a world with little variation in it. All the trees and flowers and figures are delicate, and all the heads – here notably those of Raphael and the Virgin – are very similar.

Many differences may be observed between the drawing of Raphael and Tobias and the painting. The underdrawing of the painting reflects further changes of mind (most clearly visible in the joined hands of Raphael and Tobias). Only the three angels of the central panel appear to have been transferred by means of pouncing from a preparatory cartoon, with little if any modification. Moreover, it is clear that they were painted over the underpainting of the sky. This suggests that they might have been an afterthought (perhaps inserted at the patron's wish). They were used by Perugino in at least one other painting of the same period (the *Nativity* in the Collegio del Cambio in Perugia) and do not look as if they were originally designed for the National Gallery's painting.

Fig. 59b. Detail of No. 59.

60 The Doge Leonardo Loredan *c.*1501-5

Oil, probably with some egg tempera, on poplar, 61.5 x 45cm (NG 189)

For his biography see No. 31.

The painting is signed on the small paper or parchment label attached to the marble ledge IOANNES BELLINVS – paintings by the artist's workshop are similarly signed, but this portrait is certainly by Bellini himself. It is both the most admired portrait by him to have survived and probably the best preserved of all his known paintings. The sitter was the Doge, that is, the elected ruler of the republican oligarchy of Venice, Leonardo Loredan (1436-1521). A date near 1500 would fit well with what is known of Bellini's style around this date (see No. 57), and the Doge looks like a man still in his sixties, as he was when elected in 1501.

The transparency of the shadows strongly suggests that the painting is in an oil medium. The paint also has a certain amount of relief – impasto – of a kind impossible in tempera. This is most evident in the cape and the horned cap which were the ceremonial dress of the Doge.

This style of dress was ancient, but the damask was a novelty. It includes gold thread, but Bellini has not used gold to represent this as he would probably have done early in his career. When examined closely the paint will be seen to be deliberately rough to represent effects of light on the thread rather than details of stitching. In this respect the painting foreshadows some of the most revolutionary painting by later Venetians.

The features are immobile, as was typical of Bellini's portraiture, but every part of the face seems to possess the potential for change. The lips are about to smile and the eyes about to move. The background is blue, which increases in intensity towards the top of the painting. The contrast between the blue and the flesh, clothes and the loose cap lace, lit on one side and shaded on the other, makes it hard to believe that it is in fact the same blue on both sides of the face.

IOANNES BELLINVS

61 The Crucified Christ with the Virgin Mary, Saints and Angels *c.*1503

Oil (analysed) on poplar, 280.7 x 165cm (NG 3943)

Raphael was born in 1483, the son of Giovanni Santi, an artist and poet attached to the court of Urbino. Raphael's earliest recorded paintings were made for Città di Castello and Perugia. Between 1504 and 1508 he worked in Florence, but also in Perugia. By the end of 1508 he was in Rome, decorating the apartments of Pope Julius II in the Vatican. Thereafter he served the Papal Court as a painter, architect and archaeologist until his death in 1520. By then he was regarded as a genius rivalled only by Michelangelo.

Fig. 61a. Detail of No. 61.

The painting is not a narrative representation of Christ's Crucifixion but an image of his sacrifice upon which we can meditate as the saints do in the painting. The angels collecting the blood from Christ's wounds reinforce the sacramental character of the image (see pp. 37–8). The Virgin and Saint John stand beside the cross, but the kneeling Saint Jerome and Mary Magdalene are more prominent: both of them are associated with penance (Jerome has his chest exposed in order to beat his breast with the stone in his right hand). Mary Magdalene was present at the Crucifixion, but Jerome lived five centuries later.

The painting was made for a side altar dedicated to Saint Jerome in the church of San Domenico in Città di Castello where its original carved stone frame is still in place, prominently inscribed as made in 1503 for Domenico Gavari, and carved with his arms – a hand holding a cross. There were originally three predella panels below, of which two (in Raleigh, North Carolina, and in Lisbon) survive. Both panels depict episodes in the life of Saint Jerome.

Vasari observed of this painting that it would have been thought to be by Perugino had it not been signed by Raphael. The handling, especially the thin painting of the flesh contrasted with the thicker, richer colours beside them, is typical of Perugino; as are the colours themselves, above all the startling pink worn by the Magdalen which is lemon yellow in the highlights and crimson in the shadows, and the mannerisms of the drawing, such

as the hooked folds in Jerome's robe (see Fig. 285) and the bent little fingers. The scaly wings and thin cloud platforms of the angels; the soft landscape in which copses appear like bubbles and a few individual trees arise with impossibly delicate stems; the fragile physique, unstable poses, meekly folded hands of the saints, and their tender and tranquil expressions – all of this is also derived from Perugino.

That Raphael was in some sense a pupil of Perugino is clear, but there are good reasons for doubting that he was Perugino's apprentice, as has often been assumed. His earliest documented paintings – those of about 1500 – are far less close to Perugino than this one, which was perhaps commenced in 1502 and whose frame is dated 1503. In 1500 Raphael is described as a master, so if he was closely associated with Perugino in 1501 or 1502, then it was perhaps as an assistant. It is possible that Raphael simply studied and absorbed Perugino's manner, as he later learnt from Fra Bartolommeo, Leonardo and Michelangelo.

What would have been unusual in Perugino is the linear elegance of the angels' flourishing sashes and the curvature of their wings and the lucid geometry of the segmental curve upon which the heads are placed, answering the arched shape of the panel. Typically, Raphael's lettering is beautifully spaced and wrought – that of his name on the foot of the cross (Fig. a) was scratched through paint to reveal silver leaf. This is the only part of the painting to be influenced by antique Roman art.

62 The Deposition *c.* 1500–5

Oil on oak, 74.9 x 47.3cm (NG 6470)

The artist is named after the Saint Bartholomew Altarpiece in Munich (No. 67b), and was active in Cologne towards the end of the fifteenth century and in the first decade of the sixteenth century. He was the outstanding Cologne painter of this period.

The early history of this small picture is unknown, so it is uncertain whether it was painted as an altarpiece for a church, or whether it could have been a domestic altarpiece or devotional picture, as is perhaps more probable. There are no coats of arms or other indications of ownership.

The scene appears to take place within a carved shrine, and thus to mimic the sculpted tabernacles made in the fifteenth century which were adorned with Gothic tracery and in which figures were carved almost in the round. Many painters, notably the great Netherlandish artist Rogier van der Weyden who was an important influence on Cologne painting (see No. 37), painted compositions of this type. A number of works by the Saint Bartholomew Master adopt a similar format, in particular the much larger version of the subject painted by him (Fig. a); both pictures may date from the early years of the sixteenth century.

All the traditional elements of the Deposition of Christ in painting of this

period are present: on the left the Virgin, supported by Saint John; standing on the right Mary Magdalene; and Joseph of Arimathea, who receives Christ's body from Nicodemus. Other aspects of the picture, however, suggest that its function was devotional rather than purely narrative. The absence of any landscape other than the stony foreground immediately concentrates attention on the drama of the expressively grieving figures carefully grouped around the dead Christ, and on such prominent and significant details as the skull and nail in the foreground and the crown of thorns held by one of the Maries. The pale, plainly dressed Virgin slumps in a faint, while the grief-stricken Magdalen in her brocade dress holds her hand to her head in despair. The Virgin is comforted by Saint John, the Magdalen by one of the Maries, whose quiet expression of sorrow is mirrored by the gesture of prayer made by the Mary on the left. All are red-eyed and shed glistening, over life-size tears.

At the centre of the picture the stiffness of Christ's body, his arms still flung out in *rigor mortis* as they were fixed on the cross, contrasts with the extraordinary contortions and spidery limbs of the figures handing him down from the cross. The picture is clearly designed to offer matter for meditation, in the manner of contemporary devotional manuals. The style of the Master of the Saint Bartholomew Altarpiece, combining expressive elements drawn from Rogier van der Weyden, notably the prominent tears, with a love of complex compositions and curving patterns, was well suited to catching and retaining the attention of the viewer.

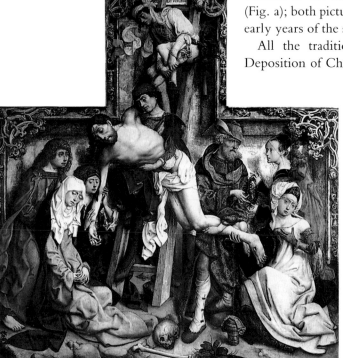

Fig. 62a. The Master of the Saint Bartholomew Altarpiece, *The Descent from the Cross, c.* 1510. Wood, painted surface 227.5 (at highest point) ×210cm. Paris, Louvre.

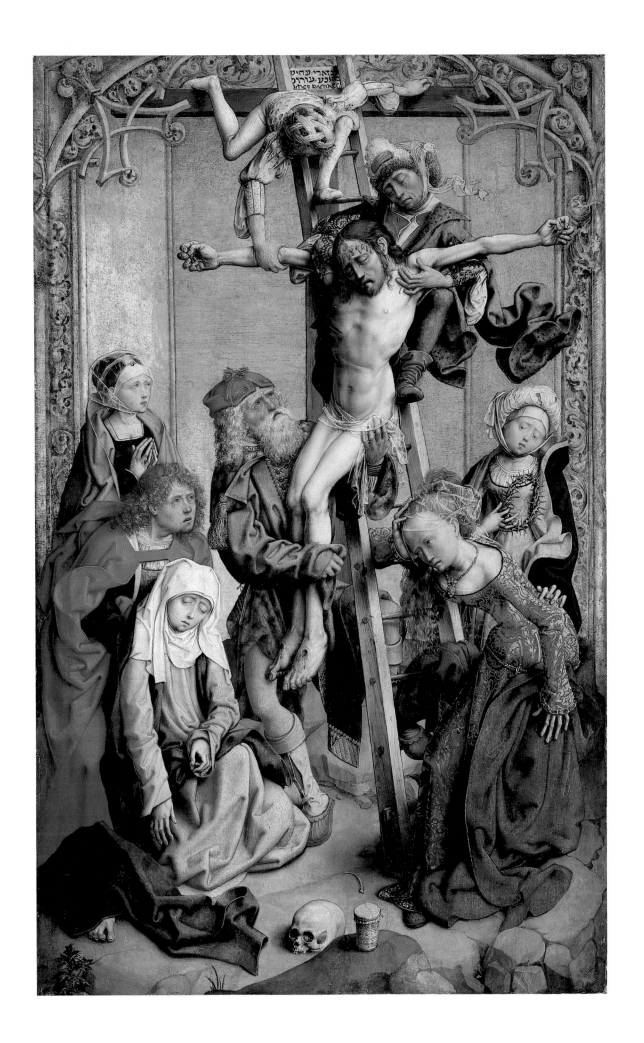

63 An Allegory ('Vision of a Knight') *c.* 1504

Egg tempera (tested) with some oil on poplar, 17.1 x 17.1cm (NG 213)

For his biography see No. 61.

Fig. 63a. Raphael, *Three Graces, c.* 1504. Oil on wood, 17×17cm. Chantilly, Musée Condé.

Fig. 63b. Attributed to Benvenuto di Giovanni, *Allegorical Scene*, late fifteenth century. Venice, Ca d'Oro.

The painting may illustrate an episode in *Punica*, an ancient Latin epic poem of the Punic Wars by Silius Italicus. While resting beneath a bay tree, Scipio Africanus Major (236-184 BC), the hero who would drive the Carthaginians from Italy, has a dream in which he is presented with the choice which once faced Hercules, the choice between Virtue and Pleasure. Pleasure in the poem has fragrant hair and is loosely draped with a shining robe, corresponding with the woman on the right. Virtue, who wears white in the poem and conducts herself more soberly, informs the hero that her dwelling is on a hill reached by a steep and rocky path, and this can be seen behind her in the painting.

It was conventional to liken a young knight to Scipio, and a painting like this would have made a flattering and edifying present at court. At least one other allegorical painting of similar character and from the same period survives: the polygonal panel in the Ca' d'Oro in Venice (Fig. b) in which a nude youth is invited by one lady to join a nude swimming party and by another to take a mountain path guarded by lions. That allegory is probably not a reference to Scipio (there is no bay tree, and no suggestion of a dream), and although Raphael's painting surely is of Scipio it is not an accurate illustration of the poem. The ladies are not contestants, as they are in the poem, and the book, sword and flower which they hold in the painting

are not mentioned in it. These attributes would seem rather to stand for the aspirations of the scholar, soldier and lover; that a young knight should be all of these, but especially the first two, was a commonplace in courtly literature.

The *Allegory* was recorded in the seventeenth century together with a painting of identical size, the *Three Graces* at the Musée Condé (Fig. a). They do not make a very good pair (the figures are not the same size) but they might have served as covers for a pair of portraits. The *Three Graces* may also refer to the gifts possessed by a young knight or more probably by his sister, his betrothed or his wife. Both paintings must date from about 1504. The tilt of the heads, Pleasure's scarf, the knight's armour all suggest Perugino, but the debt is less obvious than in the Crucifixion (No. 61).

The painting combines a daring variety of blues – the distant hills, the sky, the dress with its pink highlights worn by Pleasure, the more violet blue worn by Virtue, the blue of her book. The execution is more minute and careful than in the predella panels of similar size of the same period (see No. 65) because the painting was designed to be held in the hand and examined closely. The tranquillity of the scene (inappropriate to the contest in the poem), like the contemplative character of the Crucifixion, owes much to the nearly heraldic symmetry. A cartoon (Fig. 226) for the painting survives and is discussed on p. 169.

Glue size (analysed) on linen, 73.5 x 268cm (NG 902)

For his biography see No. 30.

In 204 BC during the Punic Wars, Cybele, goddess of Mount Ida, known as the Mother of the Gods, was carried, in the form of a small round stone which had fallen from heaven, from Pessinus in Asia Minor to Rome. The prophetic Sibylline Books made this a precondition for the expulsion of the Carthaginians from Italy. The Oracle consulted at Delphi by those who conducted the stone foresaw success if the goddess was received by the most worthy man in Rome, and the Senate designated a young man of great family, Publius Cornelius Scipio Nasica, to perform this honour. The vessel carrying the stone ran aground but a Roman matron of tarnished moral reputation, Claudia Quinta, pulled it free with her girdle (a miracle which was held to prove her chastity). The story is told by Livy, whose account can be supplemented by Valerius Maximus and by Ovid's *Fasti*. Mantegna seems to have studied all these sources.

Mantegna represents a litter carried into Rome by the goddess's priests, with the sacred stone, a bust of the goddess (wearing a mural crown to identify her as a goddess of a city or city state), and a lamp on top. The procession is regarded

with curiosity and a certain reserve by a group of Roman senators, wary of Oriental cults. Among them, in profile, gesturing with his right hand is Scipio. To the right a bearded man in a turban, perhaps a soothsayer, eagerly expounds the sibylline mysteries to a Roman soldier. In the centre of the painting kneels a figure with wild hair and an hysterical expression: this is perhaps intended for Claudia Quinta giving public thanks to the goddess, but may be meant for one of the self-castrated worshippers of the goddess. The figure gesturing to this supplicant and turning back to the goddess must certainly be one of her worshippers for he wears oriental trousers. The tombs behind on the left bear neat Roman inscriptions to Scipio's father and uncle recently killed in Spain fighting against the Carthaginians. These were placed on the Via Appia so the procession may be imagined as on the road into Rome. Two episodes may, however, be condensed, for the steps to the right of the picture must represent the entrance to Scipio's own home where the image of the goddess was for a while kept. The inscription below the figures, 'S hospes Numinis Idaei C', means that

OPPOSITE Fig. 64a. Detail of No. 64.

S·P·Q·R
GN·SCYPIO
NI·CORNELI
VS·E·P

S HOSPES NVMINIS IDAEI C

by decree of the Senate (SC = Senatus Consulto) hospitality was given to the goddess of Ida (the three words are taken from the third Satire of Juvenal).

The painting was one of a series commissioned in March 1505 by Francesco Cornaro (1481-1546), a Venetian nobleman and nephew of the Queen of Cyprus, whose family claimed descent from the *gens Cornelia*, the clan of the Scipios. Permission had first to be obtained from Mantegna's employer, the Marquis of Mantua. This was achieved by Francesco's younger brother Cardinal Marco Cornaro, Bishop of Verona, using as his emissary Giovanni Bellini's brother Niccolò. On 1 January 1506 Pietro Bembo, a kinsman and friend of the patron, wrote to the Marchioness of Mantua, Isabella d'Este, asking her to intervene since Mantegna had agreed to make the paintings months before but was now claiming that he could not continue with the work unless payment was increased.

When Mantegna died on 13 September 1506 the series had not been completed, although this particular painting was finished, and other collectors were anxious to possess it. The other compositions had been worked out but nothing is known of them. Cornaro seems to have turned to Bellini. A simulated relief by him showing another Scipio, Publius Cornelius Scipio Africanus, after the conquest of Carthage nobly restoring to Prince Albricus his betrothed rather than making her a concubine and him a slave, must have been intended for the same room (Fig. b).

That Mantegna's painting was one of a series is suggested by the way the drummer boy on the right looks out of the composition. The perspective of the steps to the right is calculated for a low viewing point and the painting must have been intended to hang high in a room. It would have been equivalent to a sculptural frieze in antique architecture.

Whereas the figures are all intended to look as if carved out of stone, the background is intended to look as if clad with coloured marble. It seems not to imitate a particular type of marble or alabaster, but its pattern (unlike the smoky mixture seen in Figs. 37 and 71) is entirely plausible and based on a careful study of actual rare specimens of the kind that Venetians set in the walls of their palaces and churches. No large ancient relief sculpture is known to us that possesses such a coloured ground, but the miniature sculpture of cameos (in which figures were cut out of one coloured stratum in the stone, and the background out of another) were the works of ancient art most prized in the Renaissance and this is a large-scale equivalent of them. Pietro and Tullio Lombardo, the leading Venetian sculptors at this date, incorporated coloured marbles into their white marble reliefs (sometimes using a streaky or clouded marble for the sky).

Although the painting is often described as monochrome, there is a considerable variety in the greys and the most excited figures are warmer in colour than the cool Romans beside them. The rhythms of the three-part composition, the contrasting movement within it, the perfectly calculated effect of every expressive gesture or face, make it one of Mantegna's more accomplished works.

Fig. 64b. Giovanni Bellini, *The Continence of Publius Cornelius Scipio, c.* 1506. Canvas, 74.8×356.2cm. Washington, National Gallery of Art, Kress Collection.

OPPOSITE Fig. 64c. Detail of No. 64.

65 Madonna and Child with Saint John the Baptist and Saint Nicholas of Bari ('The Ansidei Madonna') completed 1505

Oil on poplar, painted surface 209.6 x 148.6cm (NG 1171)

For his biography see No. 61.

Beside the high throne of the Virgin stands Saint John the Baptist with a tall crystal cross and Saint Nicholas of Bari holding his bishop's mitre, with the three golden balls by his feet (generally supposed to represent the three purses of gold which he threw into the window of a poor man's house to serve as dowries for his daughters). The painting was commissioned by Bernardino Ansidei for the chapel of St Nicholas of Bari in the Servite church of San Fiorenzo in Perugia, perhaps in 1504. It seems to have been completed in 1505 for the Roman date MDV is written on the hem of the Virgin's mantle. Some lines after this, probably intended as decorative flourishes, have sometimes been taken for extra digits (making a date of 1506 or 1507).

Raphael seems to have gone to Florence late in 1504, but only the monumental figure of Saint Nicholas is much affected by the studies he made there and the painting as a whole is still in the manner of Perugino, although less so than is the Crucifixion (No. 61). Something in the style of Perugino would no doubt have been what his patron in Perugia wanted.

The plain grey stone architecture, articulated by mouldings but otherwise unornamented, and the plain pale wooden throne, are similar to those which Perugino had used in his altarpieces, but more accomplished – the work of a painter with the makings of a great architect. The lucid geometry of the Crucifixion (No. 61) had been manifested in two-dimensional pattern. The geometry here is more spatial, but it is clear that Raphael was not yet expert in linear perspective – the seat of the Virgin's throne is not deep enough. Nor is his architecture entirely logical: there is no use served by the elegant volutes on the uprights of the throne, the throne has no arms, and steps which diminish as they descend are impractical, indeed dangerous. This last feature, however, beautifully answers the arches above – as does the tilting of the heads and the sweep of the drapery of the saints, even the dislocated anatomy of Saint John.

Of the three predella panels for this painting, only one, that originally placed below the figure of Saint John, survives and it is also in the National Gallery (Fig. a). In it the Baptist, clad much as he is in the large panel, preaches to a crowd which is arranged in three principal groups. Each group is three or four deep, united by a flowing line and a coherent spatial plan, and animated by contrasting expressions and attitudes. This composition has a narrative interest which Raphael did not yet feel to be appropriate for a Virgin enthroned with saints. It is more vital and complex than that of the *Allegory* (No. 63), but he has lavished less care on its execution and one feels that here, as perhaps generally in his early paintings, colour was added to a composition which was originally conceived without it.

Fig. 65a. Raphael, *Saint John the Baptist Preaching, c.* 1505. Wood, 23×53cm (NG 6480). Panel from the predella of No. 65.

66 The Virgin and Child with Saint John the Baptist and Saint Anne *c.*1507-8

Drawing, black and white chalk on tinted paper (now darkened), 141.5 x 106.5cm (NG 6337)

Leonardo was born in 1453 at Vinci, near Florence. By 1476 he was living in Florence in the house of Verrocchio (see No. 39), whose pupil he seems to have been. By 1483 when he became court artist to Lodovico il Moro, Duke of Milan, he was one of the most admired painters in Florence. He was esteemed as a sculptor and for his architectural and engineering ideas as well. His drawings and writings also reveal a passionate interest in the natural sciences. He left Milan in 1499 for Florence where he stayed until 1506; he then returned to Milan. Between 1513 and 1516 he was in Rome and elsewhere in Italy. In 1517 he died at Amboise on the Loire, a pensioner of the King of France.

This drawing, like the painting of the *Virgin of the Rocks* (No. 68) which was first conceived by Leonardo in the 1480s, represents a meeting, charged with intense human drama and great theological significance, between Christ and his cousin John the Baptist in a wild mountainous landscape. As a composition (also involving two adults and two children) the drawing is more concentrated than the painting. It must be connected with another drawing of similar size – now lost – which Leonardo made for a painting to be placed on the high altar of the Florentine church of SS Annunziata. This drawing, when exhibited in 1501, made a great impression on artists and connoisseurs and, according to Vasari (writing much later), on the general public. It showed Christ clutching a lamb, the Virgin rising from the lap of her mother, Saint Anne, to draw him away, and Saint Anne also rising, restraining her daughter. The whole group seems to have been given a diagonal, and probably spiral, movement, depicting each participant in motion and in a complex and subtle relationship with the others.

The subject matter of the National Gallery's drawing may suggest that it too was a project for this altarpiece, but Leonardo was also commissioned to make a painting for King Louis XII of France whose second wife's name saint was Anne. This painting, which was commenced in about 1508 but unfinished when Leonardo died in 1517, is now in the Louvre. The drawing in the National Gallery must have been made not long before 1508 to judge from the evidence of a preparatory sketch for it, and may be considered as an idea for the French altar-

piece. Leonardo has involved the child Baptist rather than the symbolic lamb in the group. Christ blesses him (as in *The Virgin of the Rocks*) and also greets him affectionately by chucking his chin. Saint Anne takes up the gesture – the finger pointed to heaven – with which the adult Baptist preaches of the coming of one who is greater than he is. She does not look very old and she seems intimately related to the Baptist so many scholars have proposed that she is meant for Saint Elizabeth, the Baptist's mother.

The drawing is surely preparatory for a painting, and full size, but it can never have been used to transfer a design on to a panel, for the outlines are neither pricked nor incised. In some parts it is badly rubbed, but many of the blurred and smudged effects are intentional. Some are designed to give a sense of movement and mystery to the expressions. The mountains in the distance and the pebbles in the foreground could have been made clearer, but Leonardo would not have wanted them to be too evident, and in his painting they would be veiled by mist or water or shadow. Also, if the figures were more sharply defined, the contortion of Christ and the uncomfortable position of Saint Anne would become obtrusive. Some areas of the drawing have been left in a rough outline (very similar to that in the unfinished parts of *The Virgin of the Rocks*) – and if Saint Anne's forearm were more substantial it would create an entirely new focus and block the blessing hand of Christ.

The dynamics of the composition, which are inseparable from the dramatic content, call into question the very idea of finality in design or finish in execution. Nothing is conclusively resolved.

67 Saints Peter and Dorothy *c.1505-10*

Oil (analysed) on oak, painted surface 125.5 x 71cm (NG 707)

For his biography see No. 62.

This is the left-hand shutter of an altarpiece of which the central panel is missing. The right-hand shutter shows Saints Andrew and Columba (Fig. a). The *Adoration of the Magi* on the back of the shutters was painted by a different artist and may not be contemporary. Saint Peter stands on the left, holding the keys to both Heaven and Hell, while Saint Dorothy on the right holds a basket of flowers, including roses, and wears a circlet of them on her head. According to her legend, while she was on her way to be martyred an unbeliever challenged her to send him some roses and apples from Heaven, and these were duly delivered to him after her death.

The background against which the saints stand is similar to that of the Saint Bartholomew Altarpiece (Fig. b), with its brocade hanging and chequered pavement, and it has been suggested that these are the outside shutters of that altarpiece.

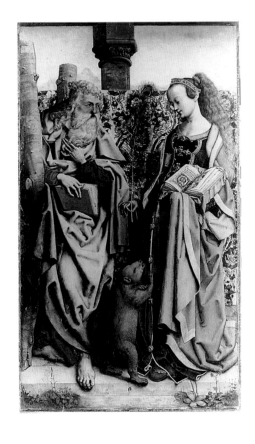

Fig. 67a. The Master of the Saint Bartholomew Altarpiece, *Saints Andrew and Columba, c.* 1510. Wood, painted surface, 127.5×72cm. Mainz, Mittelrheinisches Landesmuseum.

Fig. 67b. The Master of the Saint Bartholomew Altarpiece, *The Saint Bartholomew Altarpiece, c.* 1510. Oak, painted surface, centre 128×161cm, shutters each 129×74cm. Munich, Alte Pinakothek.

The Saint Bartholomew Altarpiece stood in the church of St Columba in Cologne, and as Saint Columba appears on the right-hand shutter it is likely that these panels were intended for an altar there, but not necessarily that of Saint Bartholomew. (For another instance of altarpieces with similar features painted for different chapels within the same church see No. 46.)

This altarpiece would seem to have been a late work of the Saint Bartholomew Master, and to date from towards the end of the first decade of the sixteenth century. In contrast to No. 62, this panel with its two standing figures demonstrates the painter's ability to work with equal conviction on a relatively large scale as well as on a small scale. Both pictures demonstrate the artist's great interest in expressions. The smaller picture is a study in grief, but here there is as much effort to animate the saints with appropriate demeanour, and to make the figures relate to each other by look and by the careful disposition of their poses. Thus Saint Dorothy appears demurely pious, while Saint Peter glances across at her. The positions of their hands and arms copy one another, whereas those of their feet are neatly reversed. This panel also demonstrates the painter's response to colours and textures, especially striking in the contrast between Dorothy's pale plain gown and the rich red brocade of its lining, and in the vivid translucency of the column of some semi-precious stone or marble which rises behind them, its bulk disturbing the sumptuous but otherwise flat hanging. Behind the column, above the hanging, a landscape is visible. In the spectacles held by Peter are what appear to be the reflections of a latticed window, an arresting suggestion of the beholder's world.

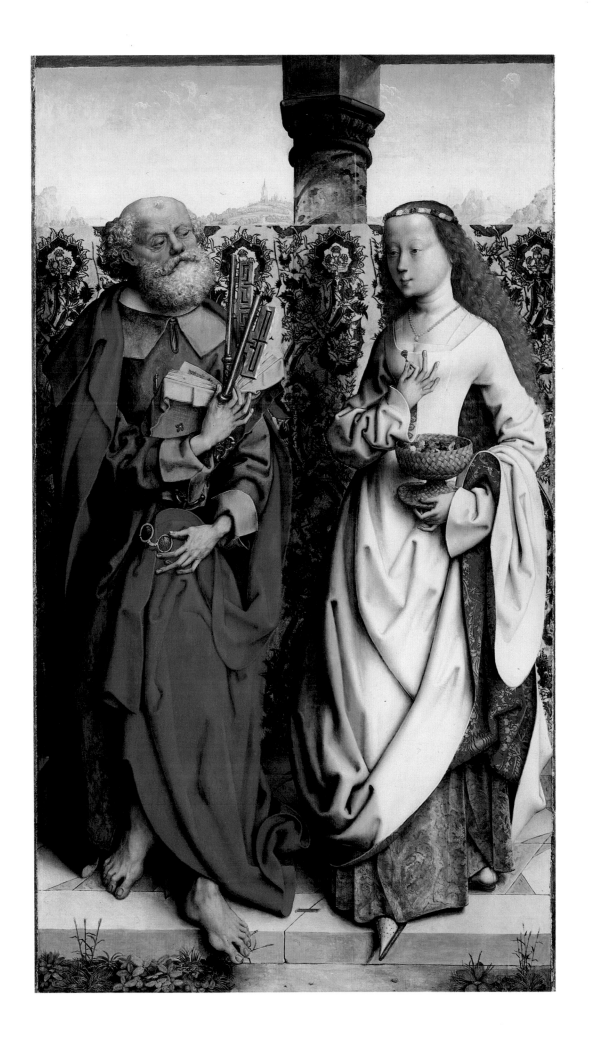

68 The Virgin of the Rocks (The Virgin with the Infant
 Saint John adoring the Infant Christ accompanied
 by an Angel) *c.*1508

Oil on wood, 189.5 x 120cm (NG 1093)

For his biography see No. 66.

The subject of the Virgin kneeling to adore her child was not a new one (see Nos. 36 and 59), but here Saint John appears and Christ blesses him. Saint John, as the patron saint of Florence, was often inserted into compositions of the Virgin and Child made by Florentine artists (see Figs. 81 and 183) and such compositions were sometimes given a narrative dimension. In Filippo Lippi's celebrated altarpiece in the chapel of the Medici Palace (now in the Staatliche Museen, Berlin, see Fig. 97), for instance, Saint John is arriving to join in the Virgin's homage. Here Saint John, although a little older than Christ, could have been mistaken for him since he is closer to the Virgin and is not wearing his characteristic camel skin. The cross and scroll have been added (at an early date, surely not by Leonardo) to clarify his identity.

The Virgin of the Rocks, with its exquisite studies of plants, its strange rocks, its veils of silk, its water over pebbles, and its transparent shadows, reflects Leonardo's special preoccupations as a painter, and also as a botanist, mineralogist and assiduous recorder of the nature of light, air and water. Yet comparison with the altarpiece by Filippo Lippi, which is also set in a cool, dark, rocky, watery place, reminds us, just as the prominence of Saint John does, of Leonardo's debts to earlier Florentine art.

When Leonardo arrived in Milan his patron, Duke Lodovico, would have wished to see him prominently employed. If, as seems likely, the Duke was consulted concerning the best artist for painting a panel for what was probably the most important altarpiece commission in Milan at that date, he would presumably have suggested Leonardo. The panel was to be inserted into the

centre of the carved wooden altarpiece, newly completed by Giacomo del Maino, in the lavish new chapel of the Confraternity of the Immaculate Conception in San Francesco. It is doubtful whether the confraternity would have thought of Leonardo unprompted, but in any case they would have needed the Duke's permission to approach him. In 1483 Leonardo agreed in a contract to paint Our Lady with Prophets. There is no mention of the Christ Child, nor can it be likely that the child Baptist was one of the prophets the confraternity had in mind. What they wanted was something such as Franciscan patrons obtained in this period for other altars dedicated to the Virgin of the Immaculate Conception: the Virgin, without a child, above a line of prophets with inscriptions from their writings taken to refer to her miraculous freedom from all taint of Original Sin. How Leonardo was able to replace this subject with an essentially Florentine composition, for which he had perhaps already been making plans before he came to Milan, is not easily explained, unless the Duke intervened on his behalf.

Mentioned in the contract of 1483 with Leonardo were the brothers Ambrogio and Evangelista de Predis. They were to help with painting and gilding the sculpture. They were also to paint the 'side panels' with four angels each, some playing instruments, some singing. An idea of the character of the carved altarpiece can be obtained from one made by Angelo del Maino, Giacomo's son, at Morbegno (Fig. 18). This includes columns and cornices and is crowned with the Virgin in a mandorla; it has a cupola surrounded by figures, a lunette enclosing God the Father escorted by angels, and numerous episodes in relief, including landscapes. We know that all

these features were included in the altarpiece carved for the Confraternity of the Immaculate Conception.

The painting which Leonardo probably started in 1483 must be the version of *The Virgin of the Rocks* now in the Louvre (Fig. a). The contract stipulated that the whole job was to be done by the following Feast of the Conception, with monthly payments commencing on 1 May and a bonus on completion. The following may have meant the following year – that is 8 December 1484 – but the painting was not complete by 1490. At some time between then and 1499, Leonardo and Ambrogio (Evangelista had died in the meantime) complained that they had not been properly paid and did not want the confraternity to take the painting. By 1503, however, the confraternity had taken possession of it, and when Leonardo returned to Milan in 1506 he agreed to complete it in two years in return for an extra fee. This was done by October 1508 but the final settlement was conditional on a copy being made. It may be surmised that this copy, or rather

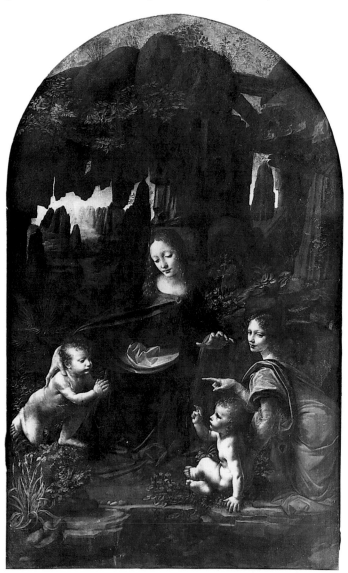

Fig. 68a. Leonardo da Vinci, *The Virgin of the Rocks*, commenced 1483. Oil on wood, transferred to canvas, 197×119.5cm. Paris, Louvre.

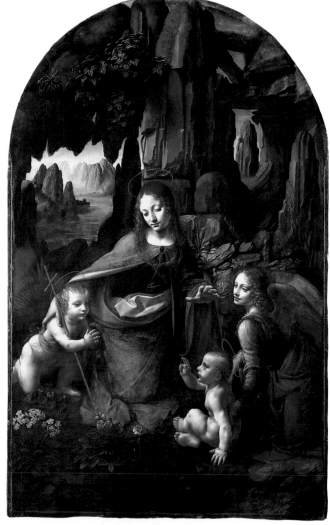

Leonardo da Vinci, *The Virgin of the Rocks* (No. 68).

second version, was then substituted for the original which was sold to the King of France, then ruler of Milan. The painting in the Louvre comes from the French Royal Collection. That in the National Gallery belonged to the confraternity and must be the second version mentioned in the contract of 1508.

The differences between the two paintings can be summarised as follows. The somewhat disturbing pointing hand of the angel in the earlier version is eliminated, as is the angel's role as intermediary between the spectator and the sacred narrative. The angel now looks at Saint John instead of pointing at him. The large folds of drapery are removed from the angel's shoulder and the buttocks are less apparent. There are fewer details in subordinate areas. The figures are made larger. The rocks are extended to the top of the painting and there is a consequent reduction in the sources of light and in local colour. There is darker shadow and more relief, especially in the head of the Virgin. All these changes seem likely to have been made by Leonardo after he had seen the first painting incorporated into the wooden altarpiece. The essentials of the composition are strengthened and many subtleties are discarded.

Not only must these changes have been planned by Leonardo but the best-preserved passages of the National Gallery painting – in particular the angel's diaphanous drapery, the yellow highlights on the gold thread in it, and on single strands of hair beside it – are inconceivable as the work of anyone else. Moreover the unfinished areas – for instance the hand of the angel on the back of the infant Christ – have a boldness and spontaneity found in Leonardo's other unfinished paintings. No doubt such passages did not register as unfinished when

Fig. 68b. Associate of Leonardo, *An Angel in Green with a Vielle, c.* 1506. Poplar, 116×61cm (NG 1661).

Fig. 68c. Associate of Leonardo, *An Angel in Red with a Lute,* 1490s. Poplar, 118×61cm (NG 1662).

the painting was installed and Leonardo had by then abandoned orthodox ideas of completion (see also No. 66).

It remains to consider the 'side panels' of the altarpiece, two of which survive in the National Gallery (Figs. b and c). They do not contain four angels such as the contract had requested, but Leonardo no

doubt had this changed so that the angels could relate to the size of the angel in the main painting. They are an unhappy pair, but if they formed two sides of a shutter placed to the right of the main painting they do make sense. Leonardo must have helped in the design, but the painting is of inferior quality.

69 The Virgin and Child with Saints and Donor *c.*1509

Oil (analysed), possibly with some egg tempera, on oak, painted surface 106 x 144cm (NG 1432)

Born in Oudewater, Holland, he was active in Bruges from 1484 where he was the leading painter; he was also a member of the Antwerp guild from 1515. He died in 1523.

Figs. 69a and b. Details of No. 69.

This is almost certainly the altarpiece from the altar of St Catherine in the chapel of St Anthony in St Donatian's at Bruges. Saint Catherine of Alexandria, with her attributes of sword and wheel just visible to her right, is to the left of the Virgin and Child. Saint Anthony Abbot is in the distance on the right. The kneeling donor in clerical dress is Richard de Visch de la Chapelle, who became cantor (a senior cleric in a collegiate church) of St Donatian's in 1463 and died in 1511. He founded a chaplaincy at the altar of St Catherine in the chapel of St Anthony there, and his coat of arms is visible on the collar of the greyhound. In 1500 he obtained leave to restore the chapel where his mother was reburied in (1504), and it was probably in connection with this restoration that David (who in 1501 apparently painted shutters for another altarpiece in St Donatian's, also in the National Gallery, see Fig. 58) was commissioned to paint this altarpiece.

The main action of the picture, as befits an altarpiece for an altar dedicated to Saint Catherine, shows her mystic marriage to Christ: the Child Christ places a ring on the saint's finger. Saint Catherine, an early Christian martyr, had refused marriage to the Emperor on the grounds that she was already the bride of Christ. Saint Barbara, identifiable by the jewelled tower attached to her headdress – according to her legend she shut herself up in a tower and became a hermit – is reading a book. Saint Mary Magdalene – who holds the traditional pot of ointment bearing an abbreviation of her name – though otherwise impassive, appears with her right hand to be turning the page of this book, an action which David inserted after he had begun painting the figure.

The Virgin and the female saints as well as the donor are all shown within a walled garden, the *hortus conclusus*, a metaphor for Mary's virginity (see No. 23). The scene is depicted with such specificity as to suggest an actual walled garden attached to St Donatian's, although no identifiable Bruges landmarks seems to have been represented. This impression of naturalism is heightened by the inclusion of such details as a woman looking out of a window and a cat washing itself (Figs. a and b). Other details are apparently included for symbolic reasons. The flowers which bloom on either side of the Virgin are all traditionally associated with her, and an angel is seen harvesting a bunch of grapes, presumably a reference to the wine of the Eucharist (see No. 15).

The donor appears slightly detached from the other figures, suggesting an intended contrast between his humanity and the heavenly beings who surround him. On the floor in front of him is his cantor's staff, crowned with a gilt bronze depiction of the Trinity (see p. 38); it corresponds with a contemporary description of a staff in the records of St Donatian's. Beside it are a prayer book and the cantor's black hat.

Although some of the colours have darkened (the purple brocade hanging behind the Virgin appears almost black), the picture well illustrates David's use of distinctive and subtle combinations of colour: scarlet and dark blue, crimson and violet, and dark green and brownish pink. These colours, set against the subdued pinks and greys of the tiled floor and the rich red marbling of the columns, create an impression of sophisticated splendour. The effect of the whole is similar to that of David's great Rouen Altarpiece of 1509. The two paintings must be close in date.

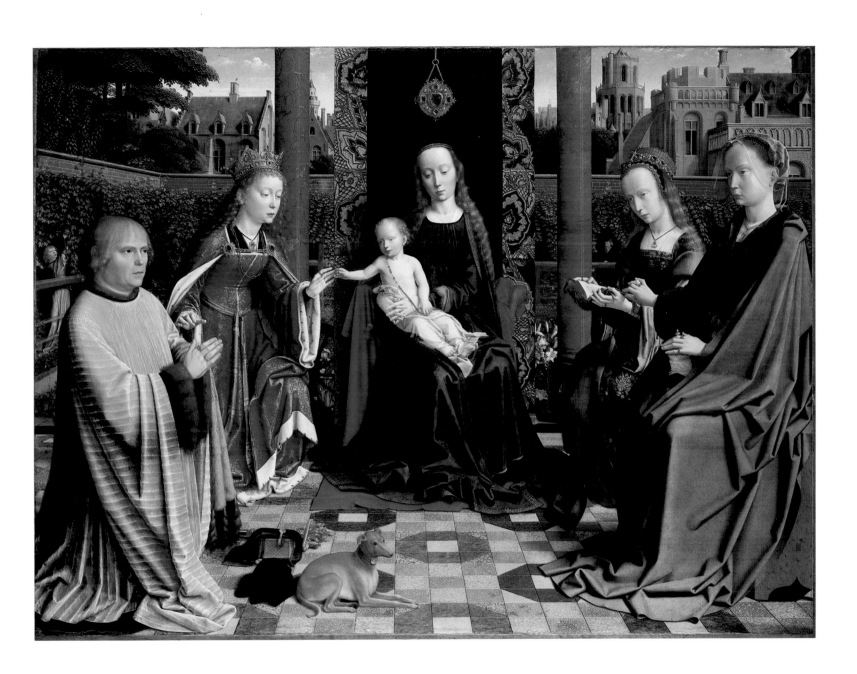

GLOSSARY

arriccio In fresco (q.v.) painting, the lower layer of plaster on which the *sinopia* (q.v.) is drawn. See also *intonaco*.

beato (pl. **beati)** Italian, blessed, beatified. Someone whose veneration is permitted locally under church law, but who is not canonised (q.v.). Many *beati* were subsequently canonised.

bole An iron-oxide-containing clay, usually of a strong reddish-brown colour, used as the underlayer for gold leaf.

braccia or **braccio** Italian, literally, arm. By analogy, the principal unit of length in Italy, varying from centre to centre and sometimes according to what was being measured. See Note on measurements.

Byzantine Relating to the Byzantine Empire, the continuation of the Roman Empire in the East after the deposition of the last emperor in Rome, AD 476. Named after its capital, the ancient Greek city of Byzantium on the Bosphorus, rebuilt by Constantine in 330 and renamed Constantinople; present-day Istanbul.

camera Italian, chamber. A room used both as a bedchamber and reception room, often lavishly decorated and furnished. See also *cassone, spalliera*.

cangiante Italian, literally, changing. A shot silk which varies in colour according to the angle of the light, made by weaving the textile using different coloured threads for the warp and the weft. In painting, these silks are represented by using one colour for the shadow and another quite different colour for the highlight.

canonise, canonisation The process by which a person is declared a saint, worthy of veneration in all Roman Catholic churches.

cartellino Italian. A small piece of paper or parchment often painted as if attached to the inner frame below half-length or bust-length portraits or images of the Madonna, sometimes inscribed with the artist's signature.

cassone Italian, large chest. A modern word used to designate the large painted or carved storage chests which formed part of the furnishings of a *camera* (q.v.). See also *spalliera*.

crocket Carved decorative leaf-shaped feature applied to sloping edges of Gothic architectural elements such as gables (q.v.) or pinnacles (q.v.).

cupola A dome, or a small domed structure on the top of a dome or roof, or projecting from the top of a throne as a canopy.

dado The lower part of an interior wall; mural decoration usually distinguishes between the upper part of the wall and the more easily damaged dado.

desco (pl. **deschi) da parto** Italian, birth tray. Decorated circular or twelve-sided trays given as presents to new mothers or in anticipation of a birth, often painted on both sides.

diptych A painting or carving on two panels, normally hinged like a book.

dossal Simple altarpiece, usually rectangular. Early dossals may have originated as frontals (q.v.) and been moved from in front of the altar to above and behind it. See retable.

dowel A cylindrical length of wood, sometimes tapered at each end, inserted into pre-drilled holes across a join between pieces of timber to reinforce that join.

ex-voto Latin. A painting, sculpture or other object given to a church or chapel in accordance with a vow, for prayers answered.

finial Decorative top of a gable (q.v.) or pinnacle (q.v.).

fresco A wall painting, usually executed using colours applied to fresh (Italian, *fresco*) and still-wet plaster.

frontal A decorated panel or cloth hanging down in front of the altar table.

gable A triangular pointed top of architectural character, as in a frame (corresponding to the pitch of a roof in a building). The term is normally confined to Gothic architecture, as opposed to the classical pediment.

gesso The Italian word for gypsum (q.v.); the material used for grounds on panel.

gesso grosso The coarse lower applications to a panel making up the gesso ground; generally composed of burnt gypsum (q.v.) mixed with animal glue.

gesso sottile The fine upper layers of a gesso ground; composed of gypsum (q.v.) formed by rehydrating burnt gypsum and bound in animal glue. See also gesso.

glory A representation of the light which emanates from, or surrounds, a saint or the Deity; another word for halo, but used here to distinguish radial patterns, as used for *beati* (q.v.), from the disc shape reserved for God and for saints in Italian art.

grisaille French, from *gris*, grey. A painting entirely in dark to light shades of a single colour – not necessarily grey – often simulating relief, carved in stone or cast in metal.

gypsum A white mineral composed of calcium sulphate dihydrate; used in the preparation of gesso (q.v.) grounds.

halo a disc or ring of light, usually represented in gold, around the head of a saint, angel or the Deity. See also glory.

hatching In painting, the application of paint with long thin parallel brushstrokes. In drawing, the use of a series of lines, usually parallel, to suggest volume and the distribution of light and shade. If the strokes are in more than one direction and cross one another this is known as cross hatching.

hortus conclusus Latin, enclosed garden. One of the metaphors for the Virgin Mary, derived from the Song of Solomon, 4:12. In art, expressed through the depiction of a walled garden in images of the Virgin and Child.

impasto Paint applied thickly, so that brushmarks etc. are evident.

Infra-red photography/ photograph Infra-red is similar to visible light, but slightly too long in wavelength for the eye to see; however, it can be photographed. In conventional infra-red photography, an image is recorded using film sensitive to infra-red radiation in an ordinary camera. An infra-red photograph shows layers just below the visible surface of a painting; *pentimenti* (q.v.) and underdrawings (q.v.) done in carbon black on a white ground show up particularly well.

Infra-red reflectography/ reflectogram A technique related to infra-red photography in which a television camera adapted to receive infra-red radiation is connected to a television monitor. The image is seen instantaneously, but recording of the image is slightly blurred since it is photographed from the screen. An infra-red reflectogram, like an infra-red photograph, shows layers below the visible surface of a painting, especially carbon black underdrawings. The two techniques are complementary: infra-red photography produces a sharper image, but infra-red reflectography can achieve greater penetration of the upper paint layers because

the detector used is sensitive to a greater range of wavelengths than infra-red film.

intonaco In fresco (q.v.) painting the fine uppermost layer of plaster on which the colours are applied. See also *arriccio*.

lake A pigment made by precipitation on to a base from a dye solution – that is, causing solid particles to form, which are coloured by a dye. Lakes may be red, yellow, reddish brown or yellowish brown and are generally translucent pigments when mixed with the paint medium. Often used as glazes.

lunette A semi-circular architectural or sculptural opening or frame; by extension, a *mezzotondo* (q.v.)

Maestà Italian, majesty. An image of the Virgin Mary enthroned as Queen of Heaven, surrounded by angels and sometimes saints.

mahlstick or **maulstick** From German, *mahlen*, to paint. A long stick, padded at one end, used by artists to steady the hand holding the brush.

mandorla Italian, literally, almond. An almond-shaped halo or glory (q.v.) surrounding the Deity or the Virgin Mary.

medium The binding agent for pigments in a painting, see also tempera.

metalpoint A metal wire, usually of silver but sometimes also of lead or even gold, employed in a holder as a drawing tool on coated paper. The point deposits a thin coating of metal on the slightly rough surface, which (in the case of lead or silver) rapidly tarnishes, producing a fine grey line like that of a hard graphite pencil.

mezzotondo Italian, half-circle. A semi-circular painting or carving.

morse A clasp or fastening on the ornamental cape – cope – of clerical dress.

muller A heavy implement of stone used to grind pigments.

ogee or **ogive** A double curve. A pointed-top arch with a concave profile at the top.

orthogonals Notionally parallel lines at right angles to the picture plane, converging at one or more vanishing points on the horizon.

pala Italian, literally, shovel or paddle. By analogy, an altarpiece constructed as a single large rectangular panel – as distinct from a polyptych (q.v.).

palmette From French, small palm. An ornamental motif resembling a small palm leaf, derived from ancient decoration.

panel A rigid painting support, usually made from planks of wood.

pastiglia Italian. Raised patterns made from gesso (q.v.).

pentimento (pl. **pentimenti**) From Italian *pentire*, to repent. An alteration made by the artist to an area already painted.

Pietà Italian, pity. A representation of the dead Christ supported by the grieving Virgin Mary.

pilaster Vertical architectural support, usually rectangular in cross-section, applied to a wall end, articulating it decoratively or structurally.

pinnacle A tall crowning element, usually of Gothic architecture, used also for the topmost projections of a picture frame or the topmost panel of a multi-tiered altarpiece.

polyptych An altarpiece consisting of several panels.

pouncing Transferring a design by dusting a coloured powder through holes pricked along the outlines of a drawing on paper or parchment; the traces of this process in the finished work.

predella Italian, literally, plinth, altar-step or dais. The long horizontal structure supporting the main panels of an altarpiece commonly decorated with diminutive images of saints or with narratives of their lives.

putto (pl. **putti**) Italian, small boy. The representation in painting or sculpture of naked or half-dressed infants, often precociously employed, influenced by antique Roman art. Sometimes loosely used to include child angels.

quatrefoil An ornamental shape used in Gothic art and architecture having four lobes arranged about a common centre, like a four-leafed clover. See trefoil.

retable Literally, behind the (altar)table. A structure above and behind an altar, often comprising both sculpted and painted elements. See also dossal.

sgraffito Italian, literally, scratched. A technique in which paint is applied over gold or silver leaf and then partially scraped away; particularly used to represent cloth-of-gold textiles.

'shell gold' Powdered gold used as a paint; so-called because traditionally it was contained in a mussel or similar shell.

sinopia Preliminary underdrawing for a fresco (q.v.) usually executed in sinoper, a red ochre pigment.

size An adhesive used to make gesso and in gilding; made from animal skin and waste. The finest size was made from parchment clippings.

spalliera Italian, from *spalle*, shoulders. A benchback, the headboard or footboard of a bed, or any similar vertical element of furniture, often decorated.

stippling In decoration of gilding, very small indentations of the surface made with a needle or clump of needles. In painting, the application of paint in short dabs or spots of colour.

studiolo Italian, little studio. A small room, often lavishly decorated, generally of relatively private character, dedicated to reading, studying, writing.

tempera In its wider sense, as used by Cennino Cennini, any one of several paint media (q.v.), hence the verb to temper, meaning to combine pigments with a paint medium, but it now often refers to egg tempera alone, that is, paint made using egg yolk as a medium.

tondo (pl. **tondi**) Italian, literally a circle, from *rotondo*, round. A circular painting or relief sculpture.

transfer To convey and reproduce a design from one surface, for example paper, to another, for example a gessoed panel. Alternatively, to remove the original painting support and replace it with a new support.

Trecento Italian, fourteenth century (literally, three hundred).

trefoil Three-lobed decorative motif common in Gothic art and architecture. See quatrefoil.

triptych An altarpiece consisting of three panels.

underdrawing Preliminary drawing on the prepared panel before the application of paint.

X-ray A form of radiation which passes through solid objects, but is obstructed to differing degrees by differing materials. The heavier the atoms of which a substance is made, the more opaque it is to X-rays. Lead compounds are particularly opaque, those

containing lighter metals less so. Thus in an X-ray image (known as a radiograph) of a painting, areas of paint containing lead pigments will appear almost white, while areas containing lighter materials will appear an intermediate grey or dark. In interpreting X-rays, it should be remembered that all layers are superimposed: thus the image of a wood panel, battens and nails may seem to overlie the image of the paint itself.

A NOTE ON SYSTEMS OF MEASUREMENT AND COINAGE

The units of measurement in Western Europe in the period 1260 to 1510 originally derived from body measurements, as their names often suggest, and so were similar, but never standard. Each state – frequently even individual cities, and, within the same city, different trades – had its own system of measurement. Thus in Florence, Milan, Venice and Mantua, for example, the length of the *braccio* (Italian for an arm) varied, although the methods of subdivision generally followed a similar pattern. In the Netherlands the lengths of the foot and the ell (a cloth measure) differed slightly not only between Bruges, in Flanders, and Antwerp, in Brabant, for example, but also often between towns within the same province. For trading purposes comparative tables were drawn up, some of which survive.

Some examples of measurements used:

FLORENCE
1 braccio a panno (a cloth measure) = 12 crazie (a small measure, a trifle) = 58.36cm
 1 crazia = 4.86cm
1 braccio a panno = 20 soldi = 58.36cm
 1 soldo = 2.92cm
1 soldo = 12 denari, each .24cm

VENICE
1 braccio da lana (wool) = 12 once = 68.34cm
 1 oncia = 5.695cm
1 braccio da seta (silk) = 12 once = 63.87cm

PADUA
1 braccio da panno = 68.10cm
1 braccio da seta = 63.75cm
1 piede (foot) = 12 once or pollici = 35.74cm

MANTUA
1 braccio = 63.80cm
1 piede = 12 once = 46.69cm

BRUGES
1 el (aune) (forearm) = 70.07cm
1 voet (pied) = 11 duymen = 27.44cm
1 duym (pouce) (thumb) = 2.5cm

COLOGNE
1 Elle = 2 Fuss = 57.48cm
1 Fuss (foot) = 12 Zoll = 28.74cm
1 Zoll = 2.4cm

LONDON
1 ell = 20 nails = 45 inches = 114.3cm
1 nail = 2.25 inches = 5.72cm
1 yard = 2 cubits or 3 feet = 91.44cm

PARIS
1 aune de Paris = 118.85cm
1 pied de Paris = 12 pouces = 32.48cm
1 pouce = 2.71cm

Coinage
The coinage in this period consisted of gold, silver, or silver and copper alloy, although copper coins were first minted in the 1470s. The value of gold coinage was such that few people used it. Gold coins were first introduced in Florence and Genoa in 1252, and their use spread rapidly after the opening of the Hungarian gold mines in the first half of the fourteenth century. Other nations had their own gold coins – in the Rhineland *Rheingulden* – but the Florentine florin and the Venetian ducat remained the great international coins. Silver coins were first introduced in Italy, and were known as *grossi* there, because of their large size, and *groten* in the Netherlands. Penny coins – the small change of Europe and the coins most frequently used – were mostly minted in silver alloy, as were the later alternative to large silver coins, known as 'white money': the Milanese *pegione*, the Rhineland *weisspfennig*, and the *patard* or *stuiver* introduced in the Burgundian Netherlands in 1433.

For the purposes of accounting a standardised system was used in Western Europe, whereby the *libra* (pound) was divided into 20 *solidi* (shillings) and each *solidus* into twelve *denarii* (pennies). The actual coinage had no fixed relationship to this scheme, but varied with the introduction of new coins and the fluctuating content of precious metal in them. For instance, the Florentine gold florin was the equivalent of the pound when first introduced, but rapidly increased in value.

BIBLIOGRAPHY

NOTE: This bibliography is in two parts. The first is a brief list of books in English and in print intended for the general reader who wishes to pursue further the subject matter discussed in this book. The second is a more specialised bibliography, which, after a list of general books on the painting of this period, follows the order in which topics are examined in the book. Under each heading works of general significance are listed alphabetically. There are followed by works on more specific topics which are indented and listed in the order in which the topics occur in the text.

FURTHER READING:

Books in print in English of general interest

Alberti, L. B., *On Painting*, translated with introduction and notes by John R. Spencer, Yale University Press (paperback edition), New Haven and London 1956.

Ames-Lewis, F., *Drawing in Early Renaissance Italy*, Yale University Press, New Haven and London, 1981. Includes descriptions of drawing materials and techniques and discusses the various and changing functions of drawing in Italian workshops of the 15th century.

Baxandall, M., *Painting and Experience in Fifteenth Century Italy* (1972), Oxford 1974. A stimulating account of the factors which might have conditioned the 15th-century Italian perception of painting.

Bomford, D., Dunkerton, J., Gordon, D., Roy, A. *Art in the Making: Italian Painting before 1400*, National Gallery Publications, London 1989. Catalogue of an exhibition in which eight works from the Collection by the Master of Saint Francis, Giotto, Duccio, Ugolino and Nardo and Jacopo di Cione are subjected to close scientific scrutiny. Includes a very full bibliography.

Burckhardt, J., *The Civilization of the Renaissance in Italy*, Harmondsworth 1990. Burckhardt's survey, first published in 1860, of the cultural and spiritual life of Italy in this period provided a view of the Italian Renaissance which has influenced all modern thinking on this subject. Modern historians have revised or rejected some of his interpretations.

Campbell, L., *Renaissance Portraits*, London and New Haven 1990. An extremely well-illustrated account of European portraiture in this period and in the 16th century with a learned and lively account of how portraits were commissioned, made, used and esteemed.

Cennini, Cennino d'Andrea, *The Craftsman's Handbook: Il Libro dell'Arte*, trans. Daniel V. Thompson, Jr, Dover edition, New York 1954. The main source of information about painting techniques in Italy in the 14th century.

Eastlake, Sir C. L., *Methods and Materials of Painting of the Great Schools and Masters* (formerly titled *Materials for a History of Oil Painting* and first published in 1847), 2 vols., Dover edition, New York 1960. Based on the study of literary sources and on the careful examination of the surfaces of paintings, this book remains an important and useful introduction to the development of oil painting, even if Eastlake's conclusions are inevitably sometimes contradicted by scientific evidence or more recent art-historical discoveries.

Holmes, G., *Florence, Rome and the Origins of the Renaissance*, Oxford 1986. An introduction to the great literature and visual art of late 13th and early 14th century Tuscany, with much on the religious and political life of the period.

Huizinga, J., *The Waning of the Middle Ages* (1919), Harmondsworth, 1955. A survey of cultural and spiritual life based on an examination of the courts of France and Burgundy, and of contemporary literature and art, complementing Burckhardt's survey of Italy but differing in its conclusions and emphasis.

Kemp, M. (ed.), *Leonardo on Painting*, Yale University Press, New Haven and London 1989. A selection from Leonardo's notebooks together with translations of some letters and documents.

Levey, M., *The Early Renaissance*, Harmondsworth 1967. An evocative and personal survey of the diverse achievements of the Early Renaissance in all the arts all over Europe.

Panofsky, E., *Renaissance and Renascences in Western Art*, London 1965. A learned account of the inspiration which artists all over Europe drew from the remains of ancient art, with a lucid exposition of changing notions of cultural rebirth, from the age of Charlemagne to that of Dürer and Raphael.

Vasari, Giorgio, *Lives of the Artists*, 2 vols., trans. George Bull, Harmondsworth 1965 and 1987. Selections from *Le Vite de piu eccellenti pittori, scultori ed architettori* (the first edition of which was 1550, revised 1568).

Wackernagel, M., *The World of the Florentine Renaissance Artist (Der Lebensraum des Künstlers in der Florentinischen Renaissance*, 1938), Princeton 1981, includes valuable sections on street tabernacles and façade painting, public festivities and spectacles, and municipal and guild patronage.

MORE SPECIALIST READING

Further information on paintings in the National Gallery's Collection can be found in the Gallery's catalogues.

Italian paintings are mostly catalogued in Martin Davies, *The Earlier Italian Schools*, revised edition 1961. Those dating before 1400 appear in *The Early Italian Schools*, 1988, by Dillian Gordon (a revised and updated version of the relevant entries in Davies, 1961). A few of the paintings, most importantly those by Raphael, are included in *The Sixteenth-Century Italian Schools*, 1975, by Cecil Gould.

Netherlandish paintings are catalogued in Martin Davies, *The Early Netherlandish School*, revised edition 1968. Fuller information on some of these paintings is given in Martin Davies, *The National Gallery, Les Primitifs Flamands, (Corpus)*, 2 vols., 1953. German paintings are catalogued in Michael Levey, *The German School*, 1959. For the Wilton Diptych and the Master of Moulins see Martin Davies, *The French School*, revised ed. 1957.

PART ONE

THE USES OF PAINTING

General Introductions to, and Surveys of, Painting of the Period 1260 – 1510

Berenson, B., *The Italian Painters of the Renaissance* (1894-1907), London 1968.

Borsook, E., *The Mural Painters of Tuscany*, 2nd ed., Oxford 1980.

Boskovits, M., *Pittura fiorentina alla Vigilia del Rinascimento 1370 – 1400*, Florence 1975.

Budde, R., *Köln und seine Maler 1300-1500*, Cologne 1986.

Carli, E., *La pittura senese del Trecento*, Venice 1981.

Christiansen, K., Kanter, L. B., and Strehlke, C., *Painting in Renaissance Siena*, exhibition catalogue, Metropolitan Museum of Art, New York 1989.

Fremantle, R., *Florentine Gothic painting from Giotto to Masaccio: a guide to painting in and near Florence 1300 – 1450*, London 1975.

Friedländer, M. J., *Early Netherlandish Painting*, 14 vols., Leiden 1967-76.

Gothic and Renaissance Art in Nuremberg 1300-1550, exhibition catalogue, Metropolitan Museum of Art, New York 1986.

Hans Holbein der Ältere und die Kunst der Spätgotik, exhibition catalogue, Augsburg 1965.

Laclotte, M., and Thiébaut, D., *L'Ecole d'Avignon*, Paris 1983 (covers the 14th and 15th centuries).

Late Gothic Art from Cologne, exhibition catalogue, National Gallery, London 1977.

Vor Stefan Lochner Die Kölner Maler von 1300 bis 1430, exhibition catalogue, Wallraf-Richartz-Museum Köln, Cologne 1974.

Meiss, M., *Painting in Florence and Siena after the Black Death*, Princeton 1951. The book proposes that there was a spiritual crisis in the art of the period. For a different interpretation of the consequences of the Black Death see H. van Os, 'The Black Death and Sienese Painting: A Problem of Interpretation', *Art History*, Vol. 4, No. 3, 1981, pp. 237-49.

Panofsky, E., *Early Netherlandish Painting*, 2 vols., Cambridge, Mass., 1953.

Ring, G., *A Century of French Painting*, London 1949.

Stange, A., *Deutsche Malerei der Gotik*, 11 vols., Berlin 1934-61.

Vasari, G., *Le Opere* (ed. G. Milanesi), 9 vols. (Milan 1878-85), Florence 1973.

Venturi, A., *Storia dell'Arte Italiana,* 11 vols., Milan 1901-40. Vols. 1, 2, 5, 7 and 9 are devoted to painting.

White, J., *Art and Architecture in Italy 1250-1400*, 2nd edn., Harmondsworth 1987.

Zehnder, F. G., *Gotische Malerei in Köln. Altkölner Bilder von 1300 – 1550*, Wallraf-Richartz-Museum Köln, Bildhefte zur Sammlung 3, Cologne 1988.

Western Europe 1260 – 1510

Burckhardt, J., *The Civilization of the Renaissance in Italy*, Harmondsworth 1990. A new edition of S. G. Middleman's superb translation but without most of the original notes supplied in earlier editions.

Huizinga, J., *The Waning of the Middle Ages* (1919), Harmondsworth 1955. An examination of the civilisation of the courts of France and Burgundy, complementing Burckhardt's survey of Italy but differing in its conclusions and emphasis.

Pastor, L., *The History of the Popes from the close of the Middle Ages*, 40 vols., London 1894-1953. This provides a survey of the Church in general and, necessarily, of international politics, as well as a detailed account of the institution of the Papacy and of the individual Popes. The volumes relevant for this period are I and II.

Southern, R., *Western Society and the Church in the Middle Ages*, Harmondsworth 1970. A survey of the institutions of the Church and their evolution in this (and an earlier) period.

Altars, Saints and Relics

Righetti, M., *Storia Liturgica* (1944), Milan 1964 (revised), includes a general account of the evolution of the altar and its furniture.

> For the sacrament tabernacle in Italy in the 15th century see H. Caspary, *Das Sakramentstabernakel in Italien bis zum Konzil von Trent*, Trier 1964.

> For Bellini's *Blood of the Redeemer* as a tabernacle door see A. Braham, M. Wyld and J. Plesters, 'Bellini's "The Blood of the Redeemer"', *National Gallery Technical Bulletin*, 2, 1978, pp. 11-24.

Images and Altarpieces

Baxandall, M., *The Limewood Sculptors of Southern Germany*, London and New Haven 1980. Although about sculpture, this includes a clear exposition of the form and function of the altarpiece in 15th century Germany.

Braun, J., *Der Christliche Altar in seiner geschichtlichen Entwicklung*, 2 vols., Munich 1924.

Burckhardt, J., *The Altarpiece in Renaissance Italy*, London 1989. A new edition of an essay published in 1893, with helpful notes by Peter Humfrey and lavish but not always useful plates.

Cämmerer-George, M., *Die Rahmung der Toskanischen Altarbilder im Trecento*, Strasburg 1966.

Dearmer, P., *Fifty Pictures of Gothic Altars*, London 1910. A fascinating collection of representations of late medieval altars in contemporary manuscripts and prints.

Ehresmann, D. L., 'Some observations on the role of liturgy in the early winged altarpiece', *The Art Bulletin*, LXIV, 1982, pp. 359-69. Discusses the function of shutters in German altarpieces of the 14th century.

Hager, H., *Die Anfänge des Italienischen Altarbildes, Untersuchungen zur Entstehungsgeschichte des toskanischen Hochaltarretabels*, Römische Forschungen der Bibliotheca Hertziana, Rome 1962.

Humfrey, P., and Kemp, M. (eds). *The Altarpiece in the Renaissance*, Cambridge 1991. Papers given at a conference in 1987, several of them of relevance and value.

van Os, H. W., *Sienese Altarpieces 1215 – 1460: form, content and function*, Vols. I and II, Groningen 1984 and 1990.

Polyptyques – le tableau multiple du moyen âge au XX siècle, exhibition catalogue, Louvre, Paris 1990. A survey of the variety and evolution of the polyptych throughout Europe.

Ressort, C., (with S. Béguin and M. Laclotte), *Retables italiens du XIIIe au XVe siècle* (les dossiers du département des peintures no. 16, Louvre), Paris 1978. A succinct and lucid survey of the evolution of the Italian altarpiece with reference to paintings in the Louvre.

> For the Westminster retable see P. Binski, 'What was the Westminster Retable?', *Journal of the British Archaeological Association*, CXL, 1987, pp. 152-74.

> For the altarpiece in Spain see J. Berg Sobré, *Behind the Altar Table: The Development of the Painted Retable in Spain, 1350-1500*, Columbia, Missouri, 1989.

> For the double-sided altarpiece see J. Gardner, 'Fronts and Backs: Setting and Structure', in H. W. van Os and J. R. J. Asperen de Boers (eds), *La Pittura nel XIV e XV Secolo. Il Contributo dell'Analisi Tecnica alla Storia dell'Arte*, Bologna 1983, pp. 297-322; for a view of the evolution of the pala see C. Gardner von Teuffel, 'From Polyptych to Pala: Some structural considerations', in the same volume pp. 323-44.

> For the predella in 14th-century Tuscan painting see A. Preiser, *Das Entstehen und die Entwicklung der Predella in der Italienischen Malerei*, Hildesheim 1973.

Christ, the Virgin Mary and the Heavenly Hierarchy

Jameson, A., *Legends of the Madonna* (1850), London 1888 (illustrated edition), supplies a useful popular history of the Cult of the Virgin and the types of image of her.

Jameson, A., *Sacred and Legendary Art* (1848), 2 vols., London 1888 (illustrated edition) includes a good account of the heavenly hierarchy and of angels.

Schiller, G., *Iconography of Christian Art*, Vol. 2, London 1972, provides a useful historical survey of the representation of the Passion including the Crucifixion.

Schiller, G., *Ikonographie der Christliche Kunst*, Vol. 4.2, Gütersloh 1980, is devoted to a survey of the representations of the Life of the Virgin.

> For half-length images of the suffering Christ see E. Panofsky, 'Jean Hey's "Ecce Homo": Speculations about its Author, its Donor, and its Iconography', *Bulletin des Musées Royaux des Beaux-Arts de Belgique,* V, 1956, pp. 95-138; S. Ringbom, *From Icon to Narrative: The Rise of the Dramatic Close-up in Fifteenth Century Devotional Painting*, 2nd ed. Doornspijk 1983; H. W. van Os, 'The Discovery of an early Man of Sorrows on a Dominican Triptych', *Journal of the Warburg and Courtauld Institutes*, XLI, 1978, pp. 65-75; and H. Belting, *Das Bild und sein Publikum im Mittelalter: Form und Funktion früher Bildtafeln der Passion*, Berlin 1981.

> For the Netherlandish pictures of the Virgin and Child in a domestic setting and the Madonna of Humility see E. Panofsky, *Early Netherlandish Painting*, 2 vols., Cambridge, Mass., 1953, p. 163.

> For the iconography of the Virgin in Sienese painting see H. W. van Os, *Marias Demut und Verherrlichung in der sienesischen Malerei, 1300 – 1450*, The Hague 1969.

> For the Coronation of the Virgin see P. Verdier, *Le Couronnement de la Vierge: Les origines et les premiers développements d'un thème iconographique*, Montreal 1980.

> For the Immaculate Conception see M. Carmichael, *Francia's Masterpiece: an essay on the beginnings of the Immaculate Conception in Art*, London 1909.

Saints, Protectors and Patrons

Jameson, A., *Sacred and Legendary Art* (cited above under Christ, the Virgin Mary and the Heavenly Hierarchy) provides by far the most complete European survey of saints in art. More is often now known of the paintings she cites, but her account of the saints is valuable.

Kaftal, G., *Iconography of the Saints in Tuscan painting*, Florence 1952, and *Iconography of the Saints in Central and South Italian Schools of Painting*, Florence 1965, also *Iconography of the Saints in the Painting of North East Italy*, Florence 1978.

The *Legenda Aurea* (Golden Legend), the most popular anthology of lives of the saints of the 14th and 15th centuries, was composed before 1264 by the Dominican Jacopo da Voragine and rapidly translated into several European languages. A French edition by H. Savon of the translation by J. B. M. Roze published in 2 vols., Paris 1967, is the most easily available.

Vauchez, A., *La Sainteté en Occident aux derniers siècles du Moyen Age d'après les Procès de Canonisation et les Documents Hagiographiques*, Ecole française de Rome, 1981.

> For Saint Jerome see B. Ridderbos, *Saint and Symbol*, Groningen 1984.
>
> For Girolamo Rucellai and the Hieronymites of Fiesole see F. W. Kent, *Household and Lineage in Renaissance Florence*, Princeton, N. J., 1977.
>
> For the Pesellino altarpiece see P. Bacci, *Documenti e commenti per la storia dell'Arte*, Florence 1944.

Orders, Confraternities and their Saints

Jameson, A., *Legends of the Monastic Orders*, 2 vols., London 1890; see also books by the same author cited under Christ, the Virgin Mary and the Heavenly Hierarchy above.

Moorman, J., *A History of the Franciscan Order from its origins to the year 1517*, Oxford 1968.

> For the altarpiece of Saint George and for the banner by Barnaba da Modena in the Victoria and Albert Museum see C. M. Kauffmann, *Catalogue of Foreign Paintings* (in the Victoria and Albert Museum), I. *Before 1800*, London 1973, nos 13 and 221.
>
> For the Florentine confraternity for boys see R. Weissmann, *Ritual Brotherhood in Renaissance Florence*, New York 1982.
>
> For the Florentine 'Compagnia de' Magi' see R. Hatfield, 'The Compagnia de' Magi', *Journal of the Warburg and Courtauld Institutes*, XXXIII, 1970, pp. 107-61.
>
> For Italian confraternities see G. Meersseman, *Ordo fraternitatis, Confraternite e pietà dei laici nel medioevo*, 3 vols., Rome 1977.
>
> For Venetian *scuole* see B. Pullan, *Rich and Poor in Renaissance Venice*, Oxford 1971.

Commerce, Convention and Innovation

Marrow, J., *Passion Iconography in Northern European Art in the Late Middle Ages and Early Renaissance*, Kortrijk 1979, discusses the relationship between the imagery of popular religious texts and religious art in this period.

Pseudo Bonaventura, *Meditations on the Life of Christ*, I. Ragusa and R. Green (eds), Princeton 1961, is an edition of an illustrated Italian 14th century copy of a Franciscan devotional work of the 13th century. It usefully demonstrates Christian imagery and stories familiar to a lay public.

Ringbom, S., *Icon to Narrative: The Rise of the Dramatic Close-up in Fifteenth-century Devotional Painting*, 2nd edn. Doornspijk 1983, supplies a stimulating account of the development of an important type of religious imagery in Europe in the 15th century.

> For Francesco Datini see I. Origo, *The Merchant of Prato* (1957), Harmondsworth 1963 (revised edn).
>
> For the Florentine art market at the end of the 14th century see Gino Corti, 'Sul Commercio dei Quadri a Firenze verso la Fine del Secolo XIV', *Commentari*, 1971, pp. 84-91.
>
> For the Netherlandish art market see L. Campbell, 'The Art Market in the Southern Netherlands in the Fifteenth Century', *The Burlington Magazine*, CXVIII, 1976, pp. 188-98.
>
> For the *Ricordanze* (account books) of Neri di Bicci from 1453-75 see B. Santi (ed.), *Le Ricordanze (10 marzo 1453 – 24 aprile 1475)*, Pisa 1976. For a useful review in English which selects and analyses the most interesting and informative aspects see E. Borsook in *Art Bulletin*, 1979, Vol. LXI, pp. 313-18.
>
> For the reproduction of images by the Bouts workshop see M. Wolff, 'An Image of Compassion: Dieric Bouts's "Sorrowing Madonna"', *Art Institute of Chicago Museum Studies*, XV, no. 2, 1959, pp. 113-25.
>
> For Saint Bridget and the nightpiece in art see Schiller, *Iconography of Christian Art*, Vol. 1, cited under Christ, the Virgin Mary and the Heavenly Hierarchy above; E. Panofsky, *Early Netherlandish Painting*, 2 vols., Cambridge, Mass., 1953, pp. 125-6; also F. Winkler, *Das Werk des Hugo van der Goes*, Berlin 1964, pp. 141ff.
>
> For Isabella d'Este and Bellini's *Presepio* see C. M. Brown with A. M. Lorenzoni, 'Isabella d'Este and Lorenzo da Pavia, Documents for the History of Art and Culture in Renaissance Mantua', Geneva 1982.

Civic Art

Ortalli, G., *La Pittura Infamante nei secoli XIII – XVI*, Rome 1979, surveys the use of painted effigies of criminals hanged or otherwise executed. Egerton. S. Y., *Pictures and Punishment*, Cornell 1985, treats the same subject, but concentrates on Florence and includes a discussion on the paintings found in judicial courts.

Wackernagel, M., *The World of the Florentine Renaissance Artist (Der Lebensraum des Künstlers in der Florentinischen Renaissance*, 1938), Princeton 1981, includes valuable sections on street tabernacles and façade painting, public festivities and spectacles, and municipal and guild patronage.

> For paintings of the Last Judgement in Netherlandish town halls see G. Troescher, 'Weltgerichtsbilder in Rathäusen und Gerichtsstätten', *Wallraf-Richartz Jahrbuch*, XI, 1939, pp. 132-214.
>
> For paintings in the Doge's Palace in Venice see P. F. Brown, *Venetian Narrative Painting in the Age of Carpaccio*, New Haven and London 1988.
>
> For portraits in Netherlandish town halls see K. G. van Acker, 'Iconografische beschouwungen in verhand met de 16ᵉ eeuwse gegravende portratten der graven van Vlaanderen', *Oud Holland*, LXXXIII, 1968, pp. 95-116.
>
> For paintings in the Palazzo Pubblico, Siena, and an account of civic imagery elsewhere in Tuscany see E. C. Southard, *The Frescoes in Siena's Palazzo Pubblico 1289-1539*, New York and London 1979.
>
> For Rogier van der Weyden as town painter see *Rogier van der Weyden, Rogier de la Pasture official painter of the Treaty of Brussels: portrait painter of the Burgundian Court*, exhibition catalogue, Brussels City Museum, 1979.
>
> For Cecca see G. Vasari, *Le Opere*, cited under General Introductions above, III, pp. 195-204.

Palace Decoration

Pedrini, A., *L'Ambiente: il mobilio e le decorazioni del Rinascimento in Italia*, Turin 1925.

Thomson, W. G., *A History of Tapestry*, revised edition, Wakefield, Yorkshire, 1973. A comprehensive history of manufacture and use.

Wackernagel, M., as listed under Civic Art above includes much on palaces in Florence.

> For the Burgundian court see R. Vaughan, *Valois Burgundy*, London 1975, and J. Huizinga, listed under Western Europe above, as well as *Rogier van der Weyden*, exhibition catalogue, listed under Civic Art above.
>
> For the palaces and collections of the Duc de Berry see M. Meiss, *French Painting in the Time of Jean de Berry*, 2 vols., London and New York 1967.
>
> For the painted decoration at Longthorpe Castle see *The Age of Chivalry* (eds. J. Alexander and P. Binski), exhibition catalogue, Royal Academy of Arts, London 1987, pp. 249-50, and M. Wood, *The English Medieval House*, London 1965, pp. 399-401. For the wall paintings in English royal palaces see *The Age of Chivalry*, pp. 125-30, and Wood, pp. 314-406; the latter also contains references to some continental schemes.
>
> For the programme of decoration proposed for the Palace of Pavia see E. S. Welch, 'Galeazzo Maria Sforza and the Castello di Pavia 1469', *The Art Bulletin*, LXXI, 1989, pp. 352-74.

For the Petrucci Palace, Siena, see *Domenico Beccafumi e il suo tempo*, catalogue of an exhibition held in Sant' Agostino and elsewhere, Siena 1990, nos. 49a and b, 190 and pp. 590-9.

For the inventory of the Medici Palace made in 1492 see E. Müntz, *Les Collections des Médicis au XVe siècle*, Paris 1888. A typescript of a more complete copy is in the Warburg Institute Library.

For the revival of interest in ancient text, inscriptions, coins etc. see R. Weiss, *The Renaissance Discovery of Classical Antiquity*, Oxford 1969. For classical subject matter and its treatment see E. Panofsky, *Renaissance and Renascences in Western Art*, London 1965.

Portraits

Büchner, E., *Das Deutsche Bildnis der Spätgotik und der frühen Dürerzeit*, Berlin 1953. A survey with catalogue of over two hundred German portraits of the 15th century.

Campbell, L., *Renaissance Portraits*, London and New Haven 1990. An extremely well-illustrated stimulating account of how European portraits in this period and in the 16th century were commissioned, made, used and esteemed.

Pope Hennessy, J., *The Portrait in the Renaissance*, New York, 1966. A series of lectures of most value for its discussion of Italian 15th century painting and sculpture.

> For the use of flowers in portraits see E. Wolffhardt, 'Beiträge zu Pflanzensymbolik', *Zeitschrift für Kunstwissenschaft*, VII, 1954, pp. 177-96.

Paintings for the 'Camera'

Lydecker, J. K., 'Il Patriziato Fiorentino e la committenza artistica per la casa' in *I ceti dirigenti nella Toscana del Quattrocento* (Atti del V e VI. Convegno, Florence, December 1982 and 1983), Florence 1987, pp. 209-21.

> For a painter whose workshop specialised in *cassoni* and *deschi da parto* see E. Callmann, *Apollonio di Giovanni*, Oxford 1974 (includes a comprehensive bibliography). Also the same author's 'Apollonio di Giovanni and painting for the Early Renaissance Room', *Antichità Viva*, XXVII, 1988, pp. 5-18.

Paintings for the 'Studiolo'

> For Cosimo Tura at Belfiore see the forthcoming catalogue of the exhibition *Le Muse e il Principe: Lo Studiolo di Belfiore (1447-1463), Arte del Corte del Primo Rinascimento* at Museo Poldi Pezzoli, Milan (September 1991).

> The *studiolo* in the Palace of Gubbio is reconstructed by C. H. Clough in 'Federigo da Montefeltro's Private Study in his ducal palace of Gubbio', *Apollo*, 1967, pp.. 278-87.

For Isabella d'Este's *studiolo* and collection see especially C. M. Brown, '"Lo insaciabile desiderio nostro de cose antique" - New Documents for Isabella d'Este's Collection of Antiquities', in C. H. Clough (ed.), *Cultural Aspects of the Italian Renaissance – Essays in honour of Paul Oskar Kristeller*, Manchester 1976.

For art collecting in this period see J. Alsop, *The Rare Art Traditions*, London 1982, Chapters X-XIII.

For the earliest European prints see A. M. Hind, *A Short History of Engraving and Etching*, London 1923 (revised edition), also the same author's *An Introduction to a History of Woodcut*, London 1935.

Range and Status

Cole, B., *The Renaissance Artist at work: from Pisano to Titian*, 1983, discusses, among other aspects, the artist in society.

Martindale, A., *The Rise of the Artist in the Middle Ages and the Early Renaissance*, London 1972, provides a brief survey of the artist's changing status and supplies a useful bibliography.

Wackernagel, M., listed under Civic Art, has a valuable discussion of the status of the artist in Florence in this period.

> For Gilbert Prince see W. A. Shaw, 'The Early English School of Portraiture', *The Burlington Magazine*, LXV 1934, pp. 171-84.

> For English Medieval painters see J. H. Harvey, 'Some London Painters of the 14th and 15th Centuries', *The Burlington Magazine*, LXXXIX, 1947, pp. 303-6.

> For Naples see F. Bologna, *I Pittori alla Corte angiona di Napoli 1266-1414*, Rome 1969.

Guilds

Baxandall, M., *Limewood Sculptors of Southern Germany*, London and New Haven 1980. Although about sculpture the account of artistic working practices and guilds is pertinent for the study of painting. The sources for the guild regulations of a number of German towns are given on p. 229, note 44: most are relevant for painters as well as sculptors.

Campbell, L., 'The Early Netherlandish Painters and their Workshops', in *Le problème Maître de Flémalle-Van der Weyden, Le Dessin sous-jacent dans la peinture*, Colloque III, Louvain 1981, pp. 43-61, provides much useful analysis of Netherlandish guild regulations. The sources for the guild regulations of the major Netherlandish towns are given in note 1, p. 54.

Campbell, L., 'The Art Market in the Southern Netherlands in the Fifteenth Century', *The Burlington Magazine*, CXVIII, 1976, pp. 188-98, discusses the guild system and its effect on the production and sale of Netherlandish paintings.

Huth, H., *Künstler und Werkstatt*, Augsburg 1923. Includes information drawn from German guild regulations.

Thrupp, S. L., 'The Guilds', *Cambridge Economic History of Europe III*, Cambridge 1963, pp. 230-80, and the same author's 'Medieval Industry 1000-1500' in *The Fontana Economic History of Europe, The Middle Ages*, C. Cipolla (ed.), 1972, pp. 221-74, provides useful accounts of the guild system in this period.

Wackernagel, M., listed under Civic Art, includes material on guilds in Florence as patrons of artists as well as corporations to which artists were attached.

> For an annotated bibliography on the Florentine and Sienese guilds see D. Bomford *et al*, *Art in the Making: Italian Painting before 1400*, listed under Further Reading, p. 213ff.

> For the Florentine guild see R. Ciasca, *L'Arte dei Medici e Speziali*, Florence 1927. For the painters' statutes (1314 onwards) and the confraternity of Saint Luke in particular, see C. Fiorilli, 'I dipintori a Firenze nell'Arte dei Medici e Speziali e Merciai', *Archivio Storico Italiano*, LXXVIII, 1920, Vol. II, pp. 5-74.

> For the statutes of the guilds of Perugia (1366) and Siena (1355), and the statutes of the Florentine confraternity of Saint Luke, (1386), see L. Manzoni, *Statuti e matricole dell'Arte dei Pittori delle città di Firenze, Perugia, Siena, nei testi originali del Secolo XIV*, Rome 1904.

> For the statutes of the guild of Padua in 1441 see G. Gaye, *Carteggio Inedito d'Artisti dei Secoli XIV, XV, XVI*, 3 vols., Florence 1840, Vol. 2, pp. 43-6.

> For Netherlandish and German paintings in Venice see L. Campbell, 'Notes on Netherlandish pictures in the Veneto in the 15th and 16th centuries', *The Burlington Magazine*, CXXIII, 1981, pp. 467-72.

Contracts and Commissions

Chambers, D. S. (ed.), *Patrons and Artists in the Italian Renaissance*, London 1970. A useful anthology of documents in translation.

Gilbert, C. E., *Italian Art 1400-1500: Sources and Documents*, Englewood Cliffs, N. J., 1980.

Glasser, H., *Artists' Contracts of the Early Renaissance*, London and New York 1977. An analysis of the evidence supplied by Italian contracts, for sculpture as well as painting.

Huth, H., *Künstler und Werkstatt*, Augsburg 1923. The edition of 1967 includes an appendix of 24 German contracts. Sculpture is covered as well as painting.

Stechow, W., *Northern Renaissance Art 1400-1600: Sources and Documents*, Englewood Cliffs, N. J.,

1966. Includes documents in translation with references to publications giving the original text (including the contracts for the altarpieces of Pacher, Quarton and Bouts discussed here). For Pacher's St Wolfgang Altarpiece see also N. Rasmo, *Michael Pacher*, Munich and Milan 1969 (English edn. London 1971).

For the contract for Benozzo Gozzoli's altarpiece for the Dominican Confraternity attached to San Marco see C. Ricci in *Rivista d'Arte*, I, 1904, pp. 1-12 (the document is given on pp. 9-12).

For Neri di Bicci see bibliography under Commerce, Convention and Innovation.

For documents concerning van der Weyden's Cambrai altarpiece see L. Laborde, *Les Ducs de Bourgogne*, Seconde Partie, I, note, p. lix, Paris 1849-52.

For the Santa Felicità altarpiece and a full discussion of the relationship between carpenter and painter, particularly as revealed in contracts, see Creighton Gilbert, 'Peintres et menuisiers au début de la Renaissance en Italie', *Revue de l'Art*, 37, 1977, pp. 9-28.

For the contract for the altarpiece for Passignano see G. Milanesi, *Nuovi Documenti per la Storia dell'Arte Sienese*, Siena 1854, p. 269.

For Piero della Francesca's contract of 1445 for Santa Maria della Misericordia see G. Milanesi, *Nuovi Documenti per la Storia dell'Arte Toscana del XII al XV secolo*, Florence 1901, p. 91.

For Nabur Martins, Cleerbout van Witevelde and Philippe Truffin see L. Campbell, 'The Art Market in the Southern Netherlands in the Fifteenth Century', *The Burlington Magazine*, CXVIII, 1976, pp. 188-98.

For the documents relating to the altarpiece by Pesellino see P. Bacci, *Documenti e commenti per la storia dell'Arte*, Florence 1944, pp. 113ff.

For the documents relating to the *Incredulity of Saint Thomas* by Cima see P. Humfrey, *Cima da Conegliano*, Cambridge 1983, pp. 110, 202-4.

For Fra Angelico's Linaiuoli altarpiece see J. Pope-Hennessy, *Fra Angelico*, 2nd edn., London 1982, p. 7.

For Ghirlandaio's Innocenti altarpiece see the English translation of the contract given in M. Baxandall, *Painting and Experience in Fifteenth Century Italy*, Oxford 1972, p. 65.

For Uccello's fresco of Sir John Hawkwood see J. Pope-Hennessy, *Paolo Uccello*, London 1950, p. 142.

For the sermon of Jakob of Lausanne see H. Huth, cited above, p. 29.

PART TWO

THE MAKING OF PAINTINGS

General Surveys

Berg Sobré, J., *Behind the Altar Table: The Development of the Painted Retable in Spain, 1350-1500*, Columbia, Missouri, 1989. Includes a chapter on Spanish painting techniques based principally on the examination of documents but supported by some scientific examination.

Bomford, D., Dunkerton, J., Gordon, D., and Roy, A., *Art in the Making: Italian Painting before 1400*, exhibition catalogue, National Gallery, London 1989. Examines eight works from the Collection by the Master of Saint Francis, Giotto, Duccio, Ugolino and Nardo and Jacopo di Cione. Includes a very full bibliography.

Gettens, R. J., and Stout, G. L., *Painting Materials: A Short Encyclopedia* (1942), Dover edition, New York 1966. This is still the best quick reference work, although inevitably some of the entries need revision in light of more recent discoveries.

Nicolaus, K., *Du Mont's Handbuch der Gemäldekunde: Material, Technik, Pflege*, Cologne 1979. A useful and well-illustrated introduction to the subject of the type which does not yet exist in English.

Thompson, D. V., *The Materials and Techniques of Medieval Painting*, London 1936, Dover edition, New York 1956. This remains a valuable introduction to the subject but it needs to be supplemented by more recent scientific investigations.

Original Sources

Anon., *The Strasburg Manuscript. A Medieval Painters' Handbook*, trans. V. and R. Borradaile, London 1966. Although in no way a Northern European equivalent to Cennino Cennini, it does contain some useful information.

Cennini, Cennino d'Andrea, *The Craftsman's Handbook: 'Il Libro dell'Arte'*, trans. D. V. Thompson, Jr, Dover edition, New York 1954. The main source of information about painting techniques in Italy in the 14th century. Examination of paintings has confirmed that the techniques described were indeed used.

Merrifield, M. P. *Original treatises dating from the XIIth to the XVIIth centuries in the arts of paintings*, 2 vols. (London 1849), Dover edition, New York 1967. The treatises relevant to the period under discussion are those of Eraclius and Alcherius and the Bolognese and Marciana Manuscripts. Also includes a useful introduction.

The Workshop Members

Bomford *et al*, *Art in the Making: Italian Painting before 1400*, cited under Further Reading, especially

pp. 9-11, 185-9 (on the San Pier Maggiore Altarpiece) and pp. 197-200 (the San Pier Maggiore documents).

Campbell, L., 'The Early Netherlandish Painters and their Workshops', listed under Guilds.

For terms of apprenticeship in Florence see N. Ottokar, 'Pittori e contratti d'apprendimento presso pittori a Firenze alla fine del dugento', *Rivista d'Arte*, XIX, 1937, pp. 55-7.

For Neri di Bicci's arrangements see *Le Ricordanze*, listed under Commerce, Convention and Innovation; see also E. Borsook's review, also cited there.

For the agreement with Squarcione see Gilbert, *Italian Art 1400-1500: Sources and Documents*, listed under Contracts and Commissions, pp. 33-4.

For the colour grinder employed at Pistoia see S. Ciampi, *Notizie inedite della Sagrestia pistoiese de' belli arredi del Campo Santo pisano, e di altre opere di disegno del secolo XIII al XV*, Florence 1810, pp. 145-50.

For Mantegna's colour maker and other documents concerning Mantegna's technique see P. Kristeller, *Andrea Mantegna*, London, 1901, Appendix, pp. 165ff.(not included in the German edition); and C. M. Brown, 'New Documents Concerning Andrea Mantegna and a note regarding "Jeronimus de Conradis pictur"', *The Burlington Magazine*, CXI, 1969 p. 538-44; and for the materials used by Mantegna in the Saint Luke Altarpiece see S. Bandera Bistoletti (ed.), *Il Polittico di San Luca di Andrea Mantegna (1453-1454), in occasione del suo restauro*, Florence 1989, pp. 67-8.

For the *compagnia* in the Corso degli Adimari see U. Procacci, 'Di Jacopo di Antonio e delle compagnie di pittori del corso degli Adimari nel XV secolo', *Rivista d'Arte*, Vol. XXXV, 1960, pp. 3-70, esp. p. 34.

Premises, Tools and Equipment

For the documents concerning San Giovanni Fuorcivitas see A. Ladis, *Taddeo Gaddi: critical reappraisal and catalogue raisonné*, Columbia and London 1982, pp. 255-8.

For Leonardo's suggestions on lighting see J. P. Richter (ed.), *The Literary Works of Leonardo da Vinci* (first published 1883), London and New York, 1970, pp. 315-16; and M. Kemp (ed.), *Leonardo on Paintings*, New Haven and London 1989, pp. 214-15.

For the contents of Filippino Lippi's workshop see D. Carl, 'Das Inventar der Werkstatt von Filippino Lippi aus dem Jahre 1504', *Mitteilungen des Kunsthistorischen Institutes in Florenz*, XXXI, 1987, pp. 373-91.

For Jacobello del Fiore's property see P. Paoletti, *Raccolta di documenti*, Padua 1894, no. 6.

For the inventory of Neroccio's workshop see

G. Coor, *Neroccio de' Landi 1447-1500*, Princeton, 1961, pp. 152-9.

For the materials bought for the chapel at Brescia see K. Christiansen, *Gentile da Fabriano*, London 1982, esp. pp. 150-9.

For Baldovinetti's brushes and other useful information about materials and workshop practice see R. W. Kennedy, *Alesso Baldovinetti. A Critical and Historical Study*, London and New Haven 1938, especially the *Ricordi*, p. 236ff.

Drawings and Props

Ames-Lewis, F., *Drawing in Early Renaissance Italy*, New Haven and London 1981.

Ames-Lewis, F., and Wright, J., *Drawing in the Italian Renaissance Workshop*, Exhibition catalogue, Victoria and Albert Museum, London 1983. Both this work and the one listed above include descriptions of drawing materials and techniques and discuss the various and changing functions of drawing in Italian workshops of the 15th century.

No equivalent study of Netherlandish or German drawings of the period exists but occasionally the role of drawings is considered in discussions of underdrawing (see Underdrawing below).

> For the use of patterns in Netherlandish workshops see L. Campbell, 'The Early Netherlandish Painters and their Workshops', listed under Guilds above, especially pp. 53-4. For the dispute between Ambrosius Benson and Gerard David see G. Marlier, *Ambrosius Benson et la peinture à Bruges au temps de Charles-Quint*, Damme 1957, pp. 15-19.

> For Filarete's jointed models see C. E. Gilbert, *Italian Art 1400-1500. Sources and Documents*, listed under Contracts and Commissions, p. 91.

> For the drawing books of Jacopo Bellini see C. Eisler, *The Genius of Jacopo Bellini: The Complete Paintings and Drawings*, London and New York 1989.

> For drapery studies in the Verrocchio workshop see *Léonard de Vinci. Les Etudes de Draperie*, Exhibition catalogue, Louvre, Paris 1989.

> For the two versions of the *Assassination of Saint Peter Martyr* see J. Fletcher and D. Skipsey, 'Death in Venice: Giovanni Bellini and "The Assassination of Saint Peter Martyr"', in *Apollo*, CXXXIII, 1991, pp. 4-9.

> For oriental carpets in paintings see J. Mills, *Carpets in Pictures, Themes and Painters in the National Gallery*, Series 2, No. 1, London 1975.

Panels and Frames

Gilbert, C., 'Peintres et menuisiers au debut de la Renaissance en Italie', *Revue de l'Art*, 37, 1977, pp. 9-28. On the relationship between painters and the carpenters of panels and frames.

Marette, J., *Connaissance des Primitifs par l'Etude du Bois du XIIe au XVIe siècle*, Paris 1961. The first (and still the most useful) investigation of the wood species used in panel construction, based on a survey of panels in French public collections.

Newbery, T. J., Bisacca, G., and Kanter, L. B., *Italian Renaissance Frames*, Metropolitan Museum of Art, New York 1990. As well as describing frames it includes an excellent account of the methods of altarpiece construction. See also Bomford *et al.*, *Art in the Making: Italian Painting before 1400* cited under Further Reading.

Verougstraete-Marcq, H., and Schoute, R. Van, *Cadres et supports dans la peinture flamande aux 15e et 16e siècles*, Heure-le-Romain 1989. A detailed and well-illustrated study of the construction of Netherlandish panels and their frames.

> For the purchase of timber for the Bouts panels see F. Van Molle, J. Folie, N. Verhaegen, A. Philippot, P. Philippot, R. Sneyers and J. Thissen, 'La Justice d'Othon de Thierry Bouts', *Bulletin de l'Institut Royal du Patrimoine Artistique*, 1, 1958, pp. 7-69.

> For detailed descriptions of original altarpiece frames see M. R. Valazzi (ed.), *La Pala Ricostituita: L'Incoronazione della Vergine e la cimasa vaticana di Giovanni Bellini. Indagini e restauri*, Venice 1988; and A. Smith, A. Reeve, C. Powell, and A. Burnstock, 'An Altarpiece and its Frame: Carlo Crivelli's "Madonna della Rondine"', *National Gallery Technical Bulletin*, 13, 1989, pp. 29-43.

Canvas Painting

Villers, C., 'Artists' canvases: a history', Preprints of ICOM Committee for Conservation, 6th Triennial Meeting, Ottawa 1981. A brief survey but includes references to Italian canvas painting.

Wolfthal, D., *The Beginnings of Netherlandish Canvas Painting: 1400-1530*, Cambridge 1989. Based on documentary sources, the author's own observations, and the few scientific examinations to have been published. No such study exists for Italian painting.

> For detailed accounts of two Netherlandish canvas paintings in the National Gallery see D. Bomford, A. Roy and A. Smith, 'The Techniques of Dieric Bouts: Two Paintings Contrasted', *National Gallery Technical Bulletin*, 10, 1986, pp. 39-57; and A. Roy, 'The Technique of a "Tüchlein" by Quinten Massys', *National Gallery Technical Bulletin*, 12, 1988, pp. 36-43.

> For some examples of Italian canvas paintings known to have been stretched over panels see J. Shearman, 'The Historian and the Conservator', *The Princeton Raphael Symposium. Science in the Service of Art History*, J. Shearman and M. B. Hall (eds.), Princeton, 1990, pp. 11-13.

Grounds

Hendy, P., Lucas, A., and Plesters, J., 'The Ground in Pictures', *Museum*, II, 4 (1968), pp. 245-76.

> For the different forms of calcium sulphate used in North Italy and Tuscany see R. J. Gettens and M. E. Mrose, 'Calcium sulphate minerals in the grounds of Italian paintings', *Studies in Conservation*, I, 4, 1954, pp. 174-89; and also Bomford *et al.*, *Art in the Making: Italian Painting before 1400*, listed under Further Reading, pp. 17-19.

> For coccoliths in chalk grounds see, for example, P. W. F. Brinkman, L. Kockaert, L. Maes, L. Masschelein-Kleiner, Fr. Robaszynski, and E. Thielen, 'Het Lam Godsretabel van Van Eyck. Een heronderzoek naar de materielen en schildermethoden. 1. De plamuur, de isolatielaag, de tekening en de grondtonen', *Bulletin de l'Institut Royal du Patrimoine Artistique*, XX, 1984-5, pp. 137-66, especially pp. 146-9 (with French summary).

> For the grounds on Botticelli's canvas paintings see M. Matteini and A. Moles, 'Indagini sui materiali e le stesure pittoriche del dipinto in La Nascità di Venere e l'Annunciazione del Botticelli restaurate', *Gli Uffizi, Studi e Ricerche*, 4, 1987.

> For the ground on Uccello's *Saint George and the Dragon* see N. Bromelle, 'St George and the Dragon', *Museums Journal* (London), LIX, 1959, pp. 87-95.

Underdrawing

Le dessin sous-jacent dans la peinture, Université Catholique de Louvain, Louvain-la-Neuve. Colloques I et II (1975 and 1977), published 1979, III (1978), published 1981, IV (1981) published 1982, V (1983) published 1985, VI (1989) to be published. Transactions of a regular series of conferences held to examine and discuss underdrawing, principally on Northern European paintings. The literature on Netherlandish underdrawing is extensive so only a few articles about painters discussed in this book are cited below.

> For the underdrawing of Duccio and Nardo di Cione see Bomford *et al*, *Art in the Making: Italian Painting before 1400*, listed above under Further Reading.

> For important studies of van Eyck's underdrawing see J. R. J. Van Asperen de Boer, 'A Scientific Re-examination of the Ghent Altarpiece', *Oud Holland*, 93, 1979, pp. 141-214; and J. R. J. Van Asperen de Boer and M. Faries, 'La Vierge au Chancelier Rolin de Van Eyck: examen au moyen de la réflectographie à l'infrarouge', *La Revue du Louvre et des Musées de France*, 1990, pp. 37-50.

> For Cosimo Tura's underdrawing see

J. Dunkerton, A. Roy and A. Smith, 'The Unmasking of Tura's "Allegorical Figure": A Painting and its Concealed Image', *National Gallery Technical Bulletin*, 11, 1987, pp. 5-35; and D. Scrase, 'Cosimo Tura: The Crucifixion with the Virgin and Saint John', *Bulletin of the Hamilton Kerr Institute*, 1, 1988, pp. 69-71.

For the use of pouncing by Perugino see D. Bomford and N. Turner, 'Perugino's Underdrawing in the "Virgin and Child adored by an Angel" from the Certosa di Pavia Altarpiece', in *Perugino, Lippi e La Bottega di San Marco alla Certosa di Pavia*, exhibition catalogue, Brera, Milan 1986, pp. 49-54.

For the use of pouncing by Raphael see, for example, C. Christensen, 'Examination and Treatment of Paintings by Raphael at the National Gallery of Art', in *Raphael Before Rome: Studies in the History of Art*, National Gallery of Art, Washington, Vol. 17, 1986, pp. 47-50; and W. Prohaska, 'The Restoration and Scientific Examination of Raphael's "Madonna in the Meadow"', in *The Princeton Raphael Symposium. Science in the Service of Art History*, John Shearman and Marcia B. Hall (eds.), Princeton, 1990, especially pp. 63-4.

For Gerard David see M. W. Ainsworth, 'Northern Renaissance Drawings and Underdrawings: a Proposed Method of Study', *Master Drawings*, 28, No. 1, 1990, pp. 5-38.

For the theory and practice of linear perspective see M. Kemp, *The Science of Art*, Yale University Press, New Haven and London 1990, especially Chapter 1, pp. 21-3 (for Alberti) and p. 44 (for Leonardo's basic perspective construction which is likely to have been applied by Bramantino).

Gilding

Bomford *et al.*, *Art in the Making: Italian Painting before 1400* listed above under Further Reading. For an account of the gilding techniques used on Italian panels see especially pp. 21-6, 43-8 (for mordant gilding and 'shell gold'), p. 69 (for Giotto's use of green earth), pp. 112-14 (for Ugolino's punchmarks), pp. 130-5 (for the execution of *sgraffito* textiles), pp. 144-7 (for *pastiglia*), pp. 177-8 (for punchmarks on the San Pier Maggiore Altarpiece), p. 24, and p. 182 (for silver leaf).

Kühn, H., Roosen-Runge, H., Straub, R. E., and Koller, M., *Reclams Handbuch der künstlerischen Techniken. Band 1. Farbmittel, Buchmalerei, Tafel- und Leinwandmalerei*, Stuttgart 1984, esp. pp. 183-190. Includes definitions of oil and water-gilding methods and of the variations of and substitutes for gold leaf.

For examples of German documents specifying the use of burnished and unburnished gold etc. see Huth, *Künstler und Werkstatt*, listed above under Contracts and Commissions.

For gilded tin see E. Borsook, 'Jacopo di Cione and the guild hall of the Judges and Notaries in Florence', *The Burlington Magazine*, 124, 1982, pp. 86-8; and L. Tintori, '"Golden tin" in Sienese murals of the early trecento', *The Burlington Magazine*, 124, 1982, pp. 94-5.

For applied relief brocades on paintings see M. Serck-Dewaide, 'Relief decoration on sculptures and paintings from the thirteenth to the sixteenth century: technology and treatment' in *Cleaning, Retouching and Coatings. Technology and Practice for Easel Paintings and Polychrome Sculpture*. Preprints of the Contributions to the Brussels Congress of the International Institute for Conservation of Historic and Artistic Works, London 1990, pp. 36-40; and M. Broekman-Bokstijn, J. R. J. Van Asperen de Boer, E. H. van Thul-Ehrnreich and C. Verduyn-Groen, 'The scientific examination of the polychromed sculpture in the Herlin Altarpiece', *Studies in Conservation*, 15, 1970, pp. 370-400.

For the best summary of progress in the investigation of punch marks see E. Skaug, 'Punch marks – what are they worth? Problems in Tuscan workshop interrelationships in the mid-fourteenth century: the Ovile Master and Giovanni da Milano', *La pittura nel XIV e XV secolo: il contribuito dell'analisi tecnica alla storia dell'arte*, H. W. van Os and J. R. J. van Asperen de Boer (eds.), Bologna 1983, pp. 253-82. For a full bibliography of this topic see Bomford *et al*, *Art in the Making: Italian Painting before 1400* op. cit., pp. 215-16.

For gold and silver on panels by Sassetta see M. Wyld and J. Plesters, 'Some Panels from Sassetta's Sansepolcro Altarpiece', *National Gallery Technical Bulletin*, 1, 1977, pp. 3-17; by Crivelli, see Smith *et al*, 'An Altarpiece and its Frame: Carlo Crivelli's "Madonna della Rondine"', listed under Panels and Frames; by Raphael see J. Plesters, 'Technical Aspects of Some Paintings by Raphael in the National Gallery, London,' *The Princeton Raphael Symposium* (1983), John Shearman and Marcia B. Hall (eds.), Princeton, 1990, pp. 15-37.

For the use of 'shell gold' on 15th-century Italian panels see F. Ames-Lewis, 'Matteo de' Pasti and the use of powdered gold', *Mitteilungen des Kunsthistorischen Institutes in Florenz*, XXVIII, 1984, pp. 351-61.

Pigments

Bomford *et al*, *Art in the Making: Italian Painting before 1400*, listed under Further Reading, especially pp. 30-42. Includes a detailed account of pigments used in 14th-century Italy together with a full bibliography. A few articles published since that exhibition or articles on pigments not introduced until the 15th century are cited below.

Feller, R. L. (ed.), *Artists' Pigments. A Handbook of their History and Characteristics*, Vol. 1, National Gallery of Art, Washington 1986. Further volumes are to follow.

Harley, R. D., *Artists' Pigments c. 1600-1835. A Study in English Documentary Sources*, London, second edition, 1982. This includes useful information about the earlier use of those pigments which continued to be employed in the 17th century.

For the involvement of the Gesuati in the supply of pigments see P. Bensi, 'Gli Arnesi dell'Arte. I Gesuati di San Giusto alle Mura e la Pittura del Rinascimento a Firenze', *Studi di Storia delle arti*, 1980, pp. 33-47.

For the Venetian pigment trade in the 15th century see L. Lazzarini, 'Il Colore nei Pittori Veneziani tra il 1480 e il 1580', *Bollettino d'Arte*, Supplemento 5, 1983, pp. 135-44.

For Cima's palette see J. Dunkerton and A. Roy, 'The Technique and Restoration of Cima's "The Incredulity of Saint Thomas"', *National Gallery Technical Bulletin*, 10, 1986, pp. 4-27.

For Isabella d'Este see E. Verheyen, *The Paintings in the Studiolo of Isabella d'Este at Mantua*, New York University Press, 1971, p. 12.

For the identification of smalt on 15th-century paintings see Bomford *et al* 'The Techniques of Dieric Bouts: Two Paintings Contrasted', listed under Canvas Painting; and Valazzi, *La Pala Ricostituita* etc. listed under Panels and Frames.

For occurrences of artificial malachite see Dunkerton *et al*, 'The Unmasking of Tura's "Allegorical Figure"', listed under Underdrawing (with further examples); and A. Massing, and N. Christie, 'The Hunt in the Forest by Paolo Uccello', *Bulletin of the Hamilton Kerr Institute*, 1, 1988, pp. 30-47.

For a recent study of the occurrence of the two types of lead-tin yellow (and several useful indications as to paint media used) see E. Martin and A. R. Dural, 'Les deux variétés de jaune de plomb et d'étain: étude chronologique', *Studies in Conservation*, Vol. 35, No. 3, 1990, pp. 117-36.

For the identification of transparent brown pigments see R. White, 'Brown and Black Organic Glazes, Pigments and Paints', *National Gallery Technical Bulletin*, 10, 1986, pp. 58-61.

Glue-size Painting

For Netherlandish painting in this medium see Wolfthal, *The Beginnings of Netherlandish Canvas Painting*; Bomford *et al*, 'The Techniques of Dieric Bouts etc.'; and A. Roy,

BIBLIOGRAPHY

'The Technique of a "Tüchlein" by Quinten Massys', all listed under Canvas Painting.

Egg Tempera Painting

Bomford *et al*, *Art in the Making: Italian Painting before 1400*, listed under Further Reading. For the handling and properties of egg tempera see especially pp. 26–9 and for Cennino's system of colour modelling see pp. 134–7.

Thompson, D. V., *The Practice of Tempera Painting*, New Haven 1936 (Dover reprint, New York and London 1962). Although this is intended more for the practising painter than for the historian of technique, it is still a useful introduction to tempera painting.

> For the non-naturalistic aspects of colour modelling in tempera painting (here used to introduce an account of the development of 'tonal unity') see J. Shearman, 'Leonardo's Colour and Chiaroscuro', *Zeitschrift für Kunstgeschichte*, XXV (1962), p. 13ff.

Oil Painting in the Netherlands

Eastlake, Sir Charles Lock, *Methods and Materials of Painting of the Great Schools and Masters* (formerly titled *Materials for a History of Oil Painting* and first published in 1847), 2 vols., Dover edition, New York 1960. An important and useful introduction to the development of oil painting, even if the conclusions are inevitably sometimes contradicted by scientific evidence or more recent art-historical discoveries.

Perier-D'Ieteren, C., *Colyn de Coter et la Technique Picturale des Peintres Flamands du XVe Siècle*, Brussels 1985. Includes a well-illustrated introduction to the techniques of Netherlandish painting in general.

> For the altarpiece for the Charterhouse at Champmol see L. Kockaert, 'Note on the Painting Technique of Melchior Broederlam', Preprints of ICOM Committee for Conservation, 7th Triennial Meeting, Copenhagen 1984, Section 19, pp. 7–9; and M. Comblen-Sonkes and N. Veronée-Verhaegen, *Le Musée des Beaux-Arts de Dijon, Les Primitifs Flamands I*, Corpus de la Peinture des Anciens Pays-Bas Méridionaux au Quinzième Siècle, 14, Brussels 1986, pp. 70–158.

> For Norwegian altar frontals in oil see L. E. Plahter, E. Skaug, U. Plahter, *Gothic Painted Altar Frontals from the Church of Tingelstad*, Universitetsforlaget, Oslo 1974.

> For a pioneering study of the technique of van Eyck see P. Coremans (ed.), 'L'Agneau Mystique au Laboratoire. Examen et Traitement' in *Les Primitifs Flamands*, III, Contributions à l'Etude des Primitifs Flamands, Antwerp 1953. This can be supplemented by P. W. F. Brinkman, L. Kockaert, L. Maes, E. M. M. Thielen and J.

Wouters, 'Het Lam Godsretabel van Van Eyck. Een heronderzoek naar de materialen en schildermethoden, 2. De hoofdkleuren. Blauw, groen, geel en rood', *Bulletin de l'Institut Royal du Patrimoine Artistique XXII*, 1988/9, pp. 26–49 (with French summary).

> For Dieric Bouts see Bomford *et al*, 'The Technique of Dieric Bouts etc.' listed under Canvas Painting; and Van Molle *et al*, 'La Justice d'Othon de Thierry Bouts', listed under Panels and Frames; and P. Coremans and R. J. Gettens, 'La Technique des "Primitifs Flamands"'. Etude scientifique des matériaux, de la structure et de la technique picturale', *Studies in Conservation*, 1, No. 1, 1952, pp. 1–19.

> For Gerard David see M. Wyld, A. Roy and A. Smith, 'Gerard David's "The Virgin and Child with Saints and a Donor"', *National Gallery Technical Bulletin*, 3, 1979, pp. 51–65.

> For the use of a lightly pigmented layer over the ground see J. R. J. van Asperen de Boer, R. Van Schoute, M. C. Garrido and J. M. Cabrera, 'Algunas cuestiones técnicas del "Descendimento de la Cruz" de Roger van der Weyden', *Boletín del Museo del Prado*, IV, No. 10, 1983, pp. 39–50; and Brinkman *et al*., 'Het Lam Godsretabel van Van Eyck', listed under Grounds, pp. 147–8.

Oil Painting in Italy

Eastlake, *Methods and Materials* etc., listed under Oil Painting in the Netherlands.

> For Antonello see J. Wright, 'Antonello da Messina: the origins of his style and technique', *Art History*, 3, 1980, pp. 41–52. This study is based on the rather limited evidence of X-radiographs and without the benefit of more recent discoveries about oil painting in Northern Italy.

> For the transition to oil painting in Spain see J. Berg Sobré, *Behind the Altar Table: The Development of the Painted Retable in Spain*, listed under The Making of Paintings: General Surveys, esp. pp. 63–9.

> For Tura and the paintings by van der Weyden in Ferrara see Dunkerton *et al*, 'The Unmasking of Tura's Allegorical Figure etc.' listed under Underdrawing; and *Le Muse e il Principe* listed under Paintings for the 'Studiolo'.

> For Cossa see A. Smith, A. Reeve and A. Roy, 'Francesco del Cossa's "Saint Vincent Ferrer"', *National Gallery Technical Bulletin*, 5, 1981, pp. 45–57.

> For Ercole de' Roberti see J. Dunkerton and A. Smith, 'Ercole de' Roberti's "The Last Supper"', *National Gallery Technical Bulletin*, 10, 1986, pp. 33–7.

> For an early Bellini in tempera see A. Braham, M. Wyld and J. Plesters, 'Bellini's "The Blood

of the Redeemer"', *National Gallery Technical Bulletin*, 2, 1978, pp. 11–24.

> For the identification of oil on the Pesaro Altarpiece see Valazzi (ed.), *La Pala Ricostituita* etc., listed under Panels and Frames.

> For other later paintings by Bellini see L. Lazzarini, 'Le Analisi di Laboratorio', *La Pala Barbarigo di Giovanni Bellini*, Quaderni della Soprintendenza ai Beni Artistici e Storici di Venezia, 3, 1983, pp. 23–7; E. C. G. Packard, 'A Bellini Painting from the Procuratia di Ultra, Venice: An Exploration of its History and Technique', *The Journal of the Walters Art Gallery*, XXXIII–XXXIV (1970–1), p. 82; and D. Bull and J. Plesters, 'The Feast of the Gods, Conservation, Examination and Interpretation', *Studies in the History of Art*, 40, National Gallery of Art, Washington 1990.

> For Cima's technique see Dunkerton and Roy, 'The Technique and Restoration of Cima's "The Incredulity of Saint Thomas"', listed under Pigments.

> For the identification of 'tempera grassa' on paintings by Botticelli see U. Baldini, *La Primavera del Botticelli*, Milan 1984; in English, *Primavera*, 1986, pp. 48–51 (in both editions); and M. Ciatti (ed.), *L'Incoronazione della Vergine del Botticelli: restauro e ricerche*, Florence 1989, especially pp. 97–8.

> For Leonardo's own writing on technique see J. P. Richter (ed.), *The Literary Works of Leonardo da Vinci*, listed under Premises, Tools and Equipment, especially pp. 360–4.

> For one of the few relatively recent studies on Leonardo's easel painting technique, concentrating principally on Leonardo's use of his fingers and the malleability of his paint, see T. Brachert, 'A distinctive aspect in the painting technique of the Ginevra de' Benci and of Leonardo's early works', *Report and Studies of the History of Art*, National Gallery of Art, Washington, 1969, pp. 85–104.

> For Perugino see D. Bomford, J. Brough and A. Roy, 'Three Panels from Perugino's Certosa di Pavia Altarpiece', *National Gallery Technical Bulletin*, 4, 1980, pp. 3–31.

> For Raphael's technique in his early paintings see Plesters, 'Technical Aspects of Some Paintings by Raphael in the National Gallery, London', listed under Gilding; see also A. Braham and M. Wyld, 'Raphael's "St John the Baptist Preaching"', *National Gallery Technical Bulletin*, 8, 1984, pp. 15–23; and *Raffaello a Firenze, Dipinti e disegni delle collezioni fiorentine*, exhibition catalogue, Milan 1984.

Conclusion

Alberti, L. B., *On Painting and On Sculpture*, London 1972. This includes a scholarly edition and translation of *De Pictura*, the Latin version of Alberti's treatise composed in 1435, with a helpful introduction by C. Grayson.

Baxandall, M., *Giotto and the Orators*, Oxford 1971. A discussion of humanism and oratory and their relationship with innovations in Italian painting 1350-1400.

Baxandall, M., *Painting and Experience in Fifteenth Century Italy* (1972), Oxford 1974.

Blunt, A., *Artistic Theory in Italy 1450-1600* (1940), Oxford 1968. The first four chapters are relevant.

Castiglione, Baldassare, *The Book of the Courtier*, London 1974. A recent edition of Sir Thomas Hoby's translation of 1561 of Castiglione's *Il Cortegiano* first published by the Aldine Press in Venice in 1528. A more accurate modern translation by G. Bull was published in 1967 (Harmondsworth).

Ghiberti, Lorenzo, *I Commentarii* (ed. O. Morisari), Naples 1947.

Hills, Paul, *The Light of Early Italian Painting*, New Haven and London 1987.

Richter, J. P. (ed.), *The Literary Works of Leonardo da Vinci*, London and New York 1970.

van Mander, Karel, *Het Schilderboek*, Haarlem 1604.

Vasari, G., *Le Opere* (ed. G. Milanesi), 9 vols. (Milan 1878-85), Florence 1973. This is mostly devoted to *Le Vite de piu eccellenti pittori, scultori ed architettori* (the first edition of which was 1550, revised 1568).

White, J., *The Birth and Rebirth of Pictorial Space*, 3rd edn., Cambridge, Mass., 1987.

PART THREE

PAINTINGS IN THE NATIONAL GALLERY

By artist and plate number

MARGARITO
1. No monograph on the artist exists, but see A. M. Maetzke, 'Nuove ricerche su Margarito d' Arezzo', *Bollettino d'Arte*, 1973, pp. 95-112, for a discussion of his main works.

GIOTTO
2. D. Gordon, 'A dossal by Giotto and his workshop: some problems of attribution, provenance and patronage', *The Burlington Magazine*, CXXXI, 1989, pp. 524-31. See also *Art in the Making: Italian Painting before 1400*, listed under Further Reading, p. 64, and p. 219 for further bibliography. A usefully illustrated monograph is Giovanni Previtali, *Giotto e la sua bottega*, Milan 1967.

DUCCIO
3. See *Art in the Making*, op. cit in No. 2; p. 72ff., and p. 219 for further bibliography. A useful monograph is J. White, *Duccio. Tuscan Art and the Medieval Workshop*, London 1979, which also publishes all documents relating to Duccio with English translations including those for the *Maestà* (pp. 192-7), and locations of surviving fragments.

4. J. White, 'Carpentry and Design in Duccio's Workshop: the London and Boston Triptychs', *Journal of the Warburg and Courtauld Institutes*, XXXVI, 1973, pp. 92-105. See also *Art in the Making*, op. cit., 1989, p. 90, and p. 219 for further bibliography.

UGOLINO DI NERIO
5. See *Art in the Making*, op. cit. in No. 2, p. 98 and p. 219 for further bibliography, and for the locations of surviving fragments.

PIETRO LORENZETTI
6. E. H. Beatson, N. E. Muller and J. B. Steinhoff, 'The Saint Victor Altarpiece in Siena Cathedral: A reconstruction', *The Art Bulletin*, LXVIII, 1986, pp. 610-31, discuss the altarpieces by the Lorenzetti brothers *et al.* for Siena Cathedral.

LORENZO VENEZIANO
7. For the artist see P. Pallucchini, *La Pittura Veneziana del Trecento*, Venice and Rome 1964, p. 163ff.

NICCOLÒ DI BUONACCORSO
8. Little has been written on this artist but see M. Boskovits, 'Su Niccolò di Buonaccorso, Benedetto di Bindo e la pittura senese del primo Quattrocento', *Paragone*, XXXI, 1980, Nos. 359-61, pp. 3-22. For the carpet see J. Mills, *Carpets in Pictures*, National Gallery, London 1983, p. 4ff.

JACOPO DI CIONE
9. For the reconstruction and the locations of surviving fragments of the altarpiece see *Art in the Making*, op. cit. in No. 2, 1989, p. 156, p. 197 for the documents and p. 220 for further bibliography. For a monograph on the artist see R. Offner and K. Steinweg, *A Critical and Historical Corpus of Florentine Painting*, Section IV, Vol. III, New York 1965, *Jacopo di Cione*.

THE WILTON DIPTYCH
10. The literature on the diptych regarding the function, date and style of the diptych is vast and complex. For a useful bibliography up to 1972 see S. Whittingham, 'The Date of the Wilton Diptych', *Gazette des Beaux Arts*, 1981, p. 148ff.
Fundamental to a study of the diptych are M. V. Clarke, 'The Wilton Diptych', *The Burlington Magazine*, LVIII, 1931, pp. 283-94, for the dating according to the heraldry; also J. H. Harvey, 'The Wilton Diptych – A Re-Examination', *Archaeologia*, 98, Oxford, 1961, pp. 1-24 (although his arguments regarding the secret society devoted to Richard II should be treated with scepticism). F. Wormald, 'The Wilton Diptych', *Journal of the Warburg and Courtauld Institutes*, XVII, 1954, pp. 191-203, is excellent but he considered the diptych to date from after Richard's death. More recently see the exhibition catalogue, *The Age of Chivalry* (eds. J. Alexander and P. Binski), Royal Academy of Arts, London 1987, pp. 134-6.

LORENZO MONACO
11. An excellent monograph on the artist is M. Eisenberg, *Lorenzo Monaco*, Princeton 1989; see p. 138ff. for discussion of the National Gallery panel, and fragments possibly associated with it.

MASTER OF SAINT VERONICA
12. For the Master of Saint Veronica see *Late Gothic Art from Cologne*, exhibition catalogue, National Gallery, London 1977, pp. 32-3.

ROBERT CAMPIN
13. For Campin see L. Campbell, 'Robert Campin, the Master of Flémalle and the Master of Mérode', *The Burlington Magazine*, CXVI, 1974, pp. 634-46. For the version of No. 13 with metal basin see J. Destrée, 'Altered in the Nineteenth Century? A Problem in the National Gallery, London', *Connoisseur*, LXXIV, 1926, pp. 209-10.

14. See No. 13.

MASACCIO
15. For a reconstruction of the altarpiece as a unified picture surface and the locations of surviving picture fragments see J. Shearman, 'Masaccio's Pisa Altarpiece: an alternative reconstruction', *The Burlington Magazine*, CVIII, no. 762, 1966, pp. 449-55. For a reconstruction of the altarpiece as a polyptych see C. Gardner von Teuffel, 'Masaccio and the Pisa altarpiece: a new approach', *Jahrbuch der Berliner Museen*, XIX, 1977, pp. 23-68. The documents for the altarpiece were published by J. Beck, *Masaccio: The Documents*, New York 1978, p. 31ff.

MASACCIO AND MASOLINO
16. There is no conclusive evidence as to what was on the front of the altarpiece. The changes in the saints and the implications are discussed in C. Strehlke and M. Tucker, 'The Santa Maria Maggiore Altarpiece: New Observations', *Arte Cristiana*, No. 719, 1987, pp. 105-24. For the view that the altarpiece was designed in 1423 and with Masaccio playing a minor role and Masolino the leading role in the collaboration see P. Joannides, 'The Colonna Triptych by Masolino and Masaccio: Collaboration and Chronology', *Arte Cristiana*, No. 728, 1988, pp. 339-46. See also A. Braham, 'The Emperor Sigismund and the Santa Maria Maggiore altarpiece', *The Burlington Magazine*, CXXII, No. 923, 1980, pp. 106ff.

JAN VAN EYCK
17. The most recent book on van Eyck is E. Dhanens, *Hubert and Jan van Eyck*, Antwerp 1980. It is exceptionally well illustrated.

18. See No. 17. E. Panofsky, *Early Netherlandish Painting*, 2 vols., Cambridge, Mass., 1953, pp. 202-3, includes a highly influential interpretation of the painting as a depiction of a wedding ceremony in which most of the objects are seen as symbolic of the theme of marriage. More recently, the theory that a wedding ceremony is represented has been questioned, (see L. Campbell, *The Renaissance Portrait*, listed under Portraits, pp. 135-6), as has the concept of 'disguised symbolism' which Panofsky uses to support his view. Current scholarship has sought contemporary documentation for such interpretations. A recent article which seeks to prove the marriage interpretation using contemporary evidence of marriage customs is J. B. Bedaux, 'The Reality of Symbols: the question of disguised symbolism in Jan van Eyck's *Arnolfini Portrait*', *Simiolus*, XVI, 1986, pp. 5-28.

SASSETTA

19. For a technical analysis of the National Gallery panels see M. Wyld and J. Plesters, 'Some Panels from Sassetta's Sansepolcro Altarpiece', *National Gallery Technical Bulletin*, I, 1977, pp. 3-17.
For the artist see the exhibition catalogue *Painting in Renaissance Siena 1420-1500*, Metropolitan Museum of Art, New York 1988, p. 63, and for the Borgo Sansepolcro altarpiece see p. 84.
See further H. W. van Os, *Sienese Altarpieces 1215-1460*, Vol. II, Groningen 1990, pp. 89ff. His reconstruction is the one followed here with the exception of the Chantilly panel, which for compositional reasons must be placed on the left of the main panel; this also accords with the sequence of Saint Bonaventura's Legend.
The contract for Sassetta's altarpiece is printed in M. Davies, *The Earlier Italian Schools, National Gallery Catalogues*, London 1961, pp. 568-70.
For documents concerning its delivery and a reconstruction with locations of surviving fragments see K. Christiansen in the exhibition catalogue *Gothic to Renaissance. European Painting 1300-1600*, Colnaghi, London and New York 1988, p. 44ff.

STEPHAN LOCHNER

20. For the Lochner altarpiece see *Late Gothic Art from Cologne*, exhibition catalogue, National Gallery, London 1977, pp. 42-4.

PISANELLO

21. G. Paccagnini, *Pisanello e il ciclo cavalleresco di Mantova*, Milan, n.d., esp. p. 219 ff. for a discussion of the National Gallery panel.

ROGIER VAN DER WEYDEN

22. The most recent book on Rogier van der Weyden is L. Campbell, *Rogier van der Weyden*, London 1979. For a recent discussion of the problems of reconstructing the altarpiece to which No. 22 belongs see *Rogier van der Weyden*, exhibition catalogue, Brussels City Museum, 1979, pp. 146-7, 162-3.

FILIPPO LIPPI

23. See G. Marchini, *Filippo Lippi*, Milan 1975, esp. p. 207, for the suggestion that the panels could have been part of a bed.

PISANELLO

24. See No. 21, esp. p. 222ff, for a discussion of the Saint Eustace panel.

GIOVANNI DI PAOLO

25. For the artist see J. Pope-Hennessy, *Giovanni di Paolo 1403-1483*, London 1937; idem, 'Giovanni di Paolo', *The Metropolitan Museum of Art Bulletin*, Vol. XLVI, No. 2, 1988, esp. pp. 17-19. He considers the association of the altarpiece in New York and predella panels in the National Gallery 'very likely'. See also *Painting in Renaissance Siena 1420-1500*, exhibition catalogue. Metropolitan Museum of Art, New York 1988, p. 168 (for the artist) and p. 218 for comment on the National Gallery panels.

PAOLO UCCELLO

26. For a discussion of the location demonstrating that the panels were not originally designed for the 'camera di Lorenzo' see P. Joannides, 'Paolo Uccello's Rout of San Romano: a new observation', *The Burlington Magazine*, Vol. 131, 1989, pp. 214-15. Most recently see V. Gebhardt, *Paolo Uccello's 'Schlacht von San Romano'*, Bochumer Schriften zur Kunstgeschichte, Frankfurt am Main 1991. Gebhardt publishes some of his conclusions in 'Some problems in the reconstruction of Uccello's "Rout of San Romano"', *The Burlington Magazine*, 132, 1991, pp. 179-85, correcting some of Joannides' assumptions.
For the artist see J. Pope-Hennessy, *Paolo Uccello*, London 1950.

PIERO DELLA FRANCESCA

27. A. Paolucci, *Piero della Francesca*, Florence 1989, is the most recent publication to illustrate and catalogue all Piero's paintings. The best account of the artist's work in English is K. Clark, *Piero della Francesca*, London 1951, revised edn 1969.

DIERIC BOUTS

28. The only monograph on Dieric Bouts is W. Schöne, *Dieric Bouts und seine Schule*, Berlin and Leipzig 1938, with a catalogue and appendix of documents. For a scientific analysis of the technique of No. 28 see D. Bomford, A. Roy and A. Smith, 'The Techniques of Dieric Bouts: Two Paintings Contrasted', *National Gallery Technical Bulletin*, X, 1986, pp. 39-57.

ROGIER VAN DER WEYDEN

29. See No. 22.

MANTEGNA

30. The best recent book on Mantegna, including illustrations and a catalogue of all his paintings, is R. Lightbown, *Mantegna*, Oxford 1986.

GIOVANNI BELLINI

31. The most recent book on Bellini is R. Goffen, *Giovanni Bellini*, New Haven and London 1989. It is well illustrated and includes a list of attributed works and an appendix of documents.

DIERIC BOUTS

32. For a discussion of the altarpiece of which No. 28 may have formed a part and the scientific analysis of its technique see D. Bomford *et al.*, under No. 28.

PIERO DELLA FRANCESCA

33. See No. 27. An English translation of the contract for this painting is given by M. Meiss, 'A Documented Altarpiece of Piero della Francesca', *The Art Bulletin*, XXIII, 1941, p. 68. For the contract see also H. Glasser, listed under Contracts and Commissions above, pp. 279-84, and J. R. Banker, 'Piero della Francesca's Saint Agostino altarpiece: some new documents', *The Burlington Magazine*, 1987, pp. 644-51.

UNKNOWN SWABIAN ARTIST

34. For the suggestion that the painting is by the Master of the Sterzing Wings see A. Stange, *Deutsche Malerei der Gotik*, VIII, Berlin 1957, p. 9.

FRANCESCO DEL COSSA

35. A. Smith, A. Reeve and A. Roy, 'Francesco del Cossa's Saint Vincent Ferrer', *National Gallery Technical Bulletin*, V, 1981, pp. 44-57. Smith, like Davies, cast doubt on the reconstruction proposed by Longhi, but the recent discovery of an 18th-century drawing establishes Longhi as correct in all essentials – see A. Bacchi, *Dipinti Ferraresi dalla collezione Vittorio Cini*, Vicenza 1990, pp. 15 and 20. See also No. 44.

PIERO DELLA FRANCESCA

36. See No. 27.

MASTER OF THE LIFE OF THE VIRGIN

37. For a recent book on the Master see H. M. Schmidt, *Der Meister des Marienlebens und sein Kreis*, Düsseldorf 1978, with catalogue, on which the reconstruction presented here is based, although his division of the artist into separate artistic personalities may require revision. For the donor of No. 37 see especially p. 124 and for the National Gallery panel, see also *Late Gothic Art from Cologne*, exhibition catalogue, National Gallery, London 1977. For the chain worn by the donor see S. M. Newton, 'A Confraternity of the Holy Ghost and a Series of Paintings of the Life of the Virgin in London and Munich', *Journal of the Warburg and Courtauld*

Institutes, XXIX, 1976, pp. 59-68, although her conclusions regarding the original location of the altarpiece should be treated with caution.

BOTTICELLI

38. The best recent book, including illustrations and a catalogue of all his painting, is R. Lightbown, *Botticelli*, 2 vols., London 1978, revised 1989 in one volume.

VERROCCHIO

39. G. Passavant, *Verrocchio: Sculptures, Paintings and Drawings*, London 1969, illustrates and catalogues paintings associated with Verrocchio. See also G. M. Achenbach, 'The Iconography of Tobias and the Angel in Florentine painting of the Renaissance', *Marsyas*, III, 1943-5, pp. 71-86; and E. H. Gombrich, 'Tobias and the Angel' in *Symbolic Images*, London 1972, pp. 26-30.

ANTONIO and PIERO DEL POLLAIUOLO

40. L. D. Ettlinger, *Antonio and Piero Pollaiuolo*, Oxford 1978, illustrates and catalogues all paintings and sculptures by, or associated with, the two brothers. See also L. Fusco, 'The Use of Sculptural Models by Painters in Fifteenth-century Italy', *The Art Bulletin*, LXIV, 1982, pp. 175-94.

ANTONELLO DA MESSINA

41. F. S. Santoro, *Antonello e l'Europa*, Milan 1986, is the most recent publication, but see also *Antonello da Messina*, catalogue of an exhibition at Museo Regionale, Messina 1981-2.

MEMLINC

42. The most recent book is K. B. MacFarlane, *Hans Memlinc*, Oxford 1971, which includes a full account of the Donne family.

MASTER OF LIESBORN

43. For a reconstruction of the Liesborn Altarpiece on which that presented here is based, and which supersedes that proposed by Levey in his catalogue, see P. Pieper, *Die deutschen, niederländischen und italienischen Tafelbilder bis um 1530, Westfälischen Landesmuseum für Kunst und Kulturgeschichte*, Münster 1986.

COSIMO TURA

44. R. Molajoli, *Cosmè Tura e i grandi pittori ferraresi del suo tempo: Francesco Cossa e Ercole de' Roberti*, Milan 1974, illustrates and catalogues all paintings by these artists. See also E. Ruhmer, *Cosimo Tura*, London 1958.

MICHAEL PACHER

45. The most recent book is N. Rasmo, *Michael Pacher*, Munich and Milan 1969 (English ed. London 1971), with an appendix of documents and catalogue. M. Baxandall, *The Limewood Sculpture of Southern Germany*, London and New Haven, 1980, pp. 252-3, also provides a useful overview of the

problem of Pacher and his workshop.

CRIVELLI

46. The best work on Crivelli, including illustrations and a catalogue of all his paintings, is P. Zampetti, *Carlo Crivelli*, Florence 1986. In his catalogue Davies did not accept that the four saints catalogued here certainly came from a different altarpiece from the Demidoff polyptych in which they had served as the uppermost tier.

BOTTICELLI

47. See No. 38. That the subject embodies profound symbolism or moral argument is proposed by E. Panofsky, *Studies in Iconology*, London 1939, p. 63; E. Wind, *Pagan Mysteries in the Renaissance*, London 1968, pp. 89-91; E. H. Gombrich, *Symbolic Images*, London 1972, pp. 66-9.

FILIPPINO LIPPI

48. For a general view of Lippi's work see A. Scharf, *Filippino Lippi*, Vienna 1950.

GEERTGEN TOT SINT JANS

49. For Geertgen's work see J. Snyder, 'The Early Haarlem School of Painting. 2 Geertgen tot Sint Jans', *The Art Bulletin*, XLII, 1960, pp. 113-32. For a painting which like that of Geertgen may have been based on a lost work by Hugo van der Goes see F. Winkler, *Das Werk des Hugo van der Goes*, Berlin 1964, pp. 141-54.

LORENZO COSTA

50. For this painting see M. Levey, *The Early Renaissance*, Harmondsworth 1967, pp. 104-7.

CRIVELLI

51. See No. 46.

MASSYS

52. The most recent book on Massys, including a catalogue, is L. Silver, *The Paintings of Quinten Massys*, Oxford 1984.

BOSCH

53. For a discussion of the depiction of Christ's tormentors in canine form see J. Marrow, 'Circumdederant me canes multi: Christ's Tormentors in Northern European Art of the Late Middle Ages and Early Renaissance', *The Art Bulletin*, LIX, 1977, pp. 167-81. For Bosch generally see R. H. Marijnissen assisted by P. Ruffelaere, *Hieronymous Bosch: The Complete Works*, Antwerp 1987.

PIERO DI COSIMO

54. M. Bacci, *L'Opera completa di Piero di Cosimo*, Milan 1976, illustrates and catalogues all paintings by Piero di Cosimo.

DÜRER

55. The most recent catalogue of Dürer's paintings is F. Anzelewsky, *Albrecht Dürer, Das Malerische Werk*, Berlin 1971. E. Panofsky, *The Life and Art of Albrecht Dürer*, 4th edn, Princeton, N. J., 1955, is still a readable account of Dürer's achievements. P.

Strieder, *Dürer*, Königstein im Taunus 1981, is a well-illustrated recent monograph.

BOTTICELLI

56. See No. 38

GIOVANNI BELLINI

57. See No. 31. For an interpretation of the bird and snake as an allusion to Virgil's reference to the best time for planting vines and hence to the sacraments (the wine being the blood of Christ) see Wind under No. 47.

MASTER OF MOULINS

58. For the Master of Moulins see C. Sterling, 'Jean Hey: Le Maître de Moulins, *Revue de l'Art*, 1-2, 1968, pp. 26-33, and N. Reynaud, 'Jean Hey Peintre de Moulins, et son client Jean Cueillette', *ibid.*, pp. 34-7.

PERUGINO

59. For this altarpiece see D. Bomford, J. Brough and A. Roy, 'Three panels from Perugino's Certosa di Pavia Altarpiece', *National Gallery Technical Bulletin*, IV, 1980, pp. 3-31, and *Perugino, Lippi e La Bottega di San Marco alla Certosa di Pavia, 1495-1511*, catalogue of an exhibition held at the Brera, Milan 1986. The best modern book on Perugino, including illustrations and a catalogue of all his paintings, is P. Scarpellini, *Perugino*, Milan 1984.

GIOVANNI BELLINI

60. See No. 31.

RAPHAEL

61. R. Jones and N. Penny, *Raphael*, New Haven and London 1983, pp. 1-20, provides a useful survey of the artist's early work. J. Plesters, 'Technical aspects of some paintings by Raphael in the National Gallery, London', in J. Shearman and M. Hall (eds.), *The Princeton Raphael Symposium*, Princeton 1990, pp. 15-37, includes an account of this painting on pp. 19-24.

MASTER OF THE SAINT BARTHOLOMEW ALTARPIECE

62. For the Master of the Saint Bartholomew Altarpiece see the forthcoming monograph by P. Pieper. See also *Late Gothic Art from Cologne*, exhibition catalogue, National Gallery, London 1977, pp. 102-3.

RAPHAEL

63. See No. 61; the brief discussion of this work by Plesters is on pp. 16-18 of her article.

MANTEGNA

64. See No. 30. Lightbown's discussion of this painting is especially valuable. For Bellini's painting in this series see Goffen under No. 31. For Mantegna's imitation of marble see R. Jones, 'Mantegna and materials', *I Tatti Studies*, II, 1987, pp. 71-90.

RAPHAEL

65. See No. 61. The discussion of this work (and especially the predella) by Plesters is on

pp. 31-6 of her article. On the predella see also A. Braham and M. Wyld, 'Raphael's Saint John the Baptist Preaching', *National Gallery Technical Bulletin*, 8, 1984, pp. 15-23.

LEONARDO

66. The finest survey of Leonardo as an artist remains K. Clark, *Leonardo da Vinci* (1959), revised edn., Harmondsworth 1967; see pp. 103-6 for the National Gallery drawing. The evidence for the dating of the drawing is succinctly presented in the entry by M. Kemp for the preparatory compositional sketch in *Leonardo da Vinci*, exhibition catalogue, Hayward Gallery, London 1989, p. 150. This catalogue also supplies a valuable introduction to Leonardo's interests – as a scientist as well as an artist. See also E. Harding, A. Braham, M. Wyld and A. Burnstock, 'The Restoration of the Leonardo Cartoon', *National Gallery Technical Bulletin*,

13, 1989, pp. 5-27.

MASTER OF THE SAINT BARTHOLOMEW ALTARPIECE

67. See No. 62. For the suggestion that the painting constitutes part of the Saint Bartholomew Altarpiece itself see *Late Gothic Art from Cologne*, exhibition catalogue, National Gallery, London 1977, pp. 86-9.

LEONARDO

68. See Clark and the exhibition catalogue cited under No. 66 for Leonardo in general. Davies's entry for this painting is exemplary in its presentation of the documentary evidence concerning it, but cautious in its interpretation. Improved transcriptions of documents were published by H. Glasser, *Artist's Contracts of the Early Renaissance*, New York 1977, who also provided a far clearer commentary on their significance, and in

particular clarified the nature of the carved ancona into which the altarpiece was inserted. New documents were published by G. Sironi, *Nuovi documenti riguardanti la "Vergine delle Rocce" di Leonardo da Vinci*, Milan n.d. (1981). W. Cannell, 'Leonardo da Vinci "The Virgin of the Rocks": A Reconsideration of the Documents and a new Interpretation', *Gazette des Beaux-Arts*, CIV, 1984, pp. 100-8, proposed a convincing date and pretext for the creation of the version in the National Gallery.

GERARD DAVID

69. For technical comment on this painting see M. Wyld, A. Roy and A. Smith, 'Gerard David's *The Virgin and Child with Saints and a Donor*', *National Gallery Technical Bulletin*, 3, 1979, pp. 51-65. The most recent book on David is Hans J. van Miegroet, *Gerard David*, Antwerp 1989.

INDEX

PICTURE CREDITS